YALE UNIVERSITY PRESS
PELICAN HISTORY OF ART
Founding Editor: Nikolaus Pevsner

Laurence Sickman and Alexander Soper

THE ART AND ARCHITECTURE OF CHINA

After leaving Harvard in 1930 Laurence Sickman spent five years in China, travelling widely and studying Chinese art in all its forms. From 1938 to 1940 he was lecturer in Far Eastern Art at Harvard, and in 1953 was appointed Director of the Nelson Gallery of Art and Atkins Museum, Kansas City, where he had previously served as Curator of Oriental Art. He has contributed numerous articles on Chinese art to many learned journals.

Alexander Soper took his Ph.D. at Princeton University in 1944 after studying Japanese art and architecture at Kyoto from 1935 to 1938. In 1939 he was appointed Associate Professor in the History of Art at Bryn Mawr College, Pennsylvania, and in 1948 became Professor at the same college. Since 1960 he has been Professor of Fine Arts at the Institute of Fine Arts, New York University. He has written numerous articles, and in 1942 published *The Evolution of Buddhist Architecture in Japan*. He is also the author of the section on Architecture in *The Fine Art and Architecture of Japan* which forms part of this series.

Laurence Sickman and Alexander Soper

THE ART AND ARCHITECTURE
OF CHINA

Yale University Press · New Haven and London

First published 1956 by Penguin Books Ltd
Third edition 1968

20 19 18 17 16 15 14 13 12 11 10 9 8

Copyright © Lawrence Sickman and Alexander Soper 1956, 1960, 1968, 1971

Set in Monophoto Ehrhardt, and printed in Hong Kong through World Print Ltd

Designed by Gerald Cinamon

ISBN 0-300-05334-7
Library of Congress catalog card number 70-125675

CONTENTS

Part Two: Architecture
Alexander Soper

This edition is based on the third hardback
edition published in 1968. The appendices from
that edition have been incorporated into the
text.

The line drawings in Part One were prepared
by Theodore Ramos; those in Part Two by
Alexander Soper and Peter Darvall. The maps
were prepared by Paul White and executed by
Sheila Waters.

FOREWORD TO PART ONE

Any student of Chinese art realizes that the accomplishments of Western scholars in this vast field are infinitesimal in comparison with what must be done before a true and well-rounded picture of Chinese material culture throughout almost four millennia can be evoked. Nevertheless, the progress that has been made in the past few decades can justify the present attempt to present a general survey. It is proper here to acknowledge my indebtedness to those Western scholars, listed in the bibliography, whose labours and pioneer interest have contributed so much and laid the foundations for further knowledge. In particular I am grateful for the publications of Dr Osvald Sirén, which present such a quantity of invaluable material, and for the work of such Japanese archaeologists as D. Tokiwa and T. Sekino, Sueji Umehara, Seiichi Mizuno and his colleagues. I wish also to mention my gratitude to Arthur Waley, whose writings and translations have contributed so much to my appreciation of the humanities in the Far East.

Inasmuch as this work is intended for Western readers, the bibliography does not include publications in the Chinese language. It would be a gross injustice, however, if I did not acknowledge the fundamental importance to me, as to all students in this field, of the meticulous work of those Chinese scholars, past and present, whose publications form the basic structure of Chinese art history.

In the selection of the illustrations material has been chosen, whenever possible, which can be seen in the original by the Western reader, in the public and private collections of Europe and America. Also an attempt has been made to introduce certain new or relatively little known examples in preference to those already well known through numerous publications in Western languages. I am deeply indebted to the museum officials, art historians, and collectors who have placed their material at my disposal.

In the preparation of this work my deepest gratitude is due Miss Jeanne Harris whose help has been invaluable and whose patience and application in correcting the manuscript and reading the proofs have been of the greatest assistance. I wish also to express my deep gratitude to my colleagues and associates at the Nelson Gallery who have aided me so much with their advice and the preparation of the photographs. And finally, I wish to speak of the debt I owe my late teacher and colleague, Langdon Warner, who early stimulated my lifelong interest in the arts of the Far East. His death in June 1955 impels me to express more fully than I would otherwise have done, my deep obligation and the admiration I share with so many others. The influence he exerted over the study of oriental art in this country is inestimable, while many collections, that of the Nelson Gallery among them, have come into being through his encouragement and initial guidance. His rare amalgam of information, wisdom, and humanity, coupled with his vital enthusiasm, made him an incomparable teacher who inspired all who had the privilege of knowing him.

LAURENCE SICKMAN
Kansas City, Missouri, 27 July 1967

FOREWORD TO PART TWO

My share in this book would not have been possible without much assistance from the Far East. My first interest in early Chinese architecture was stimulated by the work carried out in the 1930s in little-known areas of the North by the energetic and adventurous members of the Society for Research in Chinese Architecture. As the footnotes in Part Two reveal, much of my knowledge of the major surviving monuments was derived from the thorough and learned reports published by the Society's *Bulletin* as late as 1944. In seeking the broader perspective offered by a complementary study of architectural developments in Japan, I have of course been aided by many Japanese scholars and institutions. For the specific needs of this book I am indebted to two persons in particular, Professor Mizuno Seiichi of Kyōto University and Professor Sekino Masaru of Tōkyō University, without whose excellent photographs the illustrations would have been greatly impoverished.

A smaller but very important group of pictures, carrying back to the period before the Communist revolution interrupted contacts with the West, testifies to my continuing admiration for the work of one of the charter members of the Peking society, Liang Ssu-ch'eng.

This third edition can acknowledge only briefly the extraordinary expansion of Chinese architectural history that has been achieved through discoveries made everywhere in China during the decade of Communist control. The earlier of these, dating from the first century A.D. on, consist primarily of underground tomb structures, built usually of brick with corbelled tunnel or cloister vaults. The ground plans, which at first follow the elongated proportions of the coffin itself, reveal by the T'ang dynasty a new preference for centralization about a square, circle, or polygon. By that age, also, the wall decoration has become architectonic, using details – painted or in relief – that enrich our knowledge of the contemporary style created in wood.

Finds of more recent date have greatly added to the roster of preserved buildings from the Sung, Yüan, and early Ming. As yet, however, much of this material has been published only in summary, and almost always with inferior illustrations.

ALEXANDER SOPER

GLOSSARY

Amitābha (Sanskrit). The Buddha who dwells in the Western Paradise (*Sukhāvatī*); worshipped by followers of the *Ching tu* sect (*Pure Land*).

Ānanda (Sanskrit). The favourite disciple of *Śākyamuni Buddha*, said to have compiled the *sūtras* (scriptures).

apsaras (Sanskrit). Buddhist heavenly maiden, dwelling in the paradises.

Avalokiteśvara (Sanskrit). In Chinese, *Kuan-yin* Bodhisattva.

Bodhidharma (Sanskrit). The Indian monk who traditionally arrived in China in 520, founded the Ch'an sect of Buddhism, and became its first patriarch.

Bodhisattva (Sanskrit). A deity of *Mahāyāna* Buddhism who has renounced Buddha-hood and *nirvāna* in order to act as saviour to all sentient beings.

Buddha (Sanskrit). Originally, *Gautama Siddhārtha* (or *Śākyamuni*, sage of the *Śākya* clan.) Later, any one of the deities of *Mahāyāna* Buddhism who has attained enlightenment and entered *nirvāna*, or dwells in a heavenly paradise. Among the most important Buddhas are *Maitreya*, the Buddhist Messiah, *Vairocana*, and *Amitābha*.

Ch'an. Buddhist sect traditionally founded by Bodhidharma in the sixth century A.D., known as *Zen* in Japan. Sect based on contemplation and self-discipline, teaching that Buddha is immanent in all things.

Chên-yen (True Word). Buddhist sect brought to China from India in the eighth century by two monks, Vajrabodhi and Amoghavajra. Introduced ritual and magic, and the use of complex *maṇḍalas*.

Chih-hou (Painter-in-Waiting). Title second in rank, awarded to official painters of the Imperial court.

Chin-shih. Degree granted to a scholar who successfully completed the third degree examinations; equivalent to the Western doctorate.

Chün-tzu. The superior man, the perfect gentleman.

dhoti (Sanskrit). An Indian garment such as that worn by modern Hindus, and shown on figures of Bodhisattvas; a length of cloth wrapped around the hips, with the ends draped in front, hanging freely to ankle-length.

fang. A copy, an interpretation of a painting, which may be a free adaptation 'after the manner of' the original.

fei po (or *pai*) (flying white). A brush-stroke in which the brush is pulled quickly across the paper, allowing the hairs to separate so that the ink is broken and uneven, and the paper shows through.

The Five Classics:
 I Ching: Canon of Changes.
 Shu Ching: Book of History.
 Shih Ching: Book of Odes.
 Chou Li: Book of Ritual.
 Ch'un Ch'iu: Spring and Autumn Annals.

The Four Books:
 Lun Yü: Analects of Confucius.
 Mêng Tzu: Book of Mencius.
 Ta Hsüeh: Great Learning.
 Chung Yung: Doctrine of the Mean.

These books, together with the Five Classics, have formed the basis for the education of all cultivated Chinese.

Han-lin. Academy established by the T'ang emperor Ming Huang in 754, for scholarly and artistic accomplishments.

hao. One of several names chosen by an artist, used in signatures and seals on his paintings. The literary name or sobriquet assumed by an individual. In China the surname (*hsing*) is first, followed by the personal or given name (*ming*). The individual in addition has a courtesy name (*tzu*) which he assumes for general use. Frequently artists take a number of fanciful *hao* or studio names with which they sign their pictures.

Hinayāna (Sanskrit). The 'Small Vehicle'. The original form of Buddhism, with belief in the doctrine of Buddha, and with emphasis on individual salvation without divine aid.

hsien. A Taoist immortal, dwelling in the mountains.

Jātaka (Sanskrit: Birth stories). Episodes from former incarnations of the Buddha.

Kuan-yin. Chinese name of *Avalokiteśvara*, the Bodhisattva of mercy.

kung-pi. A precise style of painting, generally in colour, in which meticulous attention is paid to details; contrasted with *hsieh-i*, 'to paint the concept' – a spontaneous, free expression by means of brush and ink.

lin. A freehand copy of a painting, generally made directly from the original, in which the artist may use a certain amount of freedom.

ling-mao (feathers and fur). A classification for paintings of birds and animals.

Lohan (or *Arhat*, Sanskrit). An ascetic, in *Hinayāna* Buddhism, who attains enlightenment through his own efforts.

Mahākāśyapa (Sanskrit). The disciple of *Śākyamuni* Buddha who became leader after the death of *Śākyamuni*.

Mahāyāna (Sanskrit). The 'Great Vehicle'. The form of Buddhism, later developed, which included in the pantheon an assemblage of Buddhas and Bodhisattvas.

Maitreya (Sanskrit). The Buddha of the future, the Buddhist Messiah.

maṇḍala (Sanskrit). Schematic arrangement of the deities or Sanskrit letters in mystic diagrams. Used in paintings of the *Chên-yen* sect.

Mañjuśrī (Sanskrit). Bodhisattva of wisdom, often placed to the left of *Śākyamuni*. Emblems are the sword and the lion.

ming-ch'i. Objects placed in the tomb; made of cheaper materials, such as clay, in substitution for the more expensive bronze, precious metals, lacquer, etc.

mo-fang (or *mu-fang*). A faithful copy of an antique painting, sometimes made by tracing. Method used to preserve old compositions.

mudrā (Sanskrit). In Buddhism, a gesture of the hands and fingers of deities, indicating ritual speech or action.

nirvāṇa (Sanskrit). Release from the desires and suffering of the world, or delusion, and from transmigration after death.

pai-miao. Plain or unadorned drawing. Fine outline drawing in ink without colour.

Prabhūtaratna (Sanskrit). The Buddha who, after long years in *nirvāṇa*, appears in the sky, seated in his *stūpa*, to listen to *Śākyamuni* Buddha preach.

Śākyamuni (Sanskrit). The historical Buddha, died *c.* 487 B.C.

Sukhāvatī (Sanskrit). The Pure Land (*Ch'ing-t'u* or Western Paradise), where Amitābha Buddha dwells.

Tai-chao (Painter-in-Attendance). Highest title awarded to official painters at the imperial court.

Tao. The Taoist concept of the principle of Nature.

t'ao-t'ieh. Fantastic animal motif: face-on mask, usually without lower jaw.

ts'un. Sometimes translated as 'wrinkles'. In landscape painting, the brushwork within the outline or contour of a form, generally rocks, mountains, hills or trees, which represents modelling, texture, or the weathering and geologic structure of rocks. A great variety of these strokes have been evolved and artists may be classified by the types of *ts'un* they employ.

uṣṇīṣa (Sanskrit). Protuberance on head of Buddha symbolizing his transcendent spiritual knowledge.

Vairocana (Sanskrit). The Buddha who personifies a philosophical concept of the original creative spirit that embraces the Buddhist Law and the cosmos.

Vimalakīrti (Sanskrit). A Buddhist layman, a wealthy householder, who is often shown in sculpture and painting in philosophical discussion with the Bodhisattva *Mañjuśrī*.

wên. The Confucian concept of culture – literature, music, and all the arts of humanism which are the manifestation of a culture.

wên-jên hua (literary man's style). A personal style of painting developed by artists, beginning in the fourteenth century, which tended towards more free expressionism.

yin-yang. Ancient dual principles: symbol of male and female, sun and moon, light and darkness, positive and negative.

PART TWO: ARCHITECTURE

ang. A long transverse bracket arm, set diagonally to the rest of the complex and used originally as a lever.

chorten. The bottle-shaped Tibetan *stūpa.*

ch'üeh. An entrance marker, usually paired, used as a sign of status and so varying in size from a pillar to a great tower.

fang. A minor room.
fu. An elaborate descriptive poem.

hisashi (Japanese). An area (room or veranda) outside the central apartment of a mansion.
hsiang. An annex on left and right of the central apartment of a mansion.
hsien. An attached porch.
hsü. A minor room.
hua. A transverse bracket arm.

Karayō (Japanese). The official Southern Sung style for monumental architecture, borrowed in Japan by the *Zen* sect of Buddhism.
ko. A multi-storeyed pavilion.
kua-tzu. A longitudinal bracket arm, midway between wall and eaves purlin.
kuan. A look-out tower.

li. A linear measure of variable length: in Han about $\frac{1}{4}$ mile.
ling. The longitudinal bracket arm that supports the eaves purlin.
Ling T'ai. A tower erected by King Wên of Chou; also later imitations.
lou. A wood-framed tower.

man. A longitudinal bracket arm set above a *kua-tzu* to widen the support.
miao. Originally an ancestral shrine; later any non-Buddhist temple.
Ming T'ang. An ancient royal hall, of uncertain form and function.

p'ai-lou. An ornamental gateway or passage marker.
pao-t'a. A single-storeyed pagoda, usually with a cylindrical shaft.
Pi Yung. An ancient royal building, traditionally a school at the centre of a round pond.

shih. Originally the central apartment of a mansion.
ssu. Originally a governmental office; later a Buddhist temple.

stūpa (Sanskrit). A shrine, formed like funeral mound, raised over the relics of a Buddha or Buddhist saint.
sūtra (Sanskrit). A Buddhist scripture.

t'a. A pagoda.
t'ai. A high platform or tower, usually built of earth or masonry, but sometimes of wood so as to provide a usable interior.
t'ang. Originally a front or rear porch; later a monumental hall.
Tenjikuyō (Japanese). A monumental style borrowed by the Japanese, which probably originated as a local way of building along the south Chinese coast.
tien. A monumental hall.

yüan. A sub-precinct of a monastery-temple.

CHRONOLOGICAL TABLE

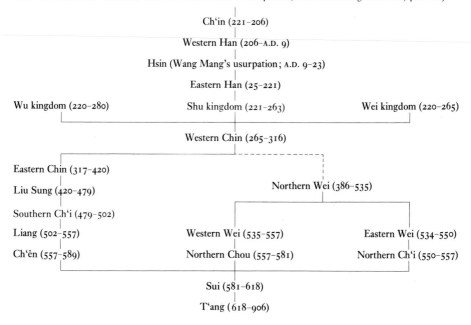

Hsia?

Shang or Yin (1766?-1122?) Revised chronology: (1523-1028)
Shang at Anyang (1300-1028)

Chou (1122?-256) Revised chronology: (1027-256)

(The royal power became a fiction at the end of the Western Chou period, 771 B.C. Thereafter authority was divided between a number of virtually independent feudal states. Historians use two convenient chronological subdivisions for the latter half of the dynasty, or Eastern Chou: the Spring and Autumn era, 722-481, named after the annals of Lu which cover that period; and the Warring States era, 480-221)

Ch'in (221-206)

Western Han (206-A.D. 9)

Hsin (Wang Mang's usurpation; A.D. 9-23)

Eastern Han (25-221)

Wu kingdom (220-280) Shu kingdom (221-263) Wei kingdom (220-265)

Western Chin (265-316)

Eastern Chin (317-420)

Liu Sung (420-479) Northern Wei (386-535)

Southern Ch'i (479-502)

Liang (502-557) Western Wei (535-557) Eastern Wei (534-550)

Ch'ên (557-589) Northern Chou (557-581) Northern Ch'i (550-557)

Sui (581-618)

T'ang (618-906)

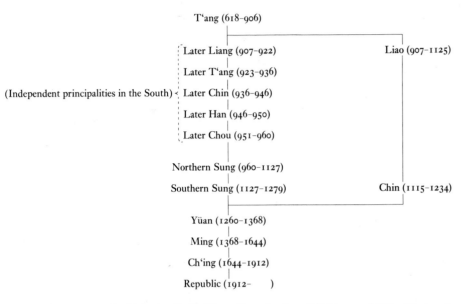

T'ang (618–906)

Later Liang (907–922)

Liao (907–1125)

Later T'ang (923–936)

(Independent principalities in the South) ⎨ Later Chin (936–946)

Later Han (946–950)

Later Chou (951–960)

Northern Sung (960–1127)

Southern Sung (1127–1279)

Chin (1115–1234)

Yüan (1260–1368)

Ming (1368–1644)

Ch'ing (1644–1912)

Republic (1912–)

Three collective terms should be noted: (1) The 'Three Kingdoms' are Wei, Shu, and Wu in the third century A.D. (2) The 'Six Dynasties' are, strictly speaking, those which used the site of modern Nanking as their capital: i.e., the Wu Kingdom, Eastern Chin, Sung, Southern Ch'i, Liang, and Ch'ên. The term is used inaccurately to designate the period between the Three Kingdoms and the Sui. (3) The 'Five Dynasties' are those of the tenth century, the Later Liang, Later T'ang, Later Chin, Later Han, and Later Chou.

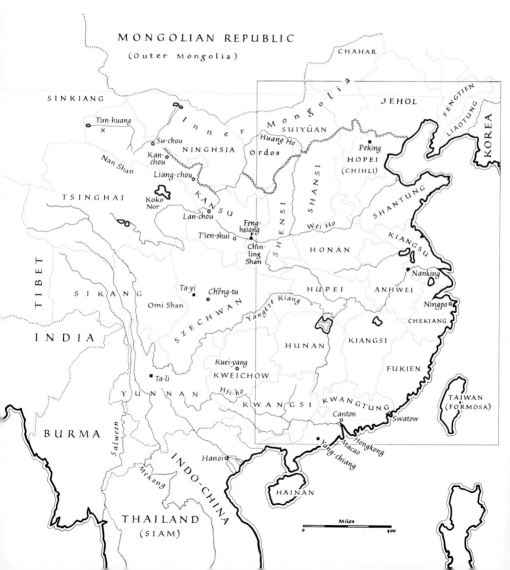

Hsi *or* Si: West
Nan: South
Pei *or* Peh: North
Tung: East
Hai: Sea
Ho; Chiang *or* Kiang; Ch'uan: River
Hu: Lake
Shan: Mountain
Chou *or* Chow ⎫
Chên ⎬ administrative centres
Fu ⎪ at different levels
Hsien ⎭

♪ Sacred mountains
△ Ancient capitals
■ Pottery centres
● Archaeological sites
✗ Buddhist caves
ⴑⴑⴑ Great Wall
---- Grand Canal
—— Boundaries of the traditional Provinces

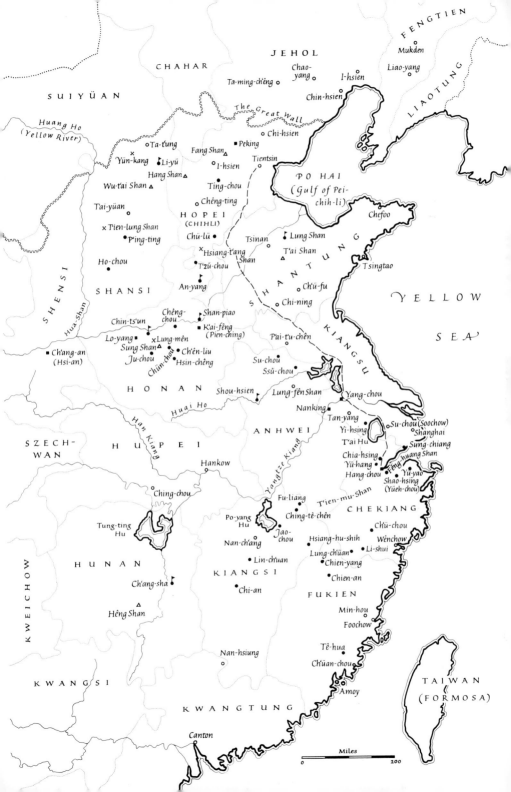

FENGTIEN

CHAHAR

JEHOL

SUIYÜAN

Mukden

Liao-yang

LIAOTUNG

Chao-yang

I-hsien

Ta-ming-ch'êng

Chin-hsien

Huang Ho
(Yellow River)

The Great Wall

Chi-hsien

Ta-t'ung

Fang Shan

Peking

PO HAI
(Gulf of Pei-
chih-li)

Yün-kang

Li-yü

Tientsin

Hang Shan

I-hsien

Wu-t'ai Shan

Ting-chou

Chefoo

Chêng-ting

Tai-yüan

HOPEI
(CHIHLI)

Tien-lung Shan

Chü-lü

Tsinan

Lung Shan

T'ai Shan

Tsingtao

Ping-ting

Hsiang-t'ang
Shan

Ho-chou

SHANSI

T'zŭ-chou

SHANTUNG

An-yang

Ch'ü-fu

YELLOW

Chin-ts'un

Chêng-chou

Shan-piao

Chi-ning

Lo-yang

Lung-mên

K'ai-fêng
(Pien-ching)

SEA

Ch'ang-an
(Hsi-an)

Sung Shan

Ch'ên-liu

P'ai-t'u-chên

Ju-chou

Chün-chou

Hsin-chêng

KIANGSU

HONAN

Su-chou

Shou-hsien

Ssŭ-chou

Yang-chou

Han Kiang

Huai Ho

Lung-fên Shan

Nanking

SZECH-
WAN

HUPEI

ANHWEI

Tan-yang

Su-chou (Soochow)

Yi-hsing

Shanghai

T'ai Hu

Sung-chiang

Hankow

Chia-hsing

Fêng-huang Shan

Yü-hang

Yü-yao

Hang-chou

Shao-hsing
(Yüeh-chou)

Ching-chou

Fu-liang

T'ien-mu-shan

CHEKIANG

Tung-ting
Hu

Po-yang
Hu

Ching-tê-chên

Chü-chou

HUNAN

Nan-ch'ang

Jao-chou

Hsiang-hu-shih

Wênchow

Li-shui

Lin-ch'uan

Lung-ch'üan

Ch'ang-sha

KIANGSI

Chien-yang

Chien-an

KWEICHOW

Chi-an

FUKIEN

Hêng Shan

Min-hou

Foochow

Nan-hsiung

Tê-hua

KWANGSI

Ch'üan-chou

TAIWAN
(FORMOSA)

KWANGTUNG

Amoy

Canton

Miles

0 200

PAINTING AND SCULPTURE

LAURENCE SICKMAN

CHAPTER I

INTRODUCTION

The Chinese possess the longest continuous cultural history of any of the peoples of the world. The civilization of eastern Asia, so distinctively Chinese, is not, however, one of the oldest. Most of the basic elements that mark the rise of a civilization, such as the planting of crops, domestication of animals, wheeled vehicles, some form of writing, and the use of metals, were known to man in other parts of the world, as in Egypt and Mesopotamia, many centuries before they appeared in China. But, whereas the ancient states of Sumeria, Babylon, and Assyria have long passed into oblivion, the China that is a world power today is the direct descendant of Neolithic, proto-Chinese cultures established in the Yellow River valley more than four thousand years ago.

In the latter part of the second millennium B.C. a state known as Shang was established north of the Yellow River at a place called Yin situated on the banks of the Huan River in northern Honan province in what is now the An-yang district.[1] Until two decades ago the Shang Dynasty was generally thought to be legendary. Now it emerges as one amazingly rich in material culture, possessed of a highly evolved form of writing, wheel-made pottery of

great technical finish, a developed architecture, high standards of craftsmanship in jade carvings, an art of bronze casting that has never been surpassed, and stone sculpture in the full round. The character of the Shang culture is such that it is necessary to presuppose a long period, at least several centuries, of development. No evidence of the immediate precursors of the Shang culture as revealed at An-yang has, however, as yet been found. It seems that the Shang, who dominated a loose, tribute-collecting state, moved from another capital to the An-yang site around the middle of the second millennium B.C. and brought their writing, their religion, their arts, and all the diverse elements of their culture with them. Some day the location of a Shang city pre-dating An-yang may be discovered and help to dispel the obscurity which now envelops the origins of Chinese art as it first appeared in the highly evolved, if not relatively late, state of the Bronze-Age culture of An-yang.

No subject concerning eastern Asia is of greater interest than the problem of the origins of Chinese culture. Chinese tradition of a fairly early date speaks of a dynasty, the Hsia, which preceded the Shang. So firmly has this tradition

been fixed in later times that the entire early period is frequently called the Three Dynasties (*san tai*), that is Hsia, Shang, and Chou. There is no convincing evidence of the existence of this early dynasty, but Creel has advanced reasons for believing there may well have been a Hsia state, a state advanced beyond its neighbours in those cultural traits which at An-yang bear so unmistakable and distinctive a Chinese stamp.[2]

Behind the Hsia Dynasty, orthodox tradition has filled the void with a nebulous, shadowed age of long duration – the Age of the Five Rulers – when culture-heroes brought the elements of civilization to their barbarian subjects. There was Fu Hsi, with serpent's body, who taught the domestication of animals, brought marriage rites and music, taught the elements of writing in the form of the eight trigrams, instructed the people how to feed the silkworm and catch fish in nets. From Shên Nung who bore the head of an ox the people learned agriculture, how to plough and reap, and he taught them the art of medical herbage. Wheeled vehicles and the potter's art were brought to the people by Huang-ti, who built the first ships, and taught the use of armour. Then there was Yao who ruled as a benign parent and with the help of Yü saved the country from great inundations. Yao's successor was Shun, whom Yao had adopted in preference to his own unworthy son. Shun displayed all the regal virtues and above all is famous as a paragon of filial piety. The legends about these ancient rulers may preserve some racial memories from remote times because the order of the cultural elements is at least suggestive: first, the domestication of animals and marriage rites, the wheeled vehicle and making of pottery relatively late, and last of all the moral virtues. These Five Rulers became heroes of the Confucian School and are frequently represented in art from the Han Dynasty onwards.[3]

Evidence of an early Neolithic culture is scant at present, but a well-developed, later stage of Neolithic man spread over the greater part of north-eastern Asia, from Chinese Turkestan on the west to Shantung on the east, northward into Manchuria and Mongolia and southward over the drainage plain of the Yellow River. These Neolithic peoples were the direct ancestors of the modern Mongoloid peoples of north China.

The Neolithic inhabitants of China were prolific potters, the initiators of that art in which China has reigned supreme throughout the centuries. The most common pottery was a coarse, grey ware made by the coiling process. It was widely distributed and continued as a peasant ware well into historical times. Some time during the Neolithic period, four thousand years ago or more, there appeared a painted pottery of extremely high quality. This painted pottery reached its highest development in western China, notably the modern province of Kansu, but is distributed right across the Yellow River valley, through Shensi, southern Shansi, and Honan. There is a wide variety of shapes and wares, but in general the painted pottery is made of a fine, close-textured clay ranging from a dark red to a pale buff. Often the ware is highly polished. The decoration consists of an extensive range of geometric forms painted in black and white, black alone, or red and black on a white ground. Large urns from Pan Shan in Kansu decorated with big spiral whorls are among the most striking.[4]

Another kind of Neolithic ware that seems to have come into north China somewhat later than the earliest painted wares is a close-grained black pottery, often polished to a high lustre and frequently extremely thin, some pieces being less than half a millimetre in thickness. This handsome, thin ware was apparently made in whole or in part with the potter's wheel. It is debatable whether the potter's wheel was used in making the painted wares. The people who made the black pottery also had a number of distinctive elements in their culture, so that the

whole complex is sometimes called the 'Black Pottery culture'. The type site is Lung Shan, near Ch'eng Tzu-yai, Shantung. Among the special features of the Black Pottery culture might be mentioned walls of pounded earth, working in jade, foretelling the future by reading the cracks produced in bones, usually the shoulder blades of oxen and deer, and distinctive pottery shapes, most especially one called the *li* tripod, a vessel with three legs that are hollow lobes continuous with the interior of the body.[5] The makers of the Black Pottery apparently had no form of writing. Sites of this culture have been identified in Manchuria, Shantung, northern Honan, southern Shansi, and as far south as the valley of the Huai River in Anhwei.[6] The Black Pottery culture appears to be of eastern and northern distribution. There are indications that the first Bronze-Age culture as it is encountered at An-yang has strong affinities with the Neolithic Black Pottery peoples, but not with those who perfected the painted pottery. The Shang were great workers in jade, they built with pounded earth, they conversed with the spirits by reading the cracks in animal bones and tortoise shells, and they had the *li* tripod. Whether or not the first great Chinese culture we know today, that of the Shang, developed directly from the Black Pottery Neolithic culture or whether both represent offshoots of an older parent culture as yet unidentified, is not at present clear. The main point is that there is strong evidence pointing to north-eastern Asia as the home of Chinese civilization rather than any wholesale importations from the home of more ancient cultures to the west.[7]

SHANG-YIN TO LATE CHOU SCULPTURE

Before the excavations at An-yang, the earliest sculpture of certain date was the rather crude, but forceful group of animals and carved boulders at the tomb of a Han general who died in 117 B.C. Even now no sculpture of important size in stone from the hundreds of years of the Chou Dynasty has been identified. Few of the discoveries made at the site of the Shang capital were more revealing, then, than the presence of large sculpture in the full round done in white limestone or marble. The style of this sculpture is formal in every respect. There is no attempt to represent movement, and the figures are rigidly frontal. All the An-yang stone sculpture is done in solid, compact masses, with well-integrated forms. There is a suppression of detail in favour of the most important and descriptive shapes. The surfaces are engraved with complex linear designs, and occasionally the lines are accentuated by slight under-cutting, and part of the pattern is in very low relief.

A bird, that may represent an owl, and a tiger-like crouching creature both exhibit a very high standard of technical skill, and certainly suggest a long tradition of craftsmanship. The owl [1] which is some seventeen and three-quarter inches high, has a large head, furnished with human-like ears and eyebrows, and deep-set eyes; the thick, sturdy legs end in bird-claws, while the tail that curls under in a sharp hook serves as a third support. The feathers on the head and back and the wing pinions that are also part of a fantastic creature (a tiger?) are rendered in very low relief. The body of a serpent outlines the wing, its flat head, seen from above, marks the shoulder, and the back of the serpent is decorated with a design derived from the

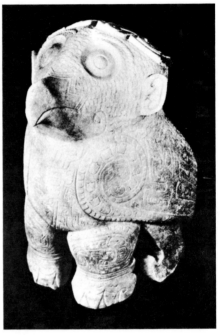

1. Owl, white marble.
Shang Dynasty, late second millennium B.C.
Taipei, Taiwan, Academia Sinica

cowry shell. There is a face-on mask, of a kind called *t'ao-t'ieh*, on the chest, and other creatures are coiled on the legs. The kneeling 'tiger' has a semi-human body and long legs.[1] Like the owl, the tiger is covered with zoomorphic and geometric designs, here lightly engraved into the surface. The importance of the mouth with jagged teeth and thick fangs is emphasized by its disproportionate size.

A great many speculations and deductions by analogy have been advanced about the symbolic

and magic significance of the animals and other motifs of Shang art. That these creatures had some religious significance to the people who made them and that all the complex of designs was purposeful rather than purely decorative there can be no doubt.[2] But the exact, or in most cases even approximate, meanings of their symbolism and paraphernalia of sympathetic magic are at present in the realm of conjecture, though some of the theories that have been advanced may, of course, be very near the mark.[3]

In the case of the owl and tiger, it is apparent that they either were once attached to some other object or carried supports because both of them have deep, straight-sided grooves in their backs running vertically the length of the bodies. It is difficult even to conjecture what purpose they served before they were placed in the tomb, and it does not appear that the Shang made objects for burial only; the *ming-ch'i*, substitution objects, were of a later date. In any event, the fact that they were placed in the tomb suggests that they were considered of good omen and would have a benevolent or protective influence. Whatever purpose they served, they are prime examples of the Chinese genius for creating fantastic creatures imbued with life and a convincing character far beyond the limits of the merely grotesque.

The Shang sculptors treated the human form in much the same generalized way – or so it seems from what little evidence is available – as they did the owl and tiger. The small figure of a seated man [2], five and three-quarters inches high, was, perhaps, intended to serve as a base or counter-weight for some round object, possibly a small pole, which rested in a shallow circular socket occupying the crown of the flat head. The exaggerated bulk of the body, the broad base as well as the braced arms, and the suggestion of thrust in the position of the head are all dictated by the original purpose. Like all the An-yang sculpture, the form is remarkably solid with well-integrated members. There is

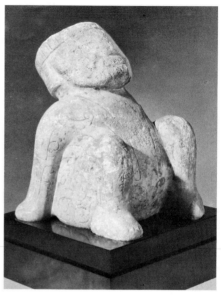

2. Seated man, white marble.
Shang Dynasty, late second millennium B.C.
Formerly Hong Kong, J. D. Chen

a good sense of consistent shapes as in the treatment of the rounded feet and hands. Unfortunately the features are very much worn, but the nose was broad and flat, and the wide-spaced eyes, square, large, and staring. Finely incised designs cover all the body save the face. There are long bands extending over the shoulders and down the front that might suggest a decorated garment, but there are no demarcation lines at the ankles or wrists, and a mask of the t'ao-t'ieh type is engraved on the lower belly.[4]

Other examples of Shang sculpture, frequently on a small scale, are blocked out in a more angular way without the smooth transitions from one form to another. All of them are remarkably powerful and possessed of an almost sinister character. Even the readily recognizable animals, as a stocky elephant and the reclining water-buffalo in the Sedgwick Collection, seem

to be images from a dark spirit world and not from our own. Although the water-buffalo [3] is rendered in a somewhat cursory fashion, and in the forequarters the transition from the front to the side plane is a right angle, it is no simple,

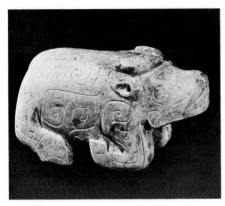

3. Water-buffalo, white marble.
Shang Dynasty, late second millenium B.C.
London, Mrs Walter Sedgwick

crude attempt at representation. The proportions of the beast, the modelling of its skull, the bovine, soft muzzle, and the flat horns curving over the back are all accurate and descriptive. The abstract designs engraved over the body serve to accentuate the form, as is especially noticeable on the squared-off fore-shoulder.

All the pieces of early sculpture we have considered so far are on a relatively small scale, but there is reason to believe that the Shang executed sculpture in monumental size.[5] Also the Shang sculptors were especially skilled in bas-relief. Many fragments and some complete vessels, resembling in shape the sacrificial vessels in bronze, have been found, decorated in several layers of relief and with linear patterns, similar to those on the bronzes, done in delicate, raised lines. The best of these display a technical skill of a very high order.

The Shang people were in residence at An-yang some three hundred years before the city was destroyed by the Chou conquerors. It is evident that they possessed a highly developed art of sculpture, but it is not now possible to speak in terms of early and late examples or, indeed, to give any proper estimate of the art as a whole from the few examples in occidental collections and the scanty material that has so far been published by the Chinese archaeologists. However, as already remarked by Creel, the surprising thing is the complete disappearance of the art of sculpture in stone, apparently at the close of the Shang Dynasty. No examples have as yet been reported that can with certainty be assigned to the eight hundred years of the succeeding Chou Dynasty.

It was in the art of bronze casting that the Shang Dynasty set a standard of excellence never surpassed. If no more than half a dozen high-quality Shang bronzes had survived they would be sufficient to establish a whole category of Far Eastern art, unique throughout the world in concepts of design, shapes, and purpose. But vessels and weapons from the Shang period and the continuation of the style into the early years of the Chou Dynasty have been recovered in hundreds during the past twenty years. If we add to these the examples that have been unearthed in earlier times and were in the collection of the twelfth-century Sung emperors, or others now in the former Imperial Manchu collection, the sheer output is almost incredible.

So far as we know today the art of casting in bronze appears very suddenly in China. These vessels are cast with such skill that it is absolutely necessary to assume a relatively long period of technical development. But the zoomorphic and geometric designs that are so much an integral part of the vessels and ceremonial weapons – they never appear applied as an afterthought – are, at An-yang, in a fairly late stage that presupposes mastery of the technique of casting. Briefly, it seems very possible that

the forms – the vocabulary of the Shang bronze caster – are more ancient than the technique. Some of the bronze vessels follow forms that suggest pottery prototypes or other containers such as gourds. But there are other shapes that are highly specialized and not derived from everyday utilitarian vessels. One theory with much in its favour is that the decoration and some of the shapes were evolved, over a long period of time, in perishable materials; the art of bronze casting, which was known much earlier in other parts of the world, was introduced to China from outside, say by the northern route across Central Asia, or through contacts even farther to the north across the Siberian and Mongolian steppes, and applied to the aristo-cratic, religious art of the sacrificial vessels.[6]

Any consideration of the bronze vessels, as such, from the Shang and Chou dynasties would lead us beyond the scope of this work, though many of them are truly sculptural not only in the low- and high-relief decorations and elements in the full round, but in the shapes as well. A few examples in which the sculptural element dominates will serve to illustrate at least one facet of this notably complex art.[7] A great deal, if not most, of the Shang style and high standards of craftsmanship appear to have been carried over into the early part of the succeeding Chou Dynasty. For this reason, it is not possible in many cases to distinguish between Shang and Early Chou pieces not excavated under con-trolled conditions, unless, of course, the piece bears an inscription, as many of them do, which places it definitely in one epoch or the other. Since the Shang after their move to An-yang are sometimes in late literature referred to as the Yin, from the name of their capital city, the earliest phase of the bronze art as we know it so far is frequently and conveniently called 'Shang-Yin to Early Chou'.

An extraordinary pot-shaped vessel with a spout, of a type called *huo*, now in the Freer Gallery, is in all probability a Shang-Yin piece

[4, 5]. The vessel, which originally had a bail-handle passing through the perforated ears, the lugs at the side and holes provided in the base, represents a monster with a human head equipped with so-called bottle horns, the body of a snake ornamented with concentric squares and triangles, and forearms springing from just below the ears and terminating in three great claws. The remaining space not covered by the body is occupied by dragon-like creatures, and a bird against a background of concentric spirals and squares. The vessel is most unusual not

4 and 5. Vessel, type *huo*, bronze. Shang-Yin to Early Chou Dynasty, *c.* twelfth to eleventh century B.C. *Washington, Smithsonian Institution, Freer Gallery of Art*

only in the strange concept but in the successful combination of two radically different treat-ments of the design. While the elements of the body are essentially linear and the drawing has a character of strong, geometric formalism, with right-angle hooks and powerful, simple curves, the human face of the lid is modelled with soft, rounded forms that flow one into the other. There are surprising touches of realism such as the thin upper and full lower lip, the broad nose

and the three furrows of the brow that, together with the wide-open, staring eyes, give it an expression of quizzical surprise. The only really formal, stylized elements are the horns, which seem to grow quite properly from the brow, the squared-off eyes, disproportionately large, and the striated eyebrows. These latter are very like those on the An-yang marble owl. A good deal of ingenuity is displayed by the way the maker has fitted the ovoid face on to the lid of a round vessel and with easy freedom allowed the cheeks and chin to flare out beyond the rim of the vessel

proper. From the point of view of technique the body of the Freer vessel can easily suggest the manner of the carver in wood or hard pottery, but the human face, with its softer forms, suggests the hand of a modeller in moist clay.

There are other vessels, of the type *tsun*, made to contain liquid offerings, that are entirely in the form of an animal or bird. These vessels show that the Bronze-Age craftsman was closely observant and possessed the ability to translate the essential qualities of his subject into terms of formal design.

No more impressive example of the innate Chinese genius for animal sculpture could be found than the large bronze rhinoceros in the Brundage Collection [6]. This vessel was found in Shantung about 1843 and bears an inscription that has been the subject of considerable study by Chinese scholars. There is very good reason to believe that it may date from the reign of the last Shang ruler, about mid twelfth century according to the traditional chronology, or the end of the first quarter of the eleventh century B.C. according to the most generally accepted revised chronology.[8] This remarkable vessel belongs to the first great early phase we know so far, the period embracing the Shang-Yin and Early Chou dynasties. The animal is modelled with great accuracy. The species with two horns and lacking the heavy skin folds, which occur only on the single-horned variety now limited to Africa, is found in Burma and the Malay peninsula, but probably, like the elephant, ranged as far north as the Yangtze valley in the second millennium B.C. Such faithful recording as the form of the skull, the folds of skin about the characteristic ears and above the forelegs, splayed feet, small eyes, and head drooping below the shoulders, to mention only a few details, can scarcely be derived from hearsay, tradition, or memory alone, but must be based on keen, analytical observation. Again, the Brundage rhinoceros, with its excellent sense of bulk and organically integrated members, possesses a strongly insistent and individual personality.

A bronze animal as accomplished as the rhinoceros poses many questions. It presupposes a long tradition of modelled sculpture, but we know nothing of its antecedents. Was it the product of a local school that flourished in Shantung? Did this art of animal sculpture come to a dead end, or was it outmoded by beliefs that demanded quite different concepts? We cannot tell, but certainly radical changes began to develop about the beginning of the first

millennium. When bronze sculpture that is remotely comparable appears again some five hundred years later, in the last centuries of the Chou Dynasty, it seems to grow from different soil rather than to have been grafted on to this ancient tradition.

MIDDLE AND LATE CHOU DYNASTY SCULPTURE

A people called the Chou had, towards the end of the second millennium, grown strong in west China, in the region of modern Shensi. One tradition has it that they acted as guardians of the western marches for the Shang kings. The Chou state certainly possessed a culture inferior to that of Shang, but was vigorous, warlike, and ambitious. In 1122 B.C., according to the orthodox chronology, Shang was destroyed by Chou, and a new dynasty reigned in the Yellow River valley. The Chou conquerors established their capital near modern Ch'ang-an (Hsi-an) in Shensi, their old home, and ruled a feudal empire from there until 771 B.C. In that year the capital was shifted eastward, probably because of pressure from the west, and established in the region of modern Lo-yang, Honan. From the time of this move, the period of Chou rule is divided into Western Chou, 1122 to 771, and Eastern Chou, from 771 to its final loss of power in 256 B.C.[9]

Many elements of the most characteristic Shang styles in the bronzes were carried on into the early reigns of the Chou Dynasty. It seems as though the craftsmen and their stock of traditional designs must have been saved by the less civilized conquerors during their destruction of the Shang capital. However, there also began to emerge a style that was new and distinctive. Although it retained many of the old designs and formulas, these were treated in a somewhat different way. They became more robust and at times heavy; restraint and elegance were frequently replaced by a massiveness which is

bes
is p
old
cre
bui
a ra
me
pro
ma
sm
sug
sku
of
pe
org
rep
tal
po
co
sh
tre
an
ph
ha
Br
re
ch
pr
sq
in

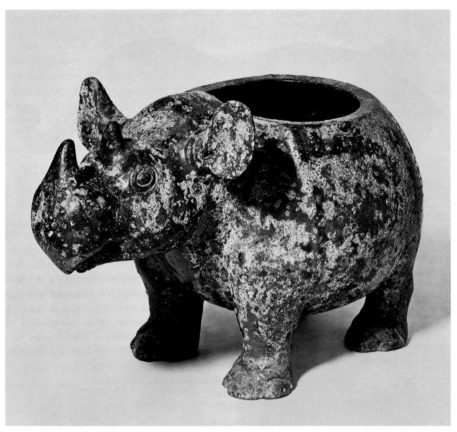

6. Rhinoceros, bronze.
Shang-Yin to Early Chou Dynasty,
c. twelfth to eleventh century B.C.
San Francisco, De Young Museum,
Avery Brundage Collection

se
Pi
of
su
li
ar
w
ac
fl
th
fi
p
th

bold, and at times slightly barbaric. There are appendages, often the heads of animals or monsters, in the round on the handles or attached to the body of the vessel. The apparent aim was to make the bronzes more immediately and obviously impressive.[10] The problem of dating within the Early Chou period is very much complicated by a wider distribution of the bronze caster's art, a process that had probably gone on for a long time and given rise to local styles.[11]

By the tenth century B.C. many of the old elements apparently had disappeared and been replaced in favour of a whole new set of motifs and shapes for the bronze vessels. The famous pair of tigers, in the Freer Gallery, is among the

bronzes recording treaties, deeds of land, and especially 'gifts or marks of favour from the king or some other superior.' Some were clearly intended for temporal entertainments, which may have had a semi-sacerdotal character. The nature of such inscriptions suggests that the spirits were not the sole concern and that the religious function was often secondary. Such an attitude would alter the form and decoration of the objects, in other words, the content of the art.

From the time of the removal of the capital to the east the Chou hegemony over the feudal states became weaker and weaker. Correspondingly the power of the feudal states increased and from that time until the Ch'in empire was established there was constant warfare. Small states were gobbled up by the larger ones, or formed defensive alliances that were broken with impunity by any member who saw greater advantages elsewhere.[14] Out of these there emerged in the third century two great states, Ch'in and Ch'u, which had consumed all the rest. The state of Ch'in became dominant after 256 B.C. and with the complete defeat of Ch'u in 222 B.C. reigned supreme and founded the first true Chinese empire.

From the sixth century on, as the old system, old beliefs, and the established order were crumbling away, numerous thinkers and philosophers came forward with theories of what was wrong with the world and how the disturbed conditions could be remedied. The centuries of the Late Chou Dynasty were certainly one of the very great epochs of Chinese creative thought. Two of the systems advanced were destined to have a profound and lasting influence on Chinese culture. Confucius, who saw about him venery, opportunism, and incompetence, taught the value of social duty, respect for authority, government by the trained and superior man, and that good government was based on moral virtues. The Confucian school stressed learning, cultivation of the spirit in a wide sense, propriety, and the social responsibilities of individuals. The school of Lao-tzu and Chuang-tzu, on the other hand, stressed the importance of the individuality of man. They were deeply sceptical about right efforts and attempts to conform to a man-made social order. They taught that everything should be left to the effortless and constant operation of nature. It was not, however, until the Han Dynasty several centuries later, that Confucianism became codified into a system, the Lao-tzu-Chuang-tzu school was transmuted into Taoism, and the concepts of the Late Chou period began to play a major part in Chinese thought.

From the sixth century to the founding of the Ch'in empire, the rise of great feudal states had a profound influence on the arts. Just as there was rivalry for power, there was rivalry in wealth and all that goes with the outward display of condition and pomp. The art of the Late Chou period is in many respects a luxury art with a sumptuous use of gold, silver, jade, and inlays of turquoise and semi-precious stones. This character is evident also in the perfection of craftsmanship. The quality of the casting in bronze returns to the high standards of the Shang-Yin and Early Chou times. Work in jade was developed to a level that in many respects marks the culmination of the art in China. There is a tendency for design to become fine and infinitely detailed, with marked attention to texture qualities in the play of light over a surface. The whole character of the art is one that is to be enjoyed at close hand and is susceptible of prolonged examination and sensuous pleasure. High premium was placed on diversity and new patterns. The rich variety of Late Chou art is, of course, to a considerable extent the result of many local styles that came into being in the regions of the more powerful states. Old motifs, such as the t'ao-t'ieh mask, that had been in abeyance for hundreds of years were revived, and influences from outside China are strongly in evidence. Braid and coil patterns, pebbling,

patterns of circles and comma-like forms on the bodies of animals, and certain kinds of winged creatures appear to have been appropriated from the repertoire of the so-called Scytho-Siberian animal styles of nomad peoples to the north and west of China. All these new features are combined in a manner distinctive from what had gone before. The austere, geometric drawing relaxed into undulating rhythmic lines or close curls. Interlacing of forms and flat strapwork became a favourite treatment.

Although few Late Chou sites have been scientifically excavated there have been a number of important finds containing large numbers of related objects, some of them so inscribed that they can be dated approximately and assigned to definite feudal states. For example, at Chin-ts'un, near Lo-yang, Honan,

tombs of the feudal state of Han were found containing quantities of bronze vessels, sculpture in bronze, elaborate jade work, lacquer, and ceramics, all datable with some certainty from the fifth to third centuries B.C. At Shou-chou in Anhwei some hundreds of bronzes have been found, a number of them bearing inscriptions referring to the late kings of the Ch'u state in the third century B.C. On the basis of such evidence it may some day be possible to determine the chronology and local features of the Late Chou style with accuracy. For the present, however, caution would suggest a broader treatment.

Late Chou sculptors in bronze have left us a lively and varied collection of animals, real and imaginary, and a series of human figures. The small, tapir-like quadruped with hoofs of illustration 10 exhibits the characteristics of the art

10. Quadruped, bronze.
Late Chou Dynasty, *c*. sixth to third century B.C.
Washington, Smithsonian Institution,
Freer Gallery of Art

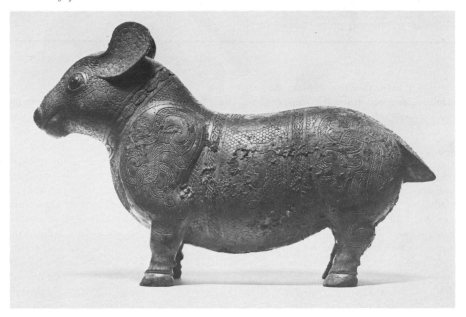

to perfection. A remote antecedent might be the style of the Pillsbury buffalo [9] because the same accentuation of the fore-quarter still lingers here and the strapwork on flank and shoulder is an echo of the older style. All the heavy mass of the earlier Chou style has disappeared, however, and the modelling is flowing, round, and full, rather as though the animal were inflated from the inside, while the large ears sweep up from the head in free, easy curves quite different from the compact system of the early style. If there is not a conscious, light humour expressed in the short legs, stubby tail, and alert expression, at least we sense a point of view far less serious, austere, or mysterious than displayed by the beasts of earlier times. The treatment of the surface with

pebbling, small scales, and interlacing straps with diagonal hatchings, has the fine, detailed character that gives an over-all surface texture. Two braided rope patterns encircling the body and a necklace of cowry shells are motifs frequently found on bronzes from the fifth to the third century.

The extreme exuberance and fanciful opulence that created ever more extravagant, complex forms, placed large birds with enormous beaks and outstretched wings in low relief on top of great bronze bells – one in the Freer Gallery is over twenty-six inches high and weighs some one hundred and thirty-eight pounds. The state chariots were loaded with bronze fittings, many of them animal forms modelled in the round and inlaid with gold and

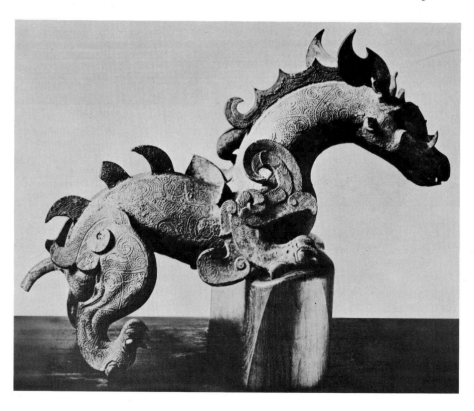

silver. Large and imposing heads such as the inlaid bronze head of a bovine creature in the British Museum, or the fantastic gilt bronze dragon with silver tongue and glass eyes in the Freer Gallery, probably were the finials of chariot poles. The true prototype of the Far Eastern dragon, as he is known in later art, does not appear until the Late Chou Dynasty – and it is not unlikely that his origin may be found in the rich folklore and fertile imaginations of the people of the Ch'u state in the Yangtze valley.

The famous dragon of the Stoclet Collection, a reptilian monster with antediluvian dorsal spikes and pinioned wings, is a masterpiece of related linear rhythms [11, 12]. The body, wings, and fins, as well as the volutes decorating the body, are harmonized by the consistent

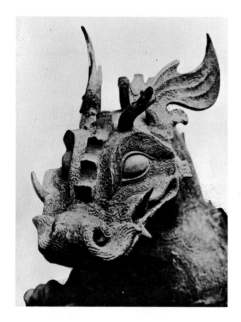

11 and 12 (detail). Dragon, bronze.
Late Chou Dynasty, c. sixth to third century B.C.
Brussels, Stoclet Collection

tension of the curves. A new interest in realism is shown in the sinews and muscles of the hind legs, and the bovine-like muzzle and lips. A fine granulation covering the surface produces a texture suggestive of skin. A vessel, type *tsun*, discovered in 1963,[15] in the form of a rhinoceros, is related in style to the Stoclet dragon [13]. Possibly because it is inspired by an actual beast, or slightly later in date, it is even more striking in its realism. In its bony head, powerful shoulders, ponderous hind quarters, thick folds of skin, firmly planted hoofs, and stance with head lifted on the alert, the essential reality of a rhinoceros is present in a bronze of superlative quality. A complex pattern of volutes inlaid in gold covers the entire surface. A comparison of this vessel, of the fourth to third century B.C., with the Brundage rhinoceros, of some eight centuries earlier, shows the effect of a new awareness of nature and the metamorphosis of an ancient conceptual image brought about by observation. Just such an interplay between formal design and realism prevails through the centuries, giving plausibility, especially in jade and hard-stone carvings, to even the most fanciful creatures.

Clearly, an art of animal sculpture in close contact with reality produced works of a very high order in the fifth to third centuries B.C. It is a curious fact that throughout the centuries the Chinese sculpture most successful in volume and three-dimensional form is generally on a small scale – small bronze castings, and works in jade and hard stones – while large and monumental sculpture consistently tends to become linear.

A series of bronze sculptures representing horses and human figures are reported to have come from the tombs of the feudal princes of Han at Chin-ts'un, near Lo-yang.[16] Not all of the figures are of the same quality and style, and the group may represent a range in time from the late sixth to the third century B.C. and some, of course, may come from other sites.

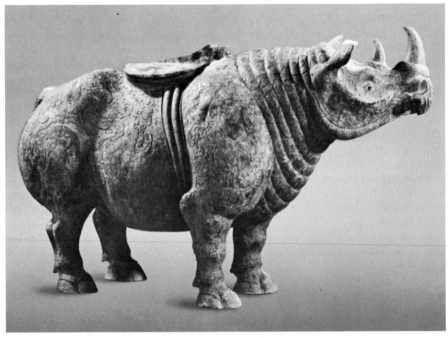

13. Rhinoceros, bronze vessel, type *tsun*. Late Chou to Ch'in Dynasty, fourth to third century B.C.
Sian, Shensi Provincial Museum

14. Pair of horses, bronze. Late Chou Dynasty, *c.* sixth to third century B.C.
Kansas City, Nelson Gallery of Art and Atkins Museum

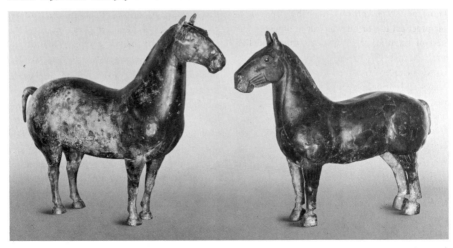

For the most part they are modelled with marked simplicity, suppression of detail, and with round, full form. In distinction to these, however, there are at least two, one in the Boston Museum and one in the Nelson Gallery at Kansas City, which are done with careful attention to details of costume and accessories. Though the two horses of illustration 14 differ from one another they are the same stocky breed, with long bodies and short legs. The one on the right is the more stylized in the squared-off muzzle, parallel lines running from jaw to mouth, suggestions of leg muscles, and curving line extending from behind the jaw to the fore-leg. It is, none the less, in proportions and stance the more realistic of the two. The treatment of the flat, semicircular cheek is a manner that remains almost fixed in Chinese sculpture for a very long time.

Among the human figures, the majority are shown kneeling and squatting on their heels, their arms extended and either holding a hollow tube in each hand or clasping a similar tube with both hands. Several of the figures have a corresponding round socket affixed to the base just below the tube.[17] Certainly they served as supports of some kind, but what they held or how they were employed we do not know, nor do we know whether they were made for practical use or only as burial objects. The best of them are certainly carefully modelled and well cast. The heads are disproportionately large, the faces broad and flat with high cheekbones and straight eyes, although the general cast of countenance is Mongoloid [15]. The bodies are somewhat squared-off on the sides, front, and back, so that the transitions from one plane to another are abrupt, almost indeed a sharp line, and the arms are like bent cylinders. The robes fold over from left to right; some of these men wear small caps with a curious harness-like arrangement of straps, one passing over the head and under the chin and another encircling the head. There is a good sense of

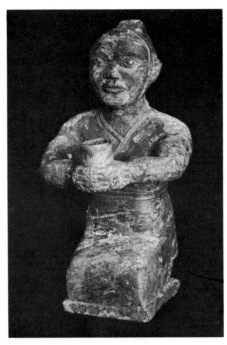

15. Kneeling man, bronze.
Late Chou Dynasty, c. sixth to third century B.C.
Minneapolis Institute of Arts, Pillsbury Collection

balanced masses, and while the modelling is simple and stylized, the effect, especially of the placid faces, is vivid and impressive.

In contrast to the static pose of this figure, the lively pair of wrestlers, or more likely acrobats, in the Spencer-Churchill Collection, are done with humour and a fine skill that can convey much movement and spring by simple means [16]. The two youths are very like one another, but the flow from the raised right of the one into the lowered right arm of the other gives variety and establishes a rhythmic movement that suggests momentarily arrested action. This combined with the half-squatting position and the heads turned in opposite directions makes a group that is extraordinarily successful in its light, humorous spirit. If these figures

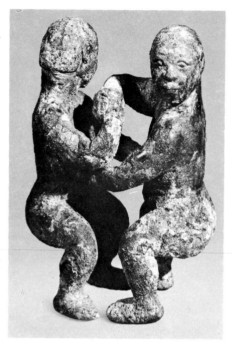

16. Wrestlers, bronze.
Late Chou Dynasty, *c.* sixth to third century B.C.
Captain E. G. Spencer-Churchill, Gloucestershire

were made for burial only so that the spirit of the departed could be accompanied by favourite entertainers, then funerary paraphernalia must have become very sumptuous towards the close of the Chou Dynasty.

Sculpture in wood from the Late Chou Dynasty has been found only in recent years. A relatively large number of pieces are now known as a result of discoveries, first made in 1936-7, in the neighbourhood of Ch'ang-sha on the banks of the Hsiang River, Hunan, south of Lake Tung-ting in the heart of the Yangtze valley. During the Late Chou period, this territory formed part of the wealthy and extensive state of Ch'u. The sculpture found there is in many respects quite different from that recovered in other parts of China, not only in material and style but in such subjects as human heads with fantastically long tongues and real deer antlers attached, and the pair of cranes standing on two intertwined snakes now in the Cleveland Museum.[18] Some of the wood carvings still retain much of their original painted decoration, which in general style is similar to certain inlaid bronzes of the Late Chou period.[19]

A number of human figures recovered from Ch'ang-sha were certainly made for burial [17]. They belong to a class of objects called ming-ch'i, made as substitutes either of people and animals or of objects in precious materials, and that, through a kind of sympathetic magic, functioned as the real thing in the spirit world. The human figures are tall and cylindrical, averaging about two feet in height. The heads are again disproportionately large, the necks greatly elongated above mere rudiments of shoulders and very short arms. Large hands were made separately and attached with dowels. The heads are relatively flat on top, notably broad across the foreheads and pointed at the chin, which is long and slightly protruding. The eyes are not indicated in the carving but were painted on. The small mouth is drawn up

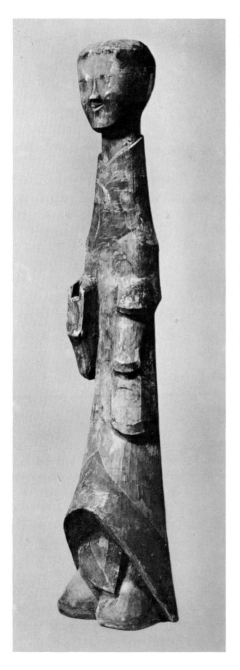

17. Human figure, wood.
Late Chou Dynasty, *c.* sixth to third century B.C.
New York, Mr and Mrs Myron S. Falk, Jun.

in a simper – the famous 'archaic smile'. This shield-shaped facial type must have persevered for a long time as it is only slightly modified and softened in numerous pottery figures from tombs of the Han Dynasty. The carving is fresh and direct. The figures were doubtless made in quantities by craftsmen engaged in preparing objects for the tomb. But the formula of the figures, with their strange elongation, large feet (or trousers?), and flaring robes drawn up in front reflect the character of an impressive and indigenous style. A new, brilliant phase of Chinese art will become apparent, when further excavations and research into the well-springs of this Yangtze valley culture, at once so homogeneous and rich in imagery, have increased our present all too scanty knowledge.

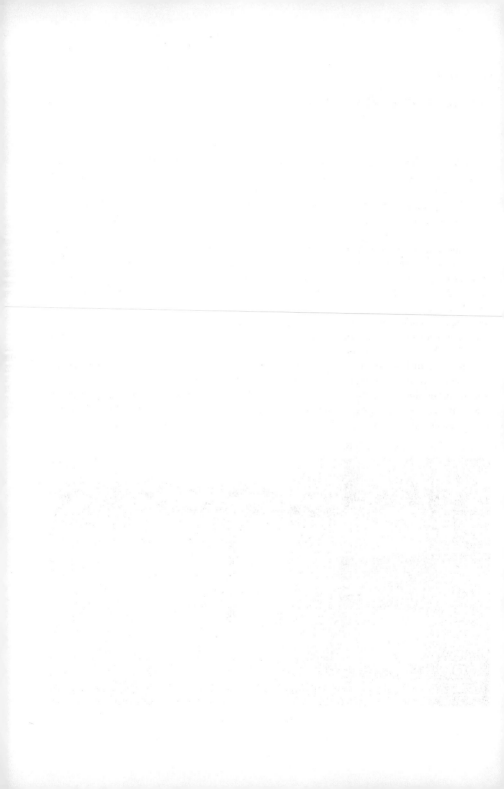

VESTIGES OF EARLY PAINTING

Throughout the history of Chinese art criticism and theories of painting, an intimate connexion between writing and painting has been consistently emphasized. In historical times similar materials have been used in both the arts of calligraphy and painting and very much the same kind of training was demanded to achieve dexterity. But in regard to ancient times it is an open question how closely the two were linked as arts. We may assume, however, that as in more recent centuries the tools and materials were alike. We know that in the Shang Dynasty characters were on occasion written with some kind of brush, and there is reason to believe that designs similar to those on Shang bronze vessels were painted in simple colours on leather or matting for use in burials.

Recently a half-completed matrix for a bronze vessel was discovered at An-yang. It is made of hard clay on which the design has first been painted in red pigment and then carved out, but since the carving was never completed, part of the painted design still remains.[1] Presumably moulds would be made from such a master-pattern. If this technique were consistently used, it seems very likely that a design such as the one here reproduced from a rubbing of a bronze vessel [18] was drawn with a brush somewhere along the line of production. It is pure speculation, but it would not be surprising if a people as advanced in the arts as were the men of Shang had extended the use of such drawings of potent religious symbols and decorated the walls of important halls used for ritual ceremonies.

Although there are references to painting in the literature of the Chou Dynasty, where, for example, silk flags with painted designs are

18. Rubbing from a bronze vessel. Shang Dynasty

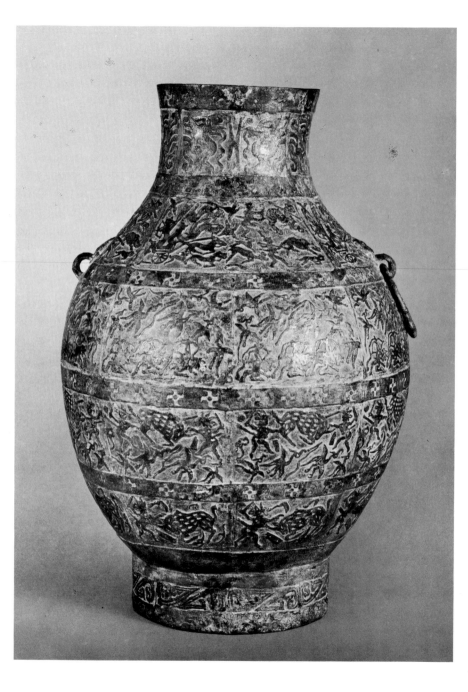

19. Vessel, type *hu*, bronze.
Late Chou Dynasty, *c*. sixth to third century B.C.
Minneapolis Institute of Arts, Pillsbury Collection

mentioned, such passages tell us nothing of what the paintings looked like, and it is not until the Late Chou period that actual material becomes available. The early evidence of a new attitude towards the world and its representation in art is again for the most part bronze vessels, but they differ from the zoomorphic and geometric designs of earlier times, because they show human figures in action and in one instance, at least, with indications of setting. Most of them are bronze jars, of a type called *hu*, that were probably wine flagons. They became more and more popular from about the fifth century B.C. on into the Han Dynasty, and many of them were richly ornamented with inlays in gold, silver, and turquoise.[2]

The vessels which are of interest to our subject have the surface divided into horizontal bands which contain designs of combats between men and beasts and scenes of the chase – the so-called hunting bronzes. Most often the designs are in intaglio, but in others the flat figures are in relief [19]. Originally the design was probably set off by inlay of some kind of paste. It is not at present possible to assign definite dates to the group or individual examples, but a tentative suggestion would be the period from the fifth to the third century B.C.

The jar in the Pillsbury Collection, Minneapolis Institute of Arts [19], is made by piece-moulds and the design is repeated vertically eight times around the vessel. In the second register, just below the neck, two men in a four-horse chariot, preceded by two hunters on foot, are pursuing a variety of game including a tiger and several kinds of birds. Below this, archers are shooting at water-birds, and there are long strings with weights attached to the arrows to facilitate the capture of the birds.[3] The main event in the lower two registers is men attacking wild oxen (?) that look very like bison. These animals are covered with heart-shaped markings indicative, like many other details on the hunting-bronze series, of influences from the animal style of the Ordos region to the north and north-west of China proper. The scenes are presented in a very simple, primitive way, elements being scattered over the field with little regard to scale or even composition, save that all available space is filled. The entire concept is far more pictographic than representational. In the scene of the chariot there is no overlapping of the two horses nearest the observer, but those on the far side are spread out and shown upside down one above the other. The most successful group is in the middle register where the archers, three identical silhouettes, are strung along a base line and the 'sky' is filled with birds.

A much more accomplished use of a base line and a more organized composition is found on a very unusual bronze jar of the hu type, in the

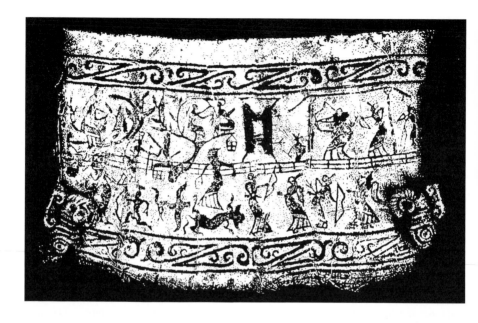

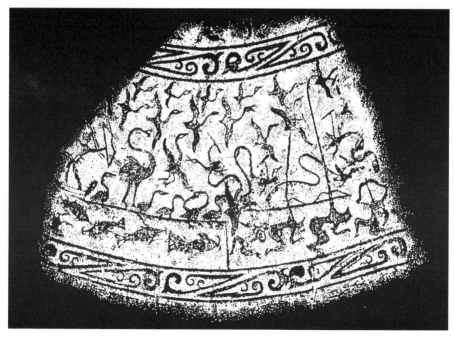

Jannings Collection, National Palace Museum, Peking [20].[4] The figures, all in silhouette profile, are tall and slim, dressed in coats with the hems on the bias and pleated skirts, very like certain miniature tomb figurines made of polished black pottery and of pre-Han date that have been found in recent years. In the scene of illustration 20 an archery contest is in progress in or in front of a building on a raised platform. To the left are two graceful trees (mulberry?) where figures are perched, apparently plucking the leaves; one basket hangs on a tree limb and others are carried by figures below; four other figures, an animal, and a bird with a snake in its mouth occupy the foreground. The surprising thing here is that one is able to speak of a foreground at all, and that some of the elements, such as the trees, overlap the platform, though this detail could be fortuitous. It may be assumed that the artist here is following a kind of perpendicular perspective in which more distant objects are raised nearer the top of the picture plane. In illustration 21 there is a more elaborate version of the bird hunters. The scene is on the bank of a lake, shown in vertical elevation and inhabited by large fish and a turtle. Here the weighted strings attached to the arrows are perfectly apparent. The details of the scene are pleasantly varied and there are some very naturalistic poses among the birds.[5] Our third scene [22] shows a building again on a platform, and within some kind of game is being played. The nobles, equipped with swords characteristic of the period, may be engaged in an ancient game called *t'ou hu*, mentioned in the Chou

20-2. Rubbings from a bronze vessel, type *hu*. Late Chou Dynasty, *c*. sixth to third century B.C. *Peking, National Palace Museum, Jannings Collection*

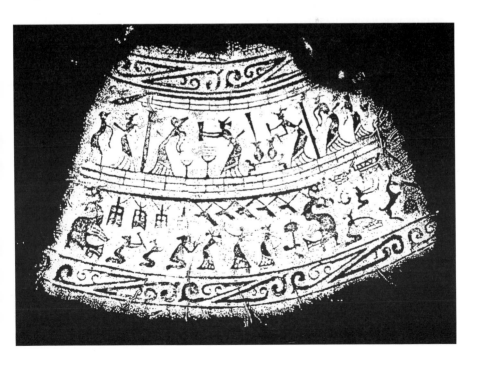

Dynasty text *Li Chi*, the Book of Rites, in which the contestants vie in pitching arrows into a pot. If this interpretation is correct, then the victor who has four counters showing above his tally cup is following the rules of the game by offering the vanquished, standing with an empty tally cup on the left, a goblet to drink.[6] Below, and possibly intended to be in front of the building, is a most interesting scene of an orchestra. The musicians are equipped with four bronze bells and five jade gongs suspended from a pole that rests on supports in the form of birds. There is also a drum on a stand and one musician with a horn or flute. To the right food is being prepared. The kneeling musicians who strike the bells remind us of the kneeling figures in bronze discussed above, while there are several details, such as the bird perched on the house roof and the trussed-up rabbit in the 'kitchen', that will recur some three to four hundred years later on the walls of stone offering chambers in Shantung.

In these vivid pictures there is no attempt to represent recession in space, and with the possible exception of the trees overlapping the platform in illustration 20, the relationship between people and between objects is obtained simply by placing the more distant ones above the nearer. On the other hand, the general arrangement, and specifically the figures strung along a base-line, are far more carefully organized from the point of view of people engaged in related actions than is the haphazard scattering of figures on the Pillsbury bronze jar. Another suggestive feature is the introduction of such elements of setting as the architecture, the pond with fish, and the two trees. These scenes seem to lie rather near the beginning of an art form which later Chinese artists developed to a very high level – the art of illustration. Also, since very similar scenes – the hunt, and entertainments with orchestras, and the preparation of food – occur in the engravings on the walls of stone funerary offering chambers of the Han Dynasty, it is not too far-fetched to imagine pictures like those on the National Palace Museum bronze to have been painted on the walls of funerary shrines, especially in the state of Ch'u.[7]

The earliest actual painting on silk so far found, within this writer's knowledge, came from one of the tombs at Ch'ang-sha, Hunan.[8] It is a small rectangle of closely woven silk, the main field occupied by finely written Chinese characters; a series of drawings of curious beasts, a three-headed man, and several unidentified objects are scattered about the outer edges and sprays of leaves occupy the four corners. These paintings are outlined in black and are coloured, with red predominating and some blue. The whole seems to be a kind of magic charm or cantrip.[9]

By far the most accomplished painting remaining from Late Chou times is on the lacquer objects recovered in considerable quantities from the tombs at Ch'ang-sha.[10] Later, in Han times, the province of Szechwan, farther to the west, apparently was one of the centres of lacquer manufacture. At any rate, the beautiful geometric designs, so like the inlaid bronzes, the spirals, whorls, and volutes, the spirited animals and creatures of fantasy show us the inventive art of the Yangtze valley which has been almost unknown until recent years. When one considers the technical difficulties of drawing fine flowing lines with a lacquer medium, the accomplishments of these pre-Han lacquer decorators are all the more impressive. All the pieces found are not of the same period, the range of styles covers several centuries, and the lacquer wares extend from the Late Chou Dynasty through Ch'in to the Han period. The borders of abstract, geometric patterns are, in the present state of our knowledge, one of the best criteria of period.

From among the many lacquer pieces recovered at Ch'ang-sha, we reproduce here the lid of a cylindrical box, similar in shape to bronze boxes of a type called *lien*, generally

supposed to be cosmetic boxes or containers for the paraphernalia common to ladies of fashion in all times [23]. This remarkable piece, in the collection of John Hadley Cox, is elaborately decorated both inside and out. The design on the exterior of the lid is in two shades of red on a black, now somewhat brown, ground and is repeated, minus the border, in black on a ver-milion-red ground on the inside of the lid and interior bottom.[11] The principal décor consists of three strutting peacocks, the proper right

wing of each intersecting the tail of the one preceding. The design is heraldic to a certain extent, with the three birds evenly spaced, approximately identical, and ingeniously inter-laced. For sheer pattern of spottings, accents, and interplay of rhythms, together with the inventive genius shown in the conventionaliza-tion of the peacocks, the concept must rank as decoration of the highest order. It is interesting to observe that although the border is completely abstract, it partakes of the same character in

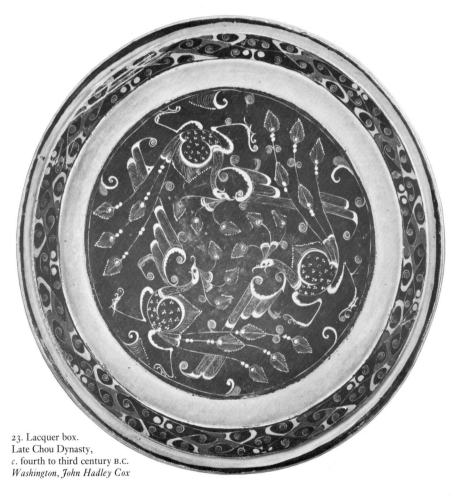

23. Lacquer box.
Late Chou Dynasty,
c. fourth to third century B.C.
Washington, John Hadley Cox

spacing, rhythm, and accents as the representational central medallion. The painting on a technical level has the easy surety and almost careless freedom of a trained craftsman doing his daily task. This Ch'ang-sha lacquer box, made during the century, say, between 350 and 250 B.C.,[12] brings us well into an era when painting in China was emerging as a fluid medium for representation and already had developed a swift, sure, and expressive brush-stroke. In the centuries just preceding the Christian era, during the Former Han Dynasty, painting became more and more a specialized art, not only for the decoration of elegant lacquer wares, but in the form of wall paintings in palaces and public halls. At length, in the early centuries A.D., painting gradually emerged from the condition of an applied craft and became a medium of expression for gifted men of cultivation and learning.

THE HAN DYNASTY

During the four centuries following the first empire of Ch'in, China experienced one of the two most brilliant epochs in her national history. Twice under Han rule, the Chinese empire attained to heights of power and extent only equalled by the empire in the eighth century A.D. under the T'ang Dynasty. It was almost as though the Chinese, through the agony of warfare and struggle, the intellectual turmoil and social upheavals of the period of the Warring States, had broken from the chrysalis of their ancient culture and emerged with a fresh vigour and a burning curiosity concerning the world about them. A new kind of energy sent the armies of Han driving across the wastes of Central Asia to the fringes of the Western world where, on one occasion, the soldiers of China confronted the legions of Rome. Intellectual freedom and penetration, of a kind not met with in ancient times, revised the calendar, made great strides in astronomy so that eclipses were predicted with accuracy, made impressive advances in chemistry, albeit heavily mixed with magic and alchemy, and delved into mathematics. In the humanities the first real histories appeared and set the Chinese standard for all times, lexicography became an independent branch of learning, while Confucianism and Taoism were codified into systems that became permanent foundations of Chinese thought.[1]

Ch'in Shih-huang-ti, founder of the brief Ch'in empire, had left China a priceless legacy – the concept of a people with common aims and a unified empire. The Han emperors and their ministers, although they rescinded many of the most oppressive laws of Ch'in, continued a strict policy of unification. The peoples of China were welded into a homogeneous nation by common laws, weights and measures, language, a uniform civil administration and, to a surprising extent, by unified thought. At the same time an extensive programme of building roads and canals served to unite the physical empire.

As in all important epochs of political and intellectual change, there were basic mutations in the social orders. Active government concern for the welfare of agriculture did much to improve the conditions of the peasants. Great expansion in manufacture and trade brought into being a merchant class and group of urban financiers that were, perhaps, the basic cause for the rise of important walled towns and the consequent new demands on architecture. Han Kao-tsu (as Liu Pang, the founder of the dynasty, was later called) revived feudalism to a limited extent by granting fiefs to his relatives and favoured followers. Many of the highest nobility preferred to live, as absentee landlords, in the capital and added the brilliance of their establishments to the imperial city.

The internal organization and ordering of the empire well under way, the Han undertook a series of military operations which engaged all the resources of the new empire. Even a cursory examination of the wars, with their almost incredible exploits, would be too long a digression, but certain aspects of Chinese expansion at that time bear directly upon the development of the arts and must be briefly mentioned. The traditional enemy of the Chinese and the most formidable was a confederation of semi-nomad peoples living in Mongolia. These were the Hsiung-nu, of Turki stock, identified with the Huns who at a later

date invaded Europe. By a series of brilliant campaigns the power of the Hsiung-nu was broken, and Chinese arms pushed ever farther and farther towards the west across Central Asia and, in 101 B.C., defeated the armies of Ferghana. Missions of Han Wu-ti were in contact with Sogdiana and Bactria, which latter was the farthest satrapy of the empire established by Alexander's followers and where a Macedonian dynasty ruled. The most famous of these Han ambassadors was Chang Ch'ien, whose trip from the Chinese capital to the easternmost outposts of the Hellenistic world occupied the years between 138 and 126 B.C.

The conquests and missions of the second and first centuries established Chinese dominion over the two great highways between East and West across the high tablelands of Central Asia. One, known as the Great Road North of the T'ien Mountains, led from the Chinese western outpost of Tun-huang across the Gobi Desert and into the neighbourhood of Balkash; the other, which was the Great Road South of the T'ien Mountains, started also from Tun-huang and passed through the Tarim Basin to Kashgar and Khotan. Over both roads came Western ideas and art motifs to be incorporated into but never to dominate the Chinese aesthetic canon.

Colonies from central China following in the wake of the victorious arms, settled in northern Shansi, in Manchuria, and most important, in Korea, where a flourishing outpost of Chinese culture was centred at Lo-lang, near modern Pyongyang. The southward expansion brought the coastal region centred about Canton under Han rule in 11 B.C. By the middle of the first century A.D. the kingdoms of Tongking and Annam were added to the empire. Contact with India was established overland by way of Yünnan and Burma, and by water through the Canton area of the southern coast and the Indian Ocean. The vastness of this empire, extending from south-west Asia to Korea and

from the Pacific to the Pamirs, so stimulated national pride that into modern times the Chinese frequently refer to themselves as the Sons of Han. Such an empire must have enormously heightened Chinese perceptions of the world about them and, in a subtle way, made them susceptible to foreign ideas, lending a cosmopolitan air to life in the capital.

Chinese intellectual life was no less active than that in the military, political, and commercial spheres. There are certain aspects of the philosophies evolved during the Han Dynasty that are so far-reaching in their effect, and basic to the characteristic Chinese points of view and social institutions, that much of Chinese art will seem to be without meaning unless some consideration is accorded them. It was during the Han Dynasty that Confucianism triumphed over all other schools and became the official, state philosophy. It has maintained this position, with temporary eclipses and some modifications, into modern times. 'In China, as in Europe, not until the advent of modern science put into man's hands another tool for reaching truth, has the power of the ancient authoritarian world-view been broken.'[2]

An intellectual suppression and literary inquisitions that had occurred during the brief Ch'in rule were followed by a lively revival of learning. Confucian scholars came out of seclusion; old texts that had escaped destruction were hunted out and frequently subjected to extensive 'editing'. Confucius himself had been a man of learning, and learning and scholarship lay at the core of Confucian doctrine. The men most active in the reconstruction of the past and versed in ancient ritual and lore were naturally Confucians. These early scholars took 'to themselves the exposition of the best of Chinese literary treasures and made those treasures into Confucian books.'[3] Thus it gradually came about that in Han times, and later, to acquire an education meant to be exposed, at least, to Confucian indoctrination.

Early in the Han Dynasty the rulers sought throughout the country for capable and honest men to serve the government. Such men were recommended from the provinces, and after the middle of the second century B.C. written examinations became the means of selecting candidates of merit.[4] The door to government office was the examination system, and since the examinations were prepared and graded by Confucians, scholarship of this kind became the only sure means to the most honourable occupation in the empire – the life of an official.

The effect Confucian concepts have had on the arts of China is complex, deep-seated, and of a kind that permeates the purpose, the various forms it will take, the techniques, and the range of aesthetic values. It will be possible here to suggest the directions, to point out a few of those qualities and characteristics that find their origin in Confucian doctrine, not so much as it was formulated by Confucius himself, but what the basic nature of the Chinese peoples made of it through their representative agents, the Confucian scholars of Han.

In the first place the examination system created a bureaucracy which had in common a classic education and a respect for learning and the arts. These men were, for the most part, practical and worldly to the extent of being capable administrators. They were recluses by nature, in the best instances, in that their leisure was spent in the seclusion of their studies or in a quiet garden where with a few congenial friends they would discuss or practise the arts of calligraphy, poetry, music, and painting. As in no other nation of the world, there grew up an entire class, active in the affairs of their country, and by the nature of their training patrons of the arts. Love of literature led early to a desire to present it in as beautiful a form as possible, and nowhere in the world has calligraphy been so fluid a medium of aesthetic expression. As we shall see, the cultivated scholar-gentleman soon raised painting from the level of a handicraft to one of the highest forms of expression practised by his class. The *Book of Songs* was one of the principal texts of the Confucians; poetry has ever been for the Chinese one of the most cherished and beloved outlets for the human spirit. It has all too frequently been said that the orthodox Confucian doctrine represented the arid, unimaginative, practical side of Chinese character. But it cannot be denied that the Confucian system produced on the one hand a profound respect for cultivation of the intellect and the spirit – a respect shared by illiterate peasants and academicians; and on the other hand was responsible for the largest single class of art patrons enjoyed by any civilization of the world.

Among the Confucian concepts that have moulded the form or the content of Chinese art, *Li* may be mentioned as an example. *Li* embraces the rules of good manners and social usage, it is the force of the *mores* imposed upon an individual in an organized society. '*Li* regulates human emotions and *Li* refines them.' It establishes propriety in the broad sense of setting the limits of expression beyond which it would be immodest to go. It is the natural restraint resulting from what we might call 'good breeding'. The expression of genuine emotions and sentiments is, for example, admirable, but *Li* would not allow the individual to go about making a fetish of being 'brutally frank'. Proper relationships of old and young, superior and inferior, ruler and ruled are set by *Li*. It engenders a natural sense of what is fit and proper under given conditions. It is very possible that much of the restraint we shall find in Chinese art, and especially in painting, comes from this Confucian concept of *Li*. Violent emotions are seldom portrayed; only in subjects from nature such as flowers and birds is painting ever fully sensuous, never in reference to human life; what is obvious, whether in over-refined or 'trick' technique or in over-bold compositions, is avoided; high premium is set on the character

of the painter as a man and the true artist must have a cultivated nature.

Hsiao, the concept of piety towards the spirits of the ancestors and filial behaviour towards the living parents, has certainly had its effect on the arts. The concept is complex and many other factors enter in, but a respect for the past and for the accomplishments of ancestors has been a powerful factor in Chinese consciousness of the continuity of their culture. As a result of this consciousness the cultured man is conservative. The Chinese painter is conservative in the choice of his subject matter and the manner of representation so that the tradition of the great painters of the past is a more potent factor than it is in the West.

The best in man's character is developed, the Confucians urge, by cultural pursuits, by the study of literature, by music, and by all those arts of humanism which are the manifestations of a culture. This is the Confucian *Wên*, which, as Arthur Waley has said, may mean 'what is decorated as opposed to what is plain, ornament as opposed to structure, and hence the things that vary and beautify human life as opposed to life's concrete needs.'[5]

Social conformity and the multiple inter-related duties of a man to his fellow-men is the cornerstone of the Confucian system. But there is another side to human nature and that is the desire to assert one's own individuality and to nurture the spirit in solitude. The urge to escape into some state free from competition, from the constraints and obligations of social order, is inherent in all of us. In China there have always been men who had the courage to obey this urge, and forsaking ambition, comforts, the gratification of ownership, and the security of position, live the lives of recluses. From these men, motivated by the aim of justifying their behaviour, came the philosophy of Taoism. Taoism as a philosophy is a very different thing from the Taoist religion with its myriad superstitions, its host of fairies and immortals, and its curious quest for longevity and the elixir of life. The Taoist church often influenced the subject matter of Chinese art but never its content or well-spring. Taoist philosophy, on the other hand, is pre-eminently the way of the artist, and it was Taoist thought of the Han Dynasty and the succeeding few centuries that, in a sense, codified those aspects of Chinese nature which produced the great schools of landscape and nature studies.

In a most general way it may be said that Taoist thought taught the way to true happiness. The life of a sage was to be found through complete conformity with the way or principle, *Tao*, of Nature. Chuang-tzu says: 'At the great beginning there was Non-being. It had neither being nor name and was the form from which came the One. When the One came into existence, there was the One but still no form. When things obtained that by which they came into existence, it was called the Tê.'[6] Fung Yu-lan, the modern Chinese philosopher, commenting on this passage writes: 'Thus our Tê is what makes us what we are. We are happy when this Tê or natural ability of ours is fully and freely exercised, that is, when our nature is fully and freely developed.'[7] This is a philosophy of individualism and complements the social morality and ethics of Confucianism. Incompatible as they may seem, Taoism and Confucianism combine in the cultivated Chinese. To quote, in part, from Lin Tung-chi, writing on the Chinese Mind: 'We are socially Confucian and individually Taoist. . . . Confucianism and Taoism supply the positive and negative elements in Chinese life – the *yin* and the *yang* which complement each other.' And farther on: 'Taoism is the philosophy of an artist, of a rustic and a vagabond who feels psychologically incompatible with the congested and sordid atmosphere of over-urbanized life. . . .'[8]

The Taoist in understanding his own nature arrives at an understanding of the nature of all things and intuitively experiences his own unity

with all things in a pantheistic identity of spirit. It is this 'pantheistic repose at once immanent and transcendental' that is the spiritual source of inspiration for the great Chinese landscape painters. 'Chinese landscape painting is the world-feeling of the Taoist recluse. . . . There is little doubt that in landscape painting, the Taoist in the Chinese has successfully immortalized the domain of freedom which he has created for himself in contradistinction to the domain of social bonds and duties of the Confucianist's making.'[9]

The two factors of Chinese thought, Confucian decorum, restraint, and conformity, and the Taoist 'escape', but an escapism with a positive content, in their full expression or in their interplay, are dominant forces throughout the history of Chinese art.

HAN DYNASTY SCULPTURE

All the Han Dynasty sculpture that has survived is, with few exceptions, associated with burials and tomb construction. The tombs of emperors and important personages were on an imposing scale, but none has been as yet scientifically excavated. However, a number of minor tombs have been investigated and these, together with descriptions in Chinese literature, give some idea about the general plan. The tomb proper was an underground chamber or series of chambers constructed of wood, brick, tile, or stone. In some cases the interior walls were finished with plaster and painted with frescoes similar to those that must have adorned temples and palaces. A mound, most often in the form of a truncated pyramid, was frequently raised over the burial chamber. A large area about the tumulus was enclosed by a wall, though none of these survives today. A road, known as the 'Spirit Road', led some distance from the tomb, generally on the south side, and this was frequently lined with stone figures. The entrance to the 'Spirit Road' was also at times marked by stone pillars simulating guard towers. Among the buildings erected in connexion with the tomb was a sacrificial hall where offerings to the spirit were presented and a funerary chamber where robes and hats similar to those worn by the departed during his lifetime were kept.[1] In some cases the walls of the offering chambers were decorated with wall paintings. None of these shrines, built of wood and perishable materials, survives today, but some surviving offering chambers were made of stone, at least in the Later Han Dynasty, with the walls engraved or sculptured in low relief presumably simulating such paintings.

If, as might be supposed, imposing stone monuments were ever erected in association with the Han imperial tombs, they have all disappeared or remain unidentified today. The only stone sculpture of importance that can be assigned to the Former Han Dynasty is a group of partially carved boulders and some more complete sulptures scattered about a tomb in Shensi that has been identified as that of a celebrated Han general, Ho Ch'ü-ping, who died in 117 B.C. The identity of the tomb is not as definite as one might wish, but there can be little doubt that the sculpture is from the Han Dynasty and most probably is from the second century B.C.[2]

The figure best known is that of a stocky horse, executed in the round, standing over a fallen warrior who lies beneath, his disproportionately large head protruding between the horse's forefeet [24]. The broad, bearded face

24. Horse trampling a barbarian, tomb of Ho Ch'ü-ping, Shensi. 117 B.C.

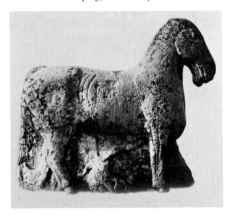

with staring, wide-spaced eyes is distinctly non-Chinese. This prostrate soldier holds a bow in his left hand while with his right he lunges a short spear into the side of the horse. If this is indeed the tomb of the famous Han general, then the intent of this sculpture may be to memorialize his triumph over the barbarians. The success of Chinese arms over the Huns of Kansu and Central Asia was in large part due to the development of a light and mobile cavalry, and the horse was undoubtedly an important factor in the victory. This might account for the presence of two additional horses among the Ho Ch'ü-ping figures, one reclining and one, but half-sculptured from the massive granite boulder, rearing up. Other sculpture represents a reclining water-buffalo, a crouching tiger, an unidentifiable quadruped,

25. Demon biting a small bear (rubbing),
tomb of Ho Ch'ü-ping, Shensi. 117 B.C.

a fantastic buffalo-like monster eating a small animal, a demon of terrifying form embracing and biting a small bear [25], and a second demon with one enormous hand outstretched as though in warning.[3] Most of these pieces follow closely the original shape of the boulder on which they are cut in very low relief. Even the horse trampling the barbarian is blocked out more as bas-relief and is nowhere cut through, the area between the four legs being solid. Others, and here we may particularly note the demons, are little more than shallow reliefs in which the design is adapted to the natural shape of the rock.

The sculptors of the Ho Ch'ü-ping series were not entirely at home in their craft and what plastic quality the works possess results more from the natural mass of the boulders than from the sculptors' efforts. It is not impossible that the practice of placing guardian figures before the gateway to the tomb and lining the 'Spirit Road' with sculptured figures was imported from the West. On the other hand, there appears to be no close parallel in style and the linear quality as well as the stylization of masses is purely Chinese. The horses at the tomb, for example, and especially the reclining one, are related to the bronze horses of the Chin-ts'un finds [14]. Viewing these monuments as a group, especially in the rubbings which emphasize the quality of the drawing, the impression is one of a strange and rather sinister gathering of malevolent monsters and of animals that are perfectly recognizable and even relaxed in natural and characteristic poses, yet possessed of a curious. kind of latent power not of this world.

In contrast to this single group of funerary sculptures from the Former Han Dynasty, a number from the Later Han, and especially the second and third centuries A.D., have survived. None the less when the four hundred years of the two Han Dynasties and the great wealth of the empire at that time are considered, it is

surprising that, if sculpture became a popular medium even in only the first and second centuries of the Christian era, relatively so little of it has remained. In fact it was not until the introduction of Buddhism and its rise to national importance in the fifth century that sculpture in stone was produced in quantity to meet the ritual demands of the new religion.

In Honan, Shantung, and Szechwan there are stone pillars that marked the entrance to the 'Spirit Road' which led from the edge of the sepulchral enclosure to the tomb mound. These pillars are adaptations in stone of wooden defence towers that flanked the gates of cities, important palaces, and buildings.[4] The most elaborate and richly sculptured are those found in Szechwan, and the pair that is best preserved and most handsome in masonry and sculpture

is that erected in Ch'ü-hsien before the tomb of an official named Shên.[5] The Pillars of Shên [26, 27] are not dated by inscription but were probably made in the second century A.D.[6] The ancient form of the lookout-tower is represented by a rectangular shaft surmounted by beams, brackets, and a tiled hip-roof, all carefully executed in stone simulating wooden architecture. The excellent proportions and a stonemason's treatment of the brackets and corbels carry the work beyond mere imitation and make the body of the monument into a kind of geometric sculpture. Of the embellishments, the tiger on the west, the dragon on the east, and the phoenix on the south are in low relief, the monster pushing out between the beam ends is in high relief as are the Atlantean figures on the corners, whose now missing heads were in the

26 and 27. Ch'ü-hsien, Szechwan, Pillars of Shên. Second century A.D.

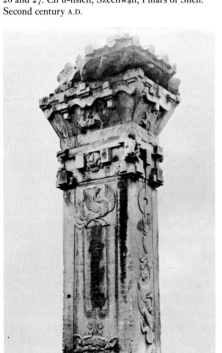

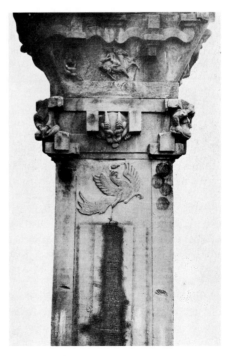

round. The White Tiger of the West and the Green Dragon of the East are, on a monumental scale, the same lithe and prancing creatures that decorated the jade carvings of the Late Chou period some centuries before. These animals have lost much of the stylization characteristic of the earlier centuries, the linear rhythms are less taut and more sensuous, and there is a naturalism about them that is quite new. Yet enough heraldic formality remains to inform us that these handsome creatures are symbols of the cosmos.[7]

The four Atlantean figures are of interest, because the full and ample forms have a solidity about them at variance with the general linear nature of Han sculpture. They are the direct descendants of the bronze kneeling men and Atlantean figures of Late Chou [15], with their smooth garments and massive volume. Kindred Atlantean figures unmutilated show us that the heads were disproportionately large, ponderous things sunk between the hunched shoulders. These burden-bearers are none other than those barbarians who, carved in wood, supported the beams of the Ling-kuang Palace and

> Gloomily decorous, with their long skulls and hollow eyes;
> Crane their big heads, and frowning seem to fight
> Some overmastering sorrow – [8]

Much of the same sense of volume is seen in certain gilt-bronze bears of a relatively small scale. A number of these are known, and we reproduce here the excellent example in the City Art Museum of St Louis [28]. The hulking creature is shown squatting on its haunches with one leg drawn under. The pose, with front legs spread and head thrust out from between the shoulders, as well as the details of small, round ears, short snout, and ruff of hair about the neck, are all well-calculated to impress the beholder with the bear-nature of the creature. There is the same easy flow of form, uniting all

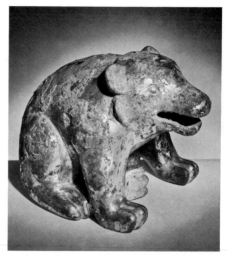

28. Bear, gilt-bronze. First century A.D. or earlier. *St Louis, City Art Museum*

the members, which we have already encountered in such early works as the bovine quadruped in the Freer Gallery [10]. These bears are probably earlier than the pillars of Shên and may date from the first century A.D. or slightly earlier. Their use or meaning is even more uncertain, but the popularity of the bear in Han art suggests that they may have been cult objects or symbols of creative power.[9]

We have mentioned these bears as a single example of a kind of sculpture, small in scale, that seems characteristic of the native Chinese genius. Examples could be multiplied to include the head and shoulders of a horse powerfully carved in jade, now in the Victoria and Albert Museum[10], or the elegant jade ladies in the collection of Mrs Walter Sedgwick.[11] Above all, the modeller in clay has left us, in the form of the figurines that accompanied the dead into the tomb, some of the best sculpture, on a reduced scale, to come out of Asia. Much of the pure Chinese tradition of stylization of the human form and, at the same time, realistic animal

sculpture, was quite literally driven underground by succeeding waves of Buddhism with its own tradition of the anthropomorphic gods, that swept over China in the centuries following the Han Dynasty. Even a cursory study of the art of the Chinese tomb figure is not possible here, but the reader should know that much of the real flavour of Chinese life in the centuries from the Han to the end of the T'ang Dynasty can be recaptured to a gratifying extent through a study of the tomb figures.

Large stone figures placed before the tombs are first encountered in the second century before the Christian era, although future excavations may discover earlier examples. The concept of such guardian figures may, as has been mentioned, be of west Asiatic origin. Osvald Sirén has pointed out very striking and curious parallels between some Chinese stone lions of the Han Dynasty and others made as early as the thirteenth and tenth centuries B.C. in the Hittite and Aramaean empires.[12]

Two lions still in place at the Wu Family shrines in Shantung were probably set up about A.D. 147,[13] while another sculpture of about the same period, or slightly earlier, was formerly in the Gualino Collection [29]. Whatever may have been the ultimate inspiration of these animals,

29. Lion, stone. Second century A.D.
Formerly Turin, Gualino Collection

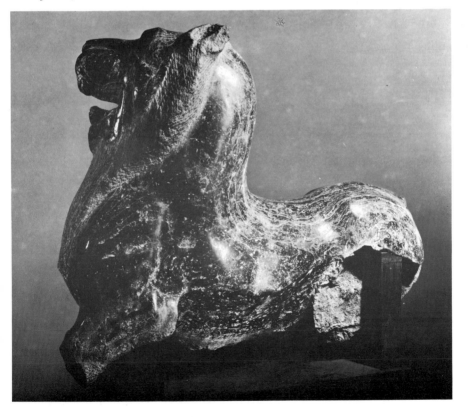

they enjoyed no great popularity. The lion is not native to China, and these early representations were probably made from descriptions or prototypes on a small scale. The animals are bulky, to say the least, with square, block-like heads growing out of a thick, powerful neck. The mane is indicated by a kind of ruff, reminiscent of the Han bears in gilt-bronze. The legs are missing on all surviving examples, but the lions apparently stood as though striding forward with both legs advanced on one side. Undoubtedly these guardian figures must originally have conveyed a forceful impression of animal strength in every way appropriate to their function. There is, nevertheless, no repetition of the type in later Chinese sculpture, and the three or four known remain the sole example of a tenuous influence.

In the lower Yangtze River valley about Nanking and Tan-yang, in Kiangsu province, standing in the fields and farmyards, are gigantic winged lions and chimeras that are the most noble creatures to guard any tomb in Asia. These great stone monsters are later in date than the period under consideration, having been erected before the tombs of the rulers of the Sung (420–79), Ch'i (479–502), and Liang (502–57) dynasties. They form a unified group, however, that evolves from styles originating in the Han Dynasty, and since they differ from the animal sculpture introduced with Buddhism, they may fit best into the present chapter. Two kinds of fantastic creatures are represented and there is some confusion about the names proper to each. We may, however, for the convenience of the Western reader, call those with stylized manes 'lions', and those more lithe and tiger-like creatures equipped with one or two horns, 'chimeras'.[14]

The best of the lions were originally erected in pairs on the 'Spirit Road' leading to the Imperial and princely tombs of the local Liang Dynasty. Of the twelve pairs that have survived, eight have been identified with datable tombs

and five pairs remain unidentified. The earliest identified lions are the well-preserved and handsome pair that mark the 'Spirit Road' to the tomb near Nanking of Hsiao Hsiu, a prince who died in A.D. 518 and who was the seventh son of the emperor Liang Wu-ti. We reproduce one of these lions as characteristic of the entire series [30]. The latest are those erected at a Liang tomb in A.D. 548 – just four hundred years later

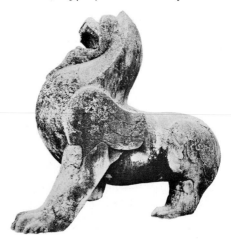

30. Lion, stone, from the tomb of Hsiao Hsiu, Nanking. Liang Dynasty, A.D. 518

than the Han Dynasty lions at the Wu Family tombs. The connexion may seem remote, and certainly drastic modifications have occurred. The ruff-like mane of the Han beasts has been reduced to a sweeping plane that descends in an 'S'-like curve from the crest of the head, following the line of the enormous arched neck, to the junction with the strongly developed shoulder. The lion rears back with the left front leg advanced and planted like a pillar to thrust up the ponderous weight of the vastly expanded chest. With long, lolling tongue and wide-stretched jaws, this noble guardian seems roaring defiance at the very centuries. Chinese propensity for linear rhythms over plastic form

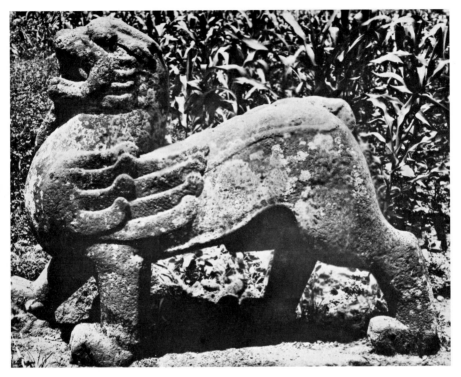

31. Chimera, stone. A.D. 209.
Ya-chou, Szechwan, tomb of Kao I

in sculpture has converted the wings into three flat and slightly overlapping pinions, while what may have originated as tufts of hair on the flanks has become arbitrary patterns in low relief that break the monotony of the large almost flat surface. The square face, thick neck, and strongly modelled fore-shoulder are more closely related to the few lions from Han times. The Lions of Liang, as they are called, have no counterpart anywhere in Asia, because these creatures have become purely Chinese – Chinese in the balance and counterbalance of the massive forms, so justly conceived in terms of stone, the simple grandeur of outline, and the convincing power of life.

More fantastic in concept than the winged lions and more complex in pedigree, the chimeras are certainly no less impressive as monuments. Sirén has pointed out some of the most likely sources that hark back to the fabulous beast combinations of Mesopotamian art which, through Babylon and Assyria to Achaemenid Persia and thence by way of Bactria, found their way across Central Asia to China.[15] They are also related to winged and bearded tigers done in jade on a small scale from the Late Chou into the time of the Former Han Dynasty, say the fifth to the second century B.C.

The earliest example in China that can be dated with certainty is the single, winged and

tiger-like creature associated with the tomb of Kao I, A.D. 209, near Ya-chou in Szechwan [31]. It is striding forward, the two right legs advanced, the forepaw crushing a small creature; the left hind leg is drawn far back, but the left foreleg is like a straight square post. The sides and flanks are quite flat with little transition to the plane of the back and none to the under-belly. The thick neck and swelling chest contribute a quality of ponderous bulk; nevertheless, the dominant character is linear, emphasized by the wing pinions that spring from the shoulders. A pair of chimeras in the Nelson Gallery at Kansas City illustrate the same style in a somewhat more developed form [32]. The

original location of these animals is not known. There is the same flat treatment of the form and the creatures are clearly most effective when seen from the side. In fact, they are almost like two high reliefs joined together down the middle. The forward stride is more effective than in the Kao I figure by reason of the left foreleg being retracted to match the hind leg. The wings are more fully developed, while the same kind of linear decoration has been extended to the back, sides, and flanks in the form of ribbon-like streamers. The dewlap has been extended out into a large, curving flap. The long beard hanging from the chin to the chest and the presence of horns distinguish these creatures

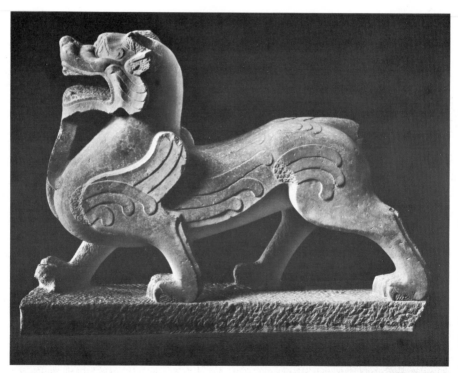

32. Chimera, stone.
Third to fourth century A.D.
Kansas City, Nelson Gallery of Art and Atkins Museum

33 (*right*). Chimera, stone. Mid sixth century A.D.
*Philadelphia, The University Museum
of the University of Pennsylvania*

from what otherwise might be winged tigers. The ends of the horns are broken on all known examples and this suggests that they may have curled up at the end, free from the body. Such horns in long, sweeping 'S'-curves, strongly reminiscent of those on the glazed-tile griffons from the Achaemenid palace at Susa now in the Louvre, occur on Chinese bronze mirrors of about this same time – the third century.[16] Among the Chinese chimeras the males have but one horn, curving from the centre of the head, while the females have two horns.

The final development of the chimera is to be seen in a dozen or more examples at the tombs of the rulers of the Southern Dynasties of Sung, Ch'i, Liang, and Ch'ên, in the region of Nanking and Tan-yang in Kiangsu province. Other excellent examples are in the University Museum, Philadelphia, the Albright Art Gallery, Buffalo, and in the Louvre. Among those still associated with identifiable tombs, the earliest are those at the tomb of Wu-ti of Southern Sung (d. A.D. 422) and the latest are the pair still guarding the tomb of Ch'ên Wên-ti (d. A.D. 566). The style of these noble creatures follows, in general, that of the winged lions in that the neck now arches back in a violent curve and the chest swells enormously. The chimeras are, however, far more lithe, more feline, and more sinuous than the lions. A single-horned

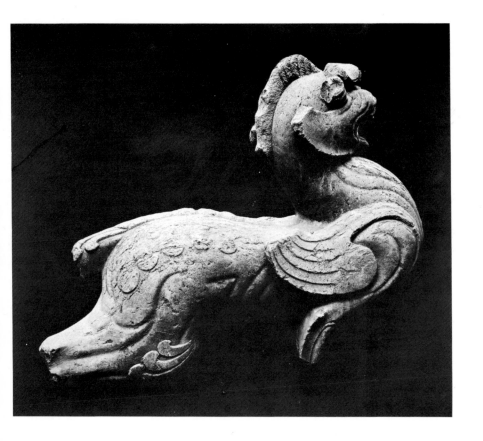

male, probably of about the mid sixth century, now in the University Museum, Philadelphia [33], shows to what extent the long, sweeping, and linear rhythms dominated the design by the sixth century. He is impelled forward by a powerful thrust of the hind leg – a movement that is countered by the great, arched neck rearing back; the wings and dewlaps are repeated shapes that have become gently sweeping curves and are in marked relief. The linear character is accentuated by deep grooves that follow the form of the neck, chest, shoulders, sides, and flanks.

For some reason both the winged lions and the chimeras on a monumental scale as guardians of the tomb disappear in the second half of the sixth century with the fall of the Southern Dynasties. Later, in the T'ang Dynasty, their place is taken by other animals such as horses and a very different kind of lion, heavy and static, derived from a type introduced with Buddhism. The winged lions and chimeras of the fifth and sixth centuries are unique monuments attesting to the high attainments of the arts south of the Yangtze River. No imperial tombs of China have had more noble guardians.

HAN DYNASTY PAINTING

The recent finds of magnificently decorated lacquer at Ch'ang-sha are added evidence to support the suggestion of Arthur Waley that painting in the Han Dynasty may have been derived from the State of Ch'u.[1] A Chinese writer of the second century A.D. relates of the poet Ch'ü Yüan (332–295 B.C.) that: 'In Ch'u he saw a royal ancestral temple with a family shrine of dukes and nobles, in which were painted the gods and spirits of Heaven and Earth, and of the Mountains and Streams, in forms curious and elusive; and strange objects and acts performed by the ancient worthies and sages.'[2] If we may judge by the surviving lacquers from Ch'u, these designs must have been of a highly fanciful nature, full of swift movement. But it is in Han times that the world of human actions becomes the artist's absorbing theme.

It was above all an age of wall painting, judging from passages in contemporary or slightly later texts. In the time of Hsüan-ti (73–48 B.C.) there were paintings of good and bad rulers of old in the Western Hall of the palace; these served to remind the living of the virtues and faults of former kings.[3] In 51 B.C. the same emperor had the portraits of eleven ministers painted in the Ch'i-lin Hall, 'copying their features and inscribing their rank and names', to commemorate their success in bringing a Hun chief to pay homage at court.[4] The Emperor Wu-ti was much given to Taoist superstitions and in the Kan-ch'üan Palace he had a tower where 'were depicted the demons and deities of Heaven, Earth, and the Supreme Unity. Sacrificial utensils were set out, by which the divine beings were to be addressed.'[5] Another more specific passage relates that, 'In the Palace the

walls are all plastered and white-washed, the plain-white spaces are bordered with dark red, and the portraits of ancient illustrious officers are painted on them.'[6] The Emperor Ming-ti had the portraits of thirty-two of his generals painted in the Cloud Terrace of the Southern Palace in the era A.D. 58–76.[7] In all likelihood wall paintings of this kind were the product of professional craftsmen attached to the imperial workshops.

There were, in addition to these large-scale frescoes, also portable paintings on silk. Wu-ti presented to a loyal minister a picture of the Duke of Chou holding in his arms the infant King Ch'êng for whom he acted as regent. During the reign of Ch'êng-ti in 29 B.C., a special bureau in charge of paintings and books was established. Some of the Han rulers, at least from the second century B.C. onward, were enthusiastic collectors of art – thus beginning that long line of imperial antiquaries and amateurs whose patronage is without parallel and whose enthusiasm in bringing together in one place all available works of art has resulted in those periodic holocausts of destruction in which ancient paintings were lost by the hundreds. A ninth-century art historian tells us that in the reign of Ming-ti (A.D. 58–76) the 'art of the whole realm was assembled like clouds'. When the capital was taken, sacked, and burned in A.D. 190, during a civil war, the silk paintings served the soldiers to make tents and knapsacks. The remainder to the number of seventy carts full were gathered up, but in carrying them westward half of this remainder was lost because of bad roads and foul weather.[8] The same author, Chang Yen-yüan, who wrote his

'Record of Famous Paintings in Successive Ages' in about A.D. 847, lists several Han painters by name, of whom it is to be noted that those of the Former Han (206 B.C.–A.D. 9) appear to have been relatively humble individuals, while, in contrast, among those of the Later Han some were high officials and others were scholars. This is of significance in that it indicates the first few centuries of the Christian era as the time when the art of painting ceased to be the work of decorators and professional craftsmen only and began to enter the sphere of approved intellectual and aristocratic accomplishments. Quotations from antique sources about pictures and painters could be multiplied, but they actually tell us little of what the paintings looked like, and we are even at a loss to know what physical form they took.

Silk had certainly been used for painting as early as the fifth to third century B.C.[9] The official date for the invention of paper by the eunuch Ts'ai Lun is 105 A.D., though in a ruder form paper may have been known earlier. There is no reason to believe, however, that paper was used for paintings to any extent until several centuries later. The writing brush, also used for painting and probably the most sensitive instrument of the craft that has ever come into an artist's hand, had been much improved in the third century B.C. When Han Ming-ti told some of his learned officials to select themes from the Classics and history to be illustrated by the painters of the imperial workshop, the result was, most likely, a silk hand-scroll that presented individual scenes separated by sections of text. The continuous scroll form, with composition and narrative unfolding from right to left, was probably not perfected until the sixth or seventh century.

What we can learn about the appearance of Han Dynasty painting comes from decorated lacquers, designs engraved on stone funerary chambers, pressed pottery tiles, painted pottery, and a few painted tombs. With the exception of the lacquer all these sources are artifacts made for the use of the dead, and so most of it has the off-hand, almost careless quality of much of Chinese funerary art which was intended, after all, to serve only as a symbol or a spiritual substitute for the real thing. None the less, in these poor echoes of Han painting we are confronted with an art of incomparable style.

Within the limitations of archaic representation the Han artists created their own world that was above all infused with the breath of life. It is primarily an art of silhouette, but a silhouette that is vibrant with action and expressive of human drama.

Japanese archaeologists working in southern Manchuria, at Liao-yang, near modern Port Arthur, found a stone tomb in which all the walls had been plastered, and four of them carried wall paintings. The tomb had been looted in ancient times and no other artifacts remained. Comparisons with other finds in the same district and the details of the stone construction established the Liao-yang tomb as the work of the Later Han Dynasty. On one wall is a procession of dignitaries in chariots accompanied by outriders [34]. The figures are scattered over the field with no suggestion of setting or diminution in scale for the more distant horsemen. The chariots, none the less, are shown approaching at an angle towards the observer so that one can see into them; the far-side wheels are in advance of the near wheels and the dashboards follow the diagonal of the axles; the riders within are in three-quarters view, but the horses are in pure profile. In spite of the uniform and even disproportionate sizes of the near and far figures, the outriders at the top of the scene are arranged at varying distances in a manner suggesting a true spatial relationship. The last horseman at the upper right is having some difficulty with his charger whose head is turned directly back while the head of the rider appears from behind the horse's neck, a device that skilfully suggests movement in depth.

34. Procession of dignitaries, wall painting,
tomb at Liao-yang, Manchuria.
Later Han Dynasty, second century A.D.

The relation of this provincial painted tomb to the art of China proper is very close, as may be seen by comparison with a detail from a pressed tile from the Yellow River valley.[10] The single horse drawing the rear chariot of the procession [35] is nearly identical with that of the third horseman in the upper part of the Liao-

yang painting. Also the legs and hoofs of the horses are treated in much the same manner, looking rather like the notes in a musical score. An even closer parallel to the south Manchurian chariots comes from another but similar tile [36] in which the chariot of the same light framework is more skilfully presented in similar

35. Pressed tile (detail).
Later Han Dynasty, A.D. 25–221.
*Kansas City, Nelson Gallery of Art
and Atkins Museum*

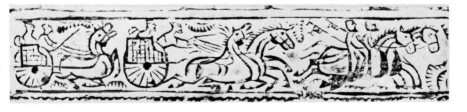

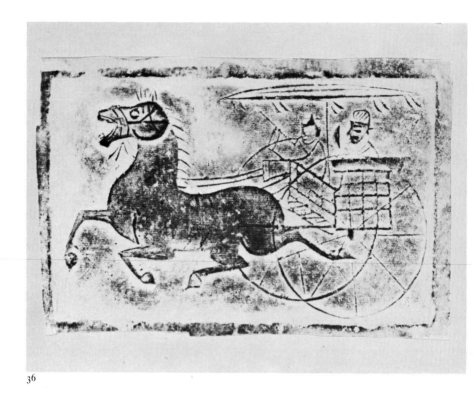

36

36 to 38. Pressed tiles (details).
Later Han Dynasty, A.D. 25-221.
*36. Kansas City, Nelson Gallery of Art
and Atkins Museum;*
*37. Cleveland Museum of Art,
Charles W. Harkness Fund;*
*38. Cleveland Museum of Art,
gift of Mr and Mrs Ralph King*

37

38

perspective. These tiles can be assigned to a period from about the middle of the first century to the end of the second century A.D. The tomb at Liao-yang is far removed from the centres of Chinese creative genius and is all the more interesting in illustrating the wide distribution and perseverance of representational formulas and the unity of the Han style. In the tiles as well as in the painting one is impressed by the light, free movement, the airy grace of the horses, and the headlong rush of the processions. A youthful eagerness animates these scenes in which man and beast seem impelled by an irresistible necessity for speed which hurtles them through space towards an unseen goal. No doubt the 'flying gallop', in which an animal is shown with both front and hind legs extended at the same

time, is a speed-device adopted by the Chinese from the West. But there are no examples in the Near or Middle East that can match the elastic spring and furious dash of the bristling tiger that pursues a horse through a curiously sinister landscape, a detail from a tile in the Cleveland Museum [37]. On the same tile two witch-like creatures seem engaged in a frantic game of leap-frog over the mountains, their attenuated bodies compounded of lithe energy [38]. Indeed this quality of life's energy was present but constrained in the formal designs of the Bronze-Age art, and seems now to break its bonds in the expanding world of Han China.

On the rear wall of the Liao-yang tomb there is a feast such as decorated some of the Han funerary offering chambers made of stone and

which may represent the offerings to the departed. On the right of this scene is depicted a three-storeyed tower with a group of musicians, acrobats, and jugglers performing in front, of which we reproduce only a detail [39]. The disproportion between the audience on the right and the performers on the left shows less skill on the part of the artist than is found in the procession of horsemen from the same tomb. The scene is, however, certainly not lacking in

the inner markings and details are suppressed to a minimum, while there is a keen observation of the gestures and attitudes that are significant of the action or occupation represented. The same bounding outline, though in a more formal style, delineates the figures on the painted pottery tray in illustration 49.

The painted tiles in the Ross Collection, Boston Museum of Fine Arts, illustrate a different manner of painting and one which

animation as the troupe dance or go through their tricks around a great drum ornamented with streamers. The onlookers are intent upon the show. The manner of execution is probably that of the classic Han tradition. The figures are bounded by an ink outline of even thickness,

39. Musicians with performers, wall painting, tomb at Liao-yang, Manchuria. Later Han Dynasty, second century A.D.

40 and 41 (*opposite*). Painted tiles (details). Han Dynasty, 206 B.C.–A.D. 221. *Boston, Museum of Fine Arts, Ross Collection*

technically seems somewhat related to the art of the lacquer painter. The painting shows an animal fight as the main theme and several groups of figures.[11] In contrast to the even line of the works described above, the brush is here given much freer play, the strokes are cursive, widening and narrowing to strengthen a shape or lend emphasis where needed in the design. It is the work of a simple craftsman with the particular skill and ease that come of long

practice. On the plain ground without indication of setting the figures move back and forth and stand in easy, natural relationships [40]. In one scene [41] a lady of elegance and nobility has, by some action, surprised and annoyed a gentleman standing at the left of the scene, while two men of humble station seem rather embarrassed and one turns to look at two haughty court ladies behind him. The story may well be one of those favourite Confucian

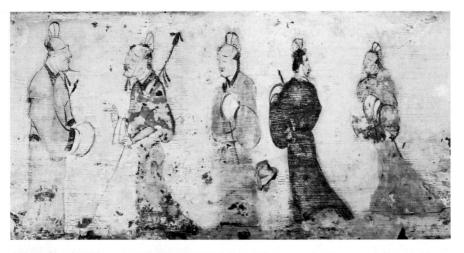

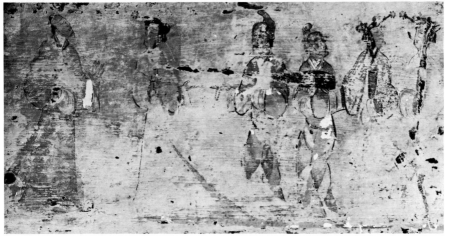

themes from the lives of virtuous empresses. The Empress Chiang, consort of a prince in the ninth century B.C., took off her jewels and asked to enter the jail for court ladies as a protest against the dissipations of her lord – a sacrifice which quickly brought him to his senses. On the Boston tile the noble lady appears to have just handed her necklace to the servile jailer. There is a poem of A.D. 232 which describes a painting of the same theme on the palace walls of a ruler of Wei.[12] This early work well illustrates some of the basic characteristics of the Chinese painter's genius – a selection of meaningful forms and suppression of what is irrelevant, a lucid and well-developed visual memory, and a perfectly fluid technique.

Decorated lacquer wares from the Han Dynasty have been recovered in quantity from Korean tombs, where they were buried with Chinese residents of a colony centred about the ancient city of Lo-lang, near modern Pyong-yang. Many of these bowls, cups, cosmetic boxes, and such utensils, bear long inscriptions stating that the lacquer ware was made far off in Szechwan province, western China, and also giving the year of manufacture. The dates range from 85 B.C. to A.D. 71. In recent years exactly similar lacquer wares were found at Yang-kao Hsien in northern Shansi province. In these beautifully made objects we are confronted with an ancient, traditional craft that made articles of high quality for daily use and not substitution utensils for the tomb. The brushwork and drawing show far greater skill than any other painted representations surviving from the Han period. The celebrated 'painted basket' found at Lo-lang in the tomb of a minor official is the best example of figure painting [42, 43]. The lid and framework of the sides are decorated with ninety-four figures illustrating the classic Han repertory of paragons of filial piety, ancient worthies, famous and infamous rulers, many characteristically identified by their names written beside them.

As in the Boston tiles, there is a strong impression of communion between the figures – their gestures are lively and natural; their poses, and even the folds of the garments, demonstrate a close observation of reality. Old and young are cleverly differentiated, as in the contrast between the youthful Shan Ta-chia [42, extreme right] and the old Po I [43, extreme left]. The positions vary between profile, three-quarters, full face, and profile from the rear. Although the figures are posed on a base-line, they are not silhouetted against a flat surface. Living-space is defined by the turn of a figure into three-quarters view, by the screen on a diagonal [42], and by the looped curtain above the heads that suggests a stage. The occasional use of pattern in the robes, the spacing against the dark ground, and the lightly sketched space fillers, like the hanging cords, create a handsome design.

The 'painted basket' is a work of the first, or at the latest the very early second, century. Probably the figures are formulas evolved by the craftsmen of the Szechwan imperial workshops, possibly based on paintings by a skilled artist. But somewhere in the process there has been close observation of men and a genius for converting life's energy into terms of brushwork. Chinese figure-painting in the first two centuries of the Christian era had become an art of great capabilities.

Other lacquered articles of the first century A.D., painted in a more purely decorative way, illustrate another facet of Han genius. On the side of a box from Yang-kao Hsien, Shansi [44, 45], tigers and peacocks inhabit a world of swirling and dissolving forms where volatile hills seem to burst into flame. A tiger climbs a hill to peer down at another that looks back from behind a knoll and two birds at either side are seeking one another. This art of interrelated rhythms and swift, light movement is in the direct tradition of the Late Chou inlaid bronzes and painted lacquers, but has broken the final

42 and 43. Painted lacquer basket (details),
from Lo–Lang, Korea.
Han Dynasty, first to early second century A.D.
Seoul, National Museum

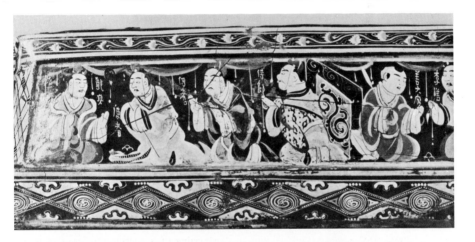

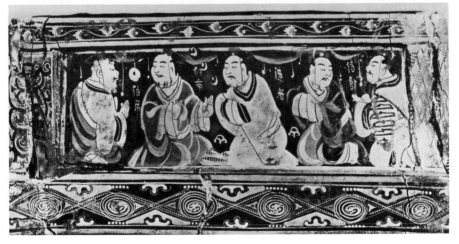

bond of geometric restriction which still lingers here in the abstract borders. It inaugurated a style of rushing, violent movement that pictured gods and beasts and clouds impelled through space by an irresistible force – a style without parallel that attains a comparable glory in the sixth-century Buddhist caves of Tun-huang and the painted tombs of Korea.

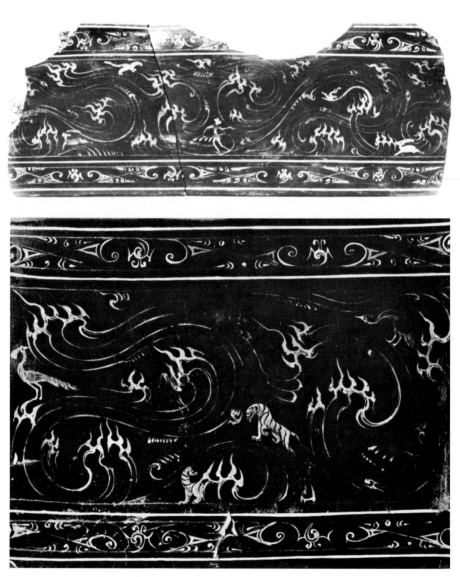

44 and 45. Decorated lacquer box (fragmentary), from Yang-kao Hsien, Shansi. Han Dynasty, first century A.D.

FUNERARY STONES AND TILES

For more complete compositions and a far wider range of subjects, we must turn to the engraved stone slabs that formed the walls of offering chambers erected in front of the tombs, subterranean burial chambers of stone decorated by engraving or low relief carving, and tiles of dense pottery carrying designs made by stamps, or dies, pressed into the moist clay before the tiles were fired. Frequently oblong, hollow tiles, averaging some twenty-four inches by forty-seven inches to eleven inches by thirty-eight inches, formed the walls, partitions, and doors of low-ceilinged underground tombs; while smaller, similarly decorated solid tiles, occasionally square, or in the form of bricks, were let into the walls. The offering chambers were simple structures erected before the tombs of minor provincial officials, shrines which by the engravings on the durable material of stone preserve echoes of the great fresco cycles that must have decorated the more important sacrificial halls and temples constructed in perishable materials.

Two oblong vertical tiles that formed the door of a tomb at Nan-kuan, Cheng-chou, Honan Province, carry pressed designs of buildings, horsemen, seated figures, walls, trees, and birds all arranged in compositions calculated to create a convincing effect of recession in depth and action within a well defined spatial environment. This is accomplished by such means as a zigzag road, walls at an angle, and devices such as a horse half-concealed as it issues from a gate. Dr A. Bulling with good reason dates these tiles to about the middle of the first century B.C. and rightly points out that since the tiles accomplished so much in definition of space by no other means than the clumsy,

static technique of a set number of dies pressed in moist clay, there must be a far more sophisticated painting tradition behind them.[1]

Although the Han stone reliefs from offering chambers are frequently described as sculpture, very few have any plastic quality, and even those rendered in low relief with slightly rounded contours and strong inner marking are essentially pictorial. The stone slabs which formed the walls of these small shrines were decorated on the interior side with a wide range of techniques. On the smooth surface of the prepared stone, the design might be executed in line-engraving alone; the background might be cut away to a slight depth, leaving the figures in flat relief; the background might be striated to create a stronger contrast; the figures might be cut in intaglio with slightly bevelled edges against a plain ground or on a striated ground; and again the background might be cut away to the depth of about half an inch with the contours of the figures slightly rounded.

The earliest of these shrines that can be assigned a date with any certainty is that of a Han general, Chu Wei, whose offering shrine was made in about 50 A.D., near present Chin-hsiang, Shantung province. It is generally agreed, as George Rowley first pointed out, that these stones have been clumsily re-cut at a later date. Enough of the delicately incised original design remains, however, to show a unified composition of a feast, conceived in spatial depth with large figures frequently overlapping and in groups that either follow the strong diagonals of the tables backed by screens, or alternatively are disposed about the room in such a manner that they accentuate the sense of space.[2]

The only offering shrine that stands today in its original form is that at Hsiao-t'ang Shan, also in Shantung province. It is some fourteen feet long, seven feet deep, and six and a half feet high, and is composed of eight stones. The interior is covered with designs executed in intaglio with slightly bevelled edges. The technique is suggestive of the lapidary and the similarity of some of the figures to small jade carvings is so close that it is tempting to believe that the traditional techniques of the jade carvers were called into service in some cases, much as the hand of the ivory carvers may be detected in certain early Buddhist sculpture of India. The shrine is earlier than the A.D. 129 date cut by a visitor, but how much earlier it is impossible to say. The manner in which the same figures are frequently repeated, the general lack of composition and other features suggest an early date. In contrast, some of the more im-

portant chariots are shown in adequate three-quarters perspective, with the far wheel in advance of the near, much as in the paintings of the Liao-yang tomb, while in one scene a small pavilion or gate is placed at a strong diagonal which certainly shows an interest in space.[3]

The relief of illustration 46 is not from Hsiao-t'ang Shan but is one of two isolated stones in the same technique and a very similar style. In the lower register men with hounds, nets, and perhaps falcons, are hunting rabbits and deer; above, warriors in armour are presenting two disarmed captives to a dignitary; and in the top register are two foot soldiers in armour and two mounted companions similarly dressed, their horses at a flying gallop, pursuing two men without armour, one of whom has just been struck with a dagger-axe. The silhouettes are reduced to a minimum with very few inner

46. Funerary stone, style of Hsiao-t'ang Shan (rubbing), from Chi-nan, Shantung. Later Han Dynasty, A.D. 25-221

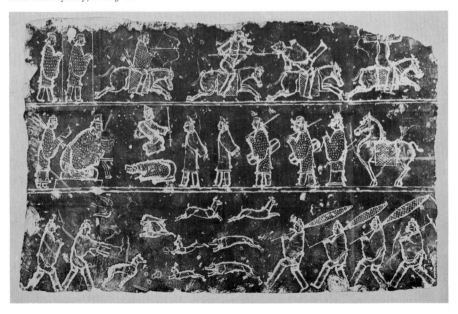

markings, and, although the drawing is stiff, there is considerable animation.

Another group of stones are strongly cut in low relief and are from Liang-ch'êng Shan, also in Shantung. They may be grouped with a slab in the von der Heydt Collection dated in accordance with A.D. 114, another isolated slab in China dated in accordance with A.D. 127, and a third slab now in the Metropolitan Museum. Still another series, in a rather advanced style, possibly of the second to early third century, and the same technical method as the Wu Family stones, was found in the neighbourhood of Hsiao-t'ang Shan. Six are now in the Tōkyō University Museum.[4]

By far the best known Han funerary stones are those from the site of the Wu Family tombs near Chia-hsiang in Shantung. Wilma Fairbank has been able to offer a most convincing arrangement of the slabs into three complete offering

design than is the case with the great majority of Han sepulchral stones. The result is an excellent, ordered decoration. The style is distinctive and may almost be said to represent a school. The figures are round and full, the extraordinarily stout horses are poised elegantly on thin forelegs, prance with great nobility of spirit, or rush at a flying gallop with apparent ease. The trees, birds, fish, and even the clouds enjoy the same ample, rounded forms.

Considerable skill is shown in the way the space is filled and shapes fit or complement one another in the true spirit of *horror vacui*, as for example the birds, fish, and contestants in boats beneath the bridge [47]. It is primarily an art of silhouette with figures, horsemen, and chariots strung along a base-line or scattered over the field, distant figures shown suspended above the nearer ones and on the same scale. Buildings are shown in elevation with the walls

47. Battle on a bridge (rubbing),
from Wu Liang Tz'u, Shantung.
A.D. 147–68

shrines and the remnants of a fourth.[5] They range in date from A.D. 147 to A.D. 168.[6] The designs are engraved and the background textured with vertical striations.

The artist of the Wu Family shrines exercised more care in the compositions and overall

removed so that the action within can be seen [e.g., 48, lower right corner]. There are very few elements introduced to suggest a setting – buildings, the bridge, trees, and hillocks occur only where necessary for the meaning of the illustration. There are some elements, however,

48. Funerary stone (rubbing),
from Wu Liang Tz'u, Shantung, A.D. 147–68

which should warn us against crediting the artists of the Wu Family shrines with too great a simplicity. There is some successful overlapping of figures, for example horses in echelon. Soper has pointed out instances on the Wu slabs of figures shown in three-quarters rear views, the superimposing of one figure over another, and other examples illustrating that somewhere in the traditions behind these designs there were artists alive to the problem of spatial logic.[7]

The heterodox character of Han thought could not be better illustrated than by the subject matter of the Wu Family reliefs. History and legend, folklore and mythology, the hunt and the feast, all are mingled in an exuberant outburst of fecund imagination. We see Confucius meeting Lao-tzu, the Confucian disciples, just rulers, and loyal subjects as objects of emulation, tyrants as objects of abhorrence. There are filial sons and heroic women depicted to point a Confucian moral. Mingled with these are the mythological personages and subjects of pure folklore which the Taoists had appropriated to themselves from tradition or created for their expanding pantheon. Gnomes, spirits, and celestial beings fill the cloud-strewn sky [48] – all are winged, even the horses, and many of the cloud-spirals end in bird-heads (messengers of the gods?). On the ground below a great dignitary has descended from his car and, with his attendants, stands in wonder before a three-peaked sacred mound where winged spirits and clouds have descended, joining Heaven and Earth. The exact meaning is uncertain, but there can be no doubt that some communion between men and gods is represented.[8]

Some idea of the kind of actual painting from which the Wu Family engravings were derived may be suggested by the style of the painted pottery tray in the Nelson Gallery at Kansas City [49]. This is a characteristic burial piece in soft pottery made as a substitute for a tray in more

49. Tray, painted pottery.
Han Dynasty, 206 B.C.–A.D. 221.
Kansas City, Nelson Gallery of Art and Atkins Museum

valuable materials, possibly lacquered wood. The painting is in vermilion and black on a white ground. As in so many of the engraved or sculptured Han stones, the human figures are in profile silhouette. The firm bounding outlines and inner markings, especially some cross-hatchings, are very like the Wu Family designs. It is notable that the birds and animals – a duck, a ram, a cock, and a pig – are less static and more freely drawn than are the human figures.

A great poet of the second century A.D. wrote a description of the wonderful frescoes he had seen on the walls of an old palace in Shantung. This palace, built in the second century B.C., by a brother of the Emperor Wu, with its painted beams and pillars, its carved brackets and supports, must have rivalled the princely and sumptuous structures of the distant capital. The poem shows the traditional character of the subjects of the Wu Family shrines and kindred Han reliefs:

And here all Heaven and Earth is painted, all
 living things
After their tribes, and all wild marryings
Of sort with sort; strange spirits of the Seas,
Gods of the Hills. To all their thousand guises
Had the painter formed
His reds and blues, and all the wonders of life
Had he shaped truthfully and coloured after their
 kinds.
First showed he the openings of Chaos and the
 beginnings of the Ancient World;
The five dragons with joined wings;
Nine-neck, the Lord of Men;
Fu Hsi with his scaly body,
Nu Wo serpent-limbed.
Vast, formless presences,
At first unmarked but to the steady gazer's eye
Rising in luminous bulk;
Huang Ti, T'ang and Yu,
Each crowned as he was crowned and robed as he
 was clad.
The Three Kings were there, many riotous
 damsels and turbulent lords,
Loyal knights, dutiful sons,
Mighty scholars, faithful wives,
Victors and vanquished, wise men and fools,
None was missing from his place.[9]

In his characterization of the Wu Family
shrines, F. S. Drake's remarks are valid for all
this Han funerary art: 'Religious art in the
narrow sense it is not; there is no special cult or
worship; nor is there anything particularly
appropriate to the tomb – no journey of the
dead, no weighing of good and evil in the
balance, no victory over the grave, nor mourning
for friends. Indeed these subjects might have
been sculptured on a palace wall as well as on a
tomb. But in a broad sense a religious spirit
runs through it, for it represents a continuity
between the spirit world and the world of
sense; the human life it pictures is surrounded
with spirit-forces, and one passes easily from
one to the other.'[10]
In spite of the animation and excellent design
of such funerary stones as those of the Wu
Family shrines, it is reasonable to suppose that

the wall paintings in important metropolitan
centres had attained to higher levels of sophisti-
cation by the second century A.D. The most re-
vealing indications of what a court art could
have been are the tiles with pressed designs that
have been found in quantities in Szechwan.
This province was, as we have seen, an im-
portant centre for the manufacture of decorated
lacquer, and it is probably significant of the
high state of the painter's art in Szechwan that
the most accomplished designs on tile ap-
parently also originated there.[11]
The most surprising and revealing of the
Szechwan tiles are those showing figures in
landscape or architectural settings. There are
scenes of men working the salt mines in a hilly
landscape where others hunt, another of people
busying themselves in the market-place, and
such wonderfully natural scenes as the reapers
and hunters reproduced in illustration 50. The
upper register in which two men, squatting on
an undulating shore, shoot at wild ducks is the
direct descendant of certain hunting scenes on
bronze vessels of the Period of the Warring
States or Former Han, say the fifth to the third
century B.C., but it has come a very long way.[12]
The landscape elements, such as the irregular
lake shore, the trees, the lotus leaves that are
elongated ovals, and the irregular placing of the
lotus buds and pods are all treated in a re-
markably easy and natural manner. The harvest
scene in the lower register could not be more
vividly portrayed with such an economy of
means. The gestures of the reapers with their
scythes, the bend of the harvesters, and the man
on the left bringing the meal are all drawn with
knowledge of stance and movement. The old
base-line of the Han tomb reliefs or the random
scattering of elements over the field have
disappeared and the figures as well as the grain
field recede in depth.
The date of these tiles is uncertain, but they
may represent an art current, in Szechwan at
least, as early as the first half of the second

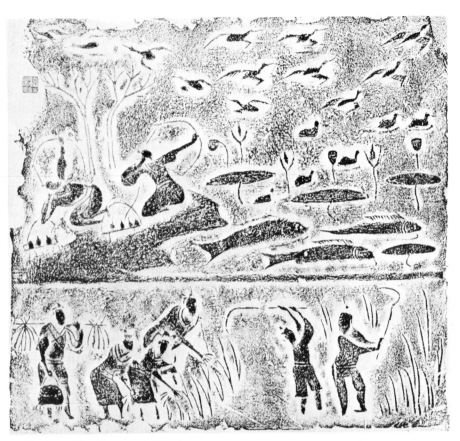

50. Hunting and threshing scene (rubbing)
on a tomb tile from Ch'êng-tu, Szechwan.
Later Han Dynasty, A.D. 25–221.
Ch'êng-tu, private collection

century, or slightly earlier than the Wu Family reliefs.[13] They represent a style which is quite distinct from that of the well-known stone reliefs of Shantung and serve to demonstrate the heterogeneous character of painting in Han times.

Yet another style and notable advances in pictorial representation are found in a highly important stone constructed tomb at I-nan in southern Shantung (cf. p. 386), datable to the end of the third or the early fourth century A.D., and hence some one hundred to one hundred and fifty years after the latest of the Wu Family shrines, which is decorated in the more fluid and manageable technique of engraved lines and low relief. Here are present a well developed bird's-eye point of view, of a kind retained throughout Chinese painting, parallel perspective, overlapping figures, and a remarkably animated narrative style throughout.

Interest in a three-dimensional setting and the actual world of human actions is emphasized by a wealth of such genre paraphernalia as furniture, varied utensils, musical instruments, and weapons as well as explicit details of costume. From the I-nan engravings it is possible to envisage a well advanced school of illustrative painting more vividly than from any other early stone tomb.[14]

*

These scattered slabs of stone and tiles of pressed clay, many disfigured and blurred by time, form the main body of concrete material on which to found our knowledge of Chinese painting in the early centuries of the Christian era. Although the datable monuments cover a period of roughly one hundred and fifty years, from A.D. 50 to about A.D. 200, they are not of a nature that permits conclusions about either the exact nature or the quality of painting during those decades. The offering chambers were the work of stone-cutters who drew upon a collection of designs derived from a variety of sources, much as modern Chinese decorators supply themselves with copy-books containing their stock of designs. That certain compositions were current among different craftsmen is shown by the re-occurrence, in different techniques and at different sites, of the same designs – the grouping of an orchestra or an especially bold concept of a four-horse chariot seen face on. It seems probable that travelling journeymen, say from the capital, might bring sketches of frescoes seen in important buildings, where they had been executed by the leading artists of the metropolis, and these would be added to the stock of old-fashioned patterns. What remains today is the survival of a funerary

art both conservative and provincial. Soper is quite right when he points out that the state of Han painting must be judged not from the funerary slabs as a whole but from the single and often isolated details that demonstrate the most advanced observation and willingness to tackle a difficult problem in representation of space, movement, and form.[15]

The political, social, scientific, and scholarly attainments, born of Chinese vitality and curiosity during the Han Dynasty, are paralleled in the arts by the development in representation. Sprung from the rich soil of Late Chou art, in which the animals and images of the fantasy had already begun to move – as in the Ch'ang-sha lacquers and the jade carvings of the Warring States – the art of Han accelerated the movement into a headlong rush charged with energy. An interest in man and his achievements centred the artist's attention on the human figure at rest, in violent action, or about his daily occupations. By observing his fellow-creatures and the animal world, the artist not only noted the turn of a head, the prance of a horse or the spring of a rabbit, but he also began to notice the space in which these living creatures moved. That there were innovators and men who followed them cannot be denied, but it is a grave question whether one can, or should, attempt to trace anything like an orderly progress or systematic evolution of style towards a fixed goal. In China no style is ever abandoned or superseded completely. New kinds of representation are evolved and take their place, most often in the main stream, but they co-exist with older, more traditional manners. So very little has survived, that to select only what seems to illustrate an imposed logical evolution would be misleading.

BEGINNING OF BUDDHIST SCULPTURE: YÜN-KANG

Unified imperial rule and central authority disappeared from the Chinese scene with the collapse of the Han Dynasty, long undermined by palace intrigues, eunuch rule, economic confusion, and the general debility of the ruling house. For the next four hundred years segments of the vast Han empire were governed by a series of dynasties, some Chinese, some barbarian, that followed one another in a bewildering succession or carved out large states and managed to survive for several centuries. The very names history has allotted to the geographical and chronological divisions evoke a melancholy picture of strife and insecurity.[1]

The political complexity is conveniently simplified by calling this the period of the 'Northern and Southern Dynasties'. The almost constant warfare, the destruction of property, the economic distress, the innumerable claims of strong men and adventurers to rule by the Mandate of Heaven caused immense suffering among the masses, and bred deep cynicism in many a scholarly mind concerning the Confucian values of social order and individual moral worth. On the credit side, the flight of so many noble families and intellectuals from the troubled north to the somewhat more stable south brought to that region the ancient culture of the Yellow River valley. It is from these early centuries of the Christian era that the lower Yangtze valley begins to gain immeasurably as a focal point of intellectual and artistic activity.

These were wintry years for the orthodox Confucian scholar. The strong central government of Han had drawn upon this class to fill the ranks of the bureaucracy, but the conditions of anarchy and opportunism following the fall of the dynasty offered little scope for officials trained in the classic tradition. The racial vitality that has maintained China among the great nations of the world could not long suffer a vacuum such as existed in the third century A.D. There was ready at hand an entirely new system of intellectual and spiritual values, the Buddhist church. It is certain that the conditions of insecurity and loss of faith in the ways of the ancients were potent factors in the spread of Buddhism.

The Buddhist doctrine from India was the first foreign system to become an integral part of Chinese culture. Other powerful influences there had undoubtedly been, but by comparison with this great religion they appear peripheral. During the first centuries after the fall of Han, Buddhism became firmly implanted on Chinese soil. For half a millennium it flourished with the same deep fervour and passionate zeal that have in certain centuries illuminated Christendom or followed the conquering armies of Islam. Its teachings and the Chinese schools that grew up about the Buddhist church have influenced Chinese thought into modern times. An inspired religion, demanding faith from its followers and offering the reward of salvation, it profoundly affected the form and content in much of Chinese art. When Buddhist missionaries along the ancient trade routes of Central Asia brought their faith to the great cities of the Yellow River valley, or came by sea to Canton and the southern court of Nanking, or penetrated the Burma jungle into Yunnan and Szechwan, they brought with them a church already some four centuries old – a complete religious system with holy scriptures, priests, monks, icons, and ritual observances.[2]

The desert road that linked China with the West has already been mentioned in connexion with the expansion of the Han empire. It now played a role of ever increasing importance as a high road for ideas and art forms that poured into China. The two main routes both started from Tun-huang in western Kansu as the gateway to the desert.

Chinese literature abounds with accounts that testify to the making of images in the fourth and fifth centuries, as well as the importation of Buddhist icons which, because they came from India or countries near to the holy land of Buddhism, were thought to be of special merit.[3] We cannot consider here the prototypes of this early Chinese Buddhist sculpture; it must suffice to say that the styles followed in the fourth and fifth centuries were ultimately derived from Indian and Gandhāran models which had been much modified in the stations on the way, thriving centres of Buddhism, through which they passed in the long journey across Central Asia.[4]

Just as the long Silk Road followed two routes, one leading north of the Taklamakan Desert and one south, so there appear to have been a southern source of influence from the Khotan area and a northern source centred about the general region of Kucha. Other influences undoubtedly did reach south and central China by way of the sea and overland from India and from the ancient kingdom of Funan. So very little of early Chinese Buddhist art from the south and the Yangtze River valley has survived, however, that it is not possible at present, from a few isolated bronzes, small in scale, to form any judgement about its character. The dominant influence in the great Buddhist centres of north China appears to have been the city-states of the oases on the northern trade road.[5]

A gilt-bronze image of the Buddha in *dhyani mudrā* [51], dated in accordance with A.D. 437, may serve to illustrate a small group of such figures that have survived from the first half of

51. Buddha, gilt-bronze. A.D. 437. *Ishikawa, Japan, Saburo Toma*

the fifth century.[6] The most notable feature of this image is the manner in which the drapery folds have been adapted to a Chinese sense of style. A Central Asian prototype can be found in the stucco Buddha images of Khotan,[7] in which the folds of the monastic robe are arranged in a close series of concentric, rounded ridges, in arcs ever widening from the neck line toward the waist – like ripples in a pool. The apex of this scheme, however, is slightly off centre in the Central Asian figure, and another naturalistic feature is the slight modelling of the chest, so that the material seems to adhere closely to the body. All this is changed in the Chinese version. The folds are frozen into a series of overlapping, scale-like pleats. The U-shaped pattern over the torso is simplified and, like the whole figure, with the exception of the fold of the robe about the neck, is rigidly symmetrical. Any lingering trace of anatomy has been suppressed so that the crossed legs have become little more than a broadened base from which a kind of abstract structure rises in a second stage, represented by the arms and torso, to support the egg-shaped head, capped, like a stupa, by the *uṣṇīṣa*. The slightly sloping eyes are mere slits as though the skin of the face were drawn so taut that the smooth eyelids revealed the pupils as elongated elliptical wedges. The mandorla of upward-swirling flame is vibrant in contrast with the static immobility of the Buddha. It has often been said that this kind of image, from the first half of the fifth century, illustrates the Chinese misunderstanding of their Central Asian models, that the schematic drapery folds are but a clumsy attempt to reproduce the mechanical, uninspired formula of an already provincial art. Admittedly, there are some Chinese examples inferior in concept and execution to the one here illustrated, but it would be rash to affirm that Chinese Buddhist art had not already before A.D. 450 evolved a style able to express deep religious conviction and worthy in its own right.[8]

A violent persecution of Buddhist institutions occurred in A.D. 444, during which much of the early ecclesiastical art perished. Succeeding emperors of the T'o-pa dynasty of Wei, beginning with Wên Ch'êng-ti in A.D. 452, must have been not only ardent Buddhists but zealots in their desire to obliterate the memory of their predecessor's iconoclasm. For almost thirty-five years, thousands of sculptors and stone-masons laboured to hollow out the living rock and profusely to adorn with sculpture a series of some twenty enormous, and numerous lesser, cave-temples in the sandstone cliffs at Yün-kang, near Ta-t'ung in north Shansi. They remain today one of the Wonders of the Eastern World. The concept of a cave-temple cut into the face of a cliff was of Indian origin and from there spread to Afghanistan, Central Asia, and China.[9]

The work at Yün-kang[10] was begun at the instigation of a monk named T'an-yao in A.D. 460 and continued until A.D. 494, when the capital was moved south to Lo-yang in Honan. A number of lesser caves and some niches that are important for their perfect expression of the mature Wei style were executed in the years between A.D. 500 and 535, after the removal of the capital. The earliest caves are the five excavated in memory of the ruling monarch and his four predecessors. The images are of colossal size, that in cave XIX being twenty-six feet high, in cave XVIII forty-five feet high, and the great seated Buddha of cave XX, also some forty-five feet from the base to the top. These five early caves are not conceived as temples or chapels in the architectural sense. They are merely hollowed out with sufficient room for the enormous images which they scarcely seem to contain. There is good reason to believe that these caves were inspired by the colossal Buddha images at Bāmiyān, famous throughout the Buddhist world.[11]

The best known of the five early caves begun in 460 is cave XX. Here the roof and front of the

52. Yün-kang, Shansi, cave XX, colossal Buddha.
Second half of the fifth century

cliff have fallen away. The central image and the remaining attendant on the right are exposed to the day. This giant Buddha, remarkable no less for style than for size, can well serve as a comprehensive example of the early Yün-kang style [52]. The Buddha is seated cross-legged, his hands resting in his lap, the pose indicative of meditation. The body is well proportioned, especially for a colossus, the full chest and broad shoulders giving it a quality of inner power. The wedge-shaped nose, arching brow, and faintly smiling mouth are sharp-cut with a decisiveness that allows of no softened outline.[12] The monastic robe is pulled fully over the left shoulder and only partially over the right, and in the mantle folds we meet a most curious manner of representation. They are not the string-like ridges of the Indian Gupta style or of late Gandhāran statues, but raised, flat bands with deep medial grooves. The closest parallel is to be found in some of the clay statues recovered by von Le Coq, from Kizil, in the region of Kucha.[13] Where the robe passes over the shoulder, the folds end in a series of flame-like points. The same curious style obtains in the treatment of the standing Buddha on the right. It is difficult to believe that this unusual manner results from any misunderstanding of a foreign model. It might be suggested that such flat and essentially linear treatment could be due to the sculptor following a drawing in which, moreover, the folds faded off into points as they passed over and behind the shoulder into shadow. A series of bronze Buddha images, both seated and standing, some dated in the last quarter of the fifth century, testify that this became a well-established iconographic type.[14]

The style finds its most successful expression in a far more finished and elegant figure, the great gilt-bronze Maitreya, the Buddha of the Future, in the Metropolitan Museum, dated in accordance with A.D. 477 [53]. This figure is close to Central Asian types, especially in the way the robe clings to the body. The folds are reduced in size and descend from the neck-line to the bottom of the robe in a rhythmic cascade, sinking between the strongly modelled thighs. Rowland describes the image well, '. . . still a very noble figure characterized by the same rising grandeur – a feeling of tremendous exaltation communicated, perhaps most of all, by the great spread and sweep of the outflung robe, like wings unfurled'.[15]

53. Maitreya, gilt-bronze. A.D. 477.
New York, Metropolitan Museum of Art

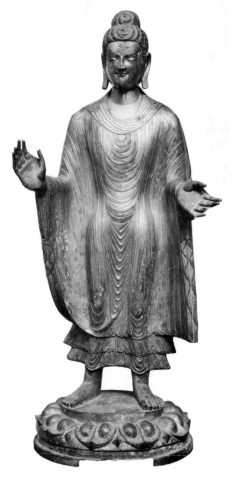

From the rather ponderous, full-bodied and round-faced images of the early T'an-yao caves, so clearly based on imported models, a more truly Chinese style rapidly evolved, or, indeed, may well have co-existed with the earlier work. In A.D. 439 the T'o-pa armies of Northern Wei had conquered the state of Northern Liang, centred in Kansu. The victors removed some 30,000 families from the region of Tun-huang, a trade centre in western Kansu and the Chinese terminus of the caravan route to the West. These families were settled at the Wei capital of P'ing-ch'êng, near modern Ta-t'ung. Tun-huang was at that time already a centre of Buddhism, and it is recorded that with the shifting of the families 'Buddhists and Buddhism had moved completely to the east'. Among these peoples from Kansu there were probably craftsmen who brought to the work at Yün-kang traditional styles of Central Asian Buddhist art. But the Northern Wei rulers rapidly succumbed to Chinese traditional culture.

The linear, geometric style, inherent in Han art, soon began to modify the forms, reducing still more any naturalism that Central Asia had retained from the modified Hellenism of Gandhāra and the sensuousness of Indian sculpture. As Codrington has remarked, a new tradition seems to be engendered 'when a provincial art extends sufficiently far afield to find a new environment and new opportunities'. Specifically the Chinese modified the forms away from any lingering naturalism and towards a formal stylization, forced the fluttering scarves and ribbons into sweeping curves of controlled tension, reduced the rounded drapery forms to flat planes interrelated in patterns of linear rhythms which successfully concealed any indications of the body underneath. By the end of the fifth century, in the best caves of Yün-kang, all the polyglot languages of Buddhism as it reached China – Hellenistic, Gandhāran, Indian, Iranian, and Central Asian – were beginning to be fused into a consistent Chinese declaration of faith and zeal.

Cave VI is the most sumptuous and logically organized of the Yün-kang group. It is also one of the latest caves made under imperial patronage before the removal of the capital to Loyang in A.D. 494. A large, square, central core-pillar is sculptured in the form of a wooden pagoda [54]. The side walls are arranged in a series of horizontal registers one above the other, most elaborately sculptured in niches containing standing or seated Buddha images surrounded by Bodhisattvas, adoring heavenly beings, musicians, and flying apsaras. The lowest register carries a series of oblong pictorial reliefs illustrating episodes from the life of Śākyamuni Buddha. These reliefs in their straightforward narrative, the vigour and simplicity of their style are among the best examples of early

54. Yün-kang, Shansi, cave VI.
Second half of the fifth century. Interior

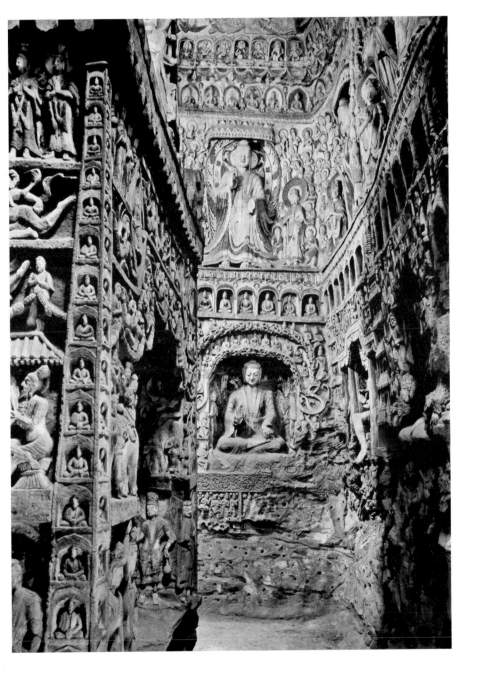

55. Yün-kang, Shansi, cave VI.
Second half of the fifth century. Relief

Chinese Buddhist sculpture that have sur-
vived.[16] In illustration 55 the young Prince
Siddhartha is shown going out on horseback
from his palace; his servant Chandaka carries
the royal parasol and Śuddhāvāsadeva, the
future Buddha's guardian spirit, flies before.
Of the three evils of life – old age, sickness, and
death – this second encounter with an ailing
man, who is seated and supported by two sticks,
shows the young prince that illness may come
to all. The flying scarves of the prince and the
spirit that hovers before him make a related
pattern on the background; the geometric
masses of the diminutive palace and the rect-
angular parasol balance and contrast with the
figures and action on the right. As in all the best
of Northern Wei religious art, there is a youth-
ful gentleness that is poignant and expressive of
simple faith.

The standing Buddhas of cave VI are still
relatively squat and broad. The figures are
almost smothered under the vast garment
arranged in a series of flat, pleat-like folds that
end at the bottom of the robe in elongated S-like
scallops. The mass of drapery at the sides of the
figure is drawn out into a series of arbitrary
sharp points. The arrangement is essentially
linear, and it takes no great stretch of the imagi-
nation to picture the sculptor working back into
the stone from a preliminary drawing executed
on the flat, prepared wall. This is the fully
developed Yün-kang style.

A series of lesser caves and isolated niches at
Yün-kang were executed after the turn of the
century, that is, following the move of the
Northern Wei capital to the south. The sculp-
ture here is done in a more advanced style and
is therefore most purely Chinese. It is represent-

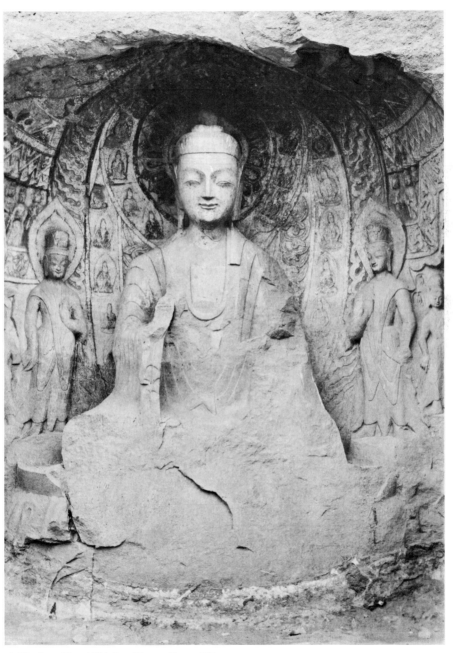

56. Yün-kang, Shansi, Trinity, niche outside cave XI.
Early sixth century

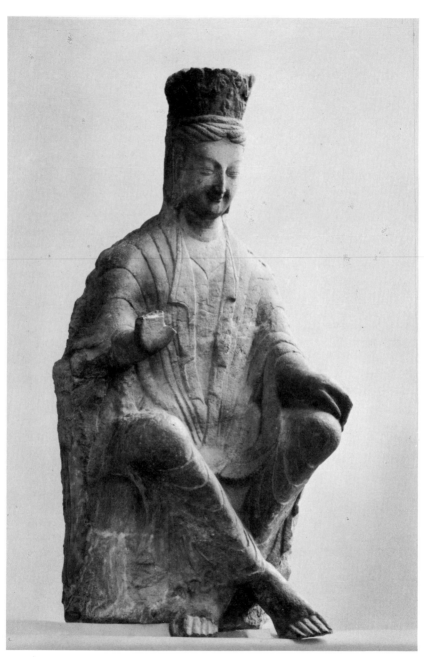

57. Bodhisattva, from Yün-kang. Early sixth century.
New York, Metropolitan Museum of Art

ative of the sixth-century style prevalent at the cave temples of Lung-mên in Honan, but some of the figures are larger in scale than comparable examples at Lung-mên and are in better condition. A few of these later Yün-kang images can well be taken as embodying the culmination of Chinese Buddhist sculpture in the first quarter of the sixth century. We reproduce [56] a detail from the niche outside cave XI. It is a trinity with the Buddha seated, his right hand in the *abhaya* (protection) mudrā, his left hand in the *varada* (charity) mudrā. The bulky mass of the earlier figures has given way to a slim form with sloping shoulders; the face too is slim, the forehead flat and squared-off at the transition from the front to the side plane, the chin is pointed with a marked medial groove, the mouth holds a lingering archaic half-smile. The eyebrows have become strongly arched and they have the tension of a steel spring. The robe is a beautifully calculated pattern of flat, slightly overlapping folds that sweep out in cascades of pleats at the wrist openings. The elongation is even more marked in the attendant Bodhisattvas with their high, ornate crowns, their crossed scarves and skirts drawn out sharply at the sides and ending in points. There is a languorous ease in their pose, as they stand with the centre of the body thrust slightly out, the chest flat, and the head bent gently forward – a pose that is reminiscent of late Gothic mannerism.

The celebrated figures seated with crossed ankles reflect Iranian influence of Sasanian times in their pose, but at Yün-kang are completely assimilated within the Chinese style. The best of these are to be found, however, in the later caves, such as caves V and VI, and in some of the niches from the early sixth century. A superb example in the Metropolitan Museum shows the long, squared face, almond eyes, pointed chin, archaic smile, and high crown of the developed manner [57]. The body forms a great diamond shape, the four points being the head, the extended knees, and the crossed ankles

– the geometry of the pattern is emphasized by the crossing scarves and the sharp V-shaped folds overlapping the long legs. There is no chance to mistake divinity for natural flesh and blood. It is not the purpose of these statues to 'function biologically', but to function as symbols for the devotion of the worshipper, symbols of beings high above the desires, the ambitions, and 'dust of the world'.

SCULPTURE DURING THE WEI DYNASTY

After the establishment of the capital at Lo-yang in A.D. 495, the style of Buddhist sculpture becomes thoroughly consistent and Chinese in character. At Lung-mên, some ten miles south of the capital, the sculptors found cliffs of dense grey limestone more suited to niceties of detail in carving than the coarse sandstone of Yün-kang. Although the walls of the Ku-yang cave, the oldest at Lung-mên, are crowded with niches in a rather haphazard way, as though each donor appropriated what space he could without a master-plan, nevertheless each unit is more logically organized than any but the latest cave, cave VI, at Yün-kang.

Much of the tradition of Han Dynasty drawing with its vital, linear rhythms and sense of rushing movement must still have been alive in the region of the old capital; for we see it animating the forms that were often heavy or unassimilated in the fifth-century caves at Yün-kang. The scarves and garments of the flying apsaras, the scudding clouds and lithe plant forms are swept into patterns of strong internal tensions [58]. Spiritual content deepens and becomes more compelling through a greater attenuation of the figures of Buddhas and Bodhisattvas. Some of the individual figures are, in their ordered geometry, the style of their symmetrical schematic drapery – especially as it cascades over the dais – and in the masterful carving of the stone, among the best expressions of the Buddhist ideal of renunciation and spiritual attainment that have been preserved in all Asia.[1]

The plan of the Pin-yang cave, probably completed in 523, is lucid and coherent. The chapel is some twenty-five feet wide and twenty feet deep. Against the back wall, directly opposite the spacious doorway, over twelve feet across, the main image and its attendants are carved in the living rock [59]. The Buddha is seated cross-legged on a dais almost nineteen

58. Rubbing from Ku-yang cave, Lung-mên.
Northern Wei Dynasty

that occurs but rarely in religious art, like the Pantocrator of Monreale or that of Moissac. Soaring flames edge the great mandorla that extends far up and flattens against the ceiling; and these flames, after a border of adoring, heavenly beings, reappear in small tongues of flame that issue directly from the body of the deity.[2] This image, and probably others like it in bronze, long since lost, were the prototype for the magnificent seventh-century Shaka and Yakushi in bronze that still stand on the altar of the kondō at Hōryūji.[3]

On the side walls are large trinities, the Buddha standing and accompanied by the Bodhisattvas Avalokiteśvara (Kuan-yin) and Mahāsthāmaprāpta, the usual attendants on Śākyamuni [60]. The space between the mandorlas and haloes is occupied by rank on rank of adoring figures. Above the images, and forming

a kind of dado around three sides, is a representation in stone of a tasselled baldachin, and above this, in the uppermost realm of Heaven, the flying angels surround a giant open lotus that occupies the entire centre of the ceiling. The front wall, on the right and left of the doorway, is divided into four horizontal registers of varying heights. The lowest contains a row of curious monsters that appear to be nature spirits of wind, trees, mountains, etc., possibly inspired by the Indian *Yaksha* types. Above this were almost life-sized representations of the emperor on the left and the empress on the right, each accompanied by a courtly entourage and appearing as donors of the cave-temple.[4]

Above these Imperial donors are reliefs of figures in landscape illustrating *jātaka* tales – events from the former incarnations of Śākyamuni Buddha. At the top, on either side next to

61. Empress and court, relief *(in situ)*
from Pin-yang cave, Lung-mên.
First quarter of the sixth century.
Kansas City, Nelson Gallery of Art and Atkins Museum

the ceiling, are Vimalakīrti on the right and the Bodhisattva Mañjuśrī on the left,[5] engaged in the famous discourse that forms the body of the *Vimalakīrti Nirdeśa*, a Mahāyāna Buddhist text which long enjoyed great popularity in China.[6] The panels of sculpture on these front walls mount, then, from the earth spirits at the bottom to the world of men, then to the former lives of the Buddha, and so to the topmost realm where the sacred text is promulgated just below the ceiling with its heavenly beings.

In the relief of female donors the elegant central figure wearing a lotus flower crown is probably the empress, the smaller figure to the right, similarly crowned, probably a secondary empress [61]. A successful effect of depth is obtained by placing the figures behind one another and by the informal relationship among the members of the group. The forward movement, which is stately and solemn, is momentarily arrested by the girl at the extreme left who turns back to face the procession.

Even a cursory comparison between the religious images in the Pin-yang cave and these bas-reliefs will reveal a striking difference in treatment. The Buddhas and Bodhisattvas are static and formalized, their garments fall in symmetrical, ridged pleats, there is no sense of bodies beneath, no hint of movement away from rigid verticality. On the other hand, the reliefs of the emperor and empress, and the jātaka scenes perhaps to a less extent, show a marked advance in the representation of stance and movement as well as the natural fall of drapery, and an adequate suggestion of grouping in space. An explanation of these seeming discrepancies probably lies in the conservative nature of the representation of the holy images and the importance of iconographic tradition. We have already seen that certain early Buddha types were copied because they were thought to be especially efficacious. It is most reasonable that stylistic innovations concerning the images of the high gods would be accepted slowly and with

reservation. Moreover, in the representation of the two donor bas-reliefs we are dealing with a court art that had its roots in the traditions of the Han linear style – a far different thing from the Western and Central Asian prototypes of the Buddhist deities.

We have devoted some space to the Pin-yang cave because it seems to represent in stone a close approximation to the interior of free-standing temples of the early sixth century – all of which have disappeared centuries ago. It is not difficult to imagine the great images executed in gilded bronze, while the designs of the forewall display convincing evidence, such as the division into registers, the linear manner, and the freedom and ease of the composition, that they are derived from frescoed walls.

A Bodhisattva, in the style of Lung-mên, identified as Maitreya, may be taken as a standard of the Chinese image-maker's art during the Northern Wei period [62]. It is, like all the images of that time, purely frontal. There is the slightly squared face, the almond eyes, the neck like a truncated cone, cusped necklace, pleated *dhoti* skirt, crossed scarves and cascade of flat drapery folds over the dais – the whole infused with deep serenity of spirit. An anonymous stone-carver has with some naivety and complete sincerity captured a convincing vision of the great Bodhisattva destined to be the Buddha of the future.

It is a matter of surprise that a great series of over two hundred cave temples should have been forgotten and remained unknown until 1952. At Mai-chi Shan, some twenty-eight miles south-east of T'ien-shui Hsien in the far western province of Kansu, these caves are hollowed from the granite walls of a single dome-shaped mountain five hundred feet high. The many Buddhist images are, like those at Tun-huang, modelled in clay. In addition there are a number of highly finished stone sculptures in the form of stelae. The work covers a very long period from the fifth century of the Wei

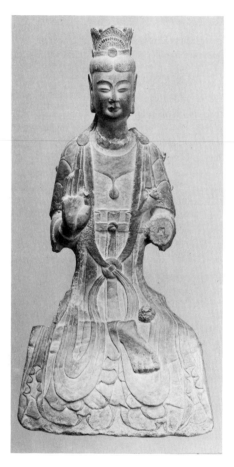

62. Maitreya Bodhisattva.
First quarter of the sixth century.
Boston, Museum of Fine Arts

Dynasty, through Northern Chou, Sui, and T'ang. Extensive restorations, with the older sculpture as a core, were carried out during the Sung, Ming, and Ch'ing dynasties, and these later modifications are themselves of considerable stylistic interest. In general the sculpture of Mai-chi Shan follows styles already known from Yün-kang, Lung-mên, and numerous Sixth Dynasty stelae. There is the important difference that the images here are modelled in clay, a technique that must have been widely employed throughout China, and so have a softer, warmer character than much of the stone-cut sculpture. Indeed in some of the lesser deities, Bodhisattvas, and adoring figures, there is a gentleness reminiscent of images of the Asuka and Nara periods in Japan. In this and other respects, especially the fragments of frescoes from the Wei and Sui Dynasties, the caves at Mai-chi Shan offer a welcome new dimension to Chinese Buddhist art.[7]

All the great temples of this period with their icons of gilt-bronze have disappeared, but some free-standing figures in stone have been preserved and, most important of all in the history of early Chinese sculpture, a gratifying number of stone steles of a kind made by subscription and donation to be set up in temples or their courtyards. Merit could be obtained by the making of a Buddha image, and such monuments erected to the greater glory of the Buddhist church were ordered by individual donors or most often, in the case of important monuments, by a large group of families, at times numbering two or three hundred individuals.

There are two basic forms of these steles. One type is a rectangular monolith set up vertically on a low base. The top is generally rounded and sculptured with two, four, or six protecting dragons, their bodies intricately intertwined. This is an old, traditional Chinese form which reached its full development at the end of the Han Dynasty, that is in the latter part of the second and the early third century. Such pre-

Buddhist monuments were set up to carry commemorative inscriptions. When adopted by the Buddhists, the inscription was greatly contracted or omitted and the surface thus left free was treated sculpturally with niches and low-relief much as the wall of a cave-temple. Characteristic examples of this traditional kind are the steles from the Boston Museum [68] and another in the Nelson Gallery, Kansas City [67].

The second basic style of early Buddhist steles generally has a relatively large trinity or a single Buddha in high relief against a great leaf-shaped mandorla. Some of the earliest surviving steles are in this form and it may antedate the use of the more traditional Chinese monument. As will be seen, the steles with the pointed, mandorla screen are very similar to some images in gilt-bronze, and it seems not unlikely that their form derives from bronze images on a large scale which according to records were cast in the sixth century. Since all Chinese Buddhist sculpture in stone, clay, and wood was painted, such a stone stele in the temple interior would look much like the more costly images in gilt-bronze. The treatment of the great mantle with its many pleats and folds in the stele of A.D. 527, formerly in the collection of C. T. Loo [63], is strikingly like that on some bronzes in a smaller scale. Nothing could better illustrate the light, fluid drawing of the period than the flames, flying angels, and floral scrolls of the engraved and delicately chiselled mandorla background. The unmistakable quality of line lies in the particular tension of the curves, which are not softly rounded but bend like a steel spring. It is not difficult to imagine a mandorla of this kind executed in bronze, either pierced as in the Metropolitan shrine [66] or cast in low-relief as in the Berenson shrine [64].

A few gilt-bronze altar groups in the main stream of the Wei style are known. One of the best is the shrine of Prabhūtaratna and Śākyamuni, dated in accordance with A.D. 518 and

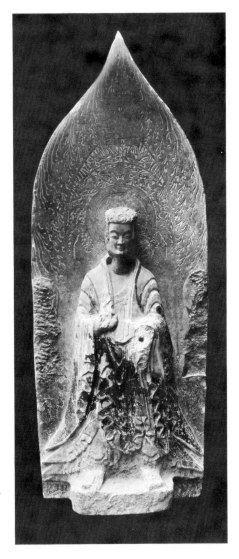

63. Buddhist stone stele.
A.D. 527.
Formerly New York, C. T. Loo

now in the Musée Guimet [65]. At one time when Śākyamuni Buddha was about to preach to the multitude, according to the *Lotus Sūtra*, a stūpa appeared in the sky, and within was the Buddha Prabhūtaratna who had entered Nirvāṇa many eons before. This Buddha had vowed, however, before his extinction that he would be present on this occasion of the preaching of the Law. Śākyamuni rose up into the air,

took his place beside the Buddha of the past, and so began his sermon. Within the limits of the highly formalized style – sloping shoulders, long neck, square forehead, and ridged drapery ending in points – these lean, ethereal Buddhas of the Guimet shrine are done with a beauty of expression, freedom of modelling, and ease of pose that produce an intimate, personal quality rarely met with in the coins of this period.

64. Buddhist shrine, gilt-bronze.
A.D. 529.
Florence, Bernard Berenson Collection

65. Prabhūtaratna and Śākyamuni, gilt-bronze shrine.
A.D. 518.
Paris, Musée Guimet

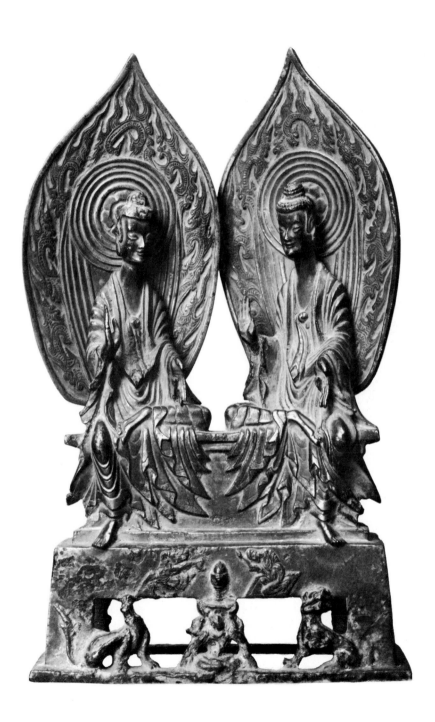

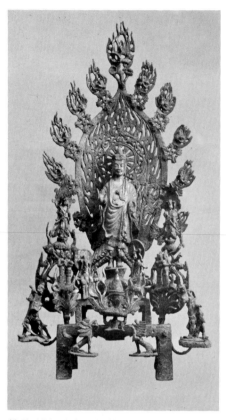

66. Buddhist shrine, gilt-bronze.
A.D. 524.
New York, Metropolitan Museum of Art

Two magnificent gilt-bronze altars, one dated in accordance with A.D. 524, are in the Metropolitan Museum. The dated shrine reproduced here [66] shows the devotion of the period to clear-cut angular shapes and a kind of flickering, upward movement – an effect that is intensified by any play of light over the burnished gold surface. From the manes of the lions in the foreground to the waving floral forms about the central incense burner and those supporting the Bodhisattvas, to the flames of the pierced mandorla and the outer group of flying apsaras,

there is a rushing movement as though an earthly breeze were sweeping everything towards heaven. Because the shrine was intended as an object of adoration and an aid to contemplation, the head of the central Maitreya Buddha is the apex of a triangular composition forcefully established by the lions and gesticulating guardian figures at the base and front of the altar. Naturalism is suppressed to a minimum, while geometric forms and tense linear rhythms produce an icon in every way suited to its spiritual purpose.

For many, the most perfect small shrine from the sixth century may well be that from the collection of Bernard Berenson [64]. Here the decisive angularity in the folds of the great mantle enveloping the Buddha and the crisp, elegant drawing of flames and angels may be fully appreciated. A curious effect, as though the edges of the mandorla were dissolving into space, is produced by the widely separated and pointed scarves and garments of the heavenly musicians. This image was dedicated in A.D. 529, and the relaxed, flowing modelling of the vine and flower rinceau in the halo of the Buddha foreshadows a style that was to gain in popularity through the thirties and forties of the century and culminate in the style of Northern Ch'i.

Throughout the sixth century devotion to Buddhism and sincere interest in its more profound teachings supplied a lively stimulus for Chinese devotees and priestly scholars to travel into the far West where they might reverence the great Buddhist holy places of Gandhāra and India and acquire more orthodox texts and relics. As a corollary, monks from these lands, so closely associated with the actual life of the founder of their religion and the development of its doctrine, were welcomed at the Chinese centres of Buddhist learning. Within the first two decades of the sixth century, it is said, some three thousand foreign monks were to be found in the Wei capital of Lo-yang.[8] Although in the

fourth and fifth centuries models for Chinese Buddhist art had, to a large extent, filtered through the roadside stations of Central Asia, the contacts in the sixth century became much more direct, with the result that the styles which Chinese native genius had developed from the beginnings at Yün-kang were modified, and in many cases superseded, by motifs and manners of presentation which more closely resembled the styles of the Buddhist countries of Gandhāra, Bactria, and India, and so were considered nearer to the true source and hence more orthodox.

A large stele from the south-west corner of Shansi, now in the Nelson Gallery [67], preserves much of the earlier linear manner together with noticeable differences from the earlier Wei style of, say, the Pin-yang cave at Lung-mên. This monument is not dated but was made about A.D. 535-40. In the deep niche the images of Buddha, attendant monks and Bodhisattvas are cylindrical and full-bodied, while the garments of the adoring monks and other lesser figures are adapted to the bodies and fall in relatively natural folds. In the band containing two guardians, two heraldic lions, and a stylized tree, the extreme tensions of the earlier style have relaxed somewhat, producing an effect that is more opulent but less dynamic. Much of the old manner remains, none the less, in the splendid upward sweep of the six musical angels descending on either side of the stūpa of Prabhūtaratna, just above the central Buddha.[9]

It is not intended to suggest a progressive sequence from one style to another; there is a persistent continuation of traditional motifs and styles in some parts of the country or in some workshops long after they had been superseded in others. A feature of the Chinese sculptor's art is the way in which new motifs or new manners of treatment are fused with the old in an amalgamation that is completely consistent. No more beautiful example of this could be found than the Wetzel stele in the Boston

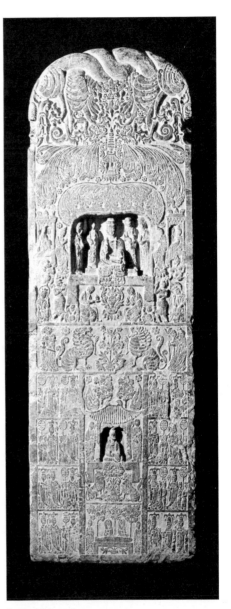

67. Buddhist stele, stone.
c. A.D. 535-40.
Kansas City, Nelson Gallery of Art and Atkins Museum

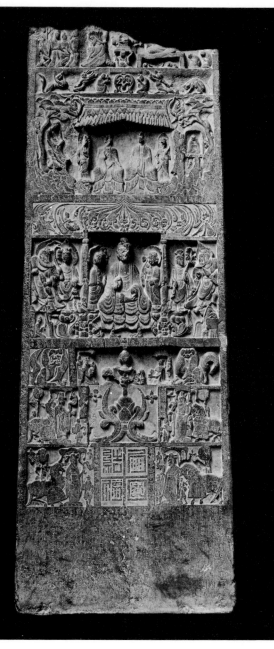

Museum [68]. This remarkable work was made in A.D. 554, in the last years of the Western Wei Dynasty. The central Buddha and his attendants have, like those in the Nelson stele, large heads and bodies no longer attenuated; the plant forms have become full and luxuriant. A number of other interesting features appear, such as the general pictorial effect of the second register from the top in which Śākyamuni and Prabhūtaratna sit under a canopy in a landscape of trees and rocks, while in the main register a certain amount of undercutting, especially in the haloes, indicates that the sculptor was striving for an effect of strong modelling; but here again we can see to what extent these sculptors still thought essentially in terms of line drawing. On the right-hand side at the bottom the donor and his horse are really little more than line engraving with some of the background removed; the donor in the next stage above has the outlines rounded, while the guardian lion above is quite deeply cut, but, nevertheless, no whit more plastic than his companion on the left.

68. Buddhist stele, stone.
A.D. 554.
Boston, Museum of Fine Arts

SCULPTURE DURING THE LATE SIXTH CENTURY

AND SUI DYNASTY

About the middle of the sixth century a different style was evolving in north China, in Shansi, Hopei, and north-eastern Honan, territory controlled by the Northern Ch'i Dynasty which had supplanted the Eastern Wei in A.D. 550. Buddhist sculpture from the second half of the sixth century, of the Northern Ch'i, Northern Chou, and Sui dynasties, has frequently been called 'sculpture of the transition period'. Such a concept is not really satisfactory, nor does it give a clear idea of the full importance of Buddhist sculpture in those five decades. With all its rich variations, the sculpture of Northern Ch'i and Sui is a consistent entity, distinct from what had gone before and from the art of the following T'ang Dynasty.

It is evident that the factors which determined the character of later sixth-century sculpture were new concepts within the Buddhist church and more direct contacts with India and other countries of western Asia. As to the former, sculpture in China has always been what it was in pre-Renaissance Europe – the art of anonymous craftsmen. Judging from what is known of later times, the sculptors of Buddhist images must have been members of guilds of professional image-makers with the trade, in many instances, traditional within a family. These sculptors were not learned ecclesiastics, and any modifications of traditionally accepted forms most likely came about through instructions from the priesthood aided by drawings and imported images. The existence of such craftsmen, who probably travelled from temple to temple plying their trade, would account to a marked extent for the striking uniformity of Buddhist sculpture within a given era. The varying concepts of different sects of Buddhism, then, would affect the content of the work, as, for example, the need of the Pure Land sect for representations of the Western Paradise of Amitābha Buddha, but it is a question how much such varying beliefs affected the style or manner of presentation, at least at this stage.

The sculpture of the classic Gupta period of India (A.D. 320–600) was the most powerful and direct stimulus to Chinese sculptors in the second half of the sixth century. The new style did not grow out of the geometric, linear style of the first half of the century, rather it superseded it. However, it is much easier to speak loosely of strong Indian influence during the Northern Ch'i Dynasty than to illustrate the argument with clear comparisons. Although in many instances the Indian devotion to solid, plastic form in the human body, and India's love of luxuriant plant growth, are reflected in the work of Chinese sculptors, these elements, at times but vaguely understood, have become so characteristically Chinese that it is seldom possible to point to any specific Indian parent example or school. There was in China at this period a sincere attempt to indicate a body beneath the garments. There appeared a new interest in plain surfaces contrasted with concentrations of extremely rich and detailed ornament of Indian origin – ropes of pearls, intricate chains, and ornate crowns on the Bodhisattvas. An urge is apparent to break away from the static calm or tense linear rhythms of the early icons and, as it were, bring the stone to life by means of swirling plant

69. Buddhist stele, stone,
from Chang-tzu Hsien, Shansi. A.D. 569.
*Kansas City, Nelson Gallery of Art
and Atkins Museum*

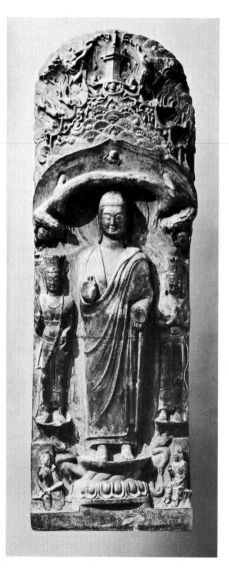

forms, writhing dragons, straining atlantes supporting every projecting member, and figures actually emerging from the stone – all executed in high relief that breaks up the surface into strong patches of light and shade. Such features are, it is true, also to be found in Indian sculpture, but not as they appear in China. In all the Chinese work there is a reticence, an understatement, a dominance of design and pattern over naturalism that seems to hold the Chinese sculptor back, almost in spite of himself, from approaching the sensuous exuberance of India or a realization of plastic form on anything approaching the level of, say, the great Bodhisattva image in the Curzon Museum at Muttra.[1]

A stele from Chang-tzu Hsien in Shansi, made in A.D. 569, displays a large central image of Śākyamuni Buddha, accompanied by the Bodhisattvas Avalokiteśvara (Kuan-yin) and Mahāsthāmaprāpta (Ta-shih-chih) [69]. The Buddha's robe falls in a relatively natural manner, the flat folds on the shoulder blending into marked ridges across the body and legs, and undulating over the torso with the intent of indicating the form of the body beneath. A certain solid grandeur results from the great simplicity of this central figure, in which even the tight curls or swirling hair usual on the Buddha's head have been omitted. The face has become round and full, the eyebrows have lost their high spring and are quite strongly marked. On either side, the two Bodhisattvas, like the Buddha, still have a lingering suggestion of the archaic half-smile, are almost cylindrical, and their garments are treated in a very simple manner as though the sculptor feared any elaboration might impair his new-found expression of weight and mass. Necklaces, chains, and crowns are, on the other hand, detailed and elegant. The stele cap is treated in a typically pictorial way with the stūpa of Prabhūtaratna supported on the shoulders of a gnome-like creature above a highly stylized landscape with

trees at the sides. A strange attitude towards the stone, as though it were a soft and pliable material, is most strikingly shown by the inexplicable head and shoulders of a small figure who is in the act of pushing his way out just above the Buddha's head. The sculptor who made this stele, it is evident, had a very different attitude towards his material than had the sculptors of the Boston stele or the Nelson Gallery stele of about A.D. 535–40 [67]. Instead of the

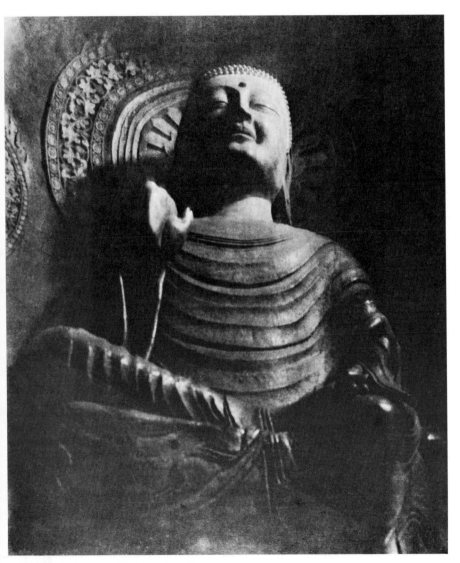

70. Northern Hsiang-t'ang Shan, Hopei, north cave,
Great Buddha. Northern Ch'i Dynasty, A.D. 550–77

design being cut into the stone, or rather cut back from a line drawing, the sculptors of about A.D. 570 hewed their figures out of the stone, employing many devices not only to create full-bodied forms but to give the impression that the very stone itself was organically alive.

At Hsiang-t'ang Shan, on the border between Honan and Hopei, a series of handsome cave-temples were hollowed out of the dark limestone cliffs and adorned with sculpture during the Northern Ch'i period. In the simplicity of treatment and sense of bulk rendered with straightforward, honest cutting in stone, some of the images at Hsiang-t'ang Shan are among the finest achievements of Chinese Buddhist sculpture [70]. One of the three great Buddhas of the north cave of Northern Hsiang-t'ang Shan sits in an easy pose with one leg pendant; the garment clings to the body in a series of close folds like the style of Gupta India, and these folds are cut with a direct, sure craftsmanship. The old archaic half-smile has softened into an expression of benign and gentle grace.

Such pictorial bas-reliefs as we have seen in the Life of Buddha series at Yün-kang and the donors' processions at Lung-mên, are numerous at Hsiang-t'ang Shan. Two are now in the Freer Gallery, and we reproduce one showing the Western Paradise of Amitābha Buddha [71]. In the century since the first caves were cut from the rock at Yün-kang, Buddhism on Chinese soil had undergone many changes. During the early centuries, both of the two great divisions, Hīnayāna and Mahāyāna Buddhism, had claimed followers in China. Of these schools, the Hīnayāna stressed individual salvation through personal effort, while the Mahāyāna preached a doctrine of universal salvation largely through the divine aid of numerous Bodhisattvas – deities of incalculable merit who, although they had reached the stage of entering into Nirvāṇa, had forgone this final Buddhist goal to aid in bringing all sentient beings to supreme enlightenment, or Buddhahood. At Yün-kang, Śākyamuni, the historical Buddha, is almost universally represented. After A.D. 500, Maitreya Buddha, the Buddha of the

71. Paradise of Amitābha Buddha, bas-relief from Hsiang-t'ang Shan. Northern Ch'i Dynasty, A.D. 550–77. *Washington, Smithsonian Institution, Freer Gallery of Art*

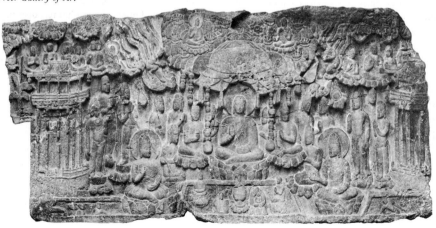

Future who rules over the Tuśita Paradise until the time when he is to visit the earth and again preach the doctrine, became more and more popular, as is evident from the inscriptions at Lung-mên. It may be that Śākyamuni, having passed into Nirvāṇa, seemed too remote and unapproachable, while the Messiah, who dwelt in a paradise, was more approachable through prayer.

Through the first half of the century the sculpture shows a kind of Chinese synthesis of Hīnayāna Buddhism (represented by the two monks, Ānanda and Mahākāśyapa, who accompany many of the Buddha images and represent the personal, individual salvation) and Mahāyāna Buddhism (represented by the attendant Bodhisattvas standing for universal salvation through the aid of these great gods). Also, Śākyamuni and Maitreya share almost equal honours. After the middle of the century another Buddha, Amitābha, is more and more frequently represented. This is the supreme Buddha of the Pure Land (Ching tu) sect, whose principal text, the *Sukhāvativyūha*, had been translated into Chinese in the second century. According to this doctrine, the immediate aim of the worshipper is not Nirvāṇa, which remains the ultimate goal, but is rebirth in the Western Paradise of Amitābha, a place of complete beauty with jewelled trees, lofty palaces, and lotus ponds, enlivened by heavenly musicians and dancers. Meditation and austerities are not necessary to reach this paradise; for one has only with sincere heart to call upon the name of Amitābha. Obviously this was a doctrine with wide popular appeal. Pictures of such paradises as that of Maitreya and Amitābha were of high propaganda value for the church and offered the Chinese artists the opportunity to exercise their imaginations.

Amitābha Buddha occupies the centre of the scene in the Freer relief [71], seated beneath a jewelled canopy surrounded by lesser deities, while the sky is filled with falling flowers,

musical instruments and flying angels. The palaces of the blessed are represented by a tall tower on either side. From a pool in the foreground, the souls of those reborn into this land of bliss are seen emerging from lotus buds. There is, as Sirén has pointed out, a very understandable, though simple, indication of space, obtained by the converging sides of the lotus pond and the perspective of the towers.[2] The figures are well grouped in successive stages one behind the other, creating a pictorial effect that originally must have been considerably heightened when the sculpture was painted. Deep undercutting in certain areas gives a strong plastic effect, so that the total impression of such a relief, in the dim light of a cave-chapel, must have been a convincing vision, a kind of diorama, of the reward awaiting the worshippers of Amitābha. It is typical of Northern Ch'i style that the figures and the lotus flowers on which they rest are done with noticeable simplicity and restraint in contrast with the ornate exuberance in the sky.

Free standing figures, divorced from the great mandorla backgrounds, were made in increasing numbers after the middle of the sixth century. A group of three such figures, said to come from a temple of Southern Hsiang-t'ang Shan, are now in the University Museum, Philadelphia. These splendid figures, over life-size, are certainly works of the Northern Ch'i period, probably of the 570s [72-4]. The images of the Bodhisattvas, especially, show that combination of garments treated in a rather simple manner in contrast to the finely executed and detailed jewellery that has already been mentioned. The monk's robe combines, in a masterly way, the flat, incised folds of an earlier style with heavy ridges in the Indian manner that lend a sense of weight to the garment. In all the figures there is a strong accent on vertical lines which, in the case of the Bodhisattvas, are softened by the long curves of the shawl ends and jewellery, and of the monk by the heavy

72 to 74. Monk and two Bodhisattvas, stone.
Northern Ch'i Dynasty, A.D. 550-77.
*Philadelphia, University Museum of
the University of Pennsylvania*

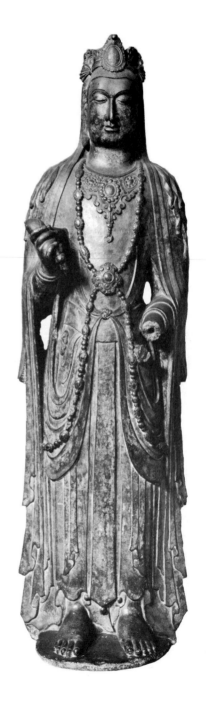

folds that cut across the front of his robe. On a
technical level alone these figures are obviously
the work of a master. But, above all, their merit
lies in the deep spiritual content. Through
excellent proportions, dignity of pose, and
sense of mass, as well as through the serene and
absorbed expressions, the sculptor has trans-
formed the blocks of stone into impressive
manifestations of the Buddhist ideal of enlight-
enment and salvation.

Excavations in 1954 at the temple site of
Hsiu-teh Ssu, at Ch'ü-yang, near Ting-chou in
central Hopei province, have recovered over
two thousand two hundred small Buddhist
sculptures executed in the white marble associ-
ated with Ting-chou, and many still bearing
traces of their original paint. A large number are
fragmentary or badly damaged in a way suggest-
ing destruction of violent iconoclastic intent.
Of the total found, two hundred and forty-seven
carry dated inscriptions. These permit not only
an arrangement of all the material in a clear
chronological sequence, illustrating changes in
style and technique, but are also an index of the
rise and decline in popularity of specific cult
images; for example, the images of Śākyamuni
give way to those of Maitreya, while those of
Amitābha appear only towards the end of the
sixth century. The fortunes of the temple, also,
its years of greatest affluence and the high point
of Buddhist zeal in Hopei, are suggested by the
relative number of inscriptions from succeed-
ing dynasties. The earliest date is A.D. 520 and
the latest 750. Within this span, seventeen are
from the Northern Wei, forty from the Eastern

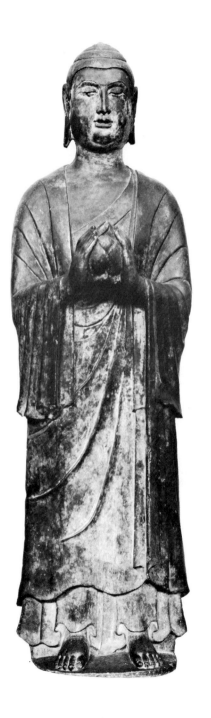
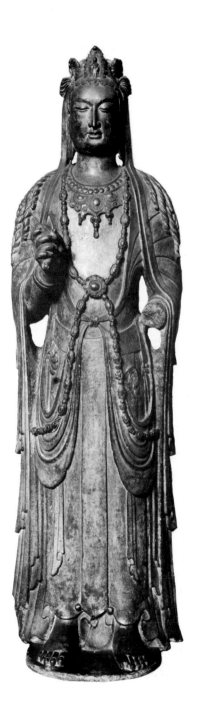

Wei, one hundred and one from Northern Ch'i, eighteen from the Sui Dynasty, and only eight from the first century and a half of T'ang. It is at present fruitless to speculate on the reason why such a vast quantity of small sculpture, ranging, on an average, from eight to ten inches high, and the majority of it uninscribed, and so undedicated, would be found at one temple. The fact does serve, nonetheless, as an indication of the enormous productivity of Chinese sculptors when state and church were flourishing, as in the years of Northern Ch'i.[3]

The influences already mentioned, from India and western Asia, are strongly in evidence at Hsiang-t'ang Shan. It is not so much to our purpose to trace these to their origins and note their modifications in China, as it is to illustrate the deep interest which the Chinese exhibited in motifs and manners of representation that were imported, their willingness and even zeal in adopting what was foreign and strange as opposed to accepted tradition. The interior door jambs of several of the caves at Hsiang-t'ang Shan [75] carry bold and handsome rinceau patterns, in some cases edged with pearl borders that obviously derive from Iranian ornament as seen in the stucco decorations from the Sasanian palaces of Kish and Ctesiphon.[4] There is a special kind of ornate incense burner so popular during Northern Ch'i that it can almost serve as a hallmark [76]. In this design the central burner, with crenellated top, rises from a rich mass of twisting foliage and is frequently flanked by lotus forms and leaves bearing smaller burners, jars, or adoring figures. The whole complex arrangement is strongly similar to the finial ornaments on the great acanthus-like trees found on the rock-cut Sasanian monuments of Taq-i-Bustān.[5]

The lotus leaves and thick vine stems of Northern Ch'i designs also have strong affinities

75. Rubbing from Southern Hsiang-t'ang Shan. Northern Ch'i Dynasty

76. Rubbing from Southern Hsiang-t'ang Shan.
Northern Ch'i Dynasty

with the sub-tropical verdure in Indian sculpture from as early as the stūpa of Sāñchī (c. 70–25 B.C.), to the sculptures of the Muttra school and the Ajaṇṭā cave-temples of Gupta times (A.D. 320–600). It is no surprise to find so many Indo-Iranian elements in Chinese sculpture at the time of Northern Ch'i.[6] Not only were there many Indians resident in China, as has been mentioned, but also a great many Persians.[7]

In the middle of the sixth century a new power, the Turks, had risen north of the Great Wall and in Central Asia. The new Turkish empire extended from Mongolia on the east across Central Asia to Afghanistan on the west. One of the Turkish rulers was joined to the royal house of Wei by marriage with a princess in 551. On the east, the Turkish rulers were in close contact with both the courts of the Later Chou and the Northern Ch'i Dynasties, and on the west formed alliances with the Sasanian ruling house of Persia. During the three decades of their full power, the empire of the Turks must have been a potent factor in the exchange of influences between China and Persia. At the same time, and increasingly towards the end of the century, there were close relations with such Central Asian cities as Kucha and Kizil which were strongly Iranian in costume and customs.

A sculptured work done in the characteristic style of Northern Ch'i, but combined with purely exotic decorations, illustrates this new influence. The monument is a stone funerary couch of a kind that was placed in important

are the figures strongly Persian in costume and pose, with their toes pointed down, but the square and roundel with palmette space-fillers occur on certain stucco decorations from the Sasanian palace of Ctesiphon.[9]

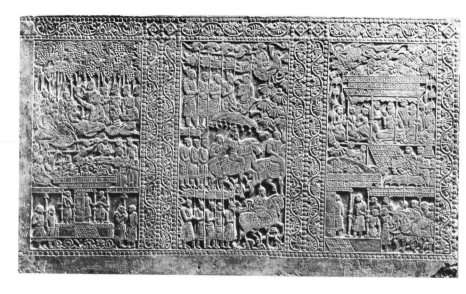

tombs from at least the time of Northern Wei and enjoyed popularity throughout the sixth century. The elements of this elaborate stone divan are scattered in various museums, and we reproduce here only the front platform and the two slabs which probably formed the back [77-9].[8] The front platform is composed like a Buddhist altar base with an elaborate example of the Northern Ch'i incense burner in the middle, guardian figures armed with tridents and trampling on lions, and kneeling apsaras holding flaming jewels in the oval openings – all done in the high relief and with the simplified garment forms of the period. But a purely Persian element intrudes in the horizontal panel of dancers and musicians within pearl-encircled roundels enclosed in squares, the triangular corners filled with palmette designs. Not only

The slabs that formed the back are even more strangely foreign. A foreign potentate on horseback with his retinue is shown in the central panels as arriving (?) and, in the side panels, as being entertained with food, drink, music, and dancing. Numerous details are quite un-Chinese. The guests drink in the Persian manner from shallow bowls, or in one case from a classic rhyton, and the pearl-edged costumes and manner of sitting, the birds with ribbons about their necks, bring to mind the silver bowls of Sasanian Persia, while the architecture with its cornice ornaments and low domes is that of the Middle East. In the overcrowded composition, profusion of geometric pattern and above all in the tight static drawing, as in the rinceau borders, there is a spirit widely at variance with the Chinese aesthetic canon. It is very probable

that the couch was made for the burial in China of some Persian, Turkish, or Central Asian dignitary, and executed from drawings by a foreign artist. The couch is an extreme example of western Asiatic style on Chinese soil. It was not a popular style. Iranian art of Sasanian times was too heraldic to become absorbed into Chinese art without far-reaching mutations.

A stele, in the Metropolitan Museum,[10] stands as one of the landmarks of Chinese

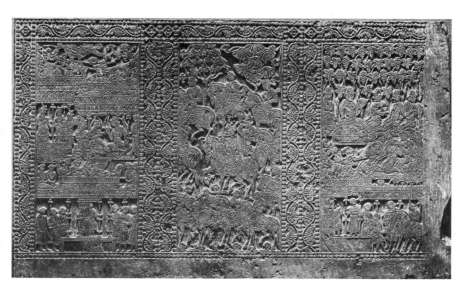

77 and 78. Funerary couch, stone. Two side slabs.
Northern Ch'i Dynasty, A.D. 550–77.
Boston, Museum of Fine Arts

79. Funerary couch, stone. Base and two additional
parts. Northern Ch'i Dynasty, A.D. 550–77.
Washington, Smithsonian Institution,
Freer Gallery of Art

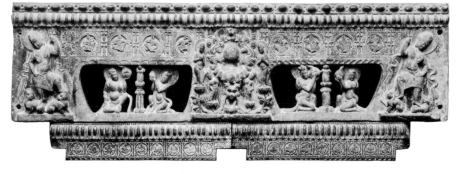

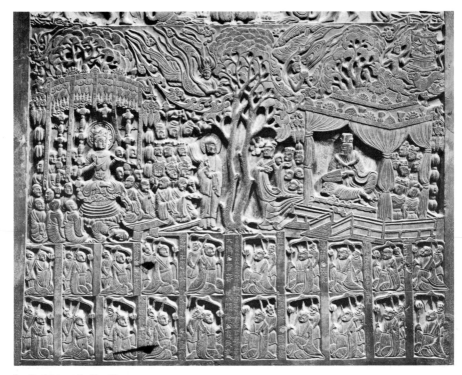

80. Buddhist stele (detail), stone.
Mid sixth century.
New York, Metropolitan Museum of Art

sculpture from around the middle of the sixth century because of the perfection of workmanship and complexity of composition [80].[11] Because of the richness of detail we reproduce here only the upper half. Deep carving and undercutting give a highly plastic effect, like that in the Western Paradise scene from Hsiangt'ang Shan [71]. In the upper register, unfortunately broken, the elaborate incense burner, of the type already mentioned, is supported by stout youths in baggy and very un-Chinese trousers; the two ascetics on either side, one holding a skull, the other a bird, have not only great individuality of expression but are rendered with striking freedom of pose and keen characterization. The tense drawing of the earlier style has been superseded by fuller and more gently curving forms. A suggestion of the old, more formal style still lingers in the serried pleats of the Buddha's robe as it falls over the dais. Below, in an oblong panel, is a highly accomplished example of the pictorial manner that enjoyed popularity throughout the second half of the century. It is a scene from the *Vimalakīrti Sūtra* in which the well-to-do householder, at the right, is shown in discourse with the Bodhisattva Mañjuśrī, enthroned on the left and surrounded by his following: two other principal actors in the drama, a monk and a beautiful apsaras, occupy the centre of the

scene on either side of a double tree. This tree, which extends from the bottom to the top and divides the composition in two, and those in the background, rendered in a formal and decorative manner, lend a lively sense of the setting.

It is difficult to define precisely the qualities of this particular style in Chinese sculpture. Rich imagination is lavished on the designs, and there is an obvious attempt to make the work more striking and vital by fuller modelling, such arresting details as Atlantean and caryatidean supports, figures, animals, and plants pushing out from the stone, and individual characterization, especially in the lesser figures such as guardians and monks. In the best monuments the result is always impressive even though the spiritual content seems often dissipated in descriptive and narrative details.

In west central Hopei, in the region of Ting-chou and Pao-ting, some miles south-west of Peking, there were, apparently, a number of very active local centres of image-making. The sculpture, distinguished by the indigenous material which is a beautiful micaceous white marble, displays a high degree of technical refinement. Free-standing figures, some of impressive size, and small steles are not only to be found in the immediately adjacent region but were transported to some distance. The Buddhas and Bodhisattvas are sculptured with great restraint, and the former, in particular, follow rather closely on Indian models of the Gupta period. The body is slightly but successfully suggested beneath the robes and the exposed chest, head, hands, and feet have a delicate, tactile quality that is quite new. In the best examples, such as the large standing Amitābha in Toronto [81], the face is expressive of a deep, introspective calm. Many of these sculptures, though strictly speaking executed in the round,

81. Amitābha, stone.
Northern Ch'i Dynasty, A.D. 577.
Toronto, Royal Ontario Museum of Archaeology

have no sides – that is, the figure is rather like two high relief sculptures, a front and a back which merely join at the sides. The heads are, in contrast, round and solid, supported on powerful necks. The style appears to have reached its peak in the 570s, when the Toronto figure, dated in accordance with 577, was made. This Amitābha Buddha is nobly proportioned, and the garment clings closely to the body, the smooth, undulating surface broken only by a few folds in thin ridges that serve to emphasize the long oval form closed at the base by the almost straight, horizontal hem with flat, stylized folds. The base, too, is characteristic of the school – a low drum, ornamented with lotus and leaves in high relief, rests on an ample rectangular base and supports an inverted lotus, the petals deeply cut.

Elements of realism at times add a kind of personal warmth in a number of images from this school. One has but to examine the better clay tomb figures of the sixth century to realize that when the purpose called for realism – as did the magic principle behind the tomb figure – the sculptor was capable of translating into clay a close and keen observation of the world about him. When this same capacity for observation was applied to the images of the high gods, at first quite tentatively, may it not indicate a change in the attitude of the worshipper to the deities? The universal salvation and the bliss of the Western Paradise offered by the Pure Land Sect to those who would but call upon the name of Amitābha Buddha, forged a bond of sympathy between men and gods far more intimate than the austere self-discipline taught in the *Lotus Sūtra*. It is only natural that the images should gradually tend to become more tender and more human.

Many examples of the splendid marble sculpture from the last quarter of the sixth century are to be seen in Western collections, particularly the extensive collection formed by Grenville Winthrop and now in the Fogg

Museum, which is rich in sculpture of the Northern Ch'i and Sui Dynasties.[12] Another especially good and important example is the torso of a Buddha formerly in the Eumorfopoulos Collection and now in the Victoria and Albert Museum. Here the sculptor has followed more closely than in other examples the powerful models of the early Gupta style of India in which the ponderous mass of the body, com-

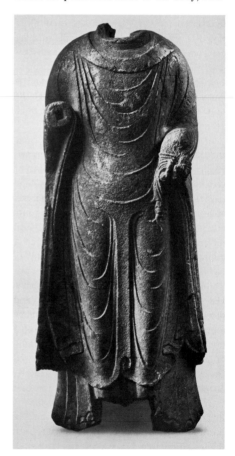

82. Buddha, stone, from Ch'ang-an, Shensi. Northern Chou Dynasty, *c.* A.D. 570. *Kansas City, Nelson Gallery of Art and Atkins Museum*

pletely covered by clinging drapery, produces an effect of strength and dignity.[13]

While Buddhist sculpture in eastern and northern China was attaining the perfection of its chosen style in the brief span of, say, 570 to 585, the sculptors of western China were producing images far less severe, in some ways more close to Indian models, and at times sumptuous. Little has been said about the sculptor's art under the Northern Chou – the dynasty that shared the rule of most of China with Northern Ch'i. In large part, the rulers of Northern Chou were anti-Buddhist and more concerned with the Confucian doctrines, especially in regard to government. Wu-ti of Northern Chou (r. 561-77) was especially hostile to the Buddhist church. A certain amount of work was done, none the less, and the most important centre seems to have been the ancient capital city of Ch'ang-an (modern Hsi-an) in Shensi. Several large Buddha images, sculptured probably around 570,[14] are now in the Hsi-an Provincial Museum. Their general appearance is massive and heavy, with over-large heads, the drapery folds done in hard, mechanical, and repetitive ridges. A better example, in essentially the same manner [82] but on a smaller scale, is made of conglomerate yellow and green stone characteristic of the Hsi-an district. Although the head, feet, and one hand are missing, a nobility of proportions, a good solidity to the body, carefully indicated under the robe, and a rhythmic play of folds that only occasionally turn into ridges, indicate that the sculptor had thoroughly mastered his Indian model.

The same masterly craftsmanship is even more evident in the monumental image of Avalokiteśvara in the Boston Museum [83]. This, too, is a work of the Ch'ang-an sculptors,

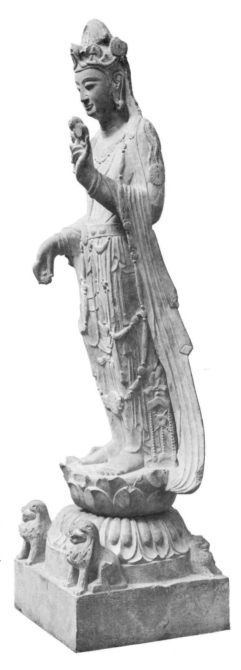

83. Avalokiteśvara, stone, from Ch'ang-an. Northern Chou Dynasty, *c.* A.D. 570. *Boston, Museum of Fine Arts*

and its affinities with Indian concepts are evident in the fleshy and sensuous modelling of hands, feet, and face, as well as in the profusion of jewellery. Although the weight rests on the left leg, the right knee is advanced, and there is a slight thrust to the right hip; the *déhanché* pose so beloved by the sculptors of India is very timidly essayed. When seen from the front the Bodhisattva retains almost completely the uncompromising verticality of earlier works. If we remember that originally all the oriental wealth of jewels and falling scarves were brilliantly painted and the flesh areas were gilded, we can, in imagination, re-create something of the grandeur of such an icon, viewed in the soft temple light. None the less, we cannot but be aware that the age of burning, spiritual zeal has passed. In the words of John Lodge, writing about the image: 'The very quality of splendour is not in itself wholly reassuring, and it seems inevitable that such elaboration of graceful detail, such facility and perfection of technique must, in the last analysis, entail a certain measure of spiritual attenuation.'[15]

The two principal emperors of the Sui Dynasty, which had united China in 590, Wên-ti and Yang-ti, were enthusiastic Buddhists.[16] It is said that the former was instrumental in the creation of over one hundred thousand new images and the repair of over one million and a half. Among the numerous sculptures carrying a Sui date, by far the most imposing is that presented to the British Government by C. T. Loo and now in the British Museum. Its enormous size, almost nineteen feet high, and masterful execution make it an appropriate representative of the power of the Buddhist church near the end of the sixth century. The image, which like so many at that time represents Amitābha Buddha, was made in the general region of the Ting-chou, Pao-ting sculpture centres. Clearly this figure, which carries an inscription dated in accordance with 585, continues the tradition that had been brought to

perfection in the 570s. The features are more deeply cut and pronounced than in earlier works, and the drapery lines and folds have become further stylized. It adds nothing new to what had already been accomplished during the Northern Ch'i Dynasty.

It must be borne in mind that the great body of Chinese Buddhist sculpture from the most creative periods has been irreparably lost. Large bronze images have been melted down, those in wood, clay, and lacquer have perished through the vicissitudes of time.[17] So little, then, is left that a just estimate of the artistic level attained in any period should only be based upon the best examples rather than on the whole body, which contains so many provincial works which, because of their relative isolation, have escaped destruction. Making every allowance, however, the output during the Sui Dynasty is not impressive in quality. Although the technical perfection is retained, many of the figures become squat, heavy, and sombre, devoid of the youthful elegance and spiritual grace of the best work of Northern Ch'i. There are a number of images that, in the words of Coomaraswamy, but help to swell the tide of accepted tradition.

A notable exception is the bronze shrine made in A.D. 593 at the pious behest of eight mothers, and now in the Boston Museum [84]. Amitābha Buddha is represented seated upon a jewelled lotus throne, accompanied by four disciples and the great Bodhisattvas Avalokiteś-vara, holding a pomegranate, and Mahāsthāma-prāpta with hands clasped in prayer.[18] In this shrine, all the rich pictorial effects found in the Freer relief of the Western Paradise of Amitābha from Nan Hsiang-t'ang Shan have been worked out to perfection. The jewelled trees, the ropes of pearls, ornate pendants, celestial nymphs, and Bodhisattvas in princely garments – all are there. Buddha and Bodhisattvas have the

84. Buddhist shrine, bronze. A.D. 593.
Boston, Museum of Fine Arts

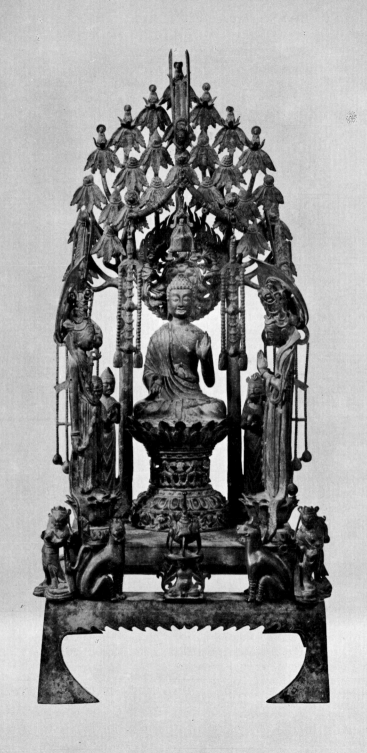

benign, tender expressions that mark the best Buddhist concepts from the later sixth century. The modelling is essentially simple and direct in spite of elaboration in design and shows that workers in bronze were as proficient in their craft as were stone-cutters.

Most, if not all, of the sculpture discussed so far represents the iconography, styles, and techniques prevalent in the areas of north and west China. This is because so very little has survived, or can be identified as coming, from the devoutly Buddhist kingdoms of the Yangtze valley to the south. The lack of southern sculpture and painting is especially regrettable because all literary evidence concerning this area points to a creativity on a nearly incredible scale in all the arts of the Buddhist church. Recently, however, the remarkable finds at the ruins of Wan-fo Ssu, outside the west gate of Ch'êng-tu in Szechwan province, cast some illumination on the rather murky history of Buddhist sculpture in the Yangtse valley during the centuries of the Six Dynasties. At present there are over two hundred Buddhist images and stelae from this site deposited in the Szechwan Provincial Museum.[19] These sculptures in many aspects differ in style as well as quality from the familiar examples of northern origin. Of the published pieces, thirteen carry dated inscriptions, and of these eleven were made under the southern dynasties of Southern Ch'i, Sung, and Liang. In quality the best of the Ch'êng-tu sculptures have a clarity and a precision in detail, a finish and an over-all sophistication found in only a few examples from the north.

The sculpture unearthed at Ch'êng-tu is the first substantial evidence, aside from a few scattered remains, of the style and workmanship of Buddhist images from the southern dynasties. As such it is of the first importance, in spite of the fact that Ch'êng-tu, far to the west, was peripheral to such cultural centres of the Yangtse valley as Nanking. The high quality and advanced style strongly fortify the thesis advanced by Dr Alexander Soper, supported by literary evidence, that during the Six Dynasties period the great creative centres of the arts, including Buddhist sculpture, lay in the south rather than the north, where, because of such factors as the creation of extensive cave temples, the great bulk of material has been preserved.[20] There are also among the Ch'êng-tu sculptures some stylistic features that relate to certain important early Japanese images in the kondō of Hōryūji and again support Dr Soper's idea that much of the inspiration of Japanese sculpture came ultimately from southern sources.[21]

What is lacking today for a proper evaluation of Chinese Buddhist art in its most vital creative period, the sixth and seventh centuries, is any one place, any surviving monument where one can get an impression of the total effect. Isolated images of Buddhas, Bodhisattvas, monks, angels, and guardians can in no way evoke a picture of the whole – the original intent of grouped images contrasting and complementing one another as an iconographic unit. The all-important close relationship of architecture, sculpture, and wall paintings as a single concept can only be found now in temples of relatively late times, and, of course, in some few early temples of Japan. Such ensembles as the Metropolitan shrine of A.D. 524 [66] and the Boston shrine assume a greater importance if we think of them as preserving, on a small scale, some suggestion of the appearance of a high altar, when Buddhist art in China was at its zenith. Moreover, no words could so well convey an idea of the changes that had occurred in Buddhism and the creative impulses of the artist-servants of the church as a visual comparison between these two shrines dedicated just sixty-eight years apart.

PAINTING DURING THE THREE KINGDOMS

AND THE SIX DYNASTIES

In the preceding chapter on sculpture, little if anything was said about the arts in south and central China after the close of the Han epoch. The reason is that there are so very few remains of southern Buddhist sculpture that no sound opinion about it can be formed at present. In painting the situation is almost reversed. It was at the courts of the southern dynasties, Eastern Chin, Sung, Southern Ch'i, and Liang, that painting flourished in the first few centuries of the Christian era.

Ku K'ai-chih (*c.* A.D. 344-406) was a man from the lower Yangtze valley, who gained a great reputation as a painter working at the Chin court of Nanking. He is the only early painter about whose work it is possible to advance a few timid conjectures. There are two scroll paintings attributed to him which can seriously be considered to represent an archaic style. These scrolls are strikingly different from one another. The one called 'Admonitions of the Instructress to the Court Ladies' [85, 86], now in the British Museum, is a very old picture, the oldest scroll that has so far become known. The other, called 'The Nymph of the Lo River', is a copy of about the twelfth century [87]. There is really no valid reason for believing that either of these paintings represents the actual manner of Ku K'ai-chih. But the 'Admonitions' in particular is so much what one would expect a painting of his time to look like, and the attribution to Ku has become so fixed in Chinese tradition since the twelfth century, that it seems but right to retain it.[1]

We are introduced at once, in these two paintings, to two types of the Chinese illustrative scroll. In the one, like the 'Admonitions', separate scenes, generally without background or with only slight suggestions of setting, are presented between passages of explanatory writing; while in the second kind, like the 'Lo Nymph' scroll, there is a more or less continuous composition of setting in which the action takes place, with frequent use of the device called 'continuous narrative', that is, the same person or persons appear several times in the same composition whenever necessary for the illustration of events.

The 'Admonitions' is a series of illustrations to a third-century composition of high moral tone. The section reproduced [85] illustrates the passage: 'If the words you utter are good, all men for a thousand leagues around will make response to you. But if you depart from this principle, even your bed-fellow will distrust you.' The illustration is literal; a gentleman of aristocratic appearance sits on the edge of a canopied and curtained bed facing a delicate and rather haughty lady who is either being responded to or distrusted. The expression of the gentleman strongly suggests distrust. Whatever it may be, a sense of tense emotion has been captured and is intensified by the brooding calm of the man and lady – action is concentrated in the fixed gaze which they exchange.

By the isometric projection of the bed leading into the background, we are made well aware of the space in which the scene takes place. As much of the drawing as is still visible and not obviously refreshened, shows a firm brushstroke of even thickness, quite delicate in the

85 and 86. Ku K'ai-chih (*c.* 344–*c.* 406):
Admonitions of the
Instructress to the Court Ladies (details).
London, British Museum

此之由

soft materials of curtains and cloths and wider to define the furniture. The shading in the gauze curtain is rather surprising at such an early date, but there are also slight shadings along some of the drapery folds which may be part of the original design, though shading of any kind in Chinese paintings is generally to be regarded as a result of foreign (largely Indian) influence. The quality of the drawing is more apparent in the scenes of a lovely and somewhat bewildered lady being admonished by her husband [86]. The folds of the garments are done in fine, even lines and are rendered by very simple curves without any doubling back, bunching of material, or hooks. The delicate drapery shading is quite clear in the lady's sleeves.[2]

The two men and two ladies in our reproductions show very successful handling of profile, three-quarters, and an almost full face, in the case of the reproachful husband. It is evident, too, that the painter of this scroll had advanced well beyond the generalized facial expressions of Han times and could depict individual character and emotion. The husband chiding his wife has an expression that might be interpreted as smug and patronizingly benign; at any rate it is quite different from the weary and puzzled expression on the face of the distrustful bed-fellow. Ku K'ai-chih was praised as a portrait painter. In this scroll, on a small scale, one may obtain a hint, at least, of the possibilities of telling portraiture in line alone

87. Ku K'ai-chih: The Nymph of the Lo River
(detail). Twelfth-century copy.
Washington, Smithsonian Institution,
Freer Gallery of Art

at a very early time in the history of Chinese painting.[3]

Although the scroll illustrating Ts'ao Chih's poem about the Nymph of the Lo River is a Sung copy, in general, it has every appearance of preserving faithfully a style we might expect in, at least, the early sixth century and probably earlier. It is interesting because of the landscape, rendered in a very simple way [87]. Rocks, hillocks, and trees rise from the bottom of the scroll to establish the foreground. The rocks and hills are drawn with lines of even thickness, and a slight shading is used to set off one layer from another. In the detail we reproduce, in which a gentleman (the poet?) seated on a low dais is attended by two servants, the rocks and generalized trees are so ordered as to create a small stage or 'space cell' in which the action takes place. The figures are quite large and obviously of paramount interest, while the landscape is limited to bare essentials. For all its naivety in scale and broad generalizations of nature, the composition is well balanced and varied, there is a play of interest between the three figures, and the result is excellent illustration.

Almost contemporary with Ku K'ai-chih there began in China the fine arts of criticism and of aesthetic theory, activities which through the centuries have profoundly appealed to cultivated Chinese because of the rich possibilities for detailed analysis, literary research, classification in categories, and general speculation. Hsieh Ho, a painter active in Nanking about A.D. 500, was but one of several artists and critics who turned their attention to qualitative judgement of painting as well as to aesthetic and technical theories. Hsieh Ho has become the best known of all the early writers because of his formulation of Six Principles which make a painting worthy. The importance of these Six Principles in all later Chinese art criticism cannot be overstated. They are indeed the cornerstone of the vast literature on art criticism that has accumulated through the ages. The first of the Six Principles is vague, and possibly so by intent. Such vagueness, or susceptibility to a variety of interpretations, by no means

uncommon in Chinese, has made it possible for the first of the Six Principles to be employed over many centuries, its flexibility making it applicable in systems of aesthetic and critical judgements quite different from those obtaining in the time of Hsieh Ho.

Many translations have been made into English. This is not the place to review them or to touch on the knotty problem of what the Six Principles meant to different generations of Chinese writers. Soper has made a concise study of what the first two Principles may have meant about the year A.D. 500, and we follow his lucid exposition.[4] He translates from Hsieh Ho's work, the *Ku hua p'in lu*: '(Good) painting has six conditions. . . . What are they?

> The first is "animation through spirit consonance".
> The second is "structural method in use of the brush".
> The third is "fidelity to the object in portraying forms".
> The fourth is "conformity to kind in applying colours".
> The fifth is "proper planning in placing (of elements)".
> The sixth is "transmission (of the experience of the past) in making copies".'[.]

First importance, then, is given to some quality that is never obtainable by technique alone – a quality that throughout Chinese criticism will be the touchstone used to separate the creative genius of an artist from the labours of a craftsman. Quoting again from Soper: 'The painter must see to it that the *ch'i* (vital spirit) of everything animate within his picture shall be able to find and respond to its like, not merely elsewhere on the silk but by infinite extension throughout all the universe. So, and so only, can it reach the ultimate source of life. In mystical language, this seems a paraphrase of the injunction that later will be more clearly stated: the artist must first of all seek and stress

the ultimate, quintessential character of his subject, the horsiness of horses, the humanity of man; on a more general level, the quickness of intelligence, the pulse of life, in contrast to brute matter. In Hsieh Ho's own words, his reward will be *sheng tung* (life movement, animation).'[5]

The remaining five Principles are all concerned with the making of a picture and involve technical procedures which we shall have occasion to refer to many times. The second Principle means that, unless the essential form is established by the brush-strokes, all other work, such as colouring and perfection of detail, is useless. Since the individual brush-stroke can never be covered up or smeared over, as in a European oil painting, but must stand for ever revealed, the brush has been misused unless the stroke is purposeful and essential in the structure of the picture. In this sense the brush performs somewhat the same task as the quill in a drawing by Rembrandt.

The third might be interpreted as simply good drawing – objects should be recognizable – though it can be interpreted to mean a kind of realism. However, it may not necessarily mean an academic realism, but only intelligibility. As the third Principle refers to the proper shapes of things, the fourth refers to their colour – and almost without exception early Chinese paintings were coloured, and the monochrome ink painting was some centuries in the future. The fifth Principle states that a good painting should be properly planned and composed. And lastly, in the sixth Principle, Hsieh Ho gives his advice on how to learn the art – study and copy the old masters. It is very unlikely that this asks the accomplished artist to spend his life copying the works of his predecessors. It does mean that the experience of the past is invaluable and that, as a form of study, one may copy the old masters in order to grasp the principles whereby good works of art are made. After one has come to understand the style and methods of an established old master, one may proceed to evolve

one's own style. With such training, the artist's pictures will themselves transmit the experience of the past.

From writings such as those of Hsieh Ho and others of the fifth and sixth centuries we may learn a good deal about the names of famous painters, the subjects in which they excelled, and a certain amount of critical evaluation. Especially valuable in this respect is a famous work of considerably later time, the 'Record of Famous Paintings in Successive Ages' by the T'ang Dynasty writer, Chang Yen-yüan (c. 847).[6]

It is clear from these records that the centres of painting through the fifth and up to the middle of the sixth centuries were the courts of the southern dynasties. Since Buddhism had been introduced into the Yangtze valley by the third century, it is natural that many of the artists painted Buddhist subjects. There was Wei Hsieh who worked in the time of Eastern Chin (A.D. 317-420) and, in addition to painting the Shang-lin Imperial hunting park, did a picture of seven Buddhas that was much praised. Lu T'an-wei, who worked under the Sung (A.D. 420-79) and Southern Ch'i dynasties (A.D. 479-502) at Nanking, was one of the greatest painters of the fifth century. Among his pictures which were preserved into the T'ang Dynasty were those of horses, ducks, 'Cicadas and Sparrows' - a theme popular to the present day - such a Buddhist subject as Ānanda and Vimalakīrti, sages of antiquity, and also portraits of princes, ministers, and potentates.

The most basic material for an insight into early figure painting in the region of the Yangtze valley is a pair of horizontal compositions made up of a number of pottery bricks with low relief linear drawings of the Seven Sages of the Bamboo Grove plus an eighth legendary Confucian worthy. The figures, four in each composition, are seated beneath trees which also serve to separate one figure from his neighbours. In the manner the trees extend from the base-line to the top of the pictures, the way they bifurcate near the ground, and in the general style of drawing, as well as the readily identifiable species, these trees are clearly the ancestors, not too far removed, of those on the sarcophagus of Filial Piety [91-3]. In the fluid and logical drawing of the drapery folds and the distinct characterization of each sage, these 'tile-paintings' are the most accomplished representations of figures yet known. The tiles were found in a tomb at Hsi-shan Bridge near Nanking and probably date from the early to middle fifth century. They are then almost contemporary with or only slightly later than the most famous early figure painter, Ku K'ai-chih (c. A.D. 344-c. 406), who worked at Nanking. These tiles are the best evidence for the style and quality of southern painting, as opposed to that of the Yellow River valley to the north.[7]

Another aspect of the southern style, in all probability, is represented by the brick constructed tomb at Teng Hsien, about one hundred and forty-five miles south and slightly west of Lo-yang. On relatively small bricks, some fifteen inches broad by seven and a half inches high, are pressed bas-relief representations of horses and grooms in procession, musicians, the ritual dance of a shaman, animals of the quadrant, and such Buddhist themes as flying apsaras and lotus flowers. The most illuminating are groups of figures in landscape settings, some of which are illustrations to stories of filial piety. In a scene of the Four Hermits of Mount Shang the foreground and middle distance are clearly established against a background of humped and rounded peaks. In comparison with the sarcophagus of Filial Piety, the Teng Hsien scenes are much simplified, possibly because of the small scale, and are far more decorative throughout, with lotus, other floral forms with long, ribbon-like floating leaves, buds, and clouds used as

space-fillers. The beauty of these elegant tiles is heightened by their being painted in brilliant colour, red and green predominating. The style is consistent and distinctive from that of the Lo-yang-Sian area. Unfortunately the tomb is not dated, and without comparable material of known date from the same region, one must fall back on material from farther north; this would suggest a time in the second quarter of the sixth century. But since the arts could well have more advanced under the southern dynasties, the Teng Hsien tombs may be a generation earlier.[8]

The most celebrated painter of the court of the Liang Dynasty at Nanking (A.D. 502–57) was Chang Sêng-yu who, it appears, was not only a consummate master of his craft but possessed a most fecund imagination so that he was able to create 'an unending variety of fantastic shapes and strange forms'. In addition to these gifts, he was an indefatigable worker. Under patronage of the pious emperor Liang Wu-ti, he decorated numerous temples and pagodas with frescoes, in one of which he made the extraordinary combination of the Buddhist saint Vimalakīrti and Confucius with his ten disciples. A number of paintings of dragons are also among the recorded titles of his works, and the painting of dragons reached a high stage in the sixth century.

All these records are, of course, of the greatest interest and importance for a general history of Chinese painting, but they tell us little or nothing of what the pictures looked like. So very little has remained, moreover, that in most instances not even a hint to the imagination is possible. In the case of Chang Sêng-yu, for example, the twelfth-century catalogue of the collection formed by the emperor Sung Hui-tsung lists eighteen paintings attributed to that artist. Among them is one entitled the 'Five Planets and Twenty-four Constellations'. There is an old scroll of the same subject attributed to Chang Sêng-yu now in the Abe Collection of

the Ōsaka Museum.[9] The painting does not appear to be a work of the sixth century, but it seems that, in part at least, it is based on sixth-century design. Of course, there is no reason at all for believing that the composition is, in fact, based on one of Chang Sêng-yu's.

At Tun-huang, in western Kansu on the borders of Chinese Turkestan, there are a number of cave chapels decorated in the Six Dynasties period. This oasis city, after its founding about the middle of the fourth century, grew into a thriving centre of trade and Buddhist learning because of its strategic location on the great highway between China and the countries to the west. Some little distance from the town, today hundreds of cave chapels remain hollowed out in the cliff of conglomerate. The material of the cliff was not suitable for sculpture, as was the stone at Yün-kang or Lung-mên, and what sculpture there was was made of clay moulded over a core of wood or straw. The great glory of Tun-huang lies in the many paintings that adorn the walls.[10] The numerous caves contain a wealth of Buddhist paintings from the last quarter of the fifth century into the first half of the eighth century, when the activity declined somewhat after the Tibetan invasion in A.D. 759.[11]

As might be supposed, there is a strong Central Asian influence, stemming from such Buddhist states as Kucha, evident in the earlier caves, and the pure Chinese style only slowly assumes a dominant position. Among the earliest surviving paintings are those of cave 101, decorated in the last quarter of the fifth century. Here the Buddha with attendant Bodhisattvas all stand on a single ground plane [88]. The curious stance with the feet wide apart and the stiff, hieratic drawing of the main figures are Central Asian, while a Chinese contribution is evident in the waving scarves of the flying angels above. The strong shading, applied in an arbitrary manner, as on both sides

88. Tun-huang, Kansu, cave 101,
Buddha and attendants, fresco.
Last quarter of the fifth century

89. Tun-Huang, Kansu, cave 135, illustration
of *Jātaka*, fresco. Early sixth century

of the arms, is certainly not Chinese and is of ultimate Western origin. But from beginnings as simple as this, vast paradise scenes with their countless figures and lofty architecture were to evolve within the next two hundred years.[12]

Large icons, like that of cave 101, served the ultimate purpose of supplying a focal point for devotional contemplation, but a second and most important aim of church art is to instruct. It is in scenes illustrating the sacred texts and legends of the faith that figures in action within a setting of landscape or buildings offered themes which allowed a wide scope to the artist's imagination. In cave 135, which was decorated in the early decades of the sixth century, there are illustrations of the jātaka story concerning a former life of the Buddha in which he gave his own body to feed a tigress so reduced by starvation that she was no longer able to nurse her cubs. The picture is divided into three registers and the narrative reads from right to left [89].[13] The landscape setting is very simple. A series of small, tooth-shaped hills rise directly from the foreground, circle a small

90. Tun-huang, Kansu, cave 120 N,
battle scene, fresco. A.D. 538–9

plane or pile up along diagonals as the case
demands the separation of one scene from
another or the creation of a limited stage for
action. These space cells, to use Bachhofer's
descriptive expression, are a convenient device
to create an area for action, to suggest depth and
setting and, when skilfully handled, to produce
a field of handsome decoration. Other successful
devices for increasing the sense of space are the
buildings on a diagonal, two horses in echelon,
horsemen appearing from behind a hill and, in
the upper left corner, a horse seen straight on –

as already used in the Han Dynasty. The
generalized trees of the Han Dynasty have given
way to more specific representation of variety.

The most beautiful and exuberant of the
early caves, 120 N, is fortunately datable by an
inscription to A.D. 538–9 [90].[14] Here the style
is almost purely Chinese. Above the deep
niches for images is a wide band with an
animated battle scene. To the left, warriors in
scale mail and mounted on armoured chargers
together with a few foot soldiers are scattered
about in a rather haphazard fashion, but the
scene on the right is more carefully organized.
Four mounted warriors in echelon close the
left, and an elaborate walled compound at a

strong diagonal closes the right. We are intro-
duced here to a point of view that was to remain
the favourite throughout the history of Chinese
painting. It is as though the audience were
standing on an eminence in the foreground look-
ing down on to the scene, or, to put it another
way, as though the most distant edge of the
ground-plane had been tilted up to an angle of
almost forty-five degrees. The artist felt no
need for consistency, and thus we look down on
the roof of the small buildings, but at the same
time up the steps and directly at the verandah
where a lady is seated. All the figures are drawn
as though seen straight on. Within the area
established by the architecture and the grouped
horsemen, a number of prisoners are being
divested of their long Central Asian coats and
blinded in front of the elegant ladies of the
palace. Above and under a gathered valance,
angels and flowers sweep through the air with
the grace and speed already familiar from
sculpture like that of the Ku-yang cave, Lung-
mên. By the first quarter of the sixth century
there had developed, then, a vivid art of
illustration, elegant and decorative, in which
the artists were concerning themselves with
conventions which would create a convincing
world of space and nature, where their charac-
ters might dwell.

Tun-huang was a long way from the metro-
politan centres of Chinese culture, and it is
likely that the work is somewhat provincial,
especially in the early caves. By the seventh or
eighth century, however, it is probable the
artists at Tun-huang were as capable as the
average run of temple decorators in the
neighbourhood of Ch'ang-an and Lo-yang. A
suggestion of what the art of the court looked
like can be gathered from engravings on a
variety of stone objects used in the tombs.

By far the most accomplished drawing on
stone from the early sixth century that has so
far been recovered is on the two sides of a stone
sarcophagus executed around A.D. 525, and now
in the Nelson Gallery [91, 92].[15] As befits the
purpose, the three scenes on each side illustrate
six of the stories concerning paragons of filial
piety. The designs are so very accomplished
that it seems impossible to consider them the
invention of the stone-cutter engaged in making
objects for the tomb (ming ch'i). It is more
probable that the composition is derived from
either a well-known scroll painting of the time
or wall decorations of an important ancestral
temple.[16] The basic principle of the composi-
tion is the same as in the scroll-like paintings in
cave 135 at Tun-huang. The action takes place
in carefully constructed space cells. Each story
and the different actions within each story
are set apart from one another by steep rocks
and tall trees. In the scene of the Filial Tung
Yung [93], the perpendicular rock formations,
with their tops all sloping in one direction, form
a semicircular amphitheatre for the action. The
foreground is strongly established by a rolling
hillock, two low, gnarled trees, and a pair of

91, 92, and 93 (detail of 92). Sarcophagus,
engraved stone. *c.* A.D. 525.
Kansas City, Nelson Gallery of Art
and Atkins Museum

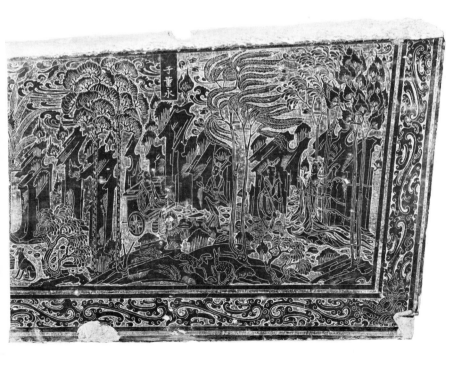

spotted deer. There is no transition from the middle distance to the background, where, as in the scene of the Filial Grandson Yuan Ku [91, right end], there is a range of low, distant hills. The intermediary space is hidden by banks of clouds in the form of long, horizontal bands. The sky in the Tung Yung scene is filled with scudding clouds with serrated caps and flying birds.

Stone engravings of the kind described above have preserved some of the compositions current in the first half of the sixth century, but they cannot convey any impression of the living brush-stroke of the artist, and the brush-stroke is the vital essence of Chinese painting. To get some notion of what such designs would look like when executed by the swift-moving brush of a skilled painter, we must turn to the painted tombs of Korea. In the neighbourhood of Pyongyang in northern Korea there are a number of tombs decorated in the latter half of the sixth century but preserving the style that must have been current in the centres of Chinese culture some decades earlier. The best drawing is to be found in tombs with the four walls carrying representations of the symbols of the quadrant.[17] We reproduce but one detail from a tomb south of Pyongyang. The scudding clouds [94] from which a small dragon emerges (upper left) and the tree in the centre show the kind of skilful brushwork and shading, the gradation in line, and the decorative splendour that would bring to life the elegant and well-organized compositions of the engraved sarcophagus.[18]

It is interesting to find in the sixth century, when Buddhism was sweeping the country, purely Confucian subjects like the Paragons of Filial Piety and Taoist material like the creatures of the quadrant. Religious subjects occupied more and more the attention of leading artists from the sixth century on to the end of the ninth, but there was a constant undercurrent that followed traditional subject-matter.

In the engraved stones and in the painted tombs of Korea we are able to catch a glimpse of the thread that leads back to the mythological creatures on the walls of the offering shrines of Ch'u and the Confucian moralist paintings that adorned the palaces of Han.

The names of many artists active in the Northern Ch'i (A.D. 550-77) and Sui (A.D. 581-618) dynasties have been preserved, and lists of their paintings by title give, at least, some

94. Tomb south of Pyongyang, Korea, wall painting. Latter half of the sixth century

inkling of what interests occupied them. The work of all these men, however, is entirely lost, and it would be too hazardous even to suggest what their paintings may have looked like.[19]

In regard to Buddhist paintings we are more fortunate, because a number from this period also are preserved on the walls of Tun-huang.

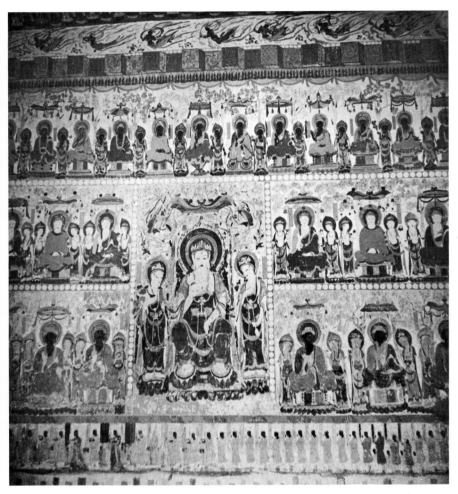

95. Tun-huang, Kansu, cave 150, Buddhist fresco.
Early seventh century

In cave 150 the wall has been divided into a number of registers and panels containing Buddhist trinities [95]. The central panel carries a Buddha seated with legs pendant, possibly Maitreya, flanked by Bodhisattvas. All the Bodhisattvas stand on lotus bases while the Buddhas are seated on high thrones, some also supported on lotus bases, which makes them look almost as though they were pictures of sculptured images set out in rows. There is little attempt to suggest a setting, save for the trees behind the figures. The entire arrangement of the trees, canopies, and tall, slim Bodhisattvas is very reminiscent of the Boston

bronze shrine of A.D. 594, although the borders of pearl design, so popular in Northern Ch'i, suggest that the decoration still retains elements of an earlier style. Recent Chinese studies suggest that the cave was painted about A.D. 617, the last year of the Sui Dynasty. In any case, the tension of the earlier drawing has relaxed, the flying angels at the top float gently rather than rush through the air; a sense of calm and equilibrium is engendered by the repetition of the theme in diminishing scale from the lower to the upper registers.

T'ANG DYNASTY SCULPTURE

Under the Sui Dynasty China was reunited into a single empire after over three and a half centuries of disunion. But at the close of the sixth and in the early years of the seventh century, the country was in revolt, and the court was weakened by corruption and unbridled luxury. The strong man of the hour was Li Shih-min, who swept away all other contestants and in 618 founded the T'ang Dynasty. The arms of the T'ang generals extended the boundaries of the empire even beyond what they had been at the peak of the Han Dynasty, and Chinese domination was recognized as far west as Bokhara and Samarkand. Foreign trade expanded to a point never reached before, and goods from China were to be found in market towns throughout the Near and Middle East. Later in the dynasty Arab traders, sailing the southern route through the Indian Ocean, opened a thriving trade with south China in the region of modern Canton. A never-ending stream of camel caravans carried Chinese goods across the highroads of Central Asia. The population of China was over 43,000,000, according to the census of A.D. 733, and the country must have been then, as now, one of the most populous of the world. Certainly the T'ang capital of Ch'ang-an in Shensi was, in the seventh and eighth centuries, the greatest city of the world. The city was laid out like a chequer-board with broad, straight streets running from wall to wall, north and south, east and west. The streets were filled with the cosmopolitan populace befitting the capital of such an extensive empire. There were priests from India, officials and merchants from Persia and the kingdoms of Central Asia, Turks, Arabs, and traders from Mesopotamia. Many of the foreigners settled in China and followed their native religions so that, enjoying the Chinese official tolerance of a kind that comes only with assurance of power, there grew up side by side with the Buddhist and Taoist temples, Muhammadan mosques, Zoroastrian temples, Manichean and Nestorian churches.

About A.D. 700 Buddhism reached the peak of its power as an organized church and a force in Chinese cultural life. During the preceding seventh century a number of brilliant Chinese theologians had brought Chinese Buddhist thought to new levels of attainment. A lively interest in Indian philosophy, both Buddhist and Hindu, sent a number of Chinese pilgrims on the long trek across Central Asia to the holy places of Buddhism and centres of Indian thought. Chief among these men was the redoubtable Hsüan-tsang – most celebrated of all Chinese pilgrims and a metaphysician of no mean powers. Hsüan-tsang left China in 629 and returned after sixteen years of travel in Central Asia and India, bringing with him many sacred texts and some images. The remainder of his life was spent on translations of these works and on teaching, a labour that contributed incalculably to the understanding and growth of Mahāyāna Buddhism on Chinese soil. Hsüan-tsang was but one, though the most noteworthy, of a number of Chinese and Indian scholars who were engaged in translating Indian works, broadening and deepening the knowledge of Buddhist theology in China. By the end of the eighth century the great period had passed, but one sect that had a far-reaching if unfortunate influence on the arts, originated in China during that century. This was the True Word, or *Chên-yen* Sect, known in Japan

as Shingon. The founders were two Indian monks who arrived in China in A.D. 719, Vajrabodhi, who was active until 732, and Amoghavajra, active until 774. This sect derived many of its features from Indian Hinduism and laid great stress on magic spells and ritual. Its ceremonies were elaborate and involved the use of complex mandalas, schematic arrangements of the deities in which Sanskrit letters often took the place of representations of the gods. A strong Tantric element introduced many new deities and new forms of the old ones, including the female counterparts of the Bodhisattvas, deities in terrible aspects, and others with multiple arms and heads. The elaborate court of Ming Huang (T'ang Hsüan-tsung, r. 713–55) was fertile ground for the magical, complex ceremonies of the *Chên-yen* practitioners. For the artists, however, the priestly dictates as to each detail of a composition, its spacing and arrangement according to a mystic formula were certain death to their creative imagination, while any self-respecting Chinese artist would look upon the painting of an intricate, geometric mandala as mere craftsman's drudgery. On the other hand, the development of more intellectual aspects of Buddhist philosophy, like the meditative sect of Ch'an (Zen in Japanese), which had great appeal to educated Chinese, found its most satisfactory expression, as will be seen, in subjects other than religious icons.

Despite the flourishing condition of Buddhism during the first two centuries of T'ang rule, the quantity of surviving religious sculpture from those centuries is less than that preserved from the preceding sixth century. One reason for this condition may be that the realistic character of much T'ang sculpture made such pliable materials as bronze, wood, clay, and dry lacquer more popular with sculptors than the more stubborn stone. All monumental sculpture of the seventh and eighth centuries in bronze, clay, and wood, has disappeared with

but few notable exceptions, due in large part to persecutions of the Buddhist church, notably that of 845, and disastrous temple fires. To catch an echo of the T'ang grand manner in such perishable materials one must turn to Japan of the late Hakuhō and Tempyō periods, where images like the great bronze trinity of Yakushiji or the images in dried lacquer in the Hokkedō of Tōdaiji[1] show the heights attained through the technique of modelling during the eighth century. In China enough sculpture in stone has survived, however, to give a relatively clear picture of T'ang Buddhist art.

The most important sculpture from the seventh century is the enormous group at Fêng-hsien temple, part of the cave-temple complex at Lung-mên in Honan [96]. The gigantic group was commissioned by the emperor Kao-tsung (r. 650–83), and work on the central figure was begun in 672 and completed in 675. The central Buddha figure measures some thirty-five feet or about fifty feet from the bottom of the pedestal to the top of the halo. The Buddha here represented is Vairocana whose worship had but recently been introduced into China. This Buddha, unlike Śākya-muni or Amitābha, is not a saviour, but personifies rather a philosophical concept of the original creative spirit that embraces the Buddhist Law and the cosmos. He is described as seated on a lotus throne of a thousand petals, each one of which is a universe with its Buddha, and each of these worlds itself contains a hundred million worlds or, as we would say today, galaxies of Buddha worlds.

The central figure, in very high relief, is full-bodied and solid. The monastic robe, which almost entirely covers the figure, is shown by a few simple folds that follow closely the contours of the body and terminate towards the shoulders in thin ridges. A new treatment is especially evident in the head which has lost all the earlier elongation; the face is now full and round, with wide-spaced eyes that are almost level, as are

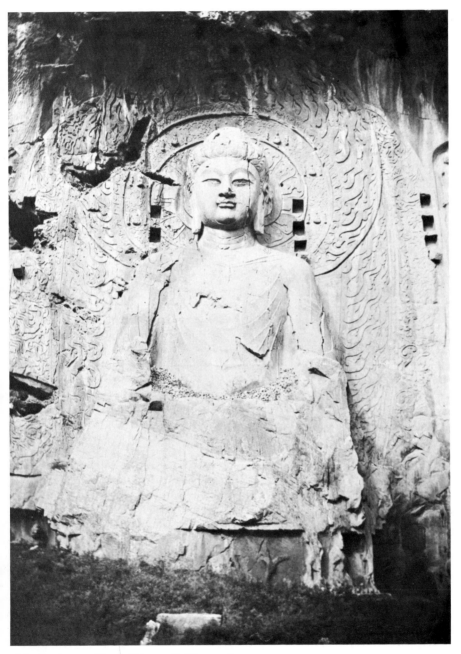

96. Lung-mên caves, Honan, Vairocana Buddha. A.D. 672-5

also the long, arched brows. A crease under the chin and a series of folds on the neck serve to emphasize the fleshy quality. The new interest in the natural fall and flow of drapery is even more evident in the detail of the attendant Bodhisattva on the left [97]. The pliant material of the dhoti is drawn in between the legs and falls in a cascade of soft folds, while the ends of the sash and the scarves at the side ripple and flutter as in a gentle breeze. In the arm and what remains of the hand there is the same full, round modelling as in the head and body of the central image.

At the Buddhist cave-temples of T'ien-lung Shan in Shansi Province there are some nine caves that were sculptured, in all probability, during the time of the empress Wu (r. 684–705) and the emperor Hsüan-tsung (r. 713–55). Here the trend towards naturalism evident at Lung-mên is further advanced. The Buddha and Bodhisattva from cave XXI are highly plastic and seem scarcely attached to the wall [98]. Both are seated in a natural way; the Bodhisattva in particular exhibits an easy pose; the head tilted to one side, a slight sway in the torso and one knee raised lend the figure something of Indian voluptuous languor. The ample form of the Buddha is pointed up by the rhythmic pattern of drapery ridges that follow so closely the form of the body, and in this case cover even the feet. A good sense for the weight and fall of cloth is shown by the way the ends of the robes in pleats and folds drape over the daisies and are caught up on the lotus petals concealed beneath. All the linear tension, the elongation of the body, and formal disregard of anatomy that contributed to the ethereal and spiritual quality of early Buddhist sculpture in the first half of the sixth century has disappeared. Instead the high gods take on a solid, almost weighty reality. In the best examples, like the Vairocana of Lung-mên, the images still seem charged with spiritual power, but it is latent rather than dynamic.[2]

97. Lung-mên caves, Honan, attendant Bodhisattva on left of central Buddha (detail). A.D. 672–5

98. T'ien-lung Shan, Shansi, cave XXI,
Buddha and Bodhisattva.
Late seventh to early eighth century

99. Eleven-headed Kuan-yin,
niche from the Ch'i-pao T'ai, Ch'ang-an.
Late seventh to early eighth century.
Washington, Smithsonian Institution,
Freer Gallery of Art

But in other images from the same period the sculptor seems to have shied away from too great a naturalism, though, indeed, this may merely represent a different school working in another tradition. The Eleven-headed Kuan-yin, now in the Freer Gallery, exhibits qualities of rigid, rather austere formalism somewhat at variance with the voluptuous fleshiness of much of the T'ien-lung Shan work [99]. This effect derives largely from the straight, unbending pose, the symmetry of folds in the sash and skirt, and the long, cylindrical left arm. The form of the body with its broad shoulders, narrow waist, bulging stomach and full, round face is well proportioned and excellently integrated. The plump hand and fingers well illustrate a manner that is a characteristic innovation of this period. The rich jewellery, the flower in the upraised hand, and the rinceau border of the halo are treated with becoming restraint. The iconographic problem of representing a deity with eleven heads has been solved by attaching ten of the heads to a high-piled chignon. This deeply carved niche once formed part of the decoration of the Terrace of Seven Treasures, the Ch'i-pao T'ai, of the K'uang-chai Temple in Ch'ang-an. There are at least four other similar niches containing eleven-headed Kuan-yins, and a number of broader slabs each sculptured with a Buddhist trinity. Some of these latter are dated and range from 703 and 704 to 724.[3]

The two large Bodhisattvas on the black stele in the Metropolitan Museum may well be taken to represent the T'ang ideal [100]. The well-proportioned bodies stand in relaxed poses, and the garments, though rendered with a minimum of folds and pleats, have all the qualities of soft material and subtly reveal the form beneath. Chains and ropes of jewels are used with the same skill as in Indian sculpture to point up the round fullness of the bodies, as, for example, those encircling the necks. Or again they hang down in long, gently curving ovals that heighten

the impression of calm and stately dignity. Such elements, combined with the plump, placid faces, bring the deities on to a level almost approaching that of young and elegant court beauties.[4] These two Bodhisattvas exemplify,

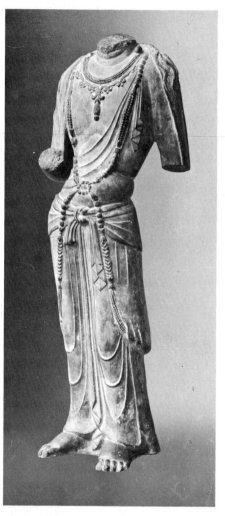

101. Bodhisattva, stone. Eighth century.
Washington, Smithsonian Institution,
Freer Gallery of Art

with technical perfection and marked restraint, a T'ang Dynasty formula that is met with in numerous other sculptures and countless miniature gilt bronzes. This Bodhisattva type, evolved in T'ang painting and sculpture, remained in vogue well into the fourteenth century if not longer. The garments consist of a skirt of the Indian dhoti type, rolled at the waist above a sash, the ends of which frequently fall down between the legs to the ground. A wide scarf is drawn from under the right arm and carried up across the torso to the left shoulder, where it is sometimes gathered in a bow. Another and very long scarf drapes across the shoulders and hangs over both arms, in a variety of ways, the ends generally extending to the ground. This arrangement is then overlaid with necklaces, chains, and ropes of jewels that frequently attain the elaboration of a complex harness. The posture is no less standardized. One hip is thrust slightly to the side and the arm on the same side bent at the elbow and raised. This complex of movement and directions is offset on the opposite side by the arm hanging in a straight thrust from the shoulder to the wrist. Often the head is bent slightly towards the side of the out-thrust hip so that the result is a gentle S-curve from the top of the head to the feet. The posture is simple, natural, and full of grace. It was employed in some of the earliest sculpture of India and occurs in the wall painting of Central Asia, at Tun-huang in the early sixth century (notably cave 120 N), and is also found in Chinese sculpture of the early sixth century. The T'ang interest in the plasticity of form, however, brought the Chinese version of this Indian formula to its final perfection.

Chinese sculpture in the round was made successfully for the first time in the T'ang Dynasty, and particularly in the eighth century. Earlier free-standing figures are essentially conceived to be viewed from the front. While most T'ang sculpture is more effective when

looked at in the same way, the planes are continuous, without abrupt transitions, and the figures are statues in the true sense. This meant, of course, a break with the ancient Chinese devotion to an essentially linear style; none the less, even in such fully modelled figures as the Freer torso of a Bodhisattva [101], the sculptor has imposed a characteristic pattern of linear rhythms. There are a number of such figures in the round that mark the golden era of T'ang Buddhist sculpture. Among them should be mentioned the excellent pair in the University Museum, Philadelphia,[5] the white marble torso in the Rockefeller Collection,[6] and the two reproduced here. The one [101] is a perfect example of the T'ang formula, both in posture and garments. The cutting is sure and precise, the soft, fleshy bulk of the body well suggested with enough formalism to save it from becoming obviously anthropomorphic. The feet are full and fleshy but they are still stone.

The sculptors of Hopei, who had produced so much of the best sculpture of the Northern Ch'i Dynasty, executed with technical perfection in the beautiful white marble of the Pao-ting and Ting-chou area, were apparently thriving and abreast of the times in the eighth century. The noble torso of a Bodhisattva now in the Cleveland Museum is sculptured with sureness and power [102]. The forms of the scarves and the multiple folds of the dhoti are rather heavy and are cut into the stone with striking directness. In contrast to the delicate elegance of the Freer figure, this Bodhisattva is conceived with grandeur from the long legs that are almost like a fluted column to the large scale of the jewellery. The thick scarves loop across and soften the strong vertical created by the close-packed folds of the skirt. Judging from this and other sculptures from the same area, it is apparent that the arms were made separately and fastened on with iron cleats sunk in the stone. Since these cleats would be visible, it is

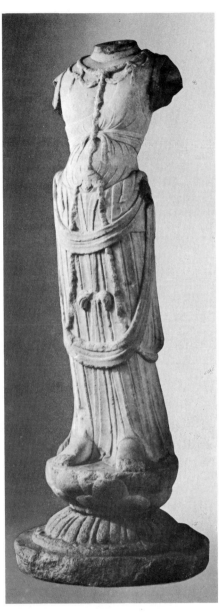

102. Bodhisattva, white marble, from Hopei. Eighth century.
Cleveland Museum of Art, J. H. Wade Collection

probable that the whole figure was originally covered with a thin coat of gesso and painted. The fresh, direct carving, in which there has been very little use of abrasives, would in that event have been covered over. Although the surface we see to-day is not precisely what the sculptor intended as his final product, this should not in the least deter us from admiring the sureness of a craftsman who was master of his art.

The same admirable proficiency of the T'ang stone-sculptor, as well as a certain kind of exuberance characteristic of T'ang art, is illustrated by a piece of sculpture which once served as the front of a small stūpa or pagoda [103]. Originally a Buddhist deity or trinity was housed within and so the façade is ornamented with dragons, lions, and threatening, super-muscular guardians all acting as protectors of the high gods within and as symbols of the church militant. An energetic dancer above the entrance and musical angels drifting down on either side, probably represent the bliss of paradise. Some of the features first

103. Front of a stūpa, stone.
Seventh century.
*Kansas City, Nelson Gallery of Art
and Atkins Museum*

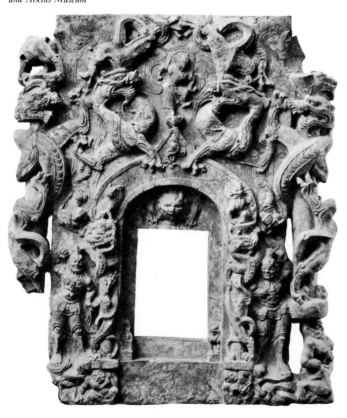

remarked in the sculpture of the Northern Ch'i Dynasty are evident here. For example, the columns on either side of the doorway and at the extreme side of the façade are supported by straining Atlantean figures. But more particularly there is the same desire to bring the stone to life, to suggest that it has no solidity. None of the cutting has yet been softened by the use of abrasives, so that in the sweeping curves of the dragon the stutters of the sculptor's chisel are still visible. In spite of the rich, ornate design, full of writhing movement, it is all held together

104. Bodhisattva, polychromed clay, from Tun-huang, cave 143. Eighth century.
Cambridge, Mass., Fogg Art Museum

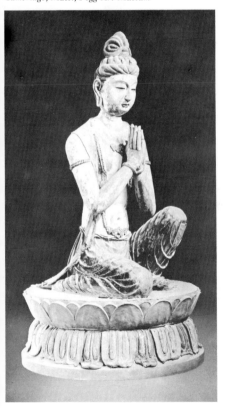

by a well-integrated system of thrusts and counter-thrusts, in which each element holds its place and contributes to the whole. T'ang realism is evident in the dragons, as organically convincing as any Eastern or Western animals of the fantasy.

The mature T'ang style with its attention to flowing drapery and rounded forms was, as already mentioned, especially suited to the modeller's technique. In the Fogg Museum, Harvard, there is a charming figure of an adoring young Bodhisattva, done in modelled and polychromed clay [104]. It originally stood with its mate in a group in cave 143 at Tun-huang which was decorated some time during the eighth century. The tender reverence of the figure has a sincerity and simple dignity about it that cannot but make us regret all the more the loss of so much Chinese religious art. There is here no hint of the grossness which creeps into later sculpture; the slim torso, sloping shoulders, and oval head, as well as the placid face in which the eyes are now almost horizontal and the brow a long, flat curve, are all expressive of supramundane religious devotion. The pleat-like folds and rounded ridges of the dhoti show how appropriate these forms are to the technique of modelling. Indeed, the easy flow and spread of the drapery forms, the sweep of the scarf and the fleshy modelling of the hands seem scarcely appropriate in any less pliant medium and raise the question whether Chinese sculpture in stone of the late sixth, the seventh, and the eighth century was not, perhaps, strongly influenced by the manner of working in clay or in wax towards a final casting in bronze.

Among T'ang Dynasty bronze images on a minor scale, one of the best is an image of Śākymuni Buddha seated with the hands in the gesture of 'Turning the Wheel of the Law', *Dharmacakra mudrā*, symbolic of the Buddha preaching, and especially the first sermon in the Deer Park at Benares [105]. This figure, now in

the Metropolitan Museum, is eight inches high and in a remarkable state of preservation, the heavy, pale yellow gilding completely covering the figure, with the exception of the hair. The very just proportions, simple, functional folds, and general treatment of the forms in broad, plastic masses, suggest a date early in the years of T'ang maturity, between, say 700 and 720. There is in the sculpture the same informing silhouette, describing the body in terms of volume, that is to be found in the best T'ang figure painting. The swelling chest with a minimum of modelling contrasts well with the rather intricate and delicately modelled hands which remind us of the beautifully painted hands of the Amida in the wall paintings of Hōryūji at Nara. Although the body is full and solid, and the three creases of the neck suggest ample fleshiness, the figure is far from stout and has that perfect balance and relationship between parts that removes all sense of scale so that the image could well be of heroic size.

Late in the T'ang Dynasty there was an ever-increasing tendency towards a complication of

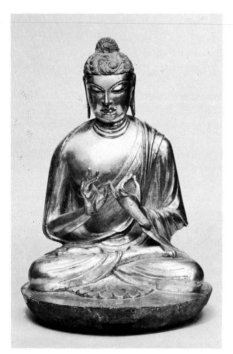

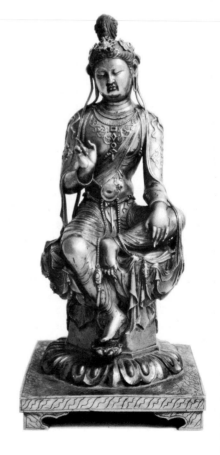

105. Buddha preaching, gilt-bronze.
Early eighth century.
New York, Metropolitan Museum of Art

106 (*right*). Bodhisattva, gilt-bronze.
Ninth century.
Philadelphia Museum of Art

forms, a break-up of the surface and restless movement of the drapery in a complexity of folds, while the bodies became increasingly stout – a plumpness especially evident in the hands and faces. A seated Bodhisattva made of gilded bronze, in the Philadelphia Museum, is probably a work of the ninth century [106]. The drapery caught up in numerous folds over the dais is rather like some of the sculpture at T'ien-lung Shan, but even more complex and less lucid. A kind of full-blown beauty, languorous to the point of being somewhat heavy, pervades the figure. The face, with its broad cheeks and small mouth, is a type obviously derived from the ample beauties popular at the T'ang court in the days of Ming Huang. The technical execution is of a high quality, all the fine details of the necklace, hair, and ribbons being cast, rather than worked in cold metal. The monumental solidity of the mature eighth-century T'ang style, like that of the Metropolitan Śākyamuni, has been sacrificed through a conscious striving for elegance and rich detail.

Several of the T'ang imperial mausoleums were enriched by large sculptured figures of horses, lions, and also of court officials. The earliest are the six bas-reliefs, over five feet high, depicting favoured battle chargers of Li Shih-min, founder of the T'ang Dynasty, who is known to posterity as T'ai-tsung. The tomb was commissioned by the emperor in 637, and these reliefs were presumably installed in a fore-temple or gate-house. Two of them are now in the University Museum, Philadelphia. There is a tradition that the designs were made by the great artist of the period, Yen Li-pên. The designs are so excellent in their unadorned and direct conceptions and so justly spaced in the rectangles they occupy that it seems probable that the cartoons were the work of such a leading court artist. As sculpture, however, they follow the old tradition, familiar from numerous steles of the sixth century, of translating linear drawings into bas-relief.[7]

Sculpture in the round is found at the tomb of the emperor Kao-tsung (d. 683), where horses, lions, and a number of officials line the long spirit road before the tomb near Hsien-yang in Shensi. Most of the pieces are the heavy, ponderous works of stone-masons, completely lacking in all the life and heroic grandeur of the lions and chimeras of the Liang and Southern Ch'i tombs near Nanking. However, the best of the figures, a large winged horse, of which we reproduce only a detail [107], is more interesting in that it combines plastic solidity and charac-

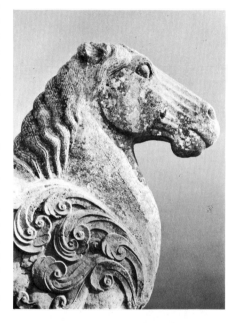

107. Hsien-yang (near), Shensi, tomb of Emperor Kao-tsung (d.683), horse (detail), stone

teristic T'ang realism with the old love of linear design. A series of arbitrary parallel grooves along the nose, that lend bony structure to the

skull, and the strong emphasis on the flat cheek plane, hark back to old Han and pre-Han formulas, while the soft character of the muzzle and lips and the waving locks of the mane are skilfully combined notes of realism. In the swirling, foliate pinions the sculptor has given full play to his genius for linear pattern. The direct, fresh cutting is done in such a manner that, as in the Bodhisattva of Lung-mên [97], the bevelled surfaces create a linear design in high-light and shadow.

It is in animal sculpture on a relatively small scale that the devotion to realism, current in all the arts of the eighth century, is most evident. There are a series of lions in marble and serpentine, in which the sculptors have combined, with great felicity, their knowledge of the structure and natural articulation of the beasts with elements of formal design at once abstract and descriptive. Such an equilibrium between representation and design, a combination of knowledge and expression held in a subtle

108. Lion, white marble.
Early eighth century.
*Kansas City, Nelson Gallery of Art
and Atkins Museum*

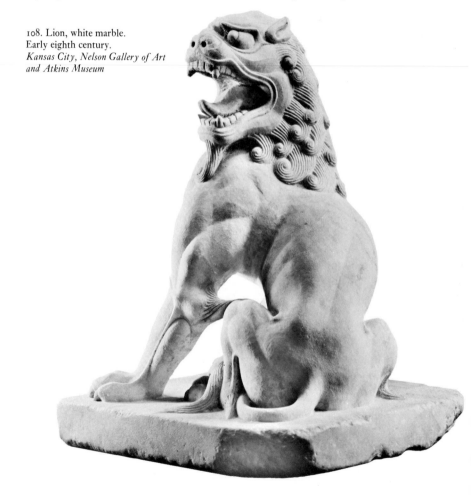

balance, marks the culmination of the mature T‘ang style.

A lion sculptured in the white marble of the Pao-ting-Ting-chou area of Hopei [108] is slightly less than a foot high but, as in the gilt-bronze Śākyamuni of the Metropolitan Museum, the justness of the proportions makes it transcend the limitations of scale. An exact dating is difficult, but the lion was probably made between 700 and 750. The lean, muscular body, glaring eyes, and roaring mouth, no less than the powerful, sharp-clawed paws, all vividly portray a beast of fierce vitality. The sculptor has employed enough of realism, derived certainly from a close observation of the material world, to create a strong conviction of energy and complete articulation. At the same time he has imposed on the whole a brilliant, formal pattern. This interplay between realism and design is accomplished as much by the cutting of the stone as by the conventionalization of some forms and the soft, natural modelling of others. In the head, with its sharply bevelled surfaces, the shoulder with its almost quilted muscles, the straight, clean line of the tendons of the foreleg, and the stylized curls of the mane, the cutting is all sharp and decisive, freely exhibiting the chisel marks. In contrast, the bulging body, with its slight indication of the rib-casing, the bone structure of the rear quarters, the folds of skin over the flanks, are all more softly modelled, and the cutting has been smoothed with abrasives. Moreover, this lion, like others of the same general type, is truly conceived in the round, to be effective from any point of view.

The degree of success or failure obtained by the T‘ang sculptors in their striving for plastic volume seems directly related to their skill and degree of contact with contemporary styles. This means that the sculpture most expressive of T‘ang ideals would have been produced in those very areas where loss and destruction have been most extensive – the large metropolitan centres, Ch‘ang-an, Lo-yang, and the Yellow River valley. In contrast, provincial and conservative work with strong tendencies to revert to traditional linear styles had better chances of survival. Thus it is difficult to arrive at a proper evaluation of T‘ang sculpture from the mature period, the second half of the seventh and first half of the eighth centuries. Some suggestions may be gleaned from surviving material of the kind described above and from Japanese sculpture of the Tempyō period.

後周武帝宇文邕在
位十八年五帝興廿五
致滅佛法

周文帝楊堅在位廿年

109. Yen Li-pên:
Portraits of the Emperors (detail).
Seventh century (?).
Boston, Museum of Fine Arts

T'ANG DYNASTY PAINTING

YEN LI-PÊN

With the return of an empire comparable in strength and prestige to the Han Dynasty, court painting in the direct tradition of early times reached new heights of accomplishment. Portraits of celebrated scholars, worthy officials, and rulers of the past had been subjects dear to the artists of Han, as were illustrations of filial piety and tribute bearers from foreign lands. These subjects had not been neglected during the intervening centuries, but it was in the T'ang Dynasty that figure painting came into its full power. During the seventh and eighth centuries, a long procession of great artists built a tradition of figure painting, both religious and secular, so brilliant that it dominated that special sphere of art throughout the rest of Chinese history.

Dragons, gnomes, witches, and the whole rich world of the supernatural faded gently out in the full sunlight of T'ang rationalism, forthright worldliness, and assurance. The ponderous majesty of an emperor, the frail emaciation of an ascetic, the poise and well-groomed refinement of a court beauty, no less than the spirit of a high-bred horse, were challenging subjects which the T'ang artist attacked with confidence. Their art is lucid, balanced, and at once elegant and solid.

With the T'ang Dynasty we are still in a period from which little has been preserved, particularly from the extensive production of the most celebrated court artists. There are, however, a few works that are possibly original, fragments and suggestions from provincial sources, and copies made in the tenth and eleventh centuries, when original works were probably still extant. From such material some glimmer, at least, of the magnitude of T'ang painting can be obtained.

Yen Li-pên, the most celebrated artist at the court of T'ang T'ai-tsung (r. 627-49) and his successor Kao-tsung (r. 650-83), is reputed to be the painter of a famous scroll entitled 'Portraits of the Emperors', now in the Boston Museum [109, 110]. The picture, done in colours on silk, shows thirteen emperors from the Han Dynasty down to the last of the Sui Dynasty rulers. The thirteen figures, several with attendants, are presented on a continuous scroll without any relationship to one another and with no background. The first six emperors are a replacement, executed by a far less skilled hand than the rest and possibly added in the tenth or eleventh century, but the other seven are much older, and whether or not they are by Yen Li-pên there is nothing in the manner of painting or style that is inconsistent with the period, A.D. 627-49, when according to tradition the scroll was painted.[1] Isolated against the plain background, the figures possess a quality of bulk and weight quite different from the light, almost ethereal figures of the Ku K'ai-chih 'Admonitions' or the Nelson Gallery sarcophagus. This sense of volume is to some extent obtained by the drawing of the garments, the folds of which so properly fit the body. A comparison between the two emperors reproduced here, Ch'ên Wên-ti (r. 560-6) [110] and Wu-ti of the Later Chou (r. 561-78) [109], will show the differences in characterization. Without reading qualities of personality into these two faces, they may be more meaningful when one knows that Ch'ên Wên-ti was absorbed in the mystic speculations of Taoism, while Chou

Wu-ti was concerned about the practical administration of government in the Confucian tradition and was an implacable foe of Buddhism. Throughout this scroll, the brush line is of even thickness and relatively broad, particularly in the outer contours. In certain areas, notably in the garments of the attendants to Wu-ti and on the skirt of Wên-ti, there is rather strong shading used in an arbitrary manner to emphasize the folds. There is also a slight amount of shading in the face of Wu-ti. As has already been said, such shading is a contribution to T'ang figure painting, probably the chief one, of foreign artists from such Central Asian cities as Khotan. This technical device died out in the Later T'ang period, but survived in certain Buddhist paintings and as an archaism in Sung Dynasty paintings consciously following the full T'ang style. Shading, when employed to suggest the plastic quality of form, is not congenial to basic aesthetic concepts of the Chinese. To the Chinese mind, perhaps, chiaroscuro, of the kind developed by late Classic and European painters, violated the proper nature of a flat surface, was an obstruction to the imagination because it defined the source and intensity of light, and so suggested a transient moment in time. Moreover, an extensive use of shading would tend to obscure the all-important clarity of the brush drawing.

Yen Li-pên is a good example of a T'ang court artist and his subjects show the kind of paintings favoured in high circles. His father, Yen Pi, and his elder brother, Yen Li-tê, were both painters of note; the latter was also employed as an architect and designer of such court paraphernalia as carriages and flags. Because of his ability as a painter, Yen Li-pên rose to high official rank, holding successively such offices as Senior Secretary of the Peerage Bureau, Grand Architect, President of the Board of Works, and finally, in 668, became one of the two State Ministers. One frequently reads in the lives of celebrated painters that they held one or another high office. It is always a question whether these offices actually involved arduous administrative duties or were merely sinecures for a favoured artist, while the real work was done by the army of secretaries and minor officials who were the draught horses of the vast Chinese bureaucracy. In any event, Yen Li-pên was called upon by the emperor to paint portraits of the eighteen distinguished scholars, and of the twenty-four famous men for the Imperial gallery. He painted the curious foreigners who thronged to the court, a lion sent from Sogdiana, and – so a disputed legend goes – a curious bird that struck the emperor's fancy. Like many other leading painters of the T'ang Dynasty, Yen also painted Buddhist subjects. His painting of the 'Visit of Mañjuśrī to Vimalakīrti' was especially famous.

BUDDHIST PAINTING

Not one of the countless Buddhist paintings executed by leading masters of the T'ang period has, in this writer's knowledge, survived. The many chapels, however, at the Caves of the Thousand Buddhas near Tun-huang, decorated during the T'ang Dynasty by extremely able professional temple painters, and the paintings on silk and paper recovered by Sir Aurel Stein from a walled-up storage cave at that site, present a vast amount of material for the study of Buddhist painting from the seventh, eighth, and subsequent centuries. By the mid seventh century the artists had begun to break away from the old manner of dividing the walls into registers and areas of relatively limited size and were essaying compositions on a grander scale, better suited to a broad expanse of wall. By the eighth century compositions had been evolved that were filled with figures, architecture, and landscape, suitable to an expanded scale. There are several such that depict the visit of the Bodhisattva Mañjuśrī to Vimalakīrti.[2] The old Vimalakīrti was ill, and Mañjuśrī alone of the

110. Yen Li-pên:
Portraits of the Emperors (detail).
Seventh century (?).
Boston, Museum of Fine Arts

Bodhisattvas was willing to visit him at Buddha's request, since all the others were fearful of the profound religious questions which the old king might ask. A host of heavenly beings attended Mañjuśrī that they might hear the discourse.[3] The most complete picture of this theme in the published reproductions is that of cave I, decorated in the eighth century.[4] The scene is like a pageant on a grandiose scale [111]. The setting is within a walled city of which the triple gate occupies the centre of the composition. On the left, surrounded by Guardian Kings, haloed warriors, and demons, Vimalakīrti is seated on a high dais under a canopy. Opposite him Mañjuśrī is enthroned surrounded by his heavenly host. By means of the ground plane being strongly tilted from the back, a wide view of landscape with hills and streams is visible beyond the city wall. In the centre at the top of the picture, Śākyamuni Buddha, with

Bodhisattvas, monks, and guardians, occupies an island. There is no single vanishing point, but a central axis of multiple vanishing points that runs through the centre of the gateway and extends beyond the upper edge of the picture in the case of the farther corner-towers to right and left. Although the thrones, altars, and architecture are drawn on diagonals converging on the vertical axis and the spectator is looking down upon the roofs of the corner-towers, each group of figures is drawn as though seen straight on. In the over-all design the multitude of figures does not overcrowd the composition because of the careful grouping in two semi-circles or converging crescents. Also the architectural setting, extending in converging diagonals back into the picture from the corner-towers at the extreme right and left of the foreground, serves to knit together the numerous groups of personages and gods.

111. Tun-huang, Kansu, cave 1, wall painting of the visit of the Bodhisattva Mañjuśri to Vimalakīrti. Eighth century

The figures are admirably drawn, and the entire painting is purely Chinese. The Tun-huang compositions of Mañjuśrī and Vimala-kīrti are strikingly similar in general scheme, suggesting that they all may be based upon one early and famous version. In the immediate foreground, to right and left are groups of individuals surrounding a person of importance, possibly the leaders of the Men of Substance who were attracted to the scene by the smell of the wonderful rice brought to Vimalakīrti by a Dhyani Bodhisattva. The figures on the side of Mañjuśrī in all the Tun-huang compositions are obviously Chinese; the principal figure with his mortar-board hat and outspread arms supported by attendants is like some of the emperors in the Boston scroll attributed to Yen Li-pên. On the opposite side, associated with Vimalakīrti, the figures are non-Chinese and wear Central Asian dress. The two groups are

of special interest in that they show non-religious figures in what were probably con-temporary costumes.

The use of shading in Chinese figure paintings has already been mentioned in connexion with the Ku K'ai-chih scroll of the 'Admonitions' and also the 'Emperors' scroll in Boston. The manner must have enjoyed considerable popu-larity during the T'ang Dynasty, if it did not form a distinct style or branch of figure painting, derived from styles of Central Asia and coun-tries farther west. A non-Chinese dignitary with his attendants, some light-skinned, others quite dark, and a retinue in Central Asian garb, show the use of strong shading in a way less arbitrary than is generally the case [112]. This group comes from the Vimalakīrti side of another version of the famous discourse with Mañjuśrī, painted probably in the first half of the eighth century in cave 51 E at Tun-huang.[5]

112. Tun-huang, Kansu, cave 51 E,
detail of a wall painting of a dignitary with his retinue.
First half of the eighth century

The main figure, barefooted like his immediate attendants, is a stout personage with very fair skin and a full red beard; his arms are supported by two attendants, while two others precede him carrying offerings. The semi-nude attendants, both light-skinned and dark, are strongly shaded on the right side, and there is also marked shading on their scarves and the garments of the entourage. Such shading is not a device to indicate a source of light but is employed solely for the purpose of creating an illusion of solidity and form – a manner congenial to the new interest in volume that had been evident in the late sixth century and played an important part in the sculpture and painting of the first two centuries of the T'ang Dynasty.

Such a way of painting was far more developed in Central Asia than in China, as is evident, for example, in the Chinese accounts about the paintings by two artists from Khotan who were active at the Chinese court – Wei-ch'ih Po-chih-na and his son Wei-ch'ih I-sêng. The latter had been sent to Ch'ang-an by the king of Khotan about A.D. 630. He executed a number of Buddhist frescoes and was greatly admired; his painting, however, was considered to be of a style at variance with the Chinese tradition, and particular mention is made of his flowers in relief that seemed to stand out from the wall. There were other painters, both Central Asian and native Chinese, who worked in a shaded style – a style that combined features of Indian painting and the modifications and additions contributed by the city-states of Central Asia. It is natural that examples should be found in the cosmopolitan art of the Tun-huang oasis, but in China proper the style must soon have been considerably altered to harmonize with Chinese tradition.

Mention should be made here of the important group of Buddhist wall paintings in the kondō of Hōryūji at Nara in Japan which, until severely damaged by fire in 1949, were the supreme examples of early Buddhist frescoes

in eastern Asia. The wall paintings were executed in the early part of the eighth century, probably about A.D. 711. Whether they were done by a Chinese, Japanese, or Korean artist is immaterial, but it is certain they have close affinities with continental T'ang art and represent a strongly Chinese version of an 'international' style, that combined elements derived from India, Iran, and Central Asia. Any of the sensuality that in the Ajaṇṭā frescoes of Gupta India was in no way inconsistent with deep religious spirituality, in the Hōryūji frescoes has been diluted and lightened, shorn of the flesh, as it were, by a Chinese intellectual distillation translated into different but equally valid terms of line drawing. Especially in some of the lesser figures at Hōryūji there is extensive, well-defined, though arbitrary shading, appearing in some as dark patches along the upper surface of the arms; but in the principal gods – Buddhas and Bodhisattvas – the shading is used with moderation, often as though only to fortify an outline, so that the fluid drawing may be more apparent in its lucidity. The shading is but an addition, a further pointing up of form already completely defined by the incomparable line of Far Eastern drawing. Although, as has been mentioned, comparisons may be found between certain elements of the Hōryūji frescoes and Buddhist paintings of Central Asia and Tun-huang, none of these latter can in any way compare in total effect with the ethereal spirituality of the Hōryūji cycle. It seems probable, then, that the Hōryūji paintings are the lone survivors of a tradition derived ultimately from the Indo-Iranian style of Central Asia, but one that evolved at the great metropolitan centres of Chinese culture during the seventh century.[6]

Among the most popular themes at Tun-huang was the Western Paradise of Amitābha, for this Buddha and his promise of heavenly bliss to the devout continued in vogue at Tun-huang some time after his worship had declined

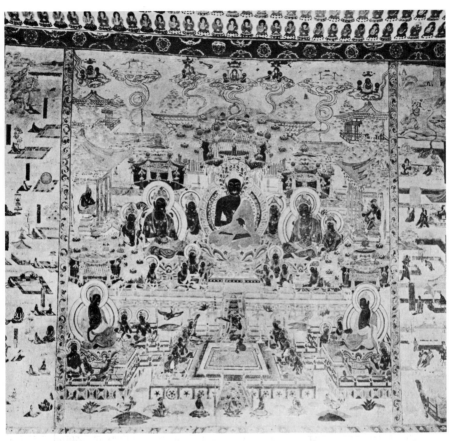

113. Tun-huang, Kansu, cave 139 A,
wall painting of the Western Paradise of Amitābha.
Latter half of the eighth century

in more important centres of Chinese Buddhism. The artists lavished on the Paradise of Amitābha all the exuberant detail of the most sumptuous earthly dwellings their imaginations could create. The splendid example in cave 139 A, painted in the second half of the eighth century, is characteristic [113]. A lotus pond is in the foreground where the souls of the reborn appear rising from the hearts of the lotus flowers. Built over this pond are three platforms connected by small bridges. On the central one a dancer performs to the music of ten musicians, five on either side; Buddhas accompanied by Bodhisattvas are enthroned to right and left. Behind, on a great platform, rise the halls, galleries, and storeyed towers that are the homes of the gods – wonderfully airy architecture that must certainly reflect the imposing temporal palaces of T'ang. Here Amitābha is seated on a multi-coloured lotus throne flanked by the

great Bodhisattvas, Avalokiteśvara and Mahā-sthāmaprāpta, and lesser gods; jewelled balda-chins hang above the three main deities and a flowering tree spreads behind the central Buddha. In later versions, these paradise scenes are filled with myriads of heavenly beings rising tier upon tier, and the architecture becomes more and more complex, as though the artists sought to raise their descriptions of bliss to a higher and higher power. Here, however, in spite of the wealth of detail, the vision is re-vealed in basically simple terms. The figures are admirably grouped and by a subtle relation-ship in scale, the main image, Amitābha Bud-dha, looms enormous and motionless, the benign Lord welcoming the devout to his Western Paradise.

The static calm created by the absolute sym-metry of the composition and the incomparable Asiatic formula for the Buddhist gods, is broken only by the young girl on the central platform, who performs her Indian dance before the deities and the blessed. The picture is a religious icon and so is constructed from the point of view of the worshipper who would be below looking up. The strong diagonals of the platforms to right and left in the foreground converge on the breast of Amitābha. An imaginary horizon, as Bachhofer has pointed out, runs through the eaves of the central hall. All diagonals below this horizon ascend and all above it descend, with the curious exception that the railing on the balconies of the two highest pavilions above the horizon also ascend.

The character of the drawing can be appreciated in a fresco fragment from this same cave, 139 A, now in the Fogg Museum, Harvard [114]. It is the most direct kind of painting, done with freshness and facility. The serene Bodhisattva, warrior-guardians of the faith, and the holy monk are painted in a straightforward way remarkably free from conscious elaboration or striving for an effect. Jewellery and patterned areas are rendered large and the inevitable preoccupation with over-abundant and meticulous detail is still some centuries off. Strong lines of even thickness define the garments and figure of the Bodhisattva, but the lumpy skull and aged face of the monk on the left are painted with a heavier and more flexible line. The drawing of this handsome head is simplified and immedi

ately telling. Altogether, in drawing and area patterns, the Fogg fragment is painted in a way perfectly suited to covering broad expanses of wall. The frescoes and paintings of Tun-huang are representative of a church art that drew its strength from an amassed tradition. An individual artist might add something from his own inspiration to the compositions, or to the figures of accepted types, or he might alter his design with a borrowed detail, but he worked always within the frame of established formulas that had been gradually evolved by generations of temple painters.

Somewhat the same formula as that of the old monk's head in the Fogg fresco appears in the head of a shouting monk, a fragment of a T‘ang painting recovered from Turfan and

114 (left). Fragment of a wall painting from Tun-huang, cave 139 A.
Latter half of the eighth century.
Cambridge, Mass., Fogg Art Museum

115 (above). Head of a monk. Fragment of a silk painting, from Turfan, Central Asia.
Latter part of the eighth century.
Berlin, German State Museums

now in the collection of the German State Museums at Berlin [115]. There is the same shape of the skull, the bulging cheek, the fold in front of the ear, one line for the chin and one for the jaw. But the drawing is of a different kind. The Berlin fragment comes from the brush of a very able artist painting on silk on a relatively small scale. There are subtleties of

line variation that would be lost in a wall painting but are expressive and suitable on silk. The form of the shoulder and outstretched left arm are admirably established by the descriptive silhouette characteristic of good T'ang drawing. Solid volume is created by the thickening of the line, where accent is needed as on the crown and the back of the head, at the corner of the jaw and on the heel of the palm of the upraised fist.

The silk banners and drawings on paper discovered by Sir Aurel Stein could not be taken for anything save the work of professional craftsmen, some possibly skilled above average. Yet the unquestionable authenticity of these paintings, the wide range of compositions, of manners of representing the gods, the portraits of donors, the illustrative scenes with contemporary figures in landscape – in short, the whole varied and incredibly rich range of a sophisticated and complex religious art is so completely represented, that the quality of painting becomes of lesser importance. Eighteen of the works are dated; the earliest is A.D. 864 and the latest 983. A number of the paintings are certainly earlier, however, than the earliest dated example.

Many of the paintings, because of the composition, colour, and character of the decorative motifs, suggest that a really great concept lay at the point of origin. However, in passing through the hands of copyist after copyist, the designs became less and less expressive of the original creative impulse, and tended to become increasingly schematic, formal, and abstract. Specifically, the Tun-huang banners seem to have lost the most in lucidity of drawing and the representation of volume and space. But they function just as effectively as icons, because to the devout the only consideration of moment was what was represented and not how it was done.

A Paradise of Amitābha, in good condition and brilliant in colour, preserves a composition that may have originated in the latter part of the

seventh or the very early eighth century [116]. The painting, which is on silk, represents a relatively high standard of craftsmanship and is probably a work of the eighth century, though how early or late within that period, is difficult to say. Compared with a paradise scene such as that of illustration 113, the design is strikingly bold and simple. The large figure of Amitābha Buddha dominates the scene. The Bodhisattvas are of rather marked Indian type in features and languorous pose, while the monks in the background are distinctly Chinese. The whole picture is remarkably flat; although the lotus throne of the Buddha is brought well into the foreground, the relationship of the figures in depth is not immediately clear, and we are only informed of their positions by one overlapping the other. A non-descriptive, schematic quality has crept into the drapery folds which are no longer as lucid and suggestive of form as we would expect them to be in the mature T'ang period. There is extensive use of shading in the deities, and a rather unusual kind, that occurs on some of the other Tun-huang paintings, is the white high-lights, limited here to the faces of the monks. All this shading, however, adds little to a sense of volume. A quality of magnificence is contributed by the rich, complicated floral ornament concentrated on the throne and baldachin, while the heavenly nature of the scene is further emphasized by the lithe young angels swooping down on clouds from the top of the picture. Despite the technical shortcomings of this Paradise of Amitābha, the concept is so valid and the formulas are so expressive of a religious ideal that only a careful examination reveals the extent to which it has become diluted. There must have been at some distance from this painting, not necessarily in

116. Paradise of Amitābha.
Painting on silk, from Tun-huang.
Eighth century.
London, British Museum

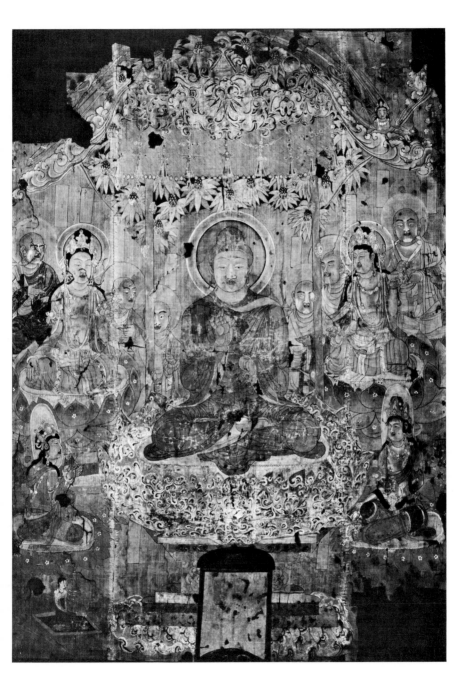

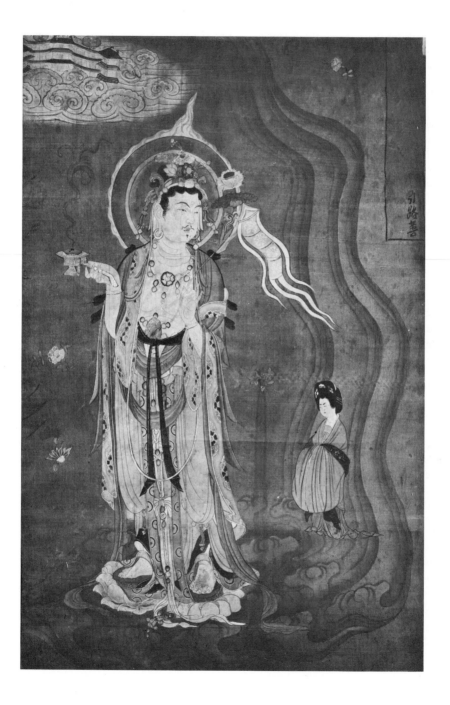

time but in freshness and clarity of vision, a grand and monumental paradise scene.

Those of the Tun-huang paintings that show a single Buddhist figure are frequently less formalized and more immediately appealing. Some are quite Indian in character, but others, like the Kuan-yin as the Guide of Souls [117], show a purely Chinese version of the Bodhisattva that was evolved in the T'ang Dynasty and became the standard for all subsequent Buddhist art. Kuan-yin, holding a lotus and a smoking incense burner, sweeps down on a purple-red cloud from the mansions of paradise in the upper left corner. The great Bodhisattva looms large over the world in contrast to the small and demure court lady who stands with head bowed. There is a distinct feminine cast to the Kuan-yin figure, but the small moustache and imperial indicate the dual nature of the Bodhisattva. Indian semi-nudity has been clothed, in conformity with Chinese taste, by a multitude of shawls, scarves, sashes, and an ample skirt caught up below the knees by ropes of jewels. The stately proportions and all the elements of dress, even to the lotus-decorated crown and the sash-ends falling between the feet, are continued well into the thirteenth century, at least in north China, as the vast wall paintings and numerous wood figures from Shansi testify. The painting was most probably executed in the tenth century.[7]

Buddhism as a great church religion had reached its culmination in China during the seventh and eighth centuries. A large part of the national creative energy, as well as finances, must have been devoted to the glorification of the faith through the building of temples and monasteries elaborately furnished with images, painting, and frescoes. Almost without exception the leading artists of the seventh and eighth

117. Kuan-yin as the Guide of Souls.
Painting on silk, from Tun-huang.
Tenth century.
London, British Museum

centuries painted religious themes, even though they may have been known for secular subjects as well. Some, like Wu Tao-tzu, were almost exclusively painters of Buddhist and, to a lesser extent, Taoist subjects. Much of the wealth of T'ang painting was on the walls of Buddhist establishments. An important temple, such as Tz'e-ên-ssu in Ch'ang-an, for example, had wall paintings by such famous artists as Wei-ch'ih I-sêng, the painter from Khotan, by Yen Li-pên, Wu Tao-tzu, and numerous other accomplished but lesser-known painters. All these are lost today. The majority must have been destroyed or fallen into decay during or shortly after a great persecution of the Buddhist church that occurred in 845. Buddhist art never really recovered from this persecution, not because of the physical devastation but because of changes within the church itself.

Buddhist and Taoist scroll paintings from the early periods were still much admired by painters, critics, and collectors in the Northern Sung Dynasty. The early twelfth-century catalogue of the Imperial Collection, *Hsüan ho hua p'u*, lists Buddhist and Taoist paintings together. Of such pictures, both hanging scrolls and handscrolls, the collection contained a total of one thousand two hundred and seven; there were one hundred and one from the centuries preceding the T'ang Dynasty, beginning with nine by Ku K'ai-chih of Chin; three hundred and forty-four T'ang paintings, and three hundred and forty-nine from the Sung Dynasty up to the early twelfth century. Although a number of the early, pre-Sung attributions may have been over-optimistic, still the collection was one of impressive size. Whether or not any of these paintings have survived into our own time, it is impossible to say. The Imperial Collection of the Ch'ing Dynasty contained, in the eighteenth century, a large number of Buddhist and Taoist paintings, but few of these have been exhibited or published, and of those that have, not many are particularly impressive.

The paintings recovered from the Caves of the Thousand Buddhas and the frescoes that still cover the walls, and those of similar lesser sites, such as the excellent frescoes at Wan-fo-hsia,[8] assume an added importance because of the light they throw on the lost Buddhist art of China proper.

It was not, however, the competent painter following with professional skill the traditions of his craft and an established iconography who moulded the course of Chinese painting. It was, rather, as in all countries and all times, the particularly gifted individual who by his creative genius inaugurated new forms significant of the intellectual and spiritual character of his epoch. And so, although the actual surviving material is lamentably meagre, it is best to return to a consideration of the men whose names are among the most famous in the history of T'ang painting.

THE COURT PAINTERS

Among the court painters the one whose fame overshadows all others, and has grown through the writings of Chinese art historians until it holds first place, is Wu Tao-yüan, better known as Wu Tao-tzu. Born about 700, his period of greatest activity appears to have begun about 725 and lasted past the middle of the century. A great natural genius and a man of limitless energy, Wu Tao-tzu poured out his talent in decorating with frescoes the walls of the great temples of Ch'ang-an and Lo-yang. The T'ang Dynasty, indeed, witnessed the culmination of this particular form of painting, so admirably suited to the nature of Chinese architecture with its broad expanses of unbroken wall. A ninth-century writer, Chu Ching-hsüan, relates that in the pagoda of the wonderful temple of Tz'e-ên-ssu there were the two Bodhisattvas Mañjuśrī and Sāmantabhadra; in the same temple was the 'Subjugation of Mara' with coiling dragons; and another temple had a wall with

scenes of Hell which, according to a later writer of the ninth century, were 'painted in outline, with a furious energy of brush. So sombre and strange were the monstrous forms that those who caught sight of them unwittingly felt their hair stand on end.'[9]

The latter two wall paintings, 'Subjugation of Mara', in which the Buddha overcomes the temptations and physical attacks of the Evil One, and the Hell cycle, were both themes allowing full scope to a rich imagination and calling for violent action and swirling movement. And these qualities seem to be among the leading contributions of Wu Tao-tzu. Unfortunately not a single work of this most celebrated of China's painters is known to have survived into modern times. Following the Buddhist persecutions of 845 that encompassed the destruction of 4600 temples and some 40,000 shrines[10] the paintings of Wu Tao-tzu became extremely rare. In the late eleventh century Su Tung-p'o, poet and painter, wrote that no more than one or two remained; and as for the scroll paintings, Mi Fei, a painter, calligrapher, and critic of the eleventh century, recognized no more than four as genuine, and this in spite of the ninety-three paintings attributed to the master in the catalogue of the early twelfth-century Imperial Sung Collection.

One could speculate at length on the individual style of Wu Tao-tzu and his contribution to the body of art tradition. There are some engraved stones from which rubbings are made and a number of later copies said to be after compositions by Wu. All of these may reflect something of his manner, but few if any bring the man to life as the towering genius he must have been. Over and above the great creative imagination of Wu Tao-tzu and his technical skill that amazed all his contemporaries, he seems to have brought to the brushwork a new kind of energy, a looser, freer, and more personal style than had existed previously – or, it is probably more accurate to say, than had pre-

viously been used by a leading artist of such creative powers. There is a rough and cursory sketch of a Bodhisattva painted in ink on coarse cloth preserved in the mid eighth-century collection of the Shōsōin at Nara in Japan [118]. The brushwork is free and bold, the scarves billow out with folds and twists that contribute materially to the sense of volume. The figure,

too, is rendered solid and plastic by means of the drawing alone, but at the same time the brush-strokes are reduced to the essential minimum. The varying thickness of the lines, like those defining the jaw and neck, may to some extent result from the hasty nature of the drawing, but they add so important a part to the sense of form that it is tempting to think them intentional.

118. Sketch of a Bodhisattva.
Ink on hemp cloth. Mid eighth century.
Nara, Japan, Shōsōin

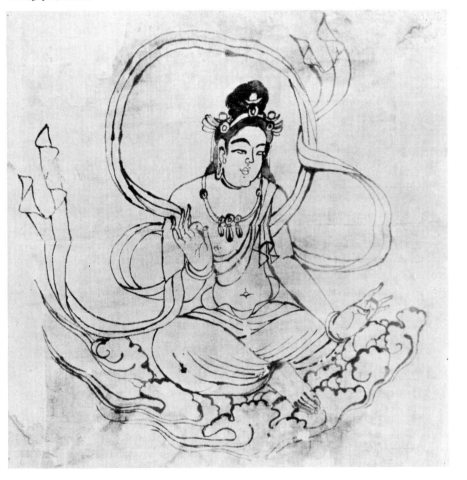

The entire drawing is basically different from the precise, restrained, and rather formal manner of the Tun-huang banners. This Shōsōin painting is offered here with all humility as possibly suggesting something of the vigour, spontaneity, and plastic solidity that was the contribution of Wu Tao-tzu.

One at least of the stone engravings traditionally after a design by the great T'ang master scheme of waving hair, flowing scarves that double and turn, and the rather thick, flowing line are strikingly similar to the eighth-century Bodhisattva of the Shōsōin. Above all, behind the hard medium of engraved stone and a design at second or third hand, there is still some glimmer of a genius that contrasted the strong diagonal of the axe-shaft and outstretched leg on the right with the turbulent movement on

strongly suggests the same style [119]. The stone, which is in a temple at Ch'ü-yang Hsien, Hopei, shows a demon armed with a halberd, gesticulating wildly and screaming in his ferocity. Details, such as the confused arm and leg muscles, suggest a later manner, but the general

119. Demon. Stone engraving, traditionally after a design by Wu Tao-tzu (from a rubbing). First half of the eighth century

120 (*right*). Sian (near), Shensi, tomb of Princess Yung T'ai, wall painting of Palace Ladies. A.D. 706

the left; there is a demoniac frenzy that may reflect something of master Wu's boundless creative energy and the kind of realism that terrified the beholder.

With other less individual court painters we are more fortunate, because some old paintings and convincing later versions have preserved a series of compositions showing stately court beauties, tribute bearers, portraits of officials and monks. The most reliable evidence of T'ang figure painting, however, is a small number of works by professional craftsmen rather than court artists. Leading this group are the extensive wall paintings, discovered in 1960, in an underground tomb some fifty-five miles west of modern Sian in Shensi. The tomb was built in A.D. 706 for the imperial Princess Yung T'ai. The approach passage-way, a forechamber, and

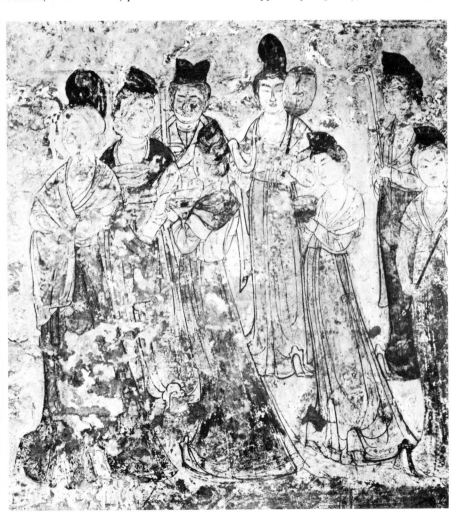

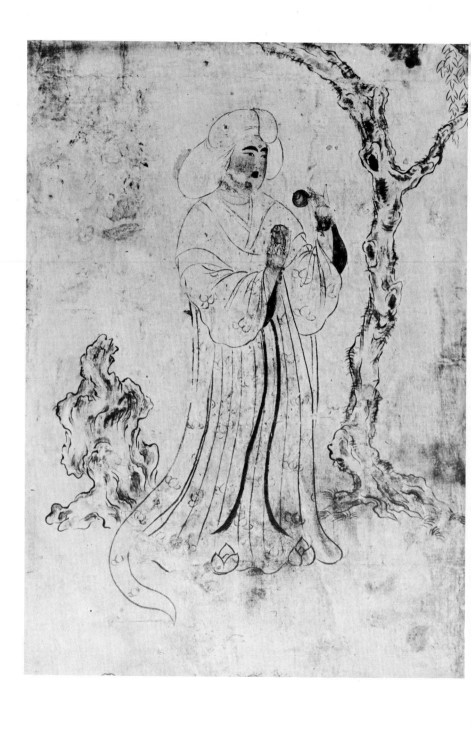

the corridor connecting it with the burial chamber, a total length of some 285 feet, are almost entirely covered with paintings of soldiers, grooms with horses, court lady attendants, the Tiger of the West, Dragon of the East, and architectural elements.[11] Illustration 120 reproduces the right-hand group of attendants from the east wall of the front chamber. Eight ladies and one male servant are shown in the varied poses of full-face, three-quarters profile, and one in a three-quarters rear view. The figures are closely grouped with a fine sense of spacing, the two central ladies standing in an arc formed by the other nine attendants.[12] A particular value attaches to these paintings because they cannot be either archaistic or provincial but must reflect the contemporary court style. The drawing is forthright and devoid of such flourishes as hooks or thinning and broadening lines in a calligraphic manner. Bounding outlines and inner drapery folds are minimal for describing solid form and pose. This essential simplicity together with knowledgeable draughtsmanship are principal reasons for the greatness of T'ang figure painting. Its character of ultimate validity and its monumentality were never approached by later artists working in the T'ang idiom [cf. 187]. The colours, which may have been stronger, are now surprisingly light, a pale green and purple predominating, with touches of orange. Flaking of the surface has revealed a number of pentimenti, especially in the faces. The same simple line is also used on a series of six screens decorated with palace beauties each standing or seated beside a tree, a garden setting being suggested by deeply eroded rocks [121]. It is probable that the screens, preserved in the Shōsōin storehouse of Tōdaiji, Nara,[13] were made in China or by Chinese artists working in

Japan shortly before 752. Sometime between Princess Yung T'ai's tomb of 706 and the period of the Shōsōin screens, almost half a century later, the fashion in feminine beauty had changed from the slender, swaying figures, popular since the early sixth century, to a more substantial kind of beauty shown to perfection in the moon-faced, plump matrons with tiny hands on the Shōsōin screens. The drawing on the Shōsōin screens is less forceful than that of the Princess Yung T'ai tomb but shares the same flowing, serene quality that seems to characterize eighth-century figure painting.[14]

The refinement and luxury of the palace circles during the first half of the eighth century, or prior to the disastrous revolt of An Lu-shan, was of a kind that seldom has occurred in history and probably was only approached in China during the Han Dynasty and again at the Sung court during the early twelfth century. It is no matter for wonder that scenes of court life, the hunt, polo games, tribute bearers, and foreigners in strange clothing were subjects well suited to the age. Above all, palace ladies engaged in their mild duties, at their elegant pleasures or more boisterous sports were themes calculated to please the brilliant, hedonistic court of Ming Huang. Among the existing old paintings of court ladies, or later versions of such T'ang designs, the most frequent attributions are to Chang Hsüan, who was active around 713 to 742, and Chou Fang, who painted about 780 to 810. The picture in the Freer Gallery of ladies playing at a kind of backgammon, called 'double sixes', is traditionally attributed to Chou Fang [122]. In all such early compositions with a plain background or setting, a good sense of space is obtained by one or two pieces of furniture and above all by the skilful relationship of the figures from front to back. In this case the diagonal of the game table is complemented by the angle of the two girls moving in from the left, and these groups, together with the two standing figures in the background,

121. Palace Lady (detail). Ink on paper.
Mid eighth century.
Nara, Japan, Shōsōin

122. Chou Fang (fl. 780-810):
Ladies playing Double Sixes. Colour on silk.
Washington, Smithsonian Institution,
Freer Gallery of Art

form an arc bending back away from the spectator. The soft colouring in shades of green and rose red, and the pattern of blacks and whites produce an effect that is elegant, restrained, and decorative. No less striking are the varied types from the stout matron with tiny hands to her lean adversary and the young girls carrying a heavy jar. The brush line is thin and flowing with few abrupt angles, in many ways like that of the Shōsōin screen [121].

'Tuning the Lute and Drinking Tea', a scroll also attributed to Chou Fang and now in the Nelson Gallery, is a painting from the tenth or eleventh century of a composition that exists in several versions.[15] There is the same masterful disposition of figures to create depth as in the Freer scroll, and the drawing in the figures is a good example of volume and attitude obtained by a simple silhouette drawn with a knowledge

based on observation. Two trees and a flat rock create a quiet corner in a palace garden. Both the Freer and the Nelson Gallery scrolls have a quality of dignity, restraint – a mood of timeless security that is strangely compelling to one of modern times. The players at 'double sixes' are as intent on their game as they were a thousand years ago. Broadness of concept, noble grandeur, and the ability to capture a mood of human relationships must have been among the qualities that made T'ang figure painting great.

The famous scroll of the 'Silk Beaters' in the Boston Museum is a copy, or version, rather, by the Sung Dynasty Emperor Hui-tsung (r. A.D. 1101-25) of a painting by the distinguished T'ang artist, Chang Hsüan. The picture is so well known that we reproduce only a detail [123]. One lady rolls up her sleeve preparatory to pounding the silk strands, one seated figure

23. Sung Hui-tsung (r. 1101–25):
Silk Beaters (detail). Colour on silk.
Boston, Museum of Fine Arts

draws out the thread, the other is engaged in sewing, and a little girl, charged with keeping the charcoal brazier for heating the irons, fans the embers, and shields her face with her sleeve. The picture is in brilliant colour, painted with exquisite delicacy. There is the same skilful disposition of the figures as in the scrolls discussed above; the same telling use of empty space and much of monumental grandeur. There are differences, however, that may be unconscious variations by the hand of the twelfth-century Imperial painter. The silhouettes are more complex and broken in outline than in the other works, while the brush-strokes are not the 'iron-wire' of even width but thicken and thin slightly and in places almost disappear. There are strokes ending in hooks or done with a refined flourish. It is a convincing T'ang design executed with all the sophistication and precise elegance of the early twelfth century. The result is perhaps less powerful, less monumental than the eighth-century prototype would have been, but the Sung emperor, nevertheless, has left us one of the most beautiful surviving figure paintings by a Chinese artist.

In the eighth century the T'ang capital of Ch'ang-an was the greatest city of the world. Tributary nations from all Asia and the Middle East sent missions with presents and curiosities, among them many animals strange to China. Yen Li-pên painted several scrolls of tribute bearers, one of which showed Westerners bringing a lion. The twelfth-century Imperial Collection contained 'Barbarian Tribute Bearers' by Chou Fang in six scrolls. In former years the Southern Section of the Palace Museum, Peking, displayed a fragment of an old scroll

attributed to Chou Fang [124]. It shows a west Asiatic or Indian with curling hair and beard and light eyes pulling on the strained leash of an ibex. The animal, of the small Himalayan type, is so convincingly drawn that it must have been done from life. The firm, strong outline of the tribute bearer, especially in the shoulders, arms, and torso, has the same quality of defining form and volume that we have noted already in such works as the lady of the Shōsōin screen. The

124. Chou Fang (?): West Asiatic and Ibex.
Fragment of a scroll, colour on silk.
Eighth to ninth century.
Taipei, Taiwan, National Palace Museum

excellent drawing of the hands reminds us of the undoubtedly T'ang fragment of a shouting monk from the Berlin Museum [115]. There is a sureness in the execution, an energy and realism in the design of a kind we might expect in T'ang painting – judging from the writings of contemporary or slightly later critics. If the picture is a copy from the Sung Dynasty, then the artist has been able to recapture the essential spirit of a former age.

The most prized animals to reach the Chinese court from the West were the wonderful horses from such centres of breeding as Ferghana and Khotan. The love of horseflesh must have been a ruling passion with the hard-riding nobles of the Imperial and princely courts. It is said that in the time of Ming Huang (r. A.D. 713–56) there were over 40,000 horses in the Imperial stable. To quote the early ninth-century writer, Chu Ching-hsüan: 'When the K'ai-yüan period (713–42) brought peace to the world, blooded horses would be sent hither in relays from foreign lands, crossing wide stretches of desert that wore their hoofs thin. Ming Huang used to select the best of them and treat them like his Chinese coursers. Of all of them he had paintings made. Thenceforth the Imperial stable possessed mounts of the "Flying Yellow" "Night-lightning", "Drifting Cloud", or "Five Blossom" types. They had unusual coats and their whole appearance was remarkable. Their sinews and bones were rounded and their hoofs were thick. . . . First they were depicted by Ch'ên Hung, and then . . . by Han Kan.'[16]

Han Kan was the most famous horse painter of the T'ang Dynasty. An often-quoted story is that the emperor, after ordering Han Kan to study horse painting with Ch'ên Hung, was surprised to note that his paintings differed from those of Ch'ên and questioned him about it. Han Kan replied that he already had his models in the horses of the Imperial stable. The virtue of a good painting of horses lay not only in faithfully depicting the flesh and sinews and bone-structure, but also in capturing the essential spirit of the animal. Something of these qualities still remains in an old painting now in the collection of Sir Percival and Lady David [125]. This scroll is celebrated in both China and Japan and may be a painting of the T'ang Dynasty. Through its various vicissitudes, the horse has almost lost his tail, and the 'thick hoofs' as well as the lower parts of the legs appear to have been somewhat restored.

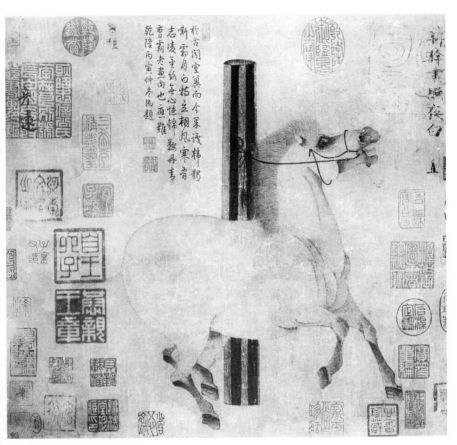

125. Han Kan: Horse. Ink on paper.
Eighth century.
London, Sir Percival and Lady David

Nevertheless, in what remains we see a broadness of concept and noble breadth of treatment quite different from later paintings of horses. The head on its thick, strong neck is especially spirited, painted with sensitivity and knowledge; it is also the best preserved part of the picture.

Portrait painting must have held a prominent place in eighth-century court circles; for we read of noble portraits not only of the emperor himself in occupations such as the hunt, but of state ministers, distinguished scholars, Taoist priests, and high Buddhist prelates. The most important surviving portraits are unfortunately in so worn a state that little can be made of them, but we reproduce one of a set of five, because it is among the oldest Chinese paintings and because some light, some faint aroma of the great eighth century, still emanates from the worn and darkened silk. Among the paintings which

a great Japanese priest, Kōbō Daishi, brought back with him in 807 after a trip to China, were the portraits of five patriarchs of the Chên-yen Sect (True Word – a Tantric sect) painted by Li Chên, a late eighth-century artist, contemporary with Chou Fang. The portrait of the fifth patriarch, Amoghavajra, active A.D. 746–74, is the best preserved [126]. It shows the

126. Li Chên: Amoghavajra. Colour on silk.
Eighth century.
Kyōto, Japan, Tōji

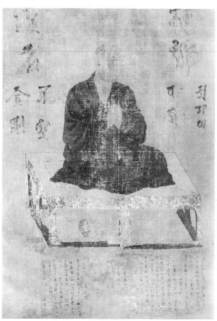

great Indian teacher seated on a simple dais isolated against a plain background, his hands clasped in a mystic gesture. The brushwork is the firm, even line we have seen in other figure paintings, the form beautifully defined by the outline. Very slight shading in the face and garment folds add to the impression of solidity.

LANDSCAPE PAINTING

In a broad view of Chinese painting, the T'ang Dynasty emerges as a period when the great artists were for the most part devoted to figure subjects, both religious and secular. But landscape painting, destined to become China's greatest contribution to the art of the world, was emerging from the archaic and mannered style current in the Six Dynasties. By becoming the concern of men gifted with genius, the manner of painting a landscape began to evolve along lines which would make it a proper vehicle for conveying profound emotions on a level with poetry and calligraphy. There are, in the records of T'ang painters, the names of many men who were proficient in landscape painting. We are told that even Wu Tao-tzu, the greatest of all figure painters, evolved a landscape style quite his own, but we know nothing of what it might have been. From this distance and our present state of knowledge, it appears that there were at least two rather different styles each associated with the names of leading artists – the one exemplified by Li Ssu-hsün and his son Li Chao-tao, the other by the poet-painter Wang Wei. Chinese writers on aesthetics and art history of later centuries, and especially the seventeenth-century critic Tung Ch'i-ch'ang, have built theories about the T'ang schools of landscape painting which are, probably, far too dogmatic. It is also improbable that either Li, father and son, or Wang Wei originated any styles. They were, rather, the most gifted men to work in styles already established or well advanced. That a man like Wang Wei, of so great a genius as we know him to be from his poetry, made landscape painting a more fluid vehicle for expression, seems very probable. But it is improbable that he created a style which was a complete and sweeping innovation.

Li Ssu-hsün, known as General Li from a post he held in a guards regiment, was a relative of the Imperial clan and a great aristocrat. He

was born about the middle of the seventh century, and after certain political vicissitudes not rare in the lives of Chinese of high position or birth, he came into court favour about 705 and lived into the brilliant era of Ming Huang (r. 713–56), dying between 715 and 719. His son Li Chao-tao, who held the same military rank, followed his father in painting, and they are

blue and green dominating, at times the rock forms outlined in gold and the clouds in luminous white. This speculation – doubtless too optimistic – of what the Li style in landscape may have looked like, is based to some extent on a beautiful landscape in the Palace Museum [127],[17] depicting the 'Emperor Ming Huang travelling in Shu'. It is executed by a skilled

127. The Emperor Ming Huang travelling in Shu.
Colour on paper. Eighth century (?).
Taipei, Taiwan, National Palace Museum

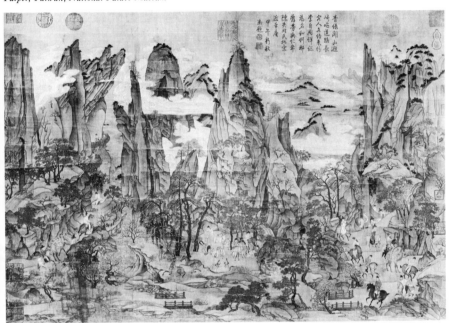

known as 'Big Li' and 'Little Li' or as 'General Li' and 'The Little General'. No paintings by either are known to exist today. From all that has been written about the style of the two Li's, however, it appears that they brought to perfection a highly detailed style, full of minutely and accurately drawn figures, flora, and fauna. These elegant and sensitive landscapes were exquisitely rendered in brilliant colour with

hand in full colour on paper. No monochrome reproduction can give a proper impression of the picture because the colour is at once refined and brilliant, with blue, green, and a good deal of red in the mountains, producing an over-all, glowing pattern that is almost Persian. A caravan of ladies and gentlemen of quality, like a Chinese version of the Canterbury Pilgrims, enters the scene on the right in double file.

Mules and a camel are being unburdened in the centre of the picture, where one of the grateful animals rolls to scratch his back. To the left a small cavalcade is disappearing into the hills. Although the mountains are drawn with much detail of crevasses, broken forms, and overhanging cliffs, there is no solidity, no real sense of the mass and the weight of piled-up rocks. In spite of the wide variety of trees, there is no impression of growing verdure. The picture is a further refinement of the kind of landscape already fairly well developed in the sixth century. There are the same tall trees and the same gnarled trees brought well into the foreground as on the stone sarcophagus in the Nelson Gallery [91, 92]; and the space in the centre, where the mules disport themselves, is but an improved 'space cell'. The distance between the curtain of mountains in the middle distance and the low hills with spits of land extending into a vast lake in the far distance is conveniently veiled by clouds.

The style which this picture represents has persisted into modern times. Under the brush of a gifted artist it can produce paintings posessing a particular kind of beauty that is lucid and a delight to the eye. It is a style perfectly suited to scenes of pure fantasy – the realm of the Taoist Immortals, the fabled Palaces of Han, or the eternal land of the Peach Blossoms. The style was used with success by Chao Po-chü of the Sung Dynasty; its last great champion was Ch'iu Ying of the Ming. But it is a style easily aped in its superficial aspects by skilled craftsmen, and this industrious class has through the centuries produced countless charming and utterly vacuous scrolls in the 'blue and green' manner. It lingered, too, in the blue, green, and gold landscape settings of certain Tibetan Buddhist banners.

Wang Wei is traditionally the father of monochrome landscape painting in ink. He represents, moreover, the Chinese ideal of a scholarly gentleman whose natural talents are brought to maturity through cultivation. Concerning Wang Wei as a poet, Arthur Waley has written: 'His poems reflect the perfect balance of his nature. Exquisite in their technique, they are more reflective, more personal, and consequently less completely lyrical than those of Li Po. At the same time, he wholly lacked the political ardour of Tu Fu. His two great contemporaries were impulsive, stupendous, inexplicable; in a word Gothic. Wei is the most classical of Chinese poets, a master of just such fresh and delicately ordered art as one finds in the introduction to Plato's dialogues.'[18] Such an evaluation helps us to an understanding of the kind of man Wang Wei was and the reasons for the great admiration the Chinese have lavished upon him. We know that while Wang Wei frequented the highest circles of Ch'ang-an court life, he dearly loved his country place, called Wang-ch'üan, not far from the capital. He was interested in Buddhism and his religious nature deepened after the death of his wife.

This is not the place to review the many speculations on the style of Wang Wei that have been advanced by Chinese, Japanese, and Western scholars.[19] In any event, like Wu Taotzu, the greatness of his work lay in the individual genius of the man, and that has been lost, at least as far as his paintings are concerned. It is of interest to know, nevertheless, that he was the first great artist to work in a style that varied materially from the traditional landscape as exemplified by Li Ssu-hsün and Li Chao-tao. As already mentioned, Wang Wei is credited with the development of monochrome landscape done in the 'broken ink' or p'o-mo style. In the technique of Chinese painting, after the outlines of mountains, hills, and individual rocks are drawn and the main inner markings representing clefts and fissures are added, the form, the geological structure of the rocks, and effects of erosion are indicated by washes of ink or multiple brush-strokes, short or long, soft or abrupt, or indeed of a great variety which will

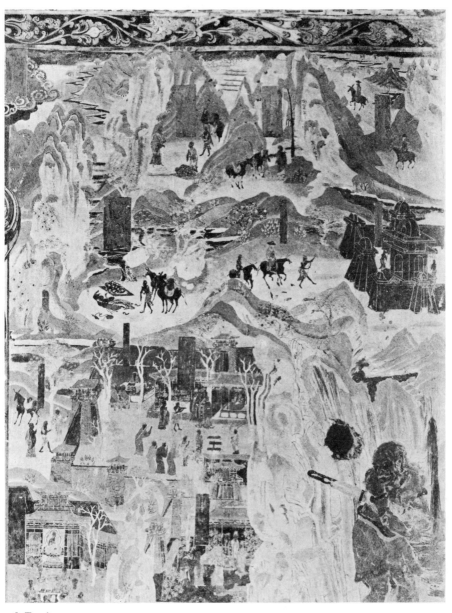

128. Tun-huang, cave 70,
fresco of a landscape (detail).
Late seventh to early eighth century

be discussed in more detail later. Exactly what 'broken ink' meant in the eighth century is very difficult to tell, but what little evidence is available tends to show that it may have been rather broad brush-strokes handled in a free manner to lend a sense of form through modelling – a modelling that had little or nothing to do with a source of light and cast shadows. The Chinese word for this brushwork within the outline or contour of a form is *ts'un*, and ts'un is frequently translated as 'wrinkles', meaning the wrinkles on the face of a mountain, hill, or rock.[20]

The paintings in a number of the caves at Tun-huang have landscape backgrounds or landscape details.[21] A detail from cave 70 [128] shows a rugged landscape, rather primitive in the arrangement of small 'pockets' for action, but quite free and bold in execution. This cave was done in the late seventh or early eighth century, about the time of Wang Wei. The hills that are piled up in echelon one behind the other have inner markings done with broad free brush-strokes, some jagged and abrupt, some that seem little more than smudges of very wet ink or thin, wet colour. This kind of brushwork is especially clear in the lower right corner just above a demon carrying something under his arm. In this area, too, the loose, sketchy outline strokes are quite evident.[22] Large trees with enormous blossoms, a stream with saw-toothed banks that winds tortuously into the far distance, and the impossibly precipitous mountains are details that suggest the old, decorative style; but the freely broken washes and evident interest in rendering form more convincingly suggest the beginnings of a technique capable of allowing a maximum flexibility and personal expression essential to great painting.

Copies of some of Wang Wei's most famous compositions have been preserved, notably the 'Picture of Wang-ch'üan' – a kind of idealization of his country home – and the scroll called 'Clearing After Snow on Rivers and Hills'. The former composition was engraved on stone several times in the Ming and Ch'ing Dynasties and rubbings from these designs exist.[23]

In later centuries we shall see Chinese devotion towards landscape develop to its full intensity. They lavished upon the world of hills and streams and trees all the keen analysis and penetration that the best artists of Europe have brought to their study of the appearance and character of humanity. All the genius, observation, intense study of anatomy, and earnest seeking for ultimate reality that Europe has devoted to the human form, China has, with comparable passion, devoted to the natural world in all its aspects. Landscape during the Han Dynasty emerged as indications of setting in scenes of the hunt, the harvest, the dwelling-place of the Immortals, and creatures of fantasy. Throughout the third to the sixth century it gained in value because of a growing interest in objective reality and as the background necessary to narrative illustrations of Confucian and Taoist themes. Such landscape was ready to hand when the demands of the church required illustrations of holy texts such as stories about the former lives of the Buddha. It is not impossible that by the eighth century landscape in its own right became a vehicle for the outpouring of emotions; that it broke away from the old-fashioned, elegant, and decorative style. It is probable that landscape was freed from a minute and niggling technique, not through any predestined stylistic evolution, but because the Chinese spirit eventually found in the world of nature an answer to its longings that was more real and gratifying than the pomp of Imperial courts, Confucian morality, or all the multiple gods of the Mahāyāna Buddhist pantheon.

SCULPTURE FROM THE TENTH TO THE FOURTEENTH CENTURY

With the disintegration of the T'ang Dynasty, the northern part of the country was overrun by conquerors of non-Chinese stock. Early in the tenth century a pre-Mongol people, the Khitans, swarmed out of south-eastern Mongolia, overcoming the P'o-hai kingdom of the Liao-tung peninsula. They continued south and in 946 sacked the capital (modern K'ai-fêng) of the Five Dynasties kingdom of Later Chin. Early in the eleventh century the Sung Dynasty entered into a humiliating treaty, whereby through the payment of tribute they bought an uncertain peace with the Liao, as the Khitan Dynasty of the north was called. At the height of their power the Liao empire extended from the gulf of Pei-chih-li on the east to the T'ien Shan range in Central Asia on the west. They did not, however, extend their power south below the Yellow River.

Early in the twelfth century the Liao were themselves attacked by the Jurchen, a Tungusic people whose home was far to the north in the region of the Amur. The Chinese formed an alliance with the Jurchen against their old enemy the Liao, and after a campaign lasting from 1114 to 1125, the Liao power in the north was destroyed. The Jurchen founded the Chin Dynasty which lasted until 1234, when it was in turn destroyed by the Mongols. The Chin empire embraced modern Manchuria, the Chinese provinces of Hopei, Shantung, Shansi, Shensi, parts of Honan, Kiangsu, and Anhwei as far as the Huai River.

The quality and prestige of the Buddhist Church had declined to a marked degree, as already mentioned, throughout the latter part of the T'ang Dynasty. Nor did it regain its former glories under Sung rule in central and southern China, although temples and monasteries were still built and enriched on an incredibly lavish scale. As ecclesiastical establishments famous in Buddhist history fell victim to civil wars, fires, earthquakes, or gradually sank into ruin because of political changes or loss of prestige, new temples took their place in a continuous process of decay and creation that seemed, like Chinese palace building, to be inexhaustible in its potency. Had any great, imperially endowed temple of the Northern Sung capital, such as Hsiang-kuo-ssu at K'ai-fêng, remained even partially intact today, with its storeyed gates, icons, and wall paintings, it would without question be judged the glory of Far-Eastern Buddhist art. But Sung Buddhist art was, in character, more a continuation of T'ang tradition, an elaboration and embellishment of existing patterns rather than an art of vital, creative impulses. We are, however, in a most unfavourable position to formulate any concise opinions concerning the Buddhist art south of the Yellow River. The entire region has been so devastated by wars and natural disasters, culminating in the T'ai-p'ing Rebellion during the nineteenth century, that almost nothing of artistic significance remains today.[1] By contrast, the number of temples from the tenth to the end of the thirteenth century still standing in north China, and the quantity of sculpture in stone, clay, and wood, probably give a misleading picture of the relative amount of temple building in northern and southern China during those centuries.

The most imposing sculpture made during the brief Sung tenure in north China is the colossal bronze Kuan-yin, some forty-five feet high, still standing amid the ruins of its temple

at Chêng-ting in Hopei Province. The temple, Lung-hsing-ssu, was built and the great image cast in A.D. 971. The figure today, which is probably the largest surviving bronze image in China, is much dilapidated, all the multiple arms having disappeared save two. In its original condition with its gildings on lacquered cloth over the bronze, and the forty-two arms surrounding the upper body like the rays of a sunburst, it must have been a striking and immediately impressive icon. But as it stands today, one sees all too clearly the poor proportions, with the pointlessly elongated legs and short torso, the drapery folds at once dry and mannered. In spite of its great size the Kuan-yin of Lung-hsing-ssu is sculpturally unsuccessful and especially so because the style, with its unfortunate mixture of restless, mannered drapery and archaistic rigidity, was one particularly ill-suited to a colossal scale.[2]

In the north Buddhism as an organized Church, not as a metaphysical philosophy, enjoyed a powerful resurgence. Just as the phenomenal growth of Buddhism and the florescence of Buddhist art in the late fifth and first half of the sixth century had occurred when China was under the domination of the T'o-pa Tartars of the Wei Dynasty, so under the nomad and semi-nomad conquerors of the eleventh to early thirteenth centuries, the Buddhist Church regained something of its old vigour. The Liao rulers no doubt found flourishing Buddhist establishments in their new-gained territories. One of the most important Buddhist centres, that of Wu-t'ai Shan in northern Shansi, must have been an impressive sight, in the eleventh century, to the somewhat uncouth invaders.

There was throughout the eleventh and twelfth centuries a great deal of temple building, especially in the provinces of Shansi and Hopei, as well as north of the Great Wall. Some of these temples and pagodas are standing today, and are of unique importance as the earliest surviving examples in China proper of Buddhist temples that present a complete scheme of architecture, painting, and sculpture. One notable exception is the mid ninth-century (A.D. 857) hall of Fo-kuang-ssu at Wu-t'ai Shan, Shansi, which contains over thirty contemporary images, a small reminder of T'ang wall painting and others dating from the Sung Dynasty.[3]

There were two distinct approaches to the representation of the gods in sculpture. One very interesting, but minor trend, was completely archaistic. Styles of the full T'ang, the Sui, and even the Six Dynasties were revived and a number of monuments that in the West had long passed for works of those periods are now recognized as revivals of Liao and Chin.[4] The true archaistic style is for the most part limited to sculpture in stone, and in this medium there was ample material in north China to serve as models for want of more creative inspiration. There were the magnificent cave-temples of Hsiang-t'ang Shan with their riches of sculpture from the Northern Ch'i, the complex of the Yün-kang caves, and undoubtedly far more steles and free-standing figures than have survived to the present day. One of the most striking examples of this revival is to be found, in fact, at Yün-kang. Work at these caves was abandoned early in the sixth century, and it was not until the Liao of the tenth and eleventh centuries that work was resumed. At that time one more large and ambitious cave was undertaken. It was never completed, but an enormous Buddha, seated with legs pendant, and two accompanying Bodhisattvas were hewn out. For many years these heavy, rather ungainly figures were thought to be remains of renewed interest during the Sui Dynasty (A.D. 581-618); but the recent researches of Mizuno have established them as sculpture of Liao times [129]. One of the most important centres for sculpture of this kind was the Hopei school centred around Pao-ting, Chü-yang, and Ting-

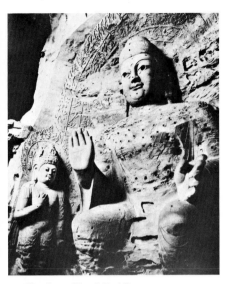

129. Yün-kang, Shansi, Buddha, stone.
Liao Dynasty, tenth to eleventh century

heavy, ill-conditioned products of fairly skilled but uninspired stone-cutters.

The true spirit of the age found its happiest expression in sculpture done in the more pliable materials of clay and wood. In these materials the sculptors of Liao and Chin developed a Buddhist art quite distinct from anything that had gone before. Although it had its roots in T'ang tradition, it was in no way a debased T'ang art, or a softening and deterioration of the mature T'ang style, but rather a different kind of art that established its own tradition which lasted with some vigour into the fourteenth century. In this new style the gods become far more human than at any previous time. They retain the full-bodied fleshiness of the mature T'ang style, indeed they become more portly, and the modelling of the faces and hands is often rendered in a most life-like manner. The images

chou, where so much excellent work in white marble had been produced from the latter part of the sixth century to the end of the T'ang Dynasty. The traditions must have been kept alive in these areas, and much of the work, especially on Buddhist monuments such as stūpas and commemorative pillars, still to be seen, reflects a further development of pictorial and decorative styles that had begun to be evident in the latter part of the T'ang Dynasty.

Interesting as these works are as illustrations of revivals and as indicative of one trend in the Buddhist Church at that time, they are of little significance as works of art. There is also a large group of sculpture that combines certain purely twelfth-century elements of naturalism, of pictorial composition and dramatic modelling, with archaic stiffness, grooved drapery, and flat folds of a much earlier time. These elements appear to be not so much conscious revivals of an archaic style as merely provincial relapses into relatively flat and linear manners of representation. They are for the most part

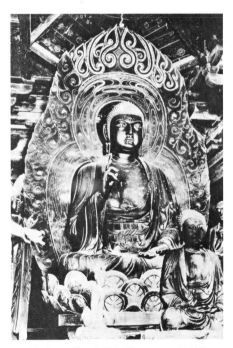

130. Ta-t'ung, Shansi, Hsia Hua-yen-ssu, Buddha, lacquered clay. Eleventh century

131 (*below left*). Śākyamuni Buddha, gilt-bronze.
Liao Dynasty, eleventh to twelfth century.
*Kansas City, Nelson Gallery of Art
and Atkins Museum*

132 (*below right*). Bodhisattva, wood.
Twelfth to thirteenth century.
Philadelphia Museum of Art

133 (*opposite*). Wall painting (detail).
Late thirteenth century.
Toronto, Royal Ontario Museum of Archaeology

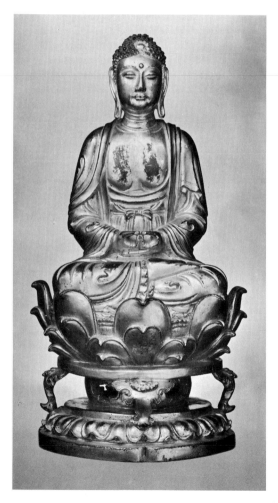

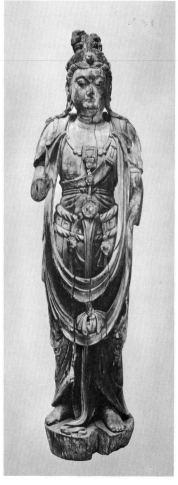

of the Buddha take on new proportions. The legs become shorter so that, as they sit cross-legged, the base of the figure from knee to knee is noticeably more narrow than previously; at the same time the torso is longer and, since the figures sit very straight, the head seems to be thrown back. The monastic garment covers almost all the body and there is a kind of skirt that is fastened with a sash high up above the waist. The standard for this type may still be seen in the impressive set of three Buddhas with Bodhisattvas and Dvarapalas on the altar of Pao-chia-chiao-tsang Hall (Preservation of the Excellent Teaching) at the Hsia Hua-yen-ssu in Ta-t'ung, Shansi.[5] This temple was built in 1038 and, though it was extensively repaired in 1140 after a fire, this hall and its sculpture clearly remain from the original structure [130]. The three Buddhas, possibly all representing Śākyamuni, are seated on huge lotus flowers and backed by mandorlas of painted wood. They are made of clay coated with lacquer and are over sixteen feet high. Their majesty does not result from their size alone. Good proportions, simple, well-modelled drapery folds, and seren-ity of facial expression all contribute to make them worthy descendants of the T'ang tradi-tion. The smaller Buddha images in front are of the same period. In the standing Bodhisattvas, as well as the seated ones, the elongated propor-tions and such details of dress as the high crown and ruffles at the elbow also occur in late T'ang sculptures of the mid ninth century. They are, as might be expected, somewhat provincial, as is evident especially in the standing Bodhisattvas, but the total effect of the group as religious sculpture is impressive and successful.

The gilt-bronze Śākyamuni [131] is charac-teristic in the relative proportions of legs and torso. The round face, level brows, small, finely modelled mouth, the garments and their arrangement in symmetrical folds are all similar to the seated Buddhas of Hsia Hua-yen-ssu, while the mannered, snaky folds on the legs and

arms are paralleled in some of the interesting sculptured brick pagodas built during the eleventh century in Manchuria. A characteristic feature is a small bald spot in the Buddha's snail-curl hair, just above the forehead and below the ushnīsha – a feature which does not, apparently, occur on Buddha images of the classic T'ang style, though it may come in as early as the late tenth century. It is typical of Buddha images of the Liao and Chin Dynasties.

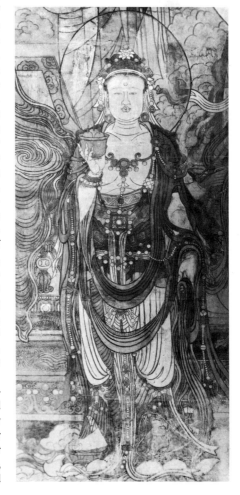

Buddhist sculpture in wood, made between the twelfth and the fourteenth centuries, furnishes today the most complete expression of the Buddhist art forms evolved in the post-T'ang period. Many excellent examples are to be seen in Western collections, and a good number still stand, fortunately, on the altars for which they were intended. The province of Shansi is particularly rich in temples constructed during the Chin Dynasty. Many of these have undergone extensive repairs and additions in the Yüan and Ming Dynasties. In spite of these modifications and restorations, there were many temples, particularly in the valley of the Fên River, running south from T'ai-yüan in Shansi, which, until recent years at least, retained their sculpture in wood and clay and the large-scale wall paintings of the twelfth and thirteenth centuries. There was in many of the cave-temples at Tun-huang a close affinity between the sculptured figures and the painted walls. This manner of presentation was continued and intensified in the northern temples of the twelfth and thirteenth centuries in which the broad wall paintings of paradises, with figures over life-size, form the background for the images sculptured in wood and painted with the same pigments [132, 133]. From the latter part of the T'ang Dynasty onwards the images of the gods tend to become more and more Chinese and less akin to their Indian prototypes. The subtropical nudity of the Indian Bodhisattvas gives way to a more complete clothing of the figures. The Shansi sculptors in wood are not concerned with the profound spirituality or mystic aspects of the gods but rather favour realistic, full-bodied types, immediate in their emotional appeal and pre-eminently approachable.

The immediate appeal to the visual senses is obtained by a new realism evident in the full, round faces, the rolls of flesh about the neck and chin, and the realistic modelling of the plump,

delicate hands that seem almost boneless; the addition of glass eyes and naturalistic colouring makes the figures seem to breathe and pulsate with life in the soft temple light. An almost uncanny impression of movement, as though the gods were stepping forward with an easy, stately pace, or had just taken their seats on the lotus thrones, is produced by the great agitation and restless movement of the garments and encircling scarves. These latter accessories are especially important in creating an almost spiral movement in three dimensions as the long, broad ribbons trail over the arms, loop across the body and curve around the back. In the actual carving the folds are deep, with sharp edges, so that the maximum contrast is obtained between highlight and shadow. Frequently the ends of garments and scarves are caught up in whorls and spirals obviously derived from the calligraphic flourishes of painting. A rich, pictorial effect translated into three-dimensional form seems to have been the ideal.

At the upper temple of Kuang-shêng-ssu, near Chao-ch'êng Hsien, Shansi, the central hall, built in the mid twelfth century, enshrines an over life-size trinity of Śākyamuni flanked by Mañjuśrī on a lion and Sāmantabhadra mounted on an elephant. These figures and their lesser attendants are in carved and polychrome wood. There is reason to believe that they are the original images of approximately 1150. We reproduce here [134, 135] the Bodhisattva Mañjuśrī on the lion and the 'Indian' attendant who seems about to goad the elephant vehicle of Sāmantabhadra. Here is all the dramatic presentation combined with lively realism that made the Buddhist images of the twelfth and thirteenth centuries so different from the restrained, elegant, and often languorous deities of the mature T'ang style of the eighth century. The Bodhisattva [134] sits upright, solidly planted on the lotus seat, the ends of the sleeve are caught in a breeze and swing out in a series

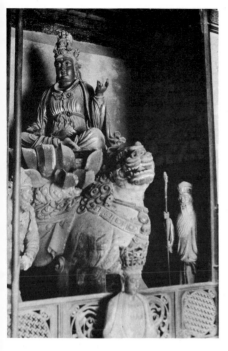

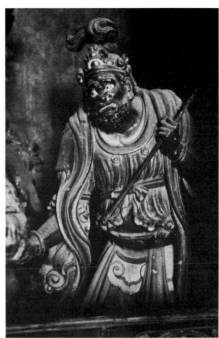

of complicated ruffles, the body is fully clothed with some fine stuff that gathers in rippling folds over the torso, and the headdress is surmounted by a curling shield of a kind much favoured throughout the twelfth century. The dark 'Indian' elephant-driver with his swirling drapery, rolling eyes, wild, strained expression, and curling beard is an excellent dramatic foil to the placid Bodhisattva whom he attends.

Two life-size Bodhisattvas, Kuan-yin and Ta-shih-chih (Mahāsthāmaprāpta), that formerly stood in a temple near Hung-tung Hsien not far from Kuang-shêng-ssu, are dated by inscription to 1195. This handsome pair, now in the Royal Ontario Museum, Toronto, exhibit all the characteristics of the best work from the Shansi school.[6] A very similar but far more complete figure, now in the Nelson Gallery, is a

134 and 135. Chao-ch'êng Hsien, Shansi, upper temple of Kuang-shêng-ssu, Bodhisattva Mañjuśrī and Indian attendant, polychromed wood. *c.* 1150

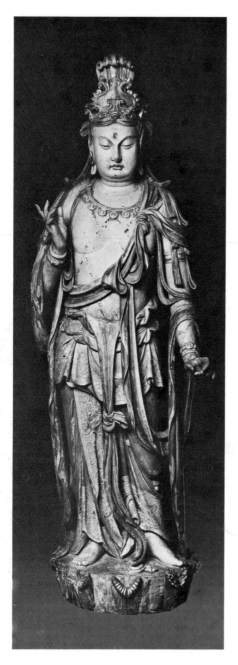

136. Bodhisattva, polychromed wood.
Late twelfth century.
*Kansas City, Nelson Gallery of Art
and Atkins Museum*

work of the same period [136].[7] The scarves and ribbons play an indispensable part by adding to the sense of movement as well as diminishing the apparent portliness of the figure. All sculptural volume has been sacrificed to obtain a rich pattern of chiaroscuro, and a realism that brings the gods down from an ideal plane so that their presence is immanent in the images on the altar. Especially in the Bodhisattvas, religious mystery and spiritual power give way to gentle and benign compassion. Although the gods are immediately approachable in this art, they are still gods; the features are generalized and still express a supramundane existence beyond the world of illusion.

The Bodhisattva Kuan-yin played an important role in the later Buddhism of north China. The emphasis on the emotional content of religion which is apparent in post-T'ang sculpture of the north naturally concentrated on this greatest of the Bodhisattvas dedicated to the aid of suffering mankind.[8] In general, all the Bodhisattvas are considered to be without gender, or, more strictly speaking, to combine the spiritual virtues of both sexes. However, among the thirty-two forms which, according to one category, Kuan-yin may assume to accomplish his aims, some are feminine, and in this later Buddhism the deity tends to become increasingly gentle, benign, and womanly.

The aspect of Kuan-yin most favoured by the sculptors of the twelfth and thirteenth centuries was 'Kuan-yin of the Southern Seas' seated at ease in a weathered grotto on the rocky shore of the fabled mountain home, Potala, or Potalaka, supposed to be situated off southern India. The position is not only expressive of the calm and tranquility of the protector but above all offers dramatic pictorial possibilities perfectly suited to the ideals of later Buddhist art. In the

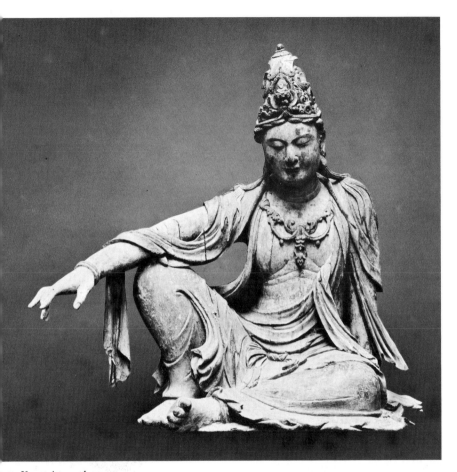

137. Kuan-yin, wood.
Twelfth to thirteenth century.
St Louis, City Art Museum

best examples the ability of the sculptors to express the gentle compassion of the Bodhisattva is deeply impressive. The image now in the City Art Museum, St Louis, is seated in the position called 'Royal Ease' – Mahārājalila – one leg flexed, the other raised, the knee supporting the right arm that reaches out as though to bless and help those who seek protection or consolation [137]. The long, easy curves of the drapery give

an effect of dignity and calm. In the face, hands, and exposed parts of the body the soft and rounded modelling creates an impression as of a living being. The high tiara, strands of hair over the shoulders, and rich necklace add a quality of incomparable elegance. The deep carving, in which intermediary planes are reduced to a minimum, produces the black, thin shadows that suggest the calligraphic lines of painting.

This figure, like many others in Western collections, has a certain amount of restraint and simplicity that is somewhat misleading. Originally such images were posed on highly intricate and elaborate bases representing the rocky shore of the Bodhisattva's mountain home; in their original positions in the temples, these rockeries were often continued up the sides and above the head of the image, forming a true grotto. The complete composition was intended, then, to be rich, ornate, and sumptuous. The Kuan-yin reproduced in illustration 138 still retains its original base and the intricately carved lotus rest for the pendant foot. The rock is deeply carved and pierced by holes while long moss drips from the top. Pendant sashes and scarves serve to unite the figure with the base.

The position of this Kuan-yin differs from the St Louis figure in that one leg is pendant – a position equally popular, if not more so, than the true 'Royal Ease' pose. It conveys the impression that the Bodhisattva, rather than being deep in contemplation, might at any moment rise and step down from the rocky niche. The formula is a good one; the pendant leg repeats the vertical of the supporting left arm so that the dominant vertical of the one side forms a striking contrast to the complex of angles and directions on the right. In both these figures certain parts of the drapery are caught up at the ends in complicated and mannered folds. Exactly the same treatment is found in numerous wall paintings of the thirteenth and early fourteenth centuries in Shansi, following in the same tradition – a point that serves to emphasize the interdependence of later Buddhist sculpture and painting.[9]

From inscriptions found on temple wall paintings and discovered within sculptured wooden figures, it is evident that temple sculpture and painting throughout this period and in subsequent centuries was the work of highly trained temple decorators who travelled about the country with their models and copy-

138. Kuan-yin, polychromed wood. Twelfth to thirteenth century. *Kansas City, Nelson Gallery of Art and Atkins Museum*

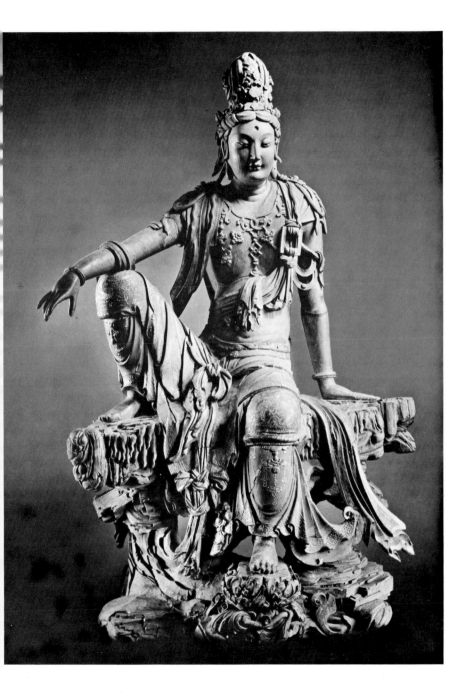

books. At Kuang-shêng-ssu, near Chao-ch'eng in the Fên River valley, the temple walls still retain a number of paintings executed and repaired in the Yüan and Ming Dynasties. Many of these bear dated inscriptions from which it may be learned that a family with the surname Yang executed and repainted wall paintings at this one temple throughout seven generations, over a period of one hundred and forty-six years. Although this is an example from a period later than that under discussion, it serves to illustrate the important part conservative tradition must have played. Provided the standards of workmanship were maintained, stylistic changes might be very slight through several generations.

There was undoubtedly a tendency, clearly evident from a study of the wall paintings, towards a coarsening of the workmanship as the original vigour of the Buddhist revival died out. The designs became more and more stereotyped, rigid, and mannered. Nevertheless, they continued for a long time to follow the iconographic types that had probably been formulated throughout the ninth, tenth, and eleventh centuries to culminate in the ample and sumptuous images of the twelfth century. The standing Bodhisattva in illustration 132 evidently belongs to the same class as that shown in illustration 136 and is, in all probability, a work of the late twelfth to early thirteenth century. The general style, and particularly the garments and ornaments, are very close to the detail here illustrated from a large wall-painting depicting an illustration to the *Maitreya sūtra* [133]. This wall painting, now in the Royal Ontario Museum, comes from Chi Shan, Shansi, the same general region that produced so much of the best wood sculpture. The wall painting was executed in the last years of the thirteenth century, and we assume it to be about one hundred years later than the wood figure. All the elements of the style have been retained, but the concept has become somewhat hard and

dry. These wall paintings[10] are imposing decoration on a grand scale, but the mechanical quality of the drawing and the crowded compositions suggest that this last important phase of Buddhist art was sinking into its final twilight glow with the closing years of the thirteenth century. The danger of generalities, however, in an art that is at once so traditional and complex as the Chinese is demonstrated by an excellent wood figure in the Metropolitan Museum which bears on the inside of the removable back panel the date of the 19th year of the Chih-yüan period of the Yüan Dynasty, corresponding to A.D. 1282. The Bodhisattva has all the qualities of excellent proportions, movement, elegance, and workmanship that one would associate with the best work of a century or more earlier. We may conclude that in isolated examples, at least, the opulent, realistic manner of late Buddhist art was still vigorous at the close of the thirteenth century.

By the fourteenth century many of the wood figures in the tradition of those discussed above become heavy and, at times, almost gross. Often proportions and articulation are clumsy, and the workmanship is cursory and rough. Interestingly enough, the depth of carving also tends to disappear, the drapery loses its agitated, fluttering movement, and the flat, linear manner that seems ever latent in Chinese sculpture begins to reappear, not, however, as a revival of any of the great linear styles of the past but rather as a relapse into provincialism.

Figures of the Lohans – those followers of the Buddha who in China became half saint, half Taoist adept, the mountain-dwelling *hsien* who lived in isolation, their natures attuned to the workings of the Tao – enjoyed a wide popularity in both north and south China from the tenth century on. As we shall see, the monk painter, Kuan-hsiu, of the Five Dynasties, was celebrated for his paintings of the Lohans as strange and almost repellent Indian types. The elegant painter Li Kung-lin evolved a more

restrained and far more purely Chinese type, and it was this latter that was sculptured with insight by the master craftsmen working for the temples of the north. If the facial expressions of the high gods were generalized to raise them above the human level, the emphasis on the individuality of the Lohans offered a rich field for portraiture and the dramatic realism so much favoured by the sculptors of Liao and Chin.

A small figure of a Lohan made in 1099 [139], and coming from the Sung territory south of the Yellow River, as is evident from the Northern Sung reign title, Yüan-fu, in the inscription engraved on the base, is of special interest in that the facial type with full cheeks, soft modelling of the rather sensuous mouth, and a chin that recedes into rolls of flesh on the neck, follows closely the Bodhisattva type evolved by the sculptors in wood and clay of Shansi

139. Lohan, dried lacquer. A.D. 1099.
Honolulu Academy of Arts

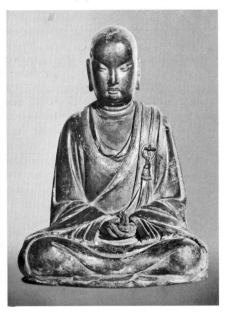

Province. The folds of the monastic robe are rendered with a happy balance between realism and symmetrical pattern. The formula is one that lingers for a very long time and occurs with slight variations as late as the seventeenth century in numerous examples of the rather large-headed images of Kuan-yin. This small Lohan, some one-third life-size, is made by the dried lacquer technique in which the sculpture was first modelled in clay. Cloth soaked in lacquer was laid over the clay form in successive layers up to the desired thickness. The surface was then finished with a final coat of lacquer or, at times, with a thin coat of gesso in which some of the finer details were modelled, and this in turn was lacquered. The outer surface was then painted or gilded. The clay core was dug out and the resultant shell of lacquered cloth made an image that was light, durable, and impervious to insects. It is not known when this technique was first used in China, but a dried lacquer image of a seated Buddha in the Metropolitan Museum may well be from the second half of the sixth century. Old dried lacquer sculpture is rare in China today, and the best examples of the technique are the important Japanese Buddhist images of the Tempyō period.

It may be that the strikingly individual and portrait-like figures of Lohans that have survived in north China are, in fact, only examples of established, traditional types. Not enough series are known today, however, for this to be apparent, and the best of them impress us as portraits of monks and great church personages whom the sculptors might have seen. Several life-size heads of Lohans, done in dried lacquer, now in Western collections, are reliably reported to have come from a temple in Hopei, south of Peking. They all possess a strong portrait quality and are modelled with great sensitivity. The characterization delves beneath the mere features and penetrates to a deeper, psychological portraiture expressive of spiritual states of being. The bony skull, glowing eyes,

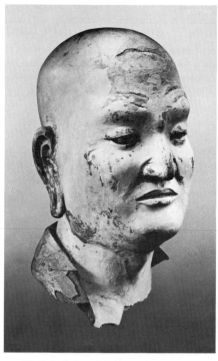

140. Head of a Lohan, dried lacquer.
Liao-Chin Dynasties, tenth to thirteenth centuries.
Chicago, Art Institute

141. Head of a Lohan, dried lacquer.
Liao-Chin Dynasties, tenth to thirteenth centuries.
Kansas City, Nelson Gallery of Art and Atkins Museum

and parted lips of the young monk [140] express an ardent religious zeal; while the round pate, full face, and square jaw of the thoughtful prelate [141] give us the portrait study of a skilled metaphysician or an experienced abbot.

The famous glazed pottery Lohans found in a series of caves near I-chou, south of Peking in Hopei, possess in an even more marked degree this portrait quality.[11] The figures are slightly over life-size and are seated on bases suggesting weathered and eroded rocks. In the modelling of the garments there is the same realistic treatment of the soft, heavy materials, and the same deep folds with sharp edges that we have already remarked in the wood sculpture of the

twelfth and thirteenth centuries. A sculpture like these Lohans has been reported in the mid ninth-century temple, Fo-kuang-ssu at Wu-t'ai Shan, and it is probable that these figures followed very closely on a style evolved in the late T'ang Dynasty. The facial types are purely Chinese; the heads show a knowledge of bone structure and anatomy rarely displayed in so clear a manner. The high cheek-bones and heavy Mongoloid fold above the eyes and the thick lips of the young Lohan of illustration 142 all describe a type to be met with in north China today. With his hands folded in his lap, his head thrown slightly back and an expression of intense concentration, he is as though

practising some Yogi breathing exercise conducive to meditation. In contrast the elderly Lohan [143] holding a sūtra scroll in his left hand might well be a learned lecturer about to discourse on the dòctrine. In these pottery Lohans there is no over-statement, no caricature, but a well-modulated, rational and sober expression of a religious concept – the possibility of salvation that is offered to all and the dignity of renunciation. The personal and emotional character of later Buddhism could not be better expressed.

These figures, decorated in the so-called 'three-colour' glaze of deep orange yellow, cream white, and shades of green, are technical masterpieces of the potter's art.

Buddhist art from the eleventh to the end of the thirteenth century was in the last important phase of its development on Chinese soil. The styles evolved during those centuries carried on with varying degrees of success into the fourteenth century, but nothing that was at once new and of artistic significance was added. The Buddhist church was crumbling from within, and what new stimulus there came to it from outside during the Mongol period of the Yüan Dynasty drew its strength from the Lamaistic church of Tibet. Lamaism, with its strong Tantric elements of demonology and female energies, brought little that would commend it to an educated Chinese, while the sculpture of the Tibetan church was an already highly formalized derivation from the images of Bihar, in India, and of Nepal. Bound, if not strangled, by rigid adherence to a complex iconography, the art of Lamaism was ill suited to the temperament of Chinese craftsmen. Buddhism still played an important role in the arts, but scarcely

142. Lohan, three-colour pottery.
Liao-Chin Dynasties, tenth to thirteenth centuries.
Kansas City, Nelson Gallery of Art and Atkins Museum

143. Lohan, three-colour pottery.
Liao-Chin Dynasties, tenth to thirteenth centuries.
New York, Metropolitan Museum of Art

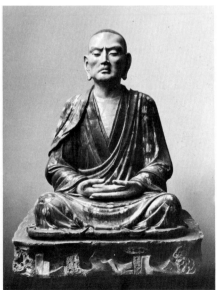

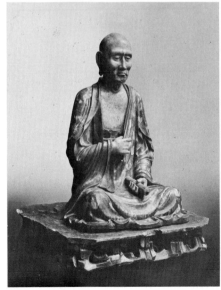

as an organized church. The monk painters of the seventeenth century drew their inspiration from the same kind of Buddhism that produced the great Ch'an painters of the Southern Sung and not the Buddhism that set Wu Tao-tzu to covering a thousand walls with frescoes.

Throughout the Ming Dynasty and the first century and a half of the Ch'ing, there was a great deal of temple building and repair of older structures. That the sculpture and paintings adorning these temples is so mannered, dry, and uninspired is a fact demanding a more adequate explanation than we are able to supply. It is evident that reasons must be sought within the Buddhist church itself, because in secular painting and in the ceramics and the scholarship of the Ming period there is ample evidence of creative national vitality.

There is, of course, much excellent sculpture from the Ming Dynasty, portrait statues in memorial temples, certain figures of Kuan-yin or such a canonized hero as Kuan-ti, but these do not seem to be related to any grand style on a national scale and are more in the nature of isolated products of especially gifted craftsmen. From the Ming and Ch'ing dynasties the true genius of the Chinese for descriptive form is to be found in abundance in the sculpture executed in jade, ivory, and wood, a world of *Kleinplastik* that follows purely indigenous traditions.

THE MASTERS OF LANDSCAPE

By the opening years of the tenth century the T'ang Dynasty had run its course and the most vast empire in Chinese political history dissolved. One after another the conquered kingdoms bordering China broke away, and China proper was again divided among usurpers, adventurers, and a brief survival of the old legitimate dynasty. The period from the end of T'ang to the founding of the Sung Dynasty is known in Chinese history as the Five Dynasties (906-60). During the latter part of the T'ang Dynasty the fierce rivalry between the Buddhists and Confucians had reached one culmination in a devastating Buddhist persecution in 845. Dissension continued throughout the Northern Sung Dynasty (960-1127) as a bitter political struggle between the radical reformers, following Wang An-shih, and the conservatives.[1]

Although the tenth century was marred by bitter dissension and political strife, it was also the century of the giants of landscape painting. Perhaps the turmoil of the age following a century of slow decay within the T'ang Dynasty was itself a potent factor among the causes that led the leading artists to paint towering piles of rocky peaks, rushing torrents, and dark cascades, tangled masses of leafless, dormant trees, and lonely temples reached by tortuous and narrow paths.

Within the space of little more than a hundred years there occur some of the most imposing names in landscape painting. The oldest of these men was Ching Hao, active from about 900 to 960; there was his younger contemporary Kuan T'ung; then the great Li Ch'êng, active around 940 to 967; Kuo Chung-shu, who was born about 920 and died about 977; and Hsü Tao-ning and Yen Wên-kuei from the end of the tenth and early eleventh centuries. Also active towards the end of the century were two of the masters destined to influence Chinese painting into modern times – Tung Yüan and Chü-jan; while the towering genius of Fan K'uan, active from about 990 to 1030, carries the art of landscape well into the eleventh century.

Almost anything one may say about the individual styles of these famous painters will be in the realm of speculation. Actually we know very little about them save the traditions that have been handed down by painters, art historians, critics, and collectors. This is not the place to examine in detail the pros and cons about the value of traditional attributions. Generalities have little or no meaning, because each painting, its history, and its claims to antiquity, presents an individual problem. There does seem to be, however, a body of tradition about the styles of early painters that is relatively consistent. It has probably happened that, when a good and ancient painting came into the hands of a collector and, in his opinion, met the requirements of the traditional style of a given master, the name of that master would be affixed either on the painting itself or the outer label, and so an attribution would begin. In the present volume the illustrations follow in general the traditional attributions with the reservation that the paintings do not necessarily represent the style of the master whose name they bear, but in the belief that they could be paintings from the periods under discussion.

Ching Hao (900-60) was the earliest of the tenth-century painters. Escaping from the political turmoil of his time, he followed a simple, secluded life, supported himself by

farming, spent his leisure hours wandering in the beautiful T'ai Hang mountains of eastern Shansi, and painted the scenes that filled his heart. There is an essay on landscape painting said to be by Ching Hao which in all probability embodies many of the concepts and ideals held by these early artists. The theme of this essay is that the art of the painter lay in grasping the ultimate reality and not the mere illusion of reality; in abstracting the spirit from the form. 'Resemblance reproduces the formal aspects of objects, but neglects their spirit; truth shows the spirit and substance in like perfection. He who tries to transmit the spirit by the means of formal aspect and ends by merely obtaining the outward appearance, will produce a dead thing.'[2] Such a criterion for art as opposed to representation of the illusion of reality is also vividly expressed in the author's classification of artists: 'Again, there are in painting the following categories: the *divine*, the *sublime* (or *mysterious*), the *marvellous*, and the *skilful*. In the class of the *divine*, there appears no trace of human effort; hands spontaneously produce natural form. In the *sublime*, an artist first fathoms the universe and the nature and circumstances of all things. Then in a style appropriate to the subject, the forms flow spontaneously from his brush. In the *marvellous* there is an unusual and unexpected representation which may be contrary to the real scenery or object, and yet possess the truth. This is owing to the master of the brush without thought. By *skilful* is meant an artist cuts out and pieces together fragments of beauty and welds them into the pretence of a masterpiece. His style is forced, and the *spirit* and *form* are highly exaggerated. This is owing to the poverty of inner reality and to the excess of outward form.'[3]

These are old Chinese ideas adapted to the thinking of landscape painters in the tenth century. 'Oriental art is not concerned with Nature, but with the nature of Nature.'[4] From the earliest times the artist of eastern Asia has never lost his character of a magician who by his magic – his 'art' – penetrates beyond appearances, grasps the essential spirit and holds it captive in the thing he makes. '. . . In the beginning, in the animistic phase, they did this as sorcerer' – by ritual and dance, by the magic designs on vessels that held the offerings they evoked the creative power of nature and partook of it – 'later on as artists who worked in the spirit of *tao*. . . .'[5] The painter showed the power of nature in operation so that the initiate might, by gazing at the picture with understanding, share the artist's communion. And what of the observer? If the artists must submit to classification, should the audience escape? Chinese painting, like the music of the West, dares to demand a reciprocal effort from the observer who, depending on his state of grace, can comprehend the *divine* or the *mysterious*, the *marvellous* or the merely *skilful*.

Again and again, the author of *Notes on Brushwork* emphasizes that a painting to be worthy must have more content than simple representation. 'There are', he continues, 'two kinds of faults: those that are dependent on representation, and those which are not. When flowers or trees are out of season, when a man is larger than a house, or a tree is taller than a mountain, when a bridge has no bank to rest upon – these are demonstrable faults of form. Such faults in drawing can be corrected. As to the faults that do not depend on representation, both the spirit and the harmony are utterly destroyed and the forms of objects are all distorted. Although the brush and ink may be active, yet everything in the picture is dead. The fruits of such poor workmanship cannot be corrected.'[6]

What kind of landscapes these men painted can be judged from a score or two of old and noble pictures that may be from the tenth century, or may be later, but still early versions varying from the ancient manner in details but still retaining most of the early classic style.

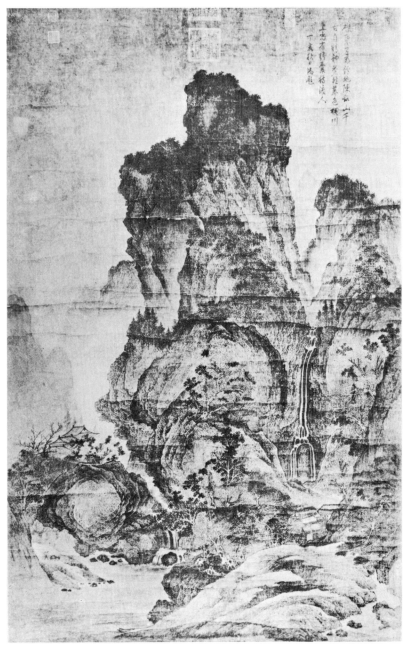

144. Kuan T'ung: Awaiting a Crossing. Ink and light colour on silk. Tenth century.
Taipei, Taiwan, National Palace Museum

An early landscape in the Palace Museum is attributed to Kuan T'ung of the tenth century, and is entitled 'Awaiting a Crossing' [144].[7] Here the human figure is reduced to the smallest possible size – a lonely peasant with his donkey approaching in the left foreground and awaiting the ferry boat in the foreground right. The human element does not intrude upon the sense of the vastness of the great, weathered peak, but rather, by striking contrast in scale, the minute figure and his beast emphasize the lonely vastness – 'in China not man but nature was the measure, and that nature was uniquely conceived as the symbol of the universe.'[8] There is a huge central peak occupying the middle of the picture, and the eye travels directly upward in a series of diagonals from the corner of land where the boat is moored in the direct foreground, to the right and upward to the group of huts, and so the forms mount one behind the other to the apex of the peak. One is led up and back not only by the overlapping forms but by the tones and by the accents created through the placing of the trees. The forms are weathered and rounded, and the repetition of almost spherical shapes gives a soft, mellow aspect of nature. The clear definition of trees and their foliage, of solid rock forms and of the exact relationship of hills and mountains to one another and to the valleys produces a landscape that is lucid and classic in its balance.

In this picture, as in all Chinese paintings, there is no apparent source of light but rather an over-all, even illumination which in its intensity and emphasis may vary from one part of the picture to another, as the artist wishes to point up a form or construct his composition in terms of ink tones. Again, like all other Chinese landscapes, this is not a portrait of a mountain but a composite of many elements of nature. Although the main design may be based on a view of some famous peak, the artist has felt perfectly free to introduce lakes, streams, waterfalls, or temple buildings to suit an ideal concept. The point of view from which the various elements are presented is also ideal and composite. There is no fixed vanishing point, or one-point perspective. Each element is presented in its most typical or pictorially satisfactory aspect. The observer may be looking down upon the scene from a great elevation and so on to the roofs of buildings and catch a glimpse inside the courtyards; or he may, in imagination, stand in the foreground and look up at the towering heights above; or from a height in the middle distance gaze through the precipitous valley walls to distant peaks rising from their misty bases. Unlike Western painting, Chinese painting does not keep the spectator rooted to the ground with a fixed gaze in one direction. 'In the European tradition', to quote Rowley, 'the interest in measurable space destroyed the "continuous method" of temporal sequence used in the Middle Ages and led to the fifteenth-century invention of the fixed space of scientific perspective. When the Chinese were faced with the same problem of spatial depth in the T'ang period, they re-worked the early principles of time and suggested a space through which one might wander and a space which implied more space beyond the picture frame. We restrict space to a single vista as though seen through an open door; they suggest the unlimited space of nature as though they had stepped through that open door. . . . They practised the principle of the moving focus, by which the eye could wander while the spectator also wandered in imagination through the landscape. By this device one might travel through miles of landscape, might scale the mountain peaks or descend into the depth of valleys, might follow the streams to their source or move with the waterfall in its plunge.'[9]

The early twelfth-century catalogue of the Imperial Collections says of the landscape painter, Kuan T'ung, that: 'Most of all it delighted him to paint autumn hills and wintry forests, with groups of cottages, river-crossings,

hermits, recluses, fishermen selling their catch, mountain-hostelries. Look well at his pictures and you will find yourself suddenly transported to the scenes which it portrays. You are standing, perhaps, "on Pa Bridge amid the wind and snow", or travelling up the Three Gorges "where gibbons scream from either shore". You who but a moment ago were a common courtier or grubber in the dusty markets of the world are suddenly transformed.'[10] The description might equally well apply to most of the leading landscape painters of the tenth and eleventh centuries if we may judge by the few remaining pictures.

The important eleventh-century writer on art, Kuo Jo-hsü, who lived in the great age of landscape painting, classes Kuan T'ung among the three supreme masters of that subject. The other two, Li Ch'êng and Fan K'uan, complete the triumvirate. 'In talent so exalted,' he writes, 'as to be beyond classification, these three – like legs of a tripod – will set the standard for a hundred generations.'[11] Time has proved Kuo's praise to be well founded. While it is not certain that any original works of these men have survived, a number of very good, old pictures attributed to Li Ch'êng and Fan K'uan and such late tenth- to eleventh-century artists as Yen Wên-kuei, in all probability reflect the style of early landscape, and, in some cases, even the individual manner of the master. A relatively small landscape in the Palace Museum, Taiwan, has the signature of Yen Wên-kuei, who was active in the second half of the tenth century [145]. 'Temples amid Mountains and Streams' may be taken as characteristic of the grand manner of early Northern Sung. A basic mountain shape of precipitous sides and weather-rounded top crowned by dense vegetation is repeated from the foreground, through the middle ground and into the far distance, ever increasing in height until the lesser peaks seem to cluster around and buttress up one great central mountain mass. Atmosphere and

recession in depth are created by the mist-filled valleys separating the ridges silhouetted against lighter tones. Within these basic mountain forms there is an infinity of varied shapes, minor ridges, deep gorges, and winding mountain paths leading to temples perched on high

145. Yen Wên-kuei (late tenth century): Temples amid Mountains and Streams. Ink on silk. *Taipei, Taiwan, National Palace Museum*

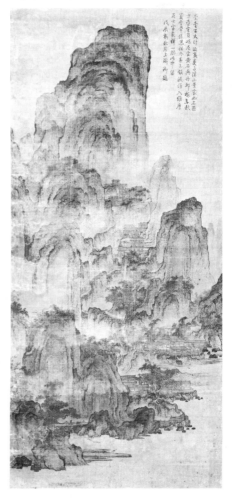

plateaus. The rock outlines are fluidly drawn with undulating lines descriptive of rugged forms. All the surfaces are closely textured with small ink dabs and washes running the entire tonal gamut. Waterfalls appear as thin white lines against black gorges. Details are explicit and descriptive, as with the small traveller on a donkey crossing a bridge in the foreground, the architecture on the middle right, and the far, high-perched temples and monasteries. Detailed as the picture is, all elements are related to and dependent on one another, carefully worked together into a single unit existing in atmosphere and spatial depth. If such a development was the contribution of the late tenth century, then by the early eleventh, landscape was well on its way to becoming a vehicle for intimate, personal expression.

Like many other landscape painters of the period, Li Ch'êng had a preference for wintry scenes, bleak, stony crags, gnarled trees with leafless, 'crab-claw' branches. It is very doubtful if any original works of his survive, but a picture bearing a traditional attribution to Li Ch'êng and possibly close to his style is 'Buddhist Temple in the Hills after Rain' [146, 147]. The autumnal skies are clearing, mist fills the valleys and the low pathway, a few leaves still cling to the trees but not in numbers to conceal the tangled branches.[12] The temple with its hexagonal tower occupies an eminence in the very centre of the picture and at the foot of the dominating peak. The background is closed by walls of pinnacles.[13] In the immediate foreground a group of huts and two pavilions built over the water provide food and drink for pilgrims. These buildings and the figures, such as those entering from the left, are painted in such detail that we can distinguish the peasants and courtiers at their meal in the rustic inn and scholars at their wine in the pavilions.

The detail [147] better illustrates the character of the drawing and brushwork. A strong, irregular outline bounds the main rock shapes,

as in the other painting [145]. There are then a series of ink washes ranging from quite light to darker tones as they are superimposed one upon another. The inner markings that make the surface texture and modelling of the rocks are not applied as washes but in a series of dabs, some triangular from the shape of the brush-point and others longer strokes made by dragging the brush. This manner – and it is handled with consummate skill – does not fit any of the standard classifications of ts'un

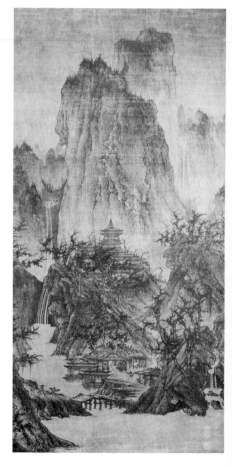

techniques but might be a relative or progenitor of the method called 'split bean' or 'raindrop' ts'un.[14] The trees are again complex but logical and well defined. They have been sketched in with sureness and above all with unlaboured ease.[15]

Li Ch'êng as a person represented a certain kind of Chinese ideal – the artist of good family, educated in the humanities, without ambition for high place and who painted for his own delight, while reserving a particular scorn for

146 and 147 (detail). Li Ch'êng (fl. 940-67): Buddhist Temple in the Hills after Rain. Ink and slight colour on silk. *Kansas City, Nelson Gallery of Art and Atkins Museum*

nobles and officials who sought examples of his work. Kuo Jo-hsü, in his sketch of Li Ch'êng, says: 'His grandfather and his father were both celebrated in their generation for their classical scholarship and their conduct of affairs. Ch'êng, however, had (no other) ambition than to lead a quiet life, and loftily declined (all) honours and advancement. In addition to being well versed in the canonical books and histories, he was a most excellent painter of landscapes with wintry forests. His inspired versatility was the quintessence of the spiritual, very far beyond normal human (capacities).'[16]

Although Hsü Tao-ning was a landscape painter from the end of the tenth and the first half of the eleventh century, a generation later than Li Ch'êng, it is best to introduce him here because he modelled his style on that of Li Ch'êng, and because the painting attributed to him which we illustrate does seem to have some relation to the brush manner just discussed. Kuo Jo-hsü, who must have been almost Hsü's contemporary, remarks that he studied Li Ch'êng and continues: 'Early (in his career) he set great store by a meticulous precision; but as an old man he cared only for simplicity and swiftness of drawing. With peaks that rose abruptly and sheer, and forest trees that were strong and unyielding, he created a special school and form of his own.'[17]

The best painting in the writer's knowledge bearing an attribution to Hsü Tao-ning is a horizontal hand-scroll, noble in proportions, depicting a portentous mountain panorama – range behind range of bleak and shattered peaks, soaring above marshy valleys where the wintry fog hangs low [148, 149]. The central mountain mass, that extends beyond the top of the scroll, rises abruptly between two broad valleys, boldly painted as receding directly back into the picture, while a third flat valley opens at the extreme left. The abrupt vertical cliffs of the central peak are in places broken by the kind of diagonal and horizontal outcrops that occur in

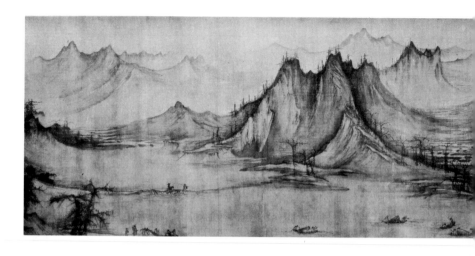

148 and 149 (detail). Hsü Tao-ning (fl. first half of the eleventh century):
Fishing in a Mountain Stream. Ink on silk.
Kansas City, Nelson Gallery of Art and Atkins Museum

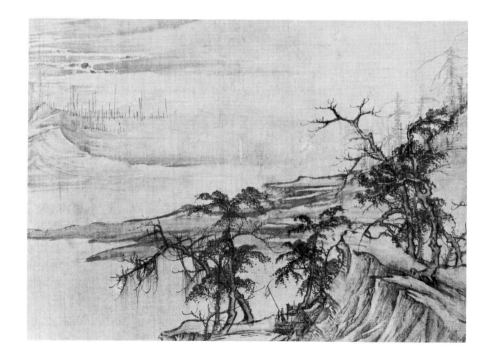

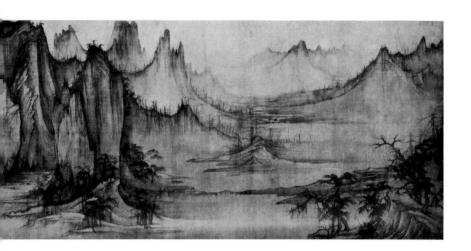

several paintings attributed to early masters. The most impressive technical feature is that bounding outlines have been abandoned throughout a great part of the picture in favour of sweeping washes of wet ink. Even in the near-by mountains the use of bounding outline is reduced to a minimum and employed more for accent than for definition of shape. The inner markings of cleavage and erosion are rendered with a few dabs and blobs, although long, vertical strokes and graded ink washes dominate.[18] In the details [149] the trees may be seen to be treated in somewhat the same manner as those in illustrations 146-7 - the trunks drawn with ragged brush-strokes, the branches ending in small hooks, and the leaves represented by close-packed dots. It is not here intended to imply any formal connexion between the two paintings in illustrations 146-9, but only to point out certain general similarities that may have been common to many of the great landscape painters of the tenth and eleventh centuries.

The Hsü Tao-ning painting is in the form of a hand-scroll, at present nineteen inches high and eighty-two inches long; originally it was probably at least as long again. Scrolls of this kind are mounted on a roll and are opened from right to left, flat on a table, the viewer seeing no more than about two feet at a time. The horizontal scroll form is the culmination of Chinese creative genius in painting. It is the only painting form in the world that brings to the art a true progression through time. As the observer progresses through such a scroll, there is a unique element of the theme unfolding and developing in much the same way, and, incidentally, with much the same mechanics, as a theme is developed in poetry or in Western music. The composition of these scrolls would be impossible with a fixed vanishing point and one-point perspective. There must be multiple vanishing points, the one fading imperceptibly into the next. Directly in front of the observer as the scroll is unrolled, is the place he stands, to the right he may look back to those scenes traversed, to the left he may look towards the new vistas being unrolled as they would reveal themselves to the traveller. It is impossible sympathetically to view a landscape scroll without becoming part of it and entering into the artist's world of peaks and streams. 'Again and again in these landscape scrolls a road or a path appears at the beginning, and we are

almost bound to follow it. These roads direct the attention of the spectator and instruct his vision. Now and again he must walk in the foreground, viewing the plains and distant hills; he is led on to the hills themselves, crosses bridges, climbs mountains, rests at high-placed temples; occasionally he may choose between the path and a boat, and often he is led completely out of sight behind a cliff or hill only to emerge again farther along.'[19] Or again, the spectator may view the scenes spread before him with Olympian detachment and discover that the world of nature and the world of man are inseparably one. The hut of the recluse, the temple in the high valley, the fisherman and the sage are in no way the intrusion of an alien element but rather integral parts of the great operations of nature. He may view the world and its oneness like an ascetic in contemplation.

The hand-scroll is never spread out and viewed in its entirety, because to do so violates its spirit and its purpose. An art that exists in time, like music and poetry, must have a progression from beginning to middle to end; to be cohesive and consistent it must have repetitions of theme and rhythm; to be stimulating it must have variations between major and minor elements. All these qualities were combined by various means in the horizontal landscape scroll. One kind of composition that became classic and may have originated in the tenth and eleventh century opens with a passage of trees, rocks, or buildings quite close to the spectator; the scene then moves back into the middle or far distance, changing rapidly in scale; again elements come close to the foreground and the mountains build up to a dramatic climax as one dominating peak soars beyond the upper confines of the scroll; the view then again pushes back and vistas open to the most distant hills. Of course there are variations: in the Freer Gallery Kuo Hsi, for example, there are two sections of towering peaks, but the first is lower and minor to the

second, and serves as an introduction to the major climax. The early landscape scrolls were constructed with the foreground, middle distance, and far distance, nicely adjusted to one another. The foreground is established by wonderfully drawn trees, frequently old, gnarled, and leafless; flat areas and streams make an easy transition into the middle-ground, where the principal mountains with their foothills and lesser peaks push forward or recede into the distance, merging with the farthest range where peaks appear out of, and disappear into, the mist, forming a kind of counterpoint or minor theme.[20] The manner in which Chinese painters of succeeding generations employed the scroll is in itself a history of the evolution of their art. Landscape scrolls of later centuries are never organized with comparable lucidity and grandeur except when they are consciously based upon the manner of the tenth- and eleventh-century masters.

Among the paintings in the Palace Museum, Taipei, attributed to masters of the tenth to eleventh century, one of the best in quality, if indeed not the best of all, is a large landscape entitled 'Travelling among Mountains and Streams' attributed to Fan K'uan – one of the three greatest landscape painters according to Kuo Jo-hsü's judgement [150]. The mountain is treated in a very simple way. It has the appearance of weathered granite and by the plainness of its bulk conveys the impression of an imponderable weight; one deep gorge has been cut by a stream on the right, where the string-like waterfall, in its cool, black cleft, adds to the verticality that dominates the composition. On the far side of a thickly wooded hill in the middle distance a temple commands a view of the waterfall, while the stream from this high-mountain source splashes and gurgles into

150. Fan K'uan (fl. 990–1030): Travelling among Mountains and Streams. Ink on silk.
Taipei, Taiwan, National Palace Museum

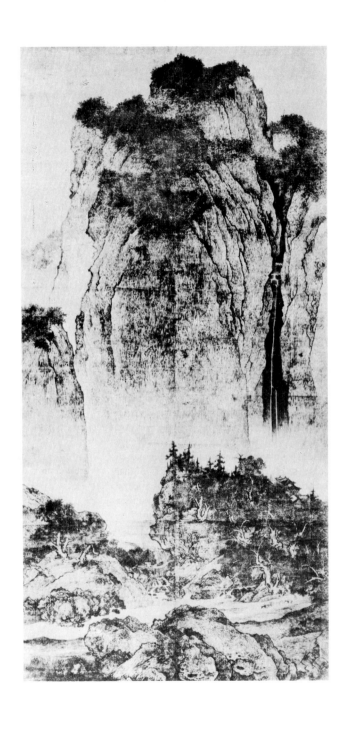

the foreground, and is crossed by a rickety bridge. A ponderous mass of worn granite occupies the centre of the foreground and brings the scene very near. On the extreme right a small rustic figure is driving four loaded mules towards the stream. A tangle of twisted deciduous trees and lance-straight evergreens, very carefully drawn, covers the slope of the nearer mound, but the sheer rock sides of the majestic pile are bare of vegetation; only on the top more extensive erosion has provided a precarious footing for a thick, scrub growth. In brief, the artist who painted this picture was familiar, from penetrating observation, with the nature of geological formations, the behaviour of mountain streams, the way trees grow in rocky ground, and the curiously clear light that makes details visible in the thin air of high places.

A technical device for creating a sense of depth is that of silhouetting the top or edge of one rock mass or clump of trees against an area of plain silk or very light ink wash suggesting mist. The device is almost universal in Chinese landscape painting, and here it is used with particular success. Anyone who has wandered in the mountains knows this effect to be based upon reality. The same jagged brush-stroke we have seen in other early paintings has been used to define the main outlines of form. The inner markings, the ts'un are neither 'too abundant' nor 'too sparse'. There is enough ink to suggest perfectly the texture, character, and structure of the rocks, but never so much that the vigorous quality of each brush-stroke is concealed.[21] Throughout this picture there is no virtuosity of brush-work, no pyrotechnic display of strongly contrasting tones, but rather an extremely competent, straightforward painting that is perfectly consistent and controlled from top to bottom and from side to side. Whoever painted 'Travelling Among Mountains and Streams', and it may very well have been Fan K'uan, was a consummate master of

his craft, working in an age when balance, moderation, realism in the sense of an understanding of natural laws, and visual integrity were the highest norm. Landscapes such as this are the apex of the grand manner born during the Five Dynasties and early Northern Sung.[22]

There are a few other excellent paintings that have been honoured with the name of Fan K'uan. One is a great winter scene of cold, austere hills, leafless trees, and pilgrims hurrying towards a distant temple – all under a dark, oppressive sky [151]. The folds, angles, and

151. Fan K'uan (fl. 990–1030): Winter Landscape. Ink on silk.
Taipei, Taiwan, National Palace Museum

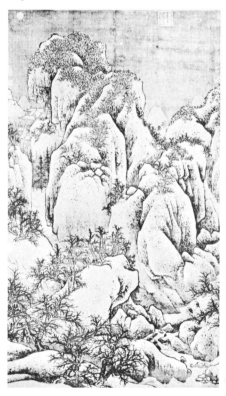

strange shapes of the mountains are exaggerated by their thick white covering of snow and the brittle trees stand out like black and frozen skeletons. In the brush-work there is the same austere restraint, but the ink is even more sparingly used, giving an almost crystalline effect. In both these compositions, the mountains fill almost the entire space and there are no vistas into the far distance, no parts concealed by banks of mist. Such completeness of statement adds to their solemn grandeur.

The same spirit of nature congealed, of an all-pervading, bitter cold, and the quiet of the world when the *yin* element dominates, is found in a small, round fan painting mounted as an album leaf in the Boston Museum.[23] Fan K'uan, whose proper name was Fan Chung-chêng, and was styled Chung-li, was active from about 990 to 1030. Critics of the following and later generations are unstinting in their praise of the man and his work. The early twelfth-century imperial collection claimed fifty-eight paintings by him, many of them in sets of two, four, and one of twelve scrolls. The catalogue of this collection, the *Hsüan ho hua p'u* (preface dated 1120), says that Fan K'uan was: 'a stern and old-fashioned man, careless in his behaviour, fond of wine and with no command of the ways of the world. . . . To begin with, he studied the art of Li Ch'êng, but one day he woke up and said to himself with a sigh: "My predecessors have not yet tried to seize the things as they really are; surely it is better to take the things themselves than men for teachers, and a still better teacher than material objects is the heart." Thereupon he gave up his old manner of study and retired to T'ai-hua in the Chung-nan mountains. . . .'[24] It was his grasp of 'things as they really are', his balanced and rational style that impressed the early critics. Kuo Jo-hsü wrote: 'The manner of Master K'uan (comprises) a crystalline hardness of rock forms; a luxuriant density in his combination of trees; an antique elegance in his

terraces and pavilions; and a lofty peacefulness in his human figures.'[25]

Two famous painters from the end of the tenth century were noted for a quality that was to become increasingly important in Chinese landscape painting – the quality of atmosphere, of misty air, and of limitless space out of which the forms emerge. Both these men, Tung Yüan and the priest Chü-jan, were from Chiang-nan, in the Yangtze valley, and painted at the Nanking court of the ruler of the Later T'ang Dynasty, the great art patron, Li Yü (937-78). Tung Yüan, also known as Tung Pei-yüan, was the elder of the two. Like many Chinese artists, he apparently worked in several styles, one of which was monochrome ink landscape described by early critics as being executed in a bold manner with coarse brush-strokes, blobs and dots of ink that only at a certain distance were seen to take on the shape of objects; and a second quite different manner in which colour was used in the old T'ang tradition and the drawing was meticulous and fine. Although this latter style was much admired, critics of the eleventh and twelfth centuries, especially, praised his 'rivers and lakes in wind and rain, torrents and valleys, mountain peaks now obscure, now clear, trees in the mist, and clouds of driving storms' – all atmospheric effects of weather.

In the Palace Museum there is a painting attributed to Tung Yüan called 'Festival in Honour of the Emperor', painted in a relatively fine and detailed manner in colour on silk.[26] The figures are infinitesimal and the view is extraordinary – a vast distance of lakes and rolling hills presented as though seen from a very great height. It may well be an example of Tung's coloured style. What his coarse, more impressionistic style may have been is even more difficult to say.[27]

There are two horizontal scrolls, however, which may be accepted as old examples of Tung Yüan's more free style. One of these, acquired

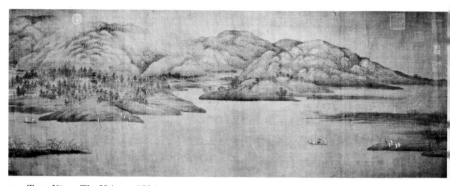

152. Tung Yüan: The Hsiao and Hsiang.
Ink and some colour on silk. Late tenth century.
Peking, Palace Museum

for the Hui-hua Kuan in Peking, may be identified with a famous composition of Tung Yüan's, 'The Hsiao and Hsiang Rivers' [152]. It is a broad, panoramic scene of softly rolling, weathered hills, a pine forest in the middle distance on the left, and a wide expanse of water stretching to the right, where long fingers of marshy shore support the effect of distance in depth by their horizontal accents. Rather long, wavering ts'un strokes model the forms in certain areas and describe the erosion of the soil. A great number of small dabs and dots suggest the distant vegetation and by their concentration in valleys and folds of the hills accentuate the modelling. In contrast to the rather accomplished spatial relationships and the atmospheric effect of a humid river valley, there are many archaic features, such as the over-large reeds, and the way the land masses meet the water abruptly in rounded shapes, somewhat reminiscent of certain T'ang Dynasty landscape details in the cave chapels of Tun-huang. The small figures contrast with the relatively free painting of the landscape and are executed in detail in the meticulous *(kung-pi)* style.

The second long hand-scroll, now in the Shanghai Museum, appears, from the repro-

ductions available,[28] to be an old painting, but somewhat more advanced than the 'Hsiao and Hsiang' scroll. The rich verdure of the trees, and the areas of white mist and horizontal ink washes representing marshes and spits of land, are organized and painted in a way more convincing of spatial relationships and atmospheric effects.

If the leading connoisseurs of later generations knew both this scroll and the famous 'Clear Weather in the Valley', now in the Museum of Fine Arts, Boston, then it is understandable why the critic Tung Ch'i-ch'ang attributed the Boston scroll to Tung Yüan.[29] The two paintings have much in common, especially the drawing of the trees and the way in which the dots are used. Both can be taken to represent aspects of Tung's style, though the Shanghai scroll seems closer to the master's time.

It is difficult to attempt to correlate the writings of the ancient critics with surviving paintings because we cannot know the visual experiences that were the basis of their judgements. Nevertheless, we can find in the 'Hsiao and Hsiang' scroll and in the Shanghai scroll many of the very features described by writers living little more than a generation after Tung Yüan. The Boston scroll of 'Clear Weather in

the Valley' appears to represent the style modified by artists of a century and a half after Tung Yüan. There are the atmospheric effects of cloud and mist – of forms but half revealed – and above all there is a technique that might well have seemed broad and impressionistic in his age. In the Five Dynasties and early Northern Sung period, the profuse use of dots must have been something of an innovation.[30] The two early painters supposed to have used this method most extensively – Tung Yüan and Chü-jan – were both active in the Yangtze valley where the warm, moisture-laden air might well suggest to a keen observer the use of a method so well suited to vague and impressionistic effects.

There is in these scrolls a total effect that is gentle, calm, and lyrical – an effect produced in part by the thick verdure, low, weathered hills, and wide expanses of water. Such characteristics may also be of southern origin in contrast to the austere and often bleak scenes of the northern landscape painters.

Chü-jan's traditional style is the most distinctive of any of the landscape painters we have so far examined. In the Palace Museum there is a medium-sized vertical landscape called 'Seeking Instruction in the Autumnal Mountains', attributed to the priest painter [153]. The use of dots we have noted in the Boston Tung Yüan is much more marked here. They no longer serve the sole purpose of suggesting low vegetation but are consciously employed for accent. Instead of sheer cliffs and rocky mountains, the hills are more softly rounded and deeply eroded. Among the technical characteristics that should be mentioned are: the white tree-trunks, outlined like those in the Tung Yüan scroll; the ts'un that are long, sometimes wavy lines following the contours of the hills and giving an effect of soft erosion as of very old formations; the flat tableland areas, as in the right foreground and middle left; the way in which the ground in certain areas is broken up into numerous hillocks or boulders, as in the left foreground and the top of the central peak. The ts'un used is a developed form of the shorter, less definite brush-strokes in the Boston Tung Yüan, and here may be classed as the kind known as 'hemp-fibre'. There is a use of moist, rich ink throughout, frequently in strong contrast with much lighter tones. The

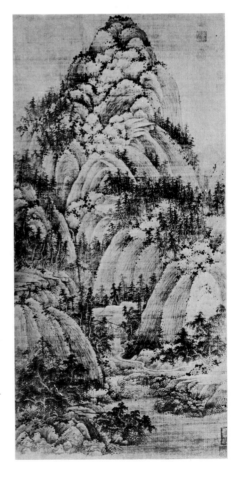

153. Chü-jan: Seeking Instruction in the Autumnal Mountains. Ink on silk. Tenth century. *Taipei, Taiwan, National Palace Museum*

effect is altogether striking and vigorous, but at the same time the very manner of painting and the conscious construction of design seem to assert themselves over representation. If this painting is a work from the second half of the tenth century, or a faithful version, then landscape was well on its way towards the flexible and sensitive medium for personal expression which it became under the genius of Mi Fei in the eleventh century and the great Yüan masters of the fourteenth.

The latest painter of this great line was Kuo Hsi, who was active in the full Northern Sung period. Born about 1020, he attained early fame and was admitted to the Imperial Academy of Painting when still a young man. He was enormously admired by his contemporaries, and Kuo Jo-hsü says of him that: 'In this generation he is the single supreme (figure).'[31] The same author tells us that Kuo Hsi studied the style of Li Ch'êng and followed that master, but at the same time was capable of expressing his own emotions, and especially speaks of his huge screens and wall paintings.[32] The twelfth-century catalogue of imperial Sung paintings tells us that after studying the manner of Li Ch'êng he evolved his own ideas, and on the walls of lofty halls he would paint towering pines and great trees, twisting streams, sheer cliffs and precipices, abrupt peaks, beautiful in the rising mist or obscured in the clouds, with all their thousand forms and myriad shapes. The critics say that he alone strode forward in his generation.

Kuo Hsi was also the author of a collection of notes on landscape painting that is certainly one of the most interesting old treatises on the subject. The work was edited by his son Kuo Ssu, who added a number of his own comments. The essay treats of the purpose and ideals of landscape painting, of the best methods, faults and virtues, composition and relative im-

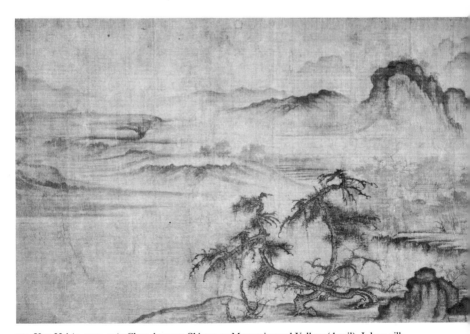

154. Kuo Hsi (*c.* 1020-90): Clear Autumn Skies over Mountains and Valleys (detail). Ink on silk. *Washington, Smithsonian Institution, Freer Gallery of Art*

portance of elements, and technical suggestions. The work has been entirely translated by S. Sakanishi and extensive parts by Osvald Sirén.[33]

In the discussion of some of the paintings above we have pointed out a tendency towards realism, and it is perfectly in keeping with the aesthetic ideas of the age that Kuo Hsi speaks in more than one passage of realism as an ideal of landscape painting. In the section of his essay called 'Comments on Landscape', he writes: 'The spring mountain is wrapped in an unbroken stretch of dreamy haze and mist, and the men are joyful; the summer mountain is rich with shady foliage, and the men are peaceful; the autumn mountain is serene and calm, with leaves falling, and men are solemn; the winter mountain is heavy with storm clouds and withdrawn, and men are forlorn. The sight of such pictured mountains arouses in man exactly corresponding moods. It is as if he were actually in those mountains. They exist as if they were real and not painted. The blue haze and the white path arouse a longing to walk there; the sunset on a quiet stream arouses a longing to gaze upon it; the sight of hermits and ascetics arouses a longing to dwell with them; rocks and streams arouse a longing to saunter among them.'[34]

It seems probable, if we may judge from the best of the surviving paintings attributed to Kuo Hsi, that he himself carried realism farther than had been done by any of his predecessors. To an eleventh-century Chinese, whose visual experiences were limited to the conventions and compromises of perspective and space representation current in his own time, the great, wide panoramas of Kuo Hsi might well have seemed far more realistic than to a modern Occidental. Kuo Hsi gave his contemporaries a realism in which their imaginations could wander at will and commune with the mood of season and scene.

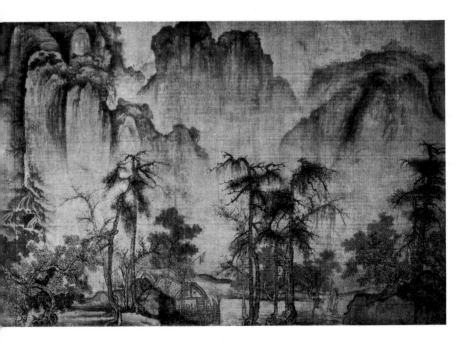

A mountain landscape entitled 'Early Spring', now in the National Palace Museum, is one of the best from the former Imperial Collection attributed to Kuo Hsi.[35] In Western collections, there is in the Freer Gallery a magnificent horizontal landscape scroll called 'Clear Autumn Skies over Mountains and Valleys' – a painting as close to Kuo Hsi as we shall probably ever come [154].[36] A beautiful and mellow autumnal mood pervades the scroll – 'serene and calm, with leaves falling'. The two old pines in the foreground are of themselves an excellent study of contrasting and complementing rhythms, and no colour is needed on the thick foliage of the trees on the right to tell us of their autumn tints. The very successful effects of broad distances, of mists rising from the valley and shrouding the temple compound, the limitless 'air' surrounding the mountains and trees is, on a technical level, rather similar to the scroll by Hsü Tao-ning – an artist who was nearing the end of his career when Kuo Hsi was born. The way most of the hills and peaks are painted without outline in ink washes and long vertical strokes is also similar in the two scrolls. Perhaps it is significant that both Kuo Hsi and Hsü Tao-ning painted in the eleventh century, and both based their style on a study of their great predecessor Li Ch'êng.

In any event, paintings so occupied with aerial perspective, with seasonal weather and atmosphere, as is this scroll, prepare the stage for a genius of great individuality who was to break with tradition, or rather push the traditional style one step farther and create a new kind of painting. The genius appeared in the person of Mi Fei.

Mi Fei was to become, in the Yüan and Ming Dynasties, the great ideal of the gentleman painter. What his position as an artist was in the Northern Sung period is more difficult to say. He was certainly a person of wide accomplishments, fastidious discrimination, and a caustic and eccentric character. He was a gifted writer of both poetry and prose, one of the greatest calligraphers of his time, a passionate collector of old paintings and writings, an expert on ink stones, an admirer of fantastically eroded rocks – he used to address the favourite one in his garden as 'my elder brother'. He held many official posts, including Secretary of the Board of Rites and Military Governor of Kiangsu, but it is said that, because of his caustic tongue and unwillingness to conform to the orthodox behaviour of officialdom, he was not a great success. Among Mi Fei's writings, the *Hua Shih*, 'An Account of Painting', is a very valuable work, though preserved in a somewhat fragmentary form. It contains material on a number of artists, interesting technical notes, and advice on the care of old pictures. Among the oddities of his personal character was a fixation on cleanliness which kept him constantly washing – he allowed no one but himself to touch his pictures, and he went about garbed in robes of the T'ang Dynasty. On good grounds, probably, he was deeply sceptical about the 'old masters' collected by the rich and powerful of his day – an age of great antiquarians. Born in 1051, he was a contemporary and friend of the great poet and painter Su Shih (Su Tung-p'o) and of the artists Wên T'ung and Li Kung-lin. Mi Fei died in 1107 in the early years of the reign of Sung Hui-tsung.[37]

Original paintings by Mi Fei are very rare, and it is a question if any have survived. The traditions, however, about his style are consistent and there can be little doubt about the kind of landscapes he painted. One of the most convincing pictures is a small landscape in the collection of Mr Fusetsu Nakamura, Tōkyō [155]. Curiously pointed, sugar-loaf mountains are but half revealed through banks of mist, the trees are hastily indicated by a few blobs of wet ink, and the whole effect is one of moisture-drenched vegetation. There is almost no drawing in the strict sense, but straight painting of coloristic effects in ink. Instead of the beauti-

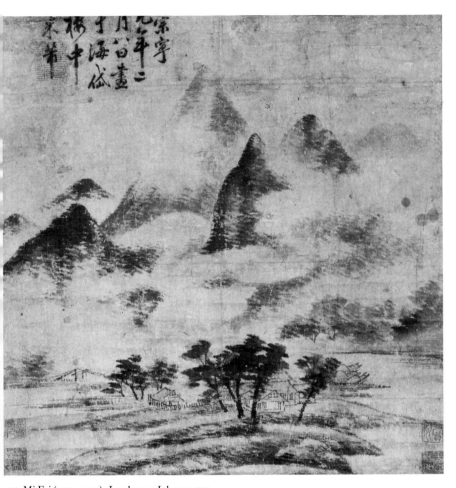

155. Mi Fei (1051-1107): Landscape. Ink on paper.
Dated 1102.
Tōkyō, F. Nakamura

fully constructed rock formations and carefully drawn trees of the earlier painters, all is sacrificed to the impressionistic recording of a mood. The solid form and realism of the painters of the tenth and early eleventh century is dissolved into a far more personal and intimate style. The drawing of the fishermen's huts and the little bridge creates the rustic setting to perfection, but they are sketched in a very loose, almost careless manner. The accompanying inscription, judged by specialists in calligraphy to be in Mi Fei's own hand, is dated in correspondence with A.D. 1102.

The soft effect of the hills, as though covered with low vegetation, is obtained by piling up successive layers of tones, each one darker than

that underneath. The brush-strokes are horizontal and parallel. They are made by laying down the side of the ink-charged brush on relatively absorbent paper. For what slight drawing there is, as in the outlines of the foreground, the fingers of land extending into the water and the houses and boats, a much drier ink is used so that in many places the paper shows through the brush-stroke. The gradations in ink tone play back and forth, in and out, in close and carefully arranged harmonies, creating at once effects of light and air, and an abstract pattern full of movement.

The style of Mi Fei was not appreciated by the most important art patron of the early twelfth century, the Sung emperor Hui-tsung. Not one of the paintings by Mi Fei, or his son Mi Yu-jên, who painted in the same style, is listed in the catalogue of the Imperial Collection. In the fourteenth century, such leading Yüan Dynasty painters as Ni Tsan discovered that Mi Fei was then a 'modern'. He became the ideal of the gentleman-scholar painters, men equally at home in Chinese literature, in music, calligraphy, and poetry, and who painted for their own enjoyment and the pleasure of their friends.

Mi Fei was as famous, or more famous, for his beautiful writing. Chinese calligraphy, done with the same brush and the same ink, has long been considered by the Chinese not only a sister art to painting, but also its superior. The same kind of training resulted in the same kind of control and offered the same fluid medium for expression in the two arts. Proficiency in one is, of course, transferable to the other.[38] As will be seen, the relationship between excellent writing and painting found on the Mi Fei scroll [155] plays an ever-increasing role from the Sung Dynasty onward.

It is interesting to note that during the age of Mi Fei the painting of bamboo in ink, the most abstract and the most close to calligraphy of all subjects in Chinese painting, attained its first period of culmination with Mi Fei's famous contemporaries, Wên T'ung and Su Tung-p'o. But before considering these men and the painting of the twelfth century there are other kinds of painting from the tenth and early eleventh centuries that deserve attention.

FIGURE PAINTERS

During the brief period of the Five Dynasties (907–60), in spite of civil strife that wracked the country, the local courts of the principal ruling houses were centres of cultural activity. None was more luxurious or elegant than the court held at Nanking by the last ruler of the Later or Southern T'ang Dynasty, Li Hou-chu. This cultured prince was himself a poet, and his interest in painting drew many distinguished artists to Nanking. We have already mentioned Tung Yüan and Chü-jan, the great landscape painters, who were active in the late years of Southern T'ang. At Nanking the final twilight of the T'ang Dynasty faded out in the splendour of a court where every accessory of life must have reflected a further refinement of the exquisite elegance familiar to us from the eighth-century treasures of the Shōsōin.

Figure painting was in favour as it had been in the heyday of the great Ming Huang and was carried on by a number of competent artists. One of the earliest of these was Ku Hung-chung, who depicted the grandees and their ladies at the court of the ruler of Southern T'ang. His most famous picture, 'The Night Entertainment of Han Hsi-tsai', has been preserved in several versions – one very early may be of the tenth century and, judging from the reproductions, probably no later than the twelfth. We reproduce here only the opening section of the scroll which, in its entirety, shows four episodes [156]. It appears that Han Hsi-tsai, while a man of great learning and accomplishments, was given to night entertainments on a lavish scale. And what is more, it is said that he '. . . allowed women of doubtful reputa-

156. Ku Hung-chung: Night Entertainment of Han Hsi-tsai (detail). Colour on silk. Tenth century. *Peking, Palace Museum*

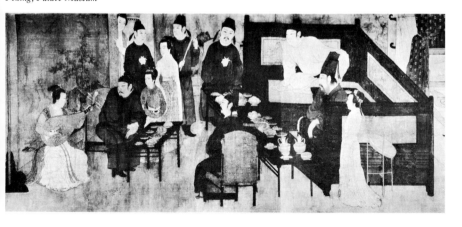

tion to frequent his house, as he liked to listen to their clever singing and playing; but he imposed no restraint on them, and they went in and out and mixed with the guests as they pleased, and this led to disorders.' The emperor wished to make Han Hsi-tsai a high official but was dubious about his night life; so he asked the painter Ku Hung-chung to attend the banquets and paint what he saw there. This scroll is traditionally the result of his candid reporting.

In this opening section we see the host, Han Hsi-tsai, wearing a tall, black cap, seated with a friend on a large dais placed in front of a bed; several members of the company are seated in front of him where food, sweetmeats, and wine flagons in bowls of hot water have been set out. All attention is concentrated upon a lovely lady playing a guitar *(p'i-p'a)*. Here the setting is elaborately indicated with furniture and paintings. It is interesting to note the lavish use of landscape paintings – on the back wall, on the screen at the left, and even on the panels of the bed interior and on the dais. In some other parts of the scroll, furniture and indications of setting are abandoned in favour of a plain background in the old T'ang manner. The favoured type of feminine beauty has changed since the days of Ming Huang, and, instead of the ponderous beauties of the eighth century, the ladies are slight and slim. The hair is not drawn down about the face, but is arranged in a chignon on top or towards the back. If we look closely at the drapery folds, it is apparent that the simple, bold silhouette of the full T'ang period and the flowing, smooth line have changed to a more complicated kind of drawing with angular folds and hooks. The long sleeves of the men are more elaborately bunched up in folds that are, none the less, still descriptive and logical.

Very much the same style of figure painting occurs in a beautiful round fan painting, mounted as an album leaf and now in the Freer Gallery [157]. The painting is attributed to Chou Wên-chü, one of the painters at the court of the last Li prince, and Painter-in-Attendance in the Han-lin College. He is said to have followed the style of Chou Fang, but to have refined upon his manner. This is probably true, but the monumental, solid grandeur of the true T'ang manner has been sacrificed. Not that the work is in any way inferior to that of an earlier epoch, but it has become a different thing, certainly refined in drawing, pattern, and soft colour. It seems somehow more personal and less of a penetrating comment on life than, say, the picture of the game players, also in the Freer Gallery. Unlike the serenity that characterizes earlier pictures there is, in this, intimate and charming narrative. The lad in the tub is having his nose held, preparatory to a ducking; the boy on the right, being disrobed for his bath, is overcome with apprehension despite his mother's encouragements; but the plump boy leaning on the tub, who has been through the ordeal and now has his hair neatly parted, enjoys the discomfort of his play-fellows. It is, altogether, a delightful glimpse of life in the inner palace.

The composition is much the same as in earlier times, with an excellent sense of space created by the placing of the figures in an arc, bending back into the picture plane. The brushstroke is still of a fine, even thickness, but like the drawing in the 'Night Entertainment', there is not a smooth, flowing line, but rather abrupt angles and hook-backs of the brush, together with a very delicate, almost imperceptible thinning and thickening of the line that in places fades off to a point. The drapery is more realistically drawn than in the full T'ang manner, but at the same time not half as descriptive of solid form.

It seems that as early as the tenth century artists looked back upon the seventh and eighth centuries of the T'ang Dynasty as a Golden Age of Painting. At any rate, there is reason to believe that artists of the Five Dynasties and Northern Sung times copied or made new

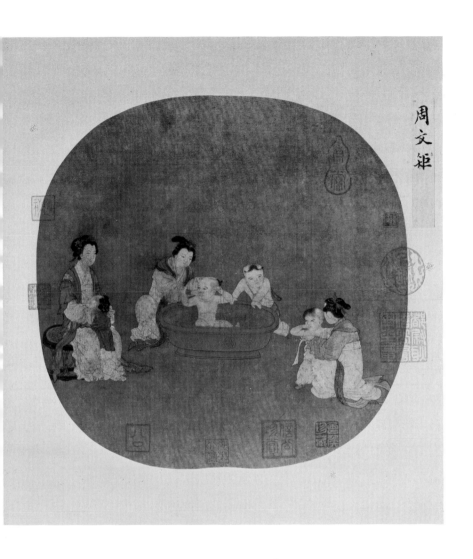

157. Chou Wên-chü: Ladies bathing Children.
Colour on silk. *c.* 970.
Washington, Smithsonian Institution, Freer Gallery of Art

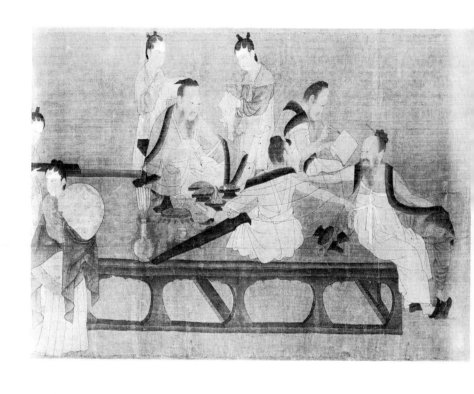

158. Scholars of the Northern Ch'i Dynasty
collating the Classic Texts (detail). Colour on silk.
Tenth or eleventh century.
Boston, Museum of Fine Arts

versions of designs by celebrated masters of T'ang.

A painting done in the tenth or eleventh century entitled 'Scholars of the Northern Ch'i Dynasty collating the Classic Texts' may be a version of a T'ang design. Mr Tomita, in his scholarly article on the painting,[1] states that it is possibly based on a composition by Yen Li-pên, the great figure painter of the seventh century, but with several alterations, while Yen's designs in turn may have been based on an earlier work by Yang Tzu-hua of the sixth century. The picture is an interesting example of the continuity of pictorial tradition. Our detail [158] shows four of the collating scholars seated on a large wooden platform. There is no indication of setting, and the figures retain the antique grandeur of the T'ang style. The triangular grouping is masterful, and the rhythmic pattern of the dark borders on the garments, furniture, and accessories plays an important part in creating a sense of space and form. There is a pale colouring of red, green, yellow, and soft purple on some of the garments. In the fine brushwork of even thickness and the flowing line without hooks or angles, the painting is closer to the old style than is, say, the 'Silk Beaters', by Sung Hui-tsung. Mr Tomita has well described the drawing: 'Although the lines are extremely delicate, the assurance and strength of the hand which drew them are marked. The soft and stiff materials, whether falling loosely or in pleats, are clearly differentiated. But most remarkable of all are the faces, especially those of the scholars. Their seriousness, their eagerness to accomplish the task entrusted to them, their jocularity when a moment of idle relaxation is their reward, are admirably expressed. The faces, which are only about one inch and a half in height in the original, when enlarged . . . reveal a masterhand capable of delineating vivid portraits – imaginary to be sure – in thin brush-strokes, without any attempt at light or shadow.'[2] The 'Scholars of Ch'i' is, within this writer's knowledge, the best surviving example of what must have been a most important school of illustrative figure painting that flourished in the late T'ang and Five Dynasties.

A word may here be said about these copies or versions of early paintings because in later centuries they play an important role in the development of Chinese painting, and they will be referred to with increasing frequency. In the Western world we set great store by originality of design, composition, and technique. Chinese critics also praise originality, but their concept of it differs from ours. The qualities they look for in a painting are vitality of spirit, intensity of realization, and freshness of perception rather than originality of composition or presentation. In China there is a kind of copy that occurs but infrequently in the Western world. With the passing of the centuries, the weight of tradition and the accumulation of recognized masterpieces of painting set standards and models for the painter from which he could not escape. Over and over we read that a certain artist studied one or more old masters, based his style on theirs and then, as he reached maturity, developed a style quite his own.

Chinese painting has always demanded the highest technical perfection because, not only are corrections and alterations impossible, but the quality of the work will depend upon the fluidity, sureness, and vigour of the individual brush-strokes. The Chinese attain their particular kind of technical perfection in calligraphy and painting by the same kind of application that a Western student of music would employ in mastering the violin or piano. Armed with a perfectly controlled technique and drawing upon his imagination and visual memory, rather than on what he saw directly before him, the Chinese artist's painting of a picture was not unlike the performance of a skilled musician. It is not plagiarism when a Chinese executes a painting after an old master, either using his

composition or his brush method, any more than it is plagiarism when a musician plays the work of a great composer of the past.

In later times, at least, three kinds of copies are recognized. They are: *mo fang* (or *mu fang*), a faithful copy, sometimes made by tracing; *lin*, a freehand copy made generally with the original in front of the artist; *fang*, an interpretation, 'after the manner of'. The first method, mo fang, can be employed to preserve old compositions, the freehand copy lin sometimes takes greater or lesser liberties with the composition, while the fang, or interpretation, can often be so free and personal that without an accompanying inscription one would recognize few elements of the style of the master whose work the painting supposedly follows.

Another group of pictures, also in the Boston Museum, illustrates a somewhat different kind of figure painting that has become extremely rare through the centuries. This set of four panels illustrates the captivity of Lady Wên-chi in Mongolia and her return to China. The heroine was a young widow of distinguished

learning and accomplishments who was captured in 195 by the Tartars and carried off to Mongolia. For some twelve years she was forced to live in that desolate country, married by compulsion to a Tartar chieftain to whom she bore two children. At last she was ransomed and returned to the amenities of her native China and another marriage to a Chinese military official. Her life in the rude surroundings of Mongolia, the kind affection of her Tartar husband, her devotion to her children and her sadness at leaving them when her rescue came are described in a series of eighteen poems traditionally by Lady Wên-chi herself. The four panels of which we reproduce one [159] appear to be the remainder of a set of eighteen illustrating the eighteen poems, though some liberties have been taken with the text.[3]

Three of the Boston panels depict Lady Wên-chi's life in Mongolia and the fourth her final return to China. It introduces us to a type of subject all too infrequently found in Chinese painting – an account of details of daily life. It is the kind of intimate recording that one finds

159. Lady Wên-chi's Captivity in Mongolia and her Return to China. Colour on silk.
Eleventh to twelfth century.
Boston, Museum of Fine Arts

so delightful and informative in the great Japanese narrative scrolls of the Yamato-e. There are many details on the frescoed walls at Tun-huang which suggest the existence in the sixth, seventh, and eighth centuries of a tradition of good genre painting, and the titles of many lost paintings from the Six Dynasties and T'ang suggest pictures of lively scenes from daily life. One reason for the scarcity today of such works may be that Chinese collectors of the Ming period, who hunted out and preserved so many old paintings, were interested in a different kind of picture, and in a general way, considered genre paintings to be of a lower order than such subjects as landscape and bamboo.

The parallel perspective characteristic of Chinese painting is especially happy in a scene such as Lady Wên-chi received into a spacious house. On the left is the public street with all its bustle, and on the right is the secluded courtyard, where she is welcomed by a group of women on the verandah. It is the moment of arrival, the lady is deeply affected and conceals her emotion by raising her long sleeve to her face; a major-domo directs the servants to carry the baggage into the guest rooms, and curious members of the household peep around the door screen. In the street the liveried attendants have dismounted and relax against the wall or buy bread from a vendor; a few of the passers-by pause in curiosity, but most of them go about their business. The drawing is crisp and lively. The artist displays a fine sense of occupational gesture and simple, descriptive action. His drawing of the tough little Mongolian ponies, the dog in the court and the ponderous brindle-bullock in the street show him equally at home in the animal world. Nor can one fail to notice the simple elegance and dignity of Chinese domestic architecture.

These four panels are not attributed to any artist, and the lack of comparable material makes it difficult to assign them to a relatively limited period. They were certainly painted no later than the Sung Dynasty and probably in the early part of the dynasty, that is, the eleventh to early twelfth century.

The best painting depicting daily life that has survived from the early twelfth century is 'The Ch'ing-ming Festival on the River' by Chang Tse-tuan.[4] The Ch'ing-ming Festival is held in the early spring, when the first green appears on the willows, and is associated with a feast of the dead and the tending of the ancestral tombs. Chang Tse-tuan was a member of the Imperial Academy, working in the Cheng-ho (1111-17) and Hsüan-ho (1119-25) eras of Northern Sung. In his time he was celebrated for 'boundary' or 'measured' paintings (chieh-hua), especially for his boats, carriages, bridges, and market places. The scroll was originally longer than it is today, but the surviving seventeen feet show the festival in progress along the banks of the Pien River as it flows through Pien-liang (modern K'ai-feng), the capital of the Northern Sung dynasty. Beginning some distance outside the east wall, we are shown rustics and gentry hurrying to the capital. The river life of boats and barges occupies much of the foreground, until, after passing under the Rainbow Bridge [160], the river bends north and the boats recede from the spectator, diminishing in the distance with remarkably sophisticated recession in depth. Passing through the East Water-gate, one traverses a broad main thoroughfare crowded with labourers and scholars, officials, Buddhist and Taoist priests, carters, sedan chairs, and mounted riders [161]. No other painting and no written record is so informative about life in a great north China city during the last peaceful years of Northern Sung. Such genre paintings were judged on the artist's fidelity and descriptive detail in showing costumes, buildings, craftsmen at work, shops, tea houses, carriages, and boats. It is clear that Chang Tse-tuan excelled in all of these.

The composition is known, with wide variations, in many later versions. None of these can, however, approach the animation of the myriad individuals and groups in the Chang Tse-tuan scroll. The excitement of the crowd gathered to watch a large river boat, mast lowered, being poled under the Rainbow Bridge, with helpful advice from onlookers, involves us in the activity as none of the later versions can. The painting is technically a revelation in that people, mules,

carts, and boats all diminish convincingly in scale as they recede from the foreground, unlike the street scene in the Lady Wên-chi series [159], where far and near figures are of equal size. The advantage in narrative illustration of the typical Chinese diagonal projection and bird's-eye point of view could not be better demonstrated than here where one can see into the tea shops and houses of the foreground, become involved in the throng on the bridge, and observe the activity on the far side as well.

The theme of popular manners and customs had a long tradition in China. At the end of the sixth century there were in existence old paintings with such titles as 'A Village Gathering', 'Customs of Various Peoples', 'Farm

160 and 161. Chang Tse-tuan: The Ch'ing-ming Festival on the River (details). Colour on silk. Early twelfth century.
Peking, Palace Museum

Houses', 'Carts Overturned at the P'ing Gate of Lo-yang', or 'The People, Carriages and Horses of Ch'ang-an'. Such subjects carried no moral precept save that of the advantages of prosperity and an empire at peace. They fell out of favour, apparently after Northern Sung, and later collectors considered them more the work of craftsmen than as pictures of high aesthetic merit, and did not restore and treasure them. For this reason, as well as for the excellent drawing and great factual interest, Chang Tse-tuan's scroll is an especially precious document in the history of Chinese painting.

The figure paintings already considered follow without any violent variations the long tradition from Ku K'ai-chih in the fourth century, through the court painters of the T'ang Dynasty, to Sung Hui-tsung's elegant copy of the 'Silk Beaters'. One striking deviation from the norm in the brief Five Dynasties period was the Buddhist monk Kuan-hsiu, who is credited with originating pictures of Lohans that were entirely different from previous concepts. The Lohan, a disciple of Buddha who has attained to enlightenment and will at death enter Nirvāṇa, was especially full of meaning to the Ch'an Sect (Zen in Japanese), with its emphasis on individual effort and the attainment of enlightenment as a personal experience.[5]

Kuan-hsiu, who was also known as the Grand Master Ch'an-yüeh, was placed in a Ch'an monastery by his parents at a tender age.

162. Kuan-hsiu (832–912): Lohan. Colour on silk.
Tōkyō, National Museum

163 (*opposite*). Li Lung-mien (*c.* 1040–1106):
The Five Horses (detail). Ink on paper.
Japan, Private Collection

In mature years he enjoyed a certain reputation as both a calligrapher and a poet. Born in 832, Kuan-hsiu did his most important work as a painter in his later years, especially in Ch'êng-tu, capital of the kingdom of Shu, where he was resident from around 902 until his death in 912. He was especially celebrated for his Lohans in series of sixteen, and several sets now in Japan have long been attributed to him. A set in the National Museum, Tōkyō,[6] has been extensively repaired and cut down so that the figures seem cramped in their space, but they serve at least to indicate the strange and almost repellent types of Lohan originated by Kuan-hsiu. The holy men are shown seated on bare and eroded rocks; only in the case of one is a gnarled tree introduced. The heads are disproportionately large; the features, exaggerated to caricature, are Indian types with deeply creased faces, lumpy skulls, and long eyebrows. The one reproduced [162] apparently cries out in wonder and ecstasy at his intuitive and instantaneous enlightenment. In the technique of painting and the boldness of the designs, these Lohans may be the last important creations reflecting T'ang solidity. As Buddhist paintings they are a new experience in Chinese art. The weird, grim Lohans which, so Kuan-hsiu affirms, came to him in his dreams, were revived by some Ch'an Buddhist painters of the Yüan Dynasty (1260–1368), coupled then with highly mannered flourishes of brush-work. But in the majority of these later expressions of the same idea the intense, burning spirit has escaped, and the results too often are mere caricature or grotesque.

The really great epoch of figure painting, both religious and secular, was the three hundred years of the T'ang Dynasty. The momentum of the style carried over into the Five Dynasties and the early Sung Dynasty, that is, throughout the eleventh century, with such painters as Chou Wên-chü, Ku Hung-chung, and a number of anonymous artists

working in T'ang style – the painters who reproduced the designs of Chou Fang and Chang Hsüan, and the artist of the 'Scholars of Ch'i' in the Boston Museum. The last great Chinese artist to work in this tradition was Li Kung-lin, better known as Lung-mien from the place of his retirement, Lung-mien Shan, the Sleeping Dragon Mountain.

on silk, but his most distinctive style was outline drawings in ink on paper. This kind of painting, which later came to be known as *pai-miao*, 'plain (or unadorned) drawing', was an old method, but it seems to have been revived and exploited with success by Li Lung-mien.

In his early years Li Lung-mien gained fame as a painter of horses. He was a friend of the

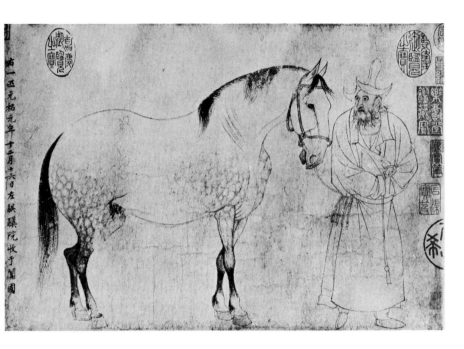

Li Lung-mien (*c.* 1040-1106) belonged to the generation and to the clique of high court officials like Su Tung-p'o and Ou-yang Hsiu who were scholar-writers, poets, and antiquarians. Li Lung-mien's artistic training was aided by his father's collection of old paintings and developed by an assiduous study of the masters of T'ang. He made accurate copies of every good, old painting that came his way and must have mastered the brush-manner of the great figure painters of the past. He probably painted a certain number of pictures in colour

Master of the Stables and had ample opportunity to observe the blooded horses sent as presents to the court from Western countries. Frequently the grooms accompanied the horses, and in the best surviving painting of this subject attributed to Li, the grooms from Khotan or some other Western kingdom are carefully depicted. This scroll, 'The Five Horses', of which the first section is reproduced, was formerly in the Imperial Manchu Household Collection and later in Japan [163]. The painting is somewhat worn so that the line work has

lost in brilliance, but what remains is enough to justify Li Lung-mien's great reputation. The general style is probably based on such T'ang horse painters as Han Kan. The archaic character of the early style is replaced by a greater elegance and realism. The picture is a straightforward statement accomplished with a sparing use of ink. Both the horse and the bearded, long-nosed groom are certainly portraits. The line is very fine and in places tenuous. The figure of the groom still suggests the descriptive silhouettes of the great T'ang figure painters, but in the inner markings of the drapery folds there is the more realistic and angular drawing that may have been a development of the tenth and eleventh centuries.

Although Li Lung-mien was reputed to have been a Buddhist, his must have been a Buddhism of a very eclectic kind, embracing Taoist and Confucian elements.[7] The Bodhisattva Kuan-yin played an important part in his works, and among the concepts which he may have brought to final perfection was the tall, elegant and entirely feminine Kuan-yin clothed in a white robe, and the 'Kuan-yin of the Southern Seas', seated on a rock in deep contemplation – a theme favoured by the Ch'an Buddhist painters of the thirteenth century.

A long scroll that gives some idea of the kind of religious art practised by Li Lung-mien, apparently considered to be an original in the Sung Dynasty, is the 'Metamorphoses of Heavenly Beings' formerly in the Imperial Manchu Household Collection and now in the British Museum.[8] The scroll is some twenty feet long, painted on paper in ink outline and delicately graded ink washes. There is no indication of setting save outline clouds on which the deities ride, or clouds in ink washes from which other more volatile spirits emerge. It is a simple, unadorned illustration of the appearance of a wide variety of gods, goddesses, spirits, and familiars. In this scroll a subject and composition that could easily slip into mono-

tony is saved by the variety in spacing and size of the figures, as well as the lively character of the brush drawing. The faces are for the most part expressionless, or rather as controlled as though this well-bred pantheon were attending an Imperial audience. There is no stimulus to religious emotion, or on the other hand, any daring flight of fantasy. Li Lung-mien's painting was factual, reserved, pure and detached. In the words of Arthur Waley, 'Li Lung-mien was China's last great prose-painter.'

SUNG HUI-TSUNG AND THE ACADEMY

When, around the middle of the tenth century, the last of the independent houses of the Five Dynasties had submitted to Sung rule, artists and men of letters gravitated to the Sung court at Pien-liang (modern K'ai-fêng in Honan). The city on the plains of the Yellow River became the centre of Chinese cultural and intellectual life, as well as the political capital, in the same way that Ch'ang-an had been dominant in the time of Ming Huang some two hundred and fifty years before. Externally the Liao Dynasty of the Khitan Tartars and the Chin Dynasty of the Jurchen Tartars continued their encroachments in the north and constantly threatened to engulf the empire. Internally the court was wracked and torn by the rivalry of the radical reform party, the Yüan Fu clique, and the conservatives, known as the Yüan Yu group. The reforms, introduced by the brilliant Wang An-shih in 1096 to bolster the already sagging political and economic conditions, were opposed by some of the most gifted men of the Sung Dynasty – chief among them was the poet and painter Su Shih, better known as Su Tung-p'o, and there were also the historian Ssu-ma Kuang, and the archaeologist and poet Ou-yang Hsiu.

It would be only natural if the almost constant political and intellectual turmoil of the Sung Dynasty had produced an atmosphere of deep apprehension and sporadic alarm in no way conducive to contemplation and the creative arts. The contrary, nevertheless, was the case. The Sung period remains one of the most brilliant in the history of Chinese art. The emperors, almost without exception, were sincere and enthusiastic patrons of scholarship and especially of painting. The second emperor

of the dynasty, T'ai-tsung (r. 976–97), was active in having good examples of painting and calligraphy sought out and added to the Imperial Collection. His curator was Huang Chü-ts'ai, the painter of birds and flowers. Jên-tsung (r. 1023–36) was himself reputed to be a painter and calligrapher of merit. In the person of Hui-tsung (r. 1101–25) art collecting became almost a mania. Imperial activity in collecting archaic bronze vessels and jade carvings was a manifestation of a new interest, shared by many, in the ancient material culture of China, so that Chinese archaeology as a branch of scholarship may be said to have started in the Sung dynasty.

To what extent Imperial patronage and interest in the arts stimulated the great florescence of painting is an open question. It seems more probable that court encouragement was itself but one facet of the same spirit that produced the paintings, and both were aspects of the culmination or fruition of the intellectual and spiritual activity from the latter part of the T'ang Dynasty and the Five Dynasties. Similarly both Ch'an Buddhism and neo-Confucianism grew from the same fertile soil, although the full flowering of these ways of thought was a product of the Sung Dynasty.

The most active Imperial support of contemporary painting was the establishment of the Painting Academy and the appointment of worthy artists to official posts. The exact status of the Painting Academy, that played so important a role during the twelfth and thirteenth centuries, is not as clear as it might be. For a long time it had been the custom to attach painters and persons of talent to the government in some way, frequently by an appointment to the Han-lin Academy. The Han-lin

was inaugurated by the T'ang emperor Ming Huang in 754; the most competent scholars of the day were gathered there and, among other duties, were charged with the preparation of edicts and similar literary activities of the court. Also in the time of Ming Huang a certain number of artists were attached to the Han-lin. The internal organization of the Han-lin underwent changes through the centuries, but up until modern times it served as a nucleus for scholarship and a bulwark against pretence and incompetence. No other scholarly organization in the world has had so long and illustrious a history.

There are numerous references in contemporary and only slightly later Chinese writings to a separate Imperial Painting Academy established by Sung Hui-tsung, and it is quite apparent that some such organization, much favoured by the Emperor, must have existed. On the other hand, Archibald Wenley has pointed out that no separate painting academy is mentioned in the official Sung History.[1] In any event, something like an academy must have functioned, and Chinese literary evidence, aside from the official history, seems to justify the use of the term. Official painters at the court were awarded various titles, the highest of which was *Tai-chao* – 'Painter-in-Attendance'; next was the *Chih-hou* – 'Painter-in-Waiting', and below these two the 'Scholar of Art' and last the students. Painters of exceptional merit, in or out of the Academy, were sometimes awarded a special mark of favour, the Golden Girdle. There were painting examinations for offices, frequently in the form of an illustration to a given line of poetry. Examples of this rather curious method for testing the ability of an artist are given by both Sirén and Waley.[2]

Many of the artists of the Academy devoted their talents to minutely painted and brilliantly coloured pictures of birds and flowers, not only because this was the subject most favoured by the emperor, but because it also fitted well the interests and aesthetic standards of the age.

BIRDS, FLOWERS, AND ANIMALS

The catalogue of the extensive collection of paintings assembled by the Sung emperor Hui-tsung and his predecessors is not arranged chronologically but by subject-matter. The seventh category in the classification is 'Domestic Animals and Wild Beasts', while the eighth is 'Flowers and Birds'. Another more general classification used in other works is *ling-mao*, literally 'Feathers and Fur', and includes both animals and birds as subjects.[1] And, as has been mentioned, paintings of animals, especially horses, were among the great achievements of the T'ang period. On the other hand, flower paintings from an early period are seldom mentioned; the Sung collection contained only one pre-T'ang example. It is not until the T'ang period that flowers as a subject appear to have attained popularity. It is quite evident that, as Arthur Waley has pointed out, Buddhist art was a powerful stimulus to flower painting, if indeed it did not bring it into being in China. The demand for flower-filled skies in the paradise scenes, for flower borders on the religious banners and wall paintings must have turned the attention of the painters to a closer study of floral forms. Engraved and low-relief borders with rich floral designs on certain stone epitaphs and steles of the eighth century show that the decorative floral rinceau of earlier times had evolved into a freer and more naturalistic manner.

Two of the most celebrated painters of animals, birds, and flowers who worked in the tenth century, during the era of the Five Dynasties, were Huang Ch'üan and Hsü Hsi. Of the surviving paintings attributed to these two artists there are few that are convincingly of the period, and they are either much restored or too much darkened for adequate reproduction. Both men are historically important, however. Huang Ch'üan, and his son Chü-ts'ai as well, were court painters, first in Shu (Szechwan) and later at the Sung court. Kuo Jo-hsü tells us that the father painted a wide variety of subjects, such as Buddhist and Taoist deities and lay figures, landscapes, and dragons in water,[2] although posterity knew him mainly as a painter of birds and flowers. All these must have been pictures in colour, but it is interesting to note that he also is credited with painting bamboo in ink alone.

Ch'üan's son, Huang Chü-ts'ai, followed in his father's footsteps and worked as Painter-in-Attendance at the Palace of the Shu prince, where he was received cordially by T'ai-tsu and followed that ruler to the Sung court in 965.[3] In Shu '. . . all of his duties were performed in the Forbidden Palace. He most often sketched the rare fowl, auspicious birds, unusual flowers, and grotesque rocks found in the aviaries on the palace lake. Still in existence at the present day (time of Kuo Jo-hsü, *c.* 1070) are such subjects [by him and his father] as: peach-blossoms, falcons, pure white pheasants, rabbits, doves by a golden bowl, peacocks, tortoises, and cranes.'[4]

Hsü Hsi was also active in the tenth century, but worked at Nanking at the court of the Later T'ang. In addition to the more regular subjects of flowers, bamboo, animals, and birds, he also painted grasses and insects, sprays of cut flowers, and ordinary vegetables. Some interesting remarks about Hsü's technique are given by the mid eleventh-century writer, Liu Tao-ch'un: 'The ordinary fine painter does nothing more than deck out his coloured painting to catch a likeness; Hsi, who can make a work

complete in spirit and structure, is the single exception. He would first of all establish his branches, leaves, pistils, and petals in ink, and then go over them in colour. Thus it was the general tone that was arrived at first. . . .'[5]

Much of the work of these men was executed on palace walls, on screens and doors, serving a decorative purpose. From earliest times to the end of T'ang and, to a lesser extent, in the Northern Sung Dynasty, the greatest painters were employed in a fashion that, from one point of view, might be considered as decoration. References to large-scale decoration by leading masters become fewer and fewer from the middle of the twelfth century onward, and by the Yüan and Ming dynasties, with the development of the very personal paintings of the 'literary man's' style, it is evident that the decoration of the large screens, seen in genre paintings as background for thrones and similar furniture, was for the most part relegated to professional craftsmen working in traditional styles.

In contrast to the vast and towering mountain scenes of the tenth and eleventh centuries, or rather in complement to them, there had developed side by side an art dedicated to the small and intimate delights of nature – flowers and blossoming trees, waving grasses and insects, birds from the sparrow to the peacock in the palace garden, foxes and rabbits, and even the humble kitchen vegetable. Like the landscape, the animals, birds, and flowers of the tenth and early eleventh centuries were probably realistic, complete and carefully organized in composition. Although the influence of the masters of still-life is especially apparent in the work of the Academy painters of the twelfth century, as will be seen, it survived with varying fortunes well into the eighteenth century.

A pair of paintings preserved in the National Palace Museum, Taipei, serves to illustrate the high quality of animal paintings done as decoration in the tenth and eleventh centuries. The pictures, which show in each a stag and several does among autumnal trees, seem to be either from a larger set or parts of a composition that was originally more extensive. The pictures are done in colour on silk in minute detail. In a small clearing beside a stream, an antlered stag and seven does have been startled by a sudden sound, a disturbance out of sight to the left, and all but one, which is still grazing, are alert [164]. The feathery, almost fern-like foliage of the trees is rendered with incomparable care and accuracy, in patterns of mass and colour. The colour, in fact, is one of the most striking features; the shades of orange, ochre, pale blue, pink, white, soft sage, and yellow greens produce a tapestry-like pattern of the glory of an autumn forest. These colours, blending in tone with the brown and cream of the deer, make a decoration that is both restrained and elegant.[6]

The Palace Museum assigns these two pictures to the period of the Five Dynasties, and the attribution is convincing. At Ch'ing-ling in Mongolia there is a tomb of 1031 with painted wall decorations, some of which show stags and does in landscape that are very close stylistically to the Palace paintings though technically on a far lower level, and possibly old-fashioned at the time they were painted.[7]

Following Huang Ch'üan and Hsü Hsi, the most famous painter of birds and flowers was Ts'ui Po, who was active in the second half of the eleventh century. Kuo Jo-hsü mentions that he also painted dragons and Buddhist subjects. He executed frescoes at the great Hsiang-kuo temple in the capital, at a temple in T'ai-yüan-fu, and decoration in the palace. Although the emperor appointed him as Scholar of Arts in the Painting Academy, he 'was by nature careless and indulgent and incapable of any practical handling of affairs, and so resigned the post'.[8] It was, however, as a painter of 'lotus, wild ducks, and wild geese that he won his fame'. So illustrious has Ts'ui Po become in the special branch of birds and flowers that in China

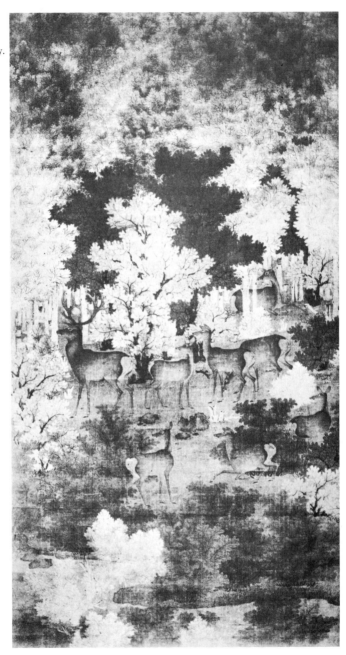

164. Deer in
an Autumnal Wood.
Colour on silk.
Tenth to eleventh century.
*Taipei, Taiwan,
National Palace Museum*

his name is appended to the majority of paintings of this kind – much as the name of Chao Mêng-fu appears regularly on horse paintings.

It is not now possible to say whether any of Ts'ui Po's original works have survived, but there are some good paintings traditionally attributed to him that can serve as examples of the kind of painting developed in the eleventh

and early twelfth centuries. Two large pictures, in the National Palace Museum, Taipei, are in colour on silk [165, 166]. The one of a hare being scolded by a pair of jays carries the signature of Ts'ui Po and a date corresponding to 1061 in small characters on the tree trunk. Both pictures are pervaded by the grey of an autumn day and a chill wind. There is no background in a

165. Ts'ui Po: Hare scolded by Jays.
Ink and colour on silk. Dated 1061.
Taipei, Taiwan, National Palace Museum

166. Ts'ui Po: Bamboo and Heron.
Ink and colour on silk. Eleventh century.
Taipei, Taiwan, National Palace Museum

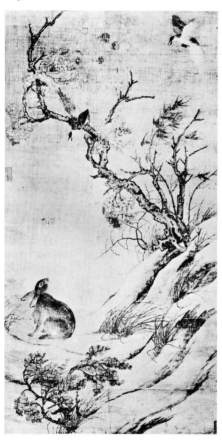

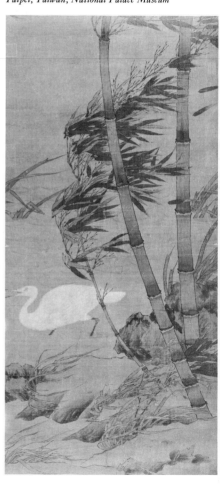

literal sense, only a limitless, rolling country in the one and a broad expanse of choppy, wind-swept lake in the other. A few elements of trees, bamboo, rocks, and a hillock in the foreground and middle distance establish the setting and atmosphere. All details are painted with the utmost skill and care, the hare is a masterpiece of realism in pose and texture, but at the same time, and without inconsistency, the ink and brush-strokes defining the land and rocks are handled in a broad, almost impressionistic manner. The painting of the bamboo [166] is an excellent example of a kind of bamboo painting in which the leaves are rendered in outline, in contrast to the method in which each leaf is done with a single stroke of the ink-charged brush. A study of the compositions will show how carefully these pictures are constructed; for example in one the three bamboo stalks progress in curvature from that at the right to the smaller shoot on the left, while in the other the placing of the trees and birds, and the roll of the land all concentrate attention on the delicately poised hare. Bird, animal, and flower painting of this kind set the standard and was especially popular with artists of the Ming period, notably Lü Chi of the sixteenth century. In these later works the fine balance between representation and design is lost in favour of striking, decorative effects. Handsome as the Ming versions are, the contact with reality is tenuous, and the sensitive restraint that almost amounts to understatement in the early works is replaced by boldness of pattern.

Hui-tsung was born in 1082, ascended the throne in 1101, and ruled until 1125. In 1126 his capital at K'ai-fêng was captured by the Chin Tartars, and he and some three thousand of his court were carried off captive to Mongolia where he died in 1135. He was an amiable person, but 'superstitious, weak, devoted to pleasures, a tool in the hands of scheming men, prodigal in the use of public money. These vices were offset to a certain extent by an aesthetic and artistic taste which caused him to encourage his Prime Minister, Ts'ai Ching, and the eunuch T'ung Kuan, to collect all kinds of artistic things from all parts of the empire'.[9] His collections were indeed enormous, including fantastic and unusual rocks, rare plants, trees, and birds, in addition to quantities of ancient bronzes and jade carvings. The catalogue of his collection of paintings, *Hsüan ho hua p'u* (preface dated 1120), lists six thousand three hundred and ninety-six paintings by two hundred and thirty-one artists from the time of the Three Kingdoms down to the emperor's own work. All these vast collections were looted and carried away, lost, or destroyed, when the capital was sacked.

Among the rather numerous paintings attributed to Hui-tsung, the great majority are intimate, detailed, and highly realistic studies of birds and flowers on a relatively small scale. There is at least one good landscape that may be by him now in the National Palace Museum, Taipei.[10] Among these pictures there are a scant half-dozen that are consistent in quality and style and in all probability by the famous emperor-painter. One of the best is the 'Five-coloured Parakeet' now in the Boston Museum [167]. This picture introduces several new features. It is a very carefully executed study of one bird and a few branches of flowering apricot in which everything is brought so close to the observer that we can see each feather and petal. It is most adroitly composed in relation to the bare silk, and the subject seems to exist in a void of its own. The space is employed in a positive way, much as it had been in certain paintings of the T'ang Dynasty, but while in the latter it is the interrelationships between the figures that are important, in the Hui-tsung composition the relation of the simple subject to the surrounding space is most telling. Rowland has described the technique of these bird paintings 'as a meticulous "magic realism" in which literally every feather is defined from the point

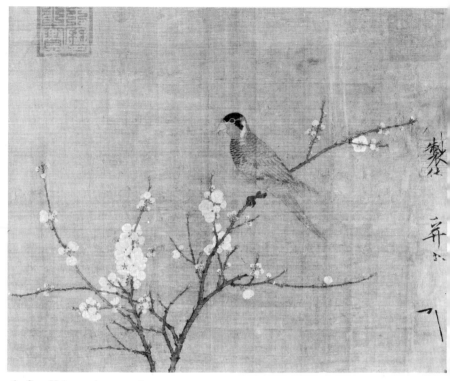

167. Sung Hui-tsung (r. 1101–25):
The Five-coloured Parakeet. Colour on silk.
Boston, Museum of Fine Arts

of view of local colour and shape. There is no real suggestion of texture, but the plumage has a kind of iridescence from the painter's technique of making the contours of the individual feathers lighter in value than the local colour of a particular area. Taken as a whole, the birds are merely coloured silhouettes. Both they and the branches that support them are entirely on the surface of the picture plane, and this restriction is emphasized by the way in which the artist's inscription forms a part of the design.'[11]

Other paintings attributed to Hui-tsung and of similar quality, for example the 'Bulbuls on a Flowering Allspice Shrub' in the National Palace Museum, Taipei,[12] display 'the same exquisite definition of individual elements in terms of precise draughtsmanship and fastidiously applied local tone ... and the austere clarity of compositional arrangement stands out as the mark of a definite artistic personality'.[13] From these works it appears that Hui-tsung's ideal was a certain kind of perfection that embraced drawing, composition, tonality, and realism based on the keenest observation. Numerous artists of the Academy followed the Imperial lead and doubtless a number of the exquisite album leaves of birds and flowering shrubs, many of them unsigned, that have survived to the present day are products from the first quarter of the twelfth century.

THE ACADEMY AT HANG-CHOU

A son of Hui-tsung was in Nanking attempting to levy troops, when disaster overcame his father and the Imperial capital. This son, known to history as Kao-tsung, was proclaimed emperor. After several years of hardships, when the Chin Tartars made a sally across the Yellow River, the invaders at length retired, and Kao-tsung, in 1138, was able to establish the court of Southern Sung at Hang-chou in Chekiang Province. For some time there was a strong party at court favouring a vigorous policy of opposition to the Tartars and the recovery of the lost provinces of the Yellow River Valley and the north. The policy advocated by this party, which was conservative and Confucian, was countered by a clique advocating compromise and conciliation. The latter won, no doubt more from realistic considerations than from the weight of their arguments. The Southern Sung then settled down to enjoy what time was left them in the productive and beautiful lands of central and southern China.

No city of the East could be better suited as the capital of a dynasty whose emperors were almost without exception devoted to cultivation of the spirit. Hang-chou on the banks of the beautiful Western Lake, in a country of streams, canals, and lakes, with rolling hills and a mild, warm climate, where the mists of morning and evening half conceal the landscape, was still the most beautiful city of China when Marco Polo visited it after its fall to the Mongols. The vast Buddhist monasteries that once rose from terraces on the hills, and the palaces and pleasure gardens, have long since disappeared through war, revolution, and wanton destruction. But the paintings and ceramics of Southern Sung that have survived are a fitting monument to the

artists of Hang-chou in the times of its glory; the metaphysics of Ch'an Buddhism and the neo-Confucianism of Chu Hsi are aspects of Southern Sung thought that have been potent factors into modern times.

With the establishment of his dynastic court at Hang-chou, the emperor Kao-tsung energetically set about trying to recapture as much as he could of the cultural brilliance that had so illuminated the court of his unfortunate father. The Academy of Painting was re-instituted, and a large number of the painters who had practised their art in the old days of Hui-tsung's Academy were reunited at Hang-chou so that, with a slight interruption, the tradition was continuous. Such painters as Su Han-ch'ên, Li An-chung, Li Ti, Chao Po-chü, and Li T'ang brought with them to the new Academy the precision, elegance, and high technical standards that had characterized the earlier establishment. Li T'ang was especially honoured; his name came first on the list of members; he was made Painter-in-Attendance and awarded the Golden Girdle.

Of the many artists whose names appear in the writings about the Southern Academy, and of whom some works survive, we can mention but very few, and so shall attempt to select those whose paintings seem representative of various trends. In the works of most of the painters of the Academy we shall find no reflection of the loss of half the empire or the ever-impending threat of barbarian invasion. The distress and misery of mankind have been consistently avoided as subjects for the artist, perhaps because they offended the sense of propriety, the Confucian *Li*. Deep and poignant sorrow at partings and long separations are themes

frequently painted but in almost every case as illustrations to poetry. China has never had a Callot or a Goya. Landscapes, birds, flowers, and scenes of palace life were still the themes of the Academy.

Of the hedonistic painters from the old Academy who later worked in Hang-chou none is more delightful or produced more beautiful pictures, within a very limited subject matter, than Su Han-ch'ên. He was a painter of children, but his children are all princelings who play

168. Su Han-ch'ên: Children at Play in a Garden. Colour on silk. Twelfth century.
Taipei, Taiwan, National Palace Museum

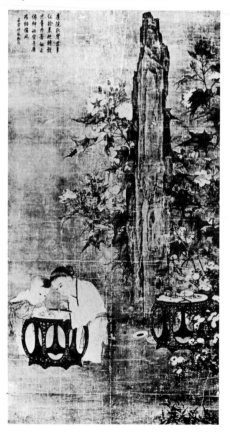

in a wonderful world of palace gardens or whose every wish is gratified by the toy-seller, his cart laden with the marvels that fill the dreams of small boys. The elegance of these earthly paradises, such as that in illustration 168, was certainly no flight of the imagination. The gardens of Hang-chou have become proverbial for their almost unearthly beauty. Here beside a towering garden-rock and an enormous peony bush, two little, sloe-eyed boys play with some small objects on a marble-topped lacquer stool. On a similar stool behind them there is a tortoise-shell box and small jars, while a pair of cymbals lie on the ground. The picture is an intimate glimpse of the protected, idyllic life fostered at an Imperial court.

Another kind of ideal figure painting popular during the Southern Sung and which was carried over into the fourteenth century was that showing the activities of scholars at leisure. A subject that gave the artist full scope was the 'Eighteen Scholars', a group of especially eminent savants who had been selected by T'ang T'ai-tsung to receive the high title of 'Distinguished Scholars' and, on Imperial order, had been painted by Yen Li-pên.[1] Such a subject allowed the painter to depict the ideal scholar-gentleman, the official at his ease in a beautiful garden-setting enjoying cultural pursuits.

Landscape painting had changed from the carefully constructed, monumental concepts of the tenth and eleventh centuries – those vast and grand scenes so lucid in their approach and emotional balance. Much of the painting of the twelfth century seems more consciously directed towards the capture of a mood; the conceptions are more soft and less severe. There were new experiments in atmospheric perspective that characterizes some of the paintings attributed to Kuo Hsi and Mi Fei. Often the horizon is lower, with wide expanses of marshy banks or rice fields over which the mist hovers. Except when consciously following the 'old masters' the pictures are far less full and de-

tailed, less explicit and more suggestive. In the paintings of Chao Ling-jan (Chao Ta-nien), a relative and close associate of Hui-tsung before he ascended the throne, low marshlands with water-birds and drifting mist, willow trees and rolling hills, an emphasis on the horizontal rather than the vertical, all are elements that contribute to a quiet, bucolic mood quite different from that of the earlier works.[2]

Yet many elements of the Northern Sung grand manner, the towering rugged peaks, the clarity of concept combined with descriptive detail, and the dense, rich brush-work were carried on and further developed by Li T'ang, one of the most gifted and original painters of the twelfth century. All the old elements are to be found in a small landscape, dated in accordance with 1124 and now preserved in the Palace Museum Collection, Taiwan [169]. Although the painting follows closely the formulae of the great eleventh-century tradition, there is a new quality of intimacy and lyricism. The design is

169. Li T'ang: Wind in the Pines amid Myriad Ravines. Ink and slight colour on silk. 1124. *Taipei, Taiwan, National Palace Museum*

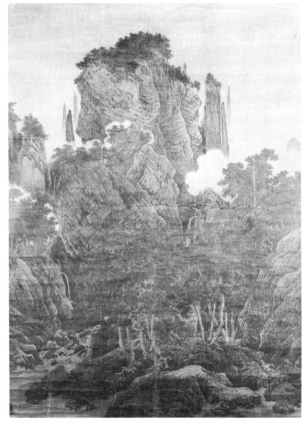

more immediately striking than those of earlier masters, because of the stronger contrasts in light and shade, the white clouds, and the finger-like needle peaks. The versatility of Li T'ang and his creative originality, and consequently his real importance as the founding master of the new academy, are borne out by half a dozen beautiful paintings that can be attributed to him, including the famous pair of landscapes at Kôtô-in, Daitokuji, Kyōto. Several of these works are done, not with the densely packed, 'small axe-stroke' ts'un, but in relatively broad washes, a 'large axe-stroke' ts'un, and soft, flowing brush-strokes in the drawing of the trees. Li T'ang's paintings of this kind establish him as the precursor of the style that was to find its most complete expression at the turn of the twelfth century under the brush of the two Academy painters, Ma Yüan and Hsia Kuei.[3]

As already mentioned, with the passing of the centuries the accumulation of tradition in Chinese painting played an ever-increasing role in the styles of individual artists. Nothing from the past was ever lost. Over and beyond the natural evolution of one style into another or the development of one school out of earlier achievements, there are numerous instances of the conscious revival of old manners of painting. We can only mention two examples of this kind, the paintings of Chao Po-chü and Chiang Ts'an, both men who had worked in the old Academy of Hui-tsung. Chao Po-chü was especially favoured by Sung Kao-tsung (r. 1127–62) and, from all accounts, his style was well suited to a court art that strove to recapture some of the glories of the past. Some of his paintings used a quasi-historical subject as a point of departure for his elaborate landscapes and architectural paintings. The small round fan painting in the Palace Museum is an imaginary vision of the fabled Palaces of Han [170]. In so small a space the artist has been able to concentrate lofty palace halls, a procession of court beauties, bullock carts and attendants, a luxurious gar-

170. Chao Po-chü: Palaces of Han. Colour on silk. Twelfth century.
Taipei, Taiwan, National Palace Museum

den, and a background of distant hills. The small painting is in ink and light colour on silk and executed with minute attention to detail. Although the complex, tapestry-like pattern harks back to the traditional style of the T'ang master Li Chao-tao, the misty, silhouetted peaks of the background are in the spirit of the full twelfth century. It was the 'blue-and-green' style of the eighth century, in fact, that has come to be most closely linked with the name of Chao Po-chü. This strongly decorative style, the effect heightened by white clouds and rock forms outlined in gold, has been used with great skill in a painting preserved in the Boston Museum, entitled 'The First Emperor of the Han Dynasty Entering Kuan Tung' (a strong-hold of the Ch'in Dynasty).[4] It is one of the most beautifully composed and fastidiously painted scrolls in the full 'blue-and-green' style. The historical subject is no more than a convenience for the artist, allowing him to pile up fantastic rocks and storeyed palaces, letting his imagination roam through elegant courtyards and gardens, while all through the scroll, in and out, between the mountain gorges, appear, like a recurring theme in music, the banners of the armies of Han. It may be charged that pictures of this kind appeal only to the senses and the part of the imagination that delights in fairy-tales. Later Chinese critics have relegated them to the superficial Northern School of painting. None the less, when executed with the mastery of the Boston scroll, this art represents, like the best of the Persian miniatures, the highest level of court painting. Doubtless the style had many practitioners, but Chao Po-chü is important as being the most accomplished artist to work in the manner, midway between Li Ssu-hsün and Li Chao-tao of the eighth century and Ch'iu Ying of the sixteenth century.

Among the styles of the past, it was the soft brush-stroke of Tung Yüan and Chü-jan that was employed by Chiang Ts'an, another member of the old Northern Sung Academy. His most important surviving work is a long landscape in slight colour wash and ink on silk now in the Palace Museum. We illustrate a detail of a smaller but very similar scroll, formerly in the ex-Imperial Manchu Household Collection [171]. The style in both these paintings is close to that associated with the monk painter Chü-jan. The long, rather soft and almost loose ts'un employed in the rock forms, related to the kind that came to be called 'untwisted hemp-fibres',

is employed to represent forms rounded and grooved by erosion. A comparison between the work of Chiang Ts'an and his famous model of two hundred years before, Chü-jan [153], will show the essential differences within the frame of a similar technical manner. The Chiang Ts'an scroll does not possess the same degree of formal organization that knits the Chü-jan into a compact harmony of related forms; instead there is a loose, informal ease of manner, and in the Southern Sung painting the forms are broken up in a much more complex way with an almost over-all pattern of strongly contrasted lights and shades. Also in the Chiang Ts'an

171. Chiang Ts'an: Landscape (detail).
Ink and slight colour on silk.
Twelfth century.
Kansas City, Nelson Gallery of Art
and Atkins Museum

scroll a more dramatic effect is obtained by sudden changes in depth; that is, in parts of the scroll, not illustrated, the foreground is brought so close that the nearest trees show only the upper half above the lower edge of the picture; and again, in the part we show, the mountains in the foreground and immediate middle-distance open and suddenly reveal a broad lake and a vast expanse of space extending to where a few hazy peaks are but half revealed through the misty atmosphere.

By devices of this kind the painter sought to create a world more free of the finite than had his predecessors, an expanding world in which the imagination could wander at will with only the minimum of guide-posts along the way to suggest the particular creative mood of the artist. Chiang Ts'an's scroll is no less worthy than the paintings of those predecessors whom he chose to call master. The brushwork, especially in the trees, is vigorous and brilliant. His ink is charged with coloristic values, and the abrupt changes from near to far distance, which could easily be bungled, are rendered with consummate skill. He was a good artist who found in the works of certain tenth- and eleventh-century painters a manner congenial to his nature. None the less, he was essentially a man of his times.

The really original contributions of the Southern Sung Academy to the body of Chinese landscape tradition lay in the work of three of the greatest painters, Liu Sung-nien, Ma Yüan and Hsia Kuei. All three won the title of Painter-in-Attendance, were members of the Academy in the last decade of the twelfth century and worked into the first quarter of the thirteenth. With these men Chinese landscape painting reached its most complete expression of an all-enveloping and limitless space. The world of nature became a vast, atmospheric void out of which emerged, with dramatic impact, the slender peaks and twisted pines of a visionary world. Although all three of these artists studied the works of the old masters and Li T'ang of the preceding generation, still the paintings attributed to them suggest a definite break with the past, at least a break with the traditions of the Five Dynasties and Northern Sung. A closer study of landscape painters preceding them within the twelfth century may some day demonstrate that the break was gradual and that Ma Yüan and Hsia Kuei are but the culmination of a consistent development. At any rate, we are at once struck by a marked increase in dramatic intensity that pervades the paintings by these men. In the first place, the compositions are, for the most part, strongly asymmetrical, of a kind called 'one corner', in which the weight of the design is confined to one or the other side with large areas of the silk or paper left bare or only lightly tinted. Frequently a straggling pine tree or branch, or the overhanging vegetation on a cliff will make a strong lateral thrust across the composition and be countered by the soaring vertical of a 'needle' peak, thrusting into the sky like a stone finger. Also there is a marked preference for angularity over curving or flowing lines; for example, the trunks and branches of a pine tree suddenly change direction at acute angles. Nor are the mountains and rocks softly rounded by long weathering but are jagged, angular, and many-faceted as though granite had been shattered by some gigantic hammer. The flat cleavage planes and faulted rock forms are outlined with jerking, staccato strokes and the inner form is modelled with a ts'un method called the 'axe-stroke' which may be large or small, or long and thin – and indeed the strokes look much like the scars left in hard wood such as oak, by the chop of an axe or chisel.[5]

Additional dramatic quality is obtained by simplifying the range of ink tones so that more telling contrasts of light and shade are possible. Much of the carefully graded washes and building up of area tonality by stroke on stroke of closely modulated ink is forsaken. The drawing

172. Liu Sung-nien (c. 1190–1230): Conversing with Guests in a Stream Pavilion. Colour on silk. *Taipei, Taiwan, National Palace Museum*

thus becomes more apparent and the impact of the picture as a whole more immediate.

The painting, 'Conversing with Guests in a Stream Pavilion' [172], is attributed to Liu Sung-nien. It is signed by the artist, and, before passing into the Imperial Ch'ing collection, it belonged to Liang Ch'ing-piao, the greatest collector of the seventeenth century. Whether it be by Liu Sung-nien or not, it is extremely well painted and is very much the kind of picture one might expect from the hand of a gifted contemporary of Ma Yüan and Hsia Kuei. Although it is done in colours on silk, it is entirely different from the heavily coloured paintings in the 'blue-and-green' style. In both concept and manner of execution it could as well be in monochrome ink. The artist's academic background, and perhaps his association with an older artist like Chao Po-chü, is evident in the careful painting of the pavilion over the stream, its furnishings and occupants. The clarity of the drawing and simple tonality result in a curious luminosity about the pavilion of a kind met with again some three centuries later in the work of Ch'iu Ying. The angles and bends of the twisted pine tree on the right are echoed in a minor key by the budding plum on the left. Individual details are painted with careful realism, but the whole is a fantasy, an ideal of quiet and seclusion – suggested by a pavilion, a stream, a pine, an inaccessible peak, a vista away to distant hills, and little more. But for all its dramatic qualities this picture retains much of the old lucidity and emotional restraint. It remained for Ma Yüan and Hsia Kuei to carry the style to its full development.

The Ma-Hsia School, as it is often called, had its roots, like so much of later Chinese landscape painting, in the works of the tenth and eleventh centuries. Elements of their style, like the straggling trees with dragon-claw roots, may be founded on the work of such eleventh-century painters as Sun Chih-wei, and both are said to have studied under the ageing Li T'ang.[6] Other artists of the twelfth century had employed needle peaks and angular silhouettes of distant mountain ranges. It was the way in which these elements were intensified and the use to which they were put that was the essence of the style which dominated the Academy in the first quarter of the thirteenth century.

Ma Yüan came from a family of painters. His great-grandfather, Ma Fên, his grandfather, and his father were all painters. Both his father and his uncle, Ma Kung-hsien, active about the middle of the twelfth century, had been Painter-in-Attendance in the Academy. A painting by Ma Kung-hsien preserved in Nanzenji, Kyōto, though a little dry, shows many of the characteristics already mentioned. Ma Yüan's son, Ma Lin, carried on the tradition with credit, as is evident from a beautiful album leaf of the 'Lady

At this stage we can only offer examples that seem good of their kind and representative of the spirit that has come to be associated with the artist.

A characteristic landscape from the National Palace Museum, Taipei [173], combines a nostalgic, poetic mood, handsome design, and brilliant, forceful brushwork. The sage with his attendants stands on a small, balustraded promontory and looks out across a deep and mist-filled chasm to where on the far left the moon is

173. Ma Yüan (c. 1190-1224):
Landscape. Ink on silk.
Taipei, Taiwan, National Palace Museum

Ling-chao Standing in the Snow', now in the Boston Museum.[7] The problem of Ma Yüan is complicated. Because he was the leading master of a distinctive style, it may well be that many paintings in the same style by other members of the Academy or by later followers have through the centuries acquired attributions to Ma Yüan.

rising behind abrupt precipices. The composition is dominated by a strong diagonal that runs from the upper right to the lower left, a line that is accentuated by the tree limbs and the sharp, straight slope of the angular boulder in the foreground. This forceful movement is to some extent countered by the powerful vertical thrust

of the peaks on the left. Although there are essentially no more than three tones of ink in the cliff on the right, these are so graded and the surface so broken up by brittle brush-strokes that the real quality of the shattered rocks is immediately apparent. Of course, above all there is a sense of air and space. In pictures of this kind the rigorous elimination of all that is unessential and the concentration upon the elements that will most directly suggest the communion of man with the wonders of the infinite world of nature, must be the product of deep sensitivity and natural genius, otherwise

174. Ma Yüan (*c.* 1190-1224): Egrets in a Snowy Landscape. Colour on silk.
Taipei, Taiwan, National Palace Museum

they slip on the one hand into mere decoration and on the other into insipid romanticism.

In this landscape the drawing has a crisp and precise kind of definition. Somewhat the same quality of drawing is in the superb and often reproduced round fan painting of landscape with willows in the Boston Museum.[8] Certain other pictures attributed to Ma Yüan display a somewhat freer and more bold brush-manner. In an excellent painting, strong in design and spontaneous in brush, several egrets huddle along a cold stream bank in the frigid atmosphere of a late winter snow [174]. From the left side a twisted old plum tree, the first, tight buds just beginning to show, stretches across the picture. In the background, only the edge of a mountain, entirely wrapped in snow, is limned against a dark sky. Again there are the same strong diagonals, here marked by the edge of the mountain and the main limb of the plum tree, countered by the opposite diagonal of the rock that juts into the scene from the left. Rocks and plum tree, snow-laden reeds and the stream bank where the snow melts, are painted with broad, free strokes, employing the full flexibility of the ink-charged brush. This picture, like our illustration of Liu Sung-nien, is done in colour on silk, but the colour is light and plays a minor role. The style is essentially that of a monochrome ink painting.

A famous picture, long considered a work of Ma Yüan, is entitled 'The Four Greybeards' - a group of scholarly gentlemen who secluded themselves in the Shang mountains during the turbulent time of Ch'in Shih-huang-ti in the third century B.C. The painting, a short handscroll, is in the Cincinnati (Ohio) Art Museum [175]. The figures are relatively large in scale, but the landscape dominates. The broad and almost heavy treatment is technically very close to the 'Egrets in a Snowy Landscape'. In particular there is the same thick outline of the bamboo leaves and strong 'axe-stroke' markings. Three of the old men can be seen on the

175. Ma Yüan (c. 1190–1224):
The Four Greybeards (detail). Ink on paper.
Cincinnati Art Museum

right, two concentrated on a game of chess. They are lightly sketched in, their robes drawn with nervous angular lines in keeping with the crisp pine-needles and rock forms around them. The detail reproduced is, like the rest of the scroll, full almost to crowding. It is charged with intricate interplays of movement that are staccato but nowhere escape the artist's control. These two pictures [174 and 175] show a Ma Yüan capable of tense, dynamic concepts matched by forceful brushwork. If Ma Yüan did paint pictures of this kind, and he very probably did, then his influence on Japanese painting of the Kanō school would be more evident. He has never enjoyed the admiration in China that has been lavished upon him in Japan. What reputation his countrymen have granted him may well be based upon paintings of this kind rather than his more carefully executed, and more academic, pictures.

The other painter, Hsia Kuei, whose name is so often linked with that of Ma Yüan, was a contemporary in the Academy. Though his exact dates are not known, he was certainly active in the first quarter of the thirteenth century, when, in the reign of Ning-tsung (r. 1195–1225) he was Painter-in-Attendance and was awarded the Golden Girdle. The differences between the two men are elusive and difficult to define. In the last analysis, they were both highly gifted men with perfected techniques. A preference for one over the other must remain a matter of personal judgement. It is of some interest, however, in this brief survey, to observe two artists who both worked within the scope of what was, after all, a relatively limited formula. We are still in uncertain territory regarding genuine works, and generalities may be more misleading than revealing. Perhaps it can be said that the landscapes of Hsia Kuei possess more rationality and emotional restraint than do those of Ma Yüan – a quality Chinese critics would call 'old-fashioned elegance'.

A small, oblong album leaf attributed to Hsia Kuei, in the Palace Museum, shows two men seated on a high promontory overlooking a stream and under an enormous overhanging cliff [176]. The artist used the same 'axe-stroke' ts'un as Ma Yüan, but the entire effect is softer and more deeply lyrical. An extensive use of graded washes of wet ink creates an impression of still, moist atmosphere. And again, beyond the farther bank, where the feathery tops of a

176. Hsia Kuei (*c.* 1180–1230): Talking with
a Friend under Pines by a Precipice. Ink on silk.
Taipei, Taiwan, National Palace Museum

177 (*left half*). Hsia Kuei (*c.* 1180–1230):
Twelve Views from a Thatched Cottage. Ink on silk.
Kansas City, Nelson Gallery of Art and Atkins Museum

bamboo grove emerge from the vaporous air, there is the void of bare silk inviting the imagination to continue the theme.

On a technical level the most striking feature is the ink quality. There is a deep, luminous black, applied in blobs and drops on the trees and splashed about in a varied pattern over the rocks. It outlines the figures in a decisive way. Though the actual range of ink-tones is limited, they are employed to produce the maximum descriptive effect. Very much the same ink quality and firm, decisive drawing may be seen in a hand-scroll in the Nelson Gallery. This painting is apparently the end third, containing four scenes, of a much longer painting which originally had twelve views. The composition is continuous but titles, traditionally in the writing of Sung Li-tsung (r. 1225-64), have been affixed identifying various themes.[9] In the section reproduced [177], the titles are, from right to left: 'Distant Mountains and Wild Geese', 'The Ferry Returns to the Village in the Mist',

'Fisherman Playing the Flute in the Quiet Dusk', and 'Anchoring at Evening on the Misty Bank'. No better example could be found of the daring and suggestive use of bare silk. A few lines about the boats, and there is a whole expanse of quiet lake; two grey fingers of ink wash, and the whole marshy lake shore emerges in the evening light. No other art of painting could so successfully. capture a mood of that poignant moment when night is hovering, the evening mists are rising, and the world is so hushed that the cry of a water-bird, the notes of a flute, or a temple bell carry far out over the smooth lake.

In a painting like this, pictorial suggestion has been pushed as far as is possible while still retaining contact with reality. After the preceding flight into the void (it must be remembered that one progresses in time through these scrolls from right to left) the closing passage with wood-cutters returning to the walled village in the distance reaffirms the life of man

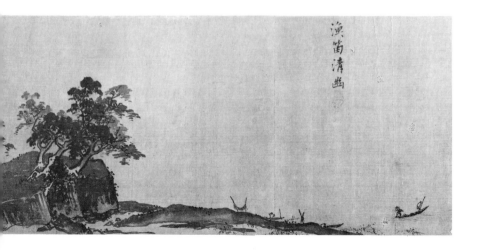

in the world of nature. Hsia Kuei reveals his classic training by holding his theme together and in check through solid and structural drawing. There is the same bold use of lustrous black ink applied in blobs, drops, and dabs that we have already noted in the Palace painting [176]. It is of interest to mention a colophon by the seventeenth-century critic and painter Tung Ch'i-ch'ang attached to this painting, because, as we shall see later, Tung Ch'i-ch'ang in weaving the fabric of his elaborate art theories is supposed to have had little respect for the paintings of the Ma–Hsia school. However, here he remarks: 'In painting Hsia took Li T'ang as a teacher, but simplified his style in a way similar to what sculptors call "simplified modelling". His aim, however, was to eradicate any semblance of following (Li T'ang's style). And his style is as though his forms were fading away and would disappear. He had the ink-play of the two Mi's (Mi Fei and Mi Yu-jên) at his brush tip. Other men work away at angles to make forms round, but this man chisels the round to make it angular.'

From the end of the eleventh century, at least, there had been a growing interest in atmospheric perspective and the representation of space, until by the first quarter of the thirteenth century space threatened to occupy the greater part of the picture. There was also an ever-growing sense for selection so that the artists turned from the grand completeness of the early landscapes to painting more intimate bits and fragments of nature, choosing often simple aspects that would be more amenable to reflecting a personal mood. At the same time there was increasing interest in the qualities of brushwork and ink *per se*. Ma Yüan and Hsia Kuei were the most able representatives of the men who had carried these tendencies about as far as they could go and still hold to the line, at times very tenuous, that led back to the great landscape heroes – Kuan T'ung, Li Ch'êng, Fan K'uan, Tung Yüan, Chü-jan, and Kuo Hsi. One of the possible directions from there onwards was pursued by a group of Ch'an Buddhists, dwelling for the most part in the beautiful monasteries about Hang-chou.

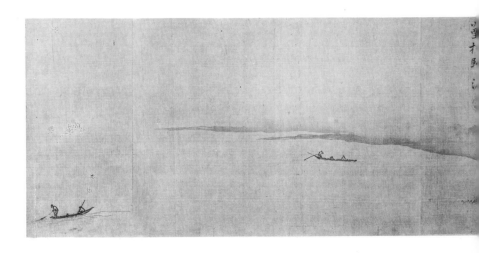

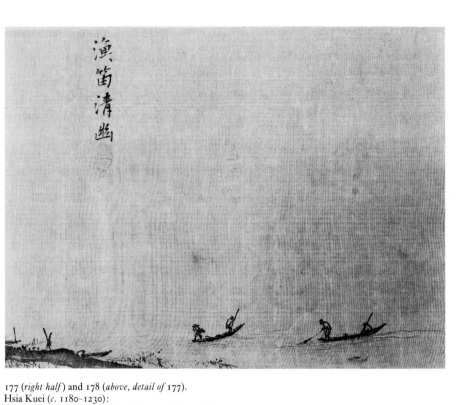

177 (*right half*) and 178 (*above, detail of* 177).
Hsia Kuei (*c.* 1180-1230):
Twelve Views from a Thatched Cottage. Ink on silk.
Kansas City, Nelson Gallery of Art and Atkins Museum

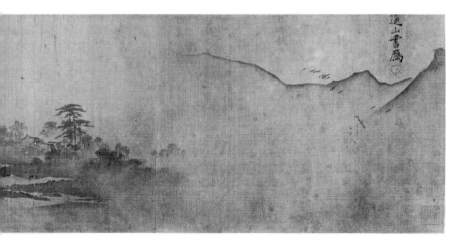

CH'AN BUDDHIST PAINTERS

Bodhidharma, an Indian monk, arrived at Nanking between 520 and 527, according to one tradition, where he preached to the Liang Dynasty ruler. His message was not readily understood, and he made his way northward to Lo-yang, then the capital of the Northern Wei. He eschewed the pomp and intrigues of the court and powerful monasteries and taught the simple tenets of his sect until his death. Bodhidharma was the Twenty-eighth Buddhist Patriarch, and the First of the Chinese sect called Ch'an, the Chinese translation of the Sanskrit word Dhyāna. The sect is better known to Western readers under its Japanese title of Zen. He taught that there is no Buddha save the Buddha that is in one's own nature. To seek Buddha outside oneself is useless. Nothing can be gained by worship or ritual, by good deeds or austerities, by reading all the sacred texts, through monastic life dedicated to devotion. Only by meditation and thus coming to know one's own nature can enlightenment be attained. 'The Absolute is immanent in every man's heart. . . . Only one thing avails – to discover the unreality of the World by contemplating the Absolute which is at the root of one's own heart.'[1] Our over-simplification can give no idea of the real meaning of the Ch'an sect. Its earliest teachings contained much that was native to Chinese thought and also drew heavily upon pre-Buddhist Indian philosophy. But as the Ch'an doctrine developed through the centuries, it became an almost purely Chinese contribution to Buddhist thought. The importance of Bodhidharma as founder of the sect, and indeed his very existence, have been seriously questioned by some modern scholars,[2] but his importance to the sect as the traditional founder is undeniable, while ideal portraits of the First Patriarch are among the best achievements of Ch'an painting.[3]

Towards the end of the seventh century a schism occurred in the Ch'an School over the selection of the Sixth Patriarch. The Fifth Patriarch, as death approached, chose Hui-nêng (638–713) as his successor rather than Shên-hsiu (d. 706) who was reputed to be the favourite. Hui-nêng remained in the Anhwei monastery and continued what came to be known as the Southern School, while Shên-hsiu betook himself off to the T'ang court at Ch'ang-an and became the founder of the Northern School. Later developments of the Ch'an school favoured the tradition and teachings of Hui-nêng, who has come to be recognized as the orthodox Sixth Patriarch, while, in later times, the Northern School came to be associated with the pomp and outward show of the court. This is important in the history of painting, because, as will be described later, when critics and art historians came to classify types of landscape painting they followed the divisions of the Ch'an school, placing in the Northern camp all those whom they judged to be painters of the superficial aspect of things and in the Southern School those painters whose works were congenial to aesthetic standards of the time.

Here we can only touch on some of the aspects of Ch'an that had a direct bearing on the art of painting. As the doctrine evolved, especially during the ninth and tenth centuries, the highest truth came to be called the First Principle, the supreme level, about which, because of its very nature, it was impossible to say anything. When a Ch'an Master was asked: 'What is the First Principle?' he replied: 'If I

were to tell you, it would become the second principle.'⁴ If the truth could not be taught by words and communicated by holy texts, the seeker could, none the less, be aided by his master who by seemingly enigmatic remarks and apparently pointless conundrums might direct the meditation of his pupil into proper channels. Other Masters expressed the First Principle simply by complete silence. There were various methods of cultivation which aimed at clarifying the mind and spirit of all but what was natural, and this cultivation had to be accomplished without effort or aim. The reward of cultivation is Buddhahood, and to this end the meditation must lead to a sudden enlightenment. This union with the First Principle comes in a lightning flash of intuitive vision, called sometimes by the Ch'an Masters 'vision of the *Tao*'. Again to quote Fung Yu-lan: 'Comprehension of the *Tao* is the same as being one with it. Its wide expanse of emptiness is not a void; it is simply a state in which the distinctions are gone. This state is described by the Ch'an Masters as one in which "knowledge and truth become undifferentiable, objects and spirit form a single unity, and there ceases to be a distinction between the experiencer and the experienced".'⁵ It is in his sudden flash of intuitive knowledge that the Ch'an practitioner becomes one with the Supreme Unity and is himself all things.

The experience cannot be described or conveyed in words, but it can be suggested in paintings which may bring the prepared observer nearer to the awareness of his own enlightenment. The point to be stressed about Ch'an in its relation to painting is the intuitive identification of 'objects and spirit', 'experiencer and experienced'. The desire to experience this sense of oneness with the world lies at the root of the intense Ch'an cultivation of Nature. If these fleeting visions of identity and unity are to be recorded in painting, they must be done in the shortest time possible, 'for ecstasy cannot

be long sustained'. Terseness and brevity, clarity of mental vision and intensity of realization are all prerequisites of the Ch'an painter. The monochrome ink technique in which the pliant brush can move with the rapidity of thought was ideally suited to the expressionism of the Ch'an school. 'For them the extremely rapid, always abbreviated recording of subjects from nature in a few pools of wash or staccato brush-strokes made for a transference to painting of the instantaneous and intuitive perception of the oneness in the workings of Nature that dominated Ch'an Buddhist thought.'⁶

Inasmuch as the First Principle, the Buddha-nature, pervaded all things it was as much revealed in a blade of grass as in a mountain range, in a bird on a branch as in the flight of the Dragon, in the rush of a waterfall as in the roar of the tiger. The subjects of Ch'an religious paintings could and did cover a wide range, but in general they fall into two main classes. There are relatively simple studies of nature, or very abbreviated landscapes; and second, such figure subjects as portraits of the Ch'an Patriarchs, the curiously individual practitioners of Ch'an exemplified by Han-shan and Shih-tê, and the two favourite Bodhisattvas, Kuan-yin and P'u-t'ai (Maitreya), the latter in the guise of a corpulent, untidy monk.

At the time when the Painters-in-Attendance of the Academy were painting their poetic landscapes, their visions of a world of limitless space and nostalgic mood – in the first quarter of that fateful century that was to witness Sung culture engulfed by the Mongol hordes – a Ch'an priest, drawn to Hang-chou by its natural beauties as much as by any other reason, refounded an abandoned monastery on the shores of the Western Lake. This priest, Mu-ch'i, also known as Fa-ch'ang, was himself a very good painter and the temple which he reanimated in 1215, Liu-t'ung-ssu, came to play an important role in the history of Ch'an monochrome ink painting.

Mu-ch'i was apparently active throughout the first half of the thirteenth century. His general style must have been practised by a number of painters at the time, especially those associated with the Hang-chou Ch'an monasteries, because interest in Ch'an concepts was general. By far the greater number of Mu-ch'i's paintings are preserved in Japanese temples and private collections.[7] The best example is the set of three large scrolls, painted in ink on silk, preserved in Daitokuji, Kyōto.[8] A white-robed Kuan-yin occupies the central panel [179]. The great Bodhisattva is seated on a rocky shore overlooking the waters in the foreground. Doubtless the setting is Kuan-yin's fabled island home of Potala. Roughly drawn and heavy brush-strokes outline the rocks, and dark ink washes heighten the impression of a lonely and sombre setting. The rhythm of the thick brush-strokes that define the robes of the serene and immobile figure is most effective in creating a sense of placidity and at the same time one of inner power, while the face has an expression of intense concentration. A comparison between this Kuan-yin and any of the other numerous versions of the same subject by Chinese and Japanese artists of the fourteenth and fifteenth centuries will serve to emphasize the extraordinary genius of Mu-ch'i. Of the other two scrolls in the set, one shows a mother ape perched on the limb of a tree and clutching her young, while in the third there is a striding crane and bamboo.[9]

The meaning of these side scrolls, flanking the Kuan-yin, is uncertain. One suggestion is that the chattering ape with its love of progeny represents the didactics and morals of the Confucians, while the crane, a standard symbol of long life, satirizes the Taoist quest for immortality.

In contrast to the size and scope of the Daitokuji triptych, illustration 180 reproduces Mu-ch'i's famous 'Six Persimmons'. This is a small picture in ink on paper, the property of

179. Mu-ch'i: Kuan-yin. Ink on silk. Thirteenth century.
Kyōto, Japan, Daitokuji

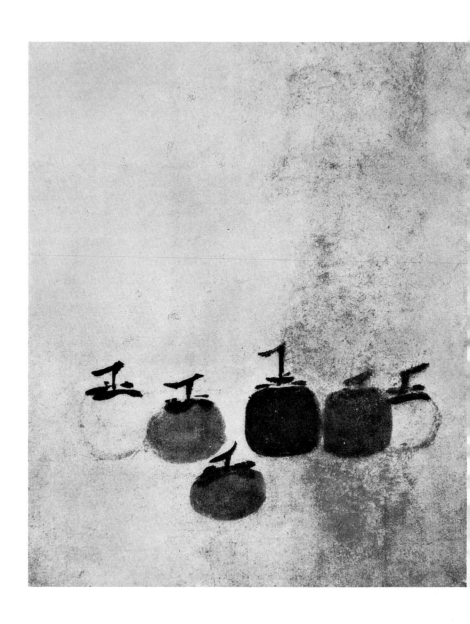

180. Mu-ch'i: Six Persimmons. Ink on paper.
Thirteenth century.
Kyōto, Japan, Daitokuji

the same monastery. From the Ch'an point of view there is no difference in importance between the great triptych with the chief of the Bodhisattvas and this small study of fruit – both to be worthy must record a communion with the Buddha-nature, and, as manifestations of the Great Unity, both are alike. Few other Ch'an paintings are so convincingly the product of an instantaneous flash of inspiration or so perfectly illustrate the way the Ch'an painter can register his fleeting visions in terms of ink splashes. There is a reality about Mu-ch'i's persimmons that is final. Here, in the phrase of Arthur Waley, 'passion has congealed into a stupendous calm'.

Some landscapes, or separated parts of one and the same scroll, are also attributed to Mu-ch'i. One of the best, or most representative, is that in the Nezu Collection [181]. In the paintings of Ma Yüan and Hsia Kuei, the bare silk, or ink washes of rising mist, suggest vistas but half concealed that may, momentarily, come into view, or suggest the infinity of space. In the Nezu landscape the forms – rocks, mountains,

Yü-chien in the Count Matsudaira Collection,[10] all sense of form is lost and the scenery dissolves into more or less suggestive puddles of varying ink tones.[11] One cannot help feeling that in such extremely dissolved paintings chance plays too important a role and that, in a sense, the artist is in danger of losing control of his medium.

Liang K'ai, who also painted in the spirit of Ch'an Buddhism, began his career in the Academy, where early in the thirteenth century, during the reign of Ning-tsung (r. 1195-1224), he became a Painter-in-Attendance and was awarded the Golden Girdle. He had, then, an academic background, and judging from the titles of recorded paintings, such as 'Confucius Dreaming of the Duke of Chou', 'Lohans', 'Wang Hsi-chih Writing on a Fan', and illustrations to sūtras, his repertoire followed the orthodox subjects of the times. It was not until later in life that for some reason he abandoned the Academy and, taking up his residence in the famous Liu-t'ung Temple, turned his talent to the painting of pictures in the pure Ch'an tradition. There is no reason to believe that he

181. Mu-ch'i: Landscape from the scenes of the Hsiao and Hsiang Rivers. Ink on paper. Thirteenth century.
Tōkyō, Japan, Nezu Art Museum

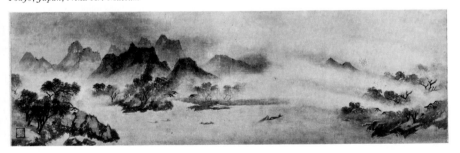

trees, and dwellings – partake of the same transient and vaporous instability. A landscape painting of this kind is significant in indicating the direction which much of Ch'an painting followed, until, in landscapes such as one by

ever took the vows of the order. Although the Chinese records give far more attention to Liang K'ai than to Mu-ch'i, none the less the most celebrated paintings attributed to him, with but few exceptions, are also in Japan. Some

182. Liang K'ai: The Sixth Patriarch chopping
Bamboo. Ink on paper.
Thirteenth century.
Tōkyō, Japan, National Museum

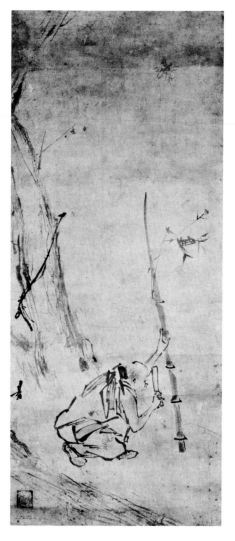

of his best paintings are figure subjects, among them 'Śakyamuni Buddha Leaving the Mountains', 'The Sixth Patriarch Chopping Bamboo' [182], and 'The Sixth Patriarch Tearing Up the Sūtras', existing now only in an early Japanese copy. The pictures that are attributed to him with any justification are what might be anticipated from a high order of Chinese intellectual turned mystic. Liang K'ai shows the Sixth Patriarch, Hui-nêng, crouching and with Ch'an concentration lopping the branches from a bamboo stalk. Although the action is the daily labour of a simple, straw-sandalled monk, there may well have been some esoteric Ch'an meaning that eludes us today. Movement and energy is given the figure through the brittle, angular drawing of his rough clothes, and in contrast the ground plane is suggested and the tree brushed in with the kind of broken strokes called 'flying white'. The simple composition is as carefully constructed as are the works of the leading old masters.

The heights that could be reached in the abbreviated style of monochrome ink, when practised by a genius, are well shown in Liang K'ai's great ideal portrait of the poet Li Po walking and reciting [183]. All the absorption of inspiration is concentrated in a dozen telling strokes of the brush. The work of this master marks the culmination of the Ch'an school. It expresses at once the spontaneity, the freshness of inspiration, the terseness of statement, and the simplicity of execution that were the Ch'an ideal. Nowhere in his work can be found even the seed of the virtuosity and studied carelessness that mars much of the work of lesser and later men working in the same tradition.

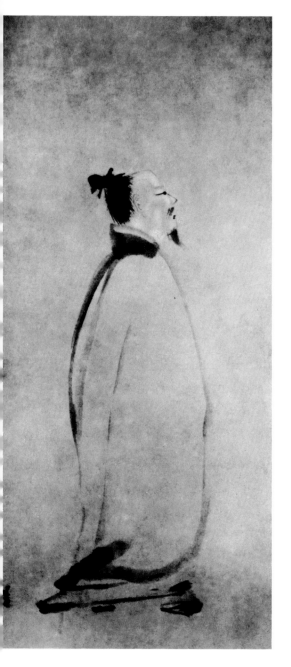

183. Liang K'ai: Li Po. Ink on paper.
Thirteenth century.
*Tōkyō, Japan, Cultural Properties
Protection Commission*

SUPERNATURAL AND TAOIST THEMES

Before leaving the Southern Sung Dynasty, there are a few scrolls that are so interesting because of their subject-matter and as examples of the variations within the free monochrome ink style of the thirteenth century that they cannot, even in a brief survey, be neglected. A great many Chinese painters have been famous for their pictures of water-buffaloes – the ponderous, plodding animal that has for millennia been of prime importance in the economy of central and south China. In the time of Southern Sung, Li T'ang, Chiang Ts'an, and Yen Tz'u-p'ing were all noted for their paintings of water-buffaloes. One of the best surviving scrolls, however, is by a very little-known artist, Fan Tzu-min, whose only recorded painting, apparently, entitled 'Herding the Oxen', was at some time in the Imperial Manchu Collection. This scroll, which is now in the Chicago Art Institute, is a monochrome ink painting on paper nine feet long [184]. The water-buffaloes and a few calves are shown in the widest variety of activities, standing, grazing, swimming a stream, lying down, one scratching his side against a tree, and another drawing a plough. The diminutive boy cowherds either ride their charges or amuse themselves at games. It is a delightful narrative of the life of a buffalo composed with all the variety and progressions that are inherent in a good hand-scroll. The style is that of the fully developed Southern Sung ink painting. The landscape is dissolved

184. Fan Tzu-min: Herding the Oxen (detail). Ink on paper. Thirteenth century. *Chicago, Art Institute*

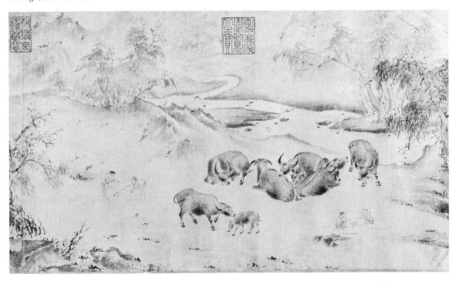

into hazy, half-suggested forms but is held together by perfectly descriptive shapes and well-graded ink washes. Both the mountains and rocks are rendered almost entirely in tones of wet ink with very little outline. In places dry ink has been hurriedly pulled over the surface so that the white paper reflects through, a technique that lends brilliance and luminosity. The feathery trees are of a kind seen in paintings by Hsia Kuei and with something of the same sure, firm drawing. The buffaloes are realistically treated in both drawing and modelled form, as well as in the characteristic leathery texture of their thin-haired hides. A simple, angular line, such as that in the Ma Yüan scroll [175], or certain paintings of Liang K'ai, is used in drawing the gamin cowherds. Fan Tzu-min, the artist of the scroll, was a Taoist. The rough water-buffalo, in his environment of countryside and stream, symbolized to the Taoist sceptic the rustic, vagabond life in harmony with natural principles and freedom from the fetters of urban society.

A more potent symbol, the very incarnation of the *Tao*, was the Dragon. In connexion with the 'Nine Dragons' painting in the Boston Museum, the late John Lodge wrote: '. . . the *Tao* is the one ultimate, tireless activity, tirelessly potential energy – relative in its activity, absolute in its potentiality. Incarnate in every phase and particle of the phenomenal universe, it inevitably retains the impression of an unlimited past and as surely moulds the ceaseless future, but is itself unconditioned by time, space, or matter, which, after all, should be regarded merely as attributed to the cosmos it produces and sustains. . . . Like all other phenomena, he (the Dragon) is an incarnation of the *Tao*, and the fact that he is manifest as a purely emblematic figment of the imagination makes him none the less real and natural.'[1] To describe the Far Eastern Dragon, we cannot do better than quote the distinguished Japanese writer, Okakura Kakuzo: 'We associate him

with the supreme power or that sovereign cause which pervades everything, taking new forms according to its surroundings, yet never seen in final shape. The dragon is the great mystery itself. Hidden in the caverns of inaccessible mountains, or coiled in the unfathomed depths of the sea, he awaits the time when he slowly rouses himself to activity. He unfolds himself in the storm clouds; he washes his mane in the blackness of the seething whirlpools. His claws are in the forks of the lightning, his scales begin to glisten in the bark of rain-swept pine trees. His voice is heard in the hurricane which, scattering the withered leaves of the forest, quickens the new spring. The dragon reveals himself only to vanish.'[2]

Ch'ên Jung, also known as Ch'ên So-wêng, the dragon painter and a Taoist, was active from about 1235, when he took his *chin-shih* degree, until past the middle of the century. He held several administrative posts in government and was active as a poet as well as a painter. His fame, however, rests on his wonderful paintings of dragons. It seems that he was of a free, tempestuous nature, and it is related that he would sometimes paint in a wild and furious manner, splashing the ink and spitting the water, or when in his cups, he would shout and, dipping his cap in the ink, smear about on the paper but finish the design with a proper brush.

The best dragon painting that has survived into our day is the great scroll of 'Nine Dragons' painted by Ch'ên Jung in 1244. It is done in ink and traces of red on paper, and is now in the Boston Museum [185].[3] The scaly bodies, organically articulate in every way, writhe in and out of stormy clouds, clutch jagged rocks, and ride with the waves that are lashed into spray and whirlpools. The painting is an ultimate achievement in the splashed ink style – the black areas dubbed in with very dry ink, the waves and waterfalls drawn with long, sweeping, but nervously broken lines, and in places the black ink quite literally splashed from the brush.

185. Ch'en Jung: Nine Dragons
(detail). Ink and slight colour on paper.
Dated 1244.
Boston, Museum of Fine Arts

Sometimes a painting may at first glance seem quite rough and coarse, but more attentive consideration will reveal brush and ink of vigour and sureness calculated to produce an effect admirably suited to the theme. Or again, these qualities which mark the highest technical skill may be half concealed by a seemingly careless and off-hand treatment. A picture of this kind is the superb scroll, 'Chung K'uei, the Demon Queller, on his Travels', painted by Kung K'ai, and now in the Freer Gallery of Art, Washington [186]. The artist Kung K'ai was active from about 1260 to 1280, living on into the Yüan Dynasty, when he went into retirement rather than serve the Mongols. Paintings of demons and the supernatural have always had a strong appeal for the Chinese and few peoples of the world have exploited the possibilities in fantasy and imagination with greater success. From the gnomes and fairies of the Han lacquer painters and the rich Taoist lore on

the walls of the sixth-century Korean tombs to the demons of Buddhist Hell scenes, and finally the adventures of Chung K'uei, demoniac and ghostly spirits have supplied a never-ending source for the grotesque and fanciful. The most current popular legend about the origin of Chung K'uei recounts that one night the great T'ang Emperor, Ming Huang, dreamed of a small demon who had slipped into the palace and stolen a jade flute with which he gambolled about the halls. But suddenly the figure of a huge man with flowing beard and dressed in tattered official garb appeared, seized the demon, gouged out and ate one of its eyes. The grateful emperor asked the newcomer about himself and learned he had been a scholar some time past but had killed himself in despair at being prevented by trickery from holding first place in the public examinations. The emperor, in reward, gave Chung K'uei, as the defunct scholar was named, official status and entitled

186. Kung K'ai: Chung K'uei, the Demon Queller,
on his Travels (detail). Ink on paper.
Thirteenth century.
Washington, Smithsonian Institution,
Freer Gallery of Art

him 'Great Spiritual Demon Chaser of the
Whole Empire'. Chung K'uei, then, devotes
himself to hunting out, destroying, enslaving,
or eating all demons and malignant spirits. The
escapades of Chung K'uei supply the Chinese
artist with an opportunity to exercise his
ingenuity in demonology much as the tempta-
tion of St Anthony served Flemish artists of the
fifteenth and sixteenth centuries. In the Freer
scroll, Chung K'uei and his sister are on tour,
accompanied by their enslaved demons and
thoughtfully provided with a certain number of
bound demons and a jar of 'demon-pickle' for
provender along the way.[4] The brush-strokes in
the robes of Chung K'uei, who looks back
threateningly for any signs of insubordination,

his sister, and her immediate attendants are
done with wet ink. They are simple and
admirably descriptive. In the demons, especially
the dark, skeletal ones, the ink is dry and piled
up with rough scumbling that gives an effect of
the coarse, parchment-like skin, while, through-
out, the bone structure is well articulated. The
combination of such robust humour as in the
small lacquer-black party with a basket beside
Chung K'uei, and such masterly composition,
drawing, and structural brushwork as Kung
K'ai has employed in this painting, makes it a
matter of great regret that very few good demon
scrolls have survived.[5]

*

In the one hundred and twenty-two years of the
Southern Sung Dynasty there evolved certain
trends in Chinese painting that have been
important into modern times. In the first place,
the refounding of the Academy, with many of

the older painters who had known the days of Sung Hui-tsung enlisted among its members, established the academic style on a firm basis. Its principles survived with vigour and a high level of competence into the Ming Dynasty and with ever-waning strength until the eighteenth century, when, ironically enough, the bird-and-flower designs and the blue-and-green landscapes as decorative motifs – ordinary craftsmen's derivations from the traditions leading back to the old Sung Academy – were the first thin echoes of Chinese painting to find favour in Europe. Ma Yüan, Hsia Kuei, and their followers exemplified a trend away from the lucid balance and completeness of the early landscape painters towards a more direct and personal emotional appeal; this result was accomplished by further selection, simplification, dramatic composition, and, above all, by the suggestion of limitless extension of space. Other painters, like Chiang Ts'an, reaffirmed the value of

tradition and based their styles on the real or supposed manners of the old masters with, of course, the modifications that were inherent in their own age. Brush methods and ink quality became subjects of intense study. In the Ch'an and Taoist painters there begin to emerge the definite personalities of artists who were individualists serving no Academy and pleasing no masters except themselves and chosen friends. There is a certain unity in the works of all the artists of the tenth, eleventh, and twelfth centuries, regardless of what subjects they painted. Perhaps the styles of the earlier painters may only appear more coherent, because they stand at a great distance and few of their works have survived. In any event, we are at least more conscious of a growing diversity first clearly evident in the thirteenth century, increasingly pronounced in the fourteenth, and dominant during the fruitful centuries of the Ming Dynasty.

YÜAN DYNASTY PAINTING

Hang-chou fell to the Mongols in 1276, and three years later, after a futile stand farther south, the Sung Dynasty came to an end. During the closing years of the twelfth century the many independent Mongol tribes had been welded together into a formidable force. By the opening years of the thirteenth century the hordes swarmed out of their native Mongolian plains and began the series of conquests that was to forge an empire extending from the southern tip of Korea to the shores of the Caspian. In 1206 their leader, Timurjin, proclaimed himself Jenghis Khan – 'Emperor of the Seas'. The Jurchen Dynasty of Chin, ruling in north China, held out until 1233 when their power was broken by a short-lived Mongol-Chinese confederation. Kubilai Khan, the grandson of Jenghis Khan, established his northern capital at Peking (Khanbaliq) in 1260 and in the following year was proclaimed emperor of China. The Yüan Dynasty began its rule from the new capital in 1270, though the official chronology does not recognize its imperial title until 1280 after the final collapse of Southern Sung.

In many respects the intellectual and cultural aspects of the Sung Dynasty had been the golden afterglow of the great creative centuries of T'ang and the Five Dynasties, and it was a fruition that might reflect credit on any nation, East or West. The Mongols were at some pains to perpetuate, or recapture, the native Chinese tradition of that epoch so rich in scholarship, the arts, philosophy, and science. To a certain extent they were successful, but many of the really significant achievements of the fourteenth century are due to the failure of the Mongol court to become a lodestone for creative genius

and to assume a dominant place as the centre of cultural life.[1]

Many of the literati were no longer employed in the bureaucracy or were reluctant to take office under a foreign dynasty. Some of them turned their attention to literary forms the farthest from official or academic standards, and as a result there occurred an unprecedented development in popular drama and the novel. Those of the intellectuals who were gifted artists tended more and more to paint for their own enjoyment or for the limited audience of men of their own stamp. When we remember the high aesthetic value of calligraphy in China, the almost magic or spiritual qualities attributed to brush and ink, and the potentials of the brush-stroke as a means of expression it is more readily understandable that men of talent, painting for their personal pleasure or as an outlet for their emotions rather than to meet academic standards or the competition of a court, became increasingly engrossed in problems of technique and forms of expression rather than striking originality in theme or composition.

At times this attitude resulted in an apparent monotony of subject-matter, and the reduction of compositional elements to formulas. A few trees – seldom more than three or five – a hut, a stretch of water, and a hill or two would describe most of the paintings by one of the greatest Yüan masters, Ni Tsan. But his paintings are among the best products of China in the quality of his ink, the character of his brushwork, and the elegance of his drawing. Again, among the numerous conventions that might be mentioned there is one tree bent at an acute angle either to the right or to the left, that appears over and

over again somewhere near the foreground in the pictures of a number of artists.

The old masters were more than ever before looked upon as the giants of landscape painting. It must be repeated that traditional styles never died, nor were they ever entirely superseded. Throughout the fourteenth century there were able artists who perpetuated the traditions of both the Northern and Southern Sung periods and produced works of great merit. But here we are not so much concerned with the tide of tradition as with the creative innovations. The great painters of the Yüan Dynasty passed over the Southern Sung Dynasty and themselves turned back to the landscape painters of the tenth and eleventh centuries. Wisely they did not attempt to produce an outward likeness to the grand landscapes of the past, but sought rather to recapture that ancient and austere spirit. The old painters had, for the most part, used very dense, close brushwork to obtain their particular kind of realism. Most especially the Yüan painters of landscape looked upon Tung Yüan and Chü-jan as the greatest masters of brushwork and ink. From what little we know today concerning these two painters [152, 153] it may possibly be that their work was congenial to Yüan ideals, because their brushwork was more open, the character of the individual strokes, and so the 'area quality', was more apparent than in the dense-packed strokes of painters like Fan K'uan and Li Ch'êng [146-7, 150, 151]. One characteristic of Yüan painting may serve to illustrate this point. A standard method for rendering rocks or mountains was to outline the main forms and shapes, then to do the mass and inner configurations with various kinds of strokes, the ts'un, and unite these individual strokes in turn and pull them together by ink washes. Such wet ink washes tended to conceal, to some extent, the character of the individual strokes. In Yüan paintings of the kind under discussion, there was a marked tendency to abandon the washes altogether or

use them very sparingly. At times the bounding outline was also abandoned, as, for example, in the landscape in illustration 191 (Chao Yung) where a ts'un of the variety known as 'hemp fibres' is employed throughout. Most fourteenth-century painters were very sparing of the use of wet, flowing ink and preferred a relatively dry ink which lent clarity to the individual strokes and produced an effect that was crisp, luminous, and crystalline.

Another characteristic notable in the work of some of the leading masters, especially Huang Kung-wang and Wang Mêng, was complete abandonment of the 'one corner' compositions and the use of empty space as developed by the Ma Yüan–Hsia Kuei school. On the contrary, there was a return to the full, detailed compositions of the early masters. Some of the hanging scrolls are packed from the bottom to within a few inches of the top with a wealth of trees, rocks, cliffs, tablelands, and peaks. The immediate effect is of a richly varied all-over pattern. There is no instant impact of a telling composition. Paintings of this kind are like long and very beautifully constructed prose essays that must be enjoyed with leisure and full absorption. At times, as in some of the pictures of Wang Mêng [195, 196], the effect of fullness and almost overwhelming detail was heightened by a change in the proportions of the hanging scroll to a tall and narrow composition which allowed relatively large elements in the foreground at the bottom and a considerable space above in which to pile peak behind peak up to a very high horizon. The effect is rather as though a thin, vertical section had been cut from a vast panorama. Such narrow compositions, originating in the Yüan period, were much favoured by some of the Ming painters of the sixteenth century.

Intense study of the old masters and preoccupation with style also had the result that an artist would frequently paint in two or more relatively distinct styles, say one fine and one

coarse, or one realistic and one more expressionistic and abstract. In most cases we do not yet know enough about the work of any individual artist to be able to say what may be his early and what his late style. In several cases it appears that the two or more styles were contemporary. This tendency, however, is nowhere nearly so marked in the Yüan Dynasty as it was to become in Ming and Ch'ing.

Painting was now more closely than ever linked to calligraphy. In the first place the growing interest in brushwork and the studied display of the strokes in a picture made it logical that the same kind of art – the expressive line – should be added to the work in the form of beautiful writing. Then, too, many of the Yüan painters were in a sense cultured amateurs for whom painting was but one form of expression available. They were scholars for whom such accomplishments as poetry, painting, calligraphy, and also connoisseurship, were closely allied. The ideas portrayed in their pictures could, with perfect consistency, be reinforced by a poem executed in beautiful and expressive writing. There were, of course, as there had

always been, men who were more or less professional painters, though it can be argued that in China the distinction between the professional and the amateur is one of definition. But in the Yüan Dynasty there distinctly begins to emerge a kind of painting produced by men who, in any event, considered themselves amateurs, and, if their works were directed to any audience at all, it was a very limited one – their own class of cultured gentlemen. Painting of this kind, known later as the 'literary man's' painting, *wên-jên hua*, reached its full development towards the latter part of the Ming Dynasty, but its most powerful initial impetus came from certain painters of the fourteenth century. To some extent, and in a general way, there were two main trends in the fourteenth century, one towards realism and, in the opposite direction, towards freer expressionism.

From the Yüan period on through the Ming and Ch'ing dynasties, there are hundreds of recorded artists, and their works have survived in gratifying quantities. Many of these men were very gifted and of distinct importance in the history of Far Eastern painting. It is manifestly

187. Ch'ien Hsüan (1235–90): Ming Huang teaching Yang Kuei-fei to play the Flute. Colour on paper.
Taipei, Taiwan, National Palace Museum

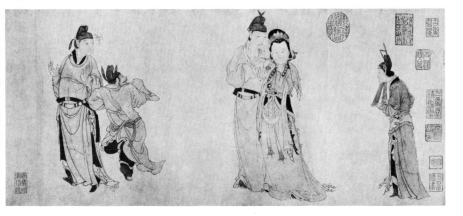

188. Ch'ien Hsüan (1235-90): Flowers.
Colour on paper.
Washington, Smithsonian Institution,
Freer Gallery of Art

impossible, however, in this volume to attempt even to name them all. The general tendencies and level of achievement can best be characterized by the work of a few, illustrated by one or more examples. If many celebrated artists are not mentioned, it is because numerous names of painters and descriptions of works not here illustrated would add complexity without the compensation of greater clarity.

Among the older artists who had worked in the last years of Southern Sung, and who refused the invitation of the Mongols to adorn their court, was Ch'ien Hsüan (1235-90). His repertoire was varied, including figure paintings, landscapes, vegetables, birds, and flowers. Ch'ien Hsüan's work continued into the Yüan Dynasty the academic realism and high standards of Sung court art. His suave, elegant figure paintings followed T'ang traditions in such subjects as ideal portraits of ancient scholars and the occupations and sports of court beauties. A scroll of this kind in the National Palace Museum, attributed to Ch'ien Hsüan,

shows Ming Huang attempting to teach his capricious mistress, Yang Kuei-fei, how to play the flute [187]. An intent youth on the right is doing his best to mark time with a pair of castanets, while a capering dwarf-like figure and an amazed court gallant on the left add a further note of humour. The drawing is light and flowing, rather similar to that of the Five Dynasties and Northern Sung in the use of hooks and complicated folds. It is an illustration done in an accomplished and charming way, but the dignity, reality, and quality of permanence that distinguished figure painting of the earlier centuries is completely lacking.

It was primarily as a flower and bird painter that Ch'ien Hsüan won his great reputation. Most of his pictures show a single spray or two, or a single blossoming branch. They are painted with the utmost care on smooth paper and are meticulously coloured. Every knot and nodule on the branches, every leaf, and vein of a leaf, is drawn with exactness, yet these pictures are in no wise mere botanical studies, but breathe, rather, the freshness of life. This quality of delicate, transient reality results, in part, from his technique of frequently painting the leaves and blossoms in colour alone without a bounding outline [188].

Ch'ien Hsüan was the last of the great bird and flower painters to work in the tradition of the old Academy. There were many Chinese artists after him who painted with great skill in a realistic manner, as, for example, Pien Wên-chin (c. 1400–40), but none of them captured the spirit of fastidious elegance, and the curiously delicate aura that emerges from the paintings of Ch'ien Hsüan.[2]

Before leaving the bird and flower painters of the Yüan Dynasty, one other painter should be mentioned because of his handsome compositions of birds among weathered rocks, bamboo, and flowering shrubs. This painter, Wang Yüan, was active in the first half of the fourteenth century. His most characteristic paintings are executed on smooth, burnished paper in dry ink, the tones wonderfully modulated through a range of silvery greys to a lustrous black. The bamboo leaves are drawn in outline and the birds painted with the greatest care and attention to texture, the colour of the plumage skilfully suggested in monochrome. In the handling of ink, and especially in the clarity of his decisive, dry strokes, Wang Yüan is more forceful and less old-fashioned than Ch'ien Hsüan, but at the same time he is more matter of fact and less poetic.[3]

By far the most gifted of the Chinese scholars who consented to join the Mongol court at Peking was Chao Mêng-fu (1254–1322) – a man whom nature had, with prodigality, endowed with position, character, and an aptitude for scholarship, the arts, and administration. Chao Mêng-fu was a scion of the Sung Imperial house and had served as an official under that dynasty for some time before 1286, when he responded to an appeal by Kubilai Khan for scholars to join his court. Although Chao Mêng-fu was himself conservative and Confucian, he was well informed in Buddhist and Taoist studies. He painted with facility many kinds of subject-matter in a wide variety of styles. He was the greatest calligrapher of his day, indeed one of the best in the long history of the art and was equally brilliant in writing the old 'seal' style, the 'official' style, the 'model' style, and the 'running' hand. Not only was he an accomplished artist but also a skilled courtier, a man of the world, and besides an able administrator who in his official career rose to ministerial rank.

Chao Mêng-fu expressed great respect for tradition and, from accounts of paintings by him, he must have painted many based directly on the old masters. He painted landscapes, figures, horses, flowers, and bamboo, and was, by all accounts, equally good in all. Posterity knows him mainly as a horse painter, a subject very dear to the hard-riding Mongols. The great number of second-rate paintings of horses alone or horses with Mongol grooms, painted in a hard, banal manner, and bearing Chao Mêng-fu's signature, can have little or nothing to do with the artist. One of the more convincing paintings of horses that has survived is a hand-scroll on paper now in the Freer Gallery showing a herd of twelve horses, with two grooms and a stable-boy crossing a stream in a wooded landscape.[4]

Other and more interesting paintings are less dependent on old models and more contemporary in style. An excellent painting of this kind that displays both the new intense interest in ink quality and the old, twelfth-century realism, is a short scroll, also in the Freer Gallery, of a long-haired goat and a fat sheep [189]. The dry, crisp painting of the ram and the wet ink mottling of the sheep are both well calculated to suggest the textures of hair and wool, while the stance and silhouettes certainly suggest a drawing from life. The two animals are beautifully spaced on the bare paper, the dark of the ram on the right being balanced by the incomparable calligraphy of Chao Mêng-fu on the left.

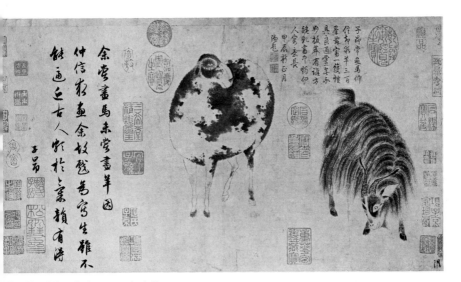

189. Chao Mêng-fu (1254–1322): A Sheep
and a Goat. Ink on paper.
Washington, Smithsonian Institution,
Freer Gallery of Art

Chinese experts in calligraphy assert that the writing on the Freer scroll may be taken as a standard of excellence for the 'model', *k'ai*, script of Chao Mêng-fu. It reads: 'I had tried to paint horses, but had not yet painted sheep (or goats), so when Chung-hsin asked for (such) a painting I did it for amusement. To draw them true to life was difficult and I could not approach it, but the men of old were versed in the rhythm of life and they were successful.'5 A passage like this, while it ostensibly served the purpose of dedicating the picture to his friend and expressing the artist's modesty and respect for the ancients, really served the end of capping the artist's beautiful, small study with his expressive calligraphy.

Of the surviving landscapes by Chao Mêng-fu one of the most significant, perhaps, for the style of the fourteenth century is a hand-scroll in ink and colours on paper dated 1295 in the National Palace Museum. The theme, 'Autumn Colours on the Ch'iao and Hua Mountains', is a classic and traditional subject. The left end of the scroll, showing Mount Ch'iao, is a rather extraordinary view of a mountain in Chinese painting, because it appears only as a low mound far on the horizon [190]. All emphasis is on the long stretch of flat lake shore, the trees, and feathery marsh-reeds. There is a greater variety of trees than is generally met with in earlier works. The trunks are drawn in a loose, almost sketchy way, but firm, vigorous brush-strokes are employed in the twigs and varied foliage. Other features characteristic of Yüan painting are the fingers of land extending out into the lake and the finely drawn, pliant reeds which, scattered through the picture, are a recurring theme throughout the composition. It is apparent that Chao Mêng-fu has arrived at this style through a profound study of the old

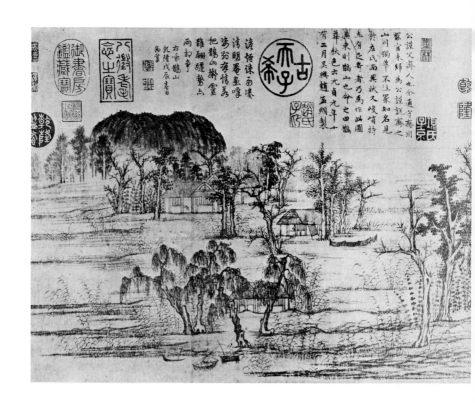

190. Chao Mêng-fu (1254–1322):
Autumn Colours on the Ch'iao and Hua Mountains
(detail). Ink and light colours on paper.
Dated 1295.
Taipei, Taiwan, National Palace Museum

masters; but he has created something quite new. There is no superficial resemblance here to the landscapes of the tenth and eleventh centuries; there is instead a realism, a vitality, and a kind of austerity that does relate to the spirit of the antique. There were other painters, one of the best of whom was T'ang Ti (early fourteenth century), who followed closely the outward appearance of old masters like Li Ch'êng and Kuo Hsi. Although they produced very competent and often excellent pictures, they were relatively minor men outside the mainstream of fourteenth-century painting.

Some characteristics of typical Yüan landscapes can be illustrated with the work of two secondary painters, Chao Yung, the son of Chao Mêng-fu, and his contemporary Shêng Mou (Shêng Tzu-chao), both active in the first half of the fourteenth century. The landscape by Chao Yung [191] is in colour on silk, the colour being limited to a brown or reddish-brown wash of varying intensities. The composition appears to be divided into two rather unrelated areas, the immediate foreground and the distant hills. This impression is due to the ground plane being violently tilted at the back from the horizontal to an angle of about forty-five degrees. In imagination, we can pull the foreground up, until it overlaps the distant hills, and flatten the intervening lake down to an angle approaching the horizontal. This distortion in Chao Yung's painting was a favoured device of painters of this century and, once we become accustomed to the convention, it is perfectly readable.

The landscape contains two distinct kinds of drawing. The boats and fishermen are done with meticulous and defining drawing while, in certain areas, a quite impressionistic type of brush painting is used for the trees, rocks, and hills. There is no outline of the rock forms, only a use of the 'hemp-fibre' ts'un strokes, which in places pile up to considerable density.

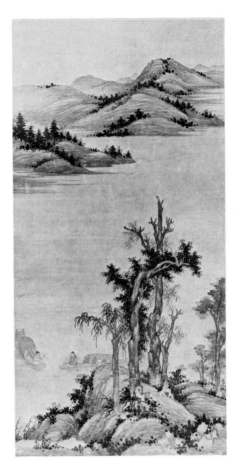

191. Chao Yung: Landscape. Ink and colour on silk. Fourteenth century.
Cleveland, Mrs A. Dean Perry

The landscape by Shêng Mou [192], 'Retreat in the Pleasant Summer Hills', is less forceful than Chao Yung's, but more lush and descriptive. An earlier style of composition in which the peaks mount to the top of the picture has been revived (cf. illustrations 146-7, 150, 151, Li

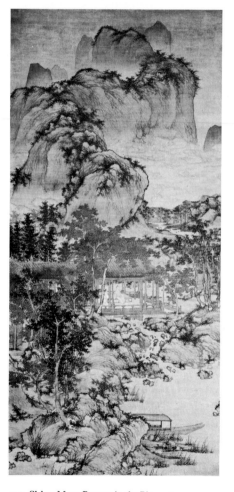

192. Shêng Mou: Retreat in the Pleasant Summer Hills. Ink and colour on silk. Fourteenth century.
Kansas City, Nelson Gallery of Art and Atkins Museum

Ch'eng and Fan K'uan). In addition to the redbrown wash, so favoured in the fourteenth century, the mountains are tinted with a soft green. The ts'un is a variety of the 'hemp-fibre' in which the wavy lines spread out like the veins of a lotus leaf, an admirable technique for representing rounded and eroded rocks. There is a greater variety of trees and some of the leaves are outlined with circles or triangles. The rich density and opulence of the painting are obtained, in part, by the thick concentrations of dots. The reeds, like those in the Chao Yung picture, are firmly drawn with a perfectly controlled line imitating the resilience of the plants as they bend in a breeze. The boat and figures are drawn with the same exactness mentioned above. The style of Shêng Mou, as may be seen by examining reproductions of several excellent paintings by him in the National Palace Museum, is one of the most consistent of the Yüan Dynasty painters.

Elements of this style, represented by illustrations 191 and 192, were used in a different way by other contemporary or slightly later Yüan painters, who carried the calligraphic tendencies farther, emphasizing the varying ink tones and the character of the individual brush-strokes. Such works became more impressionistic and accentuated the unique and subjective character of the artist at the expense of visual reality. Even pavilions and human figures are done in a cursory way, but the pictures retain a technical consistency not achieved with the carefully drawn figures of Chao Yung. Examples may be found in landscapes by K'o Chiu-ssu (active first half of the fourteenth century), Ch'ên Ju-yen (fl. 1340-80), Chao Yüan (1360-1400), and Chu Tê-jun (1294-1365).[6]

Chinese critics generally agree that the greatest landscape painters of the Yüan Dynasty were Kao K'o-kung, Huang Kung-wang, Wang Mêng, Wu Chên, and Ni Tsan. Each worked in a distinctive style, and had a profound influence on later landscape painters.

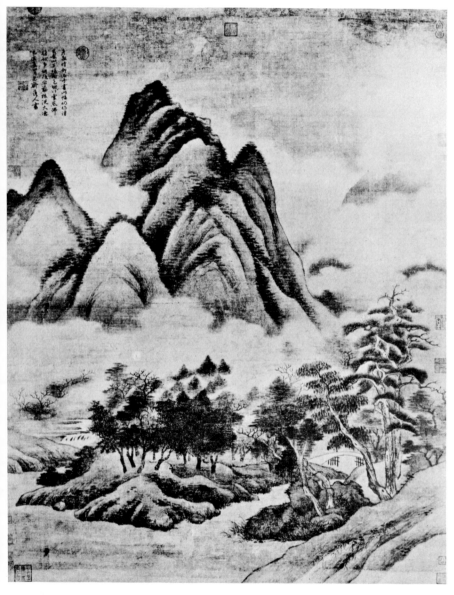

193. Kao K'o-kung: Clearing in the Mountains
after a Spring Rain. Colour on silk.
Late thirteenth century.
Taipei, Taiwan, National Palace Museum

Kao K'o-kung was the senior in the group. He rose to a high official post under Kubilai Khan. At some time after 1275 he became President of the Board of Punishments. In the latter part of his life he spent much time in Hang-chou, and some of his paintings seem to be almost literal renderings of that verdant, mist-drenched lake district. His studies in painting are said to have first concentrated upon the very personal style of Mi Fei (1051–1107) and his son Mi Yu-jên; later he turned his attention to Li Ch'êng, Tung Yüan, and Chü-jan. From these varied elements the genius of Kao K'o-kung wove a style capable of expressing a wide range of emotions and impressions, from the imposing mass of a great mountain[7] to the soft verdure of lower hills and a countryside threaded by waterways [193]. The painting illustrated is on silk, and, like many of the Yüan Dynasty landscapes, is in light colours. The poem in the upper left corner was written in 1299 by Li K'an, the most accomplished bamboo painter of the time. The horizontal strokes made with the side of the brush, so effectively employed to convey a sense of form and mass, are derived, of course, from the style of Mi Fei and his son. The free drawing of mountain and land outlines, of the tree trunks, and a certain amount of modelling in the hills, made with short, choppy strokes, all add a clarity of definition and solidity different from the work of the two Mis. Billowing clouds of mist rise from the humid lowlands and hang in the mountain valley, as the landscape clears after a spring rain. With consummate skill and knowledge of nature, the artist has shown the gradual transition of objects into the obscuring clouds, and at the same time the clarity of near objects and the peaks of the mountains. If one may attempt a distinction that is perhaps too fine, Kao K'o-kung's trees seem to emerge out of the mist as solid, growing things, and are not, as in many of the Southern Sung Ch'an paintings, dissolving into the mist, gradually

losing their reality. Historically, Kao K'o-kung holds an important place in that he was the greatest of the Yüan Dynasty painters who transmitted to later artists a style based on that of Mi Fei and Mi Yu-jên.[8]

It is difficult today to judge in even a general way the importance of Huang Kung-wang. He is universally praised by his contemporaries and later critics, but his works have become very rare, and few Far Eastern critics today are agreed on a corpus of his painting that can be considered genuine. Huang Kung-wang (also known as Tzu-chiu, Ta-chih, and I-fêng) was born in 1269 and lived until 1354. He was a man of great learning, devoted to the arts of music, poetry, and painting. His painting career must have extended over several decades, even though he began rather late, and in his later years developed great facility. Towards the end of his life he is said to have retired from the world and, as a Taoist, lived the life of a recluse, wandering in the hills constantly engrossed in the ever-changing aspects of nature and sketching scenes that were of significance to him. It is related that he penetrated ever deeper into the mysteries of nature, until in his old age he was able in his paintings to capture its very essence. It might be supposed that his technique would exhibit an increasing freedom, until he evolved a kind of personal shorthand, enabling him to jot down his impressions with all the ease and directness of expression that is the consummation of Far Eastern painting methods. This is, of course, pure supposition, but one of the most convincing paintings attributed to Huang Kung-wang strikes one as the work of a very mature artist who is capable of recording an intimate impression of nature in just such a way [194].[9]

The view of a small hamlet at the foot of a hill and beside a mountain stream is recorded very simply. The rock forms are built up with great knowledge in a free, sketchy manner. There are no ts'un of the regular kinds, but tones of very dry ink dragged over the paper or

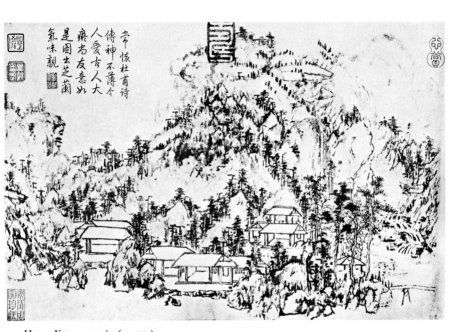

194. Huang Kung-wang (1269-1354):
Mountain Village. Ink on paper.
Tōkyō, Japan, Private Collection

piled up into dark areas of considerable density. Throughout the picture there is a play of sharp, staccato notes made by the short, horizontal strokes in black representing the foliage and limbs of trees; the buildings are reduced to the simplest forms so that they become little more than plain areas in a design. Rational, descriptive drawing has been consciously avoided in favour of local pattern and area-painting in terms of ink closely integrated in texture and tonalities. The decisive, impressionistic drawing that translates nature so uncompromisingly into terms of brush-stroke and ink brings this picture very close to what may be called a painter's painting. The observer who has no interest in the brush and ink qualities of this kind of picture is apt to be left behind.

Wang Mêng was somewhat younger than Huang Kung-wang, and though the date of his birth is unrecorded, it is known that he died in prison in 1385, having become involved in a political scrape at the beginning of the Ming Dynasty. It is interesting that on his mother's side he was a grandson of Chao Mêng-fu and so was related by blood to a family of great talents. For a while, at least, he held office under the Mongols, but much of his energies, and certainly most of his interest, were occupied with landscape painting. He was prolific and versatile. The Manchu Imperial Collection contained sixty-six paintings attributed to him as opposed to only twenty-five attributed to Huang Kung-wang. Even more than in the case of Chao Mêng-fu, we encounter in Wang Mêng an artist who was facile in a number of different ways of painting. All of them, none the less, have much in common, the chief characteristic being thickness and density of

brushwork. Huang Kung-wang in some pictures abandoned the use of ts'un altogether, but Wang Mêng piled on the ts'un inner markings and multiplied them to such an extent that the forms writhe and twist. The tonal variations are complicated by the tops of large rock masses and mountains being broken and shattered into numerous boulders and smaller stones. As though to exaggerate the towering mass of his mountains and to emphasize their volume and weight, many of his paintings are tall and narrow, with a single great mountain bulk rising from the base to the very top of the picture. Wang Mêng's visions are curiously powerful, restless, and turbulent. They stand at the opposite pole from the suave, quiet, and lyrical repose of the Southern Sung concepts. It may well be that Wang Mêng, more than any other artist of his time, reflects the political and social turmoil of the fourteenth century. His tortuous, writhing lines and restless, broken forms emphasize the variety and irregularity of nature as opposed to man-made order in a way not found in the work of previous Chinese painters.

A discussion of the various kinds of brushwork employed by Wang Mêng would lead into too much detail. The variations range from very long, wavy ts'un of the hemp-fibre class [196], through a manner more closely related to that of Tung Yüan but with the addition of many short, choppy strokes, to very short, curving strokes lightly painted but piled up in some areas to obtain great density and combined with innumerable small dots.[10] The large picture on paper, entitled 'Sound of a Waterfall in the Autumn Gorge' [195], contains one vast mountain that rises from the near foreground and builds back and up to very near the top of the picture with many small plateaus and jagged sides. A small mountain stream zigzags down on the right, and on the left a cataract plunges from a great height, its course broken by obtruding boulders, as it cascades down to

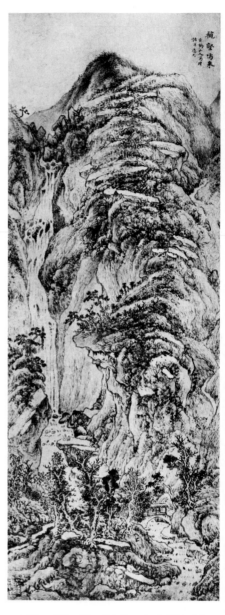

195. Wang Mêng (d. 1385): Sound of a Waterfall in the Autumn Gorge. Ink and colour on paper. *China, Private Collection*

the rocky valley floor. Two men, dwarfed by the wild and enormous scene, sit on a flat promontory in the valley, pondering the view. A group of trees, their trunks outlined in the manner of Tung Yüan and Chü-jan, and a knoll of tumbled boulders, strongly establish the foreground. This mass is built up with short, vigorous, parallel brush-strokes, curving, twisting ones, blobs, and dots. Long strokes of varying width are used to establish the basic forms of the mountain which is broken up into countless small ravines, outcrops, and cliffs. The play of tones of the dry ink is constantly varied from top to bottom so that in spite of the innumerable brush-strokes and the multiplication of forms there is no monotony. There is throughout an extraordinary sense of solidity, and one gains an almost overpowering impression of the incalculable weight of the mountain mass. The picture has many of the qualities that we in the West admire in a quill drawing by Van Gogh, arrived at, of course, through an entirely different technical method and point of view.

In another picture, 'Hermit Dwelling in the Ch'ing-pien Mountains' [196], dated in accordance with 1366, the masses are still more wildly contorted and intertwined, the landscape more dream-like and emotionally expressive. Many elements of Northern Sung landscape, such as horizontal outcroppings, piled-up boulders on the mountain tops, as in Chü-jan, and the orchestrated tonal rhythms of Kuo Hsi are harmoniously combined in an original and strongly personal vision of a turbulent mountain fastness. In pictures like these two, Wang Mêng has pushed the potentialities of dense brushwork and intricately interrelated forms about as far as possible. The contact with reality expressed in his towering compositions is convincing and concrete. So much

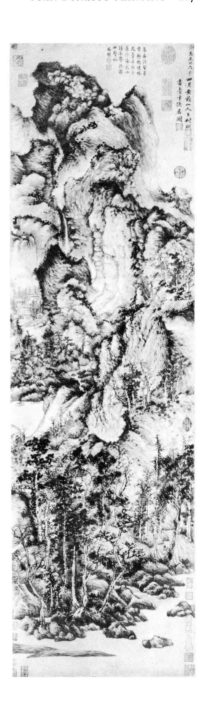

196. Wang Mêng (d. 1385): Hermit dwelling in the Ch'ing-pien Mountains. Ink and colour on paper. Dated 1366. *Shanghai Museum*

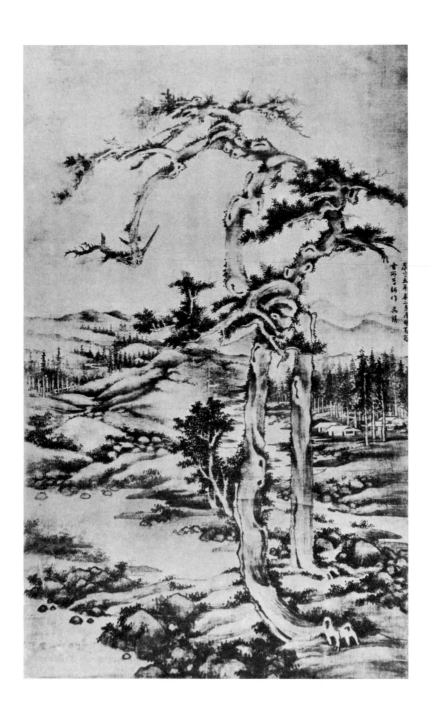

cannot always be said of his numerous followers. No artist of the Yüan Dynasty, with the possible exception of Ni Tsan, had a more profound influence on later painters, but it was frequently the virtuosity of his brush and ink and the complexity of his designs that were reproduced in various ways, rather than his profound and sombre spirit.

Wu Chên was another painter of strikingly original genius, and one whose work did much to shape the styles of succeeding generations of artists. His gifts as a poet and calligrapher fortified the growing tendency to combine the arts in a single composition. Wu Chên, who was born in 1280 and lived to 1354 or shortly after, became an ardent Taoist and followed a life of isolation from worldly affairs. His literary title was 'The Taoist of the Plum Flowers', *Mei-hua tao-jên*. His painting, in addition to landscape, included studies of trees and weathered rocks, and his bamboo paintings were among the best of the fourteenth century. He was said to have possessed a free and untrammelled spirit, and painted for his own delight and gave his paintings away to those who would enjoy them. In landscape, if we may accept the attribution to Wu Chên of several very good paintings, he followed rather closely the traditional style of Chü-jan, perhaps as handed down by such intermediaries as Chiang Ts'an of the Sung Dynasty [171]. We reproduce two pictures by Wu Chên not only as illustrations of characteristic fourteenth-century works, but also to show the wide variations possible within a style. One is a carefully finished portrait of two trees in a rolling landscape [197], the other a free expression of the artist's individual personality [198]. The first, preserved in the National Palace Museum, Taipei, and dated in accordance with

197. Wu Chên (1280–*c*. 1354): Two Cypresses. Ink on silk. Dated 1328.
Taipei, Taiwan, National Palace Museum

1328, is painted in ink on silk. The gently rolling ground, extending back to low hills, is treated in a very realistic way, simply painted with delicate ink washes and an extensive use of dots, here clearly representing low vegetation. The forest of trees that shelters a little hamlet on the right is done in a way quite close to that of Chü-jan. Careful drawing, again in rather dry ink, delineates the old and twisted trees that still can put out a sparse growth of leaves. The picture, with its excellent design and tonal pattern, is very close to nature, and the effect of flat depth is aided by the accurate diminution of trees and simplification of forms as the scene recedes into the distance. A feature that is characteristic of the age is the way ink is laid on and piled up in thick, dense masses with abrupt, forceful brush-strokes in the immediate foreground.

Twenty-four years later, in 1352, Wu Chên painted the magnificent scroll of 'Fishermen' that is one of the greatest paintings in the distinguished collection of the Freer Gallery [198]. The hand-scroll, over nineteen feet long, is a completely free and uninhibited expression by a man who loved to paint. Yet all the individual elements are derived from the same style that produced the restrained realism of the earlier picture. There are the same groupings of rounded rocks, the long strokes of a dry brush, the same closely graded ink washes, dots, gnarled trees with claw-like roots and rich, black foliage. But the entire effect is quite different. Although, from the nature of a Chinese artist's technical training, both pictures could well have been painted at the same time and there is no implication intended of anything like a progress from a tight to a free style, still the manner of the Freer scroll grows out of that in the Palace Museum painting. The freedom of drawing in the 'Fishermen' is of a kind that crowns long experience. A simplification of working methods has enabled Wu Chên to say more with less painting. If one

198. Wu Chên (1280–*c*.1354): Fishermen (detail).
Ink on paper. Dated 1352.
Washington, Smithsonian Institution,
Freer Gallery of Art

compares the two groups of trees, it will be immediately apparent that just as much is said about them in the Freer scroll with far greater directness and economy of means.[11]

The wide expanses of bare paper with the adroitly placed boats and Wu Chên's handsome calligraphy in a running hand add immeasurably to the quality of style. The fishermen themselves, who wait for a bite, pull in their catch, loll idly in a boat, or gaze out over the lake, are jotted down in a vividly descriptive kind of shorthand.

Wu Chên's scroll in its direct and spontaneous painting, its conscious exaggerations, boldly original composition and seeming disregard for niceties of drawing contains all the elements of the so-called 'literary-man's' painting that held such a dominant place in the following centuries.

Ni Tsan was born in 1301 and lived until 1374. The latter part of his life was thus spent in the midst of the break-up of the Mongol Dynasty and the series of revolts that threw the country into turmoil but led at length to the founding of the Ming Dynasty and brought China once

again under native Chinese rule. The lonely, austere landscapes of Ni Tsan reflect the escape of this sensitive genius who found the world incompatible with his ideals. He was born of a well-to-do family living at Wu-hsi on the Grand Canal, just north-west of Su-chou. He married, had several children, and the early part of his life was spent amid all the amenities available to a wealthy man of taste. He had a beautiful garden with weather-worn rocks and bamboo; he collected a number of excellent old paintings, bronzes, jades, and a large library. These collections were housed in his drawing-room, called the *Yün-lin T'ang*, and in a garden pavilion called the *Ch'ing-mi Ko*. From the former he took his most frequently used literary name of Yün-lin. He was fastidious to a degree, and in this respect very like Mi Fei. Ni Tsan was constantly washing, and if any person who was not spotless were his guest, on his departure the place he had occupied would be immediately scrubbed. He refused entrance to his garden pavilion to anyone whom he suspected not to share his own refinements of taste.[12] From these and similar accounts of his early life, Ni

Tsan appears to have been somewhat precious and eccentric. But the true character of the man became apparent in his later life. His was the real Taoist nature – the recluse in revolt against the follies of his time, social institutions, and even the demands upon the spirit inherent in possessions. Gradually he freed himself of his belongings, simplified his life more and more, until in 1356, when in his early fifties, he took the final step and broke all ties with his home. For many years thereafter he and his wife lived a roaming life on a small house-boat, wandering up and down the streams and through the lakes of south-eastern Kiangsu, among the most beautiful in China. At times he would land and spend some days in a country temple, or at a small house he had south of modern Shanghai, a cottage he called the 'Snail Hut'. After the death of his wife and when the country had become more settled as a result of the establishment of the Ming Dynasty, he returned to his old home. Ni Tsan's friends included many of the most distinguished scholars and artists of his day, among them the landscape painter Wang Mêng.

These few details concerning Ni Tsan's life are of interest, because they bear directly on the nature of his painting, and because for artists in the Ming period he became a brilliant example of the ideal man of free, clean spirit, detached from ambition but active in the uninhibited expression of his creative genius. Ni Tsan began to paint relatively late in life and his first dated painting, according to Ferguson, is of 1338. A great part of his work must have been done during his wanderings, and it is said that he freely gave his pictures away to those who wanted them, even to simple rustics. Almost all his paintings are on a relatively small scale and, in fact, a large scale would be quite unsuitable to his very intimate and personal style. The compositions, too, are of the simplest – no towering peaks, no crashing waterfalls, great, gnarled old trees, or mist-drenched hills. There are generally but a few slim trees, leafless or sparse of foliage, clinging to rocky ground, an expanse of lake, and low barren hills in the distance [199]. There is never any impression of lush growth – even his bamboo groves are sparse. Nor are there drifting clouds and banks of rising mist but rather the sharp, clear atmosphere of a cool, grey day [200]. In a few pictures there is a density of ink, as in the foreground land mass of illustration 201, but the great majority of his works are done in a limited range of light, silvery tones of very dry ink. It was said of Ni Tsan that he treasured ink like gold, and certainly no other Chinese painter has been so sparing of it.

199. Ni Tsan (1301–74): Landscape. Ink on paper. Dated 1362.
Washington, Smithsonian Institution, Freer Gallery of Art

200. Ni Tsan (1301-74): Rocks and Bamboo.
Ink on paper.
New York, Private Collection

Ni Tsan's paintings must be seen in the original, because much of their character lies in the extreme delicacy of tonality and the quality of the paper shining through the pale, dry ink lightly dragged over the surface - qualities difficult to capture in a reproduction. The picture of the 'Six Worthies' [201] was painted in 1345, before he had abandoned his home. The composition is like that of Chao Yung's painting [191] but even more exaggerated in the wide expanse of lake. The main elements are the small island in the foreground, made up of well related shapes, and the foliage with its varied leaves and brush-strokes in black, following the Mi Fei manner, gives needed emphasis. The calligraphy of Ni Tsan on the left, calligraphy that exhibits much the same qualities as the painting, is a definite part of the composition.

No human beings are present in Ni Tsan's very individual world. But the quality of isolation which all his paintings possess comes mostly from the stark severity of the very landscape, as though it had been distilled down to the minimum necessary for comment. It is a kind of puritan austerity that finds its fullest

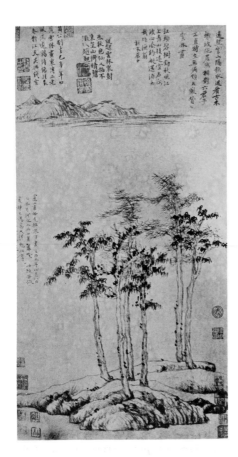

201. Ni Tsan (1301-74): The Six Worthies.
Ink on paper. 1345.
China, Private Collection

expression in understatement. The unadorned and chaste paintings of Ni Tsan are fully expressive of his personality, but it is 'personality in solitude as distinct from personality in association'. Technically the superb quality of Ni Tsan's pictures is derived from the very just spacing of the few, simple elements, and from the quality of his drawing. This latter is difficult to explain. It has the appearance of being loose, sketchy, and might seem almost thin. However, it is a kind that is admired by the Chinese almost above all others. It is strong without the appearance of strength, forceful without a display of force, seemingly off-hand and careless when it is the final result of long and arduous practice, free when it is the product of iron self-discipline. This brush-manner became the ideal of a number of the Ming and Ch'ing Dynasty painters, and some achieved it, as Shên Chou on occasion and Wên Chêng-ming in his later years. But the real greatness of Ni Tsan's art stemmed from the greatness of the man, and for this reason Chinese writers on art have declared Ni Tsan cannot be copied.

PAINTERS OF BAMBOO AND PLUM FLOWERS

The fourteenth century witnessed the culmination of the special branch of painting that depicted bamboo in ink alone. The graceful, elegant plant came, in China, to symbolize the perfect gentleman, the superior man *(chün tzu)*, the man who, like the pliant, but resilient trunk of the bamboo, bends to the times, adapts himself to society, but retains unaffected within himself his moral character. The slim, pointed leaves as they hang motionless on a still day or bend and twist with every breeze, or stream out like banners in the wind, are a fascinating delight to watch and a challenge to any artist. The very problem of the transformation of the bamboo into terms of brush-strokes must have had enormous appeal to the Chinese with their innate passion for technical perfection. Not only is the bamboo by its nature a perfect medium for expressing in terms of nature a wide range of human emotions, but the mechanics of painting bamboo present the maximum opportunities for a display of brushwork. The pliant Chinese brush is ideally suited for the painting of bamboo leaves. The tip of the brush touches the paper, an increase of pressure as the stroke is drawn out widens the leaf, and as the pressure decreases the stroke draws out to the leaf's delicate point. Just the right amount of pressure, the right flick, the right degree of curvature are all matters of intense study and arduous practice. When we add to this the multiplicity of leaves and the compositional problems of the placing and spacing, the relationship of branch to trunk and the design possibilities of the intervals and empty spaces, it can be understood that bamboo painting is no subject for a novice.

The painting of bamboo has received so much attention in China, and so many artists of the highest competence have devoted their lives to the subject, that we can only touch on some of the main features and mention but two or three artists out of scores.[1] In the earliest paintings of bamboo the trunks and leaves were outlined and most often coloured. The painting attributed to Ts'ui Po illustrates this style [166]. Like all styles that have been evolved in China, outline bamboo was frequently done by later artists. Wang Yüan, of the fourteenth century, painted his bamboo in outline exclusively, and there is a very good painting in outline attributed to Li K'an, the greatest of the Yüan Dynasty painters of ink bamboo. The origin of painting bamboo in ink alone is obscure, but in all likelihood it was not practised to any extent before the tenth century. In any event, it had gained such a prominent place by the first quarter of the twelfth century that the catalogue of the Sung Imperial paintings, *Hsüan ho hua p'u*, allocated a special section to it among the ten categories. There are no T'ang painters listed; only one artist, Li P'o, represented by one painting, is from the Five Dynasties, while there are one hundred and forty-three paintings by eleven artists of the Sung Dynasty, from which it may be judged that ink paintings of bamboo had reached a flourishing state by the eleventh to early twelfth centuries.

The greatest Sung painter of bamboo in ink was Wên T'ung. His death in 1079 was much lamented by the poet Su Tung-p'o, himself noted as a painter of ink bamboo. The paintings of Wên T'ung were admired also by his younger contemporary, Mi Fei, and throughout the

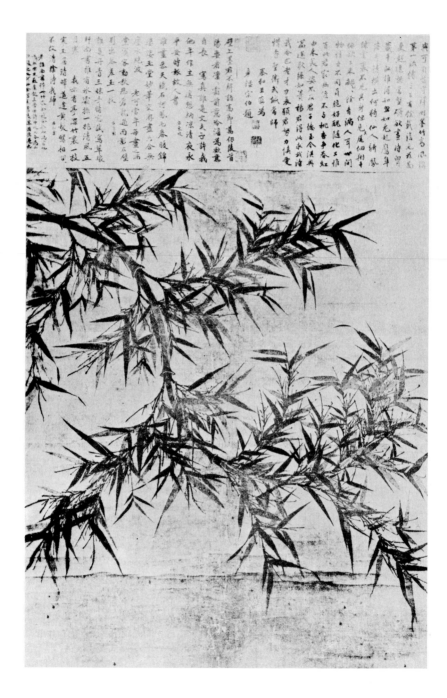

202. Wên T'ung: Bamboo. Ink on silk.
Eleventh century.
Taipei, Taiwan, National Palace Museum

centuries he has been looked upon as one of the first among the masters of the art. The best picture attributed to Wên T'ung is a large composition on silk in the National Palace Museum [202]. A single branch sweeps down in an 's' curve from the upper left to the lower right. The leaves spring from smaller branches that grow at the junctures of the segments. Several tones of ink have been used, of which the darkest tone is employed for those leaves nearest the observer. The painting is, as Wang Shih-hsiang has pointed out, a very close and detailed study of nature, displaying a profound knowledge of the laws of growth.[2] It is not, however, a botanical study. The arrangements of the leaves, the grouping, repetitions and contrast that make it such a live and rhythmic composition derive from the art of the painter. There is in the small branches or twigs a technical device very like that used by some of the early landscape painters in depicting trees – that is, there is a small blob or flick of ink at the end which suggests the bud, lends strength to the stroke and brilliance to the picture. In painting leaves of this kind, the brush is held at right angles to the silk, and the point of the brush follows down through the centre of the stroke from the base to the tip. This same kind of stroke is used in calligraphy, and bamboo painting in ink is closer in technique to Chinese writing than any other branch of painting.

The intense interest in ink qualities and brush-play as a means of personal expression that had developed in the fourteenth century, quite naturally turned the attention of painters to the possibilities inherent in paintings of bamboo. Of the leading artists we have already considered, Chao Mêng-fu was a masterful painter of ink bamboo, as may be judged from the excellent painting in the Abe Collection now in the Ōsaka Museum,[3] and several preserved in the Palace Museum.[4] His wife, known as Kuan Tao-shêng, was one of the best bamboo painters of the century and among the greatest lady painters of China. Wu Chên is perhaps more celebrated for his paintings of bamboo in ink than for his landscapes, while Ni Tsan translated the plant into his own aloof and elegant manner. There were yet other artists who devoted the greater part if not their entire artistic careers to painting bamboo, among whom were Li K'an, Ku An, K'o Chiu-ssu, and in the latter part of the fourteenth century, Sung K'o. The greatest of these was Li K'an, also known as Li Hsi-chai, who devoted his life to the study of bamboo from the points of view of both a botanist and a painter. His great hero was Wên T'ung, and he is supposed to have based his style on that master, when, after a search of many years, he finally came across an original work by him. Li K'an also composed an illustrated manual as a directive for the painting of bamboo.[5] Li K'an's paintings have become extremely rare through the centuries, but one of the best is that showing two clumps of bamboo and a single stalk, now preserved in the Nelson Gallery and of which we reproduce a detail [203].

The painting is of the same general style as that of Wên T'ung, based on the keenest

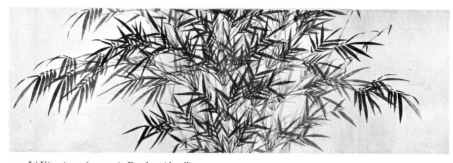

203. Li K'an (c. 1260-1310): Bamboo (detail).
Ink on paper.
Kansas City, Nelson Gallery of Art and Atkins Museum

observation and knowledge. There is a great density of leaves that hang motionless as on a hot summer day. The complex mass is held together and built upon the fan-like frame of the stalks painted in light tones. Within the intricate organization in mass, tonality, and spacing, nothing is by chance and all is perfectly controlled. There is an extraordinary sense of air and depth, of growing leaves and of their weight that gently bends the branches down. Wang Shih-hsiang, in describing the scroll, points out the apparent ease with which the artist accomplished his task: 'The stalks, stems, and leaves are brushed in with the utmost ease and spontaneity, almost carelessly – indeed the artist was a master of his craft. Few artists before or after Li K'an knew their subject so intimately, and few have possessed the technique that would permit such effortless and direct expression.... Li K'an, like Wên T'ung, had clarity of vision and so his bamboo is functional and free from empty brushwork. To the beauty of his brush-strokes Li K'an has been able to add the beauty of perfect lucidity.'6 This picture must have been painted early in the fourteenth century, because the first colophon was written by Chao Mêng-fu in 1308. Li K'an's influence on subsequent painters of

bamboo in ink has been very great, not only because his paintings set a high standard, but also because his book on bamboo painting held an important place, and both the text and illustrations were drawn upon heavily by subsequent writers.

There are two large paintings in the Palace Museum, both by Ku An, which are superb examples of bamboo in the wind.7 Ku An, whose literary name was Ting-chih, was active in the first half of the fourteenth century. Like the painting by Li K'an, the bamboo paintings of Ku An are perfectly lucid without any space-fillers or meaningless strokes, or needless multiplication of leaves.

Within the limited field of ink bamboo painting, the ordered, lucid style of Wên T'ung, Li K'an, and several other men, such as Ku An, might be called the classic manner. But there were other ways of treating the subject. Like the grand theme of landscape, bamboo could be done in a cursory, impressionistic, or almost abstract way. The important thing was to grasp the true, living spirit. Wu Chên, in his paintings of bamboo, as in his paintings of landscape, used both the realistic and impressionistic styles. Ni Tsan's bamboo was done in a very cursory fashion, but with understanding so that

it really expresses the character of the plant. He was himself little concerned with an outward likeness and once said that if someone thought his bamboo looked more like hemp or reeds he would not argue about it.

The same interest in brushwork and ink that was one of the chief contributing factors to the greatness of Chinese painting in the fourteenth century, found happy expression in representations of certain kinds of flowering plants and trees. Chief among these were the epidendrum and plum blossom and to a lesser extent the narcissus – flowers that were deeply admired by the Chinese for their natural beauty and, in the case of epidendrum and plum, had come to possess various philosophical and symbolic connotations, the one because of its great delicacy and fragrance, the other because of the twisted, knotty, and rugged old branches that yet, as the first harbinger of spring, displayed in the mass of sparkling flowers the freshness of youth and ever-returning life. The popularity of these special flowers with Yüan Dynasty painters was certainly enhanced by the fact that the long, pliant, and gracefully bending leaves of the epidendrum were ideally suited to long, flowing brush-strokes, while in the plum tree the gnarled parent trunk or branch and the gently curving or straight new shoots combined with the almost ethereal flowers offered an opportunity for virtuosity of brush drawing and ink texture. But with the best of these men, the flowers in which they specialized were no mere excuse for displays of brushwork. As Li K'an knew his bamboo, so the great Yüan flower painters understood their subjects with a botanical thoroughness and expressed the character of each with the penetration of skilled portrait painters.

We can only mention the names of a few. The late Sung artist, Chao Mêng-chien (1199-1295), painted narcissus in outline using the most delicate, hair-like line, and tones of silvery ink.[8] Among the best paintings of epidendrum that have survived from the Yüan Dynasty is a set of four done on silk, now in the National Museum, Tōkyō, by a fourteenth-century priest, P'u-ming, most commonly called by his *hao,* Hsüeh-ch'uang, who is now unknown in China. His epidendrums are combined with weathered rocks, thorns, and bamboo in compositions of great elegance and restraint, the long, twisting leaves painted with single strokes of incredible sureness and skill.[9]

The most famous artist to devote his talents to the plum flower was Wang Mien (1335-1414) who was no less eccentric than gifted. Sirén quotes, from a Chinese source, a vivid passage about Wang Mien's highly individual behaviour: 'He used to wear a high broad-brimmed hat, a green grass coat and high wooden clogs. One of his pastimes was to practise with a wooden sword; at other times he walked about singing loudly even in the market-place, or was seen riding on a yellow ox with the History of the Han Dynasty in his hands. Some people thought that he was quite crazy.'[10] In his paintings of plum trees, the new growth is represented with sweeping, vigorous strokes, the flowers are sketched in lightly, and the whole effect is one of freshness and spontaneity.[11]

One of the most impressive performances in this special field, however, is the great scroll in the Freer Gallery, by a somewhat lesser-known artist, Tsou Fu-lei [204]. The picture, painted in 1360, is done on paper with ink that has a soft, bluish cast. The view is typical of certain fourteenth-century compositions in that, like the Li K'an bamboo, it is very close to the observer so that he sees only a section of the tree, cut off at top and bottom, but greatly exaggerated in the horizontal. The different kinds of textures – the gnarled trunk and branches, the vigorous young shoots, and the soft blossoms – are all admirably translated into terms of ink. Tsou Fu-lei has made use of a brush-stroke called 'flying white', *fei po,* in

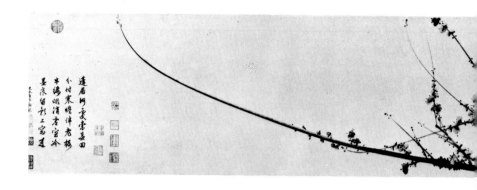

204. Tsou Fu-lei: A Breath of Spring.
Ink on paper. 1360.
Washington, Smithsonian Institution,
Freer Gallery of Art

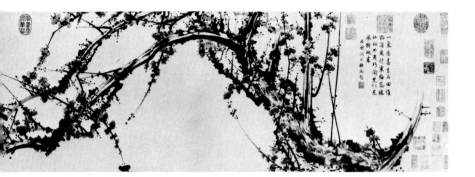

which the brush is pulled quickly across the paper allowing the hairs to part so that the ink is broken and uneven and the paper shows through. No outline is used on the blossoms, and such painting in ink-wash only lends an appropriate softness. The final stroke, over two feet long, is like the blade of a sword. It is saved from virtuosity by the excellent relation it bears to the design as a whole and particularly to the straight and curving branches which lead up to it. The equilibrium between personal expression, objective reality, and brilliant technique found in Tsou Fu-lei's scroll is a particular fourteenth-century contribution to painting in China. It is a distinct break from the detailed and accurate painting of the Northern Sung Academy; it is more descriptive and complete than the ecstatic visions of the Ch'an painters. The best of the Ming flower paintings, whether done by a specialist like Ch'ên Tao-fu or more catholic painters like Shên Chou and Wên Chêng-ming, follow, in general, this Yüan style.

Tsou Fu-lei was not, as we have mentioned, among the leading Yüan masters. He serves very well for that reason to illustrate the general high level of painting during the fourteenth century. There were many artists little known today, because their works survive in only two or three examples but who possessed exceptional talents.[12] Also, among other celebrated painters who exercised considerable influence on later artists, there was Fang Fang-hu, one of the most individual and forceful landscape painters; Ts'ao Chih-po who, in his best work, recaptured much of the antique spirit through a purely fourteenth-century manner; or Ch'ên Ju-yen who in his more extreme works seems to foreshadow some of the eccentricities of the seventeenth century.

Many of the concepts or ways of translating the world into terms of brush and ink originated by the Yüan artists were carried to fuller expression by the painters of the fifteenth, sixteenth, and seventeenth centuries, but there was little basically new to be added. The interest in technique, during the fourteenth century, brought monochrome ink painting to its final perfection – a perfection that made it one of the most direct and sensitive mediums of expression the world has known. The Yüan Dynasty, for all its social turmoil and foreign domination, was not a mere afterglow of the great Sung spirit, or a transition into the subsequent centuries, but one of the greatest creative periods of Far Eastern painting.

INTRODUCTION TO PAINTING OF THE MING DYNASTY

The two hundred and seventy-six years of the Ming Dynasty embraced the last Chinese empire under native rule. The subsequent Ch'ing Dynasty was established by the alien Manchus. Of numerous local revolts against the Mongols, the one that succeeded in founding a new Imperial line was led by a man of the people, Chu Yüan-chang, who had become a monk. The great Yangtze River city of Nanking fell to his band in 1356, the Mongols were driven from Peking in 1368 and later from their ancient seat of power at Karakorum. Chu Yüan-chang, the first emperor of the Ming Dynasty, ruled from 1369 to 1398 with the era title Hung-wu.[1] He established his capital at Nanking where it remained until the emperor Yung-lo (Ch'êng-tsu) boldly moved to Peking to be nearer his threatened northern borders. The palaces and city must have been in a damaged condition after the defeat of the Mongols, but Yung-lo was a great builder and he constructed the city, the most impressive in the Orient, on very much the scale and plan which we see today.

The reigns of Hung-wu and Yung-lo were given over to revitalizing the administration, improving the physical well-being of the empire and to the expansion of Chinese power and prestige. Classical scholarship was revived, and the interpretation of the Confucian canonical works by the Sung scholar Chu Hsi was recognized as the orthodox teaching. Civil-service examinations were based on the candidates' knowledge of the *Five Classics* and the *Four Books*. By the end of the fifteenth century the examinations had become stereotyped and conventional to a degree, originality of thought and style were discouraged – a state of affairs that

to some extent was reflected in the kind of painting favoured by the court circles.

Peace and economic security permitted a hedonistic life among the ruling and prosperous classes not unlike that enjoyed during the T'ang Dynasty. In this atmosphere the crafts flourished. In the brief reign of Hsüan-tê (Hsüan-tsung, r. 1426–35) bronze work in the form of incense burners, vases, and small utensils gained such fame by reason of their purity of shape and soft lustre, that his reign title is still used today on objects in bronze and brass that vaguely reflect the style of the great period. Also in this short, illustrious reign high-fired porcelain with underglaze blue decoration attained a particular kind of perfection.[2]

In many respects the cultural activities of the Ming period were directed towards reviving or revitalizing the native intellectual and artistic traditions. In 1403, early in his reign, Yung-lo assembled over two thousand scholars to compile a vast encyclopaedia containing the most pertinent of the past writings on history, philosophy, government, industry, the arts, and religion. The result was the *Yung-lo ta tien* in eleven thousand and ninety-five volumes. Government projects in learning did not continue throughout the dynasty on so vast a scale, but there was a continuous process of study, of writing on the literature of the past, on geography, philology, botany, and local histories.

The scholar class of the Ming Dynasty enjoyed an enviable amount of leisure. Some of them did not even seek to take office, while others would hold one post or another and, relatively early in life, retire to follow their own aesthetic or intellectual interests. Many of them,

no doubt, were disgusted at the corruption, inefficiency, and the power of the eunuchs in official circles, or found no outlet for their energies in the stereotyped and arid scholarship exemplified in the examination system. In an atmosphere of quiet and security these men, joined together in small groups of congenial spirit, could devote themselves to the pursuit of the humanities.

The beautiful cities of Hang-chou and Su-chou, with their ideal natural setting in a mild and friendly climate, became centres where such men gathered. Much serious thought and attention was devoted to the designing and construction of extensive or intimate gardens where strangely weathered rocks played a dominant role.[3] Some of the scholars at leisure were tempted into fields of literature more imaginative and less demanding than such time-honoured themes as commentaries on the *Classics,* and the novel enjoyed an unprecedented development.[4]

It was an age of great collections and development in the art of connoisseurship, of aesthetic speculations and art criticism, not unlike the eighteenth and nineteenth centuries in Europe. Many of the great book collectors turned to printing as a means of perpetuating rare books or correcting previous editions. Printed books of the Ming Dynasty, especially those of the Chia-ching period (1522-66), are technically among the best produced in China. Both Su-chou and Hang-chou were centres of this activity, where the owners of extensive private libraries spared no expense or effort in the production of beautiful books. An important development was the ever-increasing popularity of illustrated books. In the seventeenth century such well-known artists as Ting Yün-p'êng and Ch'ên Hung-shou made drawings for woodcut illustrations. The former is especially interesting because, so far as is known, his illustrations for a book on ink-cakes, the *Ch'êng shih mo yüan,* printed in 1606, are the earliest to have been printed in colour.[5] It was in the late Ming Dynasty, in 1633, that colour printing from wood-blocks reached a peak of perfection in the *Treatise on the Paintings and Writings of the Ten Bamboo Studio.*

We are probably indebted to the Ming collectors of painting for the preservation of many, if not the majority, of the old scrolls that have survived into our times. Old pictures, as well as those by the leading masters of the preceding Yüan Dynasty, were sought out, carefully repaired, remounted, and annotated. A surprisingly large number of the best paintings in the former Imperial Manchu Collection, now the property of the National Palace Museum, and those in Western collections, have passed through the hands of the great Ming connoisseurs. One of the largest private collections was that formed by Hsiang Yüan-pien, also known as Hsiang Mo-lin (1525-90). He is a good example of the Ming scholar-collector. He was a native of Chia-hsing, south of Su-chou, a city famous for its gardens. Hsiang was so overcome by the death of his father that he refused to hold public office, but he inherited a large fortune and devoted his life to collecting and painting. He was a good friend of such painters as Wên Chia and his cousin Wên Po-jên and the famous flower painter, Ch'ên Tao-fu. The collection of Hsiang Mo-lin was not, however, of uniformly high quality, and it remained for a collector born at the end of the Ming Dynasty, Liang Ch'ing-piao (1620-91), to establish a standard of excellence unsurpassed by emperors and commoners alike.

The different trends and cross-currents of Ming painting can best be appreciated in the light of the aims and ideals of the groups for whom and by whom the paintings were produced. Much has been written about the professional and the amateur artist in China, and both terms are apt to be misleading when taken in the generally accepted Western sense.

Broadly speaking, there were two kinds of professional painters. The men who devoted their lives to painting and held official positions in an academy of painting, or who held other government titles conferred on them because of their abilities as artists, all might be considered professional painters. There was also a large class of painters, called in China *chiang-jên*, of a kind we would call skilled craftsmen. They operated regular shops or studios, where pictures in almost any style were supplied to those who could not afford the products of more gifted artists; these men also painted screens and pictures to be used in a decorative way. The countless paintings of horses often attributed to Chao Mêng-fu, the white eagles attributed to Sung Hui-tsung, and highly coloured scrolls of palaces and gardens inhabited by beautiful ladies frequently attributed to Ch'iu Ying, are often the work of such craftsmen who were not infrequently extremely skilful and able. These craftsmen should not, as professionals, in any way be confused with official and academy painters.

All artists not included in these two classes might be called amateurs. The amateur, also, may be considered of two kinds. There were men like Shên Chou and Wên Chêng-ming who cultivated great natural talents by devoting most of their energies to painting. Such artists were amateurs in the same sense that Cézanne or Manet might be considered amateurs. At the other extreme were the countless officials from cabinet rank down to local magistrates who dabbled in painting because it was considered one of the proper pursuits of a cultivated man. This class was especially large in the seventeenth century and later. The manuals on painting and much of the writings on how to paint must have been in large part directed to this class. It came about in the Ming Dynasty that most of the good artists, and certainly those whose contributions were the most significant, were not associated with the court and painted because of their deep interest and natural talents. These men seldom sold their pictures but gave them to congenial friends or exchanged them with other artist-scholars of their own class. In this sense alone they were amateurs.

The Ming painters of the fifteenth century looked back on more than ten centuries of tradition in their art, and it would be indeed strange had any one of them been able to cut himself off from so impressive an accumulation. It must be remembered that on a technical level the materials of Chinese painting had changed little since the days of Ku K'ai-chih. Certain kinds of brush-strokes and ways of using ink had been evolved by great artists of the Sung and Yüan Dynasties and, quite naturally, were perpetuated by subsequent generations. The Ming painters do, however, fall into certain groups or general categories, depending upon which traditions of the past they followed most closely. Thus there were bird and flower painters who drew upon the accomplishments of Huang Ch'üan, Hsü Hsi, and the Northern Sung Academy. There was another group, centred in the Chê School and the court circles, who followed the Southern Sung Academy, notably Li T'ang, Liu Sung-nien, Ma Yüan, and Hsia Kuei. Yet a third, and the most important group of painters, centred about the Wu School, followed the supposed style of Tung Yüan and Chü-jan and that of the Four Masters of Yüan – Wang Mêng, Huang Kung-wang, Ni Tsan, and Wu Chên. Of these celebrated Yüan painters, Wang Mêng and Ni Tsan lived on into the opening decades of the Ming Dynasty, and thus the traditions of the great fourteenth century were continuous into Ming times.

During the two and a half centuries of Ming rule, well over a thousand artists were of sufficient note to be recorded. The production of pictures was enormous and original works by the leading and minor painters have survived in quantity. It is impossible to consider even the most important painters in any detail, and it has

seemed best, within the scope of this work, to illustrate the painting of the greatest artists with several examples, and only a few of their followers, rather than include a confusing number. Also, at the risk of over-simplification, the main trends of painting are here considered within four broad classifications: the early painters who continued the Yüan tradition; the court artists; the Chê School; the Wu School and its later developments.

THE EARLY PAINTERS

Several good artists carried the dense, rich style of landscape painting evolved during the Yüan Dynasty on through the last years of the fourteenth century and into the fifteenth. This characteristic style was supposed, in the main, to have been derived from Tung Yüan and Chü-jan of the tenth century. Technically the style involved the use of a ts'un in relatively long, often wavy brush-strokes that were well adapted to a wide range of tonal values, as they were piled up or drawn out thinly. The dots originally used to represent low or obscure vegetation played the more and more important role of adding accent, softening the edges of rock formations, and aiding in the complex play of light and shade in the tonal pattern. The trunks and limbs of trees were done with double outline so that they appear white against the dark mass of the foliage. The foliage, also, was of varied kinds not only to represent multiple kinds of trees but also to introduce a variety of brush-strokes and avoid monotony.

The paintings of Hsü Pên, who was active around 1370 to 1380, in the time of Hung-wu, have all the characteristics of this style. A small painting in the National Palace Museum is done with the long brush-strokes, ts'un, complicated, broken forms contrasting with relatively plain areas and interplay between dark, dense areas and those of light, silvery tones, that the Yüan masters had evolved.[1]

In contrast to the rather standard and traditional Yüan style continued by Hsü Pên, another trend led in the direction of further exaggerations of some of the more personal and expressionistic features of Yüan painting, as they appear, for example, in the Freer scroll of fishermen by Wu Chên [198]. The free, direct, and at times almost loose kind of painting, in which distortions in drawing and strong emphasis on the character of the brush and ink were used to heighten the emotional quality, could not be better illustrated than by a landscape painting by Liu Chüeh (1410–72). This artist, like many of the Ming painters, served as a high official in the government and then, at the age of fifty, retired and devoted his remaining years to gardening, humanistic studies, and painting. He lived in Su-chou and was on the most friendly terms with the family of which Shên Chou was the most celebrated member.

In a tall, narrow picture in the Motoyama Collection, Tōkyō, the elements of the landscape are sketched with a maximum of expressive freedom [205]. The brushwork is decisive and the ink tones vary from a lustrous black to silvery grey. Areas of pure white, such as the cloud, the mountain stream, and the tree trunks produce a striking pattern. There is a decided vertical distortion in the mountain and the foreground trees. The dots of ink may at first appear rather haphazard, but actually play an important role in pulling the design together and establishing emphasis where needed. A pavilion built out over the stream has been drawn with distortions of angles and perspective that are curiously in harmony with the rest of the picture. There is throughout a quality which, for lack of a better expression, one might call area painting – a harmonious relationship of ink tones and brush-strokes that are of abstract pattern value in any area, large or small, which one may isolate from the composition as a whole. Such interest in the actual character of the

painted surface, over and above what was represented, is characteristic of the work of many of the best Ming painters. At the same time there is combined with this a new kind of realism, evident especially in the trees, that is not concerned with accurate, detailed drawing, but with the effect of light. There seems to be, in the works of some painters at least, an interest in the break-up of forms in sunlight not altogether different from nineteenth-century European impressionism.[2]

The most important painter to carry the Yüan style over into the Ming period was Wang Fu, also known as Wang Mêng-tuan. He was born in 1362 in Wu-hsi, in Kiangsu, the home of several famous painters including Ni Tsan. He was known for his poetry and calligraphy, served as a minor official in the Han-lin Academy and travelled extensively. He lived until 1416, but his ability as a painter received no official recognition. It is possible that Wang Fu was influenced by artists like Shêng Mou, Ni Tsan, Wu Chên, and Wang Mêng, but it is equally possible to speak of a certain character of brush and ink that was shared by a large number of fourteenth-century painters and which each employed in his particular way.

Many of the personal elements of Wang Fu's style are apparent in a bold and simple composition, 'The Lone Tree', painted in 1404 [206]. All background has been eliminated to emphasize the character of the tree and jagged rock; only a marshy shore, some tumbled stones, a thorny bush and a few low bamboo suggest a wild and lonely setting. Roots like dragon claws

205. Liu Chüeh (1410–72): Landscape.
Ink on paper.
Tōkyō, Japan, Motoyama Collection

and the downward-bending branches of the ancient tree hark back to the trees of Li Ch'êng and Kuo Hsi of the tenth and eleventh centuries, but the manner of painting is very different. Almost all the branches are silhouetted against the dark foliage in a way that is not consistent with natural laws of growth. The device does, however, emphasize the gnarled and twisted limbs, and is a calculated pattern used quite consciously in preference to naturalism. The short, thick, curving grasses that soften the outline of the main rock are characteristic of Wang Fu's personal style, and so too are the strongly painted, stubby leaves of bamboo.

The fame of Wang Fu as a painter of bamboo presents another facet of his genius that allies him to the great spirits of the fourteenth century. His paintings of bamboo in ink show him to be a follower of the grand tradition handed down from Wên T'ung through Li K'an, Wu Chên, and K'o Chiu-ssu, a tradition of lucid, organized, and elegant ink paintings of bamboo.[3]

Chinese critics agree that Wang Fu's most gifted pupil, Hsia Ch'ang, was the last of the painters of ink bamboo to stand in the first rank. He was born in 1388 and so was twenty-eight when Wang Fu died in 1416. His best work is probably to be seen in the long hand-scrolls in which bamboo is combined with the rocks, water, and cascades of a stream bank. In some of these Hsia Ch'ang is so close to Wang Fu that the work of the one artist could easily be mistaken for that of the other. These scrolls are long views of river banks with all the elements

206. Wang Fu (1362–1416): The Lone Tree. Ink on paper. 1404. *Taipei, Taiwan, National Palace Museum*

207 (*left half above, right half below*).
Hsia Ch'ang (1388–1470):
Bamboo Bordered Stream in the Spring Rain.
Ink on paper. 1441.
Chicago, Art Institute

brought very close to the observer, so close, in fact, that they are cut off at both the top and bottom. The artist takes his audience down into the grasses, bamboo, and among the rocks to show at close range the luxurious, marshy growth. The two details from a scroll in the Art Institute, Chicago, illustrate this point of view that lends so much individual character to certain Ming Dynasty compositions [207].[4] Throughout the scroll the bamboo stalks are cut off at both top and bottom of the picture, so that they are brought strongly into the foreground. Angular rocks jut up like an obstructing wall in other sections, but through openings one glimpses a turbulent stream or a quiet pool where the bamboo dips down and some of the leaves are visible through the clear water. It is altogether an ingenious device, allowing bold

effects, such as long stretches of waving lines of water like fish nets, trailing vines, massive boulders, and churning cascades. In a scroll in the Shanghai Museum, of which there is another version in the Nelson Gallery, a large, flat rock extends back and out over the stream – it is as though the observer were lying flat on the ground.

The dependence of Hsia Ch'ang on his master Wang Fu is not only evident in the painting of the bamboos but also in the faceted rocks, and thick, bent grasses. No later painter, in this writer's knowledge, ever surpassed the variety and ingenuity, the breadth and boldness of Hsia Ch'ang's compositions. His very great genius as a painter of bamboo in ink transmitted the high standards of the Yüan Dynasty and codified a style.

THE ACADEMY AND THE CHÊ SCHOOL

Although many of the institutions of the Ming rulers aimed at recapturing the spirit and organization of native, pre-Mongol, traditions, there was no Academy of Painting established along the same lines as that of the Southern Sung Dynasty. The Dynasty followed, rather, the pre-Sung system of according special honours or official titles to painters favoured by the emperor. Painters were rewarded with such positions as officer in the imperial guard, or were assigned the title of *tai chao* to one or another of the halls at the palace set aside for scholarly work and studies. A majority of the artists who served at the court are but little known today, and it is significant of Imperial taste that, with but one or two exceptions, none of the greatest of the painters of the dynasty were awarded official recognition. For the most part the courtly taste was conservative, and favoured styles harking back to the masters of

208. Hsüan-tê (r. 1426–35): Two Hounds.
Ink and colour on paper. Dated A.D. 1427.
Cambridge, Mass., Fogg Art Museum

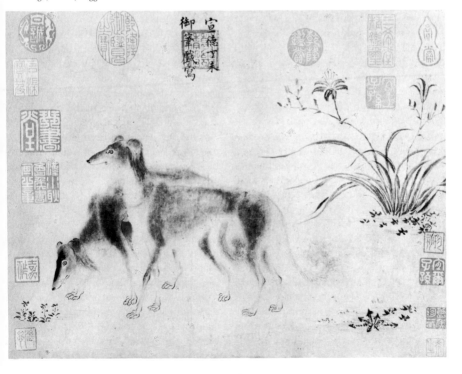

the Southern Sung Academy, or Northern Sung in birds and flowers. It is not possible here to consider the court artists under the various reigns. We can only single out two or three of the best known whose work will serve to show the general trend.

In the early part of the fifteenth century a number of competent artists were active at the court during the reign of Hsüan-tê (Hsüan-tsung) from 1426 to 1435. The emperor himself was a painter of marked ability. Indeed, of all the emperors after Sung Hui-tsung who painted or pretended to paint, it seems probable that Hsüan-tê alone possessed any real talent. He specialized in animals, dogs, cats, monkeys, goats, frequently in combination with bamboo or the flowers and rocks of a garden, following in his compositions the traditions of Northern and Southern Sung academies. He was, if one may judge from his surviving pictures, a keen observer, a painter with a light and easy touch, and a certain rather dry, Imperial humour. He frequently signed his pictures with 'playfully painted by the Imperial brush', and in one instance condescended to a rebus and a pun. A good picture by Hsüan-tê is a small one – almost album-leaf size – in the Fogg Museum [208]. The two Afghan hounds are painted with the greatest accuracy as to the slightly humped nose, lean bodies and tails with a loop at the end characteristic of the breed. A sense of the silky hair is obtained by painting the bodies without outline, and only a few strokes of black ink to point up the paws, joints, and heads. The delicacy of the drawing is matched by the colour – a soft, golden tan for the hounds and a single spot of bright colour in the turquoise blue tassel on the neck of one hound. Hsüan-tê's animal paintings have none of the hard brilliance of the Northern Sung Academy, being more realistic, in a visual sense; as knowledgeable, sensitive studies the best of them will bear comparison with the work of earlier and more famous masters.

It was during the Ming Dynasty that bird and flower paintings based ultimately on the styles of the Five Dynasties and Northern Sung developed the superb decorative qualities so familiar to Europe, through their Ch'ing Dynasty descendants, since the eighteenth century. The most famous bird and flower painter of the Ming Dynasty to work in an academic style was Lü Chi, whose name has been rather freely inscribed on a wide variety of pictures. He was active at the court of Hung-chih (Hsiao-tsung, 1488-1505). Few Chinese artists have painted the superficial appearances with so much skill and decorative beauty. Most of Lü Chi's paintings are on a relatively large scale, averaging about five to six feet high by three to four feet wide. They were not intended as objects of quiet contemplation in the scholar's study, but as sumptuous decorations in a princely hall. In the best of them, the artist combines rather bold ink painting, derived from the Ma Yüan-Hsia Kuei School, with carefully applied and often brilliant colour. He also favoured the strongly asymmetrical, or 'one corner' kind of composition that had been perfected by the Southern Sung Academy. These features, united to a fine realism in the painting of his birds, could not fail to appeal to the tastes of a conservative and luxurious court. The painting of two geese in a snowy landscape from the National Palace Collection is a composition certainly based on the academy style of the twelfth to thirteenth century but very much enlarged and emboldened [209]. The design is faultless, and if it is not truly great painting, it is certainly handsome and impressive. It can readily be seen that a style such as that of Lü Chi would have many followers. Paintings with so immediate an appeal and so easily understandable must have been in high demand, and the general appearance, without the subtlety of design and skilful brushwork of Lü Chi, could be captured by a less gifted hand. He did not originate the style or found a school; Lü Chi

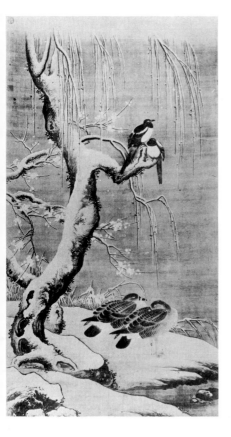

209. Lü Chi (active 1488–1505):
Geese beside a Snowy Bank. Ink and colour on silk.
Taipei, Taiwan, National Palace Museum

was, rather, the most accomplished painter to work in an academic manner that had in all probability been continued by many painters since the twelfth century.[1]

The conservative nature of the Imperial court, already mentioned, strongly favoured landscape paintings that reflected the accomplishments of the great masters of the Southern Sung Academy – Li T'ang, Liu Sung-nien, Ma Yüan, and Hsia Kuei. Of the painters who followed these traditions and were classified by later Ming critics as belonging to a Northern School, the best were active in the fifteenth century. In the Hsüan-tê era (1426–35) a number of able painters were summoned to the court at Peking. The best known among these men were Li Tsai, Ni Tuan, Chou Wên-ch'ing, and Tai Chin. Of the first three Chou Wên-ch'ing seems to have been the most gifted in translating the symmetrical compositions of the Ma Yüan–Hsia Kuei School, their angular pines, shattered cliffs, and moist ink washes, into an idiom appropriate to official taste of the fifteenth century. Judging from a large landscape composition in the Inouye Collection, Tōkyō, he was a masterful draughtsman and most skilful in handling carefully graded ink washes to produce effects of mist-drenched hills and trees half concealed in the moist air.[2] There is little of the mystery, the understatement, and genius for suggesting much by little that is found in the best works of Ma Yüan and Hsia Kuei. But there is a grandeur of mountain solitudes, and a lush quality in the play of ink tones, and above all a realism in atmospheric effects and logical relationships that makes it unnecessary to apply the imagination. Chou Wên-ch'ing must serve here to represent a number of Ming artists who continued the Southern Sung style, generally with a looser handling in the brushwork and with a more explicit realism than their great predecessors.

Far and away the most gifted of the men who answered the summons to court was, as might

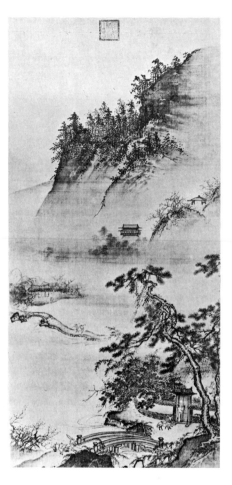

210. Tai Chin: Returning Home at Evening in
Spring. Ink and colour on silk.
Mid fifteenth century.
Taipei, Taiwan, National Palace Museum

be expected, the least successful in winning
Imperial favour, which was as contingent upon
tact as upon artistic genius. Tai Chin, frequently
referred to by his courtesy name, Tai Wên-
chin, very soon found himself out of step with
officialdom, probably because he refused to
expend his energies in petty contentions. He
soon retired to his native province of Chekiang,
where, from around 1430 until his death about
the middle of the century, he continued to paint
with whole-hearted devotion to his art. During
his lifetime, Tai Chin was neither financially
successful – he died in complete poverty – nor
was he generally recognized as a great painter
by his contemporaries. After his death, how-
ever, he gained in reputation and, because of the
numerous painters who followed his lead, Tai
Chin is historically considered the founder of
the Chê School, the name deriving from the first
character in the name of his native province.

The style in which Tai Chin became the
leading master was basically the same as that
followed by the artists who were more success-
ful at court, that is, one based on the Academy
painters of Southern Sung. Tai Chin is reputed
to have been highly skilful in copying the old
masters with exactness, and he may have made
many such copies, but in his personal style he
seems to have used the old Academy style as a
point of departure, the springboard from which
he launched into a very individual kind of paint-
ing. A painting in the National Palace Museum
attributed to Tai Chin, but unsigned, shows the
close adherence to the Ma Yüan-Hsia Kuei
tradition found in many of the works of the Chê
School [210]. The painting in ink and colour on
silk is entitled 'Returning Home at Evening in
Spring'. A man who has just dismounted from
his horse is knocking at a garden gate. The late
hour is suggested by a lantern in the hand of the
servant who hurries to unbar the door. The
composition and the twisted pines, distant
temple, and tree-clad hills are all part of an
established tradition. There is, however, a

looseness in the organization, a scattering of elements through the picture together with a completeness of description that is very different from the carefully constructed, evocative pictures of the thirteenth century. The narrative details have become multiplied – the wanderer returns home, the peasants return to their huts, a temple appears above the evening mists and there is a kiosk for enjoying the view: any one of these elements, all rather explicitly presented in the Ming painting, would have sufficed the Sung artist.

The paintings most characteristic of Tai Chin's individuality are done in a far bolder and more impressionistic style. The actual brush-manner is still derived from the 'axe-stroke' ts'un and the broad ink washes of the Ma-Hsia style, but rather loosely handled with a great deal of dash. In his painting of a Lohan stroking a tiger, the concept is as original as the manner of presentation is spontaneous [211]. The old saint is so lost in thought that he scarcely seems conscious of the real nature of the feline he pets. Behind him and between the rocks, the Lohan's rough and sullen familiar peers through a half-opened gate. There is an excellent consistency of brushwork throughout, in the rocks, trees, and rapid, calligraphic drawing of the robes.

211. Tai Chin: Lohan. Ink and colour on paper. Mid fifteenth century.
Taipei, Taiwan, National Palace Museum

Tai Chin has used an even more free and spontaneous brush manner in a long scroll of fishermen, painted in pale colour and ink on paper, now in the Freer Gallery [212]. This is one of his best works in a Western collection and one in which he is farthest from his Southern Sung models. The busy life along the river – women gossiping in a boat, fishermen with their basket-nets and rods, a picnic on the bank – is sketched in with a fine narrative sense and

to his subject – he understood the real nature of a great river and the bond between it and the people who live upon its waters and its shore.

The best painters of the Chê School maintained a relatively high level of performance. One of the most successful was Wu Wei (1459-1508) who is classed as a follower of Tai Chin. He was active as a court painter in the latter part of the fifteenth century, during the Ch'eng-hua and Hung-chih eras. His personal life and his

212. Tai Chin: Life on the River (detail).
Ink and colour on paper. Mid fifteenth century.
Washington, Smithsonian Institution,
Freer Gallery of Art

observation at first-hand of action and gesture. For all the easy freedom of brushwork, there is a strong element of visual realism in the tangled reeds and mudflats, and in the graded washes that create the proper atmosphere of the warm, moist Yangtze valley. It is a large scroll, eighteen and a half inches high and over twenty-four feet long, and is painted with the skill of a great artist whose powers of composition never fail him and who thoroughly understands the potentialities of his technique. Moreover, it is perfectly clear that Tai Chin as a man was close

character were far from the ideal of the scholar-gentleman, but he was much admired for his great facility as a painter and for the vigour of his brushwork. A painting in the Boston Museum of a scholar seated under a tree and gazing across a stream into space has all the stock elements of the Southern Sung Academy, but with a different balance in relationship between man and nature [213]. The figure of the sage is large and dominates the scene, while the very strong and almost rough painting of the trees and rock in the foreground is so assertive

One of the better painters who followed rather closely the Wu Wei tradition was Chang Lu (*c.* 1464-1538). His picture of Lao-tzu riding on a water-buffalo, now in the National Palace Museum, shows an excellent sense of design, and, although the folds of Lao-tzu's robes are done in a boldly calligraphic and somewhat mannered style, they are still descriptive. There seems to be a curious, psychological *rapport* between the old sage and his shambling, shaggy

213. Wu Wei (1459-1508):
Scholar seated under a Tree.
Ink and light colour on silk.
Boston, Museum of Fine Arts

that vision and imagination are both stopped before they reach the misty vastness of space beyond. The careful balance between the seen and the unseen, between what is shown and what unrevealed, the delicate adjustment that made the works of the great Southern Sung masters so valid and saved them from sentiment or romanticism, has been disturbed, and the content is weakened. One cannot but admire, however, the dash and brilliance of the brushwork in the trees and the nervous, calligraphic lines of the sage's robe.

214. Chang Lu (*c.* 1464-1538):
Lao-tzu riding on a Water-buffalo.
Ink and colour on paper.
Taipei, Taiwan, National Palace Museum

mount. The drawing is good in depicting the bulk of the animal and the way Lao-tzu sits firmly astride him [214].

A number of able artists working in the late fifteenth and early sixteenth centuries are

215. Chu Tuan: Landscape.
Ink and light colour on paper. 1518.
Boston, Museum of Fine Arts

classed in a rather loose way under the Chê School, though their connexions with such men as Tai Chin and Wu Wei are tenuous. Such a man was Chu Tuan, an artist of considerable

stature in the history of Ming painting. He was connected with the court in the time of Hung-chih (1488-1505) and was active, apparently, well into the second decade of the sixteenth century. His paintings are more elegant and restrained than those of most of the later Chê School artists, and, while he is traditionally supposed to have followed in general the style of Ma Yüan and such Northern Sung painters as Kuo Hsi, some of his most successful pictures are closer to Yüan artists, especially Shêng Mou. In his view of a lake, painted in 1518, now in the Boston Museum [215], the effortless, simple drawing is effective in creating a mood of the still lake and boundless solitude. The tones of ink and slight colour have been kept to a minimum, and there is no flashy display of brushwork. The broken ink of the foreground rocks, the dabs and dots on the lake shore and the distant hills are all calculated to suggest just enough, and by these simple means Chu Tuan's picture has a real character and mood that escaped Wu Wei with all his splash and dash of ink.

The Chê School reached its peak in the fifteenth century. It enjoyed a kind of revival or Indian summer with the painter Lan Ying (1578-1660), but in general, by the sixteenth century the leading artists were concerned about a different kind of painting that drew upon the great landscape masters of the Five Dynasties and Northern Sung, and the Four Masters of the Yüan Dynasty. In the main, the Chê School, with its dependence on the Southern Sung Academy, was drawing upon a special phase of Chinese painting that had been ideally suited to its own age, but which had not evolved any important, basic principles, any fundamental points of view towards painting that could be transferred with profit to another age or modified into a new idiom. Nevertheless, Tai Chin, above all, and the best of his followers made a brilliant and important contribution to painting of the Ming Dynasty.

THE WU SCHOOL

A group of leading painters who were active in the latter part of the fifteenth century and the first half of the sixteenth came to be known as the Wu School, from the first character of the place-name Wu-hsien in the region of modern Su-chou (or Soochow) in the Yangtze River delta, where many of them lived. Although the classification of painters into such schools and groups frequently becomes rather arbitrary, none the less the method has become well established in Chinese works on the history of painting and lends a kind of order that undoubtedly has a basis in fact.

The early Ming painters who were looked upon as the fountain-head of the Wu School were for the most part scholar-amateurs in the sense we have described before. They held painting to be a form of intimate, personal expression and, theoretically, at least, were opposed to the romantic realism which they considered to be centred in paintings like those of the Chê School. These men were accomplished humanists, thoroughly educated in the literature and cultural traditions of their ancient civilization. Poetry, calligraphy, painting, or the construction of a garden were all arts through which the cultivated gentleman expressed himself. Most were from well-to-do families which had followed official careers and studious lives for several generations. They were free from the necessity of working for a livelihood, and those who preferred retirement to public office lived quiet, unpretentious lives. Their paintings fulfilled no need, no demand except their own urge to create. It must not be thought that they painted only for amusement, as a pleasant dalliance. To them painting was a serious business worthy of their undivided attention and most conscientious efforts. There was nothing 'Bohemian' about the intellectual atmosphere of Su-chou.

The characteristic that dominated their painting was a kind of free expressionism, firmly anchored, none the less, in the traditions of the painter's art. There was a marked tendency for painters to work in a number of different styles – as a landscape after the manner of Wang Mêng, or after Ni Tsan, or Kao K'o-kung. Such a tendency toward eclecticism was a natural outcome of an intense interest in technique, which in China was essentially the brush-stroke. There are instances, indeed, when technical perfection of brush and ink seem to have become ends in themselves.

These Ming painters all shared a common literary tradition and, since many of them were as skilful in calligraphy as they were in painting, it became increasingly popular for the artist, and at times his friends, to add poems on the pictures – fortifying with poetry the mood or concept embodied in the picture and presenting it through the equally expressive medium of calligraphy.

Shên Chou, also known by his courtesy name of Shên Shih-t'ien, was the reputed founder of the Wu School. He came from a distinguished family of scholars and painters. Shên Chou is an example of a rich natural talent that was encouraged by every element of his environment. He did not seek an official career in government as it was customary for people of his class to do, but chose, rather, a quiet life devoted to his natural interest in literature and painting. He spent much of his time in a garden house which he built outside his native town of Chang-ch'ien (modern Su-chou). Shên Chou was born

in 1427 and lived until 1509 – a long life during which he produced an impressive number of hand-scrolls, hanging scrolls, and album leaves. His works have survived in considerable quantity – the Imperial Collection in the eighteenth century contained some one hundred and twenty-three examples. Since many of his pictures carry dated inscriptions, and there were certain seals that he used at different times of his life, it is possible to study the evolution of Shên Chou's paintings in some detail.[1] We must limit ourselves, however, to a few pictures typical of his most personal style.

Aside from his study with several teachers, Shên Chou learned the art of painting by a careful and analytical study of the old masters whose work, it is said, he could copy with great fidelity. There are several works that follow closely the

detailed style of Wang Mêng, so rich in brushwork and sombre in colouring.[2] There are others that follow the manner of Ni Tsan, but the personal style of Shên Chou seems to be one evolved from the Yüan painter Wu Chên as much as any one artist.

Even in the works done in Shên Chou's particular style there is a surprising variety and evidence of an inexhaustible imagination. In some there is a strong element of realism, especially in the atmospheric effects of distance. In the album leaf [216], rocks and trees are brought well into the foreground, and the flat field where gardeners are at work stretches off convincingly into the hazy distance. It is no easy task to paint a stone wall and a picket fence as varied and interesting as they are here. The colour, pale transparent washes of blue, greyed

216. Shên Chou (1427–1509): Gardening.
Album leaf, ink and colour on paper.
Kansas City, Nelson Gallery of Art and Atkins Museum

green, and a reddish tan, is characteristic of the colouring employed by the painters of the Wu School. Colour is decidedly secondary to the structural character of the brush-strokes and the tones of ink. In his most expressive work, Shên Chou uses a broad brush-stroke charged with ink in silvery tones or wet, lustrous black, the individual brush-strokes being pulled together by graded ink washes [217]. He makes use of a great many dots of various sizes carefully placed not only to represent vegetation but as important notes of accent. Some short, vertical strokes are used in the same way. The outline of forms is made with a rather wide, irregular stroke, frequently done with the side of the brush. The ts'un are a variety of the 'hemp-fibre' based on the style of Tung Yüan and Chü-jan, either long and wavy, or shorter

and more irregular. The flat washes in warm, grey tones used for distant peaks, or sometimes done in pale blue, are a favoured device that contrast with the areas of rather complex brush-work, giving a varied silhouette and a sense of distance. Shên Chou's drawing appears loose and easy but is strong and sure. This quality may be seen in his trees, especially in the branches and twigs, as in the group of three on the right [216]. In composition, there is a carefully organized play back and forth between relatively dense and perfectly plain areas. The water and clouds are frequently nothing but the white paper, and so the land forms, the clumps of trees, and such objects as boats and buildings become relatively isolated. This relationship of forms is especially apparent in the Freer Gallery scroll [218] where the emphasis is on inter-

217. Shên Chou (1427-1509): Poet on a Mountain.
Album leaf, ink on paper.
Kansas City, Nelson Gallery of Art and Atkins Museum

locking, horizontal shapes and the fishermen's boats are spaced with consummate skill. One device frequently used by Shên Chou is a flat tableland that also appears as a plain area in the compositions, employed either as a low bank beside a stream [218] or the flat top of a precipitous rock [217]. At times this flat top is curiously tilted up at the back so as to present a broader expanse of surface.

White clouds encircle the mountain waist like a sash,
Stone steps mount high into the void where the narrow path leads far.
Alone, leaning on my rustic staff I gaze idly into the distance.
My longing for the notes of a flute is answered in the murmurings of the gorge.

218. Shên Chou (1427-1509):
Happy Fishermen of the River Village (detail).
Ink and colour on paper.
*Washington, Smithsonian Institution,
Freer Gallery of Art*

The few illustrations presented cannot convey any just impression of the breadth of Shên Chou's genius, but they may give some indication of the variety to be found within his works. The quiet garden scene in the album leaf [216] is done with restraint – a certain delicacy in the painting of the willow tree and a realistic atmosphere all very suitable to the simplicity of the subject. In the other leaf, a much broader and more impressionistic brush-and-ink manner is used for a more sombre and more deeply emotional theme, a quality of solitude that is echoed in the short poem:

The scroll 'Happy Fishermen of the River Village' in the Freer Gallery, painted in colour and ink on paper, has the free, seemingly casual drawing so much admired by the scholar-painters. In the tradition of the 'literary man's' style, Shên Chou has added a poem to echo the mood he has sought to capture in his painting:

With sand and water boiling the waves beat on the shore,
In maple leaves and rushes, both road and court recede.
The fish-vendor beats his drum in the brisk evening breeze
Or dries his nets and moors his boat as the western sun declines.
In his raincoat made of rushes, a drunk old man reclines,
And sings a river ditty while his wife is cooking.

Among men such happiness is attained by the
 fisher folk,
While I am beset with hirelings ashamed to grasp
 the plough.[3]

Shên Chou emerges naturally out of the
individualist painters of the preceding Yüan
Dynasty, but it was his great natural genius
combined with his intellectual understanding
of the art of painting, his sincere devotion to
nature and his prolific output that established
him as the leading painter of the Ming Dynasty.
Personal preferences may lead one to admire
the works of other Ming painters, but the influ-
ence of Shên Chou was enormous, and he is
quite justly considered the founder of the Wu
School which dominated later Chinese painting.

Wên Pi, more frequently known by his
courtesy name of Wên Chêng-ming, was the
most distinguished and gifted associate of Shên
Chou. Also he embodied the ideal of the scholar-
painter. He came from a family of officials and
himself served for some time as a tai chao in the
Han-lin Academy. He retired, however, while
still in his full vigour and spent the remaining
thirty years of his long life among the intellec-
tual circles of his native town of Su-chou,
devoting himself to poetry, calligraphy, and
painting. Above all, Wên Chêng-ming appears
to have been respected for his high character
and moral integrity. He was born in 1470, so
that when, as a young man, he knew Shên Chou,
that master must have been in his sixties – a
period when some of his best painting was done.
There are some of Wên Chêng-ming's paint-
ings that show a marked influence from Shên
Chou, but he soon developed his own quite
distinct manner, and it is of interest that he was
able to maintain his independence under the
dominant position which Shên Chou must have
held in Su-chou.

A landscape in ink on paper in the Boston
Museum shows the strong, rather rough draw-
ing of the trees, the heavy outline of rock forms

and the graded ink washes derived from Shên
Chou [219]. But the dots are smaller and less
numerous than in a painting by Shên Chou, and
there is throughout a close relation of values –
which successfully represent the flat valley –
and a restraint that one comes to associate with

219. Wên Chêng-ming (1470–1559):
Mountain Landscape. Ink on paper.
Boston, Museum of Fine Arts

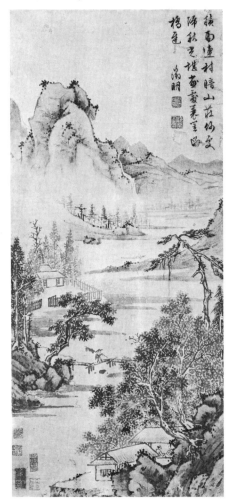

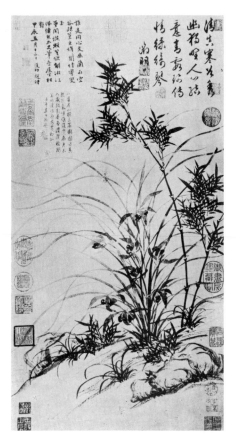

220 (*above*). Wên Chên-ming (1470–1559):
Epidendrum and Bamboo. Ink on paper.
Taipei, Taiwan, National Palace Museum

221 (*opposite, above*). Wên Chêng-ming (1470–1559):
Cypress and Rock. Ink on paper. 1550.
Kansas City, Nelson Gallery of Art and Atkins Museum

222 (*opposite, below*). Ch'ên Tao-fu (1482–1539
or 1483–1544): Lotus (detail). Colour on paper.
Kansas City, Nelson Gallery of Art and Atkins Museum

the work of Wên Chêng-ming, even when he is painting in a broad style. There are other pictures by Wên Chêng-ming that are done with the utmost delicacy and elegance. They are more like carefully constructed and lightly coloured drawings. A small picture in the Dubosc Collection has five different kinds of trees each with its particular kind of leaf minutely drawn.[4] The complicated design of foliage and branches is posed against a perfectly plain background. The colour is in a high key but very clear and vibrant. The style probably derived from a Yüan painter like Ch'ien Hsüan, and is one followed by the earlier Ming painter Yao Shou (1423–95).

Some of the paintings of bamboo and epidendrum by Wên Chêng-ming are so close to the spirit of Yüan Dynasty painting that any differences there may be are immaterial. The small picture, about one foot wide by two feet high, in the Palace Museum [220], is organized and painted according to the best tradition of the Yüan masters. The ink is rich and varied, the brush-strokes firm and structural or light and flowing. In the bending grasses and thick, short bamboo leaves, Wên Chêng-ming follows somewhat the manner of Wang Fu who transmitted the high standards of the Yüan Dynasty into Ming times. Here, as on the Boston painting, Wên Chêng-ming has added a poem in his beautiful running hand.

In his old age Wên Chêng-ming drew ever closer to the austere and sombre spirit of the Yüan masters. A number of paintings done by Wên Chêng-ming when in his late seventies and eighties are among the most noble and impressive pictures by any Ming artist. The recurrent theme, one that undoubtedly the artist associated with his own advanced years, is old trees, bent, twisted, and gnarled, sometimes singly, sometimes in tangled masses, that still put forth scattered clumps of leaves. These ancient shattered trunks and limbs cling to the soil with dragon-claw roots in bleak and stony landscapes

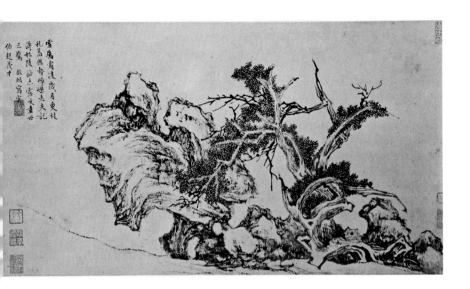

often indicated by little more than a few rocks or a cliff, a waterfall, and winding stream. In one such painting, done in 1550, when the artist was eighty, there is a single twisted cypress and a weather-sculptured rock [221]. The drawing is direct and the ink varied, not only in tone, but in quality from wet black and grey to very dry, dragged lightly over the paper. Such variations in the ink produce the surface texture and quality of 'area painting' that had concerned the Yüan artists.[5]

Many able painters followed Wên Chêng-ming, among them his son Wên Chia and his nephew Wên Po-jên. Perhaps the best, who seems related more to the restrained manner of Wên Chêng-ming than to the robust style of Shên Chou, was Lu Chih (1496-1576). Another, and more important man, who drew on both

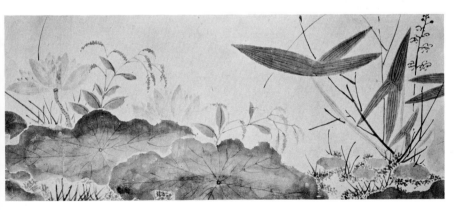

Shên Chou and Wên Chêng-ming, was Ch'ên Shun, better known as Ch'ên Tao-fu (1482–1539, or 1483–1544). He was one of the leading flower painters of the Ming Dynasty and specialized in what is called the 'boneless manner' in which the flowers are painted in ink or colour without bounding outlines, a manner which Ch'ên Tao-fu shared with Shên Chou. When well done, as in the long scroll of lotus flowers [222], the artist captures the texture of growing plants, a quality of luminosity and moisture. He takes the observer down among the blossoms and water grasses much as Hsia Ch'ang had led one along the verdant stream banks and through the bamboo thickets. Ch'ên Tao-fu's lotus scroll is entirely in colour, green and pink predominating, with no use of ink. He also painted landscapes in which he followed the free, wet style of Mi Fei as handed down by Kao K'o-kung and practised also by Wên Chêng-ming. His best paintings in this manner are in colour combined with ink.

Among the most prominent painters of the Ming Dynasty two especially, T'ang Yin and Ch'iu Ying, cannot readily be classified within either of the two main schools. They followed neither the free expressionism of the Wu School nor the decorative and bold ink style of the Chê School. Both painted in a variety of styles, but if any influence from artists of the past was more dominant than another, it was that of the Northern Sung landscape painters and Li T'ang of the twelfth century. Both were eclectic artists and no doubt drew freely upon the whole rich store of the past, and so the problem of influences and interpretations of styles becomes infinitely complex and is really only valid in relation to specific paintings or limited groups of each artist's works.

T'ang Yin (1470–1523) belonged to the same group of Su-chou artists as Shên Chou and Wên Chêng-ming. Nevertheless, his life was very different from that of his two famous contemporaries, and he did not in the strictest sense belong to the same scholar-painter class. He was neither like Wên Chêng-ming, a balanced, cultivated, retired official of high moral integrity, nor like Shên Chou, a gentleman living in quiet retirement on his estates. T'ang Yin at the beginning of his career became involved in a scandal concerning dishonesty in the examinations for official service and his degree was withdrawn – an event which terminated any plans he may have had for civil service. Although highly gifted as a painter, calligrapher and poet – all the accomplishments of the gentleman-painter – his life was a series of paradoxes. He would devote himself with intense zeal to the cultivation of his natural talents, then spend long periods in the wine-shops and pleasure places of Su-chou, and next retire for prolonged periods of seclusion in Buddhist temples. His paintings, which, for the most part, are carefully done, could never have been very numerous, and genuine examples are rare today.

T'ang Yin's landscapes are perhaps his greatest contribution, but he was also a good painter of figures, flowers, and ink bamboo. We can only illustrate the manner that has come to be closely associated with his name. His most imposing landscapes reflect something of the grand manner of the Northern Sung period, with tumbling waterfalls, piled-up peaks, deep gorges, and rich detail. There is much realism in his pictures, but not the broad atmospheric effects that the Chê School had inherited from the Southern Sung Academy. His realism, rather, takes the form of detailed description, careful, accurate drawing and well-adjusted transitions in depth. The trees in the foreground of the landscape from the National Palace Museum [223] are drawn with knowledge and loving care. The same meticulous painting runs consistently through the complex rock formations, the construction of the central peak and its supporting lesser hills. The ts'un is a combination of the short, pointed strokes used by

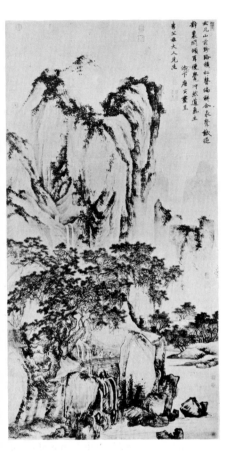

223. T'ang Yin (1470-1523): Landscape,
Early Spring. Ink and light colour on paper.
Taipei, Taiwan, National Palace Museum

Li T'ang, and in some paintings attributed to
Liu Sung-nien, and of small dabs like the 'rain-
drop' or 'split-bean' ts'un used by Fan K'uan
of Northern Sung. What is characteristic of
T'ang Yin, and in a wider sense of his time, is a
marked exaggeration in the tonal pattern.
Strong darks contrast sharply with areas that
are almost white in a restless but closely knit
scheme that plays throughout the picture. Even
in pictures done in light colours and ink on
paper and of which the theme is early spring,
the total effect is somewhat sombre and has a
spirit of antique elegance that was deeply
admired by his contemporaries.

In another landscape in ink alone on paper,
in the Freer Gallery Collection, T'ang Yin
is nearer to the ideals of the Wu School [224].
There is the same accurate and detailed drawing
in figures and trees, but in the quality of the ink,
that in places is dry and crisp and in others
flowing and wet, the effect is close to the Yüan
masters. The method of presenting a section of
landscape on a horizontal scroll in such a way
that the scene emerges from the bottom and
disappears beyond the edge at the top – filling

224. T'ang Yin (1470-1523): Voyage to the South.
Ink on paper. Dated 1505.
Washington, Smithsonian Institution,
Freer Gallery of Art

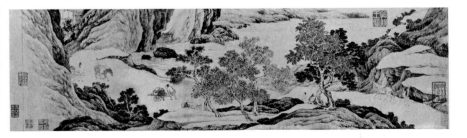

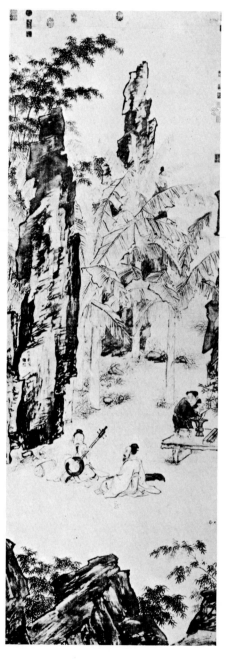

the whole space, as though it were cut horizontally from a larger composition – is a device frequently used by Ming painters. It may have begun in the Yüan Dynasty, but certainly was much more fully developed by painters of the fifteenth and sixteenth centuries. The areas of plain white paper that form a pattern of complex shapes flowing horizontally across the scroll give that kind of rhythm to the composition already remarked upon in some of the paintings of Shên Chou, and the strong contrast between concentrated dark tones and areas of relatively light tonality are especially marked. These contrast areas are very skilfully placed, though in quite an arbitrary manner. Another very handsome piece of design is the arrangement of the two trees on the right, the lacy leaves of the one in front contrasted against the deep black of the other. Such thoughtful attention to design seems to have gained in importance with the leading painters of the sixteenth and seventeenth centuries, when painting tended to become more intellectualized, expressionistic, or abstract. Whatever T'ang Yin's vagaries in life may have been, he was a sensitive, balanced painter holding to a mean, never losing his contact with reality, but presenting nature through his own particular sense of rhythmic design.

Probably the foremost artist of the Ming Dynasty who was neither a scholar nor a poet, nor famed for his calligraphy, in short, one who was exclusively a painter, was Ch'iu Ying, also known as Ch'iu Shih-chou. Because of his rather obscure social standing little is recorded about the details of his life. We do not know his exact dates, but only that he was active in the first half of the sixteenth century. Ch'iu Ying lived by his art and in this sense was a professional painter. None the less he was on friendly

225. Ch'iu Ying (fl. *c.* 1522–60):
In the Shade of the Banana Trees at Summer's End.
Ink and colour on paper.
Taipei, Taiwan, National Palace Museum

terms with the scholar-painters of Su-chou, and Wên Chêng-ming has shown his admiration for his genius by writing colophons on many of his pictures. It is recounted that Ch'iu Ying was discovered by Chou Ch'ên,[6] the teacher of T'ang Yin, who recognized his talents and took him as a pupil. In his career as a painter Ch'iu Ying had a patron who established him in his mountain house, and apparently he there had the time, free from immediate economic problems, to develop his natural talents to the utmost. He was fanatically devoted to his art and would work with the utmost concentration on his long and wonderfully detailed scrolls, finely drawn and with brilliant colour, that depicted such time-honoured themes as the palaces of Han, the escapades of Ming Huang, or the gathering of worthies in the Western Garden. Ch'iu Ying is conceded to be the last great painter who worked in the detailed and finely coloured style of 'blue and green', traditionally established by Li Ssu-hsün and Li Chao-tao of the T'ang Dynasty and handed down by Chao Po-chü of Sung.

Although Ch'iu Ying's popular reputation is associated with illustrative pictures in the 'meticulous manner', *kung-pi*, and highly coloured, perhaps his best works are his landscapes in ink and the pale colour washes favoured by the Wu School. Such a picture, over eight feet high, in the National Palace Museum, is a garden scene with fantastic towering rocks, bamboo, and banana trees, where two worthies are having a musical afternoon, one with a lute (the *ch'in*) and the other with a guitar (the *p'i-p'a*) [225]. Ch'iu Ying has used a strong, loose brush in the drawing of the rock and banana trees and very good calligraphic but defining strokes in the robes of the worthies. He has given us a convincing and delightful picture of the amenities of life in a Su-chou garden. This picture is in light colours and ink on paper.

Another manner of Ch'iu Ying is one that stands midway between such freely painted and rather bold pictures as the one just described and fine, detailed, and brilliantly coloured pictures that are at times highly mannered.

226. Ch'iu Ying (fl. *c.* 1522–60):
A Lady in a Pavilion overlooking a Lake.
Ink and colour on paper.
Boston, Museum of Fine Arts

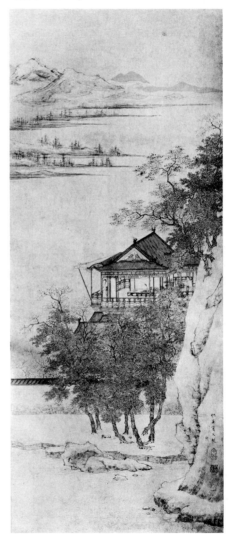

Some of the artist's best paintings are done in this balanced style, which links him to the more sensitive and refined aspects of the Wu School evolved from Yüan painting, such as that of Ni Tsan, and exemplified by other sixteenth-century artists, especially Wên Chêng-ming and Lu Chih. A beautiful painting of this kind in the Boston Museum is done in soft russet, brown, and pale green combined with delicate tones of ink [226]. An echo of Ni Tsan's unadorned and lucid style lingers in the flatlands and distant hills on the far side of the lake; although the trees are carefully and perfectly drawn with the variety of leaves rendered in fine detail, they function as a mass of foliage and in the composition as a foil to the extensive areas of bare paper. The pavilion, where one lady is seated and another gazes over the lake, is drawn with clarity and brilliance strongly reminiscent of the Southern Sung Academy painter, Liu Sung-nien [172]. There is in this, as in all Ch'iu Ying's best painting, a quality of luminosity produced by the light, clear colours, and an elegance that results from the faultless composition and sensitive, accurate drawing.

It has already been mentioned that Ch'iu Ying was especially celebrated for his pictures done in very fine detail and brightly coloured, with azurite and malachite predominating, from whence comes the name of the style, 'blue and green'. Judging from the titles preserved in old catalogues, most of these were illustrations to poems, events of history, or customs of the past. The name of Ch'iu Ying has become so intimately associated with this style that it has been freely appended to every Ming painting of the kind and the copies and conscious forgeries are legion. There are certainly a number of original works by Ch'iu Ying in the blue and green style, but the entire subject will have to be studied with great care, before the skilful imitations can be separated from the original works. For the present little more can be done than to look for the quality of drawing and composition that might conceivably be associated with the name of Ch'iu Ying. Since this style should be represented, we reproduce the first section of a long scroll done in full colour on paper. The picture, according to the title and colophons, is an illustration to a poem by Po Chü-i of the T'ang Dynasty, and the highly conventionalized and mannered style of the landscape is a Ming Dynasty interpretation of the coloured style from the time of the T'ang ruler Ming Huang [227].

This painting is an extreme example of the style. It is impossible to say at this distance in time what prototype the artist had in mind, but it seems to be a severe stylization of a landscape similar to the one we reproduce as illustration 127. It is also as though a complex landscape had been congealed or distilled by some process that straightened all the lines, exaggerated the irregularities of nature, and transformed the scene into a world of pure fantasy, where the peaks and rocks of malachite and azurite are faceted like crystals. All the elements have undergone the same process and the mountains, hills, streams, and buildings are drawn in a perfectly consistent manner. The complexities of mountain shapes are sorted out to a considerable extent by the different colours and so are more readable than in a monochrome reproduction. The mountains and rocks are in blue, green, and red-ochre, and the leaves of the trees are red, deep blue, pale and chrome yellow. All these colours, especially the blue, green, and red-ochre of the hills and peaks, are used in a wide range of tones and intensities so that what might easily be hard and enamel-like has actually a lively pattern of tonal values. Throughout the scroll there is the particular clarity, an almost luminous quality, that results from the purity of the colour tones. If Ch'iu Ying painted pictures of this kind, and it seems certain that he did, then he employed the

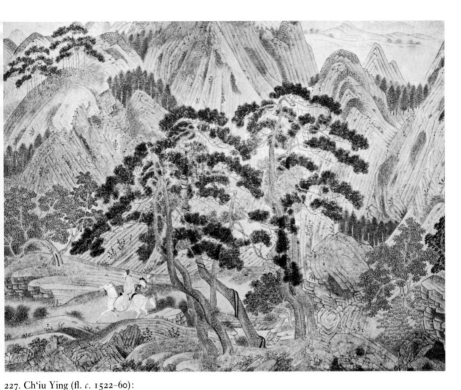

227. Ch'iu Ying (fl. c. 1522–60):
Saying Farewell at Hsün-yang (detail).
Colour on paper.
Kansas City, Nelson Gallery of Art and Atkins Museum

ancient, impersonal style with such perfection that it transcended the limits of decoration.

There are many important Ming painters of the fifteenth and early sixteenth centuries whom we have had to neglect altogether. Lu Chih, Chü Chieh, Ch'ien Ku, Hsü Wei, Hsieh Shih-ch'ên, Ting Yün-p'êng, and numerous other famous names have been passed over to concentrate on the men who were most influential in formulating the main trends of early Ming painting. The artists Shên Chou, Wên Chêng-ming, T'ang Yin, and Ch'iu Ying have been singled out by later critics – and in this there is general agreement – as the four great masters of the Dynasty. The name of Tai Chin could properly be added to the number. The paintings of these men alone can serve to illustrate well the creative vitality and also the variety of styles in the first two centuries of the Ming Dynasty.

TUNG CH'I-CH'ANG

By the latter part of the sixteenth century, the centre of activity in the traditions of the Wu School had shifted from Su-chou to Sung-chiang, also in Kiangsu province but to the south-east. The analytical studies of technical method and aesthetic aims of the old masters that had engaged the attention of the leading painters during the early Ming period were now carried farther than ever before by a group of men in Sung-chiang. The theories they evolved concerning the aim or final cause of painting and the historical styles in landscape became a manifesto for the so-called 'literary man's' school of painting and were a lasting influence in Chinese art.

The principal minds in this group were Ch'ên Chi-ju (1558-1639), Mo Shih-lung (active c. 1567-82), and Tung Ch'i-ch'ang 1555-1636). All three belonged to the scholar-official class and held the opinion that poetry, calligraphy, and painting were the highest forms of expression for the human spirit. Tung Ch'i-ch'ang was the most vocal of the three and has gained such a reputation as a calligrapher, painter, and connoisseur that, in a brief account, t is best to consider him alone. He held various high public offices, at one time rising to be President of the Board of Rites. He was considered the greatest art expert of his day, and, since he travelled extensively, he must have seen the majority of the old and important paintings that had been preserved into his generation. We cannot here go into his theories of art, an evaluation of his connoisseurship, or what is perhaps most interesting of all, his comments on technical matters. Much of this properly belongs to a history of Chinese aesthetics and of Chinese literature on art, but at the risk of over-simplification, the general trend of Tung Ch'i-ch'ang's ideas must be touched upon.

In the first place, painting, and primarily landscape, in his opinion, was a vehicle for the cultivated man to express his spiritual worth and his apperception of the operating principle of nature. Landscape painting cannot, and should not, compete with real landscape – to try to reproduce the outward appearance and labour over a physical likeness produces nothing but a weariness of the spirit. But painting possesses beauties peculiar to itself – the wonders of brush and ink. Through these means the gifted artist can express the inner realities, not the outward likeness. If painting is a means of expression, the artist must have something to express. For Tung Ch'i-ch'ang and his class, the men with something worthy of expression were the scholar-gentleman, the literati, who through education, formal or otherwise, cultivation of the humanities, and a sincere devotion to nature were attuned to the ineffable order and flow of things. Such men were at once free of low ambitions and sentimentality; their painting in consequence became also free on the one hand from vulgarity, the desire to startle or impress, and on the other from sweetness, the obvious appeal to sentiment.

How an effortless expression of the spirit could best be accomplished in painting naturally led these men to an intense study of techniques, and eventually, to evolve rather complex theories about brush and ink. They diligently studied the paintings of the old masters to discover how they had translated the natural world and their communion with it into terms of brush-strokes. They came to the conclusion

that the ts'un – that play of strokes over the surface to create form, structure, and tonal pattern – were of the greatest importance, as were also selection, spacing, and the relationships of shapes. All these technical questions had, of course, engaged Chinese artists for centuries, but they were re-examined and classified by Tung and his group from their own special point of view. Their conclusions were that proper results could only be obtained through a profound study of the old masters, and that by copying them the essence of their style or the principles underlying their success might be grasped. All former artists, however, were not equally worthy of emulation, but only those whose achievements corresponded to the ideals of the gentleman-painter.

From very early times the Chinese have had a deep respect for precedent and the authority of antiquity. To fortify their theories with this indispensable tradition, and to single out the best from the past, Mo Shih-lung and Tung Ch'i-ch'ang evolved their famous system of the Northern and Southern Schools of painting. These men were in varying degrees influenced by the ideas of Ch'an Buddhism which we have touched on briefly in its relation to the paintings of the Southern Sung Dynasty. Consequently, their division of all Chinese painters into two camps was linked to the schism that had occurred in the Ch'an Buddhist sect in the late seventh century. The painters who were considered to have painted only the outward appearance of things, the worldly and decorative, were linked to the courtly Northern Ch'an School, while the painters who were thought to have sought the inner realities and expressed their own lofty natures were called Southern School after the southern Ch'an division that followed the Sixth Patriarch, Hui-nêng. The classification of artists into these two schools appears in certain cases somewhat illogical, as it was bound to be, but there was general agreement among those

who formulated the idea that the real founder of the Southern School was Wang Wei, the great landscape painter of the eighth century who was thought to be the first to break away from the detailed, meticulous, and decorative style and use the ink ts'un to construct the form of his rocks and mountains. On the opposite side, Li Ssu-hsün and Li Chao-tao were considered the ancient exponents of the less profound Northern School.

In this classification all the great landscape painters of the Five Dynasties and Northern Sung were placed in the Southern School. The style of Wang Wei was said to have been carried on by Ching Hao, Kuan T'ung, Tung Yüan, Chü-jan, Li Ch'êng, Fan Chung-chêng (Fan K'uan), and the Mi, father and son. In the Yüan Dynasty the Four Great Masters, Huang Kung-wang, Wang Mêng, Wu Chên, and Ni Tsan, as well as Kao K'o-kung, were all placed in the Southern School. In the Ming Dynasty, the tradition was ably supported by Shên Chou and Wên Chêng-ming. Tung Ch'i-ch'ang and his colleagues relegated to the Northern School, as followers of Li Ssu-hsün and Li Chao-tao, the academy painters Li T'ang, Liu Sung-nien, Chao Po-chü, Ma Yüan and Hsia Kuei; and of course the Ming painters who followed the Chê School and Ch'iu Ying were considered in the same class.

The concepts of Tung Ch'i-ch'ang and his associates were not altogether revolutionary. To a large extent they simply codified ideas that were current towards the close of the sixteenth century. They established on a definite footing the concept of the 'literary man's' painting, the cultivated amateur who employed painting as a means of self-expression. Since also it had become increasingly fashionable for men with cultural pretensions to paint, there were large numbers of mediocre pictures, and worse, produced. The sound maxim of 'expressing much by little' frequently resulted in thin and

affected dabblings in ink. But on the other hand, there were very distinguished artists who worked within the broad concepts of Tung Ch'i-ch'ang and were much influenced by him. As always, the results did not depend upon what school or style a man followed, but upon his native genius, his application and integrity. However, there was a great deal of speculation and theorizing about the principles of painting, and a natural tendency was that the audience for whom the pictures were painted became more and more special and select. All those within such small groups understood the intellectual steps which had led to a given result. But the understanding and appreciation of painting that had become so intellectualized is most difficult for those unfamiliar with the processes which led to such particular modes of expression. In other words, there is a great deal of painting of the sixteenth and seventeenth centuries that offers rich rewards to those who have the interest and perseverance, the special knowledge and visual training to seek for it.

The intense interest in techniques led to minute classifications of the ways of painting rocks and hills, the various methods of ts'un, the way to represent the trunks, branches, and leaves of trees, the methods of painting birds and flowers. For example, Wang Lo-yü, a writer from the very end of the Ming period, lists twenty-six ways to paint rocks and twenty-seven different kinds of leaves on trees.[1] Among these technical works from the late Ming and Ch'ing Dynasties, the best known in the Occident and those which have had a wide influence in both China and Japan are the *Treatise on the Paintings and Writings of the Ten Bamboo Studio*, first published in 1633, and the *Mustard Seed Garden Painting Manual*, brought out in three parts, Part I in 1679, and Parts II and III in 1701. The importance of these works is due to their profuse wood-block illustrations, many of them in colour. In this respect they are the most important examples of early colour printing in the Far East.[2]

The theories concerning the Northern and Southern Schools of painting may now seem rather artificial, but if we consider the age and conditions which produced this kind of analytical evaluation, they take their place as part of the intellectual activity of the Ming period which was so much concerned with China's cultural past. The system moulded all subsequent Chinese writing on the history of painting and has been the guiding principle in books of reproductions published in China and Japan in modern times.

Tung Ch'i-ch'ang was not known for his theories on art and his connoisseurship alone, but was also among the best calligraphers of his time and one of the best of the late Ming painters. The group of painters around Tung Ch'i-ch'ang included, in addition to Mo Shih-lung and Ch'ên Chi-ju, the painters Shên Shih-ch'ing (fl. c. 1620–40) and Chao Tso (fl. c. 1610). Both these latter men made very good copies of Tung Ch'i-ch'ang, and the work of the three is frequently confused. Many of Tung's own paintings are inscribed by him stating that they are in the manner of one or another of the famous masters of the Southern School, in this way bearing out his pronouncements about following the antique as a model. However, in relatively few of these pictures, often in the form of albums, are the styles of his models immediately recognizable. In a word, he seems to have applied to the old masters the same principle that he advocated in regard to nature – it is the inner meaning, the essence that one seeks to capture, not the outward likeness.

Tung Ch'i-ch'ang's best pictures are very carefully organized [228, 229]. Certain forms are repeated or echo one another as major and minor themes, while the pattern of graded tones is arranged with an excellent sense of rhythmic design. The spacing is done with such skilful

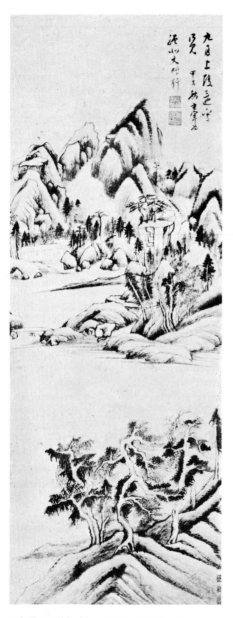

228. Tung Ch'i-ch'ang (1555–1636): Landscape.
Ink on paper. Dated 1624.
Zürich, Charles A. Drenowatz

precision that the areas of bare silk or paper play a basic and positive role in the composition – on a level with the best paintings of Shên Chou. In both our illustrations the direction and tones of the brush-strokes used for the ts'un are well calculated to bring out the form and structure. The landscape from the Drenowatz Collection is painted on paper and the ink is rather dry, dragged over the surface so that the paper shows through, or moister ink is piled up in rich, dense areas very much in the manner of some Yüan Dynasty painters [228]. The other landscape is in ink and colour on silk and the pigments are moist, giving a softer effect [229]. The silhouetting of the trunks and limbs of the trees against the foliage, a manner we have remarked before, is very pronounced, especially in the foreground trees of both pictures. This device allows a very clear effect of pattern and drawing. Curiously enough, when well done it is more convincing of the real structure of trees than if the trunks and limbs were concealed by foliage in a more natural way.

In the landscapes of Tung Ch'i-ch'ang there are relatively few elements, and the compositions are basically simple. There is a consistency in structure and tone relationships that gives them their own particular actuality. At the same time it is as though the landscape had been taken apart, the trivial and irrelevant elements eliminated, and the essential remainder reassembled to present us the world of nature not as the artist saw it but as he knew it to be. The same could be said, certainly, about the landscapes of many Chinese artists, but the character of organization and emphasis is peculiarly personal in the landscapes of Tung Ch'i-ch'ang, and of a kind not found in the work of earlier artists.

The paintings of Chao Tso (fl. *c.* 1610–20), who was an immediate follower or a colleague of Tung Ch'i-ch'ang, are less abstract and more fully descriptive [230]. They have, however, the same careful organization, attention to tonal

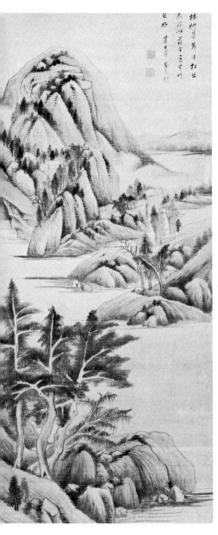

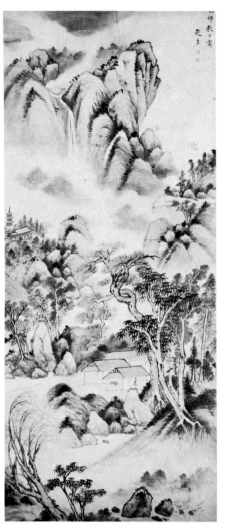

229. Tung Ch'i-ch'ang (1555–1636): Landscape.
Ink and colour on silk.
Nü Wa Chai Collection

230. Chao Tso (fl. *c.* 1610–20): Landscape.
Ink and colour on paper. Dated 1615.
Stockholm, National Museum

pattern, and repetition of forms. For example, in the landscape in the Stockholm collection there is a shape like a truncated pyramid repeated three times in the immediate middle distance and echoed again all through the picture up to the very top of the peak, but with such variations that its repetition is rhythmic and not obvious or monotonous.

It is not improbable that later Chinese painting would have developed along very much the same lines, had there been no Tung Ch'i-ch'ang and the other congenial spirits of Sung-chiang. But the prestige given Tung in his lifetime and the weight his pronouncements carried with later generations made his writings and his paintings a foundation stone on which the edifice of the 'literary-man's' school was erected in the later years of the Ming Dynasty and the subsequent Ch'ing. He codified a whole homogeneous group of tendencies in painting that had their beginnings with the noted individualists of the fourteenth century and which had, probably to a large extent unconsciously, formed the inner core of the Wu School, as its aims were represented by Shên Chou and Wên Chêng-ming. The connexion that had long existed between calligraphy and painting, at times very close, at times more tenuous, was now firmly knit for better or for worse. The impetus given to the concept of the 'literary-man's' painting by Tung Ch'i-ch'ang and his colleagues lasted with vigour for over a century.

LANDSCAPE PAINTERS OF THE CH'ING DYNASTY

The advent of the Manchus and the founding of the Ch'ing Dynasty in 1644 were less disrupting to the flow of Chinese political and cultural life than might be supposed. The Manchus had been a formidable power north of the Great Wall since the latter part of the sixteenth century, and under a very able leader, Nurhachi (1559–1626), had established their capital at Mukden in 1625, and in 1636 named their dynasty Ch'ing. In 1644, when Peking was held by a Chinese rebel, Li Tzu-ch'êng, and a Chinese general invited the Manchus in to help regain the city, the Manchu leaders gladly led their forces through the Great Wall, occupied Peking and stayed. All China was not subdued until the 1680s, when the last resistance of the supporters of the old regime was crushed in south China. In spite of the galling humiliation of foreign rule, the Chinese adapted themselves to the new conditions and numbers of the old bureaucracy took service under the alien rulers. There were no drastic changes in government administration; the Manchu rulers held Chinese civilization in the deepest respect and devoted themselves with real interest and zeal to understanding and absorbing the culture of their subjects. Manchu rule brought to the country a long era of peace and great material well-being.

During the three famous reigns of K'ang-hsi (Shêng-tsu, 1662–1722), Yung-chêng (Shih-tsung, 1723–35), and Ch'ien-lung (Kao-tsung, 1736–95) there was an unprecedented activity in official and private scholarly research, writing, and publication. The enormous work, the 'Complete Library in Four Branches of Literature', the *Ssu k'u ch'uan shu*, is the most impressive example. The work, inaugurated under Ch'ien-lung in 1773, embraced the critical review of thousands of books and the incorporation of the most important texts. 'The books they commented on and reviewed numbered approximately 10,230 titles, of which the texts of about 3450 were copied into the Library.' The completed work, which was first prepared in four identical sets, contained some 36,000 volumes in each set.[1] The Ch'ing scholars were interested in research methods and established new standards of accuracy and critical evaluation. It was an important period in lexicography and in detailed analysis and compilations in numerous other branches of study, of which painting and calligraphy were by no means the least. Some of the most important catalogues of painting collections and more general compilations of older writing on the arts were accomplishments of the late seventeenth and eighteenth centuries.

A lively interest in archaeology led to the formation of large collections of ancient bronzes and detailed studies of inscriptions. The great collections of painting formed during the Ch'ing Dynasty are of special interest to us, since so many of the important surviving pictures belonged to one or another of the leading collectors of the late seventeenth and eighteenth centuries, are identifiable by their seals, and are frequently described with care in their catalogues. Liang Ch'ing-piao (1620–91), the most discriminating, Kêng Chao-chung (1640–86), and the Korean An Ch'i (1683 to after 1742) were all collectors who owned many of the important pictures that passed into the Imperial Collection. This collection was increased considerably under K'ang-hsi, but Ch'ien-lung's acquisitiveness was on a scale approached by few emperors of China. Through the zeal of

Ch'ien-lung as a collector, many if not most of the important private collections of the seventeenth and eighteenth centuries found their way into the Palace. This great collection has survived, more or less intact, into modern times and now contains some eight thousand paintings[2] which are the property of the Chinese Government and are normally housed in the National Palace Museum. The Imperial Collection of paintings and writings was catalogued in a work, *Shih ch'ü pao chi*, of which the first part was prepared in 1745, the continuation in 1793, and the third part in 1817. Only the first part has been published. Buddhist and Taoist subjects were catalogued in a separate work, the *Pi tien chu lin*. Without any doubt the former Imperial Collection is the most important group of Chinese paintings in the world.

The personal taste of the Manchu rulers in painting does not seem to have matched their interest. Very few of the men who are now recognized as the leading artists of the Ch'ing Dynasty were popular in court circles, while the paintings of an artist like Chin Ting-piao, one of the favourites of Ch'ien-lung, are the work of an uninspired hack. The Manchu Imperial taste is also illustrated by the popularity of the Italian Jesuit, Father Castiglione (1698-1768) who, under the Chinese name of Lang Shih-ning, painted innumerable court pictures in a curious blending of occidental naturalism and a pseudo-Chinese technique. His paintings have little to do with the history of Chinese art, and his influence was ephemeral. Court painting under the Ch'ing Dynasty did not approach the level of competence it had enjoyed under the Ming. Some of the best Ch'ing painters who continued the traditions of the Wu School and 'literary-man's' style, for example Wang Chien and Wang Hui, were much admired by K'ang-hsi and Ch'ien-lung, but most of the important individualists, like Chu Ta, Kung Hsien, and Shih-t'ao, were not represented in the Imperial Collection, or only by one or two examples.

No break in the continuity of painting occurred at the fall of the Ming Dynasty. A number of painters who are classed as leading artists of Ch'ing were born and did a considerable amount of their work under the preceding dynasty, but it is customary to assign them to the dynasty in which they died. Chinese painting during the seventeenth and early eighteenth centuries is certainly one of the most stimulating studies in all Chinese art history. Its many facets, the co-existence of a variety of styles, and the very personal or individual character of some of the artists, make Ch'ing painting a subject which requires much more attention than has yet been devoted to it in Occidental works, before it can be appreciated in the fullness of its achievements. The subject is complicated by the fact that so many of the leading painters were eclectic, and frequently their paintings in one style are as characteristic as others in quite a different style.

The most important and most unified class of painting in the later seventeenth and early eighteenth centuries continued the ideals of Tung Ch'i-ch'ang and embodied modifications or variations of the Sung-chiang tradition. On the one hand, the great painters of the Yüan Dynasty, and in particular Huang Kung-wang with his brilliant, detailed brushwork and attention to surface quality, were still looked upon as the most important models. In the best instances this produced paintings that are almost indistinguishable in spirit and technique from similar works of the fourteenth century. Such a perseverance or re-creation of an earlier style – more than a style, in fact, for it embraces an entire point of view – makes a chronological history of Chinese painting often misleading or ineffectual. The intense study of the Yüan masters carried on by some of the leading painters of the late Ming and early Ch'ing period was not inspired by a love of archaisms, but probably came about because in the Yüan masters they found a perfectly satisfactory

expression of the spirit of their own age, and to them Huang Kung-wang was 'modern'.

On the other hand, the painters who continued the general tradition of Tung Ch'i-ch'ang were interested in the same aesthetic problems and branched out into a wide range of experiments, trying one style or another or indulging in the most free interpretations. For this reason a great deal of their work has almost a monotony in its variety, because they became less interested in what was painted and more in the manner of presentation, in the problems of expression through the organization of forms and the character of the brush-strokes. As in the work of Tung Ch'i-ch'ang, the expression of the rhythm of life through the elimination of what was not significant and the careful regrouping of the essentials in a closely knit composition was more important by far than the theme of the picture. Contrasting the interests of these later painters with those of the Sung artists who successfully conveyed the impression of vast and limitless space, Dubosc writes: 'But it is not so much the depth and infinity of space that the sixteenth- or seventeenth-century artist is trying to convey to us; he is concerned rather with the rhythm that makes every part of the composition partake in the whole. Hazy backgrounds dissolving into nothingness are replaced by a more analytical study of form. To the full masses of the mountains correspond empty spaces, shapes of clouds without vagueness and perfectly integrated in the composition . . . a tree becomes an organic part of the composition, so well integrated that the curve outlined by its branches *is* the way which leads, more surely than any real path, towards the highest peak. Thus every detail fills a definite need in a composition that shows rigorous growth conditioned by an inner and dominating rhythm.'

The men who worked most intensely along these lines were, for the most part, members of the official-scholar class. Wang Shih-min, from T'ai-ts'ang in Kiangsu, was the most important in transmitting the ideals and concepts of the late Ming period into the Ch'ing Dynasty and establishing them on a sound footing. Born in 1592, he had been introduced into the art of painting by Tung Ch'i-ch'ang. He lived well into the K'ang-hsi era, dying in 1680, and thus formed a personal link between the younger generation and the sage of Sung-chiang. After serving as a government official, Wang Shih-min retired to a quiet life of contemplation, painting and writing. His training and personal preferences led him to a close study of the Yüan masters and in particular Huang Kung-wang. Perhaps the most constructive influence of Wang Shih-min was that he transmitted into the Ch'ing period the high standards of technical proficiency in both calligraphy and painting set by the late Ming painters.[3]

A close associate of Wang Shih-min in T'ai-ts'ang, was his somewhat younger contemporary, Wang Chien (1598-1677), who was also a retired official and painter. Wang Chien held very much the same ideas concerning painting as those of Wang Shih-min, and the two are counted the founders of a school called the Lou-tung or T'ai-ts'ang School. Though Wang Chien was a most accomplished painter in the style that had come to be the Ming-Ch'ing version of a generalized Yüan style, in some of his large and more complete pictures he followed rather closely the grand, somewhat detailed and explicit manner of Tung Yüan and Chü-jan. Some of his more personal pictures, on a smaller scale, follow a form that had been employed by Tung Ch'i-ch'ang, that is, an album of ten or twelve pages in which each landscape is a free interpretation of a different old master. These albums, which became especially popular in the Ch'ing Dynasty, are of the greatest interest in showing us how a single artist will express what he considers the true spirit or inner meaning of a great painter of the past, translating the most characteristic elements of that artist's style into terms of his own brushwork.[4]

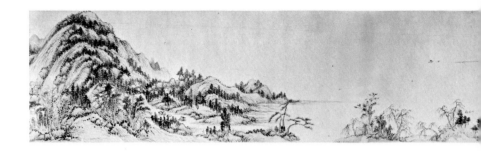

These two artists, Wang Shih-min and Wang Chien, are constantly linked with two other artists of a younger generation who also bore the surname Wang. One of these was Wang Hui (1632–1717) and the other was Wang Yüan-ch'i (1642–1715) who was the grandson of Wang Shih-min. These four men are famous in the history of later Chinese painting as the Four Wangs. According to one traditional evaluation the Four Wangs together with Wu Li and Yün Shou-p'ing are the six great masters of the Ch'ing Dynasty.

Wang Hui, also known as Wang Shih-ku, was a born painter. His genius was of that unusual kind which combines the utmost in natural talent with ambition and great powers of application. Painting was traditional in his family, but although he had this congenial atmosphere in his home, means were insufficient to allow him the proper course of study. Early in life, however, he met the painter Wang Chien who was impressed with his talent. Wang Chien took Wang Hui with him to T'ai-ts'ang and introduced him to Wang Shih-min and the latter accepted Wang Hui as a pupil. In the company of Wang Shih-min, Wang Hui had the opportunity to study not only his patron's extensive collection of old pictures but most of the important collections in the district. He pursued his studies for some twenty years, his progress was phenomenal, and he mastered a wide range of styles. In fact there are uncon-firmed but persistent rumours that in his early

years, before he won fame, he painted certain pictures in the style of Yüan masters with such painstaking fidelity that he included the sig-natures, and some of these found their way later into the Imperial Collection, but not under the name of Wang Hui.[5] Wang Hui is the epitome of the eclectic artist, and it would be impossible, short of a complete work on the subject, to review the different styles in all of which he painted with ease and success.

There are a number of paintings done by Wang Hui in his middle years, however, that possess qualities of a mature style which may be called his own. Within this group there is still wide variety, but the way he paints his massed trees, using the trunks of distant trees as persistent notes of vertical accents, and the extensive use of a variety of dots are the most apparent elements of this personal style. The dots, originally employed to represent low or distant vegetation, were, as already remarked, used by the Yüan masters and Shên Chou after them, among others, in a more abstract way. In the paintings of Wang Hui and several Ch'ing artists they play a most important role in tonal pattern, area texture, and emphasis. In one variation, Wang Hui follows the general style attributed to Tung Yüan and Chü-jan as inter-preted by Huang Kung-wang of the Yüan Dynasty and Shên Chou of Ming. The scroll in the Freer Gallery, of which we reproduce a detail [231], is on paper, painted in ink and the pale, transparent colours favoured by the Wu

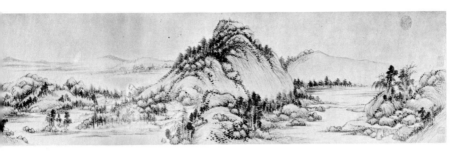

School. At the end of the scroll is a laudatory inscription written in 1673 by Wang Hui's old teacher, Wang Shih-min, in his eighty-first year. Presumably the picture was painted when Wang Hui was forty-one years old, or shortly before. The ts'un is the long, 'hemp-fibre' kind, and is used with great skill in defining the form of softly weathered hills and rocks. The strong

231. Wang Hui (1632–1717): Landscape.
Ink and colour on paper.
*Washington, Smithsonian Institution,
Freer Gallery of Art*

232. Wang Hui (1632–1717): Landscape.
Ink and colour on paper. Dated 1677.
Paris, Musée Guimet

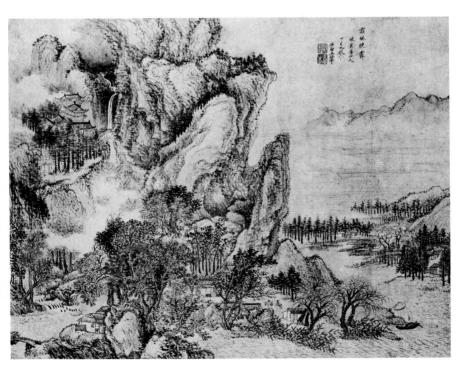

vertical accents of massed small trees are especially noticeable in the hill on the extreme left, and it is interesting to compare this detail with the Yüan Dynasty painting by Huang Kung-wang [194]. The composition is classic in its lucid balance without exaggerations, and in parts is strongly realistic, especially the logical recession of hill masses in depth and the broad expanse of lake. Wang Hui's predilection for dots is apparent, in particular as he used them to soften the silhouette of hills.

The same characteristics, or mannerisms, are carried over into other styles, as when Wang Hui paints in a style inspired by Wang Mêng [232]. In this album leaf, from the Musée Guimet, painted in 1677, when he was forty-five, the shorter, more irregular ts'un are closely massed to model complex, twisted forms of deeply eroded rocks. The varied tonal pattern, the dense foliage and the profuse but carefully placed dots produce an effect that is rich and moist. The picture is no mere adaptation from an old master or showy display of brushwork.

The fourth of the Four Wangs, Wang Yüan-ch'i (1642–1715), also known as Wang Lu-t'ai, was, as we have said, the grandson of Wang Shih-min. He was active in public office all his life, rising to be chancellor of the Han-lin Academy and senior vice-president of the Board of Finance. He was active in compilation and editorial work, notably as one of the compilers of a large miscellany on calligraphy and painting, the P'ei wên chai shu hua p'u.[6] He thus represented the scholar-official gentleman to whom painting was an avocation. His paintings gained a wide reputation and were much admired by K'ang-hsi. His artistic training must have been associated with the group at T'ai-ts'ang, his grandfather Wang Shih-min, Wang Chien, and Wang Hui. The paintings of Wang Yüan-ch'i are of a much more special kind than those of the other artists of T'ai-ts'ang; in many respects he was a painter's painter. On first acquaintance

with his work, one is conscious of a uniformity amounting almost to monotony. But Wang Yüan-ch'i was concerned with problems other than the immediate appeal of a romantic landscape and, as Dubosc has said, the great body of his work could be entitled 'Theme and Variations'. Although he painted compositions after Huang Kung-wang, Wu Chên, and in the Mi style, his most personal contribution lay in a kind of painting that superficially looks very simple but in reality is most difficult and complicated. His interest lay in presenting closely interrelated forms, outlined with light, sketchy, and brittle strokes and built up internally with dry and wet brush-strokes of great intricacy that follow none of the standard methods [233]. He was more interested in colour as a positive factor than almost any other artist, and some of his pictures have an interplay between warm and cool colours and patches of brilliant tone that are strikingly modern. Outward likeness seems to have concerned him not at all. The broad areas of white, whether they be lakes or clouds, assume intricate shapes that are integral parts of the composition, and the tonal pattern of the painted areas is complex with a wide range of ink values. Any section of the picture we may isolate presents a consistent character of rich pattern. Whether or not one admires Wang Yüan-ch'i's particular kind of art, it must at least be said that no Chinese painter has done it better.

The impressive talent of Wang Hui that allowed him to paint successfully in a number of different ways and yet assert his own individuality was shared by several other Ch'ing artists who worked within the general frame of the T'ai-ts'ang School, or Lou-tung, as it was sometimes called. Wu Li was one of the most brilliant of those artists who seem to have had a healthy interest in experiments and in constantly seeking new and more satisfactory forms of expression. Wu Li (1632–1718) was, like the Four Wangs, a man of Kiangsu, and his early

233. Wang Yüan-ch'i (1642–1715):
Landscape (detail). Ink and colour on paper.
New York, Earl Morse

training as a painter was under Wang Shih-min and Wang Chien. He was an exact contemporary and close friend of Wang Hui and many of his pictures are strongly reminiscent of that artist. Like Wang Hui, Wu Li painted some pictures in the generalized Yüan style that are close to the spirit of the fourteenth century. Others of his works are free and expressionistic with all the careful organization linked to a studied carelessness of the 'literary-man's' style. In yet others we are suddenly confronted by a surprising realism, with careful, accurate drawing and every tone and value adjusted so as to present hills and flat valleys stretching into the distance in the most visually convincing way.

In the landscapes most often associated with Wu Li, the forms of the mountains are either intricate, writhing and twisted like those of Wang Mêng or broken up into numerous piled boulders like the compositions of Chü-jan as interpreted by the Yüan artist Wu Chên. The tall, narrow landscape from the Hochstadter Collection is of the latter kind [234]. There is a vertical exaggeration of forms that begins with the tumbled pile of pointed boulders and tall trees in the foreground and, with insistent repetitions of the same shapes, mounts up to the topmost peak. Plain white shapes work in and out with the same kind of pattern found in Shên Chou and Tung Ch'i-ch'ang after him. The ts'un are made with short, crisp strokes and dabs in dry ink and the outlines accentuated with dots. By means of three areas of dark tonality – the foreground, middle-distance trees, and tops of the peaks – and by the much lighter tones of the mountain mass in the middle

distance, Wu Li has given a more definite effect of light than is generally found in Chinese painting. The picture has an austere and sombre atmosphere accentuated by the barren mountain slopes and piled rocks.[7]

Yün Shou-p'ing, also known as Yün Nan-t'ien (1633-90) was another friend of Wang Hui. His father had been a loyal supporter of the lost Ming cause and so with the complete victory of the Manchus found himself in most reduced circumstances, nor could his son hold public office. Yün Shou-p'ing supported himself and his father by means of his calligraphy, poetry, and painting. He painted some excellent landscapes in a variety of styles, but others seem rather mannered, and the real personality and interests of the artist are not easily apparent. His great fame, then as now, rests on his talent as a flower painter, and he is often considered the last great Chinese artist in that field. His best work was done in the 'boneless' style, that is, painting in ink or colour washes alone without the use of a bounding outline. Many of Yün Shou-p'ing's flower studies are highly realistic, and the painting of petals and the turn and twist of the leaves reveal keen observation. His albums in which different flowers in elegant compositions are shown on each page, combined with his free, strong calligraphy, are among the most universally appealing paintings of the Ch'ing Dynasty [235].

Just as later critics speak of the Four Great Masters of Yüan and the Four Great Masters of Ming, so the Six Masters of Ch'ing are the Four Wangs, Wu Li, and Yün Shou-p'ing.[8] The work of these men gives a clear notion of the main stream of Ch'ing painting, but the supremacy of this particular group is to some extent a matter of opinion. An impressive characteristic of the Ch'ing period is the broad

234. Wu Li (1632-1718): Landscape.
New York, Walter Hochstadter

235. Yün Shou-p'ing (1633–90): Lotus Flower.
Colour on paper.
Ōsaka Museum, Japan, Abe Collection

variety offered by a surprisingly large number of competent artists, some of whom were vigorous tributaries feeding into the main current and others so independent that their work is best understood and enjoyed against the background of their life and particular individuality - much as is the work of certain late nineteenth-century European painters.

Among such men Mei Ch'ing (1623–97), from Anhwei, painted curious landscapes, often highly mannered, frequently verging on purely abstract design and only tenuously held to the world of reality; Huang Ting (1660–1730) was a follower of Wang Yüan-ch'i who painted noble landscapes with complex mountain forms and deep ravines all full of dense detail like the landscapes of Wang Mêng; there was also Kao Ch'i-p'ei whose loose, calligraphic, and highly expressionistic paintings were often done with

his fingers rather than a brush. One of the greatest of all women painters of China was Ch'ên Shu (1660–1736), who painted powerful landscapes in the Yüan tradition and scrolls of flowers, rocks, and bamboo with a strong, free brush.

In strong contrast to the expressionism of the 'literary-man's' school, the careful drawing and fully descriptive style of the Northern Sung period was revived by Yüan Chiang, whose exact dates are not known, but whose earliest dated work is 1694, and he was apparently active throughout the first quarter of the eighteenth century, into the reign of Yung-chêng.[9] His landscapes in ink and light colour on silk are large in scale, suitable for the decoration of nobly proportioned halls. His accurately drawn pines with gnarled roots and downward-bending branches are in the style of the eleventh-century

painter Kuo Hsi. He used almost no ts'un, only a few dabs, dots, and longer broken strokes; but the forms are outlined with a soft, pliant brush and modelled with graded washes, often in light colours. The effect in single areas is strongly realistic, but the compositions of the mountains are so fantastic, and the interplay of broken curves so complex, writhing and twisting that the total impression is curiously rococo. A mundane naturalism, characteristic of one

236. Yüan Chiang: Carts on a Winding Mountain Road. Ink and colour on silk. Dated 1694. *Kansas City, Nelson Gallery of Art and Atkins Museum*

phase of eighteenth-century painting, is concentrated in the figures and buildings that enliven Yüan Chiang's landscapes. He was noted as a painter of architecture; his buildings are rendered in perspective that suggests European influence, and every brick and board, bracket and window is painted with meticulous care. The large landscape, 'Carts on a Winding Mountain Road', in colour on silk, is dated in accordance with 1694 [236]. After a period of relative obscurity, Yüan Chiang has again come into favour with modern Chinese connoisseurs because of his excellent drawing and carefully constructed, though complex, compositions.

In figure painting, Ch'ên Hung-shou (1599–1652) was admittedly master of his day, and his fame has not diminished in our own times. He was a very strange and eccentric painter, following his own quite individual style, which employed the even, thin 'iron-wire' line of such T'ang figure painters as Chou Fang and the Northern Sung artist, Li Kung-lin. The greater part of his life was spent under the Ming Dynasty. In 1645, after the triumph of the Manchus, Ch'ên Hung-shou, who was also known as Ch'ên Lao-lien, retired to a Buddhist monastery, where he remained six years, only returning home shortly before his death. He painted many pictures of Taoist fairies, and strange ladies with long faces in all of which the figures are greatly attenuated. Although his style is altogether curious and mannered, his paintings of Lohans, of scholars in landscape, and even his flowers, for which he was famous, all possess life and a sombre character quite their own. He delighted in strange shapes and unusual articles, and the men and women in his pictures appear to partake of the artist's eccentricities. The small picture in colour on silk [237] shows a scholarly gentleman in a rustic chair of gnarled wood, about to play the lute for two ladies seated at a fantastic stone table, one studying a painting of bamboo, the other

arranging a sprig of plum blossoms in a vase. The colours are soft and harmonious and the drawing has all the character of his curious, distinctive style. The popularity of illustrated books in the sixteenth and seventeenth centuries has already been mentioned. Ch'ên Hung-shou was one of the best artists to make drawings for wood-block illustrations, and his style was well suited for such reproduction. Among other works, he made illustrations for the famous Ming novel, *Shui hu chuan*.

The fondness for classification that has been remarked in the theories of Tung Ch'i-ch'ang and in the studies of techniques as seen in the printed manuals, led to the grouping of many artists of the seventeenth and eighteenth centuries into schools. Some of the so-called schools or categorical groups have no other common factor than that the artists lived in the same town or province, while others actually are bound by common elements of style. In most cases the school and group names are little more than an aid in sorting out the numerous painters into some kind of order. There were the 'Eight Eccentrics of Yang-chou' who had little in common except that they lived in the great city of Yang-chou on the Grand Canal and were all non-conformists in one way or another. Yang-chou was a centre of free thinkers who were looked upon askance by the Manchu court of Peking, and no paintings by the leading artists among the 'Eight Eccentrics of Yang-chou' found their way into the Imperial Collection during the long reign of Ch'ien-lung. In the group was Lo P'ing (1733–99) who painted demons, among other subjects. Hua Yen (1682–1755), Kao Fêng-han (1683–1743), and Chin Nung (1687–1764) also belonged to the group. Chin Nung was in many ways the most interesting. His style of painting was at once easy and strong, his compositions unorthodox, and his pictures often caught a personal mood not unlike that of some Ch'an Buddhist paintings of the thirteenth century.

Kung Hsien (1617/18–1689), also known as Kung Pan-ch'ien, was the most important painter of a group known as the 'Eight Masters of Chin-ling' (Nanking). Few Chinese artists of the late period worked in so consistent a style as Kung Hsien. He evolved a distinct and individual manner in drawing, brushwork, ink, and subject-matter and held to it throughout his career. Kung Hsien was a solitary man who seldom left his small house and garden. In one

237. Ch'ên Hung-shou (1599–1652): The Ch'in Player. Ink and colour on silk. *Nü Wa Chai Collection*

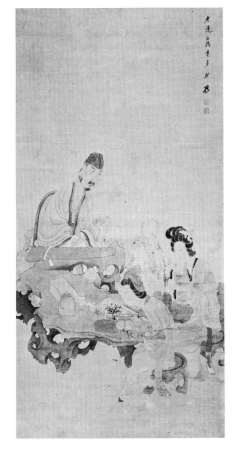

respect he was like Wang Yüan-ch'i – he was interested in certain limited aspects of expression in painting and worked within those limitations. His paintings are in ink, on paper or silk, and with ink he accomplished more than almost any other Chinese painter in constructing tonal patterns that range through numerous shades of silvery grey to soft, impenetrable black. More than any other painter, Kung Hsien used the

white of his paper or silk to weave intricate patterns that lead back and forth, in and out, with restless motion throughout the composition. When he paints trees in leaf the foliage is thick, and moist air seems to move through the branches; when his trees are leafless, they stand out stark and bare. Kung Hsien modelled his rock forms with short strokes of dry ink over which accents are drawn in wet, black ink, not unlike the manner of Wang Yüan-ch'i, then the shapes are further modelled and pointed up with dots in such profusion that at times the soft, hazy effect is like that of a *pointilliste* technique [238, 239].

238 and 239. Kung Hsien (1617/18–1689):
Landscape (details). Ink on paper.
Kansas City, Nelson Gallery of Art and Atkins Museum

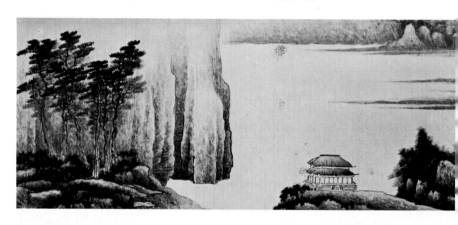

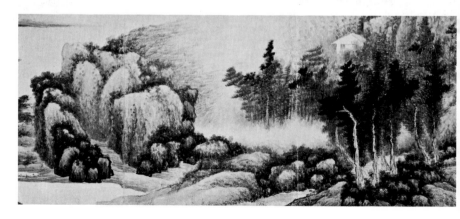

Kung Hsien repeated his compositions many times; the same themes are to be found isolated in album leaves as are woven together into long, horizontal scrolls. But in his grand panorama of shattered peaks, plunging cascades, and torn clouds, Kung Hsien created a vision of a blasted landscape that has no antecedent in Chinese tradition [240]. Kung Hsien is also like Wang Yüan-ch'i in that his paintings could

240. Kung Hsien (1617/18–1689): Landscape. Ink on paper. Zürich, Charles A. Drenowatz

tain no sign of man or of human habitation; he once said that mankind had no existence for him. Such houses as he does put into his pictures have a blank, tomb-like appearance; his villages look like grave-yards.'[10]

The sombre character pervading much of the best painting in the late seventeenth century is curiously akin to the spirit of the great landscape painters of the fourteenth century. In both epochs men had seen their native dynasties submerged under invasions from the north – in the fourteenth century it had been the Mongol, in the seventeenth century the Manchu banners. The Mongol victory had driven many thought-

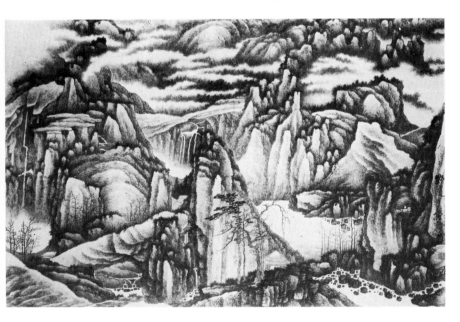

equally well be called 'Theme and Variations'. His theme is fully expressed in the words of Arthur Waley: 'He saw nature as a vast battle-field strewn with sinister wreckage. His rivers have a glazed and vacant stare; his trees are gaunt and stricken; his skies lower with a sodden pall of grey. Many of his pictures con-

ful Chinese into lives of solitude, as it drove Ni Tsan into wandering along the streams and lakes of Kiangsu. In the first decades of the Manchu conquest, some of the most individual and profound artists found a certain refuge in the Buddhist priesthood. These men were not ardent Buddhists, in the sense of the early

church fathers, but their Buddhism combined aspects of Ch'an thought and their own form of Confucianism which was very different from the formalized orthodoxy favoured by the Ch'ing court of Peking.

Hung-jên became a Buddhist monk at the fall of the Ming Dynasty. As in the case of many of these men who lived in semi-retirement and held no public office, not much is recorded about his life. Hung-jên, whose lay name had been Chiang T'ao, died aged fifty-three in 1663, so he must have been a young man, scarcely twenty, at the fall of the dynasty when he entered the Church. His home was in Anhwei province, so he is frequently classed as one of the 'Four Masters of Anhwei', of whom the other best-known painter was Ch'a Shih-piao (1615-98). Hung-jên, like Kung Hsien, followed a definite style free from the eclecticism of his age. Fundamentally Hung-jên's style was based upon Ni Tsan, but his art was not derived from the master of Wu-hsi. His paintings are very different from the many anaemic Ming and Ch'ing imitations of Ni Tsan. Hung-jên got from Ni Tsan his parsimonious use of dry ink, his bare trees and elegant, simple outline. But he used these elements in a different way; his compositions are more complete and the relationships of shapes, rock and mountain forms are more intricate. His pictures have the same quality of loneliness and withdrawal into solitude that was expressed by Kung Hsien but without the desolation and sombre gloom. The art of Hung-jên was not derivative, but the austere, cleanly drawn landscape in the Honolulu Academy is a telling illustration of how closely the artist of the seventeenth century could approach the spirit of the fourteenth [241].

241. Hung-jên (1610-63): The Coming of Autumn. Ink on paper.
Honolulu, Hawaii, Honolulu Academy of Arts

INDIVIDUALIST PAINTERS OF THE SEVENTEENTH

TO EIGHTEENTH CENTURIES

If later Chinese painting can be simplified, for our general purpose, into two main trends, then one would present a marked uniformity and the other a wide variety. The Four Wangs and their numerous followers would represent the uniformity, not so much in their work, which on closer acquaintance is remarkably diversified, but in their purpose of revitalizing the great traditions of the fourteenth century. The variety is to be found in the work of a number of strongly individual artists who, without altogether divorcing themselves from tradition, painted in their own quite personal ways, adhering to no school, group, or codified system. It cannot be a coincidence that some of the greatest of these individualists abandoned the struggle of social competition and sought freedom in the Buddhist Church and in wandering among the hills and streams of central China. Among these men the three who contributed most to the character of later painting were Chu Ta, K'un-ts'an, and Tao-chi.

The first of these, Chu Ta, was said to have been a descendant of the Ming Imperial house. His home was in Nan-ch'ang, Kiangsi, where he was born in 1626. It is not certain at what time he became a monk. Some say it was not until 1644 at the fall of the Ming, though he may well have entered the Church before that time. He enjoyed a long life and was still alive at eighty in 1705. Chu Ta used several names, but almost all his extant works are signed Pa-ta Shan-jên, by which he is most frequently known. In subject-matter the paintings of Pa-ta Shan-jên include birds, animals, fish, and land-scapes. His brush-stroke is either broad and strong or crisp, sketchy, and brittle. His ink is either wet and flowing or dry and delicate. He was a great master of composition, and while his pictures seem easily and loosely put together, they are, in fact, extremely well constructed, perhaps by reason of a natural sense of design rather than by the careful planning we have seen in other Ming and Ch'ing painters. The brush-strokes of Pa-ta Shan-jên also appear at first to be quite free and careless, but one has only to compare them with those in the paintings by his many imitators to appreciate their vitality and descriptive powers. The empty space in his compositions is employed with much the same fine skill as found in the paintings of a Southern Sung Ch'an painter like Liang K'ai. It is impossible to say what his birds meant to Pa-ta Shan-jên, but the majority of them appear to be either sullen and sulking or reduced to the last transports of rage. In these deceptively simple pictures Pa-ta Shan-jên's genius in composition is most readily evident. In his large painting of eagles a low squat rock and a tall one are complemented by the huddled bird below and the bird that cranes his neck above [242]. The balance of shapes and tones is so nicely adjusted that the picture would suffer from the slightest alteration. These birds, like all of Pa-ta Shan-jên, have ruffled feathers and look ill-kempt and cross.

The landscapes of Pa-ta Shan-jên could form a valuable study of themselves. The organization with repeated forms is in several instances reminiscent of Tung Ch'i-ch'ang. Some are

relatively complete with dense foliage and many peaks, others are little more than shorthand jottings. In a landscape of low, rounded islands, the foreground is occupied by roughly, almost violently jotted trees and rocks [243]. As the scene recedes to the distant hills, the forms are established by firm, broad outlines, washes of pale tones and strong dabs of ink. Especially in the trees one may judge the sketchy but decisive character of his drawing, never attained by other artists following his manner. Some others of his landscapes are very strange, the tree-trunks and branches outlined by a few jerky, angular lines and with big, round leaves the size of oranges, but all have the nature of a sincere, curiously personal comment on the world.

242. Chu Ta (1626–c.1705): Two Eagles.
Ink on paper.
New York, Private Collection

243. Chu Ta (1626–c.1705): Landscape.
Ink and colour on paper.
Nü Wa Chai Collection

The two other important monk painters of the seventeenth century were K'un-ts'an, also known as Shih-ch'i; and Tao-chi, most often called by his hao, Shih-t'ao.[1] K'un-ts'an was probably the more deeply religious of the two, and Shih-t'ao the more original and creative as an artist. K'un-ts'an, whose home was in Hunan, entered the church as a young man, spent all his life in Buddhist institutions and became acquainted with many of the intellectuals who had gone into retirement at the fall of Ming. The latter part of his life K'un-ts'an spent at Nanking, where he served as abbot of the Bull Head Monastery. His paintings were probably not known in his day outside the relatively small group of his associates, and only one ever found its way into the Imperial Collection.

The landscapes of K'un-ts'an have much of the same sombre atmosphere as the paintings by Kung Hsien, but they are more full and restless; the mountains are broken up into numerous peaks, valleys, and outcrops. Banks of white clouds drift in and out across the scene, and the trees are bent and twisted with jagged limbs. The restlessness of the compositions is matched by the complicated brushwork and the tonal pattern made up of a play of strong contrasts over the whole surface [244]. For all their complexity, there is a straightforward, deeply sincere character in the landscapes of K'un-ts'an that must be a result of his own direct contact with nature. His trees and rocks, clouds and hills are not out of copy-books or manuals on painting, but derive directly from his own experiences of nature and his meditations. From all we know of K'un-ts'an's life, he was simple, unambitious, detached, and of the highest moral character. Perhaps it is a mistake to attempt to read into his paintings qualities we suppose he possessed, but one is conscious of a communion with reality in the landscapes of K'un-ts'an and a sincerity that link him to the Ch'an painters of Southern Sung.

Shih-t'ao was in some ways the most gifted and in his paintings the most original of all Ch'ing artists. He stood alone in revolt against the accumulated weight of tradition which in his time must have smothered many a young genius. Tung Ch'i-ch'ang had stressed and underlined the study of the old masters as the indispensable training that led to understanding

244. K'un-ts'an (fl. *c*. 1650–75): Pao-ên Temple. Ink and colour on paper. Dated 1663. *Oiso, Japan, Kanichi Sumitomo*

and technical proficiency. Tung had emphasized that it was the spirit and not the likeness of the ancients which was worthy. But in the hands of lesser men his theories were simplified and moulded to the use of the countless dilettanti who painted in this manner or that, because it was thought proper for a literary man to do so. Even a great and gifted painter like Wang Hui, who was almost an exact contemporary of Shih-t'ao, was far too agile in donning the cloak of one or another master of the past. Against this persistent trend, Shih-t'ao asserted that it was the obligation of a painter to expose his own personality without guile and be true to the spirit of his own age.

Shih-t'ao's family traced its descent to an elder brother of the founder of the Ming Dynasty. He was born near modern Ch'üan-hsien, Kwangsi, in 1630. The fall of the dynasty to which he and his family were so closely linked must have been a saddening shock to the boy and drastically altered the course of his life. When he was but fourteen years of age he entered a monastery, and when twenty he went to the important Buddhist centre at Lu Shan in Kiangsi. Shih-t'ao was a genius who found in the arts of poetry, painting, and calligraphy a more rewarding experience and a more secure escape from the world than was to be found in monastic routine and deep religious studies. He began painting as a boy and continued an artist, in spirit and act, until his death in 1707. He was perfectly in step with the spirit of his age, when he turned his attention to theories on the origins of painting and the best method to obtain what all Chinese writers agreed was the aim of painting – to penetrate the reality of nature and express the artist's communion in terms of brush and ink. But Shih-t'ao had seen too much of the results of codified methods. He stressed the basic importance of self-discipline, a true comprehension of the appearance of nature and the high premium to be placed on individuality and

native genius. The basic precepts set forth in his essays on art, collected under the title *Hua yü lu,* have been outlined by Kojiro Tomita and Kaiming Ch'iu, from which we quote in part: '(1) In the beginning there was no method, but method came into being based on a single stroke, for the single stroke is the root of all representation. (2) Only when a painter comprehends the fundamental principle of the single stroke in relation to nature, can he develop the correct method for painting all representations. (3) Paintings are valuable for variations, so expression of one's individuality is essential. Knowledge obtained from the ancient masters is useful only as an instrument. (4) To be a great master, natural gifts come before knowledge. Unless he is endowed with natural gifts, he will not understand the significance of a single stroke which contains all things. . . .'[2]

The paintings of Shih-t'ao bear out his insistence on the free expression of individuality, a sound knowledge of the potentialities of brush and ink, and on the basic importance of genius. His works are richer in variety than those of, say, Kung Hsien, Pa-ta Shan-jên, or K'un-ts'an. The variety, however, is not at all the virtuosity found in a painter like Wang Hui, but rather the inexhaustible variety of nature, as it was observed and translated by the unique, broad talents of Shih-t'ao. He painted in washes of light colour, in ink alone, or in combinations of ink on colour, or colour over ink. Most often his colour and ink are very wet and allowed to spread and run, but always controlled to obtain the most expressive effects. In some paintings both the composition and the style are strange and completely original, as when the mountain form is painted with long, trailing, tangled veins, and covered over with dots of pale blue, green, and pinkish umber [245]. Or the theme may be the time-honoured one of the sage gazing into distance from his small boat, but the presentation is a delicate, personal kind that

245. Tao-chi (1630-1707): Landscape.
Album leaf, ink and colour on paper.
Nü Wa Chai Collection

really succeeds in expressing 'much by little' [246]. The important part played in the composition by Shih-t'ao's distinctive calligraphy is evident in this album leaf, where it complements the splashy painting of the foreground.

The atmospheric effects of Shih-t'ao's landscapes are more realistic than those of any of his contemporaries. In some of his album leaves banks of mist that curl around the mountains and the clouds that drift between the peaks blend imperceptibly with the trees and rocks, seem really wet, vaporous and shifting. Or, again, the sheets of rain that lash a lake shore, where men huddle in their boat under tattered umbrellas, envelop the scene and have the true character of a sudden, heavy downpour. The landscapes all possess this same convincing character of enveloping atmosphere. The same quality of realism is also in Shih-t'ao's trees, rocks, and mountains. It is not a realism in detail, but in total effect of weathered cliffs and massed trees, or bare wind-tossed branches.

It is not possible briefly to characterize Shih-t'ao's technique. His individual brush-strokes are never static but are purposeful – the single stroke that 'is the root of all representation'. Although he uses a wide variety of strokes, wet and thick, light and sketchy, sharp and brittle, or soft and blending, in any single picture the brushwork is consistent throughout. Moreover, there are never any empty strokes, that is, piling up of brushwork for its own sake in a meaningless way – every dot and stroke relates properly to another and is essential to the total concept. Shih-t'ao's complete mastery of his craft is perhaps most evident in his ink. The accents of tone are inevitably in the right place, and he is capable of piling black on black to obtain effects of great density and at the same time depth of tone without one value cancelling another – as he has done in the close mass of trees in the foreground of illustration 247.

Shih-t'ao was not basically opposed to tradition, but he proclaimed against an art that was derivative. 'Although ancient masters excelled each in one style, yet they had studied all models. Otherwise how could they understand so well the source of various principles? Nowadays learned men are really like withered bones and dead ashes, for they never learn widely. To know this truth is the surest means to achieve the state of dragon (the supreme height) in painting. . . . When asked if I paint in the manner of the Southern or the Northern School, with a hearty laugh I say I do not know whether I am of a school or a school is I; I paint in my own style.'[3] Why such a sound point of view, backed by the brilliant art of an undoubted genius, did not revitalize Chinese painting would be an interesting subject for speculation. Perhaps the weight of tradition had become too ponderous, or the conservatism of the Manchu Dynasty under Ch'ien-lung too stifling for a fresh and vigorous art to take root.

246 (*opposite*). Tao-chi (1630-1707): Landscape.
Colour on paper.
Boston, Museum of Fine Arts

247 (*above*). Tao-chi (1630-1707): Landscape.
Album leaf, ink and colour on paper.
Nü Wa Chai Collection

ARCHITECTURE

ALEXANDER SOPER

CHAPTER 31

INTRODUCTION

The story of Chinese architecture may be traced between the same wide chronological limits as the history of Chinese civilization. Signs of civilized building are an important part of our knowledge about the earliest city culture so far revealed, belonging to the last centuries of the second millennium before Christ. The evolution of the art may be followed thereafter down to our own times, across a span of more than 3000 years. No other great architecture except the Egyptian can match this longevity, or the slowness of change it has entailed. Within that part of the process that can be studied in detail, the latter half, there is discernible something like a cycle of growth, fullness, and decay, and the direction of development roughly parallels what is familiar to us in the West. But the extremes within which evolution has taken place are far more widely spaced than any in our experience (again excepting Egypt). If traditionalism and resistance to change have been prime characteristics of the Chinese way of life from beginning to end, there is no more vivid illustration of their working than that given by the history of architecture.

It should be noticed at the outset that longevity in Chinese cultural forms does not imply an extraordinary antiquity. We meet the first Chinese civilization around the thirteenth century B.C., at a phase of the Far Eastern Bronze Age comparable to that reached in the West a thousand years or more earlier. There are no ancient monuments in China, in our sense of the phrase. Since the chief material from time immemorial has been wood, the chances of preservation have been uncommonly poor. The earliest authenticated wooden building goes back on the continent only to the ninth century of our era (and in Japan, with more fortunate circumstances, to the seventh). The three or four earliest masonry pagodas reach to the sixth. A single stone survivor remains from around the time of Christ, the small chapel of Hsiao-t'ang Shan (whose engraved wall decorations are a landmark in the development of the Chinese figure arts).[1] Constructed material for study becomes fairly abundant only in the eighth century, mid T'ang, for masonry pagodas; and in the eleventh, Liao or Sung, for wooden halls. Our knowledge of everything prior to those periods must be gained indirectly, for the most part from references in literature. These last are reasonably informative from the Han period on (when they may be checked by engraved or

painted representations of buildings in two dimensions, and by clay models of some types). For the period covered by the next chapter, extending down to the beginning of the Imperial age in the last decades of the third century B.C., they are sparse, vague, and conflicting to such a degree that it is dangerous to use them for more than basic generalizations.

FROM EARLIEST TIMES TO THE CHOU DYNASTY

The information written for the first edition of this book in the early 1950s has been affected in varying degrees by discoveries made everywhere in China under Communist control after 1949 (and prior to the spring of 1965). This is particularly true for the earliest period, since evidence for prehistoric dwelling types, some of it highly important, has been accumulated over a very wide region. The most extensive Neolithic village uncovered, an example of the Yang-shao ('painted pottery') culture at its height, is that at Pan-po-ts'un in south-eastern Shensi. The settlement extended over a roughly circular tract of about 30,000 square metres; with cemeteries, utility pits, etc., lying beyond the periphery the total area of occupation was about 70,000 square metres. At the approximate centre of the enceinte was a large rectangular building with a floor area of about 160 square metres, perhaps used for clan assemblies. The other houses were either round or rectangular, with level or (more often) sunken floors, entered from the approximate south and provided with a central hearth. The roofs, presumably thatched, were supported by wooden posts and rafters, encased in wattle-and-daub. The 'clan house' is likely to have had four free-standing interior posts, topped by sturdy beams. Its walls were probably very low, so that its roughly pyramidal roof would have risen almost directly from the ground. The perimeter of the settlement was marked by a ditch some six metres deep, presumably for drainage and for defence.

The generally later Lung-shan ('black pottery') culture provides villages surrounded with defensive walls of rocks or rammed earth.

For the first historic phase, from around the middle of the second millennium B.C. on, a small but strategically placed area has been illuminated in the last generation by the excavations carried out in the vicinity of An-yang, in the province of Honan.[1] The architectural evidence uncovered at the site of the capital of the Shang Dynasty has the same kind of historical value as that furnished by bronze and stone sculpture. It defines Shang culture in much the same terms, as a society still primitive in some ways, but recognizably Chinese, and already in possession of many of the traits that were to characterize the periods to follow. The fragments of late Shang architecture are clearly ancestors of the traditional building style. Wood must have been the chief structural medium, and its disappearance is, of course, an impediment to study. Archaeologists have been able, however, to trace out rough ground plans because of the extraordinary durability of the material – *pisé*, or rammed earth – used for walls and platforms. In what is likely to have been a middle-period Shang capital city at modern Cheng-chou, south of An-yang across the Yellow River, there was already a long and relatively imposing city wall of rammed earth. At An-yang, the final capital site of the dynasty, the dwelling area at Hsiao-t'un village has revealed rammed earth house foundations, and rectangular dwellings laid out in orderly parallel rows. Much larger and more formally laid out structures, 'palaces' or 'temples' raised on impressive platforms, reveal the altered state of Shang society, with its new concentration of wealth and power.

One large An-yang building, traced by the remains of its podium and surviving stone

pillar bases, was a sizable hall even by later standards, an oblong over 90 feet long.[2] The ordering of its pillars is near enough to full symmetry to show that the principle was respected. Allowing for the displacement or loss of a few pillar bases, we can read into the plan a building whose structure and appearance cannot have been very different from those of later times [248].

248. An-yang, Honan,
large Shang Dynasty hall. Plan

```
0          30 FEET

0          10 METRES
```

To judge by early pictographic evidence, it is very likely that the Shang city wall was crowned by look-out towers in much the same fashion as at Peking prior to its recent modernization. That all this construction rose to an impressive height is suggested by the ancient pictograph *kao*, meaning 'lofty', which seems to show a wall surmounted by a tower with a peaked roof: . It can hardly be doubted, also, that the Shang builders knew and at least sometimes observed the later principle that the main façade should be the southern. Unfortunately, no complex of halls has been deciphered to prove the point, and the one reconstructed plan faces east (whether because it was a side building, or because the rule was not strictly observed, it is hard to say). Fortunately the testimony of An-yang can be completed by what is visible in the series of royal tombs, which must have exemplified the most feared and cherished beliefs of the time. The typical square burial chamber, set at a depth of around 40 feet, was approached by four carefully oriented means of descent on the two crossing axes. Those on west, north,

and east were steep flights of steps; that on the south was a wider, longer ramp, and so, presumably, served as the avenue by which the body was carried to its resting-place.

From another point of view the An-yang evidence points to a fairly elementary stage of civilized architecture. The city walls and platforms found are of rammed earth only, and the wall remains are no more than 12 feet thick at the base (those of the Tartar city of Peking are 40 feet high and 62 thick at the base, and are faced with brick). The vanished roofs were probably thatched; later literature speaks of that medium as proper to the age of high antiquity. The royal tombs were not marked above ground (whereas those of the Early Chou kings were to be covered by huge man-made hills). In that, as in their other general characteristics, they recall the Egyptian tombs of the First Dynasty Pharaohs at Abydos, datable nearly 2000 years earlier. The typical tomb chamber was built of wood to about the height of a man (none has survived intact); the pit around being filled with rammed earth.

Various indications tell something about the dwellings of the people who lived in north China prior to the age of An-yang.[3] Many passages in late Chou literature refer to a period in Chinese prehistory when men lived in burrows and nests, according to the season. The underground dwellings seem to have been either pits or caves, as the terrain permitted. One can hardly question the veracity of this racial memory. Even to-day there are countless cave-dwellers in north China who have taken advantage of the workability of the loess banks to dig out chambers. Chinese histories from the Han Dynasty on ascribe the custom of living in the earth to a whole series of northern peoples, who may well have continued into historic times a way of life like that of the neolithic inhabitants of the Yellow River region. Japanese archaeologists have established the dominance in their islands of an early dwelling type, doubt-

less imported from the mainland, in which the floor was sunk up to a metre. There the roof seems to have been made of poles and brush, rising directly from the ground, while the Chinese records suggest a domed-up shell of sod; the choice must have depended on the materials available, and on the severity of the winters. A large number of beehive pits, presumably neolithic, have been found in north China, particularly around An-yang (though it is not clear whether these were used as dwellings or for storage). Recent finds along the Yellow River have uncovered a more highly developed type; examples found in Kansu in 1947 had plans about three metres square, exactly oriented.[4] Both the sunken floors and the loess walls of the excavations were smoothed with mud and plastered; the typical house had a fire-pit at its centre. The objects found spoke of a pre-metal culture, which from the pottery style has been provisionally assigned to a period around 1500 B.C.

To reconstruct the look of the simplest habitation remembered by the Shang people, one can turn to the An-yang oracle bones, where one version of the pictograph for shelter is a roughly arched shape: ∧ The same character is rendered in a ∕⊓ more civilized way as an end view of a gabled building, with straight roof lines overhanging at the eaves, and ∧ a projecting ridge surmounting the gable: ∣ ∖

The 'nests' remembered in Late Chou were probably warm-weather shelters made of poles and brush, raised above ground to escape marauding animals, snakes, and the discomforts or dangers brought by water. Platform houses of this sort are to-day familiar in the tropical lands south of China. In Shang and Early Chou times even the Yellow River valley seems to have had a much warmer and wetter climate than it has now; and we know that at least by the early centuries of the Christian era the platform house was domiciled in Japan.

THE CHOU DYNASTY

Recent cursory investigations of abandoned city sites in the north-east have revealed traces of walls and platforms, and great quantities of roof tiles that seem to go back to Late Chou. Outside these our information about the art of building during the eight or nine centuries of the Chou must be drawn from written sources.[5] The books contain a great deal that is relevant to the story of Chou architecture; unfortunately the sum is insufficient to provide a clear and detailed picture, either of a style or of any but the roughest sort of development. The early sources are disappointingly meagre. The late ones either harp endlessly on one theme – the political unwisdom of extravagant building – or describe ceremonies and their settings in such minuteness, with so many contradictions and obscurities, as to strain both comprehension and credulity.

The earliest group of Chou writings, the commemorative inscriptions cast on sacrificial bronzes, are full of mentions of palaces and ancestral shrines; unfortunately only names are given. Sporadic references occur in the literary remains of Early and Middle Chou that contribute details, or give some idea of an aesthetic effect. Three songs in the 'Poetry Classic', *Shih Ching*, for example, descant admiringly on large buildings that must have headed the architectural hierarchy of the times, two being princely ancestral shrines and the third a royal palace.[6] The qualities picked out for special praise had to do, naturally enough, with size and fine workmanship. The timbers were pines and cypresses from the hills. Out of them were hewn oversize rafters, and arrays of impressively big pillars. One of the shrines, built anew by a mid seventh-century duke of the state of Lu, contained a vast state apartment; the singer describes it by a doubled adjective that means something like 'splendid'. The palace, which commentators assign to King Hsüan (r. 827–

781), had an extraordinary length. Its courtyard was level, the pillars were tall and straight. As a dwelling it was comfortable; its rammed earth walls were a tight seal against inclement weather, or the incursions of birds and rats. The song includes a series of similes that may show a more poetic response to the building's effect. It (or perhaps its owner – the critics disagree) was like a man standing on tiptoe, like a coursing arrow, like a bird with outspread wings, like a pheasant in flight. (One could trace these back naturally enough to the features of a palace building; to the height of its platform, the soaring lines of its pillars, and the wide spread of its roof.)

The ballad-like repetition of one song testifies to an important feature of the mansion's general plan, its orderly development along a central axis. A lover is pictured waiting for his sweetheart in three successive locations, first between the gate and the screen wall, then in the courtyard, and then in the front porch, just as he might do in a traditionally arranged house compound to-day.[7] (The 'screen' was presumably the ancestor of the now standard dragon screen, a short, free-standing wall, set just inside the entrance across the axis, to bar direct ingress.) Again, a dynastic ode of the royal house, recalling legends about the foundation of the first Chou city by the chief Tan-fu, describes his laying out what sounds very much like the familiar symmetrical city, with one set of rammed earth ramparts around its perimeter and another around the palace grounds, pierced by lofty and strong gates.[8] Left balanced right; there were big and little plots, methodically measured; the first structure to be raised was an awesome shrine for the clan ancestors.

The admiring note of early references gives way in the later to increasingly voluble complaints. At least by Middle Chou, architectural forms and ornament seem to have been allotted by rank (as was to be the case later in Imperial times). Violations of this custom were an early

sign that the feudal order was weakening. Confucius thought it well to draw attention to a fellow-townsman whose mansion was decked with 'mountain capitals and pond-weed kingposts', for those were symbols properly found only at a higher social level.[9] The reference incidentally tells something about the growth of architectural decoration. The motifs may have been either painted or carved. The 'mountains' probably looked like the undulating pattern found on bronze vessels of the Middle Chou style. The 'pond-weed' was very likely set under the roof as a symbolic guard against fire (as was to be the case with other water plants in Han times).

It seems to be a similar infringement that is pointed out in two passages of the Lu 'Spring and Autumn Annals', Ch'un Ch'iu, that deal with the re-decoration of his father's shrine by the ruling duke, Chuang. In 670 he had the pillars painted a bright red, and a few months later had the rafters carved. (The commentators give him a deplorable motive; he wished to marry the daughter of an ex-enemy who had murdered his father, and thought it prudent to make a gesture of propitiation.) The first rule violated is recorded in one of the standard compendia of Chou etiquette, the Li Chi: 'The pillars of the Son of Heaven are red, those of the feudal princes blackish, those of high officials blue-green, and those of the other gentry yellow.' The second is cited by a commentator to the Ch'un Ch'iu: 'The rafters of the shrine of a Son of Heaven are to be hewn, rubbed smooth, and polished with a fine stone. Those of the princes are to be hewn and rubbed only, and those of high officials merely hewn.'[10]

The characteristic complaint of the final Chou centuries appears for the first time in the Tso Chuan (that detailed history that passes as another commentary to the Ch'un Ch'iu) under the date 606. 'Duke Ling of Chin did what no prince should; he taxed heavily in order to have his walls sculptured.' The classic conclusion,

that architectural extravagance is one of the telling symptoms of misgovernment, is drawn in a *Tso Chuan* paragraph for 538. Two speakers lament the declines of their respective states; the Lu threnody runs, 'The war-horses are not yoked, the ministers never take the field. The people are weary and worn, the palace apartments many and costly.'[11]

Such criticisms are apt to be set against reminders of the simpler ways of the past. A *Tso* entry for 708 begins a description of the surroundings of a virtuous ruler by noting that 'his ancestral shrine will be roofed with thatch'. (An entry for 714 mentions a place with the name Wu-wa, literally 'roof tile'. The two references suggest that by the eighth century tiles were beginning to supplant thatch in monumental buildings.)[12]

Good and bad examples are contrasted in a *Tso* paragraph for 493, setting forth the reasons why the power of the Wu state need not be feared much longer. The earlier Wu king, Ho-lu, under whom the fortunes of the state had risen phenomenally, had 'never eaten of two dishes at a time, nor sat on doubled mats. His apartments were not lofty, his utensils were not painted or carved; his palaces had no belvederes, and his boats and carriages were plain.' In contrast the ruling king, Fu-ch'ai, 'wherever he halted, had to have towers, terraces, embankments, and pools. Wherever he spent the night, he had to have his ladies to serve him. Even on a single day's outing, everything had to be exactly as he wished, and the curios that he loved were taken with him. It was the precious and exotic that he collected, and all his endeavours went toward spectacles and musical entertainments. Such a man, who looked on the common people as enemies, to be exploited for some new end every day, was busy defeating himself. How could he be a serious threat?'[13]

Extravagance was most often epitomized in the erection of lofty look-outs, usually called *t'ai*. These were not in themselves deplorable, but became so when their purpose was frivolous. A dynastic ode describes with approval the raising of the most famous of towers, the *Ling T'ai*, by the pre-conquest chief of Chou canonized as King Wên; that was built in no time at all because the people who came in crowds to set it up looked on the chief as their father.[14] It is impossible to say what the purpose or appearance of this structure may have been. *Ling* is an adjective that indicates any of a loosely connected series of attributes having to do with the supernatural; the translators of the *Poetry Classic* have rendered it here as 'wonderful', 'magic', 'divine'. The ode also celebrates two other ling works carried out for King Wên, a deer-park and a fish-pond. It was just this combination – the high building and the park with an artificial lake – that provided the classic pattern of wastefulness in Late Chou. King Wên's trio may have been acceptable because they were modest; or more likely because they were designed as magic symbols, to win strength and prosperity for the state at whose ideal centre they lay.

In later usage a t'ai was typically an elevated platform, either unroofed or given some sort of separate superstructure. The many references in the *Tso Chuan* show the t'ai of feudal lords being used for feasting, for imprisonment, for last-ditch stands against enemies, or simply as look-out platforms. It seems safest to take the word as holding for all kinds of towers, irrespective of proportions or methods of construction. Many t'ai were certainly built of rammed earth; the character has the 'earth radical' in it, and the Han dictionary *Shih Ming* says, 'T'ai implies the idea of supporting. It is built up of earth, firm and high'. The exterior of this sort of tower might be plastered; the *Ku Liang* commentary to the *Ch'un Ch'iu* points out that that was one of the items of expenditure postponed by a good king in times of famine.[15] The philosopher Lao-tzu contributes a suggestive fragment: 'A *t'ai* of nine storeys is raised out of a

heap of dirt.'[16] It is hard to imagine such a pile except as something like a Mesopotamian ziggurat, simulating the tiers of Heaven (which the Late Chou counted as nine). Some towers, on the other hand, were likely to have been of wood, or, at least, had only bearing walls of rammed earth, and so were open inside. On the ground floor of such a t'ai Duke Wên of Lu died in 608.[17]

The frequent references to Chou architecture in the late literature that runs on down into Han promise more information than they actually provide. It is not possible even to reconstruct a fully convincing typical plan for the formal parts of the mansion that are mentioned. The two compendia of rules for formal behaviour, the *I Li* and the *Li Chi*, describe a number of social rituals – banquets, funerals, receptions of messengers, and the like – that take place in the area framed by the entrance gate and the reception hall. The actions of participants are minutely recorded, and often are oriented with respect to key architectural elements: staircases, pillars, doors, or windows, variously named rooms. One cannot be sure that the house complex referred to was really typical; like the ceremonial, it may have been less a fact than an ideal preached by the Confucian School in the face of laxity and disorder. Again, the details are not complete enough to give a clear picture. The ground plans derived from them by commentators vary considerably (and since the scholars were not architects, none looks much like the Chinese house known in later times). About all that may be safely said is that the main building, at the rear of the main courtyard, stood on a platform, and was subdivided into areas of various sizes and shapes on left and right and front and rear. The plan and its use may have borne a rough resemblance to the type of mansion found in Japan in the Late Heian period, and recorded in picture-scrolls from the late twelfth century on. The front was occupied, wholly or at least on either side of the centre, by a porch-like space called

the *t'ang*, corresponding to the Japanese *hisashi*. This was used for acts of the social ritual that did not require privacy; perhaps, like the *hisashi*, it could either be fully opened across the front, or be closed by wooden shutters. Behind the t'ang was a main room called the *shih*; on either side were (presumably smaller) rooms, *fang*, *hsü*, *chia*; a few references speak of a northern t'ang facing towards the rear court. It is not clear whether the building was framed within a rectangle, or had at least one of its east-west pairs in projecting wings.

One well-attested feature of the plan is interesting, its failure to mark the central axis with the clarity of later times. There were two front staircases to accommodate, for example, the parallel advances of the master and a guest. A key position in the t'ang was between an east-west pair of free-standing columns. Communication between the t'ang and the shih, again, seems to have been not through an axial doorway. At least part of the evidence points to an off-centre eastern door, matched by a western window. One might conclude that while left-and-right balance was one of the most ancient features of Chinese architecture, the now omnipresent emphasis on a central axis may be a relatively late addition, and a result of the cult of a single, omnipotent ruler in imperial times.

The books of etiquette make a number of statements about larger plan dispositions, which seem to be based on varying degrees of fact. Entirely plausible is the division between 'outer' and 'inner' parts of the compound, the former open to men and the latter kept secluded for women and children. The statements about the ancestral shrines of a ruler should perhaps be treated with caution because of the chances there for irregularity. The shrine compound is said to have been properly placed on the east side of the palace precincts, balanced by the mound and tree of the Altar of the Soil (the personification of the territory ruled) on the west.[18] Like all other attributes susceptible of

numerical differentiation, ancestral shrines are assigned in the books according to social status. In theory the Son of Heaven honoured the maximum number of ancestors, seven (whether by separate chapels or by subdivisions in one building is not clear), while his subjects were permitted five, three, or one. It is again plausible (and vaguely indicative of architectural character) to read that 'the ancestral shrine was awe-inspiring, but not made for comfort'.[19]

The most perilous uncertainty surrounds the building called the *Ming T'ang* (literally 'bright hall'). Some of the most circumstantial accounts in the ritual books have to do with the use of a Ming T'ang by the Son of Heaven. One chapter in the *Li Chi* makes it the setting for a grand audience of feudatories. Another, listing the activities proper to each month of the royal year, makes it a palace laid out like a chequerboard, through which the Son of Heaven must move his seat from one square to another, month after month, around a slow sunwise turn.[20] The text that serves as a kind of table of organization of the Chou administrative system, the *Chou Li*, has a chapter on Chou crafts in which the Ming T'ang is described and measured, along with predecessors of the same type that are said to have served the Hsia and Shang.[21]

Out of all this has come a problem over which scholars and architects have agonized for two millennia. We shall see below the kind of pressure that kept the issue alive, the recurring desire of emperors from the second century B.C. on to build themselves Ming T'ang of the canonical form. The question was insoluble from the outset because the only detailed information available was contradictory and at least in part fictitious. The Chou age certainly knew the use of a Ming T'ang, although the early references are so scanty as to imply that the type was normally called by some other name. A *Tso Chuan* entry for 624 quotes 'a Chou history that said, "The man who slays his overlord shall not mount to the Ming T'ang" '.[22] There is a puzzling passage in Mencius in which King Hsüan of Ch'i (r. 331–312) asks the philosopher whether he should dismantle his Ming T'ang, as everyone keeps telling him to do. Mencius's reply is: 'The Ming T'ang is the hall peculiar to royalty. If Your Majesty wishes to practise royal government, do not demolish it.'[23] The story makes it clear that the use of a Ming T'ang, like other prerogatives of the Chou house, was usurped in time by the feudal princes. One might infer, also, that the building was becoming obsolete in the last centuries of the period.

The several references to the Ming T'ang in the mid third-century *Lü Shih Ch'un Ch'iu* seem to belong already to an age when memory was being supplanted by speculation. Some are obvious pretexts for moralizing. 'In the Chou Ming T'ang the outer doors were never shut, signifying that throughout the realm there was nothing kept secret'. (xv). 'The Ming T'ang was thatched, had pillars made of brushwood, and stood on three earthen steps only, to serve as a model of frugality'. (xx). Of a different order are the paragraphs strewn through the book that describe the royal year (the apparent source of the *Li Chi*'s calendar chapter, *Yüeh Ling*). There the Son of Heaven is made to move clockwise through a series of apartments designated in twelve different ways. Each season has a key name, applied to its middle month; to its first and third months belong the apartments on the left and right of the key one. Curiously enough the name Ming T'ang is given merely to the mid-summer apartment.[24]

The first fixed date in the history of the Ming T'ang fell in the reign of Wu-ti, the best-known and most superstitious of Han emperors. In the decades when he was most obsessed by portents and rites, Wu-ti was shown what purported to be the site of an ancient Ming T'ang in the province of Shantung. He resolved to build one for himself in the same place, to carry out the ceremonies that his scholars advised him were essential to true sovereignty. Unhappily, no one

knew what the form of a Ming T'ang should be, though the whole realm was appealed to; and when in the end a design was submitted, it was not called the Ming T'ang of the Chou house, but a predecessor that had served the mythical 'Yellow Emperor', Huang-ti, in remotest antiquity. The fiction would have been transparent in any less credulous generation. Its claim to age was satisfied by an affected simplicity; the other ideas involved were thoroughly modern. The design found favour, however, and was duly translated into architecture in 109 B.C. The Ming T'ang that resulted 'had only a single apartment, lacked walls on its four sides, and was roofed with thatch. A moat encircled the shrine, and there was a double circuit of walls surmounted by wooden towers. One entered from the south-west; the precinct was called K'un-lun.'[25] These last details reveal the workings of the popular Taoism that was first taken seriously in Wu-ti's reign. In Taoist myth the south-west was the direction proper to the 'Yellow Emperor', and K'un-lun was a fabulous Paradise-mountain in the far west. Wu-ti's use of the building reveals the same sort of interests. He sacrificed there to a series of deities then in favour; beginning with his favourite 'Supreme Unity', T'ai I; passing to the Five Celestial Rulers who presided over the cardinal directions and centre, and stood at the same time for the Five Elements; and only at the end remembering the old royal tradition long enough to include his own ancestor, the founder of the Han line, among the gods.

It is against this historical background that one must judge the appearance of precise information about the Ming T'ang in the ritual books edited at the end of Western Han, around the time of Christ. That, too, was an age hag-ridden by superstition; its scholarship, in addition, was bedevilled by political complications. It is clear that the usurper Wang Mang, who rose to power through a series of *fainéant* reigns and finally took the throne in A.D. 9, tried to fortify his position by posing as a saviour-king on the ancient model. He followed the traditional patterns with exceptional scrupulousness (building himself the first Ming T'ang in the imperial capital, as we shall see). It is not unnatural to suspect that the ritual books brought out in his generation were affected; the patterns that they sanctioned may have been filled out or partly redrawn to suit immediate needs.

One of the prime Ming T'ang sources, the *Chou Li*, has never been completely redeemed from the status of propaganda. Its description of the Ming T'ang has an even more dubious authority than the rest (which is detailed to the point of absurdity); the chapter involved, on public works, is known to have been added by the Imperial librarian Liu Hsin, on his own authority. It is not surprising, therefore, to find that the accounts given of the Ming T'ang and its Shang and Hsia predecessors seem to have been worked out to achieve numbers that were valued for their magical efficacy. This holds good even for the dimensions recorded; it is most noticeable in the claim that the Ming T'ang had five apartments, shih, doubtless to link it with the theory of the Five Elements popular in Late Chou and Han thought, and so make it in the sense a microcosm.

Another striking claim is that set forth in the non-canonical edition of the *Li Chi*, compiled by a scholar, Tai Senior, who had been a pupil of Liu Hsin's father. There the Ming T'ang is described as being round above and square below (as a commentator explains, to signify the roundness of Heaven and the squareness of Earth), and roofed with thatch. Each of its nine apartments, shih, had four doors and eight windows, making a total of thirty-six and seventy-two.

The calendar chapter of the canonical *Li Chi*, edited by Tai's son, follows the *Lü Shih Ch'un Ch'iu* in naming twelve stations for the Son of Heaven, to correspond to the months; and sets up a thirteenth, the 'grand apartment of the

grand fane', to be occupied in the interval between summer and autumn.[26]

We seem closer to a real memory in the *Li Chi* chapter on 'the Stations in the Ming T'ang'. 'The Grand Ancestral Shrine, T'ai-miao (of the state of Lu corresponded to) the Son of Heaven's Ming T'ang. . . . It had mountain capitals and pond-weed kingposts; it was a two-storeyed building with double eaves, polished pillars, and windows lined up with each other (?) . . . all these being the adornments of the shrine of the Son of Heaven.'[27] Even this, however, is not above suspicion; the chapter presses a claim that the Lu court was uniquely close to the old royal dynasties, with such insistence as to seem another kind of propaganda.

The struggles to overcome these inconsistencies have produced several variant plans for the Ming T'ang. The most natural is a square sub-divided equally into nine parts. This suits the version of the Senior Tai, and with a little juggling can be made to fit the royal twelve-months rotation (one has only to assume that the king spent two months in each corner apartment; considering it first in the sense given by its eastern façade, say, and then in that of the southern). The five-apartment scheme of the *Chou Li* has been explained as a central square, with a smaller square at each corner, the apices just touching. In recent years an antiquarian has proposed a Greek cross plan reconciling all the basic numbers.[28] It is quite likely that all these variants were at one time or another tried out from the Han dynasty on. That they had any historic relevance for Early Chou is unlikely. The claim most fascinating to a historian, that the Ming T'ang was 'round above and square below', has no better textual authority than the rest. In addition it has a special improbability; round-and-square wooden buildings have always been so rare that the burden of proof is exceptionally heavy.

A possible clue to the mystery of the Chou Ming T'ang may lie in the fact that, as we have seen, the *Lü Shih Ch'un Ch'iu*'s royal calendar applies the name not to the whole building through which the king moves his seat, but merely to its midsummer apartment, at the centre of the south side. Though the Han age came to use the character t'ang to mean a building, its more ancient function seems to have been to indicate something like a front porch. So the Ming T'ang (the porch on the *ming* or bright side?) may have been merely a royal vestibule, attachable (as in the Persian *apadāna* seen at Persepolis) to any state building; which, if it were mentioned in any sort of record, would have been referred to by its specific name.

During their country's brief control of north China (1937-45) Japanese archaeologists were able to make surface investigations of several abandoned city sites whose debris indicated a Late Chou date.[29] One of the most promising, north of Lin-tzu in Shantung, has been identified as the capital of the Ch'i state. The walled area is roughly 1·3 miles east-west by 2·5 north-south. The front wall is not at right angles to the sides, but runs down to make an angle of around 70 degrees with the south-east corner. At the south-west are traces of a much smaller enclosure, apparently the palace compound; a rough square, 0·81 mile on a side, jutting out beyond the city proper on the west. The royal wall must have been over 30 feet high. At I-hsien in Hopei, again, the traces of what was probably the capital of the Yen state form a great irregular enclosure twice as big as Ch'i's. Among the half-dozen city layouts thus recovered, there is a glaring lack of the standardization presented as fact in early literature, and particularly in the *Chou Li*. The latter's description of a royal city is doubly worth quoting, however; not only as a demonstration of the utopian character of the text, but also because it provided a canonical form to be followed more or less faithfully in the Imperial age.

'The architects who laid out a capital made it a square nine *li* on a side, each side having three

gateways. Within the capital there were nine lengthwise and nine crosswise avenues, each nine chariot tracks wide. On the left was the Ancestral Temple, on the right the Altar of the Soil; in front lay the Court of State, at the rear the market-place.'[30]

The palace compound, around which these key features of the city were placed, must have been located at the centre, forming a square within a square. This ideal regularity is approached, among the surviving sites, only in the smallest, that of the T'êng state in Shantung; and even there the shapes are oblong, and the inner compound lies slightly to the rear of dead centre.

The greatest part of the surface finds made within these ancient city limits comprised roofing tile fragments. A naturally small fraction represented the kind of ornamental tile head used to enrich the eaves line. The shape is a semicircle, variously decorated; one popular design from the Ch'i site is a conventionalized tree, with flanking horses. Designs from other sources may show the *t'ao-t'ieh* mask or heraldically opposed dragons seen on Late Chou bronze vessels.

FROM CH'IN TO THE SIX DYNASTIES

CH'IN, HAN, AND THE THREE KINGDOMS
(221 B.C.–A.D. 265)

The unification of China under a centralized administration made it possible to build much more grandly than before. The change came dramatically, within one generation. The lord of Ch'in who made himself First Emperor wielded his new might with a truly imperial boldness. His palaces in the new capital, like his military highways and his Great Wall, like the striking power of his armies and the wealth of his treasury, were stupendous. His buildings were bigger and more splendid than those of any predecessors had been. They were also, perhaps, the first monuments on Chinese soil to be conceived in national terms.

It seems likely that during the Chou period architectural development followed the divisions of the feudal system and was retarded by local traditions and animosities. One instance cited by the *Tso Chuan* may stand as typical. Duke Hsiang of Lu had visited and been dazzled by the court of Ch'u. On his return he built a palace on Ch'u lines; his affronted subjects thought it a fitting sequel that he should die there a few months later.[1] The First Emperor may not have been as irked by this provincialism as he was by the other ways in which tradition blocked his plans. He may not have aimed at a national architecture as deliberately as at a national system of writing, of weights and measures, or of laws. It may have been simple exultation that made him set up along the riverside in his capital a series of pleasure palaces, copying the apartments of each of the feudal lords he had defeated. The result, however, must have been the same. From all those 'halls,

with their two-storeyed connecting galleries and encircling balconies',[2] it was for the first time possible to compute a sum of Chinese architectural achievements. The next step must have been the fusion of regional differences into what was intended to be a single imperial style.

The climax of the First Emperor's projects was the palace called O-pang or A-fang; a gigantic complex never completed, and soon destroyed in the collapse of the dynasty. The site chosen – perhaps to emphasize the sovereign's half-divine isolation – was a hunting preserve across the river. 'The Hall of State there, the "Front Hall", was 500 paces from east to west and 500 feet from north to south. Above, it could accommodate a myriad men; below [its platform] might have been set up a flagstaff 50 feet high. The carriage avenue surrounding it was a raised gallery; from the foot of the hall this led straight to the Southern Mountain, the crown of which was marked by entrance towers. From the palace a two-storeyed gallery ran over the Wei River to the city, modelled on the covered gallery in high Heaven that leads across the Milky Way. . . .'[3]

We have seen that the architectural ambitions of the feudal lords were accomplished against an *obbligato* of resentment; no one thought well of such buildings except those who enjoyed their use. The vastly more expensive works of the Imperial age were perhaps less burdensome, because the national wealth was much greater. Not that alone, however, can explain the fact that the literary references to the architecture of Ch'in and Han were couched in the language of wonder. One major department of Han poetry, the *fu*, was concerned largely with minutely detailed rhapsodies on the Imperial palaces, or

even on individual buildings. Clearly, the new style fired imaginations in a new way, as the most forceful symbol of national greatness. It was the embodiment of everything that made the thoughtful Chinese proud of his racial inheritance: wealth, power, a civilized way of life closer to the gods than to barbarian squalor. The note of complaint was still sounded from time to time to criticize aberrations – the extravagance, say, of an imperial minion – and became stronger as the dynasty declined. In the great years, however, monumental architecture seems to have been held an indispensable luxury. Even the First Emperor, whose name has been execrated for every other reason, has remained in memory uniquely great and almost beyond criticism as a builder.

The Han line, taking power after a costly civil war, was held at the outset to a relative frugality. Even in its first years, however, there was a powerful feeling that a great architecture was one of the features necessary to stable government. The history *Shih Chi* has an illuminating anecdote.[4] The first Han sovereign delegated the building of his residence at the new capital site, Ch'ang-an, to one of his generals.

'In (200 B.C.) Hsiao Ch'êng-hsiang built the Wei-yang Palace, setting up towered gates on north and east, a Hall of State, an arsenal, and a grand storehouse. When Kao-tsu returned and found how large these were, he broke out angrily, "The whole world has been beggared by agonized years of war. Our very success is still unsure. Why, then, must you build a palace so excessively grand?"' The gist of the general's excuse was: 'The Son of Heaven has for his house all within the Four Seas. Without great size and beauty, he would lack the means of inspiring awe.'

The most memorable works of Han architects were accomplished in a few periods of intense activity. In the long reign of Wu-ti (140–87 B.C.), emphasis vacillated between pleasure palaces as magnificent as those of the Ch'in, and bizarre experiments to establish contact with the supernatural world. The usurper Wang Mang, who replaced the tottering Western Han regime by an uneasy interregnum (A.D. 9–23) used architecture as one of his chief instruments. His claim to govern by goodness, like the sage-kings of old, led him to build a succession of monuments of the sort traditionally associated with kingship: a Ming T'ang, a *Pi Yung* lake-side hall, a Ling T'ai, and a nine-fold ancestral shrine, all quasi-classical in form but frankly imperial in scale. When civil war once more flared up, and obliterated most of the beauties of Ch'ang-an, the Eastern Han line that followed did its best to reproduce all but the most eccentric features of the pattern at its new centre, Lo-yang in Honan.

The momentum of the Han style was so great that it survived the second collapse of the dynasty as well. In the most troubled centuries, the third and fourth, what the Han had been able to do must have seemed the work of a Golden Age, which modern men could imitate only in fragments. When a general recovery began to be apparent, around the middle of the fifth century, something not much different from Han must still have been the natural mode. The Tartar regime of Northern Wei, in equipping itself with a proper capital in the 470s, sent its architects south from the Mongolian border to survey the ruins of Lo-yang. In 495, as a supreme tribute to the Chinese past, the Tartar court was transferred to Lo-yang itself, and the city was rebuilt after the Eastern Han formula. When in the end north and south China were reunited and Chinese culture entered a new age of imperialism, architecture shared in the general advance; but though it changed greatly,

249. Anonymous (eighteenth century): Grand Audience at the Imperial Palace. *Peking, National Palace Museum*

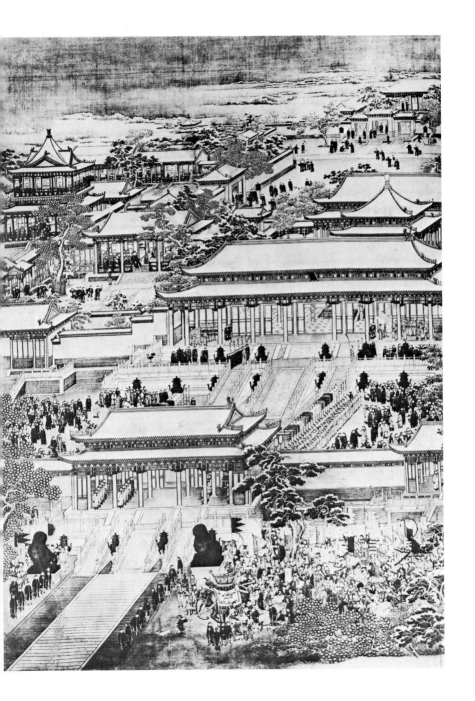

much of its stimulus must have come from a determination to equal or surpass the magnificence of Han.

Ch'ang-an, the first metropolis to be used for many generations on end, was naturally something of an experiment.[5] In its final layout order was more than usually subordinated to convenience; doubtless because the city was not planned in that form, but grew towards it gradually. The first scheme, surrounding the Wei-yang Palace, proved cramped in a few years. The principal expansion took place in 190 B.C., spreading out towards the east and north. The eventual walled enclosure was squarish, but had deep jogs on the south-east and north-east (the last being required to accommodate the river). The basic square was 15 Han *li* (about 3·86 miles) on a side, and of course faced south. Each side of the ramparts was pierced by three gateways; the gridiron of streets within was dominated by nine major avenues running each way. Against these signs of orthodoxy stood the fact that there was no principal palace on axis (and so, indeed, no proper axis at all). The original Wei-yang compound in the south-west was only roughly balanced by the Ch'ang-lo Palace in the southeast; behind this pair there were three more minor palace *enceintes*. The location of government offices and places of worship was equally irregular; they might be anywhere, in the midst of otherwise residential areas. It is not surprising to learn that when the Sui house returned to Ch'ang-an as an imperial capital in 580, the architects decided that the Han remains were too haphazardly laid out to be renovated, and so built a new city to the south-west.

Lo-yang, to judge from descriptions made under the Eastern Han and later under the Northern Wei, was much more regular.[6] The Imperial palace compound, with a big park behind it, occupied the rear centre, and the principal offices were gathered along the axial boulevards.

The Ch'ang-lo Palace began as the seat of the Han founder, and then was customarily assigned to the dowager empress. It is said to have had a perimeter of 20 (or 22) *li*, and so took up about a ninth of the city. The second emperor and his successors favoured the Wei-yang, which had a circuit of 28 (or 32) *li*. The imperial residences were increased under Wu-ti by two great pleasure-palaces outside the ramparts. The nearer, the 30 *li* Ch'ien-chang on the west, was linked to the Wei-yang by a two-storeyed covered gallery that bridged the city ramparts and moat

250. Fêng Huan cemetery, Szechwan, stone entrance marker. A.D. 121

The other, the Kan-ch'üan or 'Sweet Springs', stood on a mountain about 75 miles away. All of these palaces were full of splendid buildings of various sorts. Their park annexes, in addition, had artificial lakes and hills, were set out with fine groves and strangely shaped rocks, and were stocked with rare birds and beasts.

The largest buildings, the Halls of State, were gigantic even by the standards visible in Peking to-day [249, 327, 328]. The audience hall of the Wei-yang is said to have been 500 Han feet in length, 150 in depth, and 350 high. The last dimension presumably was guessed, and has always been the one most liable to exaggeration. The others, translated into modern terms, give a plan about 400 by 110 feet. The analogous hall in the Peking palace, the *T'ai-ho-tien*, is only about 200 by 100. The difference involves no inherent improbability, however. In a Chinese building the dimension impossible to expand beyond the limits of tree growth is the depth. Length need be limited only by expense, or use, or a sense of proportion. In the eighth century the Japanese put up a Buddha hall for their

251. Rubbing of a sepulchral tile showing a monumental gateway. Han Dynasty.
Ch'êng-tu, Szechwan, Hsi-ch'eng Museum

greatest temple, Tōdaiji, that was 290 feet long. For the Wei-yang hall proof survives in its presumed platform, a great earthen mound rising nearly 50 feet. In two millennia this has suffered much from erosion, but even its present length is around 330 feet.

The audience hall of the Ch'ang-lo Palace is said to have been 497 by 120 Han feet. That of the main Eastern Han palace was 374 by 70. The shallowness of all these structures is noteworthy, and presumably implies inexperience. The Tōdaiji hall, based on T'ang usage, was 170 modern feet deep.

Next to the Halls of State the most impressive features of the Han palaces must have been towers of various sorts. Most of these followed the ancient t'ai tradition and so were raised on bearing walls (or solid cores?) of rammed earth, now perhaps faced with stone. Gateways were marked by paired elements called *ch'üeh*, which, on a large scale, took the form of look-outs and, on a small scale, were simplified to monumental masonry pillars [250, 251]. In addition, the Han favoured what was apparently a new type of high building, the wood-framed *lou*; a structure that might be only two storeys high, but might also rise through many floors to the proportions later reached by the Buddhist pagoda [252].

None of the accounts of these towers is detailed enough to give a clear picture, or to tell whether they had any fixed place in the palace layout (as the pagoda was to have in the temple). The source at once most reputable and informative, the *Shih Chi* (written by Wu-ti's court historian), draws a rapid sketch of the skyline of the Ch'ien-chang Palace (XII). To the east of the audience hall was the Phoenix T'ai, over 200 Han feet high. To the north a large lake lapped against another t'ai of the same height (which other descriptions place at its centre). There was also a t'ai called 'Divine Radiance', Shên-ming, and a lou of 500 odd Han feet, known as the 'well-pole' because of its form. There is a much more circumstantial description, empha-

sizing an orderly east-west balance of towers, in the *San Fu Huang T'u*, a work entirely devoted to the beauties of Ch'ang-an. That, however, may be as late as the sixth century, or even mid T'ang, and is in general a little too extravagant to be completely credible.

A few towers are mentioned with suggestive details. Chang Hêng's 'Fu of the Western Capital' notes of the Ch'ien-chang Palace that 'the Heaven-reaching ch'üeh of the gateway were round, and were topped by bronze acroteria in the shape of phoenixes'. When the Cloud T'ai at Lo-yang burned in A.D. 185, 'several hundred of its rafter ends flared up together, looking like a line of ornamental lanterns. This tower, which [was said to] have been raised in Chou times, was used as a storehouse for pictures, books and records, rare *objets d'art* and curios';[7] it must have been built with rooms and a wooden superstructure. Other facts noted about some towers have to do with magic.[8] One structure mentioned in the *Shih Chi* was the T'ai for Communication with Heaven, to which Taoist Immortals were to be lured by the promise of offerings and a lofty home. A competing Taoist theory focused on the cult of a Supreme Unity was responsible for the erection of another tower: 'a t'ai (with) apartments, built in the Kan-ch'üan Palace, with paintings of Heaven, Earth, the Supreme Unity, and the various supernatural beings and equipped with sacrificial utensils so as to be able to reach the spirits of Heaven.' Cosmological ideas were certainly embodied in a precinct called 'the Radiant Year', Ming-nien, which was made up of five walled areas and twelve wood-framed lou towers.

No less insistent than the mention of height in the texts is their stress on decorations and costly materials. The most extreme claims should doubtless be discounted; the Chinese imagination has always had a weakness for gold and jade. What is certain is that palatial architecture was habitually enhanced by sculpture

and painting, to a degree unknown before and perhaps never matched again. As we shall see below, the framing of a monumental hall might be so invaded by sculpture that the two arts become almost one. Colour was everywhere. The lower wooden members were lacquered red (as might be even the courtyard pavement). Walls were a dazzling white. We read of gilded door leaves, and of bronze roof tiles and finials. Inside there might be series of wall paintings, illustrating Confucian moralities and Taoist fables; and the texts dwell so often on sparkling colours and floral motifs as to imply that all the wood surfaces were enriched by variegated patterns. Even the small-scale Han remains that have an architectural character – chiefly pottery building models, and tiles or stone slabs from tomb precincts – show a fairly rich repertory of ornamental designs; and some of these, like cloud patterns or suspended disks, can be easily identified in the texts.

A good deal of the look of the lost Ch'in and Han buildings may be recovered from the available evidence, although the picture must remain imperfect because so much is unexplained. The blocks of information are fragmentary, and usually overlap too little to help explain each other. The pottery models chiefly record the humbler levels of construction: farmhouses, granaries, ordinary watch-towers [252]. The engravings on the stone slabs from Hsiao-t'ang Shan or the Wu family cemetery show mansions in front elevation [253].[9] Much of the useful data in literature comes from casual references to parts of buildings. The deliberate attempts to describe architecture in words are made unclear by their very stylistic pretensions. The likelihood that a good deal of Han flavour survives in remaining works of the late Six Dynasties – Chinese cave temples, Korean tombs, the earliest buildings in Japan – is hard to tie in with specific details. It is possible, all the same, to make a number of general statements with confidence.

The poor in Han cities were still sheltered by thatch. The great, both in their mansions and in

252. Pottery house model. Han Dynasty.
Kansas City, Nelson Gallery of Art and Atkins Museum

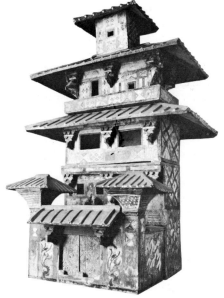

253. Wu family cemetery, Shantung,
sepulchral stone showing a palace (drawing and rubbing).
Han Dynasty

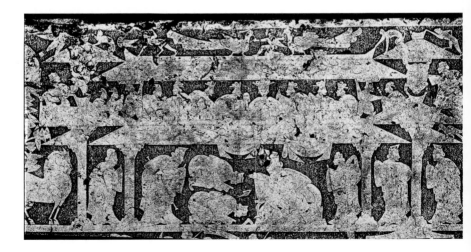

the public offices where they carried out their duties, made use of an architecture whose general layout was like that of later times. The buildings were assembled around courtyards, with left balanced against right and the main hall on centre at the rear. Along the main axis courtyards succeeded each other with a corresponding increase in privacy. There were the inevitable front and side gates; a proper gate on axis was a building in itself, with side chambers. As in the later Buddhist temples, the court might be enclosed by galleries, leading back to the hall.

The hall, with its platform and left-and-right staircases, now might be two-storeyed. The Wu slabs show more than once a scene of feasting in which the ground floor is set aside for domestic services, and the guests sit in a *piano nobile* reached by a ladder-like stair. How the interior was subdivided can be only surmised. Buildings with any claim to dignity, all the way from a gentleman's house to the audience hall of the palace, possessed east and west areas that now were called *hsiang*. If one assumes a pillar alignment like that familiar in later times, symmetrical in both senses, with a relatively large open area at the centre and a narrower surrounding space, or aisle (e.g. illustration 261), the hsiang might have been fitted into the end portions of the latter. Apparently they were separated off only by light partitions or curtains.

The dimensions recorded for the audience hall of the Ch'ang-lo Palace, on the other hand, speak of a total length of 497 Han feet, and a net length inside the hsiang of 350 feet. Each hsiang must thus have had a width of 73·5 Han feet, or about 60 English feet. It would have been impossible to construct a conventional, central-space-plus-surrounding-aisle plan from such dimensions; the hsiang were much too big. One must conclude that they formed distinct wings, with their own roofs and interior pillars.

To substantiate the possibility of a design so different from the geometrical severity of later

monumental architecture, various arguments may be proposed. One important piece of evidence is given by the form of the inner throne hall or *Shishinden* in the traditional Japanese palace, dating back at least to the ninth century and certainly based on a Chinese prototype.[10] There no surrounding aisle exists; instead, the throne chamber proper is framed by four long separate rooms [254]. The Japanese call these

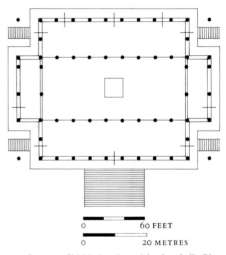

254. Japanese Shishinden (imperial palace hall). Plan

hisashi, writing the character in a way virtually identical with the Han hsiang. The twelfth-century pictures of the Shishinden show that it was then crowned by a single, over-all roof. Since the corners of the hall were deeply indented, the roof corners had no natural support and had to be propped up, each by a free-standing pillar. So awkward a solution must imply that the builders were trying to fit an up-to-date monumental roof over a ground-plan designed for something else. Actually, the form most natural to the Shishinden would have been

one in which each hisashi-hsiang had its own roof, running like a penthouse away from the main block, or equipped with a separate ridge. That such a compound mass was at least known in Japan is proved by a pottery house model,

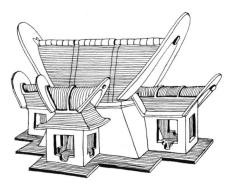

255. Pottery house model from the Gumma Prefecture. Probably fifth century A.D. *Tōkyō National Museum, Japan*

probably of the fifth century, unearthed in the prefecture of Gumma [255]. The details have the primitive look proper to early Japanese carpentry. As a whole, however, the building is unique. I suggest that it represents what was always a rare species in Japanese use, based on the nearest continental precedent – a Korean one; which in turn, like all the civilized traits that were known in Korea of the fourth or fifth century, was derived from Han usage.

Architectural paintings in the Sung style habitually deal with conglomerations of this sort, rendered with the much greater complication and elegance of that age [294]. Certainly these stand for a world of pleasure, and were permitted a gaiety that would have been out of place in the more dignified parts of the palace. The basic idea may well have been an old one by Sung times; and in the Han, when exuberance had not yet been tamed, may have been applied even for the grandest imperial problems.

The rich vocabulary of the Sung pleasure-palace included the descendant of another element referred to in Han texts, the *hsien*. The first use of the term was to describe a hood at the front of a certain type of chariot. The earliest amplification of the idea was probably something like a fixed awning or marquee set up across the front of a hall, providing a more effective shelter than could be given by the main eaves high above. Thus a passage from the Former Han history, *Han Shu*, describes the ruler attending a performance of music in the palace courtyard, from his station in the 'overlooking *hsien* above the balustrade'.[11] It must have been a second stage, a transformation into a permanent porch, that explains a phrase in Pan Ku's fu describing Ch'ang-an; the hsien he mentions are two-storeyed. Two third-century fu add illuminating details. The hsien in Tao Ssu's description of the capital of the Shu kingdom are 'high, so as to look down on the hills'; and those in his account of the Wei capital are called 'surrounding', presumably because they rose on all four sides of the hall block. Very likely these appendages, more picturesque and informal than the hsiang, were kept even in Han for semi-formal structures. The two fu that picture single buildings meticulously – one dealing with the *Ling-kuang Hall* in Lu and the other with the *Ching-fu Hall* of the Wei kingdom – mention hsien only in secondary structures.[12] It is clear that in both great halls the passage through the main doors brought at once (as it would to-day in the Peking T'ai-ho-tien) a change from sunlit brilliance to gloom.

The texts mention other plan elements whose names we have met under the Chou: shih apartments, fang chambers, and for the ruler a withdrawing room and dressing alcoves. To locate these precisely is impossible. They may well have represented as elementary a stage of subdivision as is seen in the traditional imperial residence of Japan, like the *Seiryōden* of the

Heian palace. The fu of the Ching-fu Hall likens its inner parts to the teeth of a comb; one supposes because many of the rooms had the same size and ran parallel (though the next sentence speaks of spaciousness and variety).

A single-storeyed house might or might not have a ceiling, whose utilitarian purpose was revealed by the name 'dust-catcher'. The fu speak of a grander overhead covering, the ancestor of the ceiling cupolas still to be seen in many temple buildings from Sung on [313, 315, 318, 319].[13] Though no text states the fact, it may be that this treatment was kept for imperial use; its symbolism was perhaps too potent to be permitted anyone but a Son of Heaven (and his immediate family). The fu of the Lu hall (whose builder was an imperial prince) uses an explicit metaphor; the cupola is called a 'sky-window', or 'window to Heaven', not because it was an actual skylight or dormer, but because it was a symbolic means of access, magically effective through shape and position. In conjunction with the 'sky-window' are mentioned terms that I take to mean a flat, coffered ceiling, with a roundel sunk or painted in each coffer and embellished by lotus blossoms.

The fu reach their most remarkable combination of enthusiasm and precision (and, unfortunately, their lowest point in clarity) in describing the complex of girders, beams, purlins, kingposts, struts, braces, and brackets required to hold up the mighty tiled roof. Unfortunately, again, one cannot reconstruct all this in close dependence on the look of later halls. It is puzzling, for example, to find mentioned both a cupola-ceiling and a roof-tree with kingposts. Extant buildings have either exposed under-roof constructions, or ceilings suspended at the level of the lowest girders. In Han perhaps the cupola and its coffered frame were kept like a fixed canopy for the centre bay only, above the throne.

One structural element catalogued, the combination of projecting arms and impost blocks used for bracketing, is well attested in Han remains. The pottery house or tower models and the big Szechwan cemetery pillars show the same basic form [250, 252]. The bracketing may rise from a pillar capital, or from a corbel in the wall. The first member used to spread the weight-bearing surface will be a longitudinal arm, parallel to the wall. At each end will be set a bearing block; and these two will support a longitudinal beam, or the eaves purlin, or a second-tier arm with more blocks. The system is obviously a prototype – still only partially thought out – for the more effective techniques of later times. The pottery models and the Szechwan pillars show only a single step outward, where the T'ang repertory will have as many as four. The evidence they give should perhaps be applied only to their limited fields; but Han carpenters, in the first age of colossal architecture, may well have been more cautious than their successors. Again, the tendency of Han designers to give way to fancy is seen in the variety of shapes allotted to the arm; it may be straight, or arch up towards either end in a curve suggesting the tensile strength of wood, or be cut in a sinuous line. The arm, finally, is equipped with only two bearing blocks, where the later styles will have three.

All visible remains testify to an invasion of Han architecture by sculpture. The palaces engraved on the Wu slabs, for example, may have human or animal caryatids in place of columns and bracketing. On the corners of the Szechwan pillars hunched-over bears may serve as corbels. On a tower model in the Nagao Collection in Japan, eaves brackets fan sidewise above elongated dragons' heads. In the two fu this entanglement of structure and symbolic decoration is pictured at a climax. In the Lu hall, particularly, the observer sees the underframing of the roof alive with a multitude of bird and animal forms (some perhaps painted). There, too, bears serve as caryatids; but more often the creatures simply play among the

structural members, winged serpents twining around the rafters, apes chasing each other, tigers locked in combat. So much of this extravaganza is reproduced on the more elaborate Szechwan pillars that their sculptors might almost be imagined as having followed the fu text.

It would be extremely difficult to identify and interrelate properly all the members named in the two fu. A few identifiable items deserve mention. In the Lu poem 'the crossbeams arch upward like rainbows'. We shall find the memory of such a curvature surviving later in

character *ang*, which later (and presumably then also) indicated one of the most effective parts of the bracketing system, a long slanting arm running out through the wall plane to help brace the weight of the eaves. The Wei poem speaks of their hopping like birds, across an interval; and says that they were supported by 'paired shafts', these last being probably the inverted V-shaped member we shall meet in the earliest Buddhist remains [257, 265]. One unique sixth-century tomb in north Korea has its cupola braced by a combination something like that suggested in the poem [256].

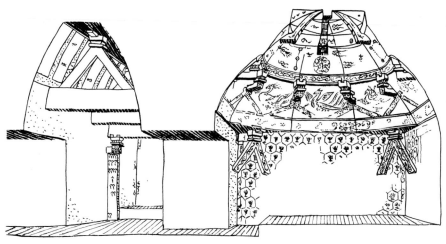

256. Koguryo kingdom, Korea,
'Tomb of the Celestial Kings and Earthly Spirits'.
Sixth century. Interior

carpenters' terminology, where the cross-beam is often 'a rainbow' or 'a moon'. An actual curve is still traceable in the earliest buildings in Japan, and thereafter will be found imitated even though the beam has stiffened to a horizontal. Again, the Lu 'bearing blocks mount tier on tier to dizzy summits; the curved bracket arms are linked together in series' (as on some of the Szechwan pillars). Most interesting is the appearance in the third-century Wei fu of the

Two exceptional categories of architecture developed under the Han should be noted, one epitomized by the quasi-traditional Ming T'ang, the other represented by the exotic Buddhist temple.

A century after Wu-ti had built the first imperial Ming T'ang in Shantung, the usurper Wang Mang raised a much more pretentious structure at the capital, in A.D. 4. Though detailed descriptions are lacking, the intellectual

atmosphere of the age makes it likely that this building embodied a cosmological symbolism similar to that related in the just-completed books of ritual. Its general mass doubtless subscribed to the memorable phrase in the Senior Tai's version, 'round above and square below'. The notice taken of a grand rite performed in A.D. 5 suggests that even the participants were drawn closely into the magical number system. Apparently to personify both lunar and solar cycles, there were present twenty-eight great lords and one hundred and twenty lesser ones. Wang Mang's temple was burned in his downfall; but when the Han house was well settled again at Lo-yang, an imperial Ming T'ang was built there in A.D. 59 that must have had at least a roughly comparable form. Chang Hêng's 'Fu of the Eastern Capital' summarizes its characteristics thus:

'A two-storeyed fane with double eaves, having eight apertures and nine chambers; compass-drawn like the Heavens and squared-off like the Earth; telling of the seasons and conforming to the cardinal directions.'

From various other sources (not always in exact agreement) one can draw a long list of symbolic numbers. The eight windows stood for the eight winds, and four other apertures for the seasons; the nine apartments for the divisions of the empire; the twelve halls or thrones for the months; thirty-six other doors for the number of ten-day periods in the year, and seventy-two other windows for the number of five-day periods. Han architects seem to have been able to assemble all these data into a building that would stand and last (the Ming T'ang of A.D. 59 was still in use under the Wei kingdom).

To those who succeeded Wang Mang, the nine shrines that he raised to his mythical ancestors were even more outrageously wonderful than his Ming T'ang. The chief of these, the shrine of the 'Yellow Emperor', is described in the *Han Shu* (XCIX) as being 'east-west north-south each 400 feet, and 170 feet high, the other shrines being half that size'. This sort of building cannot have been anything like the long, relatively shallow audience halls. In Chinese structural terms, a hall with a depth of 300 English feet could have been raised only if it had a Greek cross plan. The shrine to Huang-ti must have had something like the mass of the standard Late Byzantine church. Each arm presumably had its own roof, with a ridge running towards the main block; the latter very likely was raised a storey higher, and at that stage became round. Exactly this sort of plan has been proposed by the modern Chinese scholar Wang Kuo-wei, as the handiest way of reconciling the statements made about the ancient Ming T'ang.[14] It may very well have been adopted for Wang Mang's Ming T'ang, and followed in Eastern Han; the equation between ancestral shrine and Ming T'ang has always been drawn close to identity.

Archaeological evidence concerning the great imperial palaces and shrines has been collected by the Communists primarily around Hsi-an in Shensi, from the Ch'ang-an of Han and T'ang times. Preliminary excavations in the area of the Western Han capital have uncovered the foundations of a monumental building with a compact Greek-cross plan (the arms very short): the shape that the Chinese call *ya*, with reference to a familiar Shang graph used in bronze vessel inscriptions. The building stood on a square terrace which rose from a larger circular platform, some sixty metres in diameter. This was enclosed by a walled square, 235 metres on a side, with four axial gatehouses. Still farther out was a narrow circular moat. This interrelationship of square and circle was doubtless intended to recall the ideal forms of Earth and Heaven, and so to give the building at the centre some major cosmological role, as a Ming T'ang or as the Pi Yung 'university'.

Later clearing on the south side of the old city disclosed eight large square-within-square

complexes from 260 to 280 metres on a side, which have been tentatively identified as the mammoth shrines erected by the mid Han usurper Wang Mang to his alleged ancestors. In one of these a rammed-earth terrace, square with small square corner projections, again suggests one of the schemes proposed for the state Ming T'ang.

Buddhism is known to have made a partial penetration of China under the Eastern Han.[15] The standard term for a Buddhist temple or monastery, *ssu*, is simply the generic name given to certain governmental offices under the Han and Three Kingdoms, and may have been adopted either because of a similarity of form, or because the first recognized temples were organized by the State. Buddhist histories claim that several monasteries were founded in this age, but proof is lacking. The earliest description, however, dating about A.D. 190, shows the existence of a recognizable Buddhist sub-style. The builder, one Chai Jung of the province of Kiangsu, 'erected a Buddha shrine, making a human figure of bronze to be gilded and clad in brocade. Nine tiers of bronze disks were raised above a two-storeyed pavilion. The covered galleries could hold about 3000 persons.'[16]

We see here the germ of the later Chinese pagoda, close to the Indian *stūpa* type only in its mast and tiers of symbolic parasols. At the same time the layout seems to have followed Indian tradition in giving all emphasis to a single building, which served as both stūpa and image hall. The surrounding galleries must have been drawn from Chinese usage; we shall find them a standard feature for the next thousand years.

Evidence from underground tombs – provided both by their forms and types of decoration and by the simulated buildings they may contain – becomes plentiful from the first century A.D. on. Earlier burials, though sometimes carried out at royal scale, had been no more than exceptionally solid log cabins, sunk deep into the earth. After the middle of the Han dynasty masonry was preferred. Brick had the widest distribution, being found as far south as Vietnam. In the north, around Lo-yang in Honan, a hollow building tile was popular during much of the dynasty. In the north-east large stone slabs were used, both as walls and for corbelled ceilings. The Chinese knew the principle of the true arch, but used it as gingerly as did the Greeks, for utilitarian purposes only, and usually with brick. By the second century ground plans reach an early climax of complexity and extent. One line of development, best seen in the two large princely tombs at Wang-tu in Hopei, led to a skeletal articulation: three main rooms in line from south to north, joined by corridors, with smaller store-chambers balanced on right and left. All these spaces were covered with brick tunnel vaults; by keeping the major spaces high and the minor ones low, the problem of vault intersections was bypassed.

The stone tomb type, found chiefly in the northern coastal region, led to a highly compact plan: in principle one, two, or three narrow grave chambers side by side, surrounded by aisles and often expanded by store-chamber wings. The most interesting example is at I-nan in southern Shantung (cf. page 83), dated by some at the end of Han but probably better placed a century or so later under the brief imperial revival of Western Chin. The main ceilings, over squarish rooms, are boldly corbelled, either in simple steps or in the square-and-diamond sequence known to Western art historians as the Laternendecke. This feature was to be imitated later in the stone tombs of the North Korean kingdom of Koguryo, as well as in the painted ceilings of Buddhist cave chapels in Central Asia. The origin of the idea is still unclear: presumably it must be sought in some wood-framing tradition long practised in middle or western Asia.

The I-nan tomb is remarkable also in two other ways. Two of its main rooms have an isolated stone pillar apiece, crowned by an over-sized bracket with extensions to either side in the form of oversized, upside-down dragons: a forceful instance of the kind of sculptural exuberance described in contemporary texts (pages 382-3).

Again, the walls of the major rooms are richly decorated with engraved compositions, several of which are scenes in an architectural setting. These last are much more varied and informative than the long known Han material from Hsiao-t'ang Shan of the Wu family cemetery (page 379). The little buildings are shown in bird's-eye perspective, with a marked concern for small realistic details. Their closest analogies lie in the very numerous ceramic buildings in miniature that appear in well-furnished tombs in the final two centuries of Han. Our acquaintance with such models is of course not at all new. The Communist period has provided a great many more intact or well preserved examples, secure means of dating, and enough examples from known sites to allow at least beginning studies of regional peculiarities. In particular the region around Canton has yielded many models with a sub-tropical flavour – stilt foundations and openwork partitions. Perhaps the oddities seen in the I-nan engravings are also provincial, developed at a period when the unifying power of the imperial capital was weak.

THE PERIOD OF THE SIX DYNASTIES
(A.D. 265-581)

The demoralization of the Six Dynasties favoured chiefly those arts and systems of thought that promised escape; Buddhism, the cult of nature, painting, calligraphy, or poetry as an exercise of genius and critical speculation. The art of building was too close to fact to share

any of this profit; its best hope was to survive by the momentum acquired in Han.

At least until the sixth century, feats of construction were on a smaller scale than before, though the foremost imperial buildings might still be very splendid.[17] Conspicuous extravagance was an ever-present possibility, but its cost was likely to be the fall of a dynasty. History remembers one spendthrift at the end of Southern Ch'i (r. 499-501) who complained because a pleasure tower was painted with ordinary blue instead of lapis; and a last ruler of Ch'ên (r. 583-8) whose palace diffused for miles around the odour of sandalwood. In contrast to these familiar follies one finds a marked slackening of interest in the Ming T'ang, natural enough in an age bored by Confucian theory. With the Liu Sung regime the royal temple became merely another large hall, unusual only in the twelve bays of its façade. The Liang made their Ming T'ang out of the timbers of the Sung audience hall, and so must have reproduced a similar form. Only the Tartar regime of Northern Wei, which needed Confucian training to pull itself out of barbarism, tried to revive the old complication. Much of the result tallied with Han theory; roundness and squareness, basic numbers like 4, 5, 9, 12. There were no 'double corners', so that the plan was probably a square rather than a cross. One detail was new, and perhaps symptomatic of a change in thinking. 'Below the ceiling was set a rotating mechanism, embellished with a view of the sky, on which were painted the various celestial bodies.'[18]

A few other signs mark an accumulation of experience. One third-century tower was framed of wood with such economy that its top swayed in the wind. It was in fact perfectly safe, but when the ruler – who found its motions upsetting – ordered it to be reinforced, it collapsed because the balance had been upset. The stories told about the barbarian king

of Later Chao, Shih Hu, who ruled part of the north-east in the second quarter of the fourth century, make him as fabulously ostentatious a builder as any in the south. His *T'ai-wu-tien* was a big hall, with columns of 'silver and gold', and so on; chiefly remarkable was the fact that the platform, twenty-eight feet high and of marble, was tunnelled out to make rooms for the bodyguard. Presumably this involved a more ambitious use of vaulting than usual. If so, the fact was exceptional (perhaps a sign of contact with the West?), and had no known sequel.

The rising fortunes of Buddhism gave the architecture that served it a special stimulus. At the period when imperial piety was most intense – the first third of the sixth century, when the regimes of Northern Wei and Liang were rivals in good works as well as in politics – the balance of expenditure must have weighed down the Buddhist side more heavily than the secular. The distinction is in part artificial, since many of the most lavishly equipped monasteries began as great mansions, and required little change; but certainly the most spectacular public works were Buddhist from the start.

The quantitative side of Buddhist architecture grew with astonishing swiftness. By the beginning of the fourth century the faith was securely implanted at the Chin capital, Lo-yang. Worship was offered to the Buddha in forty-two pagoda-temples, there were holy men from India and Central Asia, the libraries of sacred literature were swelling. Two centuries later, out of these signs of early enthusiasm had swelled an institution so gigantic and potentially dangerous that even the friendly emperors of Northern Wei were constrained to impose severe limits on its growth. In and around the Lo-yang they ruled there were some 500 temples, taking up two-thirds of the available land; and the northern empire contained a registered total of 13,727. When the Wei regime collapsed in the 530s and north China fell once

more into anarchy, public despair found no hope or safety except in the Church. The number of religious rose rapidly to around two million, and the number of establishments to around 30,000. Most of this growth was levelled by the Northern Chou proscription of the 570s; but within a decade the succeeding Sui emperor found it both good and expedient to restore as much as he could.

The same pressure to expand affected the extent of single temples and the size of buildings. When the first well-remembered missionary reached south China in the third century, the monk K'ang-sêng-hui, he made himself a chapel in the Wu capital out of thatch. As soon as official interest turned to the new faith, Buddhist precincts began to be dignified in the traditional Chinese way, by walls, high gate-houses, galleries, and monumental halls. As the process became an ever more conspicuous part of the new way of life, it became necessary to defend the Church against the same complaints that once had been made against the feudal lords. Why such size, such costly materials, so much cunning craftsmanship? The best reply was the frankest; not the sort of fairy-tale indifference to fact preached in the Indian books, but good Chinese accounting. Buddhism, it was retorted, has proved so immensely valuable, both to human hearts and to public morality, as to make any monetary cost negligible.

As the principal monument of Indian Buddhism had been the stūpa, so it was the pagoda that dominated Chinese temples until late in the period. Buddhist growth may be roughly measured by an increase in pagoda storeys. The fourth-century norm seems to have been three. Wu-ti of Liang (r. 502–49) erected a number of five-storeyed pagodas at outlying holy places. For his own daily devotions he built a magnificent Buddhist centre called Tung-t'ai-ssu, just north of the palace. There the pagoda was nine storeys high; there were in addition six major

halls and ten or more secondary ones, as well as two three-storeyed t'ai on east and west. When lightning destroyed most of this in 535, the rebuilding programme centred on a new pagoda of twelve storeys.

By their own account the greatest pagodas were built by the Northern Wei. In 467 the Tartar lord erected at his capital (the present Ta-t'ung-fu in northern Shansi) a pagoda of seven storeys, over 300 Wei feet high, 'the foremost on earth', for a temple called Yung-ning-ssu.[19] At the same period was achieved a feat even rarer in China: the raising to 100 feet of a three-storeyed pagoda of stone. After the capital had been moved south to Lo-yang and Wei culture had reached its phase of rankest growth, all precedents were outdone in the construction of a new Imperial Yung-ning-ssu, from 516 on. The description of the monuments of this temple is worth quoting in part.

'At the centre was a nine-storeyed pagoda framed in wood. This rose 900 feet, and had a mast 100 feet higher still. It was visible at a distance of 100 li from the capital. . . . On the mast was a gold "treasure vase". . . . Beneath were thirty tiers of gold "dew-basins", each ringed by gold bells. Four lines of iron chains led down from the mast to the four corners of the pagoda, and these also held gold bells, each the size of a tomb statue of stone. Furthermore, there were 120 gold bells that hung from the corners of all nine storeys, from top to bottom. The pagoda had four sides, each with three doors and six windows. The doors were all lacquered red; each leaf had five rows of gold nail-heads, set into gold bosses, there being of these 5400 in all.

'North of the pagoda was the Buddha hall, formed like the Hall of State. At its centre were an eighteen-foot gold image and ten life-sized gold figures. . . . The priests' dormitories with their towers comprised more than 100 bays. . . .[20] One gateway opened in each of the four sides (of the outer wall). The southern one had a three-storeyed tower and a triple passageway. It rose 200 feet, and was formed like the outer gateway to the imperial palace. . . . The east and west gates were similar, except that their towers were only two-storeyed. The north entrance had no building and only one passage, and was similar to a "crow-head gate".'

The one fictitious item in this account, taken from a description of the Lo-yang temples made a generation after their destruction, the *Lo-yang Ch'ieh-lan Chi*, is the height claimed for the pagoda. Two other versions are more plausible. The Wei history speaks of more than 400 feet, and the contemporary gazetteer *Shui Ching Chu* records a height of 490 feet and a base dimension of 140 feet per side. Reduced to modern terms this would give a height between 300 and 400 feet, comparable on the one hand to the tallest Han lou and on the other to the most ambitious wood pagodas of T'ang (the Japanese at Tōdaiji reached about 325 English feet).

The account is valuable in stressing the close similarity between secular and religious architecture. Only the pagoda was unmistakably Buddhist. It was, therefore, the one alien element in an otherwise traditional way of building. Its use posed two basic problems, placing and form.

Nothing is clearer than the difference between the original stūpa of India and the wood pagoda. The two cannot, in fact, stand in any closer relationship than that involved in the transmission of mast and parasols. It was not the stūpa proper that the Chinese admired, but a still-mysterious substitute: the multi-storeyed tower made famous in the West by the builders of the Kushan empire. The most remarkable, the huge pile erected in the second century A.D. by the emperor Kanishka at his capital near modern Peshawar, in north-west India, was very likely the inspiration for the major Chinese efforts. The Wei pilgrim Sung Yün, who saw the Kanishka tower in the early sixth century, after it had been burned and restored three

times, found it made of wood in thirteen storeys, and topped by an iron mast with thirteen golden disks, the total height being 700 Wei feet.[21] Much nearer than north India and so known earlier were the structures of Chinese Turkestan, which must have owed their form to an eastward expansion of the same Kushan Buddhism. In the Turfan region the ruins of a number of multi-storeyed brick towers are visible to-day. The Chinese probably required only a reassurance that the focus of worship in the temple could be a tower of several storeys; and thereupon adapted for that purpose their well-established wooden lou, the belvedere used since Han.

Since the Yung-ning-ssu giant of 516 is known to have been merely an enlargement of its predecessor of 467 in the north, it is not surprising that the description should tally roughly with rock-cut pagodas in the Yün-kang cave shrines [257]. Simpler versions, based on more modest originals, are imitated in stone elsewhere at Yün-kang and Lung-mên. The type exists at full scale in three seventh-century wooden pagodas of Japan: the five-storeyed one at Hōryūji, and its three-storeyed imitations at Hōkiji and Hōrinji (the last destroyed by lightning during the Second World War). The design in all cases involves the repetition of a basic storey unit, square, with its own roof; the whole diminishing regularly, and crowned by a prominent mast and disks [cf. 274]. The number of openings on each side could range from the maximum used at Yung-ning-ssu, three doors and six windows, to the single door of Hōrinji. Where Chinese carpentry methods were dominant, as in Japan, all the members below the mast might equally well have been set on any secular building of similar size. In the stone translations at Yün-kang, it was as natural to crown the simulated wall openings – niches, not doors or windows – by the north Indian frames

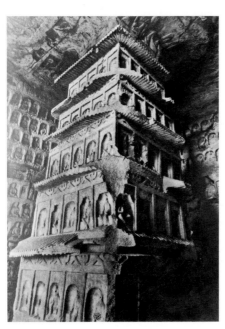

257 (left). Yün-kang, Shansi, rock-cut pagoda inside cave 39. Late sixth century

258 (right). Mount Sung, Honan, twelve-sided pagoda of Sung-yüeh-ssu. About A.D. 520

259 (far right). Shên-t'ung-ssu, Shantung, square pagoda. A.D. 544

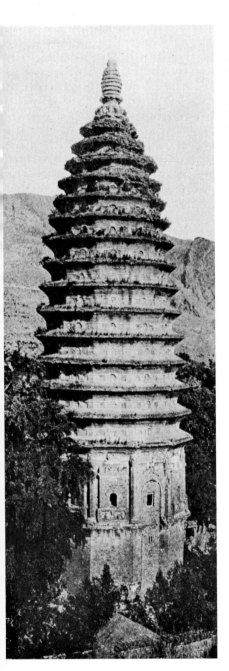

used elsewhere in the caves, flattened arches and truncated gables. Perhaps the same exotic shapes were rendered in wood on the towers of the Wei capitals.

The square, multi-storeyed pagoda was not the only form current during the Six Dynasties. Three or four different masonry survivors from the sixth century may still be seen in north China.[22] The earliest, belonging to Sung-yüeh-ssu on Mount Sung in Honan, is unique in the Far East, and doubtless when it was built in the 520s represented an exceptionally faithful reproduction of some Indian model of the contemporary Guptan style [258]. The plan is a dodecagon of brick. There is a high, plain plinth, and then a *piano nobile* with corner columns. The remainder is a succession of corbelled eaves, diminishing along an elegant curve, and topped by a masonry replica of the usual mast and disks. Details are purely Indian. An arched recess marks each cardinal face of the

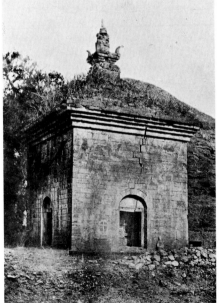

main storey, and miniature arches are spaced round the eaves. Each of the secondary façades is filled by a simpler pagoda type in relief: square, single-storeyed, with a pedestal underlined by lion busts, and a dome rising out of foliated acroteria.

It was something like this secondary form that was followed in stone in building the small 'four door pagoda' *Ssu-mên-t'a*, of Shên-t'ungssu in Shantung, in 544 [259]. A more complex version preserved at Ling-yen-ssu, the tomb pagoda of Fa-ting, has two tiers of corbelled eaves. A fourth brick survivor more like the Sung-yüeh-ssu tower has recently been discovered at the ancient pilgrimage temple of Fokuang-ssu, among the peaks of Wu-t'ai Shan in Shansi.[23] This has two hexagonal storeys, the lower one plain except for a single arched doorway leading to its core. The upper storey has squat, Indianizing columns at its corners, each banded with three rings of lotus petals. There is a smaller arched door on the axis, and the other faces have simulated latticed windows. The plinth and eaves of the upper storey are developed in tiers of small, overhanging lotus petals. The spire, now decapitated, recalls the centre of a Baroque fountain. Over each window was once painted a fictitious wooden brace, in the shape of an inverted V. The details suggest a date around the middle of the sixth century (by comparison, for example, with the cave shrines of T'ien-lung Shan in Shansi and of Hsiang-t'ang Shan in Honan).

The closest approximation to the Indian stūpa, the single-storeyed design seen in the Ssu-mên-t'a, seems to have been more popular than constructed remains suggest, since it is frequently found in relief on stelae or cave walls. A miniature variant, the reliquary held by the Guardian King of the North on the Hōryūji altar, has five spires springing from tiny domes on its flat roof; our first clear sign that Buddhism developed a cosmological symbolism as definite as that of the Han Ming T'ang. Another

miniature, the 'Aśoka reliquary' in the 'Aśoka temple', A-yü-wang-ssu, near Ning-po in Chekiang, has instead of a dome a single, central spire and four high, horn-like acroteria at the roof corners. Of this a T'ang description comments that it was like 'the *stūpas* made in Khotan, in the West' (i.e. in Chinese Turkestan). The comparison may explain the source of the single-storeyed type as a whole.[24]

The problem of placing the large pagoda within the traditional Chinese plan found one stock solution in the Six Dynasties. Being still the principal centre of worship, the tower rose isolated in the courtyard, on the axis. Behind it, also isolated, might stand a Buddha hall, with an altar set out with images. The complete scheme, as attested by numerous ruins in Japan and Korea, provided another large building on axis to close off the courtyard at the rear, the lecture hall, where the monks met to study their scriptures. Here too the source of the design may have been the practice of the great oasis cities of Chinese Turkestan; for the pilgrim Fahsien records having seen a combination of front tower and rear hall outside of Khotan, constructed eighty years before his visit in 400.[25]

Space limitations prevent any extensive analysis of Japanese architecture in the Six Dynasties style. Since the Japanese buildings are the only ones that remain in wood, however, their characteristics must be summarized. The seventh-century group comprises the front elements of the courtyard nucleus of Hōryūji – middle gate, galleries on three sides, fivestoreyed pagoda, and a Buddha hall called the *kondō*, 'golden hall' – the two neighbouring three-storeyed pagodas of Hōkiji and Hōrinji, and the architectural reliquary, the Tamamushi shrine, whose proper place is on the kondō altar [260, 264]. Historical and archaeological arguments suggest that the kondō is the earliest of these, having been built around 625 as a memorial chapel to the just-deceased founder of Hōryūji, the regent Prince Shōtoku. The

monastery itself had apparently been in existence since 607, on a site somewhat removed from its present one. It was obliterated by fire in 670. When rebuilding took place shortly afterwards, the founder's chapel (which had been saved by its outlying location) was used as a main hall, and the rest was grouped round it. These unusual circumstances presumably explain the unique general plan of the present Hōryūji, in which pagoda and hall are side by side (the original monastery had had the orthodox arrangement). The Hōkiji pagoda was erected in 685, by the evidence of an inscription that once was set on its mast. Throughout these buildings runs a common style, implying that the later ones were deliberately based on the

kondō out of reverence. The Tamamushi shrine, which varies in some details, is undated, but can hardly have been far distant from the rest in origin.

At Hōryūji the look of the main buildings has been best preserved in the middle gate [260]; the kondō and pagoda have been disfigured by additions made to increase their floor space. All roofs have been rebuilt in a Japanese technique, the kondō's with the greatest divergence.

The kondō, being designed for services at an altar, has the most interesting plan. The outer rectangle is five bays by four, about 46 by 35 English feet. The interior is strictly symmetrical about both axes [261A]. There is an open central area, three bays by two, which is almost

260. Hōryūji, Japan, middle gate.
Late seventh century

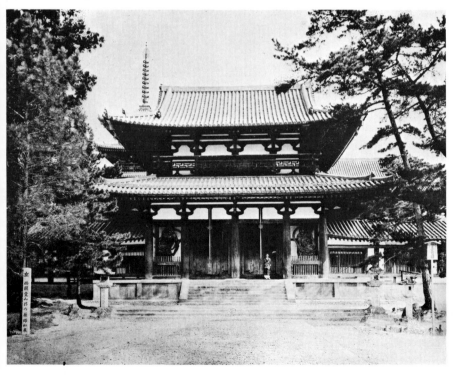

261. (A) Hōryūji kondō, Japan;
(B) Tōdaiji Hokkedō, Japan

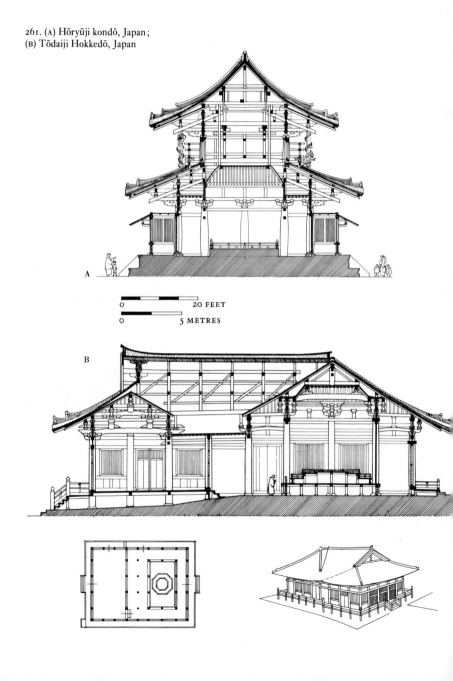

A

0 20 FEET

0 5 METRES

B

filled by a platform altar, and a surrounding aisle. The aisle has a low, reticulated ceiling and its own penthouse roof. The central area has a similar ceiling, given greater dignity by a steep cove, but still held within the limits of a ground storey; the space above is inaccessible.

The kondō altar is set out with images facing in all four directions (though the principal ones are oriented southwards). This, and the double symmetry of the plan, produce an effect not unlike that of the cave shrines at Yün-kang where a square pier, with niches on the four sides, occupies the centre of the room. The ultimate source of the idea was probably the Indian stūpa, oriented toward the cardinal points and surrounded by its processional path.

The columns typical of the Six Dynasties style in Japan have something like the proportions of the Greek Doric, with a strong entasis. The capital, too, looks Doric, though more Roman; there are equivalents to the astragal, the echinus, and the abacus, differing chiefly in the fact that the whole capital is square. The resemblance may be more than accidental, since rough imitations of all three classical orders may be picked out at Yün-kang.

The bracketing system is charming, inconsistent, and structurally immature, a combination doubtless inherited from Han. Two radically different forms are used. Above the interior columns, and throughout the courtyard galleries, support is given by short, sturdy arms let into the abaci [261A, 263]. Each arm holds three bearing blocks; the curve at the end of the arm, and the short counter-curve of the moulding produce a cyma line of great beauty and vitality. The exterior bracketing of the main buildings, on the other hand, features the slanting ang cantilever, braced by a transverse arm that inside is continued as a cross-beam. These two members are uncompromisingly straight-lined, while the others are cut out in a sinuous 'cloud-pattern' silhouette. This sort of bracketing is virtually two-dimensional. The

only lateral expansion to provide a wider bearing for the eaves purlin occurs at the top of the system. The purlin is unsupported between columns. At the corner of the building, where the span is necessarily longer, this simplicity involves a greater danger [262]; it is significant that the repairers of the kondō found it necessary to prop up the sagging corners of the main roof with special pillars. The Tamamushi shrine shows an ingenious experimental solution of the corner difficulty; its ang are set on radii, so that there is a gradual preparation for the diagonal axis at the corner, and the purlin spans may be made equal.

262. Hōryūji, Japan, middle gate, corner detail

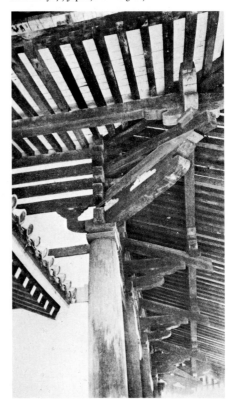

The half-decorative bracketing under the balconies of the kondō and middle gate has preserved another characteristic archaic detail: the inverted V brace, used between columns [260]. A similar form is used on a larger scale, like an embryo truss, inside the galleries, between cross-beam and ridge-pole [263].

The Tamamushi shrine [264] bears witness to the shape taken by a visually important piece of ornament, the tile acroterion rising at either end of the main ridge, and known by the descriptive name 'owl's-tail'. As to the roof itself, it should be noted that the Japanese copyists favoured the intermediate type that it is convenient to call the hip-and-gable. The original design still visible on the Tamamushi shrine makes a marked break in slope between the two halves.

All of these details except the ang complex can be roughly paralleled on the continent, painted in the tombs of north Korea [256] and cut in rock in the Chinese cave temples [265]. The ang is of course impossible to paint head-on, and nearly impossible to carve out in stone.

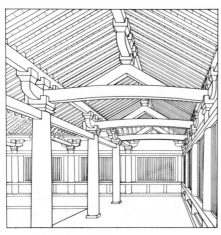

263. Hōryūji, Japan, gallery. Interior

264. Tamamushi shrine (upper portion), from the Hōryūji kondō altar. Korean or Japanese. Seventh century

265 (*right*). Yün-kang, cave 12, west wall of the fore-chamber

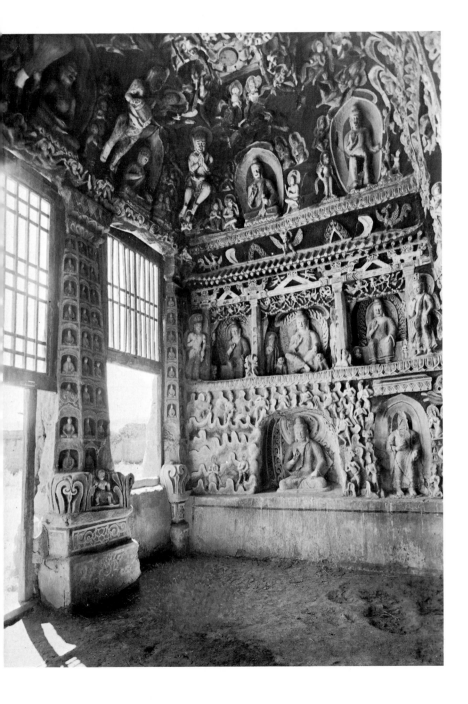

THE SECOND IMPERIAL AGE: SUI AND T'ANG

(A.D. 581-907)

GENERAL

When China was reunited under the Sui Dynasty, the ambition and the means to create a truly imperial architecture coincided again, as they had not since the Han. The volume and scale of building increased phenomenally, as a new Ch'ang-an was laid out, as new palaces were raised and Buddhist temples were restored or newly founded. It is not hard to imagine that a change in architectural style must have taken place with almost the same swiftness, replacing a worn-out tradition by new techniques and more mature aesthetic principles.

The two Sui reigns epitomized at the highest level and within little more than a generation the two immemorially contrasted uses of architecture in the grand manner, the one aimed at public profit, the other at private pleasure. All that the first emperor accomplished in the way of reconstruction and expansion, to fortify and glorify the Sui state, the second matched by a fantastic luxury. Both uses, incidentally, placed a higher premium than ever before on the knowledge and cunning of experts in construction and decoration. The Sui Dynasty was probably also the age in which the abilities of the state architect and the recognition given him met at the highest level in Chinese history. The four persons, all of high rank at court, who contributed most to the Sui operations represented an extraordinary galaxy of talents.[1] Yang Su, who helped to lay out and direct the construction of a new Lo-yang, was also a famous designer of naval junks of unprecedented size. Yü-wên K'ai, whose scientific interests made

him an expert hydraulic engineer (and aided him in designing for the emperor's pleasure a great rotating pavilion), was also enough of an architectural historian to undertake an exhaustive study of the Ming T'ang, to prepare the way for an intricate version of his own. Ho T'iao was a connoisseur of old pictures and *objets d'art,* and at the same time one of China's most distinguished engineers. With one part of his experience he designed the insignia, robes, and vehicles, and supervised the decorations required for Yang-ti's fabulous pleasure-voyage down the Grand Canal. With another he constructed the mausoleum of the empress dowager; and for the Sui armies in Korea he contributed a brilliantly improvised assault bridge over the Yalu River, and a demountable *castrum* with ramparts and towers, capable of being set up overnight. Yen Pi, father of the two celebrated figure-painters Yen Li-tê and Yen Li-pên, was himself an able painter and calligrapher. To the court's love of display he responded by building a pleasure-palace; while for the practical needs of empire he was commissioned to restore the Great Wall, and to dig a long canal to facilitate transport to the Korean front.

The T'ang Dynasty contributed what was necessary to complete the achievement: a continued high level of demand, talent, and wealth; a long period for consolidation and maturing; and sufficient change to prevent stagnation. The seventh century brought first a methodical advance, in which all immediate needs were satisfied. Under the usurpation of the empress Wu, at the end of the century, something like

the atmosphere of Wang Mang's melodramatic reign was re-created, and architecture was again used for colossal experiments. In the golden age under Ming Huang enjoyment once more rose to the top, with all its connotations of costliness and ingenuity. In a cultural sense the rest of T'ang was an anti-climax after the bubble burst in the mid eighth century, with the civil war of An Lu-shan. But there were still services to maintain at the traditionally high level, for the crown and the bureaucracy and the great religious bodies; and there was still plenty of money. Even the minor late T'ang catastrophes must have contributed at least an evolutionary stimulus. The civil wars and the imperial proscription of Buddhism in 845 destroyed an incalculable quantity of fine architecture; but they did force those who came afterwards, to attempt recovery, and so initiated large-scale building programmes that brought new opportunities for development.

The scale of building operations in the second Imperial age was appropriately huge.[2] The Ch'ang-an laid out by the Sui and inherited by the T'ang was bounded by high ramparts running more than 18 *li* east-west and 15 north-south. There was the now familiar chequerboard of avenues and streets, drawn with the strict symmetry that had been lacking in the Han metropolis. The imperial enclosure, on axis, occupied the rear two-fifths and a little less than a third of the total width. Inside it were gathered all the government offices that in earlier times had been scattered; a little less than half the enclosure, at the rear, was given over to the palace proper. There was a second and even larger 'Forbidden City' to the north-east, just outside the city walls, which became the favourite imperial residence, under the name Ta-ming. Each palace was developed around a group of three big halls on axis, comparable to what may be seen to-day in Peking. The standard of size may be imagined from the dimensions recorded for a hall completed at the

Lo-yang palace in 665, the *Chien-yüan-tien;* it was 345 by 176 feet on the ground, and 120 feet high (in a measure very close to the length of the English foot).

Buddhist architecture waxed greatest under the Sui and in the first century of T'ang; the usurping empress Wu was a particularly lavish and imaginative donor. From Ming Huang on the rulers were too often Taoist and there were too many disasters to permit anything better than a slow decline. The first Sui emperor began a practice that must have contributed greatly to the expansion of Buddhist construction all over China, and the consolidation of a national style. In order to commemorate his triumph and pay signal honour to a newly acquired set of relics, he had these last distributed to the provinces, where each tiny fraction was to be housed under a specially constructed relic pagoda. Although the great Sui and T'ang temples have been almost completely obliterated, something of their magnificence may be sensed in what remains of a comparable establishment in Japan, built expressly to rival them. The visible nucleus of Tōdaiji at Nara is a shrunken and debased descendant of the mid eighth-century original; but even so, with all its corrupt details, the 'great Buddha hall' has an extraordinary impressiveness.

The Tōdaiji hall was designed to be eleven bays by seven, 290 by 170 T'ang feet, and 156 feet high. Its size was necessitated by a bronze Buddha colossus, but its surroundings, also, were remarkably spacious and grand. One feature of the monastery plan was typical of eighth-century work at the Japanese capital, and certainly was due to a fashion seen at Ch'ang-an and Lo-yang. Instead of a single pagoda there were two. The change reduced the pagoda to a secondary status, leaving the image hall unchallenged at the front of the axis. The two towers might still be very imposing, however. At Tōdaiji they were not only balanced on left and right, outside and in front of the

courtyard, but were given their own surrounding complexes, gates, galleries, and halls. They were seven storeys tall, and reached about 325 feet to the tips of their spires [266].

behind the Buddha hall, or so far to one side that it is free of the axis.

At the outset of the imperial age force of habit made the most famous Sui architect and

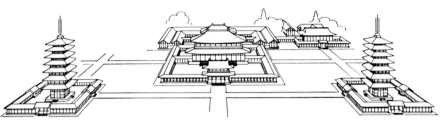

266. Tōdaiji, Japan, eighth century.
Schematic view

Two facts should be observed in connexion with the demotion of the pagoda. In the most general sense, the change marked a long step forward towards the nationalization of Buddhism in China. By it an always partially alien feature was replaced by a familiar one, a throne hall in Buddhist guise. Again, the doubling of the pagodas, that seemed a necessary sequel, marked the triumph of the Chinese ideal of order over religious needs. The stūpa-pagoda of the past had covered a precious relic, not two relics that could be divided between east and west. From a practical point of view the two-pagoda compromise pointed to the enormous accumulation of wealth in Sui and early T'ang. The formula was so expensive that it helped to make the Japanese nearly bankrupt. It proved entirely beyond the capacity of the Koreans, who had followed earlier Chinese fashions faithfully. Even in China it can have been maintained only in first-class temples with plenty of level ground, and then only in the good years. The decline of dynastic power, the proscription of 845, and the need of sharing patronage with Taoism must have brought it to an end for all but exceptional cases. We shall see that if the pagoda appears at all in later temples it is almost always single, being either

an imperial patron plan the construction of a metropolitan pagoda that was to be over 1000 feet high. The work was not carried out, and nothing like it was attempted later. The high building most favoured in T'ang seems to have been not the pagoda but a relatively new type; the *ko* or pavilion, lower and more massive, and so something like a throne hall extended upward. In one kind of great temple layout a single ko formed the culminating feature on axis; in another there would be two balanced ko. When the Japanese pilgrim Ennin reached the pilgrimage region of Wu-t'ai Shan in 840, most of the memorable buildings that he recorded in his diary were pavilions.[3] The most splendid was nine bays across, had three storeys, and reached to more than 100 feet. In the 820s one of the capital temples was equipped with what was described as 'the largest *ko* on earth' (dedicated to the deities most often addressed in that age of insecurity, the Four Guardian Kings).

Like Wang Mang, the usurping Empress Wu owed a good deal of her reputation to the feats of her architects. One minor triumph remembered was the erection of a stone *lou* to a height of 100 feet, a *tour de force* of open-work like a Late Gothic spire. Where other rulers

who wanted a Ming T'ang had been content to listen to debates about its proper form, the empress had one built in 688, at Lo-yang, as big as any predecessor and more extraordinary. It was '300 feet on a side' (the difference between the T'ang and Han measures would have made this equal Wang Mang's ancestral shrine). The description is detailed:[4]

'There were three storeys, with a total height of 294 feet. The lowest, standing for the Four Seasons, had each of its four faces coloured to correspond to its orientation. The middle stood for the Twelve Branches (of the duodenary time cycle), and was crowned by a round cupola, supported by nine dragons. The top signified the Twenty-four Solar Periods (of the year); it, too, had a round cupola. The whole was topped by an iron phoenix, ten feet tall. . . . Running up the middle so as to connect bottom and top was a huge wooden shaft of ten span circumference.'

The shaft was certainly modelled on the great pillar running up the core of the wooden pagoda. Was it meant to be primarily structural or primarily symbolic? If the latter, it must have stood for the invisible but omnipotent grand axis, joining the centres of Earth and Heaven, in which both Indians and Chinese believed. The same symbolic function was probably inherent in all stūpa masts. It is doubtless a memory of this figure of thought that makes the Japanese call the four columns at the corners of their wooden pagodas 'the four pillars of the sky'; they represent the supports at the corners of the cosmos.

To the problem of the Ming T'ang shaft history adds an equivocal postscript. After the death of the empress her Ming T'ang was remodelled in the 730s to serve as a palace pavilion. Its upper storeys were pulled down and the shaft was removed; then a new, octagonal belvedere was added above the old balcony, bringing the new height to about 200 feet. Was the shaft taken out because the change

in construction made it unnecessary – or because the building was, so to speak, deconsecrated? Very likely both motives ruled first the making and then the demolition; the Chinese have always tried to get the most for their money.

An equally gigantic structure ordered by the empress, her 'Celestial Hall', was a five-storeyed tower destined to house a colossal Buddha. From its third floor one could look down on the peak of the Ming T'ang to the south. The director of the two operations, an ambitious and persuasive cleric, 'spent public funds like dirt; while the empress, after a single audience, asked no more questions'.[5]

From the Sui and T'ang accounts of architectural extravagance a few unusual items may be picked. One rarity was the rotating pavilion executed by the Sui architect, Yü-wên K'ai (not far distant in time from the Sassanian 'Throne of Chosroes'). 'Housing several hundred guests at a time, it could be turned rapidly by a mechanism underneath. It seemed like the work of a god; the barbarians who saw it were struck with awe, and the emperor was delighted.'[6]

Two other notices have to do with a new luxury, a more effective control of temperature. The Han palaces had contained apartments called 'warm' or 'cool' which seem to have been made so by such simple means as orientation. Ming Huang could use a pleasure kiosk that was kept cool through the hottest summers by artificial rain falling on its roof (another idea that may have been borrowed, since the T'ang knew it as a feature of Byzantine life). He had also something like a Roman *tepidarium*, made of marble, with a warm pool large enough to hold boats and miniature islands.[7]

Communist excavation around the site of the T'ang capital has concentrated on the area just north of the city that held the great Ta-ming Palace. The latter has been voluminously described, as one of the wonders of the T'ang

world, in written accounts beginning with the Northern Sung. The archaeological findings have now corroborated some of the written assertions and disproved others. The basic palace compound was almost exactly two squares, 2256 metres in the north-south sense and 1135 east to west. Irregular additions on the east increased the breadth of the front (south) wall to 1674 metres. On the central axis the first of three grand halls, the Han-yüan-tien, rose 610 metres behind the main gateway, flanked by two symmetrical *ko* - presumably tall pavilions counting as vertical accents in the grand design. The second, Hsüan-cheng-tien, lay 300 metres further to the rear, with the third, Tzu-ch'en-tien (the state residence), 95 metres beyond.

An area near the western wall of the Ta-ming Palace has been identified as a less formal complex, the Lin-te-tien. There the ground plan was very far from the simple rectangle or square of monumental tradition: primarily three large blocks, eleven bays across, juxtaposed with only aisles to separate them, making a total depth of sixteen bays. On left and right, well to the rear of the centre, there were smaller, symmetrical wings; and in front of each of these was a still smaller square. The latest reconstruction, published in 1963, suggests that each one of these seven units had its own, independent roof, with that of the central block, five bays deep, much higher than the rest. The wing structures, which are preserved only as ruined terraces, are imagined as having risen from solid bases a full storey high. The two small squares would thus have had something of the look, and aesthetic usefulness as accents, of the Bell and Sūtra Tower combination in a T'ang Buddhist temple.

Whether or not the reconstruction is acceptable in all respects, it is certain that this sort of multi-unit structure must have served as the T'ang prototype for the more deliberately varied, quasi-baroque pleasure palaces of Sung and Yüan (page 440, illustration 294).

The Ta-ming Palace, according to literary accounts, contained a hall which was triangular, and so unique in ground plan. It was called the *Lin-te-tien*, the 'Hall of the Unicorn's Virtue', and Ming Huang loved to feast in it. Probably the apex faced south, for it was flanked on south-east and south-west by two *ko* pavilions, and off the east and west corners by two *lou* towers.[8]

The T'ang records bear witness occasionally to the persistence of Confucian austerity. One of the decisions that helped to establish the greatness of T'ai-tsung in popular memory was his order that the buildings of his mountain palace should be roofed with thatch. More normal must have been the feeling that ostentation was a privilege of the very great, but should be severely curtailed at lower levels. The second T'ang history refers to an illuminating incident of 827: government officials who had been using a variety of architectural adornments were ordered to desist because of popular discontent. The list of misused items includes the wooden 'hanging fish', an ornament fastened under the apex of the gable; two categories of roof ornaments, 'confronted phoenixes and tile beasts'; and two kinds of cross-beams designed for show. A decree of the same year assigns a series of maximum hall and gatehouse sizes. Those with a court rank lower than the seventh, for example, must not build halls more than three bays across and two deep. Those below the third rank must not exceed five bays by four. No person whose rank is below the level of prince or duke shall raise his gate to a second storey, or use 'superimposed brackets and cupola ceilings'.[9]

From the T'ang dynasty until the Sung, Liao, and Chin, most tombs were constructed of brick with strongly centralized plans based on a square, circular, or polygonal main room. Wall decoration, where preserved, follows an architectonic pattern. Pillars, beams, brackets, doors, and windows are usually painted in

T'ang examples, and simulated (with great care) in moulded brick later. Model buildings, on the other hand, become infrequent in T'ang, perhaps because of the much greater interest of the ceramic tomb sculpture of the time. Thereafter they die out almost entirely, except for a late revival in some large tombs of the Ming period.

A very interesting counter-current, on the other hand, may give a marked architectural interest to other parts of the tomb equipment. Thus the richly equipped mausoleum of the T'ang imperial prince of Huai-yang, who was buried in 706 outside the capital, has a stone coffin in the form of a simplified five-bay building, with a simulated tiled roof, doors, and windows. Here in addition were discovered the remains of a much more elaborate, two-storeyed building painted over the tomb entrance to a total height of 2·6 metres. The details are for the most part close to those of the long familiar lintel engraving from the Ta-yen pagoda, probably done a few years earlier (though the latter's masterly perspective gives it a much more plausible look than the front elevation used for the tomb painting). There is one important difference. Although the lower eaves of the painted building are horizontal

267. Mont Fang, Hopei,
small pagoda of Yün-chü-ssu.
Early eighth century

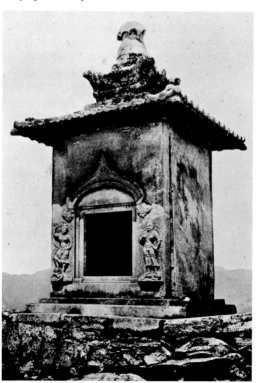

268. Multi-storeyed pagoda
of Yün-chü-ssu.
Early eighth century

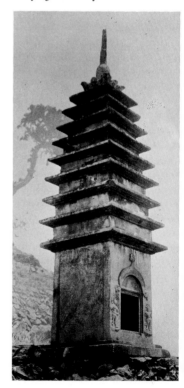

throughout, those of the second storey tilt up sharply at the corners. The silhouette, from eaves tip up along the ridge to the tall 'owl's tail' acroterion, is a continuous cyma curve. Since the eaves line *between* the corners remains horizontal, the effect is not unlike that of the standard Ming-Ch'ing style of Peking: a northern compromise with the curving eaves tradition of the South.

THE T'ANG MASONRY PAGODA

Almost all extant T'ang pagodas rise from a square plan, and all are of masonry.[10] The once widespread wooden form has survived only in Japan. The octagonal plan destined to dominate all Buddhist tower-building from the tenth century on is mentioned in a Japanese story set in the 760s. A pair was designed for the imperial temple of Saidaiji at Nara, but in execution the square was substituted; doubtless because the other still seemed experimental.

What might be called the basic pagoda unit is a cube with a simple corbelled cornice, and a roughly pyramidal superstructure crowned by some sort of spire. This stage was the proper one for a tomb monument to an abbot; one on Mount Sung in Honan, raised over the ashes of the Dhyāna Master Fa-yüan (who died in 791), differs only slightly from the Ssu-mên-t'a of 544. T'ang interests are more clearly seen in an elaborated version, where the roof is made to simulate tiling, and the door receives a pointed arch frame and a pair of guardian deities. Standard examples are in Hopei, one at Lai-shui-hsien, dated 712, and another on Mount Fang (south-west of Peking), within the jurisdiction of the famous old monastery Yün-chü-ssu [267].

The next step was to crown the cube by a series of closely set eaves, usually seven [268]. Modestly built for an abbot, this variety could remain close to the single-storeyed prototype. The same Yün-chü-ssu shows its possibilities

in dramatic fashion. One of the major remains there is a monumental brick pagoda of the Liao Dynasty, which seems to have replaced a T'ang predecessor; at the corners of its broad, square platform stand four small tomb pagodas of the early eighth century, dating from 711 to 727. This is the same symbolic equation of four and one that we have met at Hōryūji, in the reliquary held by the Guardian King of the North. The theme appears from time to time in pagodas, as we shall see, recalling the first subdivision of the Buddhist pantheon into a centre and four quarters, and drawing concrete justification from the design of the huge Mahābodhi stūpa at Bodh Gayā in India, the scene of the Buddha's Enlightenment.

At this period the proportioning of the pagoda is excellent; the silhouette tapers upward across the horizontals in a long, graceful curve. The same basic design reappears in several full-sized pagodas. Its strength and grace, undiluted by elaboration, are revealed in the 'Small Gander Pagoda', *Hsiao-yen-t'a*, of Chien-fu-ssu at Hsi-an-fu in Shensi (near the centre of the old T'ang capital). This tower was built at the beginning of the eighth century for what was then one of the most illustrious monasteries of Ch'ang-an, founded by the empress Wu in 684 in memory of her just deceased husband. Its original height comprised fifteen eaves; with the top two lost, it now reaches about 125 feet. In contrast to the multi-roofed pagoda of the Six Dynasties, like the one we have seen at Sung-yüeh-ssu, it shows perfectly the early T'ang instinct to design in big, clear, simple forms. Nothing about it is more than remotely Indian. At the same time its link with contemporary wooden pagodas like the Japanese can be drawn only in general terms.

The simple, multi-roofed type is carried to a height of about 330 feet (through sixteen eaves) in the giant square tower at Ta-li-fu in Yünnan. The dating of this work has been confused by restoration. The history of the region favours

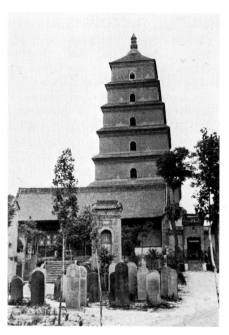

269. Hsi-an-fu, Shensi,
Ta-yen-t'a of Tz'u-ên-ssu.
Mid seventh and early eighth centuries

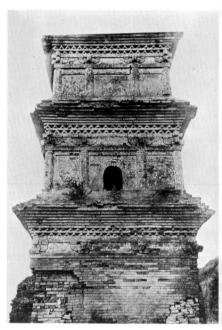

270. Hsi-an-fu, tomb pagoda
of Hsüan-tsang at Hsing-chiao-ssu (detail).
A.D. 669 or 828 (?)

the ninth century (at which time its builders would have been the princes of the independent but strongly sinicized state of Nan Chao).[11]

During the T'ang Dynasty, pagoda design was more and more strongly affected by habits of building in wood (just as the whole of Buddhism was increasingly coloured by Chinese preferences). By the tenth century the aesthetic standards evolved in wood were dominant throughout China, no matter what material was used. There are signs of this trend even in early T'ang. The big brick tower of Hsiang-chi-ssu, built south of Ch'ang-an at the end of the seventh century, is in general like the Hsiao-

yen-t'a. The fact that a separate storey exists between each pair of eaves, however, is emphasized by panelling on the walls; and wood construction is recalled by a regular spacing of simulated column capitals just under each of the eaves. The tendency is even more marked in the most famous of all Ch'ang-an remains, the 'Great Gander Pagoda', *Ta-yen-t'a*, built for the pilgrim Hsüan-tsang's home monastery of Tz'u-ên-ssu. That structure has seven clearly marked storeys, stepping back and diminishing as regularly as a wooden pagoda [269]. Although the eaves are still corbelled, the walls are divided by tall, flat pilasters (making nine bays

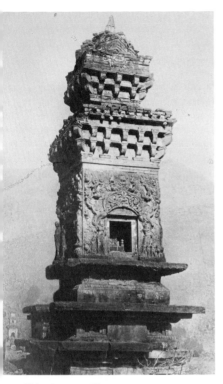

271. Shên-t'ung-ssu, Shantung,
tomb pagoda of Master Lang.
Late ninth or tenth century

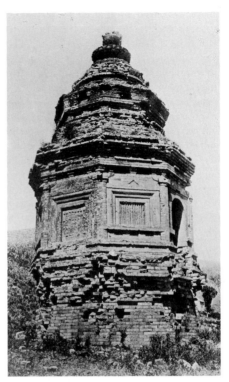

272. Mount Sung, Honan,
octagonal tomb pagoda of Ching-ts'ang at
Hui-shan-ssu. Mid eighth century

on the first storey and five on the top). The combination of simulated beams, intercolumnar struts, and capitals is obviously a simplification of carpentry practice. The mass has something of the formidable solidity of a stepped pyramid. Austerity is softened only in a way that Alberti might have admired, by well-spaced lines drawn on the brick surfaces.

The Ta-yen-t'a was first erected in 652, when Tz'u-ên-ssu had been in existence with Hsüan-tsang as its abbot for five years (he returned from India in 645). He had asked leave to build it of stone, in the manner of the great stūpas of the West; the emperor thought that

brick would be a more prudent compromise. The first structure had five storeys, and reached about 175 feet. It was not well built, and so required extensive renovation in the 701-5 era; at which time, presumably, it reached its present seven storeys, and its height of about 190 feet.

The appearance of two more important innovations in T'ang pagoda design – a more thoroughgoing imitation of wood, and a polygonal plan – is hard to place chronologically. The first is seen at a transitional stage in the tomb pagoda erected for Hsüan-tsang himself in the precincts of Hsing-chiao-ssu, south of modern Hsi-an-fu [270]. The general *parti* is a

smaller, slighter version of the Hsiao-yen-t'a, meant to comprise five storeys. The details are both more elaborate and more emphatic. The verticals subdividing the walls are simulated octagonal pillars, with proportions more nearly those of wood. Above each capital are simulated a bracket arm and an emerging beam-end cut off on a slant and bevelled. It is surprising to find that the beam at the column tops is not the simple, upright member normal in T'ang design, but the T-shaped cross-section familiar in Sung. For these reasons it is hard to believe that the visible structure is the same monument that was erected in 669, shortly after Hsüan-tsang's death. The style fits better a phase of rebuilding that is known to have been undertaken in 828. It may even represent a restoration of later times (like the great square pagoda of Pai-ma-ssu at Lo-yang, rebuilt in the T'ang manner in 1175, under the Chin Tartars).

A stage still closer to the Sung is exemplified by the unique pagoda of Master Lang, the Lang-kung-t'a, at Shên-t'ung-ssu in Shantung [271]. Here no dates are available (Lang was a hermit of the fourth century). The regularly spaced, forcibly projecting consoles that hold the eaves differ from a widely used Sung formula only in meeting the problem of the corner in a more elementary way. The relief sculptures on the shaft present traditional motifs with an almost baroque heaviness and exuberance. The work probably belongs to the transitional age of late T'ang or the tenth century.

The octagonal plan appears in another extraordinary survivor, the tomb pagoda of the Dhyāna Master Ching-ts'ang (who died in 746), in the precincts of Hui-shan-ssu on Mount Sung, Honan [272]. There the design combines both wooden and masonry features. The shaft is a simplified but otherwise close imitation of an octagonal kiosk. Doors and windows are carefully simulated (the window design recalls the Hōryūji galleries). The intercolumnar inverted V is not far from the version we have seen under the Hōryūji balconies. The quasi-octagonal pillars, and the projecting beam-ends running through the capitals, recall the monument to Hsüan-tsang. The superstructure seems to have been arranged as an elaborate preparation for the spire, mounting past a big, octagonal, lotus-petal cornice to turn into round shapes. The whole form is fairly close to those of the low, complex pagodas occasionally seen in the backgrounds of the Tun-huang paintings. It can perhaps be legitimately used to help imagine the look of the two-storeyed, octagonal pagoda that the Japanese pilgrim Ennin saw on Wu-t'ai Shan in 840.[12]

The still active Wu-t'ai Shan temple of Fo-kuang-ssu, where we have found one sixth-century tomb pagoda and shall meet two early wooden halls, has also retained the wreck of another pagoda type.[13] Though the top has been lost, it is clear that this was once a good, medium-sized representative of what was called a 'Treasure Pagoda', Pao-t'a; single-storeyed, with a cylindrical shaft rounding off into a dome and (in this case) octagonal, corbelled eaves. The original prototype was unquestionably Indian, the kind of stūpa found in the Gupta caves at Ajaṇṭā. It seems to have been carried to China in the eighth century as part of the baggage of the newly fashionable Tantric sect; a similar form was part of the architectural repertory of the Tun-huang painters from the mid century. It was transferred to Japan at the beginning of the ninth, under the name Hōtō or Tahōtō. Japanese evidence speaks unanimously for a square, wood-framed, tiled roof on the Chinese version (which must have been that current at the T'ang capital). Otherwise the resemblance to the Fo-kuang-ssu ruin is close enough to make it likely that the latter was raised at the time of the greatest prosperity of its temple, the ninth century.

WOOD-FRAMED BUILDINGS OF T'ANG STYLE

The thorough regional surveys carried out by the Communist government have located a great many more old buildings than were known in the 1940s. The oldest T'ang building that is securely datable is still the mid ninth-century main hall of Fo-kuang-ssu on Wu-t'ai Shan.[14] Fortunately this lone certain representative is outstanding in quality; and its sturdiness and masculine grace fit so perfectly among the characteristics of the T'ang style (as they are known from other sources) that the discovery of the hall in the late 1930s marked a long step in the reconstruction of Chinese architectural history.

The information displayed at Fo-kuang-ssu is corroborated and extended by other kinds of evidence. The look of the façade of a small Buddhist hall of about A.D. 700 has been preserved in an engraving on a stone lintel of the 'Great Gander Pagoda', Ta-yen-t'a [273]. Very numerous, also, though probably less faithful than the engraving and much harder to decipher, are the architectural settings that become common in the Tun-huang paintings from the eighth century on. The masonry pagodas, as we have seen, tell a good deal about T'ang liking for forceful simplicity, though their details are usually far from carpentry. Four other wooden buildings stand a good chance of being T'ang works on stylistic evidence. The earliest of these so far identified is the main hall of Nan-ch'an-

273. Hsi-an-fu, Ta-yen-t'a, design on lintel

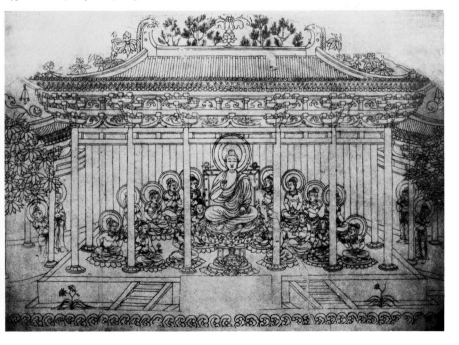

ssu, another relic in the Wu-t'ai Shan area of Shansi. This chapel is small and modest, only three bays and about 38 feet across, roofed by the hip-and-gable formula. There are no interior columns, and the roof structure is left exposed inside, relieving what would otherwise be an uncomfortable lowness. The roof framing of a typical bay resembles that of the central area of the Liao Dynasty Hai-hui-tien at Ta-t'ung-fu, further north in the same province (page 414, illustration 276B). On the outside, the column-head bracketing unit shows much the same elements as those of the somewhat later T'ang Confucian shrine at Chêng-ting-hsien in Hopei (page 420). The only inter-columnar support is a small, squat strut in the wall plane above the front door. All these characteristics indicate that the building has an excellent chance of being the original whose completion in 782 is recorded in a late temple stele.

The most useful comparative material, however, is offered by Japanese remains in which direct imitation of T'ang prototypes is unmistakable. These are not literally Chinese; but they belong to a phase of Japanese history when the desire to follow Chinese models was over-mastering, and when accuracy of copying was made natural and easy by close intercourse. Japanese architecture of the eighth and early ninth centuries, at the social levels for which T'ang standards were adopted, was a colonial style; approximately as close to its original as was the brick Palladianism of Philadelphia to the English Georgian.

Some twenty-two structures remain in Japan from the period of strongest T'ang influence. A number are not particularly useful from our present standpoint. The smaller halls and gates offer nothing that is not better illustrated in the more pretentious buildings. One sub-group of storehouses is made up of log cabins, whose origin is as likely to be Japanese as Chinese. The group of multi-storeyed pagodas, on the other

hand, is exceptionally valuable to the historian. These five (two of them accurate miniatures on a scale of about one-tenth) furnish the only direct evidence for the wooden pagoda of Sui and T'ang (as do Hōryūji and its neighbours for the Six Dynasties). A permissible sixth member is the tower of Daigoji near Kyōto, which, though not built until 951, is known to have been modelled on a (lost) predecessor, and is still clearly T'ang in style [274]. Among the six

274. Daigoji, Japan, pagoda. A.D. 951

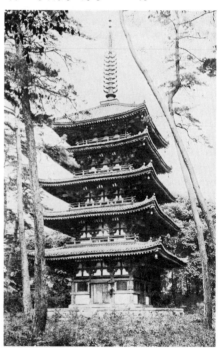

there is so much standardization that most of the variations must be explained by date. All but one are five-storeyed and follow the simple design formula we have met at Hōryūji. The one exception, Yakushiji, has three main storeys, each broken by a penthouse skirting its lower half; an awkward scheme without any known

antecedents. For a detailed stylistic study, the pagodas provide five examples well spaced in the first half of the eighth century, which vary most noticeably in their bracketing. Yakushiji, around the turn of the century, is still fairly primitive. At the other extreme Daigoji shows a higher degree of organized complexity than any other early Japanese monument; and so, probably, reflects the Chinese advances made in the first half of the ninth century, the last period when the Japanese still visited the centres of T'ang culture.

The most informative of the Japanese buildings in comparison with the Chinese survivor at Fo-kuang-ssu is the main hall or kondō of Tōshōdaiji in the outskirts of Nara. A detailed analysis of the two sums up what must have been the principal lines of development between the eighth and ninth centuries. Prior to considering these two major monuments, however, it is worth while to glance briefly at the points of special interest offered by other Japanese remains.

The modest scale of Hōryūji, which was far exceeded in the foremost eighth-century establishments round Nara, is found in one chapel, the nucleus of a precinct in the huge Tōdaiji. This *Hokkedō* or *Sangatsudō* (named because its rites were based on the 'Lotus Sūtra', *Hokkekyō*, and were held annually in the third month, *sangatsu*) was probably erected in 733. Of a size to be compared with the Hōryūji kondō, its differences tell something about the change in fashion [261]. The Hōryūji hall, for all its charm, is too small for its design; its two storeys are those of some grand mainland prototype, copied at half size, say, as a cautious first step. The Hokkedō belongs to an age of confident maturity. As its dimensions make proper, it has only one storey. The two-storeyed structures of its generation were the now vanished gatehouses and major halls of much larger precincts. The Hokkedō roof, on the other hand, is hipped, where that of Hōryūji had been a hip-and-gable.

There it is not so much a nice adjustment of shape to size that one sees, perhaps, as a special T'ang admiration for the hipped roof because of its unequalled dignity and simplicity.

The Hokkedō interior is crowned by a handsome coffered ceiling, crossed by carefully proportioned girders and framed by a bracketed cove. The exterior bracketing is unobtrusive, emerging only a single step over the column heads. T'ang liking for a clear, functional alternation is satisfied by making the intercolumnar support a single-tier strut. The space inside is laid out much as it had been at Hōryūji, with an image platform filling the whole central area (three by two), and a single bay aisle. One change shows an important step toward the acclimatization of Buddhist usage. The images no longer face in all four directions, recalling the stūpa with its ambulatory. Instead, like courtiers around a Chinese emperor, they all face forward, towards the south; and are backed by a partition closing off the rear aisle.

Two Japanese survivors are worth notice because they testify to the use of the octagon as an alternative plan at chapel scale: the *Hakkakuendō* of Eizanji, and the *Yumedono* in the Eastern Precinct of Hōryūji.

The lecture hall, *kōdō*, of Tōshōdaiji is noteworthy as the earliest representative of the type of the assembly hall. It satisfies its purpose by a spacious floor area, nine by four, and is naturally single-storeyed. Its subordination to the kondō in front is marked by a less monumental hip-and-gable roof. There is an excellent likelihood that the kōdō was first erected to be one of the courtiers' shelters in front of the Imperial audience hall at Nara. Its dismantling and transfer to the monastery about 760 stand both as a sign of imperial favour, and as a reminder that palace and temple architecture have always been interchangeable.

The Tōshōdaiji and Fo-kuang-ssu halls are well enough documented to permit their acceptance as eighth- and ninth-century monuments.

Japanese experts are in dispute about the exact date of the earlier; there can be no question that it was constructed within the last third of the eighth century or possibly the first years of the ninth, and under an even stronger Chinese influence than was prevalent in the Nara period as a whole. Its monastery was founded in the late 750s by an imperial grant of the villa of a prince of the blood to the most famous of all early Chinese missionaries, Chien-chên. The latter had arrived in Japan, old and blind after a series of trials, in 753. He was greeted with extreme deference by the court, and was granted the privilege of receiving the Imperial family into the Church. One school of historians holds that the main hall of his abbey must have been built in the first flush of imperial gratitude, before his death in 763. The other goes by a statement in an early history of Tōshōdaiji, that the process was supervised by a Chinese follower, the monk Ju-pao, who 'got together those whose Karma had given them the privilege of being donors, and erected the said hall'.[15] This sounds like a campaign undertaken after the imperial benefactions had been diverted elsewhere. Its limiting date is 815, the year of Ju-pao's death.

The degree to which Ju-pao may have functioned as architect is nowhere specified. That he may have had some responsibility for the design may be argued (weakly) from two facts. The plan of the kondō is highly exceptional in featuring an open porch across the front; that feature, also, seems to have been more at home in south China, where Chien-chên's party came from, than in the northern manner of the T'ang capitals. Secondly, Chien-chên's expedition was designed to transplant as much as possible of the monastic system with which he was familiar – objects as well as rules – and so included among its personnel a Chinese known to have been a sculptor.

A date of about 850 for the Fo-kuang-ssu hall is buttressed by several facts. Two abbots

of the temple are fairly well known in Chinese Buddhist history. Under Fa-hsing in the early ninth century a first height of prosperity was reached; he is remembered as the builder of a 'great Maitreya pavilion', seven bays wide, and three storeys and 95 T'ang feet high. During his regime, in 821, the sanctity of Fo-kuang-ssu was revealed to the T'ang court by a spectacular miracle: the appearance, among the clouds, of the Bodhisattva Mañjuśrī, the divine patron of Wu-t'ai Shan, riding on his lion and accompanied by a myriad lesser Bodhisattvas. The proscription of 845 struck at Wu-t'ai with special severity, destroying innumerable buildings and scattering the monks. The second great abbot, Yüan-ch'êng, went to the ruined Fo-kuang-ssu soon afterwards and remained there to his death in 887, growing in fame until his voice was heard even by the emperor. The existing main hall contains a realistic life-sized statue of a monk, which must be a memorial portrait of Yüan-ch'êng made to honour him as its builder. In addition the names of several donors of rank are written on the underside of one of the main girders. Signalled out there as 'the principal for the Buddha hall', is a Lady Ning from the T'ang capital. The same name and qualification appear again on a stone pillar standing on the staircase in front of the hall, there with a date of 857. Another of the contributors to the building, named with the title of Imperial Commissioner for Surveillance, seems to have been a gentleman who is known to have taken up that post in 856.

The two buildings are much alike in size and mass [275-82]. Both are seven bays by four, single-storeyed, with hipped roofs. The dimensions of the kondō, about 92 by 48 English feet, compare with a Fo-kuang-ssu rectangle of about 113 by 65. The chief difference is in height; the larger Chinese hall has eaves a

275. Tōshōdaiji, Japan, kondō, interior.
Late eighth century

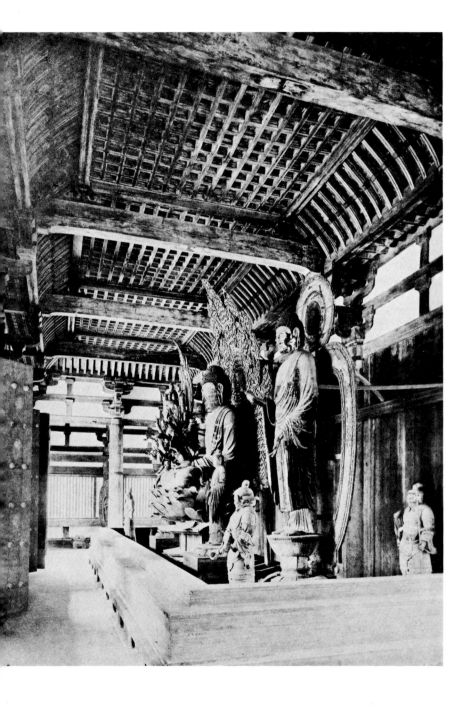

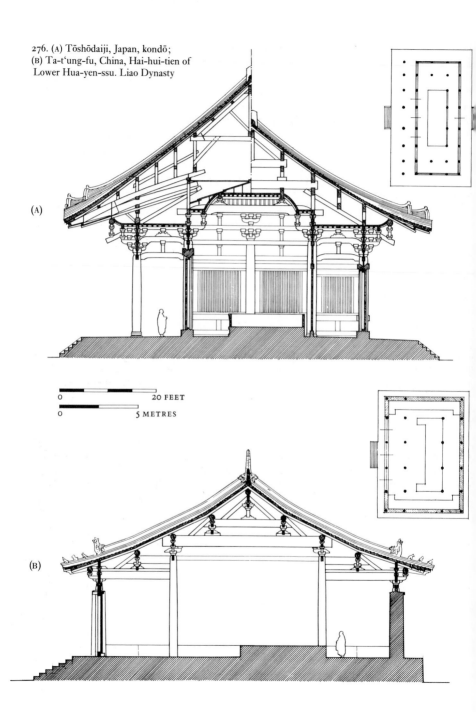

276. (A) Tōshōdaiji, Japan, kondō;
(B) Ta-t'ung-fu, China, Hai-hui-tien of
Lower Hua-yen-ssu. Liao Dynasty

(A)

0 20 FEET

0 5 METRES

(B)

little lower than those of the kondō. The Japanese roof is much steeper, also, but that is due to recent rebuilding, in a different roof-framing technique. In the Chinese roof type, the outer skin of sheathing and tiles rests directly on the purlins that often are visible inside. My drawing of the kondō restores such an original roof alongside the present one [276A], which follows the less straightforward Japanese usage of providing two skins, exterior and interior, and concealing the framing between [276A].

Neither Tōshōdaiji nor Fo-kuang-ssu was a monastery of first importance, and their main halls were scaled to that condition. In Japan the Buddhist headquarters of the powerful Fujiwara clan, Kōfukuji at Nara, had an early eighth-century kondō built on a nine by six rectangle, about 125 by 79 feet. The culmination of the Japanese effort at Nara to rival T'ang achievements, the mid century Tōdaiji, centred as we have seen on a 'great Buddha hall' that had the phenomenal size of eleven bays by seven, about 290 by 170 feet. In the more monumental layouts, also, at least one of the major buildings was likely to have two roofs (even though the lower was only a penthouse over the outermost aisle). At Tōdaiji it was naturally the great *Daibutsuden* that received emphasis, while the lecture hall behind was single-storeyed. In the slightly later and less ostentatious imperial Japanese establishment of Saidaiji, the relationship was reversed. The front kondō, about 120 by 54 feet, was single-storeyed. The second kondō was two-storeyed, and about 208 by 69 feet. This latter combination may well have been based on a developing T'ang preference for making the last major hall on the axis emphatically the highest; the type of building, *ko*, that I have loosely translated as 'pavilion'.

At Tōshōdaiji both kondō and kōdō were single-storeyed; and the monastery layout was modest, also, in having only a single pagoda, in front on the east. At Fo-kuang-ssu ambitions

were hampered to begin with by a cramped mountain site. At the peak of its prosperity the place was apparently able to show a single pavilion on axis. The restoration after 845 probably had to make do with less money, and so settled on a conventional hall. There is no sign that any large pagoda was ever erected.

Both main halls contain spacious platform altars supporting an array of colossal icons [275, 277]. Both use the basic plan that we have seen at Hōryūji and in the Hokkedō, made a little more flexible by larger size. What might be called the chancel area is so deep that only about two-thirds is required for the altar [278]. The remainder, in front, can be added to the floor space available for ritual furniture and circulation. Both interiors face south, and have the backs of their altars closed off; at Fo-kuang-ssu partitions run down the ends as well. There are two major differences in plan, which may be explained by geography. The Fo-kuang-ssu hall is enclosed by thick brick walls, to withstand severe winters. Apart from the five bays of doors across its façade, the only other openings are two sets of latticed windows, one at the back of each end wall. The walls of the kondō are only thin plaster, and at present every wall bay is opened either as a window or as a door (though it is not certain how much of this was in the original design). Even more striking is the fact that the first bay all across its front is left completely open as a porch [276A]. As I have suggested, this unusual feature may have something to do with the fact that Chien-chên, the founder, was a native of Yang-chou in Kiangsu Province, and spent most of his later years in the south coastal region.

In both plans the axial bay is the widest, and the others narrow towards the corners. The same types of doors and windows are used; the former being assembled out of planks only, and the latter being filled by sturdy, close-set vertical bars. Both eaves are held by bracketing complexes that project energetically above the

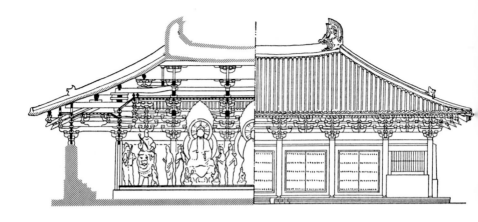

columns, so massive that their height accounts for about one-third of the total distance from floor to eaves purlin. In both the intercolumnar bracket has a radically simpler form; so that the rhythm across the façade is an alternation of major and minor accents.

Both interiors are lent variety by a marked change in height from aisle to chancel. All these spaces are covered by reticulated ceilings, held around the edges by bracketing and crossed by girders. In the kondō the chancel ceiling is given a special dignity by being raised above a high, curving cove, defined by parallel bars; at Fo-kuang-ssu the cove is used throughout. In the Chinese hall, as presumably in the original kondō, the invisible roof framing is by roughed-out logs, combined in the traditional tier-on-tier, symmetrical fashion. The Fo-kuang-ssu version culminates not in the later inevitable king post, but in a kind of small truss under the ridge-pole, like the one that we have met inside the Hōryūji galleries.

Some of the divergence between the two buildings must reflect their difference in date. The clearest demonstration of change in time is given by the bracketing. Each hall uses what must have been the normal maximum design for a second-class building in its period. The two are clearly related; the later is a degree

more elaborate above the columns, and markedly so between them.

The column-head bracketing at Tōshōdaiji is almost the final stage of complication learned by the Japanese from the T'ang. (The actual climax may be seen in the Daigoji pagoda, and differs only in locking the corner system more tightly together.) The complex begins with the bold projection of two so-called *hua* arms. The two steps these cover are so wide that they must be enclosed above by a reticulated ceiling of their own. The end of the outer arm holds in the longitudinal sense a so-called *kua-tzu* bracket, which braces an intermediate eaves beam; and in the transverse sense takes a powerful, slanting ang arm. The latter, in turn, holds its own longitudinal *ling* bracket; and that, through a cushion member, supports the round eaves purlin. The difference in level and projection between the intermediate beam and the purlin is closed by a reverse cove, rising on a complex curve.

The Fo-kuang-ssu complex differs chiefly in the fact that there are two ang, running parallel [279]. This doubling, and the way the end of the member is sliced off to a point, presage the Sung style. The extra height created means that there must be two tiers of longitudinal arms above the outer hua, the kua-tzu and a longer

277 (*left*). Mount Wu-t'ai, Fo-kuang-ssu, main hall.
Mid ninth century. Elevation and
longitudinal section

278 (*right*). Mount Wu-t'ai, Fo-kuang-ssu, main hall.
Cross-section

Scale for 277 and 278

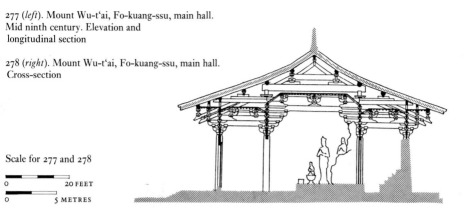

man bracket above. The same combination is repeated in the wall plane. This, too, is an elaboration unknown in Japan, but destined to be further developed under the Sung.

On the intercolumnar axes, where the kondō has simply a two-tier strut, the ninth-century hall sets a design differing from that over the columns only in its greater simplicity. This is a long step towards the Sung formula, in which for the sake of visual unity a single complex will be repeated across the façade.

The step-by-step advance of the T'ang style towards a more complicated and interrelated bracketing design is made even clearer, when one begins the comparison several generations before the kondō, at the pagoda of Yakushiji

279. Mount Wu-t'ai, Fo-kuang-ssu,
exterior eaves (detail)

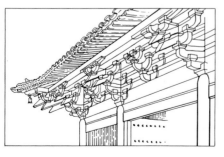

around 700. There the column-head complex is much more simply laid out than that at Tōshōdaiji, with fewer members and wider intervals. One sees quite clearly a historic relationship with the Six Dynasties technique imitated at Hōryūji, also; but while the structural principle is the same, its application is completely architectonic and logical, where that at Hōryūji is fanciful and picturesque.

The difficult problem of corner bracketing, which we have seen handled at Hōryūji with naïve insouciance, is given in the later Japanese monuments a variety of solutions. Even Tōshō-daiji is still immature. The corner complex of the kondō is built up like a multiplication by three to serve three axes of projection [282]. The diagonal axis must be handled as a special case, since it is the longest and carries the greatest burden. It has, consequently, a second slanting ang to help support the corner eaves beam. Its diagonal line is tied in with the rest by longitudinal and transverse arms; and so its second hua arm, having to hold these as well as the ang, is crowned by a scalloped bearing-block, cut out to fit all three axes. On the Daigoji pagoda the further step has been taken of making this last block hold two more members, one arm projecting to the front and a second to the side, in order to tie the complex

more tightly together. The topmost ling under the eaves purlin thus becomes a continuous member running round the corner. This innovation (which perhaps should be ascribed to the revival of monumental building in China in the last third of the ninth century) is used also at Fo-kuang-ssu. There we find an added complexity required to work out a system richer by one step than the Japanese; there are three ang on the diagonal axis.

A comparison of proportions helps to show the character of T'ang architecture, as well as the direction of its development. At Fo-kuang-ssu there is only one column height, inside and out (the corner ones are slightly elongated, to help raise the corners of the roof). The interior set is slightly sturdier, and so has a height of about 8·8 diameters; the exterior is about 9·25. There seems to be no entasis. The dimension used as a module in the Sung architectural manual of 1100, the *Ying-tsao Fa Shih*, is the depth of the standard horizontal bracket arm, or hua. Here that scales about 12 inches, so that the typical column is just under 17 modules tall. In the kondō of Tōshōdaiji, where the more usual practice is followed of making the interior columns taller, they have a height of about 9·2 diameters. Those in the walls are about 8·2 diameters. There also the hua is about 12 inches deep; since the eaves columns of the kondō are taller in comparison with the total vertical dimension, their height works out at just over 20 modules. There is a measurable, but not very effective entasis.

In the two pagodas of Taimadera, where the bracketing technique is a little less advanced, the exterior columns are about 16 modules high. At Yakushiji they are about 16·5 modules, or 8·25 diameters. To emphasize the direction of change, these figures may be compared with those drawn from earlier and later monuments. The columns of the kondō of Hōryūji, drawn with a powerful entasis, are just about 7 diameters, or 14·5 modules high. Those under the

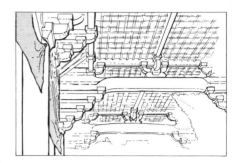

eaves of a Japanese hall that faithfully copies the thirteenth-century Chinese style, the *Shakadō* of Umeda, are about 15·5 diameters and 63 modules high. (The evolution involves not only an attenuation of the columns, but also a dwarfing of the bracket system.)

The cross-sections of our halls [276A, 278] reveal the same basic problems, solved with an appeal to the eye below the ceilings and with a matter-of-fact simplicity above. In the visible part, the main working members are transverse girders and beams, and brackets. Since it is an axiom of classical Chinese design that a bracket should not simply project from a column, but should run through and serve some weight-bearing function on the other side, there is a marked continuity of horizontals. In the kondō, where one hua arm will serve as a bracket both inside and out, and the next will swell to become an aisle beam, all this is relatively clear. At Fo-kuang-ssu there is a much greater complication, which in places goes beyond need [280, 281]. Over the aisle the first two tiers correspond to those of the kondō. The third, which outside has the same bracing function, appears inside as a timber inexplicably larger than a bracket; and terminates in a toe shape whose curve conflicts with that of the beam just below. The fourth tier has crossing brackets too sturdy for the light ceiling they hold, and crowded too close to those across the aisle. The chancel girders are raised to their higher level by four tiers of

testimony of the kondō here is made uncertain by the rebuilding of its roof.) We shall find that one of the advances made by the Sung style was the transformation of the ang into a member visible throughout, and as satisfying to the eye as it was useful.

One more sign of the increase in elaboration from middle to late T'ang is furnished by the

280 and 281. Mount Wu-t'ai, Fo-kuang-ssu, interior (details at centre and ends)

hua, so that there too one has a sense of crowding. The Western observer is tempted to see in this heaviness and lack of clarity something of the quality of European Mannerism. Appropriately enough we shall find it followed, in the Sung style, by a new visual orderliness with baroque characteristics.

Both halls make use of a transitional member between girder and ceiling bracket: a wide, richly moulded pedestal that the Chinese call a 'camel's hump', and the Japanese (thinking of its later, cut-out state) 'frog's legs'. The kondō version is much the more interesting, as are those of other Japanese remains of the eighth century. The visible girders have the arching contour that justifies their stock comparison to the moon or the rainbow. The T'ang stage is more conventionalized than that of the Hōryūji galleries with their long continuous curve. The bottom edge is just enough scalloped out to escape horizontality; the top descends sharply in a kind of shoulder at either end. The kondō version, like that of Hōryūji, has a keystone-like cross-section; at Fo-kuang-ssu it is a normal oblong. Everywhere the depth of the beam is sensibly greater than its width.

A structural characteristic of great importance is the fact that at Fo-kuang-ssu the inner ends of the two slanting ang merely butt against the underside of a transverse beam. While perfectly adequate, this practice requires an aisle ceiling to mask its visual awkwardness. (The

282. Tōshōdaiji, Japan, kondō, corner detail. Late eighth century

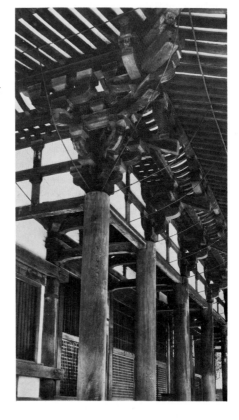

stone bases of columns. Those in Japan are designed as one or more tiers of plain, torus-like mouldings; at Fo-kuang-ssu they are carved like the pedestals of Buddhist images, with a richly detailed ring of lotus petals.

The Fo-kuang-ssu roof has a very gradual slope, which becomes only a little steeper by changes at the top two purlin points. The ratio of height to width is about 1 to 4·77. The only Japanese roofs of the T'ang group that have escaped rebuilding, those of the miniature pagodas of Kairyūōji and Gokurakuin, have similar slopes. The Tōshōdaiji kondō, in contrast, has been so radically altered that its roof has a ratio of about 1 to 2·7. Happily it has preserved one of its ridge acroteria. The design seems to represent perfectly the mid T'ang state of the traditional 'owl's tail', since it can be checked by the lintel engraving from the 'Great Gander Pagoda' [273]. A comparison with the earlier version of the Tamamushi shrine gives an object lesson. The Tamamushi tile has a lively silhouette made up of two sharply contrasted curves. In the tiles of the kondō the effect is much more sober and heavy. The outer contour is a vertical for more than half its length, and then sweeps quickly into a horizontal. The ridge acroteria of Fo-kuang-ssu are undoubtedly much later than the hall, being elaborately moulded and surfaced with a Ming glaze. The silhouette, however, is not radically different from that of the kondō 'owl's tail', though the front has been developed into the mouth of a monster, gaping to swallow the ridge. The characteristic Ming and Ch'ing acroteria fashionable at Peking have a silhouette curving in the opposite sense, i.e. outward [321]. We shall find in the earliest known original ridge acroteria in China, those of the Liao architectural cupboards inside the library of Hua-yen-ssu in Ta-t'ung, an eleventh-century stage in which the gaping monster mask supplements a form otherwise not too unlike that of Tōshōdaiji. A Sung author of the end of that century quotes from a now unknown work a remark on the change involved; the fact that Buddhist and Taoist buildings still remaining from T'ang days carried a 'flying fish shape, with a tail pointing upward', which had been superseded – when, the writer could not say – by a new design featuring an open mouth.[16]

One of the three other possible T'ang wooden buildings so far identified in China, the main hall of the Confucian shrine at Chêng-ting-hsien in Hopei, is so different from Fo-kuang-ssu in proportions and carpentry that only its rigorous simplicity can be used to argue for an early date.[17] This is a smaller building, five by three, with the usual thick brick walls of the north. Its plan shows the beginning of a desire for greater flexibility; in depth the columns are laid out so as to create a spacious chancel at the cost of very narrow front and rear aisles. There is a consistent tendency towards height in the spacing of interior levels, and in the roof slope. Both of these characteristics look forward to the Sung style (as it is found in the same city), and so suggest a relatively late date. Details like the bracketing, on the other hand, are quite unlike the Sung norm, and recall rather the early Liao style that we shall see, for example, at Tu-lo-ssu. Since the Liao work must have been based on available monuments of late T'ang or the first half of the Five Dynasties era, it seems safest to ascribe the Confucian hall to that same period.

Another probable T'ang candidate, similar but less well published, is the main hall of the Five Dragons' Shrine at Jui-ch'eng in the south-west tip of Shansi, first completed in 831. A building of the same unassuming sort at P'ing-yao in central Shansi, the main hall of Chen-kuo-ssu, erected in 963 under the ephemeral Northern Han regime, has the more monumental bracketing scheme of late T'ang, being a reduced version of the type seen at Fo-kuang-ssu.

THE FIVE DYNASTIES AND SUNG

(907-1279)

The interregnum of the Five Dynasties was too short and chaotic to make much impression on architectural history. In the prosperous and relatively untroubled south, a good deal of expert building was carried on. The middle coastal region with its great ports, in particular, was ruled by princes who were generous patrons of Buddhism. Many of the elegant masonry pagodas that they raised are still standing, in various degrees of dilapidation. When the land was again united by the Sung conquest, and the new government began to draw on the talents that had served the secession courts in Szechwan, the middle Yangtze, and the Chekiang coast, it was a man from Hang-chou, Yü Hao, who proved to be the most valuable architect.[1]

The first task of the Sung state was the usual one: the recreation of a capital city and a palace, now at Pien-ching (the modern K'ai-fêng-fu, in Honan).[2] The city posed much the same problem as had the Han Ch'ang-an. Its site was already occupied by a large enclosure inherited from the T'ang. Successive enlargements were made until an area comparable to that of Ch'ang-an was reached. The resulting irregularity proved offensive, so that further additions were made to fill out something like a square. Unfortunately this improvement came just in time to weaken the defences till they could be easily overrun by the Chin Tartar raid of 1126; and the perfected Pien was burned. The Sung palace was modelled on the T'ang usage still to be seen (after restorations) at Lo-

yang. A story implies that it was laid out with a stricter observance of axes and balances than ever before. The Sung founder insisted that the halls and gateways should face each other precisely and have no abrupt variations. 'When all was done, he took his seat in the imperial residence, called in his aides to look, and announced: "My heart is as straightforward as all this, and as little twisted. Be ye likewise." '[3]

T'ang precedent was strong, also, in the wave of building that equipped the capital with temples. The greatest, Hsiang-kuo-ssu, had been a flourishing establishment in mid T'ang, and still retained some of its old buildings.[4] Its promotion to a 'most favoured' status thus involved restoration as well as enlargement; and so it illustrated features that had probably passed out of common use, a balancing of east and west pagodas in front of the main courtyard and of bell and sūtra towers inside.

Sung architecture was probably less overwhelming than T'ang in size and heedless extravagance. Political circumstances prevented recklessness – above all, the need of sharing Chinese soil with a barbarian rival, and of paying him enormous sums annually to keep the peace. In addition the spirit of the age favoured a prudent and balanced life, even at the Imperial level. Only one conspicuous folly is recorded, the building in 1014 of a huge metropolitan Taoist headquarters, known as the Yu-ch'ing-chao-ying-kung: a project originally planned to take some fifteen years, and completed by slave-driving methods in seven.[5] It had 28 large halls (one for each lunar mansion), and a total of 2620 pillars, all the materials

being chosen for their rarity from the whole of the realm. The fact that it was almost razed in a spectacular fire a few years later may have helped to discourage further essays of the sort.

The quantity and scale of building must still have been impressive, however; and in quality the Sung style made up by cunning and elaboration what it lacked in sheer power.

A story has been preserved that makes the early Sung master-builder Yü Hao (the *émigré* from the south) appraise the gate-tower that Hsiang-kuo-ssu had inherited from T'ang times. His words were: 'They certainly were capable enough in those days. The only thing is they didn't understand how to curve up their eaves [toward the corners].' The point is an apt one. The Sung architects dealt in refinements, and the first refinement to be noticed (or missed) in the look of a Chinese building involves the outline of its roof. To judge by the best evidence, T'ang eaves in the north, at least, were straight. Curvature was perhaps first tried out in the south, where it has remained most at home. It may be traced on some of the Five Dynasties pagodas from the Yangtze region, as we shall see, and perhaps was brought to Pien-ching by Yü Hao himself. (He not only built, but wrote an authoritative treatise on carpentry, now lost.) It was developed by the Sung, in conjunction with an equally expert handling of the curvature of the roof slope, to give a new kind of beauty, elegant and light where the T'ang had been most ponderous.

Information of the highest interest and accuracy about the secular architecture of a Chinese city of the Northern Sung period is provided by the superb handscroll of the 'Ch'ing-ming Festival' now treasured in Peking. The scroll carries the observer from the farm buildings on the outskirts of the city, past the houses, shops, inns, etc., of the suburbs through a majestic city-wall gateway, and stops just inside; probably because the theme was continued in a second roll, not yet rediscovered.

Any detail will show the artist's astonishing command of factual information, and his unique ability to subordinate it to the demands of the design as a whole (cf. page 229 and illustrations 160-1). Fortunately the painting has been thoroughly studied by Mr Roderick Whitfield (as well as by numerous Chinese and Japanese specialists); and its publication with an English text may be expected in the near future.

Technical mastery and a feeling for drama drew the Sung towards high structures. In the traditional pagoda form, the most famous example at Pien was the one erected in 989 by Yü Hao over an eight-year period, to house at K'ai-pao-ssu the famous reliquary 'stūpa of King Aśoka' from Ning-po. That was octagonal, had eleven storeys, and rose 360 Sung feet, the bottom being fitted out with a rich setting for the reliquary. It was burned in 1037 (to the delight of a non-Buddhist censor, who argued, 'If a pagoda cannot even protect itself from fire, how can it bring good fortune to people?'). The tower as subsequently rebuilt was seen and described in 1072 by the Japanese pilgrim Jōjin.[6] It was then only nine storeys and 220 feet high, but had the remarkable feature of being open all the way up inside. To climb it was held to be a prerequisite for the mountain pilgrimage to Wu-t'ai Shan; Jōjin found the task exhausting.

All accounts of Pien-ching testify that it was a city of towers. Everything that could be, was pushed into the air. Hsiang-kuo-ssu had a four-storeyed south gate, built in 1001, from which the Japanese saw a breath-taking view. The second major element on the temple axis inside was one of the famous landmarks of the capital, a pavilion with five roofs. By Jōjin's account this had a lou tower on either side; apparently the three blocks were contiguous, their top floors linked by balconies, so that worship could be offered to a closely interrelated trio of deities.

The Sung capital must have dazed Jōjin as much as Ch'ang-an or Lo-yang had his prede-

cessors; his descriptions continually die out on despairing adjectives like 'indescribable'. His record is far too rich for more than the most drastic summary here. He saw, of course, the usual displays of gold, silver, and jewels as decoration. In addition he mentions many times, in various connexions, a kind of interior enrichment that seems to have been most exploited in Sung; the use of miniature buildings. The great Buddha hall of the imperial Ch'an headquarters, Fu-shêng-ch'an-yüan, 'had a ceiling that was all set out with (miniature) treasure halls'; a type of enrichment still to be seen in cupolas remaining from the Sung and later periods [315]. The great library featured a rotating bookcase, with the cabinets on its four sides crowned by miniature four-storeyed pavilions. At another Ch'an monastery in the suburbs, Ch'i-shêng-ch'an-yüan, the walls of the library room were similarly treated, with three simulated pavilions per bay above the shelves. We shall find a handsome survivor of this latter sort at the western capital of the Liao, Ta-t'ung-fu. On a somewhat larger scale, the typical enclosure given anything precious inside a monumental building was a piece of reduced architecture. The chief glory of Ch'i-shêng-ch'an-yüan was a Buddha's tooth. This had its own hall, but was more intimately housed in a 'pagoda made of the seven precious substances', eight feet tall. The tooth rested on a tiny silver lotus throne, inside a gold and glass reliquary, which in turn was deposited in a gold casket wrapped in brocades, and set within the pagoda.[7]

Jōjin's longest description of a site is concerned with a sumptuous pilgrimage temple on the Huai River, known as P'u-ch'ao-wang-ssu.[8] The chief glory there must have been colour; apparently it was in this age that the art of glazing roof and floor tiles was first worked out satisfactorily. The great Buddha hall had a yellow roof, and a green penthouse below. The compound possessed floor tiles of jade-green

and yellow, 'which gave a rare and wonderful lustre'. The pagoda must have epitomized the beauty that only the Sung knew how to create. It was octagonal and thirteen-storeyed, reaching a modest height of 150 or 160 feet; but 'each storey had its own roof of yellow tiles, that gleamed like a tea-bowl'. Outside 'the lower part of each storey was covered with a network [of small niches?] containing images of the Bodhisattvas, saints, and gods'. Inside there was a spacious chapel, with miniature 'treasure hall' reliquaries of gold and silver on the altar. Gilded busts of Bodhisattvas projected above the interior columns. The tops of the bars partitioning off the sanctuary had the forms of angels. Everywhere were banners, canopies, lamps, and the glitter of gold.

By a happy chance a great part of the technical knowledge and experience needed to produce such works has been preserved in a lengthy architectural manual, the *Ying-tsao Fa Shih*.[9] This was composed by a state architect named Li Chiai, and was presented to the Throne in 1100. The book has been handed down through a series of manuscript copies, made from the second printed edition, of 1145. One such line of transmission, leading to a copy made in 1821, has made it possible to bring out a handsome modern reprint, with full illustrations. The text has not survived this process without disfigurement, and the plates have been brought down to an amateur level; even so the *Ying-tsao Fa Shih* is a mine of information, and an acquaintance with its contents is a prerequisite to serious study of Sung architecture.

The manual was highly thought of in its time; experts found it better even than the previously incomparable 'Carpentry Classic' composed by Yü Hao a century earlier. Its high value was doubtless due to the fact that the author was not only clear-headed, methodical, and learned, but also an experienced builder. His preface speaks with veiled disapproval of those figure-head architects who know nothing

about the properties of materials, and calculate only with ideal numbers. Being a well-educated man in an antiquarian age, he was something of a historian, and so the first part of his book is a compilation of ancient references to architectural terms, drawn from the Classics, the philosophers, the Han dictionaries and *fu*, and so on. The rest is eminently practical. The order of presentation begins with a rule-of-thumb explanation of the geometry needed for such preliminaries as orientation and levelling. Then comes a section on stone-work (basements, staircases, floors, column bases, balustrades); one on carpentry on a large and a small scale; discussions of sculptural decorations in wood, of tile-work, plastering, and painting; and, finally, chapters on the use of brick and terracotta, a rationalized method of calculating labour by unit of work, and some generalizations and recipes about materials.

Once again, it is impossible to pick out more than a handful of items for mention. Noteworthy is the omission of any reference to vaulting. The chapter on small-scale carpentry leads up to instructions on how to design and set up the sort of reduced replicas that we have met in Jōjin's diary. There are altar designs of various sizes, for Buddhist or Taoist use. The altar platform will support a shrine that may take the form of a simple kiosk, or may be a conglomeration, with a kind of attic made up of miniature buildings strung together. Li Chiai's bookcases have the same sort of complication, one being intended to rotate in the middle of the room, and the other to run round the walls. The platform type itself is one new to architecture: the 'Sumeru base', so called because its silhouette was likened to the hour-glass shape of the mythical Buddhist world-mountain. There the combination of mouldings produces something like a squat, enriched version of our Classical pedestal, with widely projecting cap and base members, and a low waist. Previously this design had been common on the thrones of

Buddhist images; in the Sung style it was used chiefly for stone terraces (where it gave, as it were, a throne to the whole building), and with more delicacy in wood for altar furnishings.

Li Chiai has a good deal to say about ornamental ceilings. His cupolas are primarily octagonal. A curious recommendation, pregnant with symbolic implications, is that the cupola design should be repeated directly underneath, on the stone pavement.

The architecture of Southern Sung, produced in the century and a half after the Chin invasion and the flight of the court to the Yangtze, has left little impression on history. We may imagine its official side as an imitation of the Pien-ching pattern, with the greater modesty demanded by reduced circumstances. What impressed Marco Polo about the Southern capital, Hang-chou, when he saw its remaining buildings and heard stories about the last Sung years, was not anything outstanding, but a high average of dignity, comfort, and charm. The atmosphere must have been something like that of nineteenth-century Paris; merchants lived like princes, and the city was famous for its huge restaurants and places of entertainment.

Two wooden coffins found in Kiangsu, ascribed to the tenth century through the character of the ceramics with which they were associated, show a unique experiment with the architectonic theme. The basic form is still that of the traditional box, higher at one end than at the other. The high end, where a simulated door had been standard ever since Han, is here treated as a three-dimensional entrance façade. The design has the look of a small chapel, with two octagonal pillars and a prominent beam running between them. Simple, column-top brackets and an intercolumnar 'camel's hump' (page 419) support the purlin that holds a simulated tiled roof. The eaves line is slightly curved throughout its length. The doorway is approached by a short, arched bridge crossing a pretended pool, which in turn is enclosed by an

elegantly detailed miniature railing. The whole – assembled like a large doll's house from miniature wooden members – looks a good deal like a certain type of Shintō shrine façade in Japan; possibly because the latter was in fact derived from just such south Chinese funerary chapels.

Fortunately we know a part of the last phase of the Southern Sung style very well from its transplanting to Japan to serve the newly fashionable Zen sect. A respectable number of late thirteenth- and fourteenth-century Zen buildings remain there, and the borrowed style – called *Karayō*, the 'Chinese style' – was so strictly observed that even much later temple-halls can contribute valuable information. We shall find there a further step beyond the stage of the *Ying-tsao Fa Shih*, away from T'ang vigour and directness. Like the court culture around Hang-chou for which it was created, it is a little womanish and over-intellectual. More scattered bits of information about Southern Sung architecture may be collected from the records left by the succeeding Mongol regime in China, and will be discussed in the next chapter.

MASONRY PAGODAS

Something like sixty pagodas remain from the Five Dynasties and the two Sung regimes.[10] Their distribution in time and space is informative. Of the dated examples, seven belong to the Five Dynasties, fourteen to the eleventh century, eight to the twelfth, and none to the thirteenth. The falling-off was probably due to a change in Buddhism itself; the Ch'an sect, which monopolized Imperial favour from about 1075, had little use for pagodas. In point of location, Chekiang comes first with thirteen. Then follow Kiangsu with eleven, Honan (the

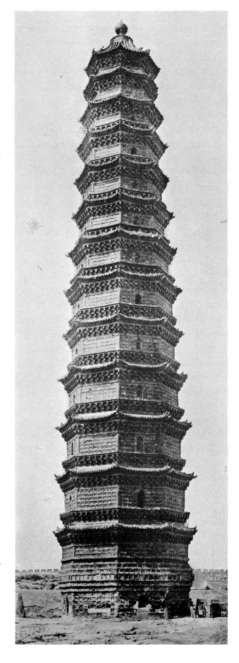

283. K'ai-fêng, Honan, 'iron-coloured pagoda'.
Mid eleventh century

region of the Northern Sung capital) with nine, and Shantung and Szechwan with five each. About half of the total number were erected in the lower Yangtze region.

The pagodas of the period run so true to type that little need be said about them. Almost all are hexagonal or octagonal, and brick. As a whole, the less progressive examples are northern. One at Hsing-lung-ssu in Yen-chou, Shantung, dated either 982 or 1063, differs from the most austere T'ang multi-storeyed standard chiefly in being octagonal instead of square. The tomb pagoda of the Sui Dharma Master Ling-yü on Pao Shan in Honan, rebuilt in 1094, follows the old square, single-storeyed formula except that its eaves are held by a vigorous range of imitative brackets.

The theme most consistently followed in the northern pagodas is set by a characteristic mode of eaves enrichment: corbel blocks closely and evenly spaced in two tiers. What may be the earliest instance of the design we have met already in the richly sculptured pagoda of Lang-kung in Shantung. There the distinction between transverse and longitudinal members is almost absolute. The former curve out and up like short bracket arms, giving an effect much like that of a Baroque cornice with modillions. The latter are simple lintels, except that the wall is carved to simulate longitudinal arms. This stage is still seen in the largest tower remaining at K'ai-fêng-fu (the old Pien-ching), the Fan-t'a of 977. Later versions show a more marked interest in imitating wood bracketing. On the pagoda at Tsou-hsien in Shantung, the first projecting lintel course is deeply cut away to give a realistic effect of longitudinal arms. The same device occurs on the T'ieh-t'a, 'iron-coloured pagoda', at K'ai-fêng, built shortly after 1044 [283].[11]

The northern monuments show other signs of stylistic change. The hexagonal Fan-t'a (now awkwardly truncated from an original nine storeys) has its walls encased in square tiles, which once were glazed a dark green. Each tile has a round niche holding a small figure. The scale is so small that this counts from a distance like a rich diaper pattern; presumably something of the kind was admired by Jōjin on the yellow pagoda of P'u-ch'ao-wang-ssu. The corbelled-out eaves of the Fan-t'a are straight. The smaller, octagonal T'ieh-t'a, erected seventy-five years or so later, has a more richly decorated tile casing whose over-all effect is more confused. The eaves are now noticeably curved and have real roof tiles. Apart from the cornice, imitation has added corner columns and simulated column-top beams. Another imitative feature, the pseudo-balcony provided to each storey above the first, had existed also on the Fan-t'a, but is more conventionally proportioned on the later tower.

The great majority of the southern pagodas were not only designed to simulate wood, but had wooden rafters to hold their tiled roofs and balconies, and sometimes even wooden brackets. Almost everywhere these have fallen away. A few structures have been kept in order by repairs that have not greatly altered their original look. One such is the 'northern pagoda', Pei-t'a, at Soochow in Kiangsu, which was re-erected after a collapse in 1900 with its old materials, and goes back to a mid twelfth-century tower (in turn a restoration of a late eleventh-century predecessor burned by the Chin).[12] The usual survivor is sadly dilapidated, but if its height be intact may retain a special impressiveness. Southern proportioning is tall and slender. With the roof and balcony horizontals gone, one has the sense of a gracefully tapering pillar.

The full-sized brick pagodas are supplemented by a few others that differ in scale and materials. The use of iron brings a shrinkage to almost miniature dimensions, and a mast-like look. Of the three iron pagodas remaining, one at Kan-lu-ssu in T'an-tu-hsien, Kiangsu, has lost all but its bottom two storeys, and a

rich pedestal ornamented with waves and peaks. The almost intact version at Ching-chou in Hopei, set up in 1061, is closely similar. One of the rare strays out of the south is an iron pagoda of 1105 at Chi-ning in Shantung. The small stone structures are more normally proportioned. Three of these remain at Hang-chou, disfigured, but elegant throughout their nine storeys: the single 'white pagoda', and the pair that flank the terrace in front of the Buddha hall of Ling-yin-ssu [284].

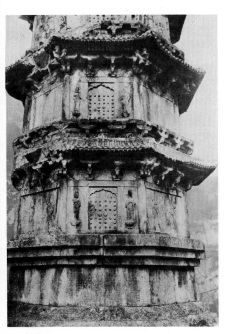

284. Hang-chou, Chekiang, miniature pagoda of Ling-yin-ssu (detail). Late tenth century

The style of early Sung pagodas is still relatively simple and sturdy, with eaves that curve up only at the corners. At that period either one or two intercolumnar bracketing units might be used; there is still only one on the Ching-chou iron pagoda of 1061, while there are two on the Ling-yin-ssu pair, for which the temple records claim a Five Dynasties date. The Chi-ning iron pagoda of 1105 shows that the style went a long way in one century towards fragile richness. The bracketing is small and crowded; there are two intercolumnar units per bay, and each unit has three outward steps. The balconies are only a degree less richly bracketed, and in addition have railings with simulated lattice-work. The eaves sweep through continuous curves. This stage seems closer to Yüan than to early Sung.

One archaic feature runs through all the southern pagodas. The column-head beam retains its T'ang simplicity, as a single member. It is only in Yüan that one finds the typical T-section of the official Sung style in the south.

The southernmost of the important pagodas, the pair at Ch'üan-chou in Fukien (built of brick in the mid twelfth century, and encased in stone in the mid thirteenth) are curiously atypical.[13] Their five storeys are wide and squat; the bracketing is by transverse projections only; and nothing but the sweeping curve of the eaves and a consistent imitation of pillars and beams marks the design as southern. The source of this local mode in a peculiar carpentry tradition, represented also in Japanese copies in the 'Indian style', will be discussed below.

The 'northern pagoda' at Soochow contains an unusual small masonry cupola, rising from an octagon to a circle. Each corner of the octagon holds a two-tier bracketing unit, the top of which helps to support the rim of the circle. In addition, a stone rib runs between each opposite pair of bracket tops, making a kind of St Andrew's cross; the four ribs meet at a capstone. This is presumably a continuation of the cupola-framing fashion we have met earlier in Korea [256].

TIMBER-FRAMED BUILDINGS

The only Sung establishment that still gives an idea of its original disposition is Lung-hsing-ssu

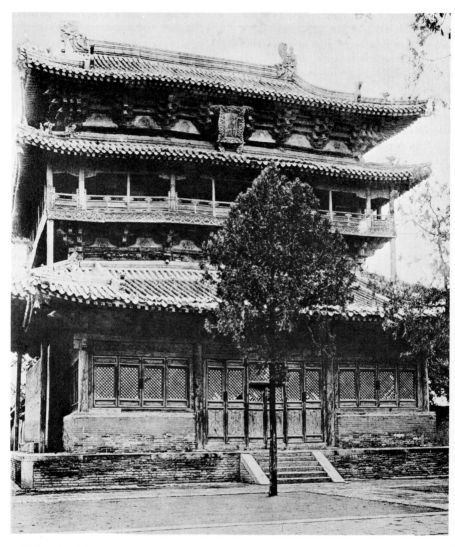

at Chêng-ting-hsien, in western Hopei.[14] There one can see three big buildings in good preservation, and the remains of a still larger fourth. The general plan is clear; very long and narrow, widening out to make a courtyard at the rear. The last element on axis is a now largely collapsed pavilion, erected by the emperor in 971 to house a colossal bronze Kuan-yin. The statue still stands, reaching a claimed height of 73 feet, and fanning out into a Tantric panoply of 72 arms. The pavilion is seven bays by five; on its still standing end and rear walls are large panoramic reliefs in stucco, showing the triumphal progress of the great Bodhisattvas and

their multitudes of followers. These, too, are certainly Sung work; the north wall has an inscription of 1089. On either side of the pavilion is a subsidiary high building, joined by balconies. On the outside, these flanking elements are entirely Ch'ing, but they may well perpetuate

285 (left). Chêng-ting-hsien, Hopei, library of Lung-hsing-ssu. Eleventh century

286 (below). Chêng-ting-hsien, Hopei, Mo-ni-tien of Lung-hsing-ssu, entrance vestibule. Mid tenth century(?)

floor balcony has a third, skirting roof of its own. Immediately in front of this pair is a Ch'ing ordination platform. Farther forward on the axis comes what is probably the earliest monument, the square *Mo-ni-tien*, or 'pearl hall', which may have been in existence when the Sung emperor first became interested in the temple, in 969 [286]. In front of it one finds a large earthen terrace, the remains of another Sung main hall; and then small mounds on east and west to mark the emplacement of the recently demolished bell and drum towers. The

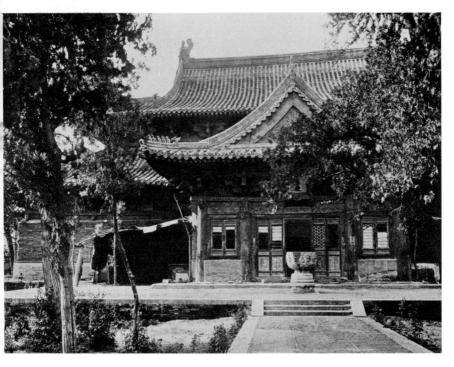

an original tripartite design like the one seen by Jōjin at Hsiang-kuo-ssu.

The rear courtyard is entered between two nearly identical pavilions facing each other: a sūtra library on the west [285] and a Mi-lo (Maitreya) pavilion on the east. Each is three bays by four, and has two storeys; the second-

gatehouse is a patchwork of Sung and Ch'ing parts.

All this is very different from the T'ang formulas imitated in Japan (and continued, as we shall see, by the Tartar regimes of Liao and Chin). The proportioning of the whole compound is closer to the Ming and Ch'ing usage

visible in Peking than to the spaciousness and the relatively few, large elements of T'ang. No remaining hall has the conventional oblong plan. The majority are two-storeyed or more; and even the relatively low, squarish Mo-ni-tien shows a pyramidal stress on height.

The Mo-ni-tien is unique among monumental Chinese halls, because a narrow entrance vestibule projects from each of its four faces [286]. Each wing is crowned by a low hip-and-gable roof, so that the entrance may be marked by a pediment-like gable. The core of the hall is seven by seven, and comprises two complete aisles (the outer with its own penthouse roof), around a three-by-three chancel. All roofs curve up at the corners.

The squareness of the 'pearl hall', like its name, must go back to the first founding of the temple in 586, when its title was Lung-tsang-ssu, 'the Temple of the Dragon's Hoard'. In Indian myth the king-dragon or Nagarāja who lives under the sea cherishes a preternaturally luminous pearl. The throne hall of any great supernatural ruler is likely to be described as having 'a single pillar'; i.e. at its centre, so that the building is square or round. When the stele of 586 that records the first establishment of Lung-tsang-ssu speaks (in cryptically allusive language) about a 'nine-storeyed, single-pillared hall', it presumably refers to a square predecessor of the present Mo-ni-tien (the 'nine storeys' must be a mere conventional tribute to Indian phraseology).

The early date of the hall is shown first by its bracketing. The scale is massive (the height being almost half that of the column), and there is a marked alternation between column-head and intercolumnar units. In both cases the method of stepping outward is simple. The sequence is: hua arm; slanting ang, which holds in the transverse sense a beam sliced off like another ang, and in the longitudinal, a continuous beam-like bracket to support the eaves purlin. The intercolumnar complex differs in including two 45 degree axes of projection, as well as the transverse one. This feature is one that we shall meet in the Liao style, where it must represent an imitation of some north Chinese prototype of the tenth century, not far distant in date from the Mo-ni-tien.

In one revealing detail the 'pearl hall' foreshadows the Sung standard. The column-head beam has a T-section; a change demanded by the development of heavy bracketing units between the columns. The feature seems to be a northern one, since it is both absent from the eleventh-century pagodas of the Yangtze region, and present (as we shall see) in contemporary work done under the Liao.

What the Sung architects achieved that was new in the design of individual buildings was a happy mixture of visual interest and structural ingenuity. In the main, the first factor was secured by a stricter regularity. The distinction between bracketing complexes was abandoned; one type was repeated all the way across the eaves. (The spacing was fairly wide, at first – the Ying-tsao Fa Shih recommends a single intercolumnar unit for ordinary bays, and two over the central door.) Within the standardized unit, as well, uniformity was gained by making each projecting arm hold the same sort of longitudinal members above it.

The Sung ideal was stated with maximum effectiveness in an improved design of the slanting ang. In the T'ang style this member had been used without full realization of its possibilities. The inner half of the ang had been hidden above a ceiling; its top end had been simply immobilized, by butting against the underside of a heavy girder. The Sung architects preferred to expose the whole ang, and to use it as a real lever, balancing one downward push by another [289]. The dramatic, upthrusting lines thus secured had something like the visual excitement given by Middle Gothic flying buttresses; and were, in the same way, as structurally alive as they seemed.

The remaining Sung buildings give a rough idea of the period and region in which these innovations were carried out. Neither is found in the earliest dated hall, the *Yü-hua-kung* of Yung-shou-ssu at Yu-tz'u in Shansi, south-east of T'ai-yüan-fu, which was built in 1008 to replace a late T'ang original.[15] That small, three-by-three chapel keeps a good deal of T'ang simplicity, and so naturally resembles its stylistic cousins of early Liao. Only the suave curve of the eaves and the T-shaped column-head beam speak for the new age.

The next dated survivors in the north, built in the 1023–32 era, are the two chief halls of the Shêng-mu-miao or 'Shrine of the Saintly Mother', at Chin-tz'u in T'ai-yüan-hsien, Shansi.[16] The two have an interesting relation-ship in plan. The larger, at the rear of the axis, is a seven-by-six main hall; the other is an open 'offering hall', some distance in front, for lay worship. The combination, fairly rare among Chinese remains, is exactly that seen in the typical Japanese Shintō shrine (and may help to indicate a forgotten Chinese source for the latter). The main hall itself has a plan that shows a new instinct for freedom and variety. An open porch surrounds it, one bay wide on the ends and rear, and two across the front. In addition the front portico is made more usable by omitting the four middle columns of the second line. Behind is a walled-in, five-by-three sanctuary.

The bracketing of the two buildings is almost identical, and while closer to the final Sung formula remains heterodox. There is still an alternation in the bracketing units, though the difference has been made inconspicuous. Both types have the beak-like projections that mark the outer ends of the Sung ang. But it is only the beak of the intercolumnar complex that belongs to a true, slanting ang; that over the column runs on the horizontal, and is actually only the free outer end of a transverse bracket arm. On the main hall there is also an arbitrary juggling

of numbers between the upper and lower eaves. Under the penthouse the column-head unit has two false ang, while under the main roof it has two tiers of hua arms and one false ang. The intercolumnar unit in the same situations has, respectively, one hua plus one true ang; and one hua plus two true ang.

One undated Shansi building belongs to this phase of immaturity: the *Wen-shu-tien*, 'hall of Mañjusri', at Fo-kuang-ssu on Wu-t'ai Shan.[17] This stands well in front of the T'ang main hall, on the proper left; originally it was balanced by a *P'u-hsien-tien*, 'hall of Sāmantabhadra'. It has seven by four bays, but only a single, gabled roof; testifying thereby to another aspect of the Sung interest in variety. The hall plan, again, is remarkably free, with only four interior columns where a conventional, chancel-and-aisle scheme would require eighteen. Even these, though they subscribe of course to left-and-right symmetry, are no more than roughly balanced in the front-and-rear sense. The rear pair, behind the altar, frame a single bay; the front pair are three bays apart. The extra girders and beams required to adapt this plan to the func-tional symmetry of the roof framing are set out with great originality and daring. The bracket-ing resembles that of the Mo-ni-tien.

The earliest timber-framed building known to have used the mature Sung formulas was the small main hall of Pao-shêng-ssu in Soochow, built in 1013 and recently demolished.[18] Its location in Kiangsu corroborates the theory that leadership in forming the Sung style came from the south; the hall may well have illustrated some of the features carried to the Sung capital by the famous architect Yü Hao. The plan was an orthodox three-by-three square, with four interior pillars. The look of its bracketing from the outside was very close to that of the Chekiang stone pagodas of the tenth century.

Several details are noteworthy in connexion with the place and the date. The column-head beam was still a single member, as on the

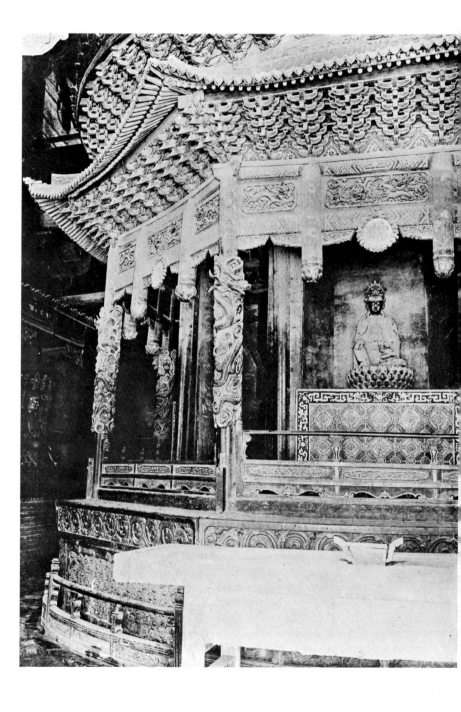

pagodas of the same region. Cross-beams and girders had a pronounced curvature, accentuated by carving (the same members in early Sung and Liao monuments in the north are straight). As true 'moon beams' they testified to the same sort of regional liking for curves that led to the development of curving eaves. An associated detail was the fanning of the rafters on radii from the corner bay outward. Northern builders have always preferred to use simple parallels, which must intersect the corner eaves-beam at a sharp angle.

Early features were the relatively large scale, the simplicity of the bracketing, and a lack of longitudinal arms. The kingpost was only a square block.

The Communists have recently identified what must be one of the earliest southern survivors, the main hall of Pao-kuo-ssu in She-yang-hsien, north-eastern Chekiang. In style this agrees with a recorded period of temple restoration in the early eleventh century, and so is presumably a work of early Northern Sung. The building is three bays square, with a fairly steep hip-and-gable roof. The eaves bracketing has intercolumnar units, one for each of the end bays and two for the centre. Each unit culminates in sturdy double ang arms, used for their structural value. The interior 'moon' beams are carved so as to suggest a springy curve. These characteristics show the sort of sturdy prototype out of which grew the more delicate, small-scale Southern Sung repertory, carried to Japan in the thirteenth century for use in the new Zen temples. One marked difference from Japanese 'Karayō' practice is seen in the first interior area, a sort of forechamber made more roomy and serviceable by displacing the interior columns toward the rear. Each of the three bays in this quasi-narthex is covered

by an octagonal wooden cupola, designed around eight strong ascending bracket lines.

The northward advance of this style is first marked by the twin, two-storeyed pavilions of Lung-hsing-ssu in Chêng-ting. These certainly belong to the eleventh century; they are a degree more advanced than Pao-shêng-ssu, since they possess both the T-shaped column-head beam and a full quota of longitudinal bracket arms. The capacities of their time are revealed most remarkably in the big revolving sūtra case that fills much of the ground floor of the library [287]. This has a penthouse following its octagonal perimeter, and a round roof above. The bracketing is exceptionally rich; there are five outward steps, two hua and three ang, and since the longitudinal complement is complete, one sees six identical, three-headed arms, overlapping like scales. For the first time the eaves purlin has its final Sung cross-section, a high oblong instead of the circle. We are here much closer than before to the small-scale intricacy copied by the Japanese Zen builders two centuries later. Specific similarities to the Japanese Karayō are the sharp taper given to the top of the pillar; and the way in which the column-head beam is carved where it projects at the corner. All these innovations are described in the Ying-tsao Fa Shih of 1100, however; and a fairly close parallel is visible under the eaves of the iron pagoda of 1105.

The 'chapel of the First Patriarch', Ch'u-tsu-an, at the back of Shao-lin-ssu on Mount Sung in Honan, fits neatly into the evolutionary sequence indicated by its date of 1125.[19] There both lateness and a three-by-three, chapel-like scale produce an effect very close to that of some early Karayō survivor in Japan. The greater potential richness of a Sung original is typified by the use of delicately sculptured stone for the pillars. On the other hand, the interior lacks a typical Southern Sung detail, meticulously reproduced in Japan: the square ceiling over the altar is merely coffered, instead of being a

287. Chêng-ting-hsien, library of Lung-hsing-ssu, revolving sūtra case. Eleventh century

flat surface painted in ink with a dragon among clouds.

The one well-attested wooden building of Southern Sung is the main hall or *San-ch'ing-tien* of the Taoist Yüan-miao-kuan in Soochow.[20] This establishment goes back to the pro-Taoist policy of the Sung ruler Chên Tsung in the early eleventh century. Like almost everything else in the area overrun by the Chin armies a century later, it was burned; a rebuilt main hall was completed in 1179, and may be traced through later repairs to-day. The building is exceptionally large, nine bays by six, or about 150 by 84 feet, with a penthouse over the outer aisle and a hip-and-gable roof. Much directly foreshadows the Karayō, now partly because of location. The climate of Soochow permits thin wooden partitions like the Japanese ones, instead of massive brickwork. An exterior wall detail, with vertical battens over the joints and a cusped top to the window frame, will look very much like the Kamakura relic hall of Engakuji. There are both true 'moon beams' and the smaller, more complex type of curving timber that the Japanese call *ebi-kōryō*, 'shrimp beam', because it swells higher at one end and so may be used to join two different levels.

The San-ch'ing-tien has various types of bracketing for different situations, all small and closely spaced. The use made of the ang suggests that the Southern Sung architects were no longer stimulated by the problems posed by frankness. Dissimulation is so widespread, indeed, that it seems almost to have replaced frankness as an ideal. Under the main eaves one finds the false ang that is actually a horizontal [288]. Elsewhere there are slanting members that act like interior ang, but are more than half hidden among horizontals. These devices had been permitted by the *Ying-tsao Fa Shih* (and even there may testify to a functional decadence); but it is hard to believe that an eleventh-century builder would have flaunted them on so monumental a scale.

288. Soochow, Kiangsu, San-ch'ing-tien, eaves brackets. Schematic drawing

For a systematic discussion of the Japanese copies, the reader must be referred to the volume of this work which deals with Japan, or to my earlier monograph. A few comments will show how the material is historically related to what we have found in China. Although the dates are late (the earliest remaining Zen building, the relic hall of Engakuji, was erected around 1280, and the others belong to the fourteenth century), it is clear that the source was Southern Sung. Ch'an or Zen Buddhism was transmitted from the Yangtze region centring on Hang-chou, and intercourse came to an end with the Mongol conquest.

The Japanese certainly modified what they took, for pressing practical reasons. For the roof, in particular, they might use shingles instead of tiles, or substitute their double-shell framing technique. They borrowed only part of the Chinese repertory, leaving out for example everything done in stone, or anything outstandingly high. The early survivors in Japan are all of chapel size; larger halls remain to-day only in much later versions, with somewhat coarsened details. With such qualifications, we may accept the Karayō as an important

witness to the official architectural code regu-
lated by the Hang-chou court.

Comparison of the eleventh-century Pao-
shêng-ssu hall with a descendant like the
Shakadō of Umeda, south of Ōsaka, will show
both the Sung constants and the drift of the
style towards small-scale richness [289]. In the
Japanese version everything is filled out for
visual consistency, and a good deal is carved.
There is a characteristic change in the kingpost;
the Karayō form is no longer a utilitarian block,
but has been made like a truncated pillar, and
overlaps the beam in a decorative way.

It should be noticed that the Karayō ang may
be used either frankly or fictitiously. In one
example there are two ang that run straight

289. Umeda, Japan, Shakadō, eaves
and interior bracketing

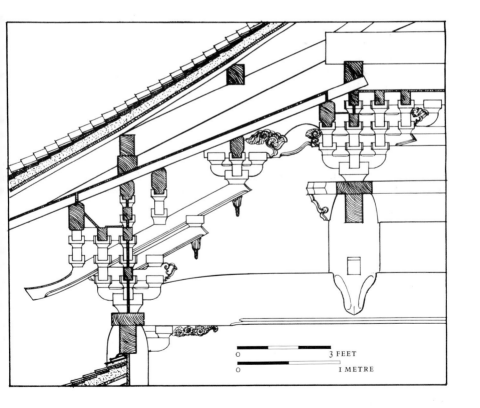

O 3 FEET

O 1 METRE

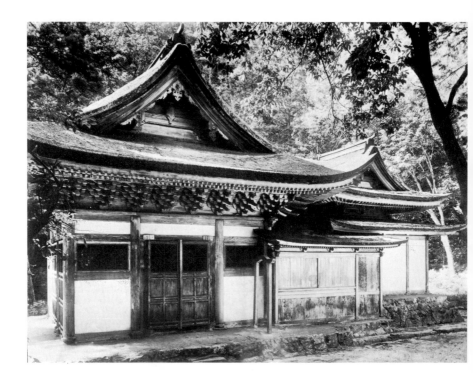

290 (*above*). Eihōji, Japan, Kaisandō or 'founder's hall', side view. A.D. 1352

291 (*right*). An-p'ing-hsien, Hopei, Shêng-ku-miao. A.D. 1309. Schematic perspective and plan

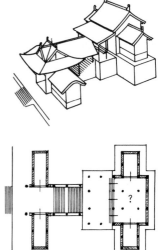

through from beaks to inner purlin, functioning as a double lever. In another the upper beak belongs to a true ang, while the lower is a simulated one. The ang is braced by a second slanting member inside, but that stops against the wall.

One Japanese monument of 1352, the 'founder's hall' or *Kaisandō* of Eihōji near Nagoya, is worth special mention because its complex form is rare on the continent. The building has three parts, intricately fitted together: a sanctuary, an enclosed passage, and a front chamber for worship [290]. Historically, this scheme was doubtless an improvement made for convenience' sake on the type of isolated main hall plus fore-hall that we have seen in the Shêng-mu-miao. Something very much like it, with a northern flavour imparted by brick walls, survives in the Shêng-ku-miao of 1309 at An-p'ing-hsien in western Hopei [291].[21] In the Kaisandō the three roofs have different heights, and are locked together with the picturesqueness that Sung architects loved. The Shêng-ku-miao roofs, conversely, have a northern directness. The Japanese version is further remarkable in a Sung way for the dramatic effect gained in its fore-chamber by the omission of all interior pillars.

Three Japanese buildings of the late twelfth century bear witness to the existence of a Chinese style very different from the Karayō, for which contemporary evidence on the mainland has almost entirely disappeared. One of these monuments of the so-called 'Indian style', *Tenjikuyō*, the towering great south gate of Tōdaiji at Nara, serves as a reminder that its mode of building came to Japan with very high recommendations [292, 293]. The Tenjikuyō was used exclusively on the most important project of that time, the reconstruction of Tōdaiji after it had been burned in a civil war. The 'Indian style' stands at an opposite extreme from everything characteristic of the official Sung development. It is almost brutally power-ful and masculine. Its directness permits no subtleties, and no enrichment. Two features identify it at first glance. The bracketing is made up of transverse members only, except for a single spreader at the top to carry the eaves

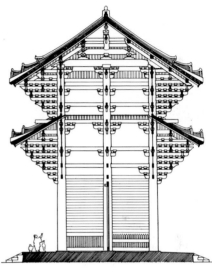

292. Tōdaiji, Japan, great south gate.
Late twelfth century

purlin. On the column axes these transverse, horizontal arms are stabilized by being passed through the body of the pillar. As many as possible are used as cross-beams, for greater safety. Where the scale of the building makes it necessary, an intercolumnar eaves support is provided in the form of a true ang, reduced to simplest terms as a lever balancing two purlins.

The misnomer 'Indian style' must have been coined by Japanese who had forgotten the actual source (if they ever knew it). The home of the Tenjikuyō seems to have been the south Chinese coast. In parts of Chekiang, Fukien, and Kwangtung there remain buildings to testify to the fact in various ways. The twin pagodas at Ch'üan-chou in Fukien show that the style was powerful enough there in the

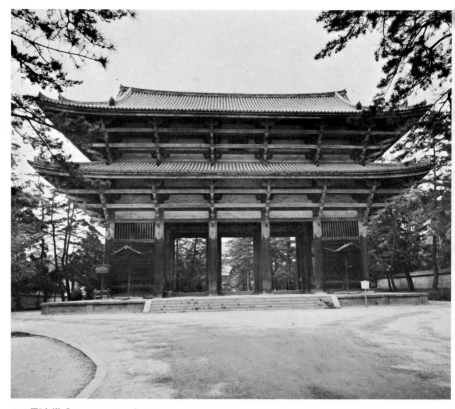

293. Tōdaiji, Japan, great south gate.
Late twelfth century

Southern Sung to affect even masonry. In Fukien a fairly large group of wooden buildings of Late Ming or Ch'ing is permeated with Tenjikuyō memories. In the Buddha hall of Wan-fo-ssu in Fu-ch'ing-hsien, or the halls and gates of Ch'ung-shêng-ssu in Min-hou-hsien, most of the features found in Japan are still visible (though with nothing of the earlier forcefulness).[22]

The ultimate origin of the Tenjikuyō is more mysterious. A style that could retain so much simplicity against the pressure of a different official code must have been protected by geographical isolation. Probably for the same reason that Canton has preserved the sounds of Chinese as it was spoken in the T'ang, the Tenjikuyō perpetuated a building technique that may well have been equally old. The style very likely acquired and kept its bigness because its builders could exploit richer and better timber-lands in the coastal ranges than were available elsewhere. Its dependence on transverse bracketing axes recalls the Six Dynasties tradition seen at Hōryūji.

THE BARBARIAN EMPIRES: LIAO, CHIN, AND YÜAN

(907-1367)

GENERAL

Like the other official arts, architecture under barbarian control lapsed into stagnation. The subject Chinese whose skills were exploited must have worked under the handicap of depressed morale. The Tartars or Mongols of the ruling class were hunters, warriors, and administrators at their best, and lazy debauchees at their worst. Their ancestors had known shelter only in the waggon and the tent; in civilized architecture they can have appreciated little but size and magnificence. The earlier remains from the barbarian empires merit attention in spite of this disadvantage because of their historical significance. In addition their best qualities – though perhaps second-best by Chinese standards – are still extremely impressive. The Yüan survivors are neither rare nor individually so interesting, and so may be treated merely as a postscript to the Sung.

The process by which barbarians became great builders was in every case substantially the same. The invaders, coming from the north, would seize and occupy Chinese territory, and force the inhabitants into their service. At the peak of success they would capture a Chinese emperor with his household and treasures, learn how a ruler should live, and carry off experts to reproduce the pattern for themselves. Circumstances made the process work out differently for the three races. The Khitans in the tenth century took over only the extreme north of China, and in the process met nothing more impressive than one of the ram-shackle courts of the Five Dynasties. The

memories of T'ang, the energy and openness, that survived in this cultural booty must have made it relatively congenial to nomad instincts; the Liao built with some independence. The Chin successes carried the frontier across the Yellow River into the heart of the Sung domain. The second Tartar empire included a much larger Chinese population, bred to more subtle and sedentary ways. The emperor abducted in 1127, Hui-tsung the painter and collector, was the leader of a metropolitan society of extra-ordinary sophistication. The cultural gap that resulted was nearly unbridgeable. The Chin warriors must have lost confidence in their own values long before they began to comprehend more than the first steps of the Chinese scale. In architecture their best hope was imitation. Their most ambitious imperial seat, at the present Peking, was a copy (made by Sung masters) of Hui-tsung's ruined palace at Pien-ching. Elsewhere they followed Sung or even Liao precedents with a bewildered docility. The Mongol conquest, which smashed the Chin realm in 1234 and broke down the last Sung defences in the 1270s, carried the equation to its final extreme. All of China now lay on one side of the scale, huge, infinitely complex, immeasurably old and wise. The barbarians raised what they had destroyed with Chinese architects and craftsmen who earlier had served the Chin or the Sung. They themselves can have contributed nothing except the ambition and the means to build with a naïve boastfulness.

The Liao empire had five capital cities (modelled on the fivefold division of power at the centre of a Tantric Buddhist *maṇḍala*).[1] All

were inherited by the Chin, whose southward expansion gave them also the old Sung capital. Most of the northern sites were in open country in Manchuria. Those in China proper were famous cities, the modern Peking, Ta-t'ung-fu in Shansi, K'ai-fêng-fu in Honan. Almost all have preserved some architectural proof of their status, in addition to vestiges of walls and platforms. There are usually one or two pagodas; Ta-t'ung has had the good fortune to keep two ancient monasteries in which seven buildings carry back to the great days under the Liao and Chin.

All of these predecessors were greatly exceeded in size and costliness by the Mongol Peking, where Marco Polo found the Grand Khan's seat 'the most extensive that has ever yet been known'. The historical evidence for the Mongol palaces is much more detailed also, since the layout and character of the buildings were methodically catalogued just after the Ming restoration. Almost everything done must have been based on Chinese usage, either on that of the Southern Sung or on the mongrelized Sung style practised under the Chin. Several descriptions are worth quoting, then, for the light that they throw backward on the Sung repertory; particularly as they illumine its fondness for picturesque massing.[2]

The central south entrance to the palace was '12 bays across with five passage-ways [below], 187 by 55 feet in plan, and 85 feet high. To left and right there were two crenellated towers, *lou*, from which one could mount to the gatehouse [top] by two slanting [staircase] galleries of ten bays each. On the two flanking *chüeh* barbicans were *kuan* look-outs, each of which had three crenellated *lou*; these last being linked by five-bay galleries running east and west.'

The Hsing-shêng Palace that housed the harem was disposed around an axial group of three buildings. The front hall, 200 by 94 feet, was seven bays across. A closed gallery of five bays led back to the imperial bedchamber, which had a width of five bays and a three-bay wing at either end. At the back was a 'Sweet-scented Pavilion' of three bays, 77 feet deep This way of linking two halls by a short axial corridor had probably existed for a long time in China wherever convenience outweighed monumentality. The modern note here was probably the picturesque variety of the building forms.

One way of attaining animation in design that must have been tried out in Sung times was to break up the geometrical simplicity of the roof. An open gable field, with its shadows and rich decoration, would be set at right angles to the centre of the main ridge, like a pediment. One large Yüan pleasure-pavilion, a square 79 feet on a side, is described as having a cross-shaped roof (i.e. two equal ridges, and so a gable field above each face). The ridges were of blue glazed tiles, and there were gilded vase-shaped finials along them and at the corners of the eaves.

The descriptions of the Yüan palaces are further valuable as a check on a potentially rich field of historical evidence, architectural painting. The masters of that genre had reached their greatest successes in early Sung, when their work might pass an architect's inspection. Meticulous accuracy is obvious in the best surviving pictures ascribed to the Sung or Yüan [294]. Their subject-matter is drawn from the informal parts of the palace; the buildings shown carry out the desired mood of luxurious gaiety by a remarkable diversity in grouping and form. The simple, rectangular, single-roofed hall that has always been the basic element in Chinese design is conspicuously absent. Instead there is a constant playing with proportions, storey heights, attached porches, wings, and galleries. Most of this versatility may be traced in the descriptions of the Yüan palaces.

294. Li Jung-chin: A Pleasure Palace. Yüan Dynasty.
Taipei, Taiwan, National Palace Museum

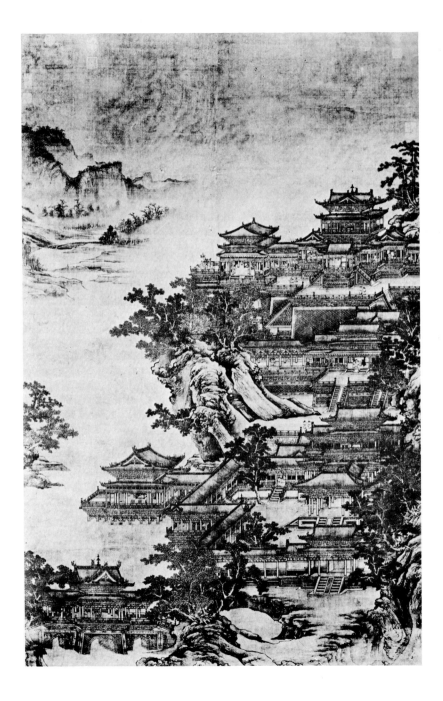

The tomb of a Taoist abbot who died in 1252 under the Yüan, found in the far south-west tip of Shansi, contained a stone sarcophagus of traditional form. The engraved decoration, executed with great precision and delicacy of line, includes two remarkable drawings of architecture. Half of each long side of the coffin is occupied by a secular palace scene in one-point perspective, looking like a continuation of the Paradise palace-and-garden settings in the late Tun-huang frescoes. The realistic details include the sort of diagonally projecting brackets that had been favoured earlier in the North in Liao and Chin buildings (page 444). On the front end of the sarcophagus, above the traditional false doorway, a two-storeyed gate-tower is drawn with the same descriptive virtuosity.

PAGODA TYPES

Liao Buddhism created a distinct brick pagoda type, capable of great beauty and dignity [297]. The distinguishing features are an octagonal plan, and an elevation in which three stages – base, shaft, and crown – are sharply differentiated. The base is fairly high, and is subdivided into courses enriched by sculpture. The shaft is relatively plain, serving as a background for Buddhist groups in relief; some sort of corner accent maintains verticality. The crown is a series of close-set roofs, usually thirteen. The bottom-most eaves are bracketed in a fashion based on Chinese carpentry; most often the rest will be corbelled out. The whole multiple crown diminishes as it rises, and is topped by some sort of spire.

The two types of octagonal pagoda used by the Liao and the Sung differ in much the same way as do the two kinds of palace façade current in Europe from the Renaissance. The Sung version has the directness and clarity of an Alberti design. The Liao alternative shows the more pronounced specialization of the Baroque. In their time the two were rivals; and though the northern was the more dramatic and original, the other exercised a greater influence – doubtless because it was the property of a superior civilization. The Liao tower followed the Khitan armies, and halted at the frontier. Even in the border regions like Hopei it lost purity by borrowing from its Sung competitor. The latter, as an agent of Chinese culture, had an international currency that allowed it to be used deep inside the Tartar domain. Two of the most impressive monuments remaining on what was once Khitan soil follow the general Sung design, and reveal their affiliation only in details.

Neither the origins nor the stylistic development of the Liao pagoda can be accurately traced. T'ang masons, as we have seen, had used a related form, simpler and square [268]. The closest prototype is the Wei tower on Mount Sung in Honan [258]. The connexion is less likely to be direct, however, than to be the result of a common derivation from some Indian model, long remembered. The octagonal ground-plan may also have owed something to India, through the influence of Tantric Buddhism. Tantric speculation preferred its cosmological pattern to be subdivided into eight compass points instead of four. All stūpas and pagodas are more or less elaborate cosmological symbols; in the Liao type the mystical importance of the eight-fold partition is explicitly reiterated.

Only a very small number of northern pagodas are dated, and it is difficult even to separate the remains into dynastic groups. The type continued in favour under the Chin without marked change, and still later might be carefully imitated; restoration has often been drastic. Out of the resulting confusion it is possible to disentangle only a tentative list of Liao originals. From the accounts of Chinese and Japanese authorities I have assembled twenty-three: six from Hopei, the rest from Manchuria.

The largest of the Liao group is the 'great pagoda' of the old Khitan Middle Capital, at Ta-ming-ch'êng in Jehol, which reaches 260 or 270 feet. The smallest run to around 50 to 60 feet. The standard plan and elevation permit several recurring variations. Small scale may bring a reduction of sides to six, and of roofs to nine or seven. A half-dozen examples have imitative brackets under all their roofs, instead of the bottom eaves only. A group of four pagodas in or near Chao-yang, in Chin-chou, Jehol, stands apart from the rest in retaining a square plan. It is obvious, however, that the first of these, which served as model for the rest, was originally a T'ang work, similar to the 'Small Gander Pagoda' at Hsi-an-fu [295]. The Liao

295. Chin-chou, Jehol, northern pagoda of Chao-yang. Eighth and eleventh centuries

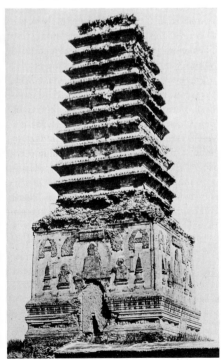

contribution was merely a refacing that increased the bulk of the lower half; being carried out probably soon after 1042, when the status and privileges of Chao-yang were raised by the favour of a Khitan ruler.

The change effected on the Chao-yang 'northern pagoda', the provision of four spacious walls against which reliefs could be placed, tells a good deal about the Liao conception of a proper pagoda. The design is much more explicit than any T'ang predecessor or Sung rival can have been in underlining cosmological significance. Each face holds a large Buddha of Tantric type, throned on a distinctive seat. Beyond the flanking attendants, the remainder of the wall is taken up by a small, square pagoda in relief, like the T'ang multi-roofed form except for a more elaborate podium. Details make it clear that the scheme brought together the Tantric Buddhas of the Four Quarters and the Eight Great Stūpas of Mahāyāna tradition. It was in effect an epitome of Buddhist space and of that portion of Buddhist time that had been defined by the career of Śākyamuni. Since in the developed Tantric system the four directional Buddhas exist only as a frame around the ineffable Vairocana, it is likely that the latter was symbolized at Chao-yang by the pagoda as a whole.

The Four Buddhas occasionally appear on octagonal or hexagonal pagodas, where they must be adjusted to the treatment of the other faces. More frequently the standard octagon is fitted directly to an iconographic set of eight, usually Buddhas. On the twelfth-century pagoda of Yüan-t'ung-ssu north of Mukden, the more familiar Tantric alternative is followed: the eight sides hold an alternation of Buddhas and Bodhisattvas. The 'great pagoda' of Ta-ming-ch'êng uses the other canonical favourite, a set of the Eight Great Bodhisattvas.

The portions of the typical podium that have escaped damage show a sculpture that vies with the icons above in quality, and greatly exceeds

them in variety. An ancient tradition may be recalled by the use of grotesque caryatids at the corners. One striking feature appears three times: the forequarters of a huge lion, projecting from each face. The lion is the Tantric 'vehicle' of Vairocana; and so its emphatic repetition in the base may well stress the fact that the whole tower was intended to stand for the body of that primal Lord.

The prominence given to reliefs on the typical northern pagoda accentuates the divergence of

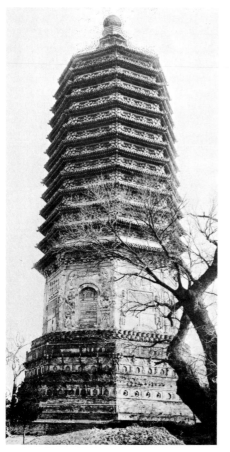

296. Peking, pagoda of T'ien-ning-ssu.
Eleventh or early twelfth century

the sub-group – chiefly found in Hopei – in which little or no major sculpture appears. On the handsome 'south pagoda' of Yün-chü-ssu on Mount Fang, south-west of Peking, erected in 1117, the faces have only doors and windows.[3] The version at T'ien-ning-ssu, just outside Peking, is less severely architectonic, but the change is clear.[4] The big figures are merely the conventional threatening door-keepers; the great Trinities appear only in miniature in lunettes; and the other reliefs seem to have no special purpose [296]. It would be unwise to assume that this reticence, and that of the Sung style on which it was modelled, sprang from a less superstitious form of Buddhism than the Manchurian. The typical Sung pagoda had a serviceable interior, in which images were probably enshrined as they were inside the wooden pagodas of Japan. Several of the Hopei towers of mixed Liao-Sung style, including Yün-chü-ssu's, have real openings; and even where the doors were merely simulated, as at T'ien-ning-ssu, the original design probably called for images somewhere inside.

The bracketing of the Liao pagoda is one of its greatest aesthetic assets. The details imitate those of contemporary carpentry, with a like forcefulness and generosity. In brick the projection can be only about half that of wooden eaves; so that even on a large pagoda there will be no more than two tiers. In compensation the vocabulary of forms is very rich. A special complication is created by the ground-plan. Corner brackets must always be the most intricate; on an eight-sided pagoda there are twice as many corners as usual, set closer together. In addition, the Liao architects seem to have deliberately exploited variety. As a general rule no scheme is found twice. Sometimes the effect is sober, as on the Chao-yang 'northern pagoda', where identical units are spaced out. More often a marked richness is gained by use of the diagonal [299]. The Liao must have inherited this idea from tenth-century China, and used it long

after the Sung had evolved a more rigorous discipline. The feature may be ingeniously fitted into the corner complex, by placing a second diagonal at right angles to the natural one (or, if the plan is octagonal, on correspondingly modified axes). The other obvious place for a fanning complex is at the centre of the bay. Where the pagoda shaft is narrow enough to justify using only a single such unit, the play of its branches against the double diagonals of the corners creates an animated in-and-out rhythm. Unfortunately the Liao designers were not always satisfied by even such energetic harmonies. In many of their schemes the search for variety has produced equally strong discords.

It should be noted that the Liao style gradually underwent the same change in proportioning as the Sung. Early bracketing units are sturdy and well isolated; by the end of the dynasty the scale is more delicate and the spacing crowded.

A small number of Manchurian towers possess a feature that was probably borrowed from the Sung: a bracketed balcony surrounding the podium. The northernmost occurrence of the loan at an early date is on the large imperial pagoda at Chin-hsien, raised in the 1050s or 1060s. An advance of Chinese influence must explain the balconies found farther north on a pair of towers at Pei-chên that betray a later date by crowded bracketing and curving eaves [297]. A late-comer in the series, the huge 'white pagoda' of Liao-yang, built in the 1160s or 1170s by a Chin empress, marks the end of creativity by its close resemblance to the Chin-hsien tower. Only the much smaller scale of its bracketing shows the passage of a century.

All the Hopei examples have bracketed balconies; a larger proportion than in Manchuria have bracketing under all their eaves. The few dated examples sum up the direction and pace of change.[5] The small, seven-roofed pagoda at P'u-shou-ssu in Chou-hsien, completed in 1079, has a noticeable eaves curve. All its roofs

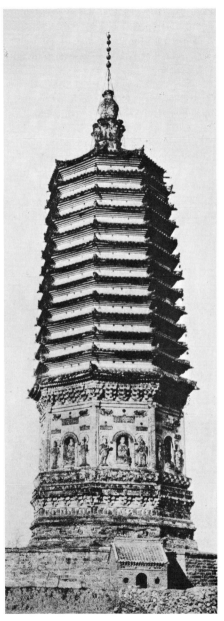

297. Chin-hsien, Manchuria, eastern pagoda of Pei-chên. Mid eleventh century

are bracketed, with rather widely spaced units. The southern pagoda of Yün-chü-ssu supports its date of 1117 by a little more crowding. The Chin tower at Hsi-kang in Lai-shui-hsien, said to date in the era between 1161 and 1190, points to a more disturbing degree of Sung influence than we have seen elsewhere. It has a separate top storey above the twelfth roof, with a shaft and bracketing of its own.

The multi-storeyed brick pagoda is found in Liao territory in four closely interrelated monuments.[6] The sole Manchurian example is the seven-storeyed 'white pagoda' of Ch'ing-chou in Jehol [298, 299], rising near the mausolea of three Khitan rulers. At Chou-chou in Hopei, just inside the frontier, there are two five-

storeyed structures, the northern one dated 1092. At I-chou, not far to the west, there is one of three storeys. All are faithful to the practices of wooden building, following the convention of setting an arched doorway on each cardinal face and a window on the others (the Jehol tower betrays its northern setting by using this formula only on the bottom storey, and filling the rest with niches and relief pagodas). The bracketing changes from storey to storey, rising towards simplicity. All four pagodas share an unusual decorative feature that must be part of their common debt to the Sung style. The small wall surface between bracketing units is carved with the kind of floral motifs recommended in the *Ying-tsao Fa Shih*.

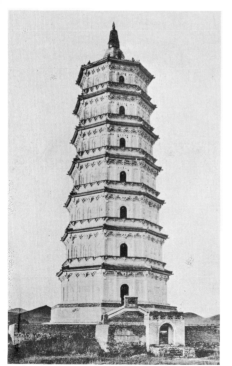

298. Ch'ing-chou, Jehol, 'white pagoda' of Pai-t'a-ssu. Eleventh or early twelfth century

299. Detail of the 'white pagoda'

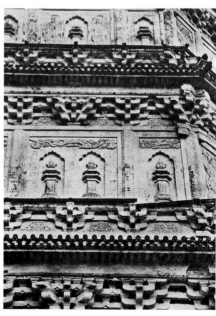

One wooden pagoda erected under the Liao in 1058 survives to bridge the gap between masonry and carpentry: the five-storeyed structure at Fo-kung-ssu, in the Shansi town of Ying-hsien.[7] The eaves there have the emphatic projection (and so require the more developed bracketing) that we shall see in Liao wooden halls [300]. The total effect has a certain timidity, as if the wood-framed tower had been a problem not often tackled by Liao architects. The storeys are squat, and the silhouette is so broad and low that it looks almost as much like a multi-storeyed *ko* pavilion as a pagoda.

The Sung form imitated in the Liao multi-storeyed pagodas must also have been a wooden one, and so has vanished except for its occasional mention in books. A single famous monument may just possibly have set the fashion, the giant eleven-storeyed pagoda of K'ai-pao-ssu at the Sung capital. If so, the difference between Yü Hao's masterpiece of 989 and the Khitan versions must first have been one of proportions. The K'ai-pao-ssu tower was much higher than any known construction across the frontier, and may well have had something of the columnar slenderness of the Chekiang style.

A small number of Tartar works are markedly heterodox. The 'northern pagoda' on Mount Fang has a dome and masonry spire surmounting a conventional lower half [301].[8] The effect is close enough to that of a Tibetan *chorten* to be puzzling; the structure looks as if

300. Ying-hsien, Shansi, pagoda of Fo-kung-ssu, elevation. A.D. 1058

301. Mount Fang, Hopei, northern pagoda. Early twelfth century(?)

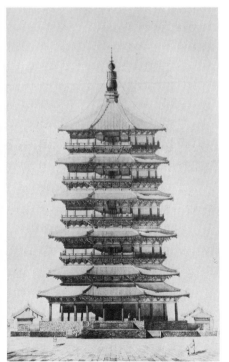

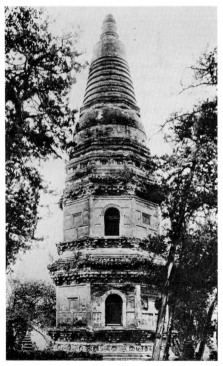

it might have been remodelled in an age of Lamaist dominance like the Yüan or Ch'ing. The dome-and-cone termination occurs, however, on a related type of Liao monument, the stone pillar carved with *dhāraṇī* spells, and so requires no Lamaist explanation. The Mount Fang hybrid is usually attributed, like its southern neighbour of 1117, to the end of Liao. The combination reappears at reduced dimensions in three other Hopei pagodas that appear to belong to the Chin, at Chi-hsien, Shun-tê, and I-hsien.[9]

The strangest of all pagodas, the *Hua-t'a* of Chêng-ting-hsien, Hopei, probably acquired enough of its present form under the Chin to warrant mention here.[10] The details of the second storey look earlier than the rest, and perhaps go back to the tenth century. There is a record of rebuilding between 1161 and 1189; probably at that time the first storey was refaced so as to make a larger octagon, and on the alternate sides were added four hexagonal, single-storey wings, with the intention of reproducing the four-around-one scheme of the Tantric maṇḍala. The extraordinary handle-like top thickly encrusted with sculpture – stūpas resting on lion or elephant protomes, grotesque caryatids, lion heads – is so unlike anything else in China that it is hard to date. At least one can say that it shows a desire to reproduce some Indian Buddhist prototype, and so is better placed under the Chin than later (when communication with India was no longer fruitful for Buddhism).

Almost all the Liao and Chin pagodas rise singly. Most seem to have stood on the main axis of their temple; usually behind the main hall, though sometimes in front. The one east-west pair is at Pei-chên in Manchuria, and very likely was raised on T'ang foundations.

The few Yüan pagodas offer little in the way of new interest. Those in the south, like the tower of the 'King Aśoka Temple', A-yü-wang-ssu, near Ning-po,[11] are likely to be re-erections

on Sung bases, in a late version of the local style. Northern examples, like the early fourteenth-century pair at Peking, are apt to reproduce the nearest Liao multi-roofed prototype.[12] Since the Mongol state gave its chief patronage to Lamaist Buddhism, the first wholesale introduction of the Tibetan bottle-shaped stūpa

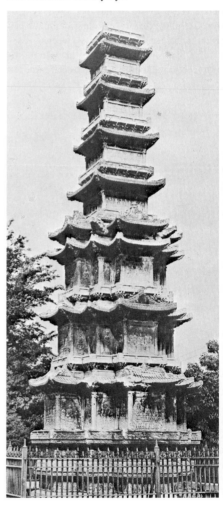

302. Seoul, Korea, Yüan pagoda in park (detail). Mid-fourteenth-century style

form, the chorten, must have taken place at that time. One quarter of Peking is still dominated by a huge 'white pagoda' of that sort, built by Kubilai.[13] There is a tradition that its first erection went back to a Liao emperor of the 1090s, but if so that forerunner can hardly have been so completely exotic.

By an accident of history, the one pagoda that adds materially to our knowledge of Yüan style has been preserved in Korea.[14] It is a pillar-like stone tower, with the proportions and carpentry details common in Sung monuments of the Yangtze region, now re-erected in a Seoul park [302]. Most remarkable, as a testimony to the baroque interests of the age, is the way the lower half is expanded by miniature pavilions *en ressaut*, much like a pleasure-pavilion in a painting. The pagoda used to be explained as a gift made by the last Mongol emperor, built by Chinese workmen, when his favourite granddaughter was married to the Korean king. An inscription found in 1946, dated 1468, proves that the explanation must be more complex. The Yüan original probably lies in fragments in Seoul, and what we see is a faithful copy executed about a century later.

WOODEN HALLS

The two oldest Liao buildings, survivors from A.D. 984, belong to a still more ancient temple, Tu-lo-ssu, at Chi-hsien in Hopei, some sixty-three miles east of Peking.[15] The compound is a nondescript huddle, out of which rise a gatehouse, *Shan-mên*, and a 'pavilion of Avalokiteśvara', *Kuan-yin-ko*. The former, three by two, or about 55 by 29 feet, has a single hipped roof. The pavilion, five by four, measures about 67 by 47 feet on the ground, and rises about 68 feet from its platform. Its elevation is that of a two-storeyed building with a balcony; inside there are three floor levels, the upper two surrounding a well through which rises the colossal clay image [303-6].

A stele of 986 records the construction date; the donor was a member of the Khitan ruling clan. The text speaks of a 'restoration', and since the style followed is visibly close to that of the mid ninth-century main hall of Fo-kuang-ssu, it is probable that the Liao craftsmen followed a T'ang prototype (that in its turn had

303. Chi-hsien, Hopei, Kuan-yin-ko of Tu-lo-ssu, upper part of interior and image. A.D. 984

presumably been erected after the persecution of 845). Later repairs have been numerous but minor. The most noticeable is the addition of pillars to prop up the sagging corners of the pavilion roofs.

The modest size and shallow eaves of the Shan-mên have kept its bracketing simple. Only

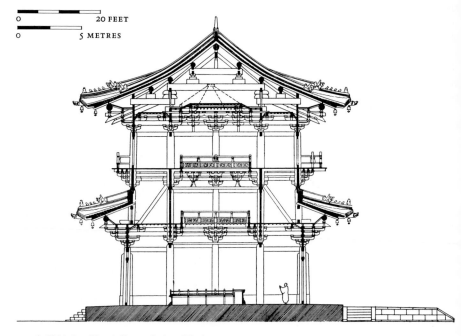

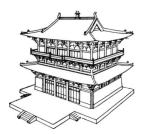

304–6. Chi-hsien, Hopei, Kuan-yin-ko of Tu-lo-ssu.
A.D. 984

304. Section, plan, and elevation

305 (*opposite, above*). Façade

306 (*opposite, below*). Detail of eaves

horizontal arms are used; the single inter-
columnar unit has a T'ang look, widening out
(as at Fo-kuang-ssu) from the top of a strut.
The gatehouse as a whole shows in simplified
form the style more grandly exhibited in the
pavilion. Its one superior feature is its ridge
acroteria, which like those of the Fo-kuang-ssu
hall clearly belong somewhere between T'ang
and Ming.

The pavilion contains no less than twenty-
four types of bracketing, so that every set of
structural conditions can have its own solution.
The exterior accounts for half of these [305,
306]. Different designs are used under the two
eaves and the balcony. At each level, in addition
to the difference between column-top and
corner complexes, there is at least one inter-
columnar type; and that may be further varied
to suit the width of the bay. No more than a
single intercolumnar unit appears per bay, and
under the main roofs there is a marked alterna-
tion of form. Below the balcony the bracketing

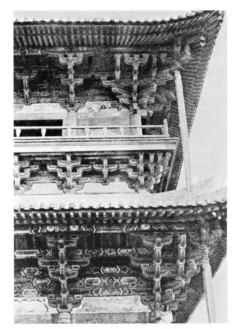

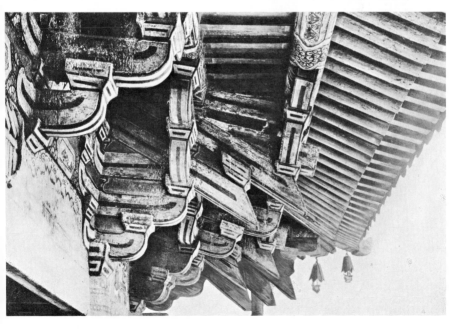

307. I-hsien, Manchuria, Fêng-kuo-ssu, façade of the main hall. A.D. 1020

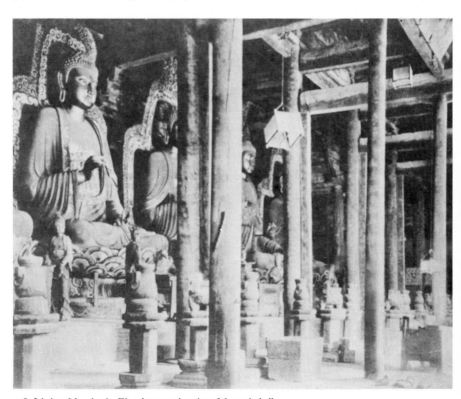

308. I-hsien, Manchuria, Fêng-kuo-ssu, interior of the main hall

design is nearly uniform, and so approaches Sung usage.

The most elaborate bracketing occurs under the top roof, where projection is deepest. Both repeating complexes recall Fo-kuang-ssu. Over the columns a four-step scheme is used, two hua arms and two slanting ang; in between there are three steps, without ang. The corners already have the secondary diagonal axis that we have found on Liao pagodas, though this is still fairly unobtrusive.

As at Fo-kuang-ssu the two ang run parallel; are cut off outside on an acute angle; and inside butt against the bottom of a cross-beam, above a coved and coffered ceiling.

Under the lower roof the column-top system used four tiers of hua and a beam end, sliced off to look like a short ang. The balcony has three shallow hua.

In one detail the pavilion is closer to the Sung standard than to T'ang; its longitudinal bracket arms are usually set in vertical pairs, the lower dimensioned to the hua arm that it intersects and the upper – in Sung terminology called a *man* – markedly longer. In the wall plane such arms are simulated in relief on tiers of beams. The one arm never paired is the farthest out, the *ling*, which holds only a cushion member between it and the eaves purlin.

The main roof timbers inside are hidden, and so have been left rough. As at Fo-kuang-ssu, the purlins are braced by slanting props. There is an octagonal cupola over the colossus, but its design suggests a restoration. On the other hand, the interior balconies around the well retain their original posts and panelling and show an interesting variety of lattice-work designs.

The next oldest of the great Liao halls survives at I-hsien, Fêng-t'ien Province, Manchuria.[16] Again the temple as a whole, Fêng-kuo-ssu, is now a pitiful remnant; but the size of its great hall and the majestic sweep of the roof are awe-inspiring even from a distance [307]. Inside, the impressiveness lent by the

309. Fêng-kuo-ssu, eaves of the main hall (detail)

dimensions is reinforced by an array of colossal images, the Seven Buddhas in a row [308]. To accommodate them the building is nine bays by five, or about 160 by 83 feet. According to an extant stele of 1303, it was erected in 1020.

By listing the principal elements that made up Fêng-kuo-ssu in 1303, the stele gives a good idea of its general plan. There were then two nine-bay structures, the existing hall and a Dharma Hall behind it, intended to hold 1000 monks. Farther to the rear was a trio of pavilions, central, eastern, and western, dedicated respectively to Kuan-yin, the Three Vehicles, and O-mi-t'o (Amitābha).

In the plan of the Fêng-kuo-ssu hall the old chancel-and-ambulatory formula is sensibly loosened. The interior is equally divided into two spacious chambers, seven by two (each achieved by omitting a row of six columns). The rear chamber houses the seven images, and is dignified by handsome girders. The front, public space is covered only by exposed rafters, like a double aisle. The dividing row of columns probably was once reinforced by curtains.

Under the eaves [309] the column-head bracketing is like that under the main roof of the

Kuan-yin-ko. The stylistic advance in thirty-five years is marked in two ways. The inter-columnar complex is almost the same as the other, differing only in its first step; and by the same corollary that we have found under the Sung, the column-head beam has been given a T-section.

At Pao-ti-hsien in Hopei, south of Tu-lo-ssu, is another ancient monastery, Kuang-chi-ssu, with a single Liao main hall.[17] The latter is called the *San-ta-shih-tien*, because it enshrines three seated Bodhisattvas (probably Kuan-yin at the centre, Wên-shu on the east, and P'u-hisen on the west). A stele of 1025 dates it in the same year (and records, also, that it was once backed up by a Liao wooden pagoda of 180 feet).

The San-ta-shih-tien is five bays by four, or about 83 by 60 feet; its proportions and hipped roof make it look like a larger edition of the Tu-lo-ssu gatehouse. The floor space is again halved between a sanctuary and a public area. Since there are only four bays of depth available, however, and the last serves as a rear aisle, each chamber can have only a bay and a half. The dividing row of columns must stand midway between the axes followed elsewhere; an eccentricity that requires an unusually complicated girder and beam framework above.

The eaves bracketing, though a little later than that of Fêng-kuo-ssu, is still close in style to Tu-lo-ssu (and so points out the danger of expecting too orderly a development within a short period). There is a fine tile ridge, with a frieze of dragons in relief, and acroteria that re-state the theme of the Tu-lo-ssu gatehouse with greater richness.

The town of Ta-t'ung-fu, in the borderlands between Shansi and Mongolia, has inherited two temples from the age when it served as a Tartar capital.[18] One, Hua-yen-ssu, was so highly esteemed that it was granted the privilege of housing images of the Khitan emperors, presented in 1062. Two halls remain from that

first age, while a third belongs to a phase of restoration under the Chin. The other temple, called P'u-ên-ssu or Shan-hua-ssu, owns two structures attributable to the Liao, and two more that clearly are Chin.

Hua-yen-ssu faces east, a fact that may record some special influence from Central Asia or India, since the terrain permitted a free choice. There are two precincts, side by side. The 'upper temple' on the north centres on a very large Chin main hall. The 'lower temple' features a somewhat smaller library, the *Pao-chia-chiao-ts'ang-tien*, completed in 1038 (according to an inscription on a beam). A little in front on its left and facing toward the axis is another hall of the same scale, the *Hai-hui-tien* [276B]. The dual plan presumably was a result of the rise in the temple's fortunes that accompanied its receipt of the Imperial images in 1062. The original foundation had the library as its principal building; Imperial patronage brought the need for a whole new precinct alongside, with a larger main hall set farther back for greater dignity. Liao and Chin stelae mention a number of other buildings. It is noteworthy that there was a balanced pair of pavilions, of which the northern one held the Khitan statues; and also a 'treasure pagoda', Pao-t'a.

The library is five bays by four, about 85 by 62 feet, with a hip-and-gable roof. The interior preserves the old chancel-and-ambulatory division. A platform altar of brick is covered with images in T'ang fashion; but the most remarkable asset of the building is a set of architectural book cupboards running around the ends and rear [310-12].

The eaves are bracketed in a fashion like that seen at Kuang-chi-ssu. The interior is covered by ceilings throughout, with an octagonal cupola rising over each of the three main icons. Over the chancel the woodwork still retains an elaborate painted decoration, varied to suit the forms to which it is applied.

Nothing else among Liao remains comes so close to the Sung ideal of crisp, well-organized richness as do the two-storey wall cupboards. Each section has a prominent central motif. Those on the ends of the hall feature a miniature, three-part pavilion. The long rear façade has a more complicated five-part design, laid out on academic principles; the centre is made dramatic

by an arching bridge. The miniature pavilion roofs all have the hip-and-gable form, and their ridges terminate in fish-monster acroteria not unlike those of the Tu-lo-ssu gate (though more vertical, and so more like the T'ang tradition).

The bracketing is highly diversified, largely because of a differentiation between corners,

310. Ta-t'ung-fu, Shansi, library of
Lower Hua-yen-ssu, sūtra cupboards, façade

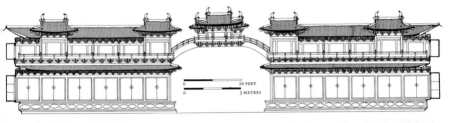

311 and 312. Ta-t'ung-fu, Shansi,
library of Lower Hua-yen-ssu,
sūtra cupboards (details). A.D. 1038

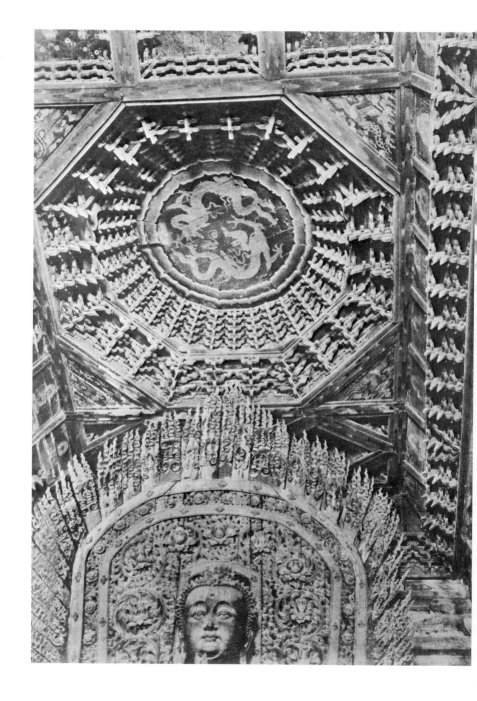

salient and re-entrant. No distinction is drawn between column-head and intercolumnar units. In addition the single repeated complex approaches Sung practice by having its intermediate steps filled out with longitudinal arms; only the first step lacks a full longitudinal complement. There is one intercolumnar unit that fans out on diagonals, at the centre of the northern façade. All of this is so much like the mature Northern Sung style that it is tempting to imagine that the Liao architects made a special effort to reproduce some Chinese prototype, either by bringing in a consultant or by referring to some manual that preceded the *Ying-tsao Fa Shih*.

The Hai-hui-tien is so simple that it serves best to demonstrate the basic principles of Chinese timber construction [276B].

Shan-hua-ssu faces south, and has three big buildings on axis. The first two, a gatehouse and a 'Hall of the Three Holy Ones', *San-shêng-tien*, must have been erected again under the Chin, after the temple was burned in the 1120s. The main hall must have escaped the fire. Its

plan is the now familiar two-chamber one, with a complicated framework above to restore symmetry; the central Buddha has a magnificent cupola overhead [313, 314].

A contemporary work must be the surviving one of a pair of small two-storey pavilions that until recently balanced each other just behind the San-shêng-tien. In these two Liao remains the chief novelty is the use of intercolumnar units over the central bays that branch at 60 or 45 degrees (in much the same fashion as on the wood pagoda of Fo-kung-ssu, dated 1056).

K'ai-yüan-ssu at I-hsien in Hopei has kept three chapel-sized buildings in an east-west row that was probably completed in 1105.[19] The central and eastern halls are three-bay squares with hip-and-gable roofs; the western one is three by two, with a hipped roof. All have extremely simple bracketing. The interiors have preserved a good deal of their original decoration, best seen around the intricate cupola of the central hall [315]. A Sung flavour is strong throughout, justified both by the relatively late date and by the location of I-hsien close to the

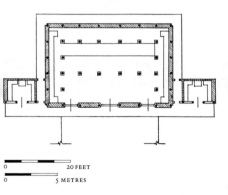

```
0          20 FEET
0       5 METRES
```

313 (*left*) and 314 (*above*). Ta-t'ung-fu, Shansi, main hall of Shan-hua-ssu, ceiling and plan. Eleventh century

315 (*right*). I-hsien, Hopei, central hall of K'ai-yüan-ssu, ceiling. A.D. 1105(?)

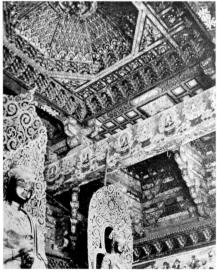

border. The east-west trio recalls the row of three pavilions that once towered at the rear of Fêng-kuo-ssu.

Chin architecture in general, as we have seen, had none of the racial *élan* that helped to redeem awkwardness under the Liao. At Ta-t'ung the three big twelfth-century halls show an uncertain style, compounded of Liao traditions and Sung innovations in fluctuating proportions, with the virtues of neither original. Most like the earlier standard is the giant main hall at Hua-yen-ssu, a nine-by-five-bay structure comparable in size to Fêng-kuo-ssu. The interior (though much re-decorated) is a fine sight still, with more than usual of the mysterious semi-obscurity of Tantric Buddhism [317]. The plan is novel, but in comparison with its Liao predecessors sacrifices too much to symmetry [316].

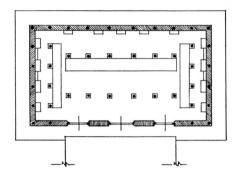

316 and 317. Ta-t'ung-fu, Shansi, main hall of Upper Hua-yen-ssu, plan and interior. Twelfth century

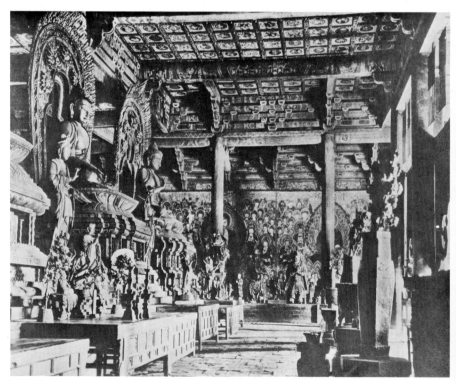

The eaves bracketing continues the late Liao interest in diagonal fanning.

The two Chin buildings of Shan-hua-ssu have a stronger Sung colouring, which in the gatehouse goes so far as to bring in curving 'moon beams', and closely spaced bracketing with beaks. Still closer to Sung orthodoxy is the main hall of Ching-t'u-ssu at Ying-hsien, Hopei, built in 1124 under what must have been purely Chinese direction. The building has a notable ceiling, framed by a cornice made up of miniature buildings with curving roofs and rich banks of tiny brackets. Also very like the Sung standard are two small two-storey kiosks at the main headquarters of the Confucian cult at Chü-fu in Shantung, which probably stem from a rebuilding at the end of the twelfth century.[20]

Nothing that remains from the Yüan period suggests even remotely the stupendous scale and lavishness described by Marco Polo. The most impressive surviving building, the two-storeyed, nine-by-six-bay main hall of the Taoist 'Shrine of the Northern Peak' at Ch'ü-yang-hsien in Hopei, is a Sung structure in everything except its date of 1270.[21] The details that may be amassed are close to those imitated by the Japanese in their Karayō.

Two features appearing in buildings of the Mongol period deserve special notice. One has been cited already: the rare tripartite plan of the Shêng-ku-miao of 1309 [291]. At Kuang-shêng-ssu in Chao-ch'êng-hsien, Shansi, a group of buildings erected again by 1319 reveals a unique structural exploitation of the lever arm.[22] Thus in the front hall of the 'lower temple', what corresponds to an ang has the proportions of a beam, and runs all the way up inside the hall to meet its opposite number under the centre of the main cross-beam. The bracketing proper, at the same time, is so dwarfed as to be almost vestigial. The combination, except for its frankness, is oddly like that found in Japanese construction, hidden above the ceilings. There can hardly have been any transmission of influence; both cases doubtless represent logical conclusions drawn separately about the advantages of the ang form. In China there seems to have been no sequel to the Kuang-shêng-ssu experiment.

318. Ching-hsien, Hopei, main hall of Kʻai-fu-ssu,
cupola. A.D. 1462

MING AND CH'ING

(1368-1912)

To abbreviate the last half-millennium as drastically as is done in this chapter seems justifiable on two counts. In the first place, its subject-matter has already been well presented to the West;[1] in the second, the level of interest is relatively low. Ming and Ch'ing remains represent a prolonged decadence of the art and science of fine building. The major creative effort of the age went at its start into the formation of a recognizable style; but even that was little more than a modification of Southern Sung, and, once it was achieved, the process of change virtually came to an end. The Manchus, whose rule took up half the period, were no more enlightened or confident as patrons than the Mongols or Chin Tartars. They too were satisfied to follow their Chinese predecessors, perhaps with an even greater punctiliousness. Under them – particularly under the energetic Ch'ien-lung emperor of the eighteenth century – a vast quantity of monumental architecture was erected or refaced. In the best of that work, as seen in the Peking palaces, there are a good many inherited virtues. The big halls with their courtyards and gates are still majestic; the pleasure-quarters around the lakes are still charming. But even the appreciative visitor to Peking is conscious, before long, of an underlying monotony. The historian, who should balance what he sees against the imagined accomplishments of earlier times, can hardly help finding the late style unimaginative and timid.

It has been a roughly accurate axiom of Chinese history that each major dynasty should emerge from chaos with the ambition to recon-struct the world of its predecessor. The first recognizable style of each period is relatively backward-looking; only after a few generations do the altered times produce their own standard. We have seen that this process operated under the Northern Sung to delay the appearance of a characteristic Sung architecture until the second half of the eleventh century. Under the Ming it meant that buildings erected in the fifteenth century were likely to retain a good deal of Sung flavour. The main hall of K'ai-fu-ssu at Ching-hsien in Hopei, for example, though it dates from 1462, is still dominated outside by subtly curving eaves, and in its low porch echoes something of the Sung love of picturesque massing. The spiralling cupola inside testifies to mental liveliness as well as to dexterity [318]. For special local reasons, and particularly in out-of-the-way regions, this conservatism might rule even longer. Buildings in the north-west as late as 1600 may still feature diagonal bracketing complexes in the Liao tradition. On the other hand, it is clear that by at least the mid fifteenth century an official Ming style had been worked out at the capital. A convenient landmark is furnished by the buildings of the most interesting early temple remaining in Peking, Chih-hua-ssu, which was completed around 1444.[2]

Chih-hua-ssu foreshadows a great deal of what was to be done at Peking, or wherever else the official code was followed, in the next four centuries. Its individual character, on the other hand, is a quality that was not destined to survive much longer. The general plan is typical, a narrow, deep oblong with a succession

of courts of various sizes. The first court is dominated by the east-west balance of two-storey bell and drum kiosks, and is left through a second gatehouse containing dramatically posed images of the Four Guardian Kings. The larger second court has a pair of side buildings with more fine, realistic sculpture; the western one, decorated in the Lamaist style, is a library with a high, hexagonal, stationary sūtra case. At the back is the first axial Buddha hall. The temple's chief monument, the two-storeyed *Ju-lai-tien,* stands isolated in the third court.

319. Cupola from the Ju-lai-tien of
Chih-hua-ssu at Peking. Mid fifteenth century.
*Kansas City, William Rockhill Nelson Gallery of
Art and Atkins Museum*

Behind is a rear compound, with living quarters for the monks and also housing some subsidiary chapels.

Signs of lateness are apparent everywhere at Chih-hua-ssu. The scale, to begin with, reveals an age of religious decline. Most of the buildings are small; even the Ju-lai-tien measures only about 60 by 40 feet on the ground floor.

The plan and elevations of the Ju-lai-tien show a new insensitivity to spacing. The pillars are so unevenly set – with a very wide central bay, and very narrow corner ones – that they contribute no apprehensible rhythm. The bracketing, which even in the Northern Sung style had stressed rhythmic subdivision, is here so dwarfed and crowded that it counts only as a continuous cornice. It is not even clearly visible any more, being half hidden by a band of scroll-work suspended from the edge of the eaves. The most noticeable feature of the façade, the arch form used in the three doorways of the upper storey, is an exotic novelty paid for by a falling-off in consistency. The interior is handsomely appointed, and when it contained the fine timber cupola now exhibited in the Nelson Gallery of Art [319] at Kansas City, must have been still more impressive; but in comparison with earlier work even the cupola is a little dry and mechanical. An almost identical cupola, from the Buddha hall, is now installed in the Philadelphia Museum of Art.

One kind of timidity exhibited at Chih-hua-ssu and destined to rule thereafter is a structural one. The bracketing is as vestigial as the rib articulation in a fan vault; the real work is done by big beams, with the help of a shallower eaves projection. The typical beam is not even well designed, however, being a good deal wider in cross-section than necessary. Even the science of carpentry seems to have been blunted in this age (when the growing difficulty of obtaining good timber should have set a premium on efficiency). The effect of an open ceiling in the Ming and Ch'ing style, with ponderous members closely set in tiers, totally lacks the openness and dynamic variety of earlier combinations.

Timidity and lack of imagination, again, must explain, at least in part, the late architects' abandonment of almost all the variations of mass that had been so tempting to their Sung forerunners. The typical Ming or Ch'ing building has a simple oblong plan, with columns set out in the chancel-and-aisle formula. An enclosed porch on the front or rear, with a separate roof (often curved in section) is not uncommon, nor are wings; two parallel halls may be joined by an axial corridor; but all this is a meagre substitute for the baroque play with projections and heights seen in Sung and Yüan paintings.

Structural timidity and conservatism of a special sort may be held against the late builders for their failure to exploit the principle of vaulting (though here the critic must be less confident, for no one can be sure that earlier architects would not have made the same rejection). Perhaps as a legacy from the pan-Asiatic age of the Mongols, most of the great city gates of Peking were designed in the early fifteenth century with passages covered by big tunnel vaults. Even more remarkably, two large temple halls were built and tunnel-vaulted entirely in brick in the late sixteenth: one at Shuang-t'a-ssu in T'ai-yüan-fu, and the other the 'beamless hall', *Wu-liang-tien*, in Soochow. It is conceivable that these last owed their form to the advice given by European missionaries. They remained mere curiosities, almost on a par with the playful adaptations of the late European Baroque laid out for the Ch'ien-lung emperor in his Summer Palace gardens west of Peking.[3]

What survived best in late architecture were the most obvious ways of appealing to the eye. The traditional monumentality given by great size and simple parts could be perpetuated, at least in the largest palace buildings, like the

320. Peking palace, the Grand Ancestral
Shrine (T'ai-miao). Fifteenth century with later
refurbishing

321. Peking palace, first grand audience hall
(T'ai-ho-tien), acroterion. Ch'ing Dynasty

front throne hall, T'ai-ho-tien, or the Grand
Ancestral Shrine, T'ai-miao, with their sur-
rounding walls and gates [320, 321, 327].[4] Most
often the observer's eye was attracted by
decoration. So far as any chronological distinc-
tion may be drawn, one may say that decorative
effects were still varied and ingenious under the
Ming, but with the Manchus became stan-
dardized and obvious. The late Ming style is
apt to turn to small-scale sculpture as a means
of enlivening its details. One finds first in six-
teenth-century China the sculptured trivia that
the Japanese were to pick up and exploit at
Nikkō: bracketing 'beaks' turned into animals'
heads, puppet-show figurines strung along the
architraves, a honeysuckle liveliness festooned
over the dying style. Under the Manchus such
irreverence seems to have been permitted only
outside the official code. It was particularly at
home in the south, where the native culture
was stronger; and shows itself still wonderfully
exuberant in the tile decorations of southern
roofs, or in panels on the faces of the charac-

eristic entrance-markers of the time, the *p'ai-lou*. In Peking, Ch'ing taste favoured a kind of neo-classical respectability [322-5]. Profit was still drawn even there from an inherited colour sense. In the latest traditional architecture as in antiquity, paint is indispensable to enhance every visual effect, from sumptuous dignity to playfulness; and, though its use is as stereotyped as everything else, the conventions followed are bold and brilliantly successful. The typical imperial building is crowned by a roof of gleaming glazed tile, uniformly coloured except for the finials, in a hierarchic scheme ranging from the ruler's own sunny yellow down to deep blue and green. In the building boom of the eighteenth century the further step was sometimes taken of encasing the vertical surfaces as well with coloured tiles, imitating

the designs normal in paint (as well as such decorative forms as bracketed cornices, entablatures, and pilasters).

The long-used capital, Peking, is so much an epitome of late architectural style – at least in the official versions – that its curious admixtures of tradition and decadence merit special attention. The city plan as a whole, first of all, exhibits a kind of evolutionary struggle between formality and irregularity. The walled area divides into two very dissimilar major elements, a roughly square 'Tartar city' with a perimeter of nearly fifteen miles on the north, and a wider, shallower 'Chinese city' about five miles by two on the south. The former is much the more important and monumental, containing as it does the imperial palace compound. There run the grand avenues of immemorial Chinese

322. Peking, ornamental coloured tile gateway in the 'northern lake'. Ch'ing Dynasty

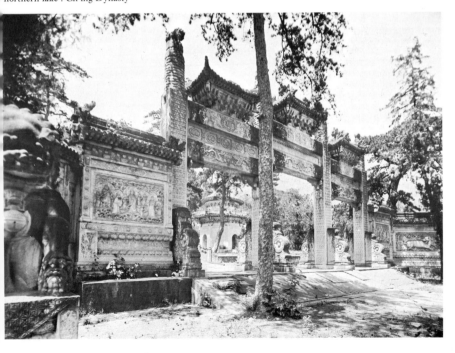

practice, past what remains of the major government offices, the mansions of princes and dignitaries, the artificial lakes and hills of the palace gardens, the more spacious temples. There the ramparts are truly formidable, some forty feet high, strengthened by great outthrusting buttresses, and pierced by nine spectacular towered gateways. The 'Chinese city' has lower walls; apart from the one north-and-south avenue that divides it on the grand axis, its streets are as irregular and accidental as those of London or old Boston. It is clearly a suburban zone, walled in with the rest for practical reasons. Appropriately, then, its most important contents are the two wooded altar precincts which, by ancient custom, always lie south of the capital proper: here the Temple of Heaven east of the central avenue and the smaller Temple of Agriculture on the west.

The 'Tartar city', the true metropolitan nucleus, is itself an obvious product of conflicting forces. Its first premise reveals a desire to draw authority from the distant past: as the Chou ritual books had prescribed, the imperial palace lies near the centre of the city, instead of spreading across its rear (as had been the solution from the Six Dynasties to Sung). The centring is far from precise, however. The Imperial walls and moat press fairly close on the south city gate; and within the palace, in turn, the major elements are to the front. The point falling midway between the south and north city gates marks not a throne hall, as the symbolism of the emperor as cosmic pivot might have demanded, but an artificial hill, rising just north of the palace *enceinte*. It seems to have had no connexion with the ceremonial life of the ruler; and, apart from its advantages as a

323. Tung-ling, Hopei, Manchu imperial mausoleum, offering hall, interior. Ch'ing Dynasty

324. Peking, ornamental detail from the 'southern lake' precinct, Nan-hai. Ch'ing Dynasty

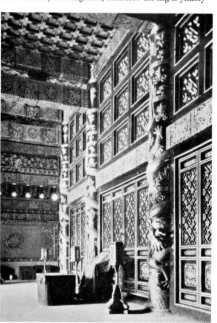

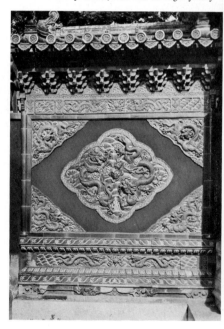

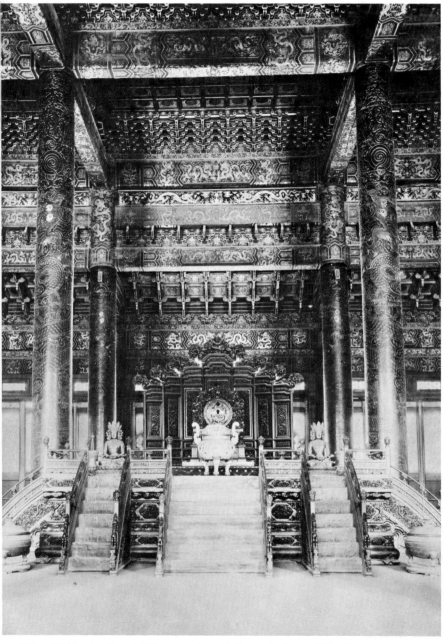

325. Peking, T'ai-ho-tien, Imperial Throne together with decorated columns. Ch'ing Dynasty

look-out post, was important merely as a geomantic barrier against malign influences that might invade the palace from the north.

Again, though both the ancient books and later practice had emphasized a regular gridiron of avenues, at Peking not even the central, axial boulevard runs from wall to wall on a straight line. The spacing, too, is irregular; presumably because Peking has served four dynasties in turn, and in the transfers has been modified rather than created anew. (The Mongol capital on the same site had been much more strictly classical and uniform.)

The outermost of the two palace enclosures, the 'Imperial City', shows a specific accommodation to circumstances: its high red wall extends well beyond the proper limits of symmetry on the west, to take in a chain of artificial pleasure-lakes and hillocks. Only around the

grand central axis is the ancient ideal followed faithfully. On the approach to the inner nucleus, the 'Forbidden City', there is another balancing of religious precincts inspired by the memories of Chou ritual; now the shrine to the Imperial ancestors, the T'ai-miao, on the east, and the altar to the Gods of the Soil and Harvest on the west. (The contents of the two precincts are entirely dissimilar, but from the ground the fact is concealed by their walls. The T'ai-miao scheme is like that of a palace, with three big halls on a south-north line; the dead rulers, first Ming and then Ch'ing, were still remembered as men, and so were housed in something like the state they had known on earth. The western precinct is dominated by an open-air altar platform, square to symbolize the Earth.)

The 'Forbidden City', lying beyond a majestic five-towered gatehouse, is subdivided into a

326. Peking, marble bridges over the Golden River. Ch'ing Dynasty

series of major walled areas. Most monumental is the complex of audience courtyards and halls extending in a narrow, deep rectangle up the grand axis (the counterpart of the front court and reception hall in the city residence of any Chinese gentleman). Just to the rear the axis continues through a somewhat smaller and less formal precinct, the chief Imperial living quarters. The space remaining on east, north, and west is filled with a congeries of smaller compounds: more specialized imperial buildings, the quarters of the palace ladies, shrines, and temples. The south-east and south-west corners are dignified by particularly spacious groups announcing the ruler's devotion to scholarship and literature: a library group on the east and a printing-house on the west.

In the showpiece of Peking architecture, the grand audience group, all the traditional assets that still survived in Ming and Ch'ing have been combined with maximum effectiveness. Huge size is reinforced by an absolute symmetry; the interplay between spaces and forms is made more dramatic by mounting heights. Though all subtlety has gone, the main blocks are still powerfully proportioned. Their parts are distinguished, and their visual impact is greatly heightened, by a masterly choice of colour: the white of marble for terraces, stairs, and balustrades, a gleaming golden yellow for the tile roofs, deep red on the woodwork in general and a mosaic-like sparkle of polychromy discernible in the half-shade under the eaves.

The entering visitor finds himself first in a relatively modest forecourt, crossed lengthwise by a bow-shaped moat with five marble bridges [326]. Beyond the next axial gate lies the

327. Peking, T'ai-ho-tien, view from the north-east. Ch'ing Dynasty

audience courtyard proper, a great square of about 200 yards width, broken at the rear by a massive triple terrace and stairs. The three halls that rise in sequence from this stepped basement are interestingly varied in form. The first, the T'ai-ho-tien [327] where the ruler sat throned at the greatest mass audiences of the year, is the largest (eleven bays by five, about 200 by 100 feet), and has an appropriately monumental hipped roof, above a skirting penthouse. The middle hall, the *Chung-ho-tien* [328], used chiefly as a waiting place, is a much smaller, five by five, square with a pyramidal roof. The final building, the *Pao-ho-tien* [329] used for state banquets, is a reduced version of the first, nine by five, with a hip-and-gable roof. (The marble terrace, to fit these different dimensions, moves in and out in a squared-off dumb-bell silhouette.)

The three-part scheme so splendidly embodied here must have been derived from the insistence of the Chou ritual that the Son of Heaven rule from three 'courts', *ch'ao*. Its sanctity at Peking is attested not only in the grand audience group, but also in the Imperial living quarters just beyond to the north, and in the T'ai-miao group; as we have seen earlier in this account, the idea seems to have been reintroduced as a classicizing reform in Sui and T'ang.

The details of the architectural history of Peking, from the fifteenth to the end of the nineteenth century, form an intricate and confusing pattern of modifications, restorations, rebuildings, and new constructions. Much of what is visible to-day was determined when the Yung-lo emperor moved his capital north in 1417, and was an admitted imitation of the first

328. Peking, Chung-ho-tien from the north-east and part of the T'ai-ho-tien. Ch'ing Dynasty

Ming capital at Nanking. From that first period the most memorable and least altered survivor is the huge offering hall in the same ruler's mausoleum precincts, north of the city: a building comparable to the T'ai-ho-tien in size, general design, and details, but carried out with more energy and taste. The largest of the T'ai-miao halls as well has retained a good deal of its original fifteenth-century character in spite of successive restorations. The group of the audience hall stands chiefly as a Ch'ing re-building, done around 1700 on the basis of late Ming predecessors of 1627.

How long the union of design and crafts-manship could survive at a respectable level is shown strikingly at the Altar of Heaven in the 'Chinese city'. The general layout dates from 1420, though most of the visible materials stem from a programme of repairs ordered in 1754.

The round altar itself, mounting with its three-fold marble terrace like the tiers of Heaven inside a square enclosure, epitomizes both the Chinese reverence for the past – the design was already thought ancient in the Han – and the pure, ordered clarity of the monumental style. The best-known building in the precinct, the round 'Hall of Annual Prayers', *Ch'i-nien-tien*, north of the altar, belongs to the very end of the nineteenth century (and to a world so altered that its largest timbers could be best supplied from Oregon). To all but the most experienced eyes, however, it is distinguished from the rest of official architecture in Peking not by any obvious marks of decadence, but by a spectacu-lar beauty, drawn from geometry and colour: dazzling white, red, and a deep blue for the conical roofs that seems to dramatize the lustre of a night sky.

329. Peking, Pao-ho-tien, decorated gable and roofs. Ch'ing Dynasty

NOTES

Bold numbers indicate page reference

NOTES TO PART ONE

CHAPTER I

21. 1. Excavations were begun at An-yang in 1928 through the joint enterprise of the National Research Council in Peking and the Freer Gallery of Art, Washington, D.C. Under the direction of the Academia Sinica, important finds were made from 1934 to 1937. These excavations, together with the patient labours of many Chinese and some Occidental scholars, have thrown much light on the first proto-historic dynasty of China. See *Preliminary Reports of Excavations at Anyang*, Academia Sinica (Peking, 1929-33).

22. 2. H. G. Creel, *Studies in Early Chinese Culture* (Baltimore and London, 1937), 97-129.

3. For an excellent outline of Chinese history and material culture, see G. D. Guest and A. G. Wenley, *Annotated Outlines of the History of Chinese Arts*, Freer Gallery of Art, Smithsonian Institution (Washington, D.C., 1946).

4. What connexion there may be between the Neolithic painted pottery of China and comparable wares of eastern Europe and the Near East is not clear at present. The distribution of painted pottery across Central Asia, northern China, and into southern Manchuria has suggested to some scholars that it may have followed the northern route from the West to China. The route became famous in historic times as the Silk Road.

23. 5. Creel, *op. cit.*, 198-218.

6. G. D. Wu, *Prehistoric Pottery in China* (London, 1938).

7. For good, brief discussions of the elements of early Chinese culture probably borrowed from the West, see C. W. Bishop, 'A Civilization by Osmosis', *The American Scholar* (Summer 1936), and same author, 'The Beginnings of Civilization in Eastern Asia', *Journal of the American Oriental Society* (hereafter referred to as *JAOS*), no. 4 (December 1939) (Supplement).

CHAPTER 2

25. 1. Reproduced in L. Sickman, *University Prints, Early Chinese Art, Oriental Art*, Series O, Section 11 (Newton, Mass., 1938), Plate 089 (left).

26. 2. It appears that the Shang people made profuse offerings to the spirits of the ancestors of the royal clan and probably those of all great families. Among the other spirits were a supreme spirit, Shang-ti, possibly the first ancestor of the royal clan, gods of wind, rivers, and earth, and such deities as 'Dragon Woman' and the 'Western Mother'. See H. G. Creel, *The Birth of China* (London, 1936), chapter xii.

3. See, for example, Florance Waterbury, *Early Chinese Symbols and Literature: Vestiges and Specula-tions* (New York, 1942).

4. A fragment of a human figure was among the first finds of the Academia Sinica. The figure is seated in a squatting position, the hands clasping the shins; the head and upper part of the body are lost. It is like the owl and tiger slotted in the back. Reproduced in *Preliminary Reports of Excavations at Anyang*, part 11 (Peking, Academia Sinica, 1930), plate 10.

27. 5. Creel reports having seen the head of an ox over life size, excavated by the National Research Institute, while large horns, of a kind known as 'bottle horns', tenoned for attachment, are known through several examples. See Creel, *op. cit.*, 107.

28. 6. Umehara believes that in Shang times vessels with decorations typical of the bronzes were carved in wood, and it is possible that some of the Shang bronze *décor* and shapes followed prototypes in wood. See S. Umehara, 'Antiquities Exhumed from the Yin Tombs outside Chang Tê Fu in Honan Province', *Artibus Asiae*, XIII, 3, 149 ff. Because of the sharpness of design and complex shape of certain bronzes it has been supposed they were all cast by the lost wax, *cire perdue*, process. The discovery of many piece moulds at An-yang and, in 1960-1, of many complex piece moulds at an Eastern Chou site, Hou-ma in Shansi,

indicate that the piece mould method of casting was extensively if not exclusively used rather than the *cire perdue* as has always been supposed. See Noel Barnard, *Bronze Casting and Bronze Alloys in Ancient China* (Tōkyō, 1961).

7. For excellent material on early Chinese bronzes and illustrations of examples of the highest quality, see Lodge, Wenley, and Pope, *A Descriptive and Illustrative Catalogue of Chinese Bronzes*, Oriental Series No. 3, Freer Gallery of Art, Smithsonian Institution (Washington, 1946). Also S. Mizuno, *Bronzes and Jades of Ancient China* (Tōkyō, 1959) (text in Japanese with English summary).

30. 8. I am deeply indebted to Mr Archibald Wenley, Director of the Freer Gallery of Art, for placing at my disposal the results of his investigation of the inscription. See A. Wenley, 'A *Hsi Tsun* in the Avery Brundage Collection', *Archives of the Chinese Art Society of America*, VI (1952), 41–3.

9. The first definite historical date in Chinese history is 841 B.C. The traditional dates of the Shang Dynasty, 1766 to 1122, which we follow here, are certainly open to question. Some Chinese and Western scholars, basing their conclusions on researches in the Chinese calendar, place the establishment of the Shang capital at An-yang at 1300, and the end of Shang at 1027. The last few centuries of Chou, when the dynasty was much weakened and held little more than the traditional power of feudal investiture, may be divided into the period of the *Spring and Autumn Annals*, 722 to 481 B.C., and the period of the *Warring States*, from 480 to the establishment of the Ch'in empire in 221, although Ch'in was dominant from 256 B.C. Here, for convenience, we shall refer to the period from the seventh or sixth century to the third century B.C. simply as the Late Chou Dynasty.

31. 10. Good examples which, on the basis of their inscriptions, can be placed in the early years of the Chou Dynasty are a square *i* in the Freer Gallery (Lodge, Wenley, Pope, *op. cit.*, plates 21–2), and the *kuei* of the Marquis of K'ang in the collection of Major-General Sir Neill Malcolm (*The Chinese Exhibition, A Commemorative Catalogue of the International Exhibition of Chinese Art, Royal Academy of Arts, Nov. 1935-March 1936* (London, 1936), plate 7, no. 260A).

11. As an example of such a local style one might cite the *huo* in the form of an elephant now in the Freer Gallery. See Lodge, Wenley, and Pope, *op. cit.*, plate 24.

33. 12. For example, a vessel type *tsun* in the form of a water-buffalo, in the Fogg Museum of Art, Cambridge, Mass.

13. H. G. Creel, *The Birth of China* (London, 1936; New York, 1954).

34. 14. The most important states to emerge were: Shu in the west, in the territory that is largely modern Szechwan; Ch'u in the south central, occupying the main Yangtze valley and extending northward through modern Anhwei and southern Honan; Yueh on the east coast, embracing the Yangtze delta; Han in the Yellow River valley; Wei, Chao, and Yen in the north and north-east; Ch'in in the north-west in Shensi, the original home of the Chou.

37. 15. See Shensi Archaeological Survey, 'Shensi Hsing-p'ing Hsien ch'u-t'u-ti Ku-tai Ch'ien-chin Hsi Tsun', *Wen Wu*, no. 7 (1965), 12 ff. For comparable examples of realism of the period, see the reclining rams on the Li Yu cauldron, L. Bachofer, *A Short History of Chinese Art* (New York, 1946), plate 49.

16. W. C. White, *Tombs of Old Loyang* (Shanghai, 1934), and also S. Umehara, *Rakuyō kinson kobō shūei [Selections from the Ancient Tombs at Chin-ts'un, Lo-yang]* (Kyōto, 1937). Excellent selection of reproductions in the latter work.

39. 17. For a somewhat similar figure found in a Han period tomb of Indo-China, see O. R. T. Janse, *Archaeological Research in Indo-China*, II, *The District of Chiu-chên During the Han Dynasty* (Cambridge, Mass., 1951).

40. 18. H. C. Hollis, 'Cranes and Serpents', *Bulletin of the Cleveland Museum of Art* (October 1938).

19. Many elements of the early Yangtze valley art do not seem to be shared by other parts of China. There are some indications of influences from India, and the region may some day prove to be the home of much of the folklore and imagery later appropriated by Taoism. For a preliminary publication, see Chiang Yuen-yi, *Chang-sha, the Chu Tribe and its Art*, 2 vols. (Shanghai, 1949–50). See also A. Salmony, *Antler and Tongue* (Ascona, 1954). Remarkable carved and lacquered figures of exceptionally high quality and related stylistically to the Ch'ang-sha finds have recently been recovered at Hsin-yang in Honan province. For a preliminary report, see *Wên-wu Ts'an-k'ao Tz'u-liao*, no. 9 (Peking, 1957), 26–32, and A. Salmony, 'With Antler and Tongue', *Artibus Asiae*, XXI (Ascona, 1958).

CHAPTER 3

43. 1. Shih Chang-ju, 'Recent Discoveries at Yin-hsu, Anyang, with a Note on the Stratification of the Site', *The Chinese Journal of Archaeology* (Institute of History and Philology, Academia Sinica, Nanking, 1947), 39–40, and text figure (in Chinese).

45. 2. A number of important examples, including the well-known basin in the Freer Gallery, are reproduced

in S. Umehara, *Étude des bronzes des royaumes combattants* (Kyōto, 1936).

3. See W. P. Yetts, 'A Datable Shang-Yin Inscription', *Asia Major*, I, Part I (London, 1949), 80 ff., where this method of hunting is discussed in some detail.

47. 4. The rubbings and drawings are reproduced here through the generous permission of Dr Eleanor Consten. See E. Consten, 'A *Hu* with Pictorial Decoration', *Archives of the Chinese Art Society of America*, VI (1952), 18–32.

5. This hunting scene by the shore of a lake is an ancestor of the more advanced scene on a Han Dynasty tile from Szechwan [50].

48. 6. For a complete description of the game which seems to fit the scene well, see G. Montell, 'T'ou Hu – The Ancient Chinese Pitch-pot Game', *Ethnos* (Stockholm, 1940).

7. See Chapter 6: Funerary Stones and Tiles.

8. Another painting in colour on silk, a lady with a peacock and a dragon, dated by Chinese archaeologists to the fifth century B.C., has since been discovered at Ch'ang-sha. See Chêng Chên-to (ed.), *Great Heritage of Chinese Art*, vol. I, part I, plate 12 (Shanghai, 1954) (in Chinese, with English captions).

9. John Pope has drawn my attention to a similar three-headed man on one of the so-called hunting bronzes of the Late Chou period.

10. Apparently the excellent condition of the lacquer cups, boxes, etc., from Ch'ang-sha is due to the fact that the tombs are below water-level and the objects have been preserved in a state of complete saturation for over two thousand years.

49. 11. For a detailed description of the construction of a similar box with a far more abstract design, reproduced in colour, see F. Low-Beer, 'Two Lacquer Boxes from Ch'ang-sha', *Artibus Asiae*, X, 4 (Ascona, 1947).

50. 12. The border is related to some inlaid bronzes, for example, the covered *ting*, Pillsbury Collection, Minneapolis Institute of Arts, from the Chin-ts'un tombs of *c.* 450–250 B.C. The dominant element of the lacquer-box decoration is the repetition of the eye-feathers of the peacock. It is this eye of the peacock reduced to a heart-shaped or petal form and often arranged as a quatrefoil about the central knob of mirrors, that is very evident in many mirrors of the fourth to third century B.C. recovered from Shou Chou and, like the lacquer box, associated with the Ch'u State. At least three mirrors, nos. C 74, 75, 76 illustrated by Karlgren, 'Huai and Han', *BMFEA*, no. 13 (1941), and there dated to the third century B.C., clearly derive from the peacock with its sweeping tail and one straight wing. In this connexion it is interest-

ing to point out the peacock feathers incorporated in the designs on the Stoclet dragon [11, 12].

CHAPTER 4

51. 1. The Han Dynasty is historically divided by an interregnum into Early or Western Han with the capital at Ch'ang-an in Shensi from 206 B.C. to A.D. 9, and the Later or Eastern Han with the capital at Lo-yang in Honan from A.D. 25 to 221. The years A.D. 9 to 23 were occupied by the brief rule of the usurper Wang Mang.

52. 2. H. H. Dubs, 'The Victory of Han Confucianism', *JAOS*, vol. 58, no. 3 (1938).

3. *Ibid.*

53. 4. In 125 B.C., at the investigation of Confucian scholars, an Imperial University was established which, in a few centuries, numbered thirty thousand students. See L. C. Goodrich, *A Short History of the Chinese People* (New York, 1951), 49.

54. 5. A. Waley, *The Analects of Confucius* (London, 1938; New York, 1939), 39. For Confucian terms see Fung Yu-lan, *A History of Chinese Philosophy* (Princeton, 1952), translated by D. Bodde.

6. Chuang-tzu and a work attributed to Lao-tzu, the *Tao-tê-ching*, are the two principal Taoist works.

7. Fung Yu-lan, *A Short History of Chinese Philosophy*, edited by D. Bodde (New York, 1950), 105. For Taoism see chapters 6, 9, 10. H. A. Giles, translator, *Chuang Tzu* (London, 1889). A. Waley, *The Way and Its Power* (London, 1934; New York, 1935).

8. Lin Tung-chi, 'The Chinese Mind: Its Taoist Substratum', *Journal of the History of Ideas*, VIII, 3 (New York, June 1947), 259-72.

55. 9. *Ibid.*

CHAPTER 5

57. 1. Pan Ku, *History of the Former Han Dynasty*, translated by H. H. Dubs (Baltimore, 1938, 1944), I, 185, note 5; and II, 33, note 3.9.

2. Ho Ch'ü-ping was one of the most distinguished generals of Emperor Han Wu-ti. He rose to fame through his victorious campaigns against the Hsiung-nu. The emperor ordered his tomb to be constructed near his own in Hsing-p'ing, Shansi, and to resemble in form the Ch'i-lien mountain (also known as T'ien Shan) where the general had gained his victory. First published in V. Segalen, G. de Voisins, J. Lartigue, *Mission archéologique en Chine* (Paris, 1923-4), 33-43.

58. 3. The bear in the composition of the demon and bear has a close stylistic similarity to a bear in combat

with a tiger, on a bronze plaque dated in accordance with 123 B.C. in the Nelson Gallery Collection at Kansas City.

59. 4. Pan Ku, *op. cit.*, 11, note p. 252.

See also this volume, Soper, Part Two: *Architecture*, Chapter 33, 'Ch'in, Han, and the Three Kingdoms'. ·

5. An important series of these funerary pillars, including the Pillars of Shên, are published in the scholarly work by Segalen, de Voisins, Lartigue, *op. cit.*, and in *L'Art funéraire à l'époque des Han* (Paris, 1935).

6. The Shên pillars are close in style to those of Fêng Huang, near by, datable to A.D. 121, but they may be as late as the pillars of Kao I at Ya Chou of A.D. 209.

60. 7. The creatures symbolizing the celestial and terrestrial quadrants are: the Red Bird of the South, the Sombre Warrior of the North (represented by a snake and tortoise in combat), the Green (or Azure) Dragon of the East, and the White Tiger of the West. In Chinese literature the four are first mentioned in Huai-nan Tzu, second century B.C., and appear not to have been generally represented as a group in art until the first century A.D., though earlier examples may exist. For an excellent account of Han cosmology see W. Perceval Yetts, *The Cull Chinese Bronzes* (London, 1939), 116–65.

8. Wang Yen-shou, *Ling-kuang-tien Fu*, partial translation, from which the above is quoted. Arthur Waley, 'The Ling-kuang Palace at Lu', in *The Temple and Other Poems* (London, 1923).

9. For a discussion of the bear and the dates of its appearance in Chinese art see Yetts, *op. cit.*, 89 ff.

10. *Commemorative Catalogue of the International Exhibition of Chinese Art*, Royal Academy of Arts (London, 1936), plate 48, no. 553.

11. *Op. cit.*, plate 45, no. 559.

61. 12. O. Sirén, 'Indian and Other Influences in Chinese Sculpture', *Studies in Chinese Art and Some Indian Influences* (London, 1938). See also L. Bachhofer, *A Short History of Chinese Art* (New York, 1946), 61–2.

13. Rather unsatisfactory photographs of these lions at the Wu Family shrines are reproduced in T. Sekino, *Sepulchral Remains of the Han Dynasty in the Province of Shantung, China* (Tōkyō, 1916), plates 32–3.

62. 14. Some forty-four of these guardian animals, in varying states of preservation, are described in the excellent study edited by Chu Hsi-tsu and others, 'The Tombs of the Six Dynasties', *Monumenta Sinica*, I (Nanking, 1935) (in Chinese). This thorough examination of the existing monuments and references to them in literature, straightens out a number of the

correlations between the sculpture and the tombs they guard – identifications which have been somewhat confused in numerous Western publications. We here follow the identifications of Chu Hsi-tsu. Concerning the 'chimera', Chu Hsi-tsu suggests that those with one horn are properly called *t'ien-lu*, and those with two horns *pi-hsieh*, while *t'ao-pa*, apparently an imported word, applies equally to both. In A.D. 87 the Yueh-chih sent a delegation to China with *fu-pa* lions, and Chu suggests that *fu-pa* is the proper term for the hornless creatures; p. 194.

63. 15. Sirén, *op. cit.*, 19: 'Most illuminating in this respect is the bronze statuette from the Oxus Treasure in the British Museum, which is said to be a Bactrian work of the fourth century B.C. It shows a somewhat Hellenized transformation of the Achaemenian griffon. . . .'

65. 16. See S. Umehara, *Selected Ancient Mirrors Found at Shaohsing Tombs* (Kyōto, 1939), especially plate 42.

CHAPTER 6

67. 1. A. Waley, *An Introduction to the Study of Chinese Painting* (London, 1923), 22.

2. F. S. Drake, 'Sculptured Stones of the Han Dynasty', *Monumenta Serica*, VIII (1943), 287. This article contains a valuable series of early Chinese references to painting. I am also much indebted to Alexander Soper for the use of his unpublished paper, 'Literary Evidence for Early Chinese Painting'.

3. Drake, *op. cit.*, 288.

4. Drake, *op. cit.*, 289.

5. *Han Shu*, XXV, chapter on 'Chiao-ch'i'. Reference and translation: A. Soper, *op. cit.*, note 2.

6. Drake, *op. cit.*, 290.

7. Soper, *op. cit.*, '*Hou Han Shu*'.

8. A. Waley, 'The Rarity of Chinese Paintings', *Burlington Magazine* (June 1917), XXX, 210.

68. 9. The only surviving examples in the writer's knowledge are the two fragments recovered at Ch'ang-sha which are of uncertain date, but certainly pre-Han.

69. 10. These tiles are of pottery, the designs being applied by pressing moulds into the soft clay before firing. They are about 18 in. by 45 in. on an average and were used for the construction of underground tomb chambers. See O. Jansé, *Briques et objets céramiques funéraires de l'époque des Han appartenant à C. T. Loo* (Paris, 1936), and W. C. White, *Tomb Tile Pictures of Ancient China* (Toronto, 1939).

73. 11. It is difficult to assign a precise date to these tiles, but the painting is close to that on a small tortoiseshell box decorated with lacquer, recovered in Korea

and datable to the first or second century A.D. See Y. Harada, *A Report on the Excavations of Wang Hsü Tomb* (Tōkyō, 1930). Also see K. Tomita, *Portfolio of Chinese Paintings in the Museum* (Boston, Museum of Fine Arts, 1938), plates 1-8.
74. 12. Drake, *op. cit.*, 292-3.

CHAPTER 7

77. 1. A. Bulling, 'A Landscape Representation of the Western Han Period', *Artibus Asiae*, XXV, 4 (Ascona, 1962), 293-317.
2. The best discussion of the Chu Wei shrine is Wilma Fairbank, 'A Structural Key to Han Mural Art', *Harvard Journal of Asiatic Studies*, VII, 1 (April 1942), 52-88. It is impossible to say when the stones were re-cut, but there is some reason to believe that at least part of this 'freshening up' may have been done around A.D. 527 at the time when the shrine is first mentioned in Chinese writings.
78. 3. E. Chavannes, *Mission archéologique dans la Chine septentrionale* (Paris, 1909), plates XXIV, XXVII.
79. 4. See Sekino, *Sepulchral Remains of the Han Dynasty in the Province of Shantung*, plates 149-55.
5. Wilma Fairbank, 'Offering Shrines of the "Wu Liang Tz'u"', *Harvard Journal of Asiatic Studies*, VI, 1 (1941), 1-36. This article contains a good bibliography of the chief publications relating to the Wu Family shrines. Reproductions of these and other Han stones are in Chavannes, *op. cit.*, and in *La Sculpture sur pierre en Chine au temps des deux dynasties Han* (Paris, 1893); S. Ōmura, *Shina Bijutsu-shi, Chōsōhen* (Tōkyō, 1915); Sekino, *op. cit.*; Université de Paris, *Corpus des pierres sculptées Han (estampages)*, I, II (Pékin, Centre d'Études Sinologiques, 1950-1). Other stones of quite individual style are those from the neighbourhood of Nan-yang in Szechwan. Some are reproduced in *Ssu-ch'üan Han-tai Hua-hsiang T'iao-chi* (Shanghai, 1955). The most sophisticated and highly evolved funerary stones are those, in a lightly engraved technique, discovered in a tomb at I-nan, south central Shantung, in 1954. Chinese archaeologists date the tomb, on stylistic grounds and other objects found in it, in the third century, towards the end of Eastern Han. The designs seem to be derived directly from paintings. In some of the larger figures, the garments have a fine hatching that strongly suggests shading along the folds of a kind found in the 'Admonitions' scroll attributed to Ku K'ai-chih. See especially plates 55 and 57 in Ts'eng Chao-yueh and others, *Yi-nan Ku Hua-hsiang Shih-mu Fa-chüeh Pao-kao (Report on the Ancient Designs from the Stone Tomb Discovered at Yi-nan)* (Shanghai, 1956).

6. Fairbank, *op. cit.*, 33.
81. 7. A. Soper, 'Life Motion and the Sense of Space in Early Chinese Representational Art', *The Art Bulletin*, XXX, 3 (1948), 167-86.
8. Kim, Chewon, 'Han Dynasty Mythology and the Korean Legend of Tan Gun', *Archives of the Chinese Art Society of America*, III (New York, 1948-9), 43-8. For the full range of the artists' repertory of subjects in the Wu Family shrines, the reader must turn to such publications as those of the French sinologist Édouard Chavannes.
82. 9. Wang Yen-shou, in A. Waley, *The Temple and Other Poems* (London, 1923), partial translation. Complete translation, von Zach, *Asia Major*, III (1926), 31 ff. See also, Drake, *op. cit.*, 291-2.
10. Drake, *op. cit.*, 284.
11. R. C. Rudolph, in collaboration with Wen Yu, *Han Tomb Art of West China* (Berkeley and Los Angeles, 1951).
12. Vessel type *hu*, Pillsbury Collection, Minneapolis [19]; vessel type *hu*, Chinese government, former Jannings Collection [20-2].
83. 13. A similar type of Szechwan tile reproduced in *I lin yüeh k'an*, no. 32 (August 1932), carries an inscription dated in accordance with A.D. 123.
84. 14. Ts'eng Chao-yueh, *Yi-nan Ku Hua-hsiang Shih-mu Fa-chüeh Pao-kao (Report on the Ancient Stone Reliefs in a Tomb Excavated at I-nan)* (Nanking, 1956); Li Wen-hsin, 'I-nan Hua-hsiang Shih-ku-mu Nien-tai Kuan-chien' (Views on the Date of the Pictures in the Ancient Stone Tomb of I-nan), *K'ao Ku T'ung Hsin*, no. 6 (1957), 67-76; Shih Hsio-yen, 'I-nan and Related Tombs', *Artibus Asiae*, XXII, 4 (Ascona, 1959), 277-312.
15. An excellent discussion of early Chinese painting, both in general and in detail, is that presented by Soper in two articles in *The Art Bulletin*: 'Early Chinese Landscape Painting', XXIII, 2 (1941), and 'Life-motion and the Sense of Space in Early Chinese Representational Art', XXX, 3 (1948).

CHAPTER 8

85. 1. The 'Three Kingdoms' of Wei in the north, Shu or Shu Han in the west, and Wu in the south each claimed the Imperial mandate of the defunct dynasty and lasted from A.D. 221 until 265 in the north and 280 in the south. The Western Chin reunited much of the empire for a time from 265 until 316, when it was overrun by five tribes of Turkic, Mongolian, and Tibetan stock, which briefly contended in the north in a period so confused that it has won the name of the 'Sixteen Kingdoms'. From these there emerged the vigorous T'o-pa tribe of the

Hsien-pi, a Turkic stock, which founded the Northern Wei dynasty in 386. In the south, from the capital city of Nanking, the 'Six Dynasties' of Wu, Eastern Chin, Sung, Ch'i, Liang, and Ch'ên ruled until 581. In the north the Northern Wei divided, in 534, into Eastern Wei and Western Wei, followed by Northern Ch'i and Northern Chou.

2. For a concise account of some of these early missionaries, see Goodrich, *op. cit.*, chapter 3.

86. 3. The Japanese scholar S. Ōmura in his book *Shina Bijutsu-shi, Chōsōhen (History of Chinese Sculpture)* (Tōkyō, 1915) has collected references to Buddhist images from innumerable Chinese texts and inscriptions; his work forms an invaluable compendium for the detailed study of early Buddhist art in China. A selection of this material has been translated and extensively edited by Soper, in 'Literary Evidence for the Early Buddhist Art in China, I. Foreign Images and Artists', *Oriental Art*, II, 1 (1949), 28–35; and II. 'Pseudo-Foreign Images', *Artibus Asiae*, XVI, 1, 2, (1953), 83 ff.

4. See B. Rowland, 'Chinese Sculpture of the Pilgrimage Road', *Bulletin of the Fogg Art Museum*, IV, 2 (March 1935), 22–8; 'Notes on the Dated Statues of the Northern Wei Dynasty and the Beginnings of Buddhist Sculpture in China', *The Art Bulletin*, XIX, 1 (March 1937), 92–107; and *The Art and Architecture of India* (Pelican History of Art, first impression, Harmondsworth, 1953), Part Three, 75–117 (paperback edition, Harmondsworth, 1970).

5. Soper, 'Literary Evidence for the Early Buddhist Art in China', *op. cit.*, 29.

87. 6. The earliest dated figure in the writer's knowledge is that from the collection of Mr Avery Brundage. It comes from a small state in Hopei province, north China, and bears a date corresponding to 338. An illustration in the *Harvard Journal of Asiatic Studies*, 11, 3, 4 (December 1948), opposite page 321, shows it to be the same general type as our illustration 51, somewhat more provincial but strongly modelled. The head is disproportionately large. For a list of fifty-five images dated from 390 to 501, see Rowland, 'Buddhist Sculpture in China', *The Art Bulletin*, XIX, 1 (March 1937), 106–7.

7. Sir Aurel Stein, *Serindia* (Oxford, 1921), plate viii.

8. Soper mentions as the 'earliest Buddhist image in China for which a proper historical backing is possible' a shrine constructed around A.D. 190. For an excellent presentation of the literary evidence relating to early Buddhist art in China, its inscriptions, iconography, and other features, see A. Soper, *Literary Evidence for Early Buddhist Art in China* (Ascona, 1959).

9. The idea could not have been utterly new to China. For hundreds of years dwellings had been hollowed out in the loess soil of the Yellow River valley and the rock-cut tombs from the Later Han Dynasty of Szechwan were, on a minor scale, rock-cut temples to the ancestors.

10. During World War II an expedition of Japanese scholars from the Kyōto Research Institute studied the caves for eight years. The results of their meticulous labours are being published, and since this great work is likely to remain standard for many years, we follow its system of numbering the caves. S. Mizuno and T. Nagahiro, *Yün-kang the Buddhist Cave Temples of the Fifth Century A.D. in North China* (Kyōto, 1951). See also Mizuno, 'Archaeological Survey of the Yün-kang Grottoes', *Archives of The Chinese Art Society of America*, IV (1950).

11. See Rowland, *The Art and Architecture of India*, chapters 11 and 12.

89. 12. The rather absurd, brown pottery pupils of the eyes are disfiguring additions of the twelfth century.

13. O. Sirén, 'Indian and Other Influences in Chinese Sculpture', *Studies in Chinese Art and Some Indian Influences* (London, 1938), figure 29.

14. Examples in stone could be multiplied both at Yün-kang and in several free-standing steles, such as the archaic stele in the Ōkura Museum, Tōkyō.

15. B. Rowland, 'Notes on the Dated Statues of the Northern Wei Dynasty and the Beginnings of Buddhist Sculpture in China', *The Art Bulletin*, XIX, 1 (1937), 101. The continuation of this Buddha type is an excellent example of the perseverance of styles in China for iconographic or other reasons. It occurs in stone in the late sixth century, is popular during the Ming Dynasty, and is found in good Lamaistic examples in the eighteenth century.

92. 16. For other illustrations of these relief sculptures, see Sirén, *Chinese Sculpture*, 11 (London, 1925), plates 30–2.

CHAPTER 9

97. 1. The earliest niche in the Ku-yang cave was made in A.D. 495, the main figure was completed in 500, and the majority of the sculptured niches were made before 525. The Pin-yang cave is probably that done by Imperial order of Hsüan Wu-ti (r. 499–515) and completed in 523. Originally the plan included three caves, but only the one was completed during the Wei Dynasty. There are a number of other important caves and niches sculptured at this period, notably the Lien-hua cave, but the Pin-yang is the most complete expression of the Northern Wei style.

The sculptures of Lung-mên have been extensively reproduced. See Chavannes, *Mission archéologique dans la Chine septentrionale*; Sirén, *Chinese Sculpture*; Tokiwa and Sekino, *Buddhist Monuments in China* (Tōkyō, 1926–38). The most recent and authoritative in many ways is S. Mizuno and T. Nagahiro, *A Study of the Buddhist Cave-Temples of Lung-mên, Honan* (Tōkyō, 1941) (text in Japanese with English summary).

100. 2. B. Rowland, 'The Iconography of the Flame Halo', *Bulletin of the Fogg Museum of Art* (January 1949).

3. R. T. Paine, *The Art and Architecture of Japan* (Pelican History of Art, Harmondsworth, 1955), Part One.

4. To the deep regret of all, these two bas-reliefs were chipped out in the 1930s. All available fragments of the empress relief were assembled from various sources by the Nelson Gallery of Art, Kansas City; the bas-relief of the emperor has been assembled by the Metropolitan Museum, New York.

101. 5. The Vimalakirti figure is now in the collection of Myron S. Falk, Jun., New York.

6. LeRoy Davidson, 'Traces of Buddhist Evangelism in Early Chinese Art', *Artibus Asiae*, XI, 4 (1948), 251–65.

102. 7. Bureau of Cultural Affairs, *Mai-chi Shan Shih-k'u (The Rock-cut Caves of Mai-chi Shan)* (Peking, 1954); Y. Nadori, *Mai-chi Shan Caves* (Tōkyō, 1957).

106. 8. Goodrich, *op. cit.*, 99.

107. 9. For a good discussion of the iconography of this and other Chinese sculpture and painting inspired by the same text, see J. LeRoy Davidson, *The Lotus Sûtra in Chinese Art* (New Haven, 1954).

CHAPTER 10

112. 1. See B. Rowland, *The Art and Architecture of India*, plate 82B.

115. 2. O. Sirén, 'Indian and Other Influences in Chinese Sculpture', *op. cit.*, 32.

118. 3. Yang Po-ta, 'Ch'ü-yang Hsiu-teh Ssu Ch'u-tu Chi-nien Tsao-hsiang ti Mei-shu Feng-ko yü T'e-cheng' (The Style and Characteristics of the Dated Images Excavated at Hsiu-te Ssu, Ch'ü-yang), *Gugong Bowuyuan Yuankan*, no. 2 (Peking, 1960), 43–52.

4. Cf. A. Pope, ed., *A Survey of Persian Art* (London and New York, 1938), I, 616, figure 194; II, plates 171, 172.

5. Pope, *op. cit.*, IV, plates 167 and 168.

119. 6. These ornate Indian floral designs appear in Chinese Buddhist art as early as the 530s, for example,

the Cleveland Museum stele of A.D. 537, and even begin on the Berenson shrine of A.D. 529, but reach full development only in the second half of the century.

7. The Zoroastrian religion of the Persians was recognized at Lo-yang as early as the Northern Wei period and its ceremonies were conducted in the capitals of Later Chou and Northern Ch'i.

120. 8. One side slab is in the Louvre, the location of the second is unknown; two railing pieces that partially closed the front are in the Cologne Museum. These latter have architectural elements that are nothing more than the old funerary pillars (*ch'üeh*) of Han times. For a detailed description of this unique monument and a discussion of the non-Chinese elements and identification of the subjects, see G. Scaglia, 'Central Asians on a Northern Ch'i Gate Shrine', *Artibus Asiae*, XXI (Ascona, 1958), 9–28. The term 'gate shrine' used by the author is puzzling. There is no convincing evidence that the object was a shrine, and there is no gate but rather confronted towers of the *ch'üeh* type.

9. Pope, *op. cit.*, IV, plate 174.

121. 10. See A. Priest, *Chinese Sculpture in the Metropolitan Museum of Art* (New York, 1944), 30–3, plates XL–LII.

122. 11. Although the stele bears an inscription containing the two dates 533 and 543, which may refer to the building of a temple, the general style is very close to that of other sculptures dated in the 550s, and if the stele is as early as 543 it may be taken as a precursor of the Northern Ch'i manner, especially since it was found in northern Honan – a region that formed part of the Northern Ch'i empire.

124. 12. Especially important sculpture from the Northern Ch'i period in the Winthrop Collection is a series of bas-reliefs representing monks, adoring figures, and flying apsaras from the walls and ceilings of cave-temples cut in a sandstone cliff at T'ien-lung Shan, south of T'ai-yuan, Shansi.

125. 13. For a more detailed consideration of all the variations in the products of the many local workshops of northern Hopei and eastern Shansi, see Sirén's monograph on the subject: 'Chinese Marble Sculpture of the Transition Period', *BMFEA*, no. 12 (Stockholm, 1940), 473–96.

14. Sirén, *Chinese Sculpture*, III, plate 270.

126. 15. John E. Lodge, 'Introduction to the Collection of Chinese Sculpture', *Museum of Fine Arts Bulletin*, XIII, no. 78 (August 1915). A figure very similar to the Boston Avalokiteśvara, now in the Minneapolis Institute of Arts, bears a reign title of Northern Chou and is dated in accordance with A.D. 570.

16. In 577 Northern Chou, allied with the Turks, was able to destroy the pious but impractical dynasty of Northern Ch'i, only to succumb itself in 581 to the intrigues of one of its own officials, Yang Chien. Within a few years Yang Chien absorbed the last remaining dynasties of the south, Liang and Ch'ên, and by 590 China was again united under one ruling house. The dynasty was short and ended in 618.

17. One exception is probably the beautifully modelled image of a seated Buddha done in dry lacquer and now in the Metropolitan Museum. As Bachhofer has pointed out, this is very likely a work of the Northern Ch'i period.

18. This shrine has been admirably described and discussed by K. Tomita, *Bulletin of the Museum of Fine Arts*, XLIII, no. 252 (June 1943), and by J. Lodge, *op. cit.*, XXIV, no. 141 (February 1926). In both articles the adherence of the design to scriptural descriptions and the iconographic identifications are discussed in some detail. For good photographs bringing out the important three-dimensional character of the sculpture, see Tomita, *op. cit.*

128. 19. Liu Chih-yüan and Liu T'ing-pi, *Ch'eng-tu Wan-fo Ssu Shih-k'o Mei-shu (Art of the Stone Sculptures from Wan-fo Temple at Ch'eng-tu)* (Peking, 1958).

20. A. Soper, 'South China Influence on the Buddhist Art of the Six Dynasties Period', *The Museum of Far Eastern Antiquities, Bulletin*, XXXII (Stockholm, 1960), 47-112. This is the best account of the political, religious, and artistic factors contributing to the cultural affluence of the southern states. Regarding the Ch'eng-tu material, the author calls attention to a seated figure of Amitāyus, dated in the year 483 during the Southern Ch'i, which stylistically finds its counterpart in the north only some two or three decades later, and points out the Indian influence of the Gupta period present in several standing Buddha images, one dated to 529 in the Liang Dynasty.

21. Soper, *ibid.*, 80. In addition to the Amitāyus of 483 with its drapery scheme similar to the Shaka at Hōryūji, and probably sharing a common ancestor in the Nanking school, a now headless seated Buddha (Liu Chih-yüan, *op. cit.*, plate 13) displays details of drapery folds as they fall over the dais that are also close to the Hōryūji Shaka, while a standing guardian king from Ch'eng-tu (*op. cit.*, plate 23) may well share a common ancestor with the curious Four Guardian Kings in wood on the altar of the kondō at Hōryūji. Similarities are the three-quarter-length jerkin with pleats of an undergarment showing below, the knotted shawl, and the long sleeves; the strangely unfunctional turtle-neck collars of the Hōryūji guardians could be a misunderstanding of an arrange-

ment like the high, flaring collar of the Ch'eng-tu figure.

CHAPTER 11

129. 1. The painting and Ku K'ai-chih have been discussed in detail by A. Waley, *An Introduction to the Study of Chinese Painting* (London, 1923), 45-66. Some Western writers have classed the 'Admonitions' as a T'ang Dynasty copy on what appears to this writer to be very slender evidence. There is no original detail that would suggest the hand of a T'ang painter, and opinions based on the writing are far from conclusive. The problem of the approximate date is made extremely difficult by extensive repairs and restoration work of successive periods. The scroll belonged to the three greatest collectors of the sixteenth to eighteenth century: Hsiang Mo-lin, Liang Ch'ing-piao, and An I-chou. The 'Nymph of the Lo River', now in the Freer Gallery, also belonged to Liang Ch'ing-piao.

131. 2. A kind of shading and other details reminiscent of the 'Admonitions' scroll are found in the figures and compositions engraved on the stones of a third-century A.D. tomb at I-nan in Shantung. See Note 4, Chapter 7.

132. 3. There is a small section of landscape in the 'Admonitions' that has been much discussed by Western writers. It is this writer's belief that this section has been so extensively restored that it would only be possible to hazard an opinion about its nature after careful study under ultra-violet light. The main concept of the sharply peaked hills inhabited by over-large animals clearly evolves from the same sources that inspired the Han Dynasty 'hill-jar' lids and such drawings as a salt-mining scene on a Szechwan tile. On the other hand, the flats of table-land atop the cliffs on the right appear to be early restorations, possibly of the T'ang Dynasty.

133. 4. A. Soper, 'The First Two Laws of Hsieh Ho', *Far Eastern Quarterly*, VIII, no. 4 (August 1949), 412-23. See also S. Sakanishi, *The Spirit of the Brush* (London, 1939), 46-51; Waley, *op. cit.*, 72-4; O. Sirén, *A History of Early Chinese Painting* (London, 1933), I, 31-6.

5. Soper, *op. cit.*, 423.

134. 6. A partial translation of this important work is published in *Some T'ang and Pre-T'ang Texts on Chinese Painting*, by W. R. B. Acker (Leiden, 1954).

7. First published in *Wen Wu*, nos. 8-9 (1960), 37-42. For a discussion of the subject and style see A. Soper, 'A New Chinese Tomb Discovery: The Earliest Representation of a Famous Literary Scene', *Artibus Asiae*, XXIV, 2 (Ascona, 1961), 79-86. Also

T. Nagahiro, 'On the Mural Engravings of the "Seven Sages in a Bamboo Grove" and Yung Ch'i-ch'i, 'Dating Between the Chin and Sung Dynasty of China', *Kokka*, no. 857 (1963). This article presents the best reproductions available.

135. 8. Field Team of the Honan Bureau of Cultural Affairs, *Teng-hsien Ts'ai-su Hua-hsiang Chuan-mu (The Brick Tomb with Coloured Pictures at Teng Hsien)* (Peking, 1958). For good reproductions, some in colour, see Yoshiho, Yonezawa, and others, *Chugoku Bijutsu*, I (Kodansha Sekai Bijutsu Taishi, Tōkyō, 1963).

9. Reproduced in *Sōraikwan Kinshō, Catalogue of Mr Abe Fusajiro's Collection* (Ōsaka, 1930), plates 1–17. The painting bears seals which may be those of the Sung Hui-tsung Collection. It belonged to Liang Ch'iang-piao and to An I-chou. The identification with a work by Chang Sêng-yu seems to have been made by the latter eighteenth-century collector.

10. The most complete publication is Pelliot, *Les Grottes de Touen-Houang*, 6 vols. (Paris, 1920). The cave numbers used here are those of Pelliot's publication. See also Sir Aurel Stein, *Ruins of Desert Cathay*, 2 vols. (London, 1912), *Serindia*, 5 vols. (Oxford, 1921), *Innermost Asia* (Oxford, 1929). For the paintings recovered by Stein see also L. Binyon, *The Thousand Buddhas*, text, and 2 vols. of plates (London, 1921), and A. Waley, *A Catalogue of Paintings Recovered from Tun-Huang by Sir Aurel Stein* (London, 1931).

11. There are, however, valuable works from later centuries. In addition to the wall paintings a great number of beautifully painted silk banners and invaluable manuscripts were recovered by Sir Aurel Stein from a cave room that had been walled up some time in the tenth century. The majority of these paintings are divided between museums in Delhi and London.

136. 12. In the past ten years much study has been conducted at Tun-huang under the direction of the Peking government. A number of dated inscriptions have been found and the stylistic development more thoroughly studied at the site and from better photographs than were formerly available. Consequently a number of the caves can be more precisely dated than formerly. (See Basil Gray, *Buddhist Cave Paintings at Tun-huang*, photographs by J. B. Vincent, preface by Arthur Waley, Chicago, London, 1959.) Gray dates this cave (Pelliot 101) as early sixth century.

13. Good analyses of this painting are in A. Soper, 'Life Motion and the Sense of Space in Early Chinese Representational Art', *op. cit.*, and L. Bachhofer, *History of Chinese Art* (New York, 1944), 96.

137. 14. For good colour plates and other details of this cave, see Gray, *op cit.*, plates 20–6.

138. 15. For a selection of reproductions of engraved pictorial stones from the Han Dynasty to the T'ang Dynasty, including a number of the sixth century, see Wang Tzu-yün, *Chung-kuo Ku-tai Shih-k'o-hua T'iao-chi (Selection of Ancient Chinese Stone Engravings)* (Peking, 1957).

16. An offering shrine in the form of a small house datable to A.D. 524 and now in the Boston Museum is decorated with engravings inside and out. Those on the interior, representing feast scenes, are especially well done and of great interest in that they occupy the exact spaces which would carry wall paintings in a normal wooden building.

140. 17. The most famous and generally reproduced paintings of this subject are on the stone walls of a tomb at Guken-ri, Korea. See O. Sirén, *A History of Early Chinese Painting*, I, plates 16–17.

18. Excellent reproductions of important painted tombs in Korea that reflect Chinese style of the Late Han and Six Dynasties are in O. Mori, H. Naito, and others, *Ying-ch'êng-tzu, Archaeologia Orientalis*, IV (Tōkyō and Kyōto, 1934), and H. Ikeuchi, S. Umehara, and J. Harada, *T'ung-kou* (Tōkyō and Hsinching, 1940).

19. There was Chan Tzu-ch'ien (*c.* 550–618), famous for his very fine detail in paintings of horses and carriages and for the vast amount of landscape he could suggest or pack into a small space; Chêng Fa-shih was celebrated for his pictures of processions and portraits in which he was most accurate as to details of dress; spirits, devils, and strange creatures were the speciality of Sun Shang-tzu; and there were others whose reputations rested on their ability to paint buildings, horses, scenes of the court, and beautiful ladies.

CHAPTER 12

144. 1. See R. T. Paine, *The Art and Architecture of Japan* (Pelican History of Art, Harmondsworth, 1955), part one.

146. 2. The caves of T'ien-lung Shan were severely damaged in the 1930s and much of the sculpture removed. The seated Buddha in illustration 98 is now in the Winthrop Collection, Fogg Museum, Harvard.

148. 3. Sirén, *Chinese Sculpture*, III, plates 391–7.

150. 4. Published in A. Priest, *op. cit.*, 35–7.

151. 5. Sirén, *op. cit.*, plate 378.

6. Sirén, *op. cit.*, IV, plate 539.

155. 7. Sirén, *op. cit.*, plates 426–7, where four of the T'ai-tsung horses are reproduced.

CHAPTER 13

159. 1. The history of the scroll and the style are admirably discussed by K. Tomita, *Bulletin of the Museum of Fine Arts, Boston*, XXX, no. 177 (February 1932).

160. 2. Reproductions in P. Pelliot, *op. cit.*, showing details or complete compositions are: caves 1, 8, 52, 74, 84, and 149.

162. 3. For details of the iconography in Tun-huang banners depicting similar scenes, see Waley, *Catalogue of Paintings Recovered from Tun-Huang by Sir Aurel Stein*, nos. XXXI, LVII, LXXVI.

4. Arthur Waley reports that Pelliot considered this cave was probably done in the late ninth century.

163. 5. In altering the date of this cave from 'latter part of the eighth century' to first half of the eighth, I follow the dating in Basil Gray's book on Tun-huang (*op. cit.*, Note 10, Chapter 11), which reproduces the same detail in colour, plate 49; Mizuno, however, places it about A.D. 775.

164. 6. For a detailed account of the Hōryūji paintings see T. Naito, *The Wall-Paintings of Hōryūji*, translated by Acker and Rowland (Baltimore, 1943); also R. T. Paine, *op. cit.*, Chapter 3.

171. 7. Among other features, the long finger-nails of the Bodhisattva may indicate the relatively late date.

172. 8. L. Warner, *Buddhist Wall-Paintings, A Study of a Ninth-Century Grotto at Wan Fo Hsia* (Cambridge, Mass., 1938).

9. Chu Ching-hsüan, 'The Famous Painters of the T'ang Dynasty', translated by A. Soper, *Archives of the Chinese Art Society of America*, IV (1950), 5–25, and note 29.

10. See L. C. Goodrich, *op. cit.*, 125–7 for a good, brief account of the reasons for the persecution and the edicts.

177. 11. Chu Chang-ch'ao, *T'ang Yung T'ai Kung-chu Mu Pi-hua Chi* (Peking, 1963). For the funerary epitaph of Princess Yung T'ai and the excellent drawing of figures on the slabs of the stone sarcophagus see M. Nishikawa, ed., *Saian Hirin (Monuments in the Pei-lin of Sian)* (Tōkyō, 1966). For a concise account in English, see Richard C. Rudolph, 'Newly Discovered Chinese Painted Tombs', *Archaeology*, XVIII, no. 3 (Autumn, 1965), 171–80.

12. The costumes with tight sleeves, high-waisted skirts, short jackets, long scarves, and court shoes with broad, upturning toes is said to derive from the southern dynasties of the late sixth century. For a discussion of the clothes worn by the attendants and the objects carried, see Wu Po-lun, 'T'ang Yung T'ai Kung-chu Mu Ch'u-t'u Pi-hua Ho T'ao-yung', *Wên-wu Ching-hua*, no. 3 (Peking, 1964).

13. J. Harada, *Catalogue of the Imperial Treasures in the Shōsōin* (Tōkyō, 1929), English notes, 11, 28–30.

14. It appears that a fine line of unvarying thickness was used by the court painters working in what we may call the classic T'ang figure style. However, a line of varying width was occasionally used, particularly in delineating features expressive of high emotion, as is evident in the fragmentary painting of a monk in Berlin [115] and in the face of a groom, tomb of Princess Yung T'ai, reproduced on plate 8 of Chu Chang-ch'ao, *op. cit.*

178. 15. L. Binyon, *The Sprit of Man in Asian Art* (Cambridge, Mass., 1935), plate 19, and text, 77.

180. 16. Chu Ching-hsüan, translation by A. Soper, *op. cit.*, 12.

183. 17. This is a very different version from the late copy on silk lent by the Chinese Government to the London Exhibition. See the *Catalogue of the International Exhibition of Chinese Art* (Royal Academy of Arts, London, 1935–6), no. 1015.

184. 18. A. Waley, *An Introduction to the Study of Chinese Painting*, 143–4.

19. Accounts of Wang Wei's life and material on his style and his most famous lost paintings is given in some detail by Waley, *op. cit.*, 141–9, and Sirén, *History of Early Chinese Painting*, I, 79–92.

186. 20. The various kinds of ts'un and their manner of application are of basic importance in Chinese landscape painting. Since there is no proper English equivalent, it seems justifiable to retain the Chinese word ts'un as a technical term which has no counterpart in occidental art vocabulary.

21. Although a full compendium of the landscape details at Tun-huang is yet to be done, valuable material is published in Anil de Silva, *The Art of Chinese Landscape Painting in the Caves of Tun-huang* (New York, 1964).

22. This cave was never finished, as may be seen from the trees in the detail we reproduce. It appears, though one cannot be certain, that the ink or light colour washes have been applied *first* and the outline drawing later, because these outlines or contour lines are only consistently applied in one area and much of the rest appears to have no outline at all. This would be a complete reversal of the usual procedure and would suggest a technical origin for ink paintings without bounding outlines – a manner generally supposed not to have been used until the tenth century.

23. For reproductions see Sirén, *History of Early Chinese Painting*, I, plates 52–6.

CHAPTER 14

187. I. A very illuminating description derived from literary sources of an Imperial temple in the Northern Sung capital as well as a valuable discussion of Sung Buddhism in relation to the arts is: A. Soper, 'Hsiang-kuo-ssu, an Imperial Temple of Northern Sung', *JAOS*, no. 68, 1 (1948).

188. 2. Reproduced, Sirén, *Chinese Sculpture*, IV, plate 573. See also this volume, Soper, Part Two: *Architecture*, Chapter 35, Timber-framed Buildings.

3. Liang Ssu-ch'êng, 'Record of the Architecture of Fo-kuang-ssu', in *Bulletin of the Society for Studies in Chinese Architecture* (in Chinese), vol. 7, no. 1 (Szechwan, 1944). See also Soper, Part Two: *Architecture*, Chapter 34, Wood-framed Buildings of T'ang Style.

4. An illuminating series of such pieces has been published by Sirén: 'Chinese Sculpture of the Sung, Liao and Chin Dynasties', *BMFEA*, no. 14 (Stockholm, 1942), 45–64. See especially plates 11 and 12.

191. 5. See Soper, Part Two: *Architecture*, Chapter 36, Wooden Halls.

193. 6. L. Bachhofer, 'Two Chinese Wooden Statues', *Burl. Mag.*, LXXIII (October 1938), 142–6.

194. 7. The inscription stating when the figure was made is lacking, but an inscription on paper found inside the figure states that it, together with a Buddha image and another Bodhisattva, was repainted in 1349.

8. The *Lotus Sūtra* in the prose section of the chapter on Avalokiteśvara enumerates seven calamities from which the Bodhisattva will rescue petitioners, while the section in verse names twelve perils from which those who call upon the name of Kuan-yin will be preserved.

196. 9. A seated Bodhisattva in bronze, recently acquired by the British Museum, is remarkable for its size, 55 in. high, and quality of workmanship. It appears to belong in the best tradition of north China from the tenth or eleventh century and is of great interest in being one of the few surviving works in bronze on so large a scale.

198. 10. Large wall paintings of the thirteenth and fourteenth centuries are in the Royal Ontario Museum of Art and Archaeology, Toronto, the University Museum, Philadelphia, the Museum of Fine Arts, Boston, the Cincinnati Art Museum, and the Nelson Gallery, Kansas City. The most important that have survived, however, are those covering the walls of two large halls at the Taoist temple, the Yung-lo Kung, some forty miles south of Yung-chi Hsien, Shansi Province. The Hall of the Three Precious Ones presents a vast Taoist pantheon painted in 1325, and the Shun Yang Hall events from the adventures

of Lü Yen done in 1358. See Bureau of Cultural Affairs, Shansi, *Yung-lo Kung* (Peking, 1964).

200. 11. Two of these figures are in the Metropolitan Museum, New York, others are in the British Museum, the Museum of Fine Arts, Boston, the Royal Ontario Museum, Toronto, the University Museum, Philadelphia, the Nelson Gallery of Art, Kansas City, the Matsukata Collection, Japan, and the Östasiatische Kunstabteilung, Berlin State Museums (present location unknown). Fragments of others probably from the same set are known.

CHAPTER 15

203. 1. A good picture of the intellectual ferment during the eleventh century is given in Lin Yu-t'ang, *The Gay Genius, the Life and Times of Su Tung-po* (New York, 1947).

204. 2. Ching Hao, 'Note on Brushwork', translated by S. Sakanishi, *The Spirit of the Brush* (London, 1939), 87. Here the translation of the Chinese word *ch'i* as 'spirit' is very general. *Ch'i* is a complex concept that includes among its meanings the all-pervading life-force of nature and also the particular qualities appropriate to each thing. Reference, Note 4, Chapter 11, of this volume.

3. Sakanishi, *op. cit.*, 89.

4. A. Coomaraswamy, 'Introduction to the Art of Eastern Asia', *The Open Court* (March 1932), 18.

5. Z. Takacs, *Francis Hopp Memorial Exhibition, 1933, The Art of Greater Asia* (Budapest, 1933), 40.

6. Sakanishi, *op. cit.*, 89–90.

206. 7. The picture has no signature, and the attribution may be only fortuitous, but the work seems to be no later than the Northern Sung period.

8. G. Rowley, *Principles of Chinese Painting* (Princeton, 1947), 66.

9. *Ibid.* In this writer's opinion the Chinese artist faced the problems of spatial depth earlier than in T'ang Dynasty.

207. 10. A. Waley, *An Introduction to the Study of Chinese Painting*, 168, translated from the *Hsüan ho hua p'u*, 49, 2.

11. A Soper, *Kuo Jo-hsü's Experiences in Painting* (Washington, 1951), 19.

208. 12. For contrast see the tortured and writhing mass of disorganized wood in the painting attributed to Li Ch'êng, 'Reading a Stone Tablet', Abe Collection, Ōsaka Museum, reproduced, Sirén, *History of Early Chinese Painting*, I, plate 91A.

13. The composition as a whole is rather unusual in that the temple occupies the exact centre and the scene closes with some abruptness on the left. It is

very probable that this is the right-hand scroll of a complementary pair.

209. 14. A Soper, 'Some Technical Terms in the Early Literature of Chinese Painting', *Harvard Journal of Asiatic Studies* (June 1948), 163–73.

15. A very good, old painting long attributed to Li Ch'êng and with a somewhat different brush manner is the often reproduced 'Travellers Among the Snowy Hills' in the Boston Museum. K. Tomita, *Portfolio of Chinese Paintings in the Museum* (Cambridge, Mass., 1938), plate 32; Sirén, *op. cit.*, plate 90.

16. A. Soper, *Kuo Jo-hsü's Experiences in Painting*, 46.

17. Soper, *op. cit.*, 58.

211. 18. The manner of painting in ink washes alone without any kind of outline was popular with painters of the late twelfth and thirteenth centuries, because it well suited their more impressionistic and less descriptive style. The method appears, however, to have been at least in limited use by the early eleventh century.

See also Soper, *op. cit.*, 59, and note 510, describing the style of Li Yin, a painter active 1008–17.

212. 19. A. Priest, 'Southern Sung Landscapes; The Horizontal Scrolls', *Bulletin of the Metropolitan Museum of Art* (March 1950), 199.

20. The scrolls used in the above generalities are: the Freer Gallery Kuo Hsi, the Toledo Museum Kuo Hsi, the Boston Museum Tung Yüan, the Nelson Gallery Hsü Tao-ning, the Abe Collection (Ōsaka Museum) Yen Wên-kuei (which may well be a later copy), and a scroll in a Chinese private collection attributed to Sun Chih-wei. It is difficult to be accurate in general statements, because the material is so scant and most of the old scrolls have been cut and divided by later collectors. Among the above, the Freer Gallery Kuo Hsi is apparently still its original length.

214. 21. The brush-strokes are not of a kind readily identified with any of the later classifications. There are a number of small, powerfully jabbed dots that might be construed as the type called 'rain-drop', but in addition there are many short, abrupt parallel strokes that may well be the kind called *ch'iang* by Kuo Jo-hsü in describing the work of Fan K'uan. Soper defines the technical term *ch'iang*, used in such early paintings, '. . . as a verb descriptive of physical motion, like the jab that drives a stake into the ground. The "wrinkle" (*ts'un*) formula so described must have been a repetition of a short, abrupt, presumably pointed stroke. . . . The *ch'iang* had the narrowness of a spear, and of a drawn line . . .' Soper, 'Some Technical Terms in the Early Literature of Chinese Painting', *op. cit.*, 172.

22. It is instructive to compare this picture with a mediocre copy, also in the Palace Museum, Taipei, reproduced in *Ku kung shu hua chi*, 11 (Peking, 1931–), plate 2. Slight changes in the composition are all for the worse, all 'drawing' has disappeared, and the ts'un have become mechanical to a melancholy degree.

215. 23. Reproduced: Tomita, *op. cit.*, plate 40; Sirén, *History of Early Chinese Painting*, I, plate 100.

24. Translation, Sirén, *op. cit.*, I, 135.

25. Soper, *Kuo Jo-hsü's Experiences in Painting*, 19.

26. *Ku kung shu hua chi*, 11, plate 1; also, *The Chinese Exhibition. A Commemorative Catalogue of the International Exhibition of Chinese Art* (London, 1936), plate 70.

27. There are a few paintings, some of them in Japanese collections, that are done with heavy blobs of ink and long, thick strokes as though with the stub of a brush. When a critic of the tenth or eleventh century says a painter worked in a 'coarse' or 'rough' manner he was, of course, thinking in terms of his own age when 'rough' would mean relative to the work of such painters as, say, Li Ch'êng or Fan K'uan. One feels that the 'roughness' of some of the paintings attributed to Tung Yüan has been a little overdone. These pictures are, for the most part, so mannered and lacking in rationality, that they impress one as works of a later age based on verbal descriptions of Tung's coarse style. Two such paintings are reproduced in *The Pageant of Chinese Painting* (Tōkyō, 1936), plates 44, 45. The painting from the Palace Museum, reproduced on plate 43 of the same book, looks like a Yüan Dynasty work, possibly by Kao K'o-kung. Another is in the Abe Collection, Ōsaka Museum.

216. 28. See J. D. Ch'en, *The Three Patriarchs of the Southern School in Chinese Painting* (Hong Kong, 1955), plate 8, A–D.

29. Reproduced in K. Tomita, *Portfolio of Chinese Paintings in the Museum (Han to Sung Periods)* (Cambridge, Mass., 1938), plates 33–6.

217. 30. Such dots are very seldom found in the work of other early painters – there are a few in the Nelson Gallery Hsü Tao-ning (a painter slightly later than Tung Yüan), and none can be seen in the paintings attributed to Li Ch'êng or Fan K'uan. Such dots, called *tien* in Chinese, are not only used to represent vegetation but most skilfully employed for accent, emphasis, or to separate one depth of distance from another. Under the brush of such fourteenth-century painters as Huang Kung-wang or Wu Chên, and a Ming painter like Shên Chou, the way in which these dots, or *tien*, are employed becomes almost a signature.

218. 31. Soper, *op. cit.*, 60.

32. *Ibid.*

219. 33. S. Sakanishi, *An Essay on Landscape Painting* (London, 1935); Sirén, *op. cit*, II, 14–22.

34. Sakanishi, *op. cit.*, 38–9.

220. 35. Reproduced, Sirén, *op. cit.*, II, plate 2; also, *Ku kung* (edited by the Directors of the Palace Museum in Peking, 2nd ed., 1930), x, plate 1.

36. Among the few other good pictures attributed to Kuo should be mentioned a short horizontal scroll of autumn landscape, very close in style and brushwork to the Freer painting, in the collection of John Crawford, New York.

37. Mi Fu is the correct pronunciation of the artist's name, but Mi Fei is established in Western usage. Translations from Mi Fei's *Hua Shih* are in Sirén, *op. cit.*, II; also a very interesting work is R. H. Van Gulik, *Mi Fu on Ink-Stones* (Peking, 1938).

222. 38. It will require much study to determine clearly the relationship that existed between calligraphy and painting in pre-T'ang and early T'ang times. There was, for example, in the Han Dynasty a free and cursive style of writing, employing the variations and fluidity of the brush. So far no painting that fully exploits the potentialities of a flexible brush is known from the Han Dynasty, or, indeed, until about the eighth century. The theory that painting and writing had a common origin is appealing, however, and has the sanction of the most distinguished Chinese art historians from the T'ang Dynasty on.

CHAPTER 16

227. 1. K. Tomita, 'Scholars of the Northern Ch'i Dynasty Collating the Classics', *Bulletin of the Museum of Fine Arts, Boston*, XXIX, no. 174 (August 1931), 58–63.

2. Tomita, *op. cit.*, 59.

228. 3. K. Tomita, 'Wên-chi's Captivity in Mongolia and Her Return to China', *Bulletin of the Museum of Fine Arts, Boston*, XXVI, no. 155 (June 1928), 40–1; also Tomita, *Portfolio of Chinese Paintings in the Museum*, 10, and plates 61–4. A complete set of eighteen by a later hand and inferior in quality is reproduced in the Chinese art journal *I lin yueh k'an*, nos. 25 to 43.

229. 4. Originally in the Ch'ing Imperial Collection, the painting was removed from the Palace by the last emperor and, after a brief period in Mukden, returned to the Peking Palace Museum collection in 1958. The most complete publication with nineteen loose plate illustrations and an excellent text is *Ch'ing-ming Shang-ho T'u-chüan, painted by Chang Tse-tuan* (Chung-kuo Ku-tien I-shu Publishing Company, Peking, 1958).

231. 5. For a detailed account of the Lohan beliefs and also Kuan-hsiu's art, see M. W. de Visser, *The Arhats in China and Japan* (Berlin, 1923).

232. 6. Another set of sixteen appears to have existed at a temple in Hang-chou until its disappearance in the eighteenth century. Stone engravings of the series from which rubbings are made still exist at the Shêng-yin temple near Hang-chou. These are similar in general style and composition to the famous set that once belonged to Baron Takahashi and is now deposited in the National Museum, Tōkyō.

234. 7. The repertoire of Li Lung-mien was extensive. The list by title of the one hundred and seven paintings attributed to him in the Sung Imperial catalogue indicates that he painted strange rocks, butterflies, flowers, and landscape. But the majority of his scrolls were either religious subjects, both Buddhist and Taoist, or pure illustrations of historical events, and such Confucian themes as illustrations to the *Classic of Filial Piety*.

8. Basil Gray, 'A Great Taoist Painting', *Oriental Art*, XI, 2 (1965), 33 ff.

CHAPTER 17

236. 1. There was, in 1104, a school of painting – along with a school of calligraphy and one of mathematics. In 1110 these schools were discontinued, but the school of painting was placed under the Han-lin Academy as a bureau. Wenley's conclusion is that: '. . . we may suppose that while necessarily submitting to the emperor's whims in regard to the honours bestowed on painters for their painting alone, the really patriotic men of the court managed to keep the art officially as a minor branch of the government, hence no Hua Yüan (Painting Academy) appears in the history.' A. Wenley, 'A Note on the So-called Sung Academy of Painting', *Harvard Journal of Asiatic Studies* (June 1941), 269–72. See also Soper, *Kuo Jo-hsü's Experiences in Painting*, note 210, p. 131. A good account of the Academy, especially during the Southern Sung Dynasty, is J. C. Ferguson, 'The Imperial Academy of Painting', *T'ien Hsia Monthly* (Oct.–Nov. 1940), 109–18.

2. See Waley, *An Introduction to the Study of Chinese Painting*, 178; Sirén, *History of Early Chinese Painting*, II, 7.

CHAPTER 18

237. 1. These subjects have for many centuries been close to the Chinese heart. In the period of the Three Kingdoms, Wang I of the fourth century is said to have painted such animal subjects as a lion attacking an elephant, a rhinoceros, and such scaly subjects as

fish and dragons; Hsieh Chih of the fifth century painted horses; Lu T'an-wei, also of the fifth century, painted sparrows and cicadas, a subject which became classic; he also painted horses, ducks, and monkeys.

2. A. Soper, *Kuo Jo-hsü's Experiences in Painting*, 33-4.

3. Some idea of the output of a Chinese court painter can be gathered from the fact that in the early twelfth century, little more than one hundred years after the time of the Huangs, father and son, the Imperial Collection claimed three hundred and forty-nine paintings by the father and three hundred and thirty-two by the son – these scrolls in addition to the vast number of wall paintings and similar decorations they must have executed.

4. Soper, *op. cit.*, 20.

238. 5. *Sheng ch'ao ming hua p'ing*, IV, translated by A. Soper, *op. cit.*, 176, note 522.

6. The companion picture to the one reproduced here was shown in London in 1935-6, and a detail is reproduced in colour as the frontispiece of the *Commemorative Catalogue of the International Exhibition of Chinese Art*.

7. See J. Tamura, 'The Murals at Ch'ing-ling, Mongolia' (in Japanese), *The Bijutsu Kenkyu* (Tōkyō, 1949), no. CLIII, vol. II; J. Tamura and Y. Kobayashi, *Tombs and Mural Paintings of Ch'ing-ling, Liao Imperial Mausoleums of Eleventh Century A.D. in Eastern Mongolia* (Kyōto, 1953); also K. A. Wittfogel and Fêng Chia-shêng, *History of Chinese Society, Liao* (Philadelphia, 1949), figure 1.

8. Soper, *op. cit.*, 65-6 and note 541. See also 'Hsiang-kuo-ssu, An Imperial Temple of Northern Sung', *Journal of the American Oriental Society*, LXVIII, 1 (January-March 1948).

241. 9. J. C. Ferguson, 'The Emperor Hui-tsung', *The China Journal of Arts and Sciences* (reprint).

10. Reproduced in *Ku kung shu hua chi*, I, plate 4.

242. 11. B. Rowland, 'The Problem of Hui-tsung', *Archives of the Chinese Art Society of America*, V (1951).

12. *Ku kung shu hua chi*, XLV, plate 2.

13. B. Rowland, *op. cit.*

CHAPTER 19

244. 1. In the Palace Museum there is a set of four large, vertical scrolls depicting this group; there are two paintings with five scholars each and two with four making up the number of eighteen. The pictures are unsigned but are probably no later than the thirteenth century. They show the standard of craftsmanship set by the Academy, and the scenes are probably not far from the actual amenities of life in a Hang-chou garden during the twilight of the Sung

Dynasty. Reproduced, *Ku kung shu hua chi*, XXV, plate 5; XXVI, plate 5; XXXIV, plate 3; XLIV, plate 4.

245. 2. Pictures attributed to Chao Ta-nien, reproduced: Sirén, *History of Early Chinese Painting*, II, plate 13; J. Harada, *Pageant of Chinese Painting*, plate 89.

246. 3. For many of the most important of Li T'ang's paintings and a good analysis of his various styles and influence, see R. Edwards, 'The Landscape Art of Li T'ang', *Archives of the Chinese Art Society of America*, XII (Kansas City, 1958), 48-59.

4. K. Tomita, *Portfolio of Chinese Paintings in the Museum*, 10-11, plates 66-9.

249. 5. This kind of stroke is made by laying the brush on its side and dragging it down using the flat of the brush. The stroke is straight across the top and ends in irregular points as the ink runs dry or the brush is lifted.

250. 6. In the Palace Museum collection, Taiwan, there is a scroll attributed to Li T'ang which may have been painted in his old age and proves him to be the originator of much that is basic in the Ma-Hsia style. The painting, entitled 'The Secluded Fisherman', is in a much abbreviated, strong, and simple manner, somewhat related to the Kôtô-in paintings but different from his other accepted works. Reproduced: *Ku kung chou k'an*, IX, nos. 185, 186, 187.

251. 7. Tomita, *op. cit.*, plate 99.

252. 8. Sirén, *op. cit.*, II, plate 57; Tomita, *op. cit.*, 14, and plate 94.

255. 9. The painting is recorded in Chinese art literature under its full title of *Ts'ao t'ang shih erh ching*, 'Twelve Views from a Thatched Cottage.'

CHAPTER 20

259. 1. A. Waley, *An Introduction to the Study of Chinese Painting*, 216. Waley's chapter on 'Zen Buddhism: The Dragon' and his monograph, 'Zen Buddhism and Its Relation to Art' (London, 1922), both give a good account of this sect in its relation to painting. For an excellent brief account of the development of Ch'an, see Fung Yu-lan, *A Short History of Chinese Philosophy*, ed. by Derk Bodde (New York, 1950), chapter 22, 'Ch'an-ism: The Philosophy of Silence'.

2. For the problems concerning Bodhidharma, see P. Pelliot, *T'oung Pao*, XXIII, 253. The non-existence of Bodhidharma itself has a Ch'an twist that would, no doubt, please the Patriarch.

3. For portraits see Helen B. Chapin, 'Three Early Portraits of Bodhidharma', *Archives of the Chinese Art Society of America*, I (New York, 1945-6).

260. 4. Fung Yu-lan, *op cit.*, 257.

5. Fung Yu-lan, *op. cit.*, 261-2.

6. B. Rowland, *Masterpieces of Chinese Bird and Flower Painting*, Fogg Art Museum (Cambridge, Mass., 1951), 8.

261. 7. It has been pointed out by several Western writers that the problem of the exact authorship of many paintings attributed to Mu-ch'i and preserved in Japan is complicated by the fact that a Japanese artist went to China in the early fourteenth century, and practised his art in some of the Hang-chou temples made famous by Mu-ch'i. He followed the latter's style with such perfection that, as a reward for his application, so the story goes, the abbot of Liu-t'ung-ssu gave him the seals of Mu-ch'i to use as his own. The former part of the story is especially credible, and it is possible that a number of the paintings in Japan stamped with the seal of Mu-ch'i are the work of a Japanese master adhering closely to the Mu-ch'i tradition. Exact attributions may never be determined and, since the concepts embodied and the technique employed in these paintings were for a brief period so alike in the two countries, in the case of the best examples the problem tends to become an academic one.

Ferguson's Index of Recorded Paintings, *Li tai chu lu hua mu*, lists only nine, two of which went into the Imperial Palace Collection. Both of them, from the titles, are studies of birds, flowers, plants, and animals in hand-scroll form. I have seen only one of these, that entitled 'Nature Studies' (*hsieh-sheng*), which is in the Old Palace Museum Collection, Taiwan. It presents, in ink on paper, a series of unrelated studies of fruit, vegetables, flowers, bamboo, and birds. The scroll is exceptionally large, being $17\frac{1}{2}$ inches wide by 32 feet $8\frac{1}{2}$ inches long. It is signed and sealed by Mu-ch'i and dated in accordance with 1265. The painting is of superb quality and might well serve as a standard in a study of the various pictures in Japanese collections that are attributed to Mu-ch'i.

8. Reproduced: *Tōyō Bijutsu Taikwan* [*Masterpieces of Far Eastern Art*], IX (Tōkyō, 1908), plates 22-3.

9. Among the other paintings in Japan attributed to this gifted priest, the 'Sparrows on a Branch' in the Nezu Collection and the 'Ch'an Master in Meditation', belonging to Baron Iwasaki, are on a very high level. The latter is related to the Daitokuji 'Kuan-yin' and has a powerful dramatic note in that a great serpent of python-like proportions curls about the meditating figure and rears its hissing head in the very lap of the holy man who, with closed eyes, ignores it. Reproduced: Sirén, *History of Early Chinese Painting*, II, plates 82, 84.

263. 10. Reproduced: Sirén, *op. cit.*, plate 86.

11. In some later landscapes in the Ch'an manner one has an uncomfortable feeling that the mist has gained the upper hand. One almost senses that a strong breeze could carry it all away and thus attain the ultimate Ch'an goal.

CHAPTER 21

268. 1. John E. Lodge, 'Ch'ên Jung's Picture of Nine Dragons', *Bulletin of the Museum of Fine Arts, Boston*, XV (December 1917), 67-73.

2. K. Okakura, 'The Awakening of Japan', 77-9, quoted in Lodge, *op. cit.*, 72.

3. An official of the National Palace Museum, Peking, once remarked: 'When you talk about dragon paintings, there is only one - Ch'ên Jung's "Nine Dragons".'

270. 4. Freer Gallery of Art, *Gallery Book, Gallery XIII* (Smithsonian Institution, Washington, D.C.), includes excerpts from an amusing poem by Sung Wu (1260-1340) attached to the scroll.

5. Two other good paintings of demons are also in the Freer Gallery: 'Battling Demons in the Mountains', reproduced Sirén, *Chinese Paintings in American Collections* (Paris and Brussels, 1928), plates 34, 35, 36; and 'Taoist Demons', Yüan Dynasty (?), attributed to Ho Ch'êng (?).

CHAPTER 22

273. 1. In certain respects the brief Yüan Dynasty was one of the most vigorous and creative in Chinese history. The vast extent of the Mongol empire again gave Chinese society much of the cosmopolitan character it had enjoyed in the heyday of the T'ang empire. There was a marked Near Eastern influence in ceramics and metal objects, because many of these were destined for export. But there is no discernible foreign influence in Chinese painting, understandably so because of the far more vigorous Chinese traditions. In administration, economics, transportation, and sciences, Yüan contributions were basic and permanent. For a good brief account see L. C. Goodrich, *A Short History of the Chinese People*, chapter vi.

278. 2. For a discussion of the well-known scroll of insects and plants called 'Early Autumn' and attributed to Ch'ien Hsüan, see R. Edwards, in *Archives of the Chinese Art Society of America*, VII (1953).

3. B. Harada, *Pageant of Chinese Painting*, plates 302-3.

4. Reproduced, Sirén, *History of Later Chinese Painting*, I, plate 103.

279. 5. Translation: Freer Gallery of Art, Smithsonian Institution, *Gallery Book: Paintings*, 31. 4.

282. 6. All are illustrated in *The Pageant of Chinese Painting*: K'o Chiu-ssu, plates 294-7; Ch'ên Ju-yen, plates 388, 389; Chao Yüan, plates 392-4; Chu Tê-jun, plates 298-300.

284. 7. Reproduced, *Ku kung shu hua chi*, XIII, plate 5.

8. The often reproduced landscape attributed to Kao K'o-kung, shown in the Chinese Exhibition, London, 1936-7, reproduced in the *Commemorative Catalogue*, plate 85, and in *Ku-kung*, IX, plate 12, is, in this writer's belief, a work of the sixteenth century, possibly by Wên Chêng-ming; while another, reproduced in *Ku kung shu hua chi*, XXXIII, plate 6, is certainly a late painting of the seventeenth to eighteenth century.

9. The painting which is a small, horizontal composition, formerly belonged to such distinguished collectors as Liang Ch'ing-piao and An I-chou before passing into the Imperial Manchu Collection, and is now in a private collection in Japan.

286. 10. An example in this style is the short hand-scroll in light colour on paper, no. 35.59, in the Freer Gallery of Art.

290. 11. There is an interesting example here of how the Chinese artist, so often working from the imagination, is inclined to develop formulas, or a simplified vocabulary. In both paintings the claw-like roots are done with two prongs emerging from below a knothole. In the 'Fishermen' scroll the roots are done with exaggeration and freedom, and yet their clinging to the rocky surface is the more descriptive of the two.

291. 12. See J. C. Ferguson, 'Ni Tsan', *Monumenta Serica*, V (1940), 428-36.

CHAPTER 23

295. 1. Bamboo painting is briefly but very well discussed by Wang Shih-hsiang, in 'Chinese Ink Bamboo Painting', *Archives of the Chinese Art Society of America*, III (1948-9).

297. 2. *Ibid.*

3. Reproduced in the Abe Catalogue, *Sōraikwan Kinshō* (Ōsaka, 1930), plate 31.

4. Wang Shih-hsiang, *op. cit.*, plate vb.

5. For a translation into German see Ernst Aschwin, Prince zur Lippe-Biesterfeld, *Li K'an und seine 'Ausführliche Beschreibung des Bambus'*, *Beiträge zur Bambusmalerei der Yüan-zeit* (Berlin, 1942).

298. 6. Wang Shih-hsiang, *op. cit.*, 54.

7. Reproduced in *Ku kung shu hua chi*, I, plate 8, and XXXVI, plate 7.

299. 8. Example in the Freer Gallery of Art, accession no. 33.8, reproduced in Sirén, *History of Early Chinese Painting*, I, plate 94.

9. Set of four, reproduced: Harada, *Pageant of Chinese Painting*, plates 398-401. A good example of Hsüeh-ch'uang's work is in the Seattle Art Museum.

10. Sirén, *History of Later Chinese Painting*, I, 17.

11. Examples reproduced, Harada, *op. cit.*, plates 385-7. That on plate 385, formerly in the Marquis Maeda Collection, is now in the collection of the Nelson Gallery of Art, Kansas City.

301. 12. For examples see *Pageant of Chinese Painting*: Li Hêng, plate 304; Chang Yen-fu, plate 391; or Lai An, the painter of fish, plate 412.

CHAPTER 24

303. 1. Since the emperors of the Ming and Ch'ing dynasties all ruled with a single era name throughout each reign, it has become common usage to designate these emperors by their era names, or reign titles, rather than by their posthumous names.

2. In fact the reign titles of some Ming monarchs are better known to the West than those of any other Chinese emperors, with the exception of K'ang-hsi and Ch'ien-lung, because of the consistently high quality of the porcelains produced at Ching-tê-chên throughout the dynasty.

304. 3. Sirén, *Gardens of China* (New York, 1949), chapter 7: 'Some Private Gardens'.

4. Among the better-known novels was the lively romance of love and intrigue in a great house, the *Chin p'ing mei*; the *Hsi yü chi*, a story filled with wonderful Taoist and Buddhist lore, about a monkey who aided the famous pilgrim Hsüan-tsang across Central Asia; and there were stories of fighting and high adventure such as the *San kuo chih yen i*, based on the troubled times in the century following the end of the Han Dynasty.

5. For an excellent brief account, see K. T. Wu, 'Ming Printing and Printers', *Harvard Journal of Asiatic Studies*, vol. 7, no. 3 (February 1943).

CHAPTER 25

307. 1. Reproduced: *Ku kung shu hua chi*, XI, plate 9.

308. 2. Another interesting picture by Liu Chüeh, preserved in the National Palace Museum, painted in 1458, is a landscape more restrained than is our illustration and more in the traditional Yüan style, as carried on into the Ming period by Wang Fu. It has inscriptions by Shên Chou, his father, and his grandfather. Reproduced, *Ku kung shu hua chi*, IV, plate 12.

309. 3. One of the best ink bamboo paintings by Wang Fu in Western collections is a small picture on paper in the Fogg Museum, Harvard. A relatively long hand-scroll is in the Freer Gallery of Art, Washington.

310. 4. Something of the variety and inventiveness of these great horizontal compositions may be suggested by their length; the Chicago scroll is fifty feet long, one in the Nelson Gallery over thirty feet, and a third in the collection of the Philadelphia Museum, 'Bamboo Under Spring Rain', an unusually bold and free painting, is over thirty-one feet long by some twenty inches wide.

CHAPTER 26

313. 1. In the seventeenth and eighteenth centuries, the large sets of ten and twelve scrolls representing the 'hundred birds', and eventually the Chinese wallpapers in eighteenth-century Europe with their riotous assembly of birds and flowers, were the last, debilitated descendants of a style that in the Ming Dynasty had reached its zenith under the brush of Lü Chi.

2. Reproduced: Sirén, *History of Later Chinese Painting*, 1, plate 24; and *Tōsō Gemmin Meigwa Taikwan* (Illustrated Catalogue of the Exhibition of Chinese Paintings in Tōkyō, December 1928) (Tōkyō, 1929), plate 234.

CHAPTER 27

320. 1. The most detailed study, as yet, in a Western language is R. Edwards, *The Field of Stones, A Study of the Art of Shên Chou, 1427-1509*, Smithsonian Institution, Freer Gallery of Art, Oriental Studies, no. 5 (Washington, 1962).

2. One excellent example, painted in 1467, is in the National Palace Museum, reproduced, *Ku kung shu hua chi*, 1, plate 12, and another, painted in 1491, is in the collection of Jean-Pierre Dubosc, reproduced, *Great Chinese Paintings of the Ming and Ch'ing Dynasties*, Wildenstein exhibition catalogue (New York, 1949).

323. 3. A translation of this is to be found in the *Gallery Book*, Freer Gallery of Art, Smithsonian Institution, no. 39.2.

324. 4. Illustrated, Dubosc, *Great Chinese Paintings of the Ming and Ch'ing Dynasties*. This fine style of Wên Chêng-ming does not represent an early phase in his painting; the Dubosc painting was done in 1531 when the artist was sixty years old.

325. 5. Other paintings belonging to this period are one painted in 1549, reproduced *Ku kung shu hua chi*, 11, plate 13; one from the same year and one from 1551, reproduced, Sirén, *History of Later Chinese Painting*, 1, plates 77-8.

329. 6. Chou Ch'ên, active in the first half of the sixteenth century. His style followed that of Li T'ang and Liu Sung-nien. An excellent example in the

Boston Museum of Fine Arts is reproduced in Sirén, *History of Later Chinese Painting*, 1, plate 98.

CHAPTER 28

335. 1. For list and descriptions of the principal methods, see B. March, *Some Technical Terms in Chinese Painting* (Baltimore, 1936).

2. For detailed material on the contents and the various editions, see R. T. Paine, 'The Ten Bamboo Studio' and A. K'ai-ming Ch'iu, 'The Chieh Tzu Yüan Hua Chuan', both in *Archives of the Chinese Art Society of America*, v (New York, 1951).

CHAPTER 29

339. 1. A. W. Hummel, *Eminent Chinese of the Ch'ing Period* (Washington, 1943), 121. This work also contains concise biographies of the leading artists of Ch'ing.

340. 2. Verbal communication from an official of the National Palace Museum.

341. 3. For reproductions of Wang Shih-min, see *The Pageant of Chinese Painting*, plates 769-71.

4. For reproductions of Wang Chien, see *op. cit.*, plates 772-3.

342. 5. For example, Landscape by Hsü Pên, *Ku kung shu hua chi*, VIII, plate 12.

344. 6. Imperial encyclopaedia in 100 vols. compiled by various officials; first published in 1708.

346. 7. A very interesting fact of Wu Li's life is that, when in his forties, he was converted to Christianity and at the age of fifty-six was ordained a priest in the Jesuit order. From that time until his death in 1718 he devoted himself to missionary work.

8. For detailed material on these six men and good reproductions of their paintings, see V. Contag, *Die sechs berühmten Maler der Ch'ing Dynastie* (Leipzig, 1940).

347. 9. For a thorough examination of the style of Yüan Chiang and his associates, see James Cahill, 'Yüan Chiang and His School', in *Ars Orientalis*, v (1963), 259-72, and Part II, VI (1966), 191-212.

351. 10. A. Waley, *An Introduction to the Study of Chinese Painting*, 251.

CHAPTER 30

355. 1. The most recent work on these two painters is V. Contag, *Die beiden Steine* (Brunswick, 1950).

356. 2. K. Tomita and K. Ch'iu, 'An Album of Twelve Landscapes by Tao-chi', *Bulletin of the Museum of Fine Arts, Boston*, XLVII (October 1949), 269.

358. 3. *Ibid.*

NOTES TO PART TWO

CHAPTER 31

361. 1. For this and subsequent citations of material drawn from the representational arts, see Part One.

CHAPTER 32

363. 1. Account based primarily on Creel, *The Birth of China* (New York, 1937), and on Eberhard, 'Bericht über die Ausgrabungen bei An-yang (Honan)', *Ostasiatische Zeitschrift*, Neue Folge, VIII, 1–2 (1932), 1 ff.

364. 2. At least from the beginning of the Imperial age the Chinese have used a linear measure called the *chih*. The length of this gradually increased for a thousand years or so, from a Han chih that was about 9 of our inches long, to a T'ang chih that was very nearly equal to the English foot. I have thus translated the characters as 'foot' throughout, and have not troubled to distinguish between Chinese and English feet except for the pre-T'ang age, when the difference was a substantial one.

3. Account based primarily on Itō Seizō, *Shina Kenchiku*, 431 ff., and on Lung Fei-liao, 'Cave Dwellings', *Chung-kuo Ying-tsao Hsüeh Shê Hui-k'an* (hereafter referred to as *Bulletin*), V, 1 (1934).

365. 4. Reported in *American Journal of Archaeology*, LII (1948), 405; LIII (1949), 309. The translators seem to have been unfamiliar with the Chinese term for metre, and so rendered the plan dimension first as 3 feet and then as 30 feet.

5. Account based primarily on Itō, *op. cit.*, 489 ff.

6. No two translators of the 'Poetry Classic' agree in full, and it would be cumbersome to list fully even the better known. Excellent, accessible versions of the three songs are given by A. Waley, *The Book of Songs* (London, 1937), 273, 280, 282.

366. 7. *Op. cit.*, 33.

8. *Op. cit.*, 248, 249.

9. Translated by A. Waley, *The Analects of Confucius* (London, 1938), 111.

10. For the *Ch'un Ch'iu* and its commentary on the rafters, see translation by J. Legge, *The Chinese Classics*, V, 1 (Oxford, 1895), 105, 107. The *Li Chi* injunction (which seems to be lacking in the edition translated by Legge and Couvreur) is quoted in the Sung architectural manual *Ying-tsao Fa Shih*, 1, under the heading 'column'. The *Ch'un Ch'iu* commentary regarding pillar colours looks garbled. 'The pillars of the Son of Heaven and of the feudal princes are to be painted blackish; those of high officials green; and

those of the other gentry yellowish. Red pillars are improper.'

367. 11. Legge, *op. cit.*, 1, 290; 2, 589.

12. *Op. cit.*, 1, 40, 25.

13. *Op. cit.*, 2, 795.

14. Waley, *Songs*, 259.

15. Legge, *op. cit.*, 2, 509.

368. 16. Translation by Waley, *The Way and its Power* (London, 1935), 221.

17. Legge, *op. cit.*, 1, 281.

18. Translated by S. Couvreur, '*Li Ki*', *Ho Kien Fou*, 11 (1913), 316.

369. 19. *Op. cit.*, 287–8, 599.

20. *Op. cit.*, 1 (1913), 725 ff., 330 ff.

21. Translated by E. Biot, *Le Tcheou-li*, 11 (Paris, 1851), 556 ff.

22. Legge, *op. cit.*, 1, 233. The entry, however, occurs in a passage of dialogue, i.e. in the type of material least likely to have been found in early annals. Perhaps it was interpolated when the commentary was completed towards the end of Chou.

23. Legge, *op. cit.*, 11, 161.

24. The most thorough discussions of the Ming T'ang in its magical aspect have been written by M. Granet, *Danses et légendes de la Chine ancienne* (Paris, 1926), 116–19; and *La Pensée chinoise* (Paris, 1934), 178–81, 209–10, 250–73, 318–19. As he admits, it is unlikely that any of his theories can be applied to the pre-imperial age.

370. 25. *Shih Chi*, XXVIII. For this whole chapter, see translation by E. Chavannes, *Les mémoires historiques de Se-ma Ts'ien*, III (Paris, 1895–1905).

371. 26. Couvreur, '*Li Ki*', 1, 330 ff.

27. Cf. *op. cit.*, 734.

28. See Wang Kuo-wei, 'Ming-t'ang'.

29. Account based primarily on Sekino Takeshi, 'Investigation of Lin-tzu'.

372. 30. Biot, *Tcheou-li*, 11, 555–6.

CHAPTER 33

373. 1. Legge, *op. cit.*, V, 2, 563.

2. *Shih Chi*, VI, 26th year of Shih Huang Ti.

3. *Op. cit.*, 35th year.

374. 4. *Op. cit.*, VIII, 8th year of Han Kao Tsu.

376. 5. Account based primarily on Wang Pi-wên, *Chung-kuo Chien-chu*; on Itō Chūta, *Tōyō Kenchiku*; on Adachi, *Chōan Shiseki*; and on Liu Tun-tsêng, 'Ta-chuang Shih Notes', *Bulletin*, III, 3 (1932).

6. Account drawn from Mizuno, 'Rakuto'.

378. 7. *Hou Han Shu*, XXIV, chapter on disastrous fires.

8. Drawn from *Shih Chi*, XXVIII; see Note 24.

379. 9. See Note 1.

381. 10. See the Pelican History of Art: *The Art and Architecture of Japan*, 201, 204–6.

382. 11. *Hou Han Shu*, LXXXII, biography of Shih Tan.

12. Both translated by E. von Zach, the former in *Asia Major*, III (1926), and the latter in *Monumenta Serica*, IV (1940). Though these renderings are in general praiseworthy, neither does justice to the technicalities of architectural description.

383. 13. Cf. pp. 454, 457, and 461 below.

385. 14. See Note 28, Chapter 32.

386. 15. Account based primarily on Itō Chūta, *Tōyō Kenchiku*, and on Tanaka, 'Archaic Type of Buddhist Temples'.

16. Descriptions in *Hou Han Shu*, CIII, biography of T'ao Ch'ien; and in *San Kuo Wu Chih*, IV, biography of Liu Yao. My rendering follows the latter; the former speaks of 'galleries round about the hall'.

387. 17. Account of secular architecture drawn primarily from Wang, *Chung-kuo Chien-chu*, and from Liang Chi-hsiung, 'Collected Biographies of Master Craftsmen' (in Chinese), *Bulletin*, III, 1 (1932), 138 ff.

18. From the contemporary gazetteer *Shui Ching Chu*. This summary has been drawn from the account of the Ming T'ang given in the Ch'ing Imperial encyclopaedia *T'u Shu Chi Ch'êng*.

389. 19. See chiefly Mizuno, 'Rakuto'. A basic historical text on the patronage of Buddhism by the Wei Tartars has been translated by J. Ware, 'Wei Shou on Buddhism', *T'oung Pao*, XXX (1933).

20. I have omitted passages on the splendour of the decorations which follow the word patterns of the Han palace fu, and so should perhaps not be taken literally.

390. 21. For the stūpa, see the Pelican History of Art: *The Art and Architecture of India*. Sung Yün has been translated by S. Beal, *Buddhist Records of the Western World*, I (London, 1906), ciii–cvi.

391. 22. Account drawn primarily from Tokiwa and Sekino, *Shina Bukkyō Shiseki*.

392. 23. Described by Liang Ssu-ch'êng in *Bulletin*, VII, 2 (1944).

24. See Soper, 'Japanese Evidence for the History of the Architecture and Iconography of Chinese Buddhism', *Monumenta Serica*, IV, 2 (1940), 641 ff.

25. Beal, *op. cit.*, xxvii.

CHAPTER 34

399. 1. Data taken from Liang Chi-hsiung, 'Collected Biographies', *Bulletin*, III, 1, and VI, 3.

400. 2. Account drawn primarily from Adachi, *Chōan*, 115 ff. The city rectangle measured about 6·2 by 5·2 miles.

401. 3. *Nittō Guhō Junrei Gyōki*, reprinted in the anthology of Japanese Buddhist literature *Dainihon Bukkyō Zensho*, volume on travels, I (Tōkyō, 1926). See especially p. 239, describing the 'Golden Pavilion Temple', Chin-ko-ssu.

402. 4. Quoted from *T'ang Shu*, XXII.

5. Quoted from *Tzu-chih T'ung Chien*, CCV.

6. Quoted from his biography in *Sui Shu*, LXVIII. For the 'Throne of Chosroes' see K. Lehmann, 'The Dome of Heaven', *Art Bulletin*, XXVII (1945), 24.

7. For the *tepidarium*, see the Sung anthology *T'ai P'ing Kuang Chi*, CCXXXVI, quotation from the *Ming Huang Ts'a Lu*. For the 'cool hall', see *T'ang Yü Lin*, IV.

403. 8. See the *T'u Shu Chi Ch'êng* chapter on the T'ang palaces, quotation from the *Liang Ching Chi*.

9. *Hsin T'ang Shu*, XXIV.

405. 10. Account drawn primarily from Boerschmann, *Baukunst*, III; from Tokiwa and Sekino, *Shina Bukkyō Shiseki*; and from Pao Ting, 'Pagodas of the T'ang and Sung Periods' (in Chinese), *Bulletin*, VI, 4 (1937).

406. 11. Description by Liu Tun-tsêng in *op. cit.*, VII, 2 (1945), in report on Yünnan pagodas.

408. 12. *Nittō Guhō Junrei Gyōki*, 234.

13. Description by Liang Ssu-ch'êng in *op. cit.*, 2, in section on Fo-kuang-ssu.

409. 14. Description by Liang Ssu-ch'êng in *op. cit.*, 1; summary account in *Asia Magazine* (July 1941).

412. 15. Quoted from the section on Tōshōdaiji in the *Shoji Engi Shū* (an eleventh-century summary of the histories of ancient temples).

420. 16. Cited in Liang Ssu-ch'êng, etc., 'Report on the Ancient Architecture of Ta-t'ung' (in Chinese), *Bulletin*, IV, 3–4 (1934), 47.

17. Description by Liang, 'The Ancient Architecture of Chêng-ting Hsien' (in Chinese), *op. cit.*, IV, 2 (1933), 38 ff.

CHAPTER 35

421. 1. Data taken from Liang Chi-hsiung, 'Collected Biographies', *op. cit.*, III, 2 (1932), 135.

2. Account drawn primarily from Wang, *Chung-kuo Chien-chu*.

3. Cited under the biography of the architect, Li Huai-i, in *Bulletin*, III, 2, 133.

4. See Soper, 'Hsiang-kuo-ssu, an Imperial Temple of Northern Sung', *Journal of the American Oriental Society*, LXVIII, 1 (1948).

5. Cited under the biography of the supervisor, Ting Wei, in *Bulletin*, VI, 3, 166.

422. 6. *San Tendai Godaisan Ki*, reprinted in *Dainihon Bukkyō Zensho*, volume on travels, III, 396.

423. 7. *Op. cit.*, 394–5.

8. *Op. cit.*, 375 ff.

9. Extensive review by P. Demiéville, *Bulletin de l'Ecole Française d'Extrême-Orient*, XXV (1925), 213 ff.; reprinted in *Bulletin*, 11, 2.

425. 10. Account drawn as in Note 10, Chapter 34.

426. 11. Descriptions also by Yang T'ing-pao, 'The Ancient Architecture of K'ai-fêng and Chêng-chou' (in Chinese), *Bulletin*, VI, 3, 1 ff.; and by Lung Fei-liao, 'The Iron Pagoda of K'ai-fêng' (in Chinese), *op. cit.*, III, 4, 53 ff.

12. Description also by Liu Tun-tsêng, 'The Ancient Architecture of Soochow' (in Chinese), *op. cit.*, VI, 3, 43 ff.

427. 13. See Ecke and Demiéville, *Twin Pagodas*.

428. 14. Description by Liang in *Bulletin*, IV, 2, 14 ff.

431. 15. Description by Mo Tsung-chiang in *op. cit.*, VII, 2.

16. Description by Lin Whei-yin and Liang in their field report on 'The Ancient Architecture of the Upper Fên River Valley' (in Chinese), *op. cit.*, V, 3 (1935), 57 ff.

17. Description by Liang in *op. cit.*, VII, 2 (in section on Fo-kuang-ssu).

18. See Ōmura, *Soheki Zanei*.

433. 19. Descriptions by Liu, 'The Ancient Architecture of Northern Honan' (erroneously given as Hopei; in Chinese), *Bulletin*, VI, 4, 112 ff.; and by Tokiwa and Sekino, *Shina Bukkyō Shiseki*, II, 155.

434. 20. Description by Liu in *Bulletin*, VI, 3, 21 ff. Sirén, *Histoire*, IV, plate 17A.

437. 21. Description by Liu in his field report on 'The Ancient Architecture of the Western Section of Hopei Province' (in Chinese), *Bulletin*, V, 4, 34. Sirén, *op. cit.*, plate 115.

438. 22. See Tokiwa and Sekino memorial volume, especially 199 ff., 260 ff.

CHAPTER 36

439. 1. Liao and Chin data are drawn primarily from Murata, *Manshū*, and from Sekino and Takeshima, *Ryōkin Jidai.*

440. 2. Account based primarily on Wang, *Chung-kuo Chien-chu*, and on quotations from the Ming catalogue, *Chou-kêng Lu*, given in the *T'u Shu Chi Ch'êng* chapter on the Yüan palaces.

444. 3. Descriptions in Sekino and Takeshima, *Ryōkin Jidai*, 308 ff.; in Tokiwa and Sekino, *Shina Bukkyō*, III; in Ecke, *Monumenta Serica*, XIII, 355; and by Liu in *Bulletin*, V, 4, 31 ff. Sirén, *Histoire*, IV, plate 76.

4. Descriptions in Sekino and Takeshima, *op. cit.*, 303 ff.; and in Tokiwa and Sekino, *op. cit.*, V, 226 ff.

445. 5. For this group, see Liu in *Bulletin*, V, 4.

446. 6. For this group, see Ecke, *op. cit.*

447. 7. Sirén, *op. cit.*, plate 35.

8. See references in Note 3 to this chapter.

448. 9. For Chi-hsien's, see Liang in *Bulletin*, III, 2, 93 ff.; for I-hsien's, see Liu in *op. cit.*, V, 4, 21; for Shun-tê's, see Tokiwa and Sekino, *Shina Bukkyō Shiseki*, V, 199.

10. Descriptions in *op. cit.*, IV, 186 ff., and by Liang in *Bulletin*, IV, 2, 35 ff.

11. Descriptions by Boerschmann, *Baukunst*, III, 178; and by Tokiwa and Sekino, *op. cit.*, V, 174.

12. Description by Boerschmann, *op. cit.*, 327.

449. 13. Description by Tokiwa and Sekino, *op. cit.*, V, 223 ff.

14. Description by Sekino Tadashi, *Chōsen no Kenchiku to Bijutsu* (Tōkyō, 1941), 751 ff.

15. Descriptions by Sekino and Takeshima, *Ryōkin Jidai*, 17 ff.; and by Liang Ssu-ch'êng, 'Two Liao Structures of Tu-lo-ssu' (in Chinese), *Bulletin*, III, 2.

453. 16. Description by Sekino and Takeshima, *op. cit.*, 47 ff.

454. 17. Description by Liang, 'The San-ta-shih Tien of Kwang-chi-ssu, Pao-ti Hsien' (in Chinese), *Bulletin*, III, 4.

18. Descriptions by Sekino and Takeshima, *op. cit.*, 74 ff.; and by Liang, etc., 'Report on the Ancient Architecture of Ta-t'ung' (in Chinese), *Bulletin*, IV, 3-4.

457. 19. Description by Liu in *op. cit.*, V, 4, 10 ff.

459. 20. Description by Liang, 'The Architecture of the Temple of Confucius, Chü-fu' (in Chinese), *op. cit.*, VI, 1 (1935), 37 ff.

21. Description by Liu in *op. cit.*, V, 4, 44 ff.

22. Description by Lin and Liang, *op. cit.*, V, 3, 41 ff.

CHAPTER 37

461. 1. See especially Sirén's volumes on Peking (of which a selection is given in his *Histoire*, IV).

2. Description by Liu, 'The Ju-lai Tien of Chih-hua Ssu, Peiping' (in Chinese), *Bulletin*, III, 3 (1932).

463. 3. For the vaulted structures, see Sirén, *Histoire*, IV, 45 ff. The Summer Palace has been ably described by C. Lancaster, 'The European Style Palaces of the Yüan Ming Yüan', *Gazette des Beaux-Arts* (October 1948).

464. 4. The T'ai-miao is a true survivor from the Ming Age, having been first completed in 1420 and then rebuilt, after a fire, in 1464. The three chief audience halls, called *T'ai-ho, Chung-ho,* and *Pao-ho,* date from the end of the seventeenth century.

BIBLIOGRAPHY

PART ONE

1. HISTORY

ANDERSSON, J. G. *Children of the Yellow Earth.* London and New York, 1934.

BAGCHI, P. C. *India and China, a Thousand Years of Cultural Relations.* 2nd edition, Bombay, 1950.

BISHOP, C. W. 'The Geographical Factor in the Development of Chinese Civilization', *Geographical Review*, XII, 1922.

BISHOP, C. W. 'The Rise of Civilization in China', *Geographical Review*, XXII, 1932.

BISHOP, C. W. *Origin of the Far Eastern Civilizations.* Washington, D.C., 1942.

CREEL, H. G. *The Birth of China.* London, 1936; revised edition, New York, 1954.

CREEL, H. G. *Studies in Early Chinese Culture.* London and Washington, D.C., 1938.

DUBS, H. H. *The History of the Former Han Dynasty.* 3 vols. Washington, D.C., 1938, 1944, 1955.

EBERHARD, W. *A History of China.* London, 1950.

EDWARDS, E. D. *Chinese Prose Literature of the T'ang Period.* 2 vols. London, 1937.

FAIRBANK, J. K., and REISCHAUER, E. O. *East Asia: The Great Tradition.* Boston, *c.* 1960.

FITZGERALD, C. P. *China, A Short Cultural History.* London, 1935. Revised edition, London, 1950.

GOODRICH, L. C. *A Short History of the Chinese People.* Revised edition, New York, 1951.

GRANET, Marcel. *Chinese Civilization.* London, 1930. Translation of *La Civilisation chinoise.* Paris, 1929.

GROUSSET, René. *Histoire de l'extrême orient.* 2 vols. Paris, 1929.

HUMMEL, A. W. *Eminent Chinese of the Ch'ing Period.* 2 vols. Washington, 1943.

LATOURETTE, K. S. *The Chinese, Their History and Culture.* 2nd revised edition. New York and London, 1934.

LI CHI. *The Beginnings of Chinese Civilization.* Seattle, 1957.

LIN YUTANG. *The Gay Genius: The Life and Times of Su Tung-p'o.* New York, 1947; London, 1948.

MASPÉRO, Henri. *La Chine antique. Histoire du monde,* IV. Paris, 1927.

WALEY, Arthur. *The Life and Times of Po Chü-i.* London and New York, 1949.

2. PHILOSOPHY AND RELIGION

CREEL, H. G. *Confucius, the Man and the Myth.* New York, 1949; London, 1951.

DAVIDSON, J. L. *The Lotus Sūtra in Chinese Art.* New Haven and Oxford, 1954.

DE VISSER, M. W. *The Arhats in China and Japan.* Berlin, 1923.

FUNG YU-LAN. *A History of Chinese Philosophy.* Translated by Derk Bodde. 2 vols. 2nd edition, Princeton, 1952-3.

FUNG YU-LAN. *A Short History of Chinese Philosophy.* New York, London, 1948. Edited by Derk Bodde.

GILES, H. A. *Chuang Tzu, Mystic, Moralist, and Social Reformer.* London, 1889; Shanghai, 1926.

GRANET, Marcel. *La Pensée chinoise.* Paris, 1934.

GROUSSET, René. *In the Footsteps of the Buddha.* London, 1932.

HUGHES, E. R. *Chinese Philosophy in Classical Times.* London and New York, 1942.

SHYROCK, J. K. *The Origin and Development of the State Cult of Confucius.* New York, 1932.

SUZUKI, D. T. *A Brief History of Early Chinese Philosophy.* London, 1914.

SUZUKI, D. T. *An Introduction to Zen Buddhism.* Kyōto, 1934.

WALEY, Arthur. *The Way and Its Power.* London, 1934; New York, 1935.

WALEY, Arthur. *The Book of Songs.* London and New York, 1937.

WALEY, Arthur. *The Analects of Confucius.* London, 1938; New York, 1939.

WALEY, Arthur. *Three Ways of Thought in Ancient China.* London, 1939, 1946.

3. ART—GENERAL

A. BOOKS

ASHTON, Leigh, and GRAY, Basil. *Chinese Art.* London, 1936.

BACHHOFER, Ludwig. *A Short History of Chinese Art.* New York, 1946.

BINYON, Laurence. *The Flight of the Dragon*. London, 1911.
BINYON, Laurence. *The Spirit of Man in Asian Art.* Cambridge, Mass., and London, 1935.
BURLING, Judith and A. H. *Chinese Art.* New York, 1953; London, 1954.
BUSHELL, S. W. *Chinese Art.* 2 vols. Revised edition, London, 1909.
CARTER, Dagny. *Four Thousand Years of China's Art.* New York, 1948.
COHN, William. *Chinese Art.* London, 1930.
CONSTEN, ELEANOR VON ERDBERG. *Das Alte China. Grosse Kulturen der Frühzeit.* Neue Folge. Stuttgart, 1958.
FISCHER, Otto. *Die Kunst Indiens, Chinas, und Japans. Propyläen Kunstgeschichte, IV.* Berlin, 1928.
GROUSSET, René. *The Civilizations of the East. China, III.* London, 1934.
GUEST, G. D., and WENLEY, A. G. *Annotated Outlines of the History of Chinese Art.* Freer Gallery of Art, Smithsonian Institution, Washington, 1946.
HACKIN, Joseph, and others. *Studies in Chinese Art and Some Indian Influences.* India Society, London, 1937.
Illustrated Catalogue of Chinese Government Exhibits for the International Exhibition of Chinese Art in London, 1935. Text in Chinese and English. 4 vols. Shanghai, 1936.
Imperial Household Museum. *Catalogue of the Imperial Treasures in the Shōsōin.* English notes by Jirō Harada. 15 vols. Tōkyō, 1929-43.
LEE, Sherman E. *A History of Far Eastern Art.* New York, 1964.
PALMGREN, Nils. *Selected Antiquities from the Collection of Gustaf Adolf, Crown Prince of Sweden.* Stockholm, 1948.
SICKMAN, Laurence, ed. *The University Prints, Oriental Art, Series O. Early Chinese Art, Section II.* Newton, Mass., 1938.
SIRÉN, Osvald. *History of Early Chinese Art.* 4 vols. London, 1929-30.
SIRÉN, Osvald. *Kinas Konst under Tre Artusenden.* 2 vols. Stockholm, 1942.
SPEISER, Werner. *Die Kunst Ostasiens.* Berlin, 1946.
SULLIVAN, Michael. *An Introduction to Chinese Art.* Berkeley, 1961.
The Chinese Expedition, A Commemorative Catalogue of the International Exhibition of Chinese Art in 1935-36. London, 1936.
Toyo Bijutsu Taikan: Masterpieces Selected from the Fine Arts of the Far East. Vols. 8-14. Tōkyō, 1908-18.
WILLETTS, William. *Chinese Art.* 2 vols. Harmondsworth, 1958.

B. PERIODICALS

Archives of the Chinese Art Society of America. New York, 1945 ff.
Artibus Asiae. Ascona, Switzerland, 1925 ff.
Bulletin of the Museum of Far Eastern Antiquities, Stockholm (Ostasiatiska Samlingarnen). Stockholm, 1929 ff.
Eastern Art. 3 vols. Philadelphia, 1928-31.
Monumenta Serica. Peking, 1935-48; Tōkyō, 1949-
Oriental Art. London, 1948-51; 1955-
Ostasiatische Zeitschrift (Gesellschaft für Ostasiatische Kunst). Berlin, 1912-37.
Revue des Arts Asiatiques, Paris, 1924-39. Now published as *Arts Asiatiques.* Paris, 1954-

PERIODICALS IN CHINESE

K'ao Ku, also written *K'ao Ku T'ung Hsin, Kaogu Tongxun.* Peking, 1955 ff.
Kaogu Xuebao, also written *K'ao Ku Hsüeh Pao* (Chinese Journal of Archaeology). Peking, 1951 ff.
Wen Wu, also written *Wen Wu Ts'an K'ao Tzu Liao.* Peking, 1950 ff.

4. SCULPTURE

i. GENERAL WORKS

A. BOOKS

ASHTON, Leigh. *An Introduction to the Study of Chinese Sculpture.* London, 1924.
CHAVANNES, Édouard. *La Sculpture sur pierre en Chine au temps des deux dynasties Han.* Paris, 1893.
CHAVANNES, Édouard. *Mission archéologique dans la Chine septentrionale.* 3 vols. Paris, 1909-15.
CHAVANNES, Édouard. *Six Monuments de la sculpture chinoise. Ars Asiatica, II.* Paris and Brussels, 1914.
MIZUNO, S., and NAGAHIRO, T. *The Buddhist Cave Temples of Hsiang-t'ang-ssu.* English summary and list of plates. Kyōto, 1937.
MIZUNO, S., and NAGAHIRO, T. *Ryūmon Sekkutsu no Kenkyū: A Study of the Buddhist Cave Temples at Lung-Mên, Honan.* English summary. Tōkyō, 1941.
MIZUNO, S., and NAGAHIRO, T. *Unkō Sekkutsu: Yün-Kang, The Buddhist Cave Temples of the Fifth Century A.D. in North China.* Text in Japanese with English summary. 16 vols. Kyōto, 1951-6.
MIZUNO, Seiichi. *Chinese Stone Sculpture.* Tōkyō, 1950.
MUNSTERBERG, H. *Chinese Buddhist Bronzes.* Rutland and Tōkyō, 1967.

ŌMURA, Seigai. *Shina Bijutsu-shi, Chōsōhen* (*History of Chinese Art, Sculpture*). 2 vols. Tōkyō, 1922.

PRIEST, Alan. *Chinese Sculpture in the Metropolitan Museum of Art*. New York, 1944.

RUDOLPH, Richard. *Han Tomb Art of West China*. Berkeley and Los Angeles, 1951.

SEGALEN, V., VOISINS, G. DE, and LARTIGUE, J. *Mission archéologique en Chine* (1914-17). 2 vols. (atlas). Paris, 1923-4.

SEGALEN, V., VOISINS, G. DE, and LARTIGUE, J. *L'Art funéraire à l'époque des Han*. Paris, 1935.

SEKINO, T. *Shina Santosho ni okeru Kandai Funbo Hyoshoku Fuzu* (*Sepulchral Remains of the Han Dynasty in Shantung*). Tōkyō, 1916.

SEKINO, T., and TAKESHIMA, T. *Ryōkin Jidai no Kenchiku to sono Butsuzo* (*Buddhist Architecture and Sculpture of the Liao-Chin Dynasties*). 2 vols. Tōkyō, 1934.

SEKINO, T., and TOKIWA, D. *Shina Bunka Shiseki* (*Cultural Monuments in China*). 12 vols. Tōkyō, 1939-41.

SIRÉN, Osvald. *Chinese Sculpture from the Fifth to the Fourteenth Centuries*. 4 vols. London, 1925.

SOPER, A. C. *Literary Evidence for Early Buddhist Art in China*. Ascona, 1959.

SWANN, Peter C. *Chinese Monumental Art*. New York, 1963.

TAKESHIMA, T. *Ryōkin Jidai no Kenchiku to sono Butsuzo* (*Buddhist Architecture and Sculpture of the Liao and Chin Dynasties*). Tōkyō, 1944.

TOKIWA, D., and SEKINO, T. *Shina Bukkyo Shiseki* (*Buddhist Monuments in China*). Text in English. 6 vols. Tōkyō, 1926-38. 6 portfolios plates.

TORII, Ryūzō. *Kōkogaku-jo yori mitaru Ryō no Bunka* - (*Zufu*) (*Illustrations of Archaeology*). 4 vols. Tōkyō, 1936.

Université de Paris. *Corpus des pierres sculptées Han* (*estampages*). 2 vols. Peking, 1950-51 (other volumes in preparation).

WHITE, W. C. *Chinese Temple Frescoes*. Toronto, 1940. Chapters 5, 6, 7.

CHINESE BOOKS

Ch'eng-tu Wan-fo-ssu shih-k'e I-shu (*The Art of Stone Carving in the Wan-fo Temple of Ch'eng-tu* (Szechwan Province). Edited by Liu Chih-yüan and Liu T'ing-pi. Peking, 1958.

Mai-chi-shan Shih-k'u (*Stone Grottoes of Mai-chi-shan*). Introduction by Cheng Chen-to. Peking, 1954.

Ssu-ch'üan Han-tai Hua-hsiang Hsüan-chi (*Selected Rubbings from Szechwan of the Han Dynasty*). By Wên Yu. Shanghai, 1955.

Yi-nan Ku-hua-hsiang Shih-mu Fa-chüeh Pao-kao (*Report on the Ancient Stone Relief Carvings Excavated from a Tomb at Yi-nan*). By Ts'eng Chao-yueh. Shanghai, 1956.

JAPANESE BOOKS

MATSUBARA, S. *Chinese Buddhist Sculpture*. Tōkyō, 1961.

MATSUBARA, S. *Chinese Buddhist Sculpture* (*Continuation*). Tōkyō, 1966.

B. MONOGRAPHS AND ARTICLES

BACHHOFER, Ludwig. 'Two Chinese Wooden Statues', *Burlington Magazine*, 73, 1938.

DAVIDSON, J. L. 'Traces of Buddhist Evangelism in Early Chinese Art', *Artibus Asiae*, XI, 4, 1948.

DRAKE, F. S. 'Sculptured Stones of the Han Dynasty', *Monumenta Serica*, VIII, 1943.

FAIRBANK, Wilma. 'The Offering Shrines of Wu Liang Tz'u', *Harvard Journal of Asiatic Studies*, VI, 1941.

FAIRBANK, Wilma. 'A Structural Key to Han Mural Art', *Harvard Journal of Asiatic Studies*, VII, 1942.

LODGE, J. E. 'Introduction to the Collection of Chinese Sculpture', *Museum of Fine Arts Bulletin*, (*Boston*) XIII, no. 78, 1915.

MIZUNO, Seiichi. 'Archaeological Survey of the Yünkang Grottoes', *Archives of the Chinese Art Society of America*, IV, 1950.

ROWLAND, Benjamin. 'Chinese Sculpture of the Pilgrimage Road', *Bulletin of the Fogg Art Museum*, IV, 2, 1935.

ROWLAND, Benjamin. 'Notes on the Dated Statues of the Northern Wei Dynasty and the Beginnings of Buddhist Sculpture in China', *The Art Bulletin*, XIX, I, 1937.

ROWLAND, Benjamin. 'Indian Images in Chinese Sculpture', *Artibus Asiae*, X, 1947.

SIRÉN, Osvald. 'Indian and Other Influences in Chinese Sculpture', *Studies in Chinese Art and Some Indian Influences*, London, 1938.

SIRÉN, Osvald. 'Chinese Marble Sculpture of the Transition Period', *Bulletin of the Museum of Far Eastern Antiquities*, no. 12, 1940.

SIRÉN, Osvald. 'Chinese Sculpture of the Sung, Liao, and Chin Dynasties', *Bulletin of the Museum of Far Eastern Antiquities*, no. 14, 1942.

SOPER, A. C. 'Hsiang-kuo-ssu, an Imperial Temple of Northern Sung', *Journal of the American Oriental Society*, no. 68, 1948.

SOPER, A. C. 'Literary Evidence for Early Buddhist Art in China, I. Foreign Images and Artists', *Oriental Art*, II, I, 1949.

SOPER, A. C. 'Literary Evidence for Early Buddhist Art in China, II. Pseudo-Foreign Images', *Artibus Asiae*, XVI, 1, 2, 1953.

YETTS, W. P. 'A Dated Bodhisattva Image from the Eumorfopoulos Collection', *The Burlington Magazine*, LXVIII, 1936.

ii. BRONZES

BARNARD, Noel. *Bronze Casting and Bronze Alloys in Ancient China*. Tōkyō, 1961.

JUNG KÊNG. *Shang Chou i ch'i t'ung k'ao* (The *Bronzes of Shang and Chou*). 2 vols. Peking, 1941.

KARLGREN, Bernhard. 'Yin and Chou in Chinese Bronzes', *Bulletin of the Museum of Far Eastern Antiquities*, no. 8, 1936. (*Yin and Chou Researches*, Stockholm, 1935.)

KARLGREN, Bernhard. 'New Studies on Chinese Bronzes', *Bulletin of the Museum of Far Eastern Antiquities*, no. 9, 1937.

KARLGREN, Bernhard. 'Huai and Han', *Bulletin of the Museum of Far Eastern Antiquities*, no. 13, 1941.

KARLGREN, Bernhard. *A Catalogue of the Chinese Bronzes in the Alfred F. Pillsbury Collection*. Minneapolis and London, 1952.

KELLEY, D. F., and CH'EN MENG-CHIA. *Chinese Bronzes from the Buckingham Collection, Art Institute of Chicago*. Chicago, 1946.

LODGE, J. E., WENLEY, A., and POPE, J. *A Descriptive and Illustrative Catalogue of Chinese Bronzes*. Freer Gallery of Art, Smithsonian Institution, Oriental Series, no. 3. Washington, 1946.

LOEHR, Max. 'The Bronze Styles of the Anyang Period', *Archives of the Chinese Art Society of America*, VII, 1953.

MIZUNO, S. *Bronzes and Jades of Ancient China*. Translated by J. O. Gauntlett. Nihon Keizei, Tōkyō, 1959.

PALMGREN, Nils. *Selected Chinese Antiquities from the Collection of Gustaf Adolf, Crown Prince of Sweden*. Stockholm, 1948.

UMEHARA, Sueji. *Étude des bronzes des royaumes combattants*. Japanese text. Kyōto, 1936.

UMEHARA, Sueji. *Rakuyō Kinson Kobō Shūei* (*Catalogue of Selected Relics from the Ancient Tombs of Chin-ts'un, Loyang*). English captions. Kyōto, 1937.

UMEHARA, Sueji. *Kanan Anyō Ihō: Selected Ancient Treasures Found at An-yang, Yin Sites*. English captions. Kyōto, 1940.

WATERBURY, Florance. *Early Chinese Symbols and Literature: Vestiges and Speculations*. New York, 1942.

WATSON, William. *Ancient Chinese Bronzes*. Rutland, 1962.

WHITE, W. C. *Tombs of Old Lo-yang*. Shanghai, 1934.

YETTS, W. P. *The George Eumorfopoulos Collection: Catalogue of the Chinese and Corean Bronzes, Sculpture, Jade, etc.* 3 vols. London, 1929–33.

YETTS, W. P. *The Cull Chinese Bronzes*. London, 1939.

5. PAINTING

A. BOOKS

ACKER, William R. B. *Some T'ang and Pre-T'ang Texts on Chinese Painting* (translated and annotated). Leiden, 1954.

BINYON, Laurence. *Painting in the Far East*. 4th revised edition, London, 1934.

CAHILL, James. *Chinese Painting*. Cleveland, 1960.

CAHILL, James. *Fantastics and Eccentrics in Chinese Painting*. New York, Asia Society, 1967.

CHIANG YEE. *Chinese Calligraphy*. London, 1938; new edition published 1954.

Chinese National Palace Museum and Chinese National Central Museum. *Chinese Art Treasures*. Taichung, Taiwan, 1961–2.

Chōsen Koseki Kenkyū Kwai: Detailed Report of Archaeological Research in Lo-lang. Keijo, 1934, 1935. Vol. I, *The Tomb of the Painted Basket*; Vol. II, *The Tomb of Wang Kuang* (English summary).

COHN, William. *Chinese Painting*. London, 1948.

CONTAG, Victoria. *Die sechs berühmten Meister der Ch'ing-Dynastie*. Leipzig, 1940.

CONTAG, Victoria. *Die Beiden Steine*. Braunschweig, 1950.

CONTAG, Victoria, and WANG CHI-CH'UAN. *Maler- und Sammler-Stempel aus der Ming- und Ch'ing-Zeit*. Shanghai, 1940.

DRISCOLL, L., and TODA, K. *Chinese Calligraphy*. Chicago, 1935.

EDWARDS, Richard. *The Field of Stones, A Study of the Art of Shên Chou, 1427–1509*. Smithsonian Institution, Freer Gallery of Art, Oriental Series, no. 5. Washington, 1962.

FISCHER, Otto. *Chinesische Landschaftsmalerei*. München, 1921.

FISCHER, Otto. *Die Chinesische Malerei der Han-Dynastie*. Berlin, 1931.

GRAY, BASIL. *Buddhist Cave Paintings at Tun-huang*. Photographs by J. B. Vincent; preface by Arthur Waley. University of Chicago, 1959.

HACKNEY, L. W., and YAU CHANG-FOO. *A Study of Chinese Paintings in the Collection of Ada Small Moore*. New York, 1940.

HARADA, B. *Shina Meigwa Hokan: A Pageant of Chinese Painting.* (Names in English.) Tōkyō, 1936.

HARADA, Yoshito. *Lo-lang, A Report on the Excavation of Wang Hsü's Tomb.* English summary. Tōkyō, 1930.

IKEUCHI, Hiroshi. *T'ung-Kou, The Ancient Site of Kao-kou-li in . . . Manchoukuo.* English summary. 2 vols. Tōkyō and Hsin-ching, 1938-40.

Ku Kung Shu Hua Chi: Collection of Calligraphy and Painting in the Palace Museum. 45 vols. Peking, 1929-35.

Ku Kung. Nos. I-XX. Edited by the Directors of the Palace Museum, Peking. 2nd edition, 1930.

Ku Kung Chou K'an (Palace Museum Miscellany). 22 vols. National Palace Museum, Peking. 1929-1937.

KUO HSI. *An Essay on Landscape Painting.* Translated by S. Sakanishi. Wisdom of the East Series. London, 1936.

LEE, Sherman E. *Chinese Landscape Painting.* Revised edition, Cleveland, *c.* 1962.

MARCH, Benjamin. *Some Technical Terms of Chinese Painting.* Washington, D.C., 1935.

NAGAHIRO, T. (ed.). *The Representational Art of the Han Dynasty.* Tōkyō, 1965.

National Palace Museum. *Three Hundred Masterpieces of Chinese Painting.* 6 vols. Taichung, Taiwan, 1959.

NORI, O., NAITO, H., and others. *Ying-ch'êng-tzu, Archaeologia Orientalis,* IV. Tōkyō and Kyōto, 1934.

PELLIOT, Paul. *Les Grottes de Touen Houang.* 6 portfolios plates. Paris, 1914-24.

ROWLEY, George. *Principles of Chinese Painting.* Princeton, 1947.

SAKANISHI, Shio. *The Spirit of the Brush.* Wisdom of the East Series. London, 1939.

Shina Nanga Taisei (Collection of Chinese Paintings of the Southern School). 24 vols. Plates. Tōkyō, 1935.

SICKMAN, Laurence (ed.). *Chinese Calligraphy and Painting in the Collection of John M. Crawford, Jr.* New York, Pierpont Morgan Library, 1962. Sections by L. Sickman, J. Cahill, R. Edwards, A. Lippe, M. Loehr, A. Fang, and S. Shimada.

SILVA, Anil de. *The Art of Chinese Landscape Painting in the Caves of Tun-huang.* Photographs by Dominique Darbois. New York, Crown, 1964.

SIRÉN, Osvald. *Chinese Painting, Leading Masters and Principles.* 7 vols. New York and London, 1956-8.

SIRÉN, Osvald. *Chinese Paintings in American Collections.* 2 vols. London, 1927-8.

SIRÉN, Osvald. *The Chinese on the Art of Painting.* Peking, 1936.

So Gen Meigwa-shu: Selected Masterpieces of Sung and Yüan Dynasties from Public and Private Collections in Japan. 2 vols. Plates. Tōkyō, 1930.

Sō Gen Min Shin Meigwa Taikan (Collection of Famous Paintings of the Sung, Yüan, Ming, and Ch'ing Dynasties). 2 vols. Tōkyō, 1931.

SOPER, A. C. *Kuo Jo-Hsü's Experiences in Painting.* Washington, 1951.

Sōraikwan Kinshō: Chinese Paintings in the Collection of the Abe Fusajiro. 6 vols. Ōsaka, 1930 ff.

SPEISER, Werner. *Meisterwerke Chinesischer Malerei.* Berlin, 1947.

STEIN, Sir Aurel. *The Thousand Buddhas.* London, 1921.

TAMURA, J., and KOBAYASHI, Y. *Tombs and Mural Paintings of Ch'ing-ling, Liao Imperial Mausoleums of Eleventh Century A.D. in Eastern Mongolia.* 2 vols. Kyōto, 1953.

Three Hundred Masterpieces of Chinese Painting in the Palace Museum. 6 vols. By the Joint Board of Directors of the National Palace Museum and the National Central Museum of the Republic of China, Taiwan, Taipei (in preparation).

TOMITA, Kojiro. *Portfolio of Chinese Paintings in the Boston Museum of Fine Arts (Han to Sung).* 2nd revised edition. Cambridge, Mass., 1938.

To Sō Gen Min Meigwa Taikan: Catalogue of Exhibition of Chinese Paintings of the T'ang, Sung, Yüan, and Ming Periods, Tōkyō Imperial Museum, 1928. 2 vols. Tōkyō, 1930.

Toyo Bijutsu Taikan: Masterpieces Selected from the Fine Arts of the Far East. Vols. VIII-XII. Tōkyō, 1908 ff.

VINCENT, Irene. *The Sacred Oasis.* Chicago, 1953.

WALEY, Arthur. *An Index of Chinese Artists.* London, 1922. ('Ergänzungen zu Waley's Index', by W. Speiser, *Ostasiatische Zeitschrift,* 1931 and 1938).

WALEY, Arthur. *An Introduction to the Study of Chinese Painting.* London, 1923.

WALEY, Arthur. *A Catalogue of Paintings Recovered from Tun-huang by Sir Aurel Stein.* London, 1931.

WARNER, Langdon. *Buddhist Wall Paintings from the Caves at Wan Fo Hsia.* Cambridge, Mass., 1938.

WHITE, W. C. *Tomb Tile Pictures of Ancient China.* Toronto, 1939.

WHITE, W. C. *Chinese Temple Frescoes.* Toronto, 1940.

CHINESE BOOKS

Hua-yüan To-ying (Gems of Chinese Painting). Catalogue of the Shanghai Museum collection. 3 vols. Preface by Hsü Sên-yü. 1955.

Sung-jên Hua-pan (Paintings of the Sung Dynasty). 13 vols. (all album leaves; others in preparation). Selected and reproduced by the Palace Museum, Peking. Peking, 1958.

B. MONOGRAPHS AND ARTICLES

BULLING, A. 'A Landscape Representation of the Western Han Period', *Artibus Asiae*, XXV, 4. Ascona, 1962.

CH'IU, A. K. 'The Chieh Tzu Yüan Hua Chuan', *Archives of the Chinese Art Society of America*, V. New York, 1951.

CONTAG, Victoria. 'The Unique Characteristics of Chinese Landscape Pictures', *Archives of the Chinese Art Society of America*, VI. New York, 1952.

DUBOSC, J. P. *Great Chinese Painters of the Ming and Ch'ing Dynasties*. Wildenstein Exhibition Catalogue. New York, 1949.

EDWARDS, Richard. 'Ch'ien Hsüan and "Early Autumn" ', *Archives of the Chinese Art Society of America*, VII. New York, 1953.

EDWARDS, Richard, and TSENG HSIEN-CH'I. 'Shên Chou at the Boston Museum', *Archives of the Chinese Art Society of America*, VIII. New York, 1954.

FAIRBANK, W., and KITANO, M. 'Han Mural Paintings in the Pei-yüan Tomb at Liao-yang, South Manchuria', *Artibus Asiae*, XVII, 3, 4. Ascona, 1954.

LOEHR, M. 'Chinese Paintings with Sung Dated Inscriptions', *Ars Orientalis*, IV. Baltimore, 1961.

MARCH, Benjamin. 'Linear Perspective in Chinese Painting', *Eastern Art*, III, 1931.

PAINE, R. T., Jr. 'The Ten Bamboo Studio', *Archives of the Chinese Art Society of America*, V. New York, 1951.

ROWLAND, Benjamin. 'The Problem of Hui Tsung', *Archives of the Chinese Art Society of America*, V. New York, 1951.

SHIMADA, S. 'Concerning the *I-P'in* Style of Painting', *Oriental Art* (New Series), VII, 2, 1961; VIII, 3, 1962; X, 1, 1964. Translated by J. Cahill.

SOPER, A. C. 'Early Chinese Landscape Painting', *Art Bulletin*, XXIII, 1941.

SOPER, A. C. 'Life-motion and the Sense of Space in Early Chinese Representational Art', *Art Bulletin*, XXX, 1948.

SOPER, A. C. 'The First Two Laws of Hsieh Ho', *Far Eastern Quarterly*, VIII, no. 4, 1949.

SOPER, A. C. (translated by). CHU CHING-HSÜAN, 'The Famous Painters of the T'ang Dynasty', *Archives of the Chinese Art Society of America*, IV. New York, 1950.

SULLIVAN, Michael. 'On the Origin of Landscape Representation in Chinese Art', *Archives of the Chinese Art Society of America*, VII. New York, 1953.

SULLIVAN, Michael. 'Pictorial Art and the Attitude toward Nature in Ancient China', *Art Bulletin*, XXXVI, 1954.

WANG SHIH-HSIANG. 'Chinese Ink Bamboo Paintings', *Archives of the Chinese Art Society of America*, III. New York, 1948-9.

CHINESE BOOKS

Shansi Province, Bureau of Cultural Affairs. *Wall Paintings in the Taoist Temple of Yung-lo Kung*. Peking, 1964.

PART TWO

I. GENERAL WORKS

BOERSCHMANN, E. *Die Baukunst und religiöse Kultur der Chinesen: Pagoden*. Berlin and Leipzig, 1911-31.

ITŌ, Chūta. *Tōyō Kenchiku no Kenkyū* [*Studies in Far Eastern Architecture*]. Tōkyō, 1936.

ITŌ, Seizō. *Shina Kenchiku* [*Chinese Architecture*]. Tōkyō, 1929.

LIANG, Ssu-ch'êng. *Ch'ing Shih Ying-tsao Tsê-li* [*Rules for Construction in the Ch'ing Style*]. Peking, 1934.

MURATO, Jirō. *Manshū no Shiseki* [*Manchurian Monuments*]. Tōkyō, 1944.

PRIP-MØLLER, J. *Chinese Buddhist Monasteries*. Copenhagen and London, 1937.

SEKINO, Tadashi, and TAKESHIMA, Takeuchi. *Ryōkin Jidai no Kenchiku to sono Butsuzō* [*Liao and Chin Buildings and their Sculptures*]. Tōkyō, 1925 (plates), 1944 (text, by Takeshima only).

TOKIWA, Daijō, and SEKINO, Tadashi. *Shina Bukkyō Shiseki* [*Monuments of Buddhism in China*]. Tōkyō, 1926-9.

WANG, Pi-wên. *Chung-kuo Chien-chu* [*Chinese Architecture*]. Peking, 1943.

2. SPECIALIZED SUBJECTS

ADACHI, Kiroku. *Chōan Shiseki no Kenkyū* [*A Study of the Monuments of Ch'ang-an*]. Tōkyō, 1937.

CREEL, H. G. *The Birth of China*. London, 1936; revised edition, New York, 1954.

EBERHARD, W. 'Bericht über die Ausgrabungen bei An-yang (Honan)', *Ostasiatische Zeitschrift*, Neue Folge, VIII, 1-2, 1932.

ECKE, G. 'Structural Features of the Stone-built T'ing Pagoda', *Monumenta Serica*, I, 1935-6, and XIII, 1948.

ECKE, G., and DEMIEVILLE, P. *The Twin Pagodas of Zayton*. Cambridge, 1935.

ITŌ, Seizō. *Hōten Kyūden Kenchiku Zushū* [*An Album of Pictures of the Old Palace Buildings in Mukden*]. Tōkyō, 1929.

LIANG, Ssu-Ch'êng, LIU, Tun-tsêng, and others. Monographs and field reports in *Chung-kuo Ying-tsao Hsüeh Shê Hui-k'an* [*Bulletin of the Society for Research in Chinese Architecture*]. II–VII, Peking, 1931–7; VII, Szechwan, 1944–5.

LIANG, Ssu-ch'êng, LIU, Tun-tsêng, and others, as editors for the 'Society for Research in Chinese Architecture'. *Chien-chu Shê-chi Ts'an-k'ao T'u Chi* (Portfolios for the Comparative Study of Architectural Details). IV–VII, IX–X, Peking, 1936–7.

MIZUNO, Seiichi. 'Rakuto Einōji Kai' [*On Yung-ning-ssu at Lo-yang*]. *Kōkogaku Ronsō*, X, 1939.

ŌMURA, Seigai. *Soheki Zanei* [Remains of Wall Sculptures]. Tōkyō, 1926.

SEKINO, Takeshi. Article listed on English title-page as 'The Site of the Ling-kuang Hall of Lu in the Former Han'. *Kōkogaku Zasshi*, XXXI, 1940.

SEKINO, Takeshi. Article listed as 'Investigation of Lin-tzu of Ch'i-tou (i.e. of the site of the Old Ch'i capital at Lin-tzu, Shantung)'. *Kōkokagu Zasshi*, XXXII, 1942.

TANAKA, Tōyōzō. Article listed as 'The Archaic Type of Buddhist Temples in China'. *Bijutsu Kenkyū*, XVI, 1933.

WANG, Kuo-wêi. 'Ming-t'ang-miao-ch'in-t'ung-k'ao' (A Study of the Ming T'ang, the ancestral shrines, and the royal residence), German translation by J. Hefter, *Ostasiatische Zeitschrift*, Neue Folge, VII, 1–2, 1931.

3. INTRODUCTORY WORKS IN EUROPEAN LANGUAGES NOT CITED ABOVE

BOERSCHMANN, E. *Chinesische Architektur*. Berlin, 1925.

SIRÉN, Osvald. 'Chinese Architecture'. *Encyclopedia Britannica*, 14th edition.

SIRÉN, Osvald. *The Walls and Gates of Peking*. London, 1924.

SIRÉN, Osvald. *The Imperial Palaces of Peking*. Paris and Brussels, 1926.

SIRÉN, Osvald. *Histoire des arts anciens de la Chine, IV, L'Architecture*. Paris and Brussels, 1930.

4. JAPANESE ARCHITECTURE

PAINE, R. T., and SOPER, A. C., *The Art and Architecture of Japan*. London, 1955.

SOPER, A. C., *The Evolution of Buddhist Architecture in Japan*. Princeton, 1942.

ADDITIONAL BIBLIOGRAPHY TO PART TWO

Almost all publications in the field have been Chinese, issuing from Peking and in the Chinese language only. Archaeological discoveries have in general been first reported in the periodical *Kaogu* (called prior to 1959 *K'ao-ku t'ung-hsün*). Surveys or more careful studies of buildings have usually appeared in the periodical *Wen-wu* (formerly *Wen-wu ts'an-k'ao tzu-liao*). In normal times both of these have been monthlies; both suspended publication in the spring of 1966.

Detailed archaeological studies, most often of Neolithic villages or tombs, have been published in *Kaogu Xuebao* (formerly *K'ao-ku hsüeh-pao*), normally a quarterly, sometimes with excellent English summaries.

The results of early excavations (1957–9) on the site of the T'ang imperial pleasure palace Ta-ming Kung are the subject of an exhaustive monograph by the Peking Institute of Archaeology, *Ta Ming Kung of the T'ang Capital Ch'ang An* (1959), with a two-page English abstract.

A picture-book, *Chung-kuo chien-chu* (Peking, 1957), illustrates a large number of extant buildings from late T'ang on, by rather mediocre photographs. Two views are given of the mid-ninth-century hall of Fo-kuang-ssu on Wu-t'ai Shan, and one of the main hall of Chen-kuo-ssu.

Most essential information on architecture of the pre-Han period may be found scattered through the four volumes in which Professor Cheng Te-k'un of Cambridge University has brought recent archaeological finds to a Western audience: his *Prehistoric China, Shang China, Chou China* (all Cambridge University Press, 1959, 1960, and 1963 respectively), and a sequel, *New Light on Prehistoric China* (University of Toronto Press, 1966). Professor Cheng's publishing schedule speaks of a volume in preparation on Han China.

LIST OF ILLUSTRATIONS

Except where credits are given in brackets, copyright in the photographs belongs to the gallery or owner cited as location.

1. Owl, white marble. Shang Dynasty, late second millennium B.C. H.45cm: 17¾in. *Taipei, Taiwan, Academia Sinica*
2. Seated man, white marble. Shang Dynasty, late second millennium B.C. H.*c*. 15cm: 5¾in. *Formerly Hong Kong, J. D. Chen*
3. Water-buffalo, white marble. Shang Dynasty, late second millennium B.C. *c*.12 × 21cm: 4⅝ × 8⅜in. *London, Mrs Walter Sedgwick*
4 and 5. Vessel, type *huo*, bronze. Shang-Yin to Early Chou Dynasty, *c*. twelfth to eleventh century B.C. 18 × 21cm: 7⅛ × 8¼in. *Washington, Smithsonian Institution, Freer Gallery of Art* (Archibald Wenley)
6. Rhinoceros, bronze. Shang-Yin to Early Chou Dynasty, *c*. twelfth to eleventh century B.C. *c*.22 × 37 cm: 8⅛ × 14½in. *San Francisco, De Young Museum, Avery Brundage Collection* (Courtesy Avery Brundage)
7 and 8. Tigers, bronze. Chou Dynasty, *c*. tenth century B.C. 25 × *c*.75cm: 9⅞in. × 2ft 5⅝in. *Washington, Smithsonian Institution, Freer Gallery of Art* (Archibald Wenley)
9. Water-buffalo, bronze. Chou Dynasty, *c*. tenth century B.C. *c*.11 × 21cm: 4½ × 8¼in. *Minneapolis Institute of Arts, Pillsbury Collection*
10. Quadruped, bronze. Late Chou Dynasty, *c*. sixth to third century B.C. *c*.11 × 18cm: 4½ × 7¼in. *Washington, Smithsonian Institution, Freer Gallery of Art* (Archibald Wenley)
11 and 12 (detail). Dragon, bronze. Late Chou Dynasty, *c*. sixth to third century B.C. L.*c*.65cm: 25⅝in. *Brussels, Stoclet Collection*
13. Rhinoceros, bronze vessel, type *tsun*. Late Chou to Ch'in Dynasty, fourth to third century B.C. 34·4 × 58·8cm: 13½ × 22¾in. *Sian, Shensi Provincial Museum*
14. Pair of horses, bronze. Late Chou Dynasty, *c*. sixth to third century B.C. (*left*) *c*.21 × 27cm: 8¼ × 10½in. (*right*) *c*.20 × 24cm: 7⅞ × 9¼in. *Kansas City, Nelson Gallery of Art and Atkins Museum*

15. Kneeling man, bronze. Late Chou Dynasty, *c*. sixth to third century B.C. *c*.28 × 15cm: 11⅛ × 6in. *Minneapolis Institute of Arts, Pillsbury Collection*
16. Wrestlers, bronze. Late Chou Dynasty, *c*. sixth to third century B.C. *c*.15 × 15cm: 6 × 6in. *Captain E. G. Spencer-Churchill, Gloucestershire*
17. Human figure, wood. Late Chou Dynasty, *c*. sixth to third century B.C. H.58·4cm: 23in. *New York, Mr and Mrs Myron S. Falk, Jun.*
18. Rubbing from a bronze vessel. Shang Dynasty (drawn by Theodore Ramos)
19. Vessel, type *hu*, bronze. Late Chou Dynasty, *c*. sixth to third century B.C. 35 × 24cm: 13⅞ × 9½in. *Minneapolis Institute of Arts, Pillsbury Collection*
20. Rubbing from a bronze vessel, type *hu*. Late Chou Dynasty, *c*. sixth to third century B.C. *Peking, National Palace Museum, Jannings Collection* (drawn by Theodore Ramos)
21. Rubbing from a bronze vessel, type *hu*. Late Chou Dynasty, *c*. sixth to third century B.C. (drawn by Theodore Ramos)
22. Rubbing from a bronze vessel, type *hu*. Late Chou Dynasty, *c*. sixth to third century B.C. (drawn by Theodore Ramos)
23. Lacquer box. Late Chou Dynasty, *c*. fourth to third century B.C. D.*c*.20cm: 8in. *Washington, John Hadley Cox*
24. Horse trampling a barbarian, tomb of Ho Ch'ü-ping, Shensi. 117 B.C. *c*.1·63 × 1·91m: 5ft 4in × 6ft 3in. (Segalen, de Voisins, and Lartigue)
25. Demon biting a small bear (rubbing), tomb of Ho Ch'ü-ping, Shensi. 117 B.C. *c*.2·69 × 1·75m: 8ft 10in × 5ft 9in. (L. Sickman)
26 and 27. Ch'u-hsien, Szechwan, Pillars of Shên. Second century A.D. H.*c*.2·67m: 8ft 9in. (Segalen, de Voisins, and Lartigue)
28. Bear, gilt-bronze. First century A.D. or earlier. H. 13·6cm: 5⅜in. *St Louis, City Art Museum*
29. Lion, stone. Second century A.D. *Formerly Turin, Gualino Collection* (C. T. Loo)
30. Lion, stone, from the tomb of Hsiao Hsiu, Nanking. Liang Dynasty, A.D. 518. L.*c*.3·66m: 12ft (Dr Osvald Sirén)
31. Chimera, stone. A.D. 209. *Ya-chou, Szechwan, tomb of Kao I.* L.*c*.1·65m: 5ft 5in. (Segalen, de Voisins, and Lartigue)

550–77. *c*.1·58 × 3·05m: 5ft 2in × 10ft 10in. *Washington, Smithsonian Institution, Freer Gallery of Art* (Archibald Wenley)

72 to 74. Monk and two Bodhisattvas, stone. Northern Ch'i Dynasty, A.D. 550–77. Monk 1·68m: 5ft 6in; Bodhisattvas 1·93 and 1·88m: 6ft 4in and 6ft 2in. *Philadelphia, University Museum of the University of Pennsylvania*

75. Rubbing from Southern Hsiang-t'ang Shan. Northern Ch'i Dynasty (drawn by Theodore Ramos)

76. Rubbing from Southern Hsiang-t'ang Shan. Northern Ch'i Dynasty (drawn by Theodore Ramos)

77 and 78. Funerary couch, stone. Two side slabs. Northern Ch'i Dynasty, A.D. 550–77. 1·13m × 65cm: 3ft 8⅛in × 2ft 1⅝in; 1·15m × 65cm: 3ft 9¾in × 2ft 1⅝in. *Boston, Museum of Fine Arts* (Kojiro Tomita)

79. Funerary couch, stone. Base and (*below*) two additional parts. Northern Ch'i Dynasty, A.D. 550–77. 60·3cm × 2·34m: 1ft 11¾in × 7ft 8⅛in. *Washington, Smithsonian Institution, Freer Gallery of Art* (Archibald Wenley)

80. Buddhist stele (detail), stone. Mid sixth century. H.*c*.3·66m: 12ft. *New York, Metropolitan Museum of Art* (Alan Priest)

81. Amitābha, stone. Northern Ch'i Dynasty, A.D. 577. H.2·68m: 8ft 9¾in. *Toronto, Royal Ontario Museum of Archaeology*

82. Buddha, stone, from Ch'ang-an, Shensi. Northern Chou Dynasty, *c*. A.D. 570. H.71cm: 2ft 4in. *Kansas City, Nelson Gallery of Art and Atkins Museum*

83. Avalokiteśvara, stone, from Ch'ang-an. Northern Chou Dynasty, *c*. A.D. 570. H.2·49m: 8ft 2in. *Boston, Museum of Fine Arts* (Kojiro Tomita)

84. Buddhist shrine, bronze. A.D. 593. H.*c*.76·5cm: 2ft 6⅛in. *Boston, Museum of Fine Arts* (Kojiro Tomita)

85 and 86. Ku K'ai-chih (*c*.344–*c*.406): Admonitions of the Instructress to the Court Ladies (details). 25cm × 3·47m: 9¾in × 11ft 4½in. *London, British Museum* (Courtesy of the Trustees)

87. Ku K'ai-chih: The Nymph of the Lo River (detail). Twelfth-century copy. *c*.24cm × 3·71m: 9½in × 12ft 2in. *Washington, Smithsonian Institution, Freer Gallery of Art* (Archibald Wenley)

88. Tun-huang, Kansu, cave 101, Buddha and attendants, fresco. Last quarter of the fifth century (Irene Vincent)

89. Tun-Huang, Kansu, cave 135, illustration of *Jātaka*, fresco. Early sixth century

90. Tun-huang, Kansu, cave 120 N, battle scene, fresco. A.D. 538–9 (Irene Vincent)

91, 92, and 93 (detail of 92). Sarcophagus engraved stone. *c*. A.D. 525. 61cm × 2·24m: 2ft × 7ft 4in. *Kansas City, Nelson Gallery of Art and Atkins Museum*

94. Tomb south of Pyongyang, Korea, wall painting. Latter half of the sixth century (Professor Sueji Umehara)

95. Tun-huang, Kansu, cave 150, Buddhist fresco. Early seventh century (Irene Vincent)

96. Lung-mên caves, Honan, Vairocana Buddha. A.D. 672–5. H. (including pedestal) 13·37m: 46ft (Professor Seiichi Mizuno)

97. Lung-mên caves, Honan, attendant Bodhisattva on left of central Buddha (detail). A.D. 672–5. H.*c*.11·54m: 40ft

98. T'ien-lung Shan, Shansi, cave XXI, Buddha and Bodhisattva. Late seventh to early eighth century. H. of Buddha (without base) *c*.1·11m: 3ft 7½in. (Daijo Tokiwa and Tadashi Sekino)

99. Eleven-headed Kuan-yin, niche from the Ch'i-pao T'ai, Ch'ang-an. Late seventh to early eighth century. 77·8 × 31·5cm: 2ft 6⅝in × 12¾in. *Washington, Smithsonian Institution, Freer Gallery of Art* (Archibald Wenley)

100. Buddhist stele, stone. Late seventh to eighth century. H.1·64m: 5ft 4½in. *New York, Metropolitan Museum of Art* (Alan Priest)

101. Bodhisattva, stone. Eighth century. H.*c*.97cm: 3ft 2in. *Washington, Smithsonian Institution, Freer Gallery of Art* (Archibald Wenley)

102. Bodhisattva, white marble, from Hopei. Eighth century. H.1·575m: 5ft 2in. *Cleveland Museum of Art, J. H. Wade Collection* (Courtesy Dr Sherman Lee)

103. Front of a stūpa, stone. Seventh century. 69 × 62cm: 2ft 3¼in × 2ft ½in. *Kansas City, Nelson Gallery of Art and Atkins Museum*

104. Bodhisattva, polychromed clay, from Tun-huang, cave 143. Eighth century. H.1·22m: 4ft. *Cambridge, Mass., Fogg Art Museum*

105. Buddha preaching, gilt-bronze. Early eighth century. H.*c*.20cm: 8in. *New York, Metropolitan Museum of Art* (Alan Priest)

106. Bodhisattva, gilt-bronze. Ninth century. *c*.23 × 11cm: 9 × 4⅜in. *Philadelphia Museum of Art* (Jean Lee)

107. Hsien-yang (near), Shensi, tomb of Emperor Kao-tsung (d. 683), horse (detail), stone (Segalen, de Voisins, and Lartigue)

108. Lion, white marble. Early eighth century. 30 × 25 × 20cm: 11¾ × 9¾ × 8in. *Kansas City, Nelson Gallery of Art and Atkins Museum*

109 and 110. Yen Li-pên: Portraits of the Emperors (details). Seventh century (?). 19·5cm × 1·21m: 1ft 8¼in × 17ft 4¼in. *Boston, Museum of Fine Arts* (Kojiro Tomita)

143. Lohan, three-colour pottery. Liao-Chin Dynasties, tenth to thirteenth centuries. H.1·05m: 3ft 5¼in. *New York, Metropolitan Museum of Art* (Alan Priest)

144. Kuan T'ung: Awaiting a Crossing. Ink and light colour on silk. Tenth century. 1·68 × 1·08m: 5ft 6½in × 3ft 6½in. *Taipei, Taiwan, National Palace Museum*

145. Yen Wên-kuei (late tenth century): Temples amid Mountains and Streams. Ink on silk. 103·9 × 47·4cm:41 × 18½in.*Taipei, Taiwan, National Palace Museum*

146 and 147 (detail). Li Ch'êng (fl. 940-67): Buddhist Temple in the Hills after Rain. Ink and slight colour on silk. *c*.1·12m × 56cm: 3ft 8in × 1ft 10in. *Kansas City, Nelson Gallery of Art and Atkins Museum*

148 and 149 (detail). Hsü Tao-ning (fl. first half of the eleventh century): Fishing in a Mountain Stream. Ink on silk. 48cm × *c*.2·10m: 1ft 7in × 6ft 10½in. *Kansas City, Nelson Gallery of Art and Atkins Museum*

150. Fan K'uan (fl. 990-1030): Travelling among Mountains and Streams. Ink on silk. 2·33 × 1·16m: 7ft 7¾in × 3ft 9⅝in. *Taipei, Taiwan, National Palace Museum*

151. Fan K'uan (fl. 990-1030): Winter Landscape. Ink on silk. 2·03 × 1·21m: 6ft 8in × 3ft 11⅝in. *Taipei, Taiwan, National Palace Museum*

152. Tung Yüan: The Hsiao and Hsiang. Ink and some colour on silk. Late tenth century. *Peking, Palace Museum*

153. Chü-jan: Seeking Instruction in the Autumnal Mountains. Ink on silk. Tenth century. 1·74m × 86cm: 5ft 8⅜in × 2ft 9⅞in. *Taipei, Taiwan, National Palace Museum*

154. Kuo Hsi (*c*.1020-90): Clear Autumn Skies over Mountains and Valleys (detail). Ink on silk. 26cm × 2·06m: 10¼in × 6ft 9¼in. *Washington, Smithsonian Institution, Freer Gallery of Art* (Archibald Wenley)

155. Mi Fei (1051-1107): Landscape. Ink on paper. Dated 1102. 51 × 49cm: 1ft 8¼in × 1ft 7¼in. *Tōkyō, F. Nakamura*

156. Ku Hung-chung: Night Entertainment of Han Hsi-tsai (detail). Colour on silk. Tenth century. 29cm × 3·38m: 11½in × 11ft 1in. *Peking, Palace Museum*

157. Chou Wên-chü: Ladies bathing Children. Colour on silk. *c*.970. 23 × 24cm:*c*.9 × 9⅜in. *Washington, Freer Gallery of Art* (Archibald Wenley)

158. Scholars of the Northern Ch'i Dynasty collating the Classic Texts (detail). Colour on silk. Tenth or eleventh century. *c*.28cm × 1·14m: 10⅞in × 3ft 8⅞in. *Boston, Museum of Fine Arts* (Kojiro Tomita)

159. Lady Wên-chi's Captivity in Mongolia and her

Return to China. Colour on silk. Eleventh to twelfth century. 25 × 53cm: 9⅞in × 1ft 9⅞in. *Boston, Museum of Fine Arts* (Kojiro Tomita)

160 and 161. Chang Tse-tuan: The Ch'ing-ming Festival on the River (details). Colour on silk. Early twelfth century. 25·5 × 525cm: 10in. × 17ft 22 in. *Peking, Palace Museum*

162. Kuan-hsiu (832-912): Lohan. Colour on silk. 1·27m × 67cm: 4ft 2in × 2ft 2in. *Tōkyō, National Museum*

163. Li Lung-mien (*c*.1040-1106): The Five Horses (detail). Ink on paper. 30cm × 1·82m: 11¾in × 5ft 11⅝in. *Japan, Private Collection* (C. T. Loo)

164. Deer in an Autumnal Wood. Colour on silk. Tenth to eleventh century. 1·33m × 71cm: 4ft 4¼in × 2ft 4⅛in. *Taipei, Taiwan, National Palace Museum*

165. Ts'ui Po: Hare scolded by Jays. Ink and colour on silk. Dated 1061. 2·23 × 1·15m: 7ft 3⅝in × 3ft 9⅜in. *Taipei, Taiwan, National Palace Museum*

166. Ts'ui Po: Bamboo and Heron. Ink and colour on silk. Eleventh century. 1·14m × 56cm: 3ft 9in × 1ft 10in. *Taipei, Taiwan, National Palace Museum*

167. Sung Hui-tsung (r. 1101-25): The Five-coloured Parakeet. Colour on silk. *c*.53cm × 1·25m: 21in × 4ft 1¼in. *Boston, Museum of Fine Arts* (Kojiro Tomita)

168. Su Han-ch'ên: Children at Play in a Garden. Colour on silk. Twelfth century. 1·78 × 1·09m: 5ft 10in × 3ft 6¾in. *Taipei, Taiwan, National Palace Museum*

169. Li T'ang: Wind in the Pines amid Myriad Ravines. Ink and slight colour on silk. 1124. 1·80 × 1·31m: 5ft 9in × 4ft 3½in. *Taipei, Taiwan, National Palace Museum*

170. Chao Po-chü: Palaces of Han. Colour on silk. Twelfth century. D.25·4cm: 10in. *Taipei, Taiwan, National Palace Museum*

171. Chiang Ts'an: Landscape (detail). Ink and slight colour on silk. Twelfth century. *c*.32cm × 2·75m: 12¾in × 9ft 8½in. *Kansas City, Nelson Gallery of Art and Atkins Museum*

172. Liu Sung-nien (*c*.1190-1230): Conversing with Guests in a Stream Pavilion. Colour on silk. 1·34m × 63·5cm: 4ft 4⅞in × 2ft 1in. *Taipei, Taiwan, National Palace Museum*

173. Ma Yüan (*c*. 1190-1224): Landscape. Ink on silk. *c*.86cm × 1·42m: 2ft 10in × 4ft 7¾in. *Taipei, Taiwan, National Palace Museum*

174. Ma Yüan (*c*.1190-1224): Egrets in a Snowy Landscape. Colour on silk. 61 × 40·3cm: 2ft × 1ft 3⅞ in. *Taipei, Taiwan, National Palace Museum*

175. Ma Yüan (*c*.1190-1224): The Four Greybeards (detail). Ink on paper. *c*.34cm × 3·08m: 13¼in × 10ft 1in. *Cincinnati Art Museum*

176. Hsia Kuei (*c*.1180-1230): Talking with a Friend under Pines by a Precipice. Ink on silk. *c*.25 × 43cm: 9¾in × 1ft 5in. *Taipei, Taiwan, National Palace Museum*

177 and 178 (detail). Hsia Kuei (*c*.1180-1230): Twelve Views from a Thatched Cottage. Ink on silk. 28cm × *c*.2·31m: 11in × 7ft 6¾in. *Kansas City, Nelson Gallery of Art and Atkins Museum*

179. Mu-ch'i: Kuan-yin. Ink on silk. Thirteenth century. *c*.1·42m × 96cm: 4ft 8in × 3ft 2in. *Kyōto, Japan, Daitokuji*

180. Mu-ch'i: Six Persimmons. Ink on paper. Thirteenth century. 36 × 38cm: 1ft 2¼in × 1ft 3in. *Kyōto, Japan, Daitokuji*

181. Mu-ch'i: Landscape from the scenes of the Hsiao and Hsiang Rivers. Ink on paper. Thirteenth century. 33cm × 1·13m: 1ft 1in × 3ft 8½in. *Tōkyō, Japan, Nezu Art Museum.*

182. Liang K'ai: The Sixth Patriarch chopping Bamboo. Ink on paper. Thirteenth century. *c*.71 × 32cm: 2ft 4in × 12½in. *Tōkyō, Japan, National Museum*

183. Liang K'ai: Li Po. Ink on paper. Thirteenth century. *c*.78 × 33cm: 2ft 6⅞in × 1ft 1⅛in. *Tōkyō, Japan, Cultural Properties Protection Commission*

184. Fan Tzu-min: Herding the Oxen (detail). Ink on paper. Thirteenth century. 27cm × 2·75m: 10⅝in × 9ft ¼in. *Chicago, Art Institute* (Courtesy Charles Kelley)

185. Ch'en Jung: Nine Dragons (detail). Ink and slight colour on paper. Dated 1244. *c*.46cm × 10·96m: 18¼in × 35ft 10in. *Boston, Museum of Fine Arts* (Kojiro Tomita)

186. Kung K'ai: Chung K'uei, the Demon Queller, on his Travels (detail). Ink on paper. Thirteenth century. *c*.33cm × *c*.1·66m: 12⅞in × 5ft 6¾in. *Washington, Smithsonian Institution, Freer Gallery of Art* (Archibald Wenley)

187. Ch'ien Hsüan (1235-90): Ming Huang teaching Yang Kuei-fei to play the Flute. Colour on paper. *Taipei, Taiwan, National Palace Museum*

188. Ch'ien Hsüan (1235-90): Flowers. Colour on paper. *c*.29 × 78cm: 11½in × 2ft 6⅞in. *Washington, Smithsonian Institution, Freer Gallery of Art* (Archibald Wenley)

189. Chao Mêng-fu (1254-1322): A Sheep and a Goat. Ink on paper. *c*.25 × 48cm: 9⅞in × 1ft 7in. *Washington, Smithsonian Institution, Freer Gallery of Art* (Archibald Wenley)

190. Chao Mêng-fu (1254-1322): Autumn Colours on the Ch'iao and Hua Mountains (detail). Ink and light colours on paper. Dated 1295. 28·5cm × 1·04m: 11¼in × 3ft 5in. *Taipei, Taiwan, National Palace Museum*

191. Chao Yung: Landscape. Ink and colour on silk. Fourteenth century. *c*. 86 × 43cm: 2ft 10in × 16¾in. *Cleveland, Mrs A. Dean Perry* (C. T. Loo)

192. Shêng Mou: Retreat in the Pleasant Summer Hills. Ink and colour on silk. Fourteenth century. *c*.1·21m × 58cm: 3ft 11¾in × 1ft 10¾in. *Kansas City, Nelson Gallery of Art and Atkins Museum*

193. Kao K'o-kung: Clearing in the Mountains after a Spring Rain. Colour on silk. Late thirteenth century. H.1·41 × 1·12m: 4ft 7½in × 3ft 8in. *Taipei, Taiwan, National Palace Museum*

194. Huang Kung-wang (1269-1354): Mountain Village. Ink on paper. *Tōkyō, Japan, Private Collection*

195. Wang Mêng (d. 1385): Sound of a Waterfall in the Autumn Gorge. Ink and colour on paper. *China, Private Collection*

196. Wang Mêng (d. 1385): Hermit dwelling in the Ch'ing-pien Mountains. Ink and colour on paper. Dated 1366. *Shanghai Museum* (Courtesy Dr James Cahill)

197. Wu Chên (1280-*c*.1354): Two Cypresses. Ink on silk. Dated 1328. 2·03 × 1·22m: 6ft 8in × 4ft. *Taipei, Taiwan, National Palace Museum*

198. Wu Chên (1280-*c*.1354): Fishermen (detail). Ink on paper. Dated 1352. *c*.82cm × 5·62m: 12¾in × 18ft 5in. *Washington, Smithsonian Institution, Freer Gallery of Art*

199. Ni Tsan (1301-74): Landscape. Ink on paper. Dated 1362. *c*.30 × 51cm: 11⅞in × 1ft 7⅞in. *Washington, Smithsonian Institution, Freer Gallery of Art*

200. Ni Tsan (1301-74): Rocks and Bamboo. Ink on paper. *c*.67 × 37cm: 2ft 2¼in × 1ft 2½in. *New York, Private Collection*

201. Ni Tsan (1301-74): The Six Worthies. Ink on paper. 1345. *China, Private Collection*

202. Wên T'ung: Bamboo. Ink on silk. Eleventh century. 1·46 × 1·17m: 4ft 9⅝in × 3ft 10in. *Taipei, Taiwan, National Palace Museum*

203. Li K'an (*c*.1260-1310): Bamboo (detail). Ink on paper. *c*.37cm × 2·38m: 1ft 2¾in × 7ft 9½in. *Kansas City, Nelson Gallery of Art and Atkins Museum*

204. Tsou Fu-lei: A Breath of Spring. Ink on paper. 1360. *c*.34cm × 2·22m: 13½in × 7ft 3¼in. *Washington, Smithsonian Institution, Freer Gallery of Art*

205. Liu Chüeh (1410-72): Landscape. Ink on paper. *Tōkyō, Japan, Motoyama Collection*

206. Wang Fu (1362-1416): The Lone Tree. Ink on paper. 1404. 1·28m × 44cm: 4ft 2¼in × 1ft 5¼in. *Taipei, Taiwan, National Palace Museum*

207. Hsia Ch'ang (1388-1470): Bamboo Bordered Stream in the Spring Rain. Ink on paper. 1441. L.15·24m: 50ft. *Chicago, Art Institute*

208. Hsüan-tê (r. 1426-35): Two Hounds. Ink and colour on paper. Dated A.D. 1427. 26 × 34cm: 10¼ × 13½in. *Cambridge, Mass., Fogg Art Museum*

209 Lü Chi (active 1488-1505): Geese beside a Snowy Bank. Ink and colour on silk. 1·85 × 1·24m: 6ft ¾in × 4ft 1in. *Taipei, Taiwan, National Palace Museum*

210. Tai Chin: Returning Home at Evening in Spring. Ink and colour on silk. Mid fifteenth century. 1·87m × 92cm: 6ft 1⅞in × 3ft ⅜in. *Taipei, Taiwan, National Palace Museum*

211. Tai Chin: Lohan. Ink and colour on paper. Mid fifteenth century. 1·26m × 41cm: 4ft 1¾in × 1ft 4¼in. *Taipei, Taiwan, National Palace Museum*

212. Tai Chin: Life on the River (detail). Ink and colour on paper. Mid fifteenth century. 47cm × 7·38m: 1ft 6½in × 24ft 2¾in. *Washington, Smithsonian Institution, Freer Gallery of Art* (Archibald Wenley)

213. Wu Wei (1459-1508): Scholar seated under a Tree. Ink and light colour on silk. 1·46m × 83cm: 4ft 9½in × 2ft 8¾in. *Boston, Museum of Fine Arts* (Kojiro Tomita)

214. Chang Lu (c.1464-1538): Lao-tzu riding on a Water-buffalo. Ink and colour on paper. 1·14m × 61cm: 3ft 9in × 2ft ¼in. *Taipei, Taiwan, National Palace Museum*

215. Chu Tuan: Landscape. Ink and light colour on paper. 1518. 1·23m × 62cm: 4ft ½in × 2ft ½in. *Boston, Museum of Fine Arts* (Kojiro Tomita)

216. Shên Chou (1427-1509): Gardening. Album leaf, ink and colour on paper. c.39 × 60cm: 1ft 3¼in × 1ft 11¾in. *Kansas City, Nelson Gallery of Art and Atkins Museum*

217. Shên Chou (1427-1509) Poet on a Mountain. Album leaf, ink on paper. c.39 × 60cm: 1ft 3¼in × 1ft 11¾in. *Kansas City, Nelson Gallery of Art and Atkins Museum*

218. Shên Chou (1427-1509): Happy Fishermen of the River Village (detail). Ink and colour on paper. 25cm × c.1·69m: 9¾in × 5ft 6½in. *Washington, Smithsonian Institution, Freer Gallery of Art* (Archibald Wenley)

219. Wên Chêng-ming (1470-1559): Mountain Landscape. Ink on paper. c.88 × 29cm: 2ft 10½in × 11½in. *Boston, Museum of Fine Arts* (Kojiro Tomita)

220. Wên Chêng-ming (1470-1559): Epidendrum and Bamboo. Ink on paper. 66 × 35cm: 2ft 2in × 1ft 1⅞in. *Taipei, Taiwan, National Palace Museum*

221. Wên Chêng-ming (1470-1559): Cypress and Rock. Ink on paper. 1550. 26 × 49cm: 10¼in × 1ft 7¼in. *Kansas City, Nelson Gallery of Art and Atkins Museum*

222. Ch'ên Tao-fu (1482-1539 or 1483-1544): Lotus (detail). Colour on paper. c.30cm × 5·79m: 12in ×

19ft 1in. *Kansas City, Nelson Gallery of Art and Atkins Museum*

223. T'ang Yin (1470-1523): Landscape, Early Spring. Ink and light colour on paper. 2·33m × 1·16m: 7ft 7¾in × 3ft 9in. *Taipei, Taiwan, National Palace Museum*

224. T'ang Yin (1470-1523): Voyage to the South. Ink on paper. Dated 1505. 24cm × 1·11m: 9½in × 3ft 7⅝in. *Washington, Smithsonian Institution, Freer Gallery of Art* (Archibald Wenley)

225. Ch'iu Ying (fl. c.1522-60): In the Shade of the Banana Trees at Summer's End. Ink and colour on paper. 4·87 × 1·10m: 16ft 3⅜in × 3ft 7⅜in. *Taipei, Taiwan, National Palace Museum*

226. Ch'iu Ying (fl. c.1522-60): A Lady in a Pavilion overlooking a Lake. Ink and colour on paper. c.90 × 38cm: 2ft 11¼in × 1ft 2¾in. *Boston, Museum of Fine Arts* (Kojiro Tomita)

227. Ch'iu Ying (fl. c.1522-60): Saying Farewell at Hsün-yang (detail). Colour on paper. c.34cm × c.3·96m: 13¼in × 13ft 1¼in. *Kansas City, Nelson Gallery of Art and Atkins Museum*

228. Tung Ch'i-ch'ang (1555-1636): Landscape. Ink on paper. Dated 1624. *Zürich, Charles A. Drenowatz* (Dr Walter Hochstadter)

229. Tung Ch'i-ch'ang (1555-1636): Landscape. Ink and colour on silk. c. 1·42m × 60cm: 4ft 8in × 1ft 11½in. *Nü Wa Chai Collection*

230. Chao Tso (fl. c.1610-20): Landscape. Ink and colour on paper. Dated 1615. *Stockholm, National Museum*

231. Wang Hui (1632-1717): Landscape. Ink and colour on paper.c.38cm × 7·44m: 15⅛in × 24ft 4¾in. *Washington, Smithsonian Institution, Freer Gallery of Art* (Archibald Wenley)

232. Wang Hui (1632-1717): Landscape. Ink and colour on paper. Dated 1677. c.53 × 41cm: 21 × 16⅛in. *Paris, Musée Guimet*

233. Wang Yüan-ch'i (1642-1715): Landscape (detail). Ink and colour on paper. c.36cm × 5·44m: 14in × 17ft 10¼in. *New York, Earl Morse*

234. Wu Li (1632-1718): Landscape. *New York, Walter Hochstadter*

235. Yün Shou-p'ing (1633-90): Lotus Flower. Colour on paper. *Ōsaka Museum, Japan, Abe Collection*

236. Yüan Chiang: Carts on a Winding Mountain Road. Ink and colour on silk. Dated 1694. 1·78m × c.93cm: 5ft 11⅛in × 3ft ¾in. *Kansas City, Nelson Gallery of Art and Atkins Museum*

237. Ch'ên Hung-shou (1599-1652): The Ch'in Player. Ink and colour on silk. 91 × 46cm: 2ft 11⅞in × 1ft 6⅛in. *Nü Wa Chai Collection*

INDEX

References to the notes are given only when they refer to matters of special interest or importance: such references are given to the page on which the note occurs, followed by the number of the chapter to which it belongs, and the number of the note. Thus, $485(17)^1$ indicates page 485, chapter 17, note 1.

Chinese words (except those which, like Peking, Canton, are usually written in English without syllabic division) are indexed according to their first element, without reference to the aspirate (if any exists); thus, Ch'i-sheng-ch'an-yüan precedes Chia-hsiang.

Museums, collections, etc., are placed under their location: thus, for Freer Gallery *see* Washington.